DÜRER'S LOST MASTERPIECE

ART AND SOCIETY *at the* DAWN OF A GLOBAL WORLD

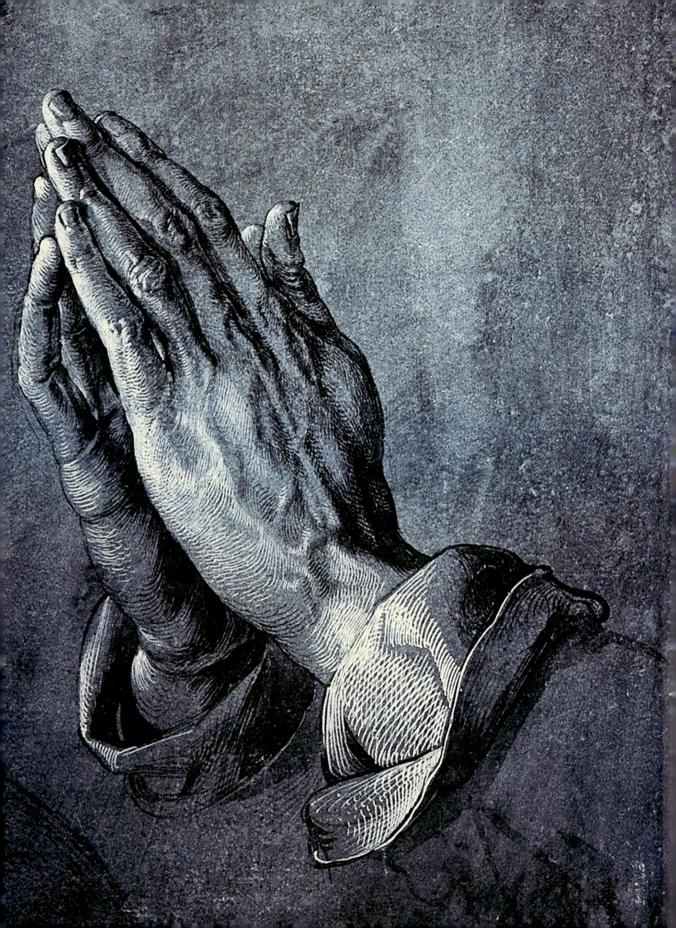

By the same author:

*The Astronomer & the Witch: Johannes Kepler's Fight
for His Mother*

Dressing Up: Cultural Identity in Renaissance Europe

Reformation Europe

The Crimes of Women in Early Modern Germany

Edited works include:

Hans Holbein, The Dance of Death

The Oxford Handbook of the Protestant Reformations

Protestant Empires: Globalising the Protestant Reformations

A Concise Companion to History

*The First Book of Fashion: The Books of Clothes of Matthäus
and Veit Konrad Schwarz*

ART AND SOCIETY *at the*
DAWN OF A GLOBAL WORLD

DÜRER'S LOST MASTERPIECE

ULINKA RUBLACK

OXFORD
UNIVERSITY PRESS

Great Clarendon Street, Oxford, OX2 6DP,
United Kingdom

Oxford University Press is a department of the University of Oxford.
It furthers the University's objective of excellence in research, scholarship,
and education by publishing worldwide. Oxford is a registered trade mark of
Oxford University Press in the UK and in certain other countries

© Ulinka Rublack 2023

The moral rights of the author have been asserted

All rights reserved. No part of this publication may be reproduced, stored in
a retrieval system, or transmitted, in any form or by any means, without the
prior permission in writing of Oxford University Press, or as expressly permitted
by law, by licence or under terms agreed with the appropriate reprographics
rights organization. Enquiries concerning reproduction outside the scope of the
above should be sent to the Rights Department, Oxford University Press, at the
address above

You must not circulate this work in any other form
and you must impose this same condition on any acquirer

Published in the United States of America by Oxford University Press
198 Madison Avenue, New York, NY 10016, United States of America

British Library Cataloguing in Publication Data
Data available

Library of Congress Control Number: 2022952226

ISBN 978–0–19–887310–5

DOI: 10.1093/oso/9780198873105.001.0001

Printed in the UK by
Bell & Bain Ltd., Glasgow

Links to third party websites are provided by Oxford in good faith and
for information only. Oxford disclaims any responsibility for the materials
contained in any third party website referenced in this work.

For João

ACKNOWLEDGEMENTS

THIS book has emerged from research conducted over fifteen years, and it is my pleasure to be able to acknowledge all the support I have received. Magnificent institutional support was offered by St John's College, Cambridge; the History Faculty, University of Cambridge; the Humboldt-Foundation; the Herzog August Library, Wolfenbüttel; NIAS in Amsterdam; and the Wissenschaftskolleg in Berlin. I am deeply grateful.

Part One of this book, on the making and significance of the Heller altarpiece, was rooted in teaching a Special Subject on *Albrecht Dürer and Cultures of the Visual in Renaissance Germany* over several years. I thank all my students who joined me on that journey, provided stimulating discussions, wrote astonishingly original essays, and were excited to try out the remaking of historical artefacts as new historical practice. We practically retraced many of the steps that an artist like Dürer would have involved himself in to create an altarpiece. This immeasurably deepened my understanding of complex painting as a material embodied process with its own temporality, and of what it meant to create and work with colour. Lucy Wrapson and Spike Bucklow, with whom I have had the enormous privilege to converse over many years, enabled our work at the Hamilton Kerr Institute for Picture Conservation at Cambridge University. Their knowledge and wisdom have benefited the book in so many ways, and Spike generously read over Part One and provided comments. I have co-taught this Special Subject with Sachiko Kusukawa and discussed key ideas—my respect for her scholarship and gratitude are immense. I have been fortunate to be part of a wave of scholars in my own institution and abroad who are turning material cultural history into one of the most exciting fields of current scholarship, to change both the theory and practice of history. I have been privileged to serve on the Advisory Board of the Making and Knowing Project at Columbia University. Pamela H. Smith has provided intellectual leadership of the highest calibre and boundless inspiration. At Cambridge, a large group of outstanding interdisciplinary scholars of material culture made new research initiatives a wholly collaborative happening that continuously rolled on. I treasure this and thank all the MPhil and PhD students, post-docs and undergraduate students I was privileged to work with or encounter, and especially five former PhD students who co-taught with me: Katy Bond, Holly Fletcher, Ana Howie, Suzanna Ivanič, and Sophie Pitman. I further thank my colleagues involved in the Material Culture Forum for the inspiration they have provided through initiatives and discussions, in particular Melissa Calaresu, Mary Laven, Caroline van Eck, Helen Pfeifer, Alexander Marr, John Robb, Nicholas Thomas, Anita Herle, and Elizabeth deMarrais. I also benefited immensely from discussions that evolved from a Swiss National Foundation-funded project 'Materialized

x *Acknowledgements*

Identities: Objects and Affects', for which I served as co-investigator and researched feathers as matter. My colleagues Christine Göttler, Susanna Burghartz, and Lucas Burkhart created a pleasurable, intense, and investigative research environment that resulted in an Open Access publication with the same title. Michele Seehafer's and Katy Bond's contributions as early career staff were greatly appreciated. Above all, I would like to pay tribute to Stefan Hanß's exceptional energy and insight as we worked together on the materiality of feathers and practices relating to their use, as well as on methodological questions. Jenny Tiramani in London generously taught us about feather crafting. I furthermore deeply appreciate the insights and opportunities to handle and research extant objects that a group of outstanding curators from Cambridge to New York and Berlin offered while I worked on this project – they have changed the way I understand objects and their lives. In Frankfurt's Historical Museum, Jan Gerchow guided me through the current display of the Heller altarpiece and supported my research in every possible way.

Parts Two and Three and the conception of the book furthermore benefited from Inger Leemans's invitation to spend time at the NIAS to join her research group on Knowing the Market. Here I was able to discuss the culture of art lovers with Inger and an outstanding team of young Dutch researchers as well as with Anne Goldgar, Claudia Swan, and Martin Mulsow. I thank Inger Leemans too for her inspired leadership, and Claudia, Anne, and Martin, in particular, for sharing their brilliant new work with me. Anne Goldgar's *Tulipmania* has long provided me with an appreciation of the best scholarship on material culture history. I also thank the Past & Present Society for permission to republish reworked sections of my article 'Matter in the Material Renaissance', published in *Past & Present*, 5/2013, 41–84, in Part Two, Chapters 3 and 4.

Part Three on Philipp Hainhofer took me to Wolfenbüttel for extended periods of time, as I worked hard to decipher this man's correspondence and get through the mountain of his papers. This book really could not have been written without the support of Peter Burschel, the library's director, and the Humboldt Foundation's Reimar Lüst-Prize. Ulrike Gleixner followed the project as it emerged, and the entire staff of the library was at hand to help and lend their formidable expertise when needed. Above all, Michael Wenzel was the perfect conversation partner as my understanding of Hainhofer's world deepened, and I have benefited greatly from his unrivalled expertise and shrewd assessments. I have much enjoyed a joint trip to Uppsala, and, most recently, the opportunity to jointly examine Hainhofer's Great Friendship Album in front of the original and in detail.

I am extremely grateful to the anonymous readers of a detailed book proposal I submitted to Oxford University Press, and in particular to one reader who took the trouble to work out arguments to challenge some of my positions. I am most indebted to colleagues who took time off their pressured calendars to read and comment on the entire manuscript: Renate Dürr, Bridget Heal, and Sachiko Kusukawa. Because of the pandemic, I was increasingly unable to try out ideas in front of seminar audiences; hence their response to the manuscript was even more precious than it would have been in

any case. Jeffrey Chipps Smith, Susan Foister and Giulia Bartrum kindly answered my questions. Anthony Ossa-Richardson, Jan Gerchow, and Ruth Scurr generously read individual chapters from the book or the proposal at a final stage. The book furthermore gained immensely from expert style- and copy-editing provided by Helen Clifford, alongside commentaries in some places—Helen herself being a formidable historian of material culture. All remaining mistakes, needless to say, are my own.

I was so lucky to be able to finalize the book during my year as a Fellow at the Wissenschaftskolleg in Berlin. Its director, Barbara Stollberg-Rilinger, offered an ideal environment and every possible support. The librarians Dominik Hagel, Stefan Gellner, Anja Brockmann, and Kristin Graupner have been exceptional in their help. Lena Heidemann joined that unique team to provide all the picture research in the cleverest and most organized way. This made all the difference.

I am furthermore grateful to my agent Catherine Clarke at the Felicity Bryan Agency, whose insightfulness and clear-headedness provide such wonderful guidance, and to Matthew Cotton and Cathryn Steele from Oxford University Press and Christoph Selzer and Tom Kraushaar from Klett-Cotta, with all of whom it is such a pleasure to work again as enlightened publishers. Many thanks also to the OUP production team for their patience and resilience in dealing with a demanding project.

Francisco Bethencourt, my husband, was my first and much-needed reader of the entire draft manuscript. He has supported me throughout the research process and all that life has thrown at us, however unexpected and demanding. I rejoice in our love, happiness and intellectual companionship. Sophie and João have tolerated my long fascination with Dürer and my research trips to Wolfenbüttel with good humour, always making life interesting and amusing. This book is dedicated to João, to his creativity and his ability to do things his own way, while honouring our family's roots; and I do so with great pleasure and love.

TABLE OF CONTENTS

List of Illustrations xvii

Introduction 1

PART ONE: Letters to Heller

1. What Few Can Do 23
2. Herr Jakob Heller 27
3. Dürer's Revenge 43
4. A Trio of Unconventional Friends 55
5. Preparing to Paint 63
6. Apelles AD 75
7. Letter 3 83
8. Who Will See It? 89
9. Oil and Pigment 97
10. Colour 113
11. Delivering 119
12. Journey to the Netherlands 127
13. Becoming Lutheran 141

xiv *Table of Contents*

PART TWO: Tastemakers

14. Hans Fugger and the Age of Curiosity	155
15. Hans Fugger's Taste for Painting	173
16. In Style!	185
17. Spending on Style	201
18. The Court of Bavaria	213
19. The Flow of Things	219
20. The Debt Crisis Implodes	231
21. Wilhelm V, Duke of Bavaria	241

PART THREE: Dürer and the Global Commerce of Art

22. The Lives of Northern Painters	259
23. The Art Agent	267
24. Becoming Philipp Hainhofer	275
25. Networks for Success	279
26. Visiting Wilhelm's Court	289
27. Trading Silks and a Fragile Career	291
28. The 'Old Lord'	295
29. Material Presence	315
30. Agent for the Duke of Pomerania	321
31. The Garden of Eichstätt	327
32. The Age of Maximilian I	343
33. Hunting Dürer	359

34. The Chase: Buying the Heller Altarpiece 369

35. Special Things 379

36. A British Spy? 389

PART FOUR: Shopping for Dürer in the Thirty Years' War

37. Art and Life in a Time of Crisis 397

Epilogue 423

Digital Resources for Further Viewing and Reading 433
Index 435

LIST OF ILLUSTRATIONS

1.1 Albrecht Dürer, self-portrait in a fur-trimmed coat, 1500, oil on panel, 67 × 49 cm. Alte Pinakothek, Munich. © Bayerische Staatsgemäldesammlungen, licence: CC BY-SA 4.0, URL: https://www.sammlung.pinakothek.de/de/artwork/Qlx2QpQ4Xq. 3

1.2 Albrecht Dürer, Rhinoceros, woodcut, 1515, 23.5 cm × 29.8 cm, National Gallery of Art, Washington DC, public domain. 4

1.3 Albrecht Dürer, Praying hands—most likely his own, 1508, 29 × 19 cm, pen and ink on blue paper, Albertina, Vienna, public domain. 6

1.4 Portrait of Ferrante Imperato's Museum, 1672. Ferrante Imperato, Historia naturale ... In questa seconda impressione aggiontovi da Gio[vanni] Maria alcune annotationi alle piante nel libro vigesimo ottavo, 2nd edn. (Venice, 1672), unpaginated insert. Courtesy of the Wellcome Library/Creative Commons Attribution only licence cc by 4.0. 11

1.5 Anton Mozart, c.1615/6, The Presentation of the Pomeranian Cabinet, oil on wood, 39.5 × 45.4 cm. Kunstgewerbemuseum Berlin, bpk/Kunstgewerbemuseum, SMB/Saturia Linke. 14

2.1 Circular stained glass, an angel holding the Heller and von Melem arms. © Historisches Museum Frankfurt, Fotograf: Uwe Dettmar. 29

2.2 Coloured title page of Eucharius Rösslin's bestselling treatise for pregnant women and midwives, Der Schwangerenn frawen und Hebammen Rosengarten, 1513. Bavarian State Library, Munich, CC BY-NC-SA 4.0, public domain. 33

2.3 Institut für Stadtgeschichte Frankfurt am Main, Best. S1-1004-08 (Holzhausen-Archive). Depiction of Jakob Heller and Katharina von Melem in the Melemsches housebook, sixteenth century. 34

xviii *List of Illustrations*

2.4a–c Early seventeenth-century copy of the Heller altarpiece, Jobst Harrich, oil on panel, 189 × 138 cm, 1614: a. whole view, b. Dürer's central panel, c. detail of Dürer's figure. © Historisches Museum Frankfurt, Photos: Horst Ziegenfusz. 37

3.1 Hausbuch der Mendelschen Zwölfbrüderstiftung. A Nuremberg's butcher during Dürer's lifetime, dressed in fashionable 'liver-colour', Stadtbibliothek im Bildungscampus Nürnberg, Amb. 279.2°, f. 17v. 44

3.2 Woodcut for the Ship of Fools, published by Sebastian Brant, Basel, 1494, public domain. 46

3.3 Jakob Heller and Katharina Melem as donors, part of the altarpiece commissioned from Dürer. © Historisches Museum Frankfurt, Photo: Horst Ziegenfusz. 52

3.4 Master of the Stalburg altar, Claus and Margarethe Stalburg, 1504, 188 × 56 cm, mixed technique on fir wood, Städel Museum, Frankfurt am Main, public domain. 53

4.1 Albrecht Dürer, Nude self-portrait, ink and watercolour, *c.*1509, Klassikstiftung, Weimar, Wikimedia Commons, public domain. 57

5.1 Albrecht Dürer, Studies for his *Adam and Eve* engraving, 1504, British Museum, BM, SL,5218.181 © The Trustees of the British Museum. 64

5.2 Albrecht Dürer, Landauer Altarpiece, 1511, 135 × 123.4 cm, oil on lindenwood © Kunsthistorisches Museum, Vienna, KHM-Museumsverband. 66

5.3 The cheese seller, Hans Thom, would have been among the first to worship in the Landauer foundation's newly built chapel containing Dürer's panel and stained glass. 68

6.1 Adam Kraft, Self-portrait of the Sculptor, Tabernacle in Nuremberg's St Laurence church © Theo Noll/www.nuernberg.museum. 80

8.1 Lucas van Leyden, Man writing, 1512, pencil on paper © The Trustees of the British Museum, London. 90

12.1 Albrecht Dürer, Instructions on Measurement, *1525*, copy with his own additions. Bavarian State Library, Sign 4° L.impr.c.n.mss.119, 17, and 200, public domain. 133

12.2 Albrecht Dürer, St Jerome in His Study, oil on panel, 1521, 60 cm × 48 cm, Museum Nacional de Arte Antiga, Lisbon, CC-BY 3.0 Foto: Sailko. 136

List of Illustrations xix

13.1 Albrecht Dürer, Willibald Pirckheimer, engraving, 1524.
Metropolitan Museum of Art, New York, public domain. 143

13.2 Matthäus Merian, View of Frankfurt am Main, Detail with the
Dominican monastery and the Jewish ghetto. Frankfurt
Historisches Museum © Historisches Museum Frankfurt, Fotograf:
Horst Ziegenfusz. 146

13.3 Attributed to Eberhard Schön, Dürer as an old man with his
coat of arms, woodcut, *c.*1538. Metropolitan Museum, New York,
public domain. 150

14.1 Wenzel Jamnitzer, Merkelsche table ornament in silver with life
casts of plants, insects, snakes, and lizards as an ode to Mother
Earth (in the centre) and all it brings forth, Nuremberg 1549,
100 × 46 cm, Rijksmuseum, Amsterdam. 158

14.2 Hans Muelich or Mielich, Archduchess Anna of Bavaria (1528–90),
daughter of Ferdinand I, Holy Roman Emperor, oil on canvas, 1556,
211 × 111 cm, Vienna, Kunsthistorisches Museum Neue Galerie,
KHM-Museumsverband. 164

14.3 Albrecht Dürer, Ill-assorted couple, the man wearing fashionable
elongated shoes with wooden overshoes. Engraving, 15 × 14 cm,
*c.*1495. Metropolitan Museum, New York, public domain. 166

15.1 Paolo Fiammingo and his Workshop, The Element of Water, oil on
canvas, 1596, public domain. 178

16.1 A sheet of Italian leather wallcovering, with pomegranate motifs,
*c.*1560, 66 × 59 cm, Museumslandschaft Hessen Kassel, Deutsches
Tapetenmuseum, Foto: Gabriele Bößert. 187

16.2 One of a pair of *Porsequine* shoes, leather, *c.*1590–1600, Spanish (?),
length 22 cm, width 6.5 cm, height 7 cm, Bavarian National
Museum, Munich, I 7–44. 190

16.3 Page from Hans Weigel, Trachtenbuch, Nuremberg 1577.
© The Master and Fellows of Trinity College, Cambridge. 196

17.1 Franz Pourbus the Younger, Margherita Gonzaga (1591–1632),
Duchess of Mantua, *c.*1601, oil on canvas. 93 × 69 cm.
Metropolitan Museum of Art, New York, public domain. 205

18.1 Hans Mielich, Albrecht and Anna of Bavaria with their five
descendants, Wilhelm kneeling to the left of his father, placed

xx *List of Illustrations*

under the Virgin Mary's protection. Liebfrauenmünster, Ingolstadt. Photo: Georg Pfeilschifter. 215

19.1 Hans Fugger, a coloured plate in the publication Fuggerorum et Fuggerarum Imagines, 1619, Bavarian State Library, License: http://creativecommons.org/licenses/by-nc-sa/4.0/deed.de; page 75 v. 226

20.1 Silk curtain, fifteenth century, Granada. Metropolitan Museum of Art, New York, public domain. 233

21.1 Braun and Hogenberg's contemporary depiction of Munich. Georg Hoefnagel, 1586, public domain. Wikimedia Commons. 242

21.2 Serpent labret with articulated tongue, gold, Aztec, 1300–1521, 6.67 × 4.45 × 6.67 cm, Metropolitan Museum of Art, New York, public domain. 243

22.1 Jan van der Straet, 'Color Olivi' from the Nova Reperta series, engraving, c.1580–1600. The Metropolitan Museum of Art, New York. The Elisha Whittelsey Collection, The Elisha Whittelsey Fund, 1949, public domain. 261

22.2 Dominic Custos, Maximilian I of Bavaria and his first wife Elisabeth of Lorraine as youthful rulers of Bavaria, engraving. © The Trustees of the British Museum. 264

23.1 After Albrecht Dürer, a copy, probably in a seventeenth-century hand, of the figure of the artist depicted in the middle distance of his painting 'The Coronation of the Virgin', the central panel of the Heller altarpiece of 1509, pen and brown ink, 18.2 × 10 cm © The Trustees of the British Museum. 268

23.2 Detail of a cabinet, assembled by Philipp Hainhofer, after 1617. Gustavianum, Uppsala. © Photo: Massimo Listri. 272

25.1 Double page from Philipp Hainhofer's large friendship album. Exquisite miniatures of flowers, insects, and shells. © Herzog August Bibliothek Wolfenbüttel, https://diglib.hab.de/mss/355-noviss-8f/start.htm. 280

25.2 Cornelis Vroom, Return of the Dutch Second Voyage to Nusantara, oil on canvas, 1599, Rijksmuseum, Amsterdam, public domain. 283

25.3 Geneaology of the Hainhofer Family, 1629, Ahnentafel Philipp Hainhofers, Ratsherr zu Augsburg, Bavarian State Library, public domain. Hainhofer's elaborate commission of a genealogy

attempted to visualize the nobility of his Augsburg merchant family. An idealized view of the city surrounded by the river Lech serves as backdrop. He was primed for this enterprise not least by helping to work on the Fuggers' genealogy as young man. 287

27.1 Franz Hals, Portrait of Isaac Abrahamszoon Massa (1586–1643) and his wife, oil on canvas, 1622. Rijksmuseum, Amsterdam, public domain. 292

28.1 Anon., Wilhelm V, after 1600, engraving, 17.5 × 12 cm. © The Trustees of the British Museum. The abdicated ruler Wilhelm of Bavaria as 'old Lord', pointing to his Order of the Golden Fleece. 296

28.2 Gerardi Mercatoris, Atlas sive Cosmographicae Meditationes [...] excusum in aedibus Iudoci Hondii Amsterodami, Amsterdam, 1609. Stanford Libraries, public domain mark 1.0. 300

28.3 Depictions of the Dutch fight against polar bears with different weapons on the Nova Zembla expedition that were adapted by Hulsius. Rijksmuseum, Amsterdam, public domain. 302

28.4 Ottoman rain hat, felt, sixteenth century. Gustavianum, Uppsala, Uppsala university collections/Mikael Wallerstedt. 305

28.5 Theodor de Bry, America, Title page, Frankfurt 1590. Courtesy of the John Carter Brown Library. 310

29.1a,b Peter Isselburg, Basilius Besler, *Fasciculus rariorum et aspectu dignorum varii generis*, 1618, engraving, 18.6 × 28.2 cm. Frontispiece and image of shells, Johann Christian Senckenberg University Library Frankfurt am Main, public domain. 316

29.2 Unpolished shells from the wreck of the VOC ship Witte Leeuw that sank en route from Bantam to Amsterdam in 1613, including the *conus marmoreus*, named after its marble effect. Rijksmuseum, Amsterdam, public domain. 317

29.3 A small, delicate nautilus shell, polished and engraved with astonishing skill as a cabinet piece with wine leaves and insects by Cornelis Bellekin, 1650–1700. Rijksmuseum, Amsterdam, public domain. 318

30.1 Lucas Kilian, Philipp II of Pomerania-Stettin, 1613, engraving. © Herzog August Bibliothek, Wolfenbüttel, CC BY-SA 3.0 DE. 323

31.1 Wolfgang Kilian, Johann Konrad von Gemmingen, Prince-Bishop of Eichstätt, 1606, engraving. Missouri Botanical Garden, Peter H. Raven Library, public domain. 328

xxii *List of Illustrations*

31.2 Philipp Hainhofer, The Willibaldsburg in 1611, watercolour and ink, HAB Cod. Guelf. 23.3. Aug. 2°, fol.13v–14r © Herzog August Bibliothek Wolfenbüttel <http://diglib.hab.de/mss/23-3-aug-2f/start.htm>. 329

31.3 and 31.4 Depictions of rare, vibrantly coloured flowers from the bishop's Hortus Eystettensis, 1613. Hochschul- und Landesbibliothek RheinMain, CC-BY 4.0. 332

31.5 Roelandt Savery, Orpheus, 1628, oil on oak, 53 × 81.5 cm. © National Gallery, London. 335

31.6 Basilius Besler, Hortus Eystettensis, 1613, British Library, London. © British Library Board (10.Tab.29), title page. 337

32.1 The trophy painting on white silk satin of Emperor Rudolph II in Hainhofer's friendship album—a ruler he had never met. © Herzog August Bibliothek Wolfenbüttel, https://diglib.hab.de/mss/355-noviss-8f/start.htm. 349

33.1 Lukas Kilian, Portrait of Albrecht Dürer, after Rottenhammer's copy of Dürer's self-portrait from The Feast of the Rose Garlands, engraving, 34 × 20.5 cm, 1608. Wikimedia commons, public domain. 360

34.1 Lucas Kilian, Alberti Dureri Noribergensis, Pictorum Germaniae Principis effigies genuina duplex, *c.*1628, engraving, 38 × 26.4 cm. Photograph retrieved from the Library of Congress, https://www.loc.gov/item/2015650882/. 376

35.1 A bird-house by or in the tradition of Johannes Schwegler in Hainhofer's Uppsala cabinet, Uppsala university collections/Mikael Wallerstedt. 380

35.2 Matthias Kager?, drawing of small farmyard model with a large variety of lifelike miniature birds, Augsburg, *c.*1611. Germanisches Nationalmuseum, Nuremberg. Photo: Monika Runge. 381

36.1 Anton Mozart, The Presentation of the Pomeranian Cabinet, *c.*1615. Kunstgewerbemuseum Berlin. © bpk/Kunstgewerbemuseum, SMB/Markus Hilbich. 390

37.1 A depiction of Elias Holl's new town hall in Augsburg in 1620 and its wide square. Herzog August Library, Wolfenbüttel, http://diglib.hab.de/mss/23-2-aug-2f/start.htm. 403

37.2 Lucas Vorsterman I (after Anthony van Dyck), Alathea Talbot, Lady Arundel, with a compass and armillary sphere, and

Thomas Howard, earl of Arundel, engraving, *c.*1640–50.
© Trustees of the British Museum. 404

37.3 Wenzel Hollar, engraving of Albrecht Dürer's 1498 self-portrait,
1645. Rijksmuseum, Amsterdam, public domain. 410

37.4 Johann Gregor van der Schardt, bust of Anna Imhoff (1528–1601),
terracotta and paint, *c.*1580. Bode Museum, Berlin. bpk/
Skulpturensammlung und Museum für Byzantinische Kunst,
SMB/Jörg P. Anders. 412

Introduction

In August 1471, the city of Nuremberg prepared for the entry of Emperor Frederick III (1415–93), who arrived with an entourage on eight hundred horses. Seated on a white horse in a black riding costume, a coat, a cap, and large bonnet on top, despite the summer heat, Frederick III was welcomed by men from the city's patrician families, the clergy, and by schoolboys, all of them waving banners bearing his coat of arms. A brewer stood amongst those who watched the Habsburg Emperor make his way into the German city. His chronicle notes that it was the finest and driest summer known for a century. The sun had risen early above Nuremberg castle, flooding the church spires and rooftops in bright morning light. Nuremberg, one of the Holy Roman Empire's most important political, religious, and economic centres, numbered around 40,000 inhabitants. Its councillors proudly presented Frederick III with a jewel once owned by the Emperor Charlemagne and a gilt ostrich egg filled to the brim with valuable coins.

As he toured the city, the Emperor did something which might surprise us, as it did our brewer, who was naturally keen to note it down. Clad in fine robes, Frederick III moved through the quarters in which the common people lived. He talked to three different smiths in their foundries. One of them made knives, another was noted for the rapid manufacture of great quantities of guns, while the third displayed a copper bathtub. He rewarded each of them for their clever inventions, and also admired a new wooden bridge and a brewery.

Over the course of two evenings, Frederick III attended dances held by the local elite, joined by his sister who arrived with six wagonloads of beautiful girls. He gave each of these virgins a golden ring, and his sister a golden gown lined with sable fur, held together by a clasp worth 200 florins. Frederick III stayed in Nuremberg for thirteen days. On the last day, the Emperor left at exactly one o'clock in the morning. It was, the brewer thought, as if he was following his astrologers' instructions.[1]

Albrecht Dürer, born three months before Frederick III's visit, lay swaddled in his cradle that summer. His father was one of Nuremberg's prized master goldsmiths, whom the city council had ordered to 'speedily finish' the Emperors' drinking vessels'.[2]

[1] *Die Chroniken der fränkischen Städte: Nürnberg*, vol. 4, Deichsler Chronik (Leipzig, 1872), 327–30.

[2] Three years later, Frederick III summoned him to his castle in the Austrian city of Linz. Dürer the Elder presented him with a selection of his designs on paper, for which Frederick III rewarded him with four florins

2 Ulinka Rublack

Dürer was meant to follow in his father's footsteps as a valued goldsmith, crafting rings, reliquaries, goblets, and tankards, embellishing coconuts and ostrich eggs, making shafts for weapons and clasps for gowns that would endear him to Emperors. Although young Dürer learnt his craft from his father, as he matured, he came to love the rich colours of the paintings in Nuremberg's churches, and drawing from life. Aged thirteen, he sat down and took up a silver pen to portray himself. This was a different kind of art from goldsmithing. He asked his father if he could be apprenticed to a painter. Dürer remembered his father as a man of few words, clearly upset by his request. A Hungarian immigrant, his father had only become a master with his own Nuremberg workshop aged forty and now was already past his fifties. At that moment years of training might have appeared to have been wasted as he knew he would not be handing over his workshop to this talented son. Finally, he relented. Within years, Albrecht Dürer excelled in drawing, woodcutting, water-colouring, engraving, and painting, and wanted to become the greatest German artist of all time. [1.1]

One way of telling Dürer's story is of straightforward success. His spectacular self-portrait in oil, painted when he was twenty-eight in 1500, which now hangs in the Alte Pinakothek in Munich, can be viewed as equivalent to the Louvre's Mona Lisa. In it he depicted himself as having been created in the very image of Jesus Christ, proving that Germany could stand at the height of civilization through learning, true Christian devotion and eloquence in an age when young German patricians studying in Italy were insulted as barbarian pigs.

Dürer's creativity, output, and ambition were enormous. He produced endless innovative works for different media that were the first of their kind. In 1498, Dürer published the *Apocalypse*—a terrifying spectre of ravaging plague, famine, and war at the end of times. It was the first uncommissioned book of large woodcut prints to have been created. Propelled by the possibilities of a new age of print, Dürer also created cheap woodcuts of novel subjects in naturalistic detail. One of his most famous prints looks as if he had actually *seen* the Indian rhinoceros that had disembarked from a boat in Lisbon in 1515, although he had not. His delight and excitement with the creature are palpable. What a curious beast! It was 'such a marvel' that he 'had to' represent it. It scared elephants, Dürer learnt, and, despite looking so heavy with its solid outer plates, was 'very lively and alert'. Dürer's woodcut made this the best-known rhinoceros ever, as the print ran hot off presses, and was imitated across Europe as far as India.[3] [1.2]

An outstanding portraitist and great storyteller, Dürer shaped the European Renaissance, north and south, east and west. For elite audiences, the artist produced engravings so fine and inventive that no one has since been able to rival them. Their visual wit and trickery showed off the patience, perfection, and passion for detail his father had taught him as a goldsmith. They involved weeks of painstaking work with

and orders to give himself a treat. Eventually, he was granted leave to return home, hoping that the Emperor would not only pay for the trip's expenses but also commission some work, Jeffrey Ashcroft, *Albrecht Dürer: Documentary Biography* (New Haven, 2017), vol. 1, 53–4.

[3] Ashcroft, *Dürer*, vol. 1, 419–20.

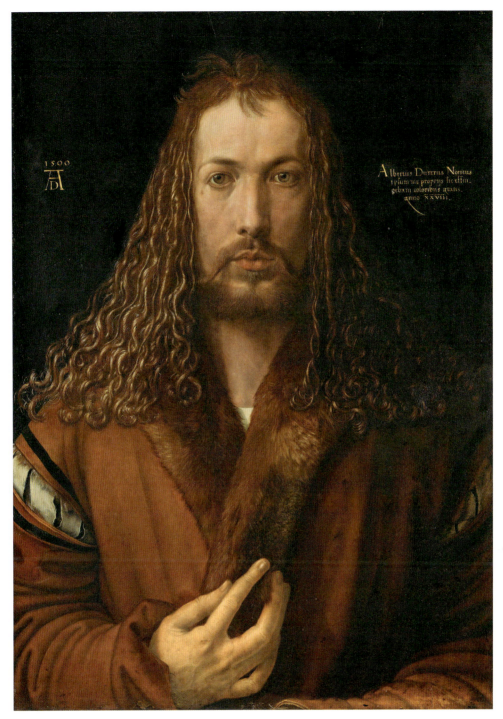

Fig. 1.1 Albrecht Dürer, self-portrait in a fur-trimmed coat, 1500, oil on panel, 67 × 49 cm. Alte Pinakothek, Munich. © Bayerische Staatsgemäldesammlungen, licence: CC BY-SA 4.0, URL: https://www.sammlung.pinakothek.de/de/artwork/Qlx2QpQ4Xq. Albrecht Dürer's self-portrait with his monogram AD and an inscription in gold letters, echoed in the golden highlights in his hair. It was painted in 1500, a century pregnant with hopes for a future 'golden age' of learning. Earthen colours and black were associated with a melancholic disposition that befitted this identification with Christ's humanity, wisdom and suffering, yet also reflecting the sober style of dress adopted by Nuremberg's councillors as well as Dürer's interest in working with just four pigments in imitation of the ancient masters. Dürer kept this portrait in his house.

4 Ulinka Rublack

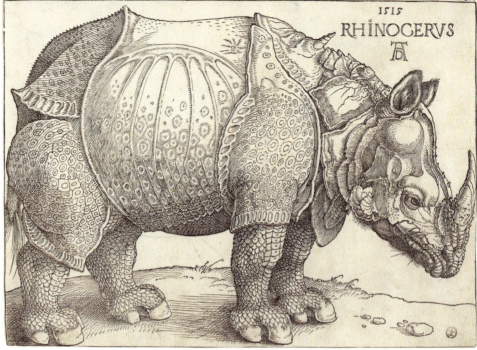

Fig. 1.2 Albrecht Dürer, rhinoceros, woodcut, 1515, 23.5 cm × 29.8 cm, National Gallery of Art, Washington DC, public domain.

burins on a copper plate. Between 1512 and 1519, the Habsburg Emperor Maximilian I enlisted Dürer to glorify his powerful dynasty through the new technology of print. As Dürer's confidence grew, he laboured over theoretical books about the arts of perspective and lifelike imitation of nature with a grand vision: to make accessible educative material that would enable makers to improve their work and livelihoods. Few of his peers attempted anything similar.

When Dürer visited Antwerp in 1520, when he was in his fifties, the art community welcomed him as a celebrity. In his diary, he relives the experience and conveys his excitement. The painter's guild had invited him and his wife Agnes to attend a festive dinner in his honour at their hall. As the couple entered, everyone rose as Dürer made his way to the head of a table brilliantly decked out with 'silver cutlery and other precious tableware, and splendid food'. As well as relishing fine food Dürer also loved playing to an audience. All attention was on him. He particularly noted how 'eminent' people bowed deeply, as if 'some great lord were entering'. Six cans of wine were ceremoniously presented to him as gifts. The evening turned into a long convivial night. Antwerp showered him with honours.[4] That night symbolizes a wider recognition of

[4] Ashcroft, *Dürer*, vol. 1, 555–6.

Northern Renaissance art, something that Dürer's generation had fought so hard to achieve. After his death in 1528, Dürer's fame endured not only through his self-portraits and prints but also through his drawings and watercolours of landscapes, plants, and animals. Leave Munich airport today and you can buy Nuremberg gingerbread presented in tin boxes decorated with a selection of his images, including his famous watercolour of a hare.

Yet there is a different way to look at Dürer's story. Rather than presenting a smooth linear path to success it pays attention to the big shifts and changes in his life. It takes notice of what he stopped doing and broke away from, for example when he left his father's world.[5] After 1500, Dürer never again portrayed himself on a self-standing panel, or indeed in any medium for public display after 1512. Nor did he produce another puzzling print open to endless interpretation after his famous *Melencolia I* made in 1514. Mid-career, Dürer stopped engaging with classical mythology in his work. After 1516, he took nature as his only guide, and mostly abandoned work that displayed his inventive imagination.

One of Dürer's most radical decisions dates to 1511, when he gave up producing altarpieces, even though they offered unique opportunities to work creatively on compositions over a long period of time, to try out new materials. Imagine if a composer of complex symphonies, or a writer of novels, suddenly stopped work while at the top of their game. Understanding such transformative decisions opens a new window into Dürer and his age, when patterns of consumption and commerce changed. Succeeding as an artist meant confronting contradictions that were part of this world and experiencing losses and gains, compromises, and expanding to new horizons.

This was a time that witnessed great shifts in how wealth was spent. Art became part of a growing luxury goods sector that included fine fashion, pedigree horses or dogs, exotic foods and plants. There were few clear-cut distinctions between the fine and decorative arts.[6] The market for uncommissioned artwork rapidly grew. Specialized luxury merchants generated supplies to capture the imagination of consumers. Art works across a spectrum of quality and price points were among their fare. Rulers expressed their ambition by collecting extensively for their courts, often scaling up their collection projects through new, dedicated buildings; urban elites and middling classes began decorating their homes with paintings, prints, and smaller collections of rarities and decorative objects. These trends were linked to the great expansion of cultural production. Dürer's rise as an artist and lasting fame was linked to the emergence and

[5] Thomas Schauerte, *Dürer: Das ferne Genie. Eine Biographie* (Leipzig, 2012) adopts a similar perspective.

[6] For a seminal conference charting these trends in Europe see Pamela H. Smith, Paula Findlen eds., *Merchants and Marvels: Commerce, Science, and Art in Early Modern Europe* (London, 2002); and Simonetta Cavaciocchi ed., *Economia e Arte Secc. XIII–XVIII* (Florence 2002); for a comparative perspective see also Neil de Marchi, Hans J. Van Miegroet eds., *Mapping Markets for Paintings in Europe, 1450–1750* (Brepols, 2006) and Christof Jeggle et al. eds., *Luxusgegenstände und Kunstwerke vom Mittelalter bis zur Gegenwart: Produktion—Handel—Formen der Aneignung* (Constance, 2015).

6 Ulinka Rublack

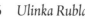

Fig. 1.3 Albrecht Dürer, Praying hands—most likely his own, 1508, 29 × 19 cm, pen and ink on blue paper, Albertina, Vienna, public domain.

greater integration of these international art markets; he actively branded himself as an easily identifiable artistic type through his look and copyrighted monogram.[7]

 This book tells the story of Dürer's art set within this new age of commerce and art collecting by focusing on an altar painting that belongs to his best, though least-known, works. It remains famous through one preparatory drawing, the 'praying hands'. [1.3] The motif is on the cover of an album by the rapper Drake, and, taken up by Andy Warhol, it appears on brands everywhere. It is on that gingerbread jar in Munich

[7] Joseph Leo Koerner, *The Moment of Self-Portraiture in German Renaissance Art* (Chicago, 1993); the best discussion of scholarship on Dürer as commercial artist is provided by Wolfgang Schmid, *Dürer als Unternehmer: Kunst, Humanismus und Ökonomie in Nürnberg um 1500* (Trier, 2003), 19–31. The wider historical background to these developments is perfectly outlined in Berit Wagner, *Bilder ohne Auftraggeber: Der deutsche Kunsthandel im 15. und frühen 16. Jahrhundert* (Petersberg, 2014); for a brief English summary see ead., '"kunst stucke vorkauffen, so theuer als er weyss"– Pricing and Marketing Skills in the German Art Market around 1500', in Andreas Tacke et al. eds., *Kunstmärkte zwischen Stadt und Hof: Prozesse der Preisbildung in der europäischen Vormoderne* (Petersberg, 2016), 12–22.

airport. These are among the most famous hands in the world, expressing a deep-felt human wish for hope and acceptance. Perhaps this is because they do not clasp or press together, the fingers touch lightly, as if they have already been released from anxiety.

Dürer drew the praying hands in preparation for an altar painting commissioned by a Frankfurt merchant called Jakob Heller. Grand Renaissance art was often personally commissioned and thus reflected a social relationship. As merchants asserted themselves as new elites, they became important patrons. Throughout the sixteenth century, this was Dürer's best-known painting, yet soon after completing it in 1509, Dürer stopped taking on such commissions. Heller had made him furious. Nine of Dürer's letters to Heller survive, more than from almost any other artist to their patron in the Renaissance. These famous letters reveal that Dürer fought a historical battle to assert the value of art. Heller proved stronger. Scarred and angry, Dürer moved on, abandoning altarpieces to create commercially viable works. Despite the fact that he had given up the prospect of a lucrative career as a goldsmith for the pleasure of painting, Dürer decided at the height of his career that painting complex compositions for such patrons was just not rewarding enough.

How did a Frankfurt merchant propel Germany's leading artist to the brink of exasperation? *Dürer's Lost Masterpiece* tells this story of a deeply ruptured relationship between one of Europe's most accomplished artists and his merchant patron from both sides. It shows why Dürer was a different man when he delivered the commission to when he started work on it, full of creative hope for such a piece. Based on the unique treasures of his letters to Heller, it tracks the history and effects of a crucial turning point in his career.

Dürer, moreover, would have been astonished to know what happened to his painting. It left the Frankfurt church it had been installed in. In 1614, Duke Maximilian I of Bavaria, a noted art connoisseur, acquired Dürer's central panel for the Heller altarpiece for his private gallery. It remained at the Munich court until it was destroyed in a fire there in 1729. As a result, the Heller altarpiece slipped from view, and today it is the least known among the artist's major works. The copy that replaced Dürer's panel in the church survives. But Dürer's original is his lost masterpiece.[8] For my book, the story of this painting functions as a lens through which to view the new relationship developing between art, collecting, and commerce in Europe after Dürer's death and up to the

[8] Major biographies of Dürer either do not mention, or just quickly touch on, the Heller altarpiece, see, for instance, Peter Strieder, *The Hidden Dürer* (Oxford, 1978); while Dürer's letters to Heller are of course usually discussed. Jane Campbell Hutchinson, *Albrecht Dürer: A Biography* (Princeton, 1990), 97–107, provides extensive extracts from Dürer's correspondence with Heller, summarizes them, interprets the outcome broadly as a success for Dürer, and makes a strong case for the outstanding quality of his final altarpiece within European Renaissance art, as does Norbert Wolf, *Albrecht Dürer* (Munich, 2019), although in passing, 149, and, most recently, Antonia Putzger, *Kult und Kunst—Kopie und Original: Altarbilder von Rogier van der Weyden, Jan van Eyck und Albrecht Dürer in ihrer frühneuzeitlichen Rezeption* (Berlin, 2021), esp. 193–197, published after this book manuscript was completed. Further specialized literature on the Heller-Altar of course exists and will be cited in Part I. In France, Charles Ephrussi was the first to translate and edit Dürer's letters to Heller, with much sympathy for the artist, in the 1859 Gazette des Beaux-Arts.

Thirty Years' War (1618–48). This too turns out not to be a linear story about the success of painting. At the heart of the book is the argument that merchants, and their mentalities, were crucial for the making of Renaissance art and its legacy for modern art in a commercializing world. This helps to explain why many other types of aesthetic objects could be valued more highly than painting throughout the period.[9]

Yet contrasting the mindset of a merchant patron and a creative Renaissance artist as if they had little in common is misleading. In fact, it could be argued that Dürer decided against painting more altarpieces partly because he was himself adopting the behaviour of a merchant. He did not want to live in poverty. Nuremberg nurtured an environment that encouraged aspiring middling craftspeople like him to be exceptionally commercially minded. His career began at the time of an emerging world of commercial print, which taught him how to earn money as a merchant of art by skilfully creating an international collectors' market, and by showcasing his singularity through a personal style even as he collaborated with others. Right up to the end of his life Dürer made money far beyond the immediate needs of his small family. He relished engaging with the new world of exciting global commodities. Despite his reformist religious beliefs in support of Martin Luther, long-distance merchants were among the people whose company he enjoyed most.

Firm boundaries between successful 'artists' and 'merchants' dissolved during Dürer's lifetime and even more so as the sixteenth century progressed. Merchants facilitated commercial transactions. But in addition, they could creatively shape what was produced and how. They increasingly expressed themselves through collecting and talking about aesthetic objects. Meanwhile artists behaved more like merchants. Many of the most successful artists focused on subjects attractive to the largest possible audience and turned their houses into showrooms. Moreover, rather than just responding to demand they began to create it, producing items ready for purchase, actively marketing their wares through new strategies and networks.

Scholars associated with artists followed a similar route, as Europe's book market expanded in scope. The humanists excelled in curating an image of themselves and others. The cultivation of recognizable and distinct profiles and the befriending of

[9] This is amply demonstrated by pioneering studies on global material culture, see Ann Goldgar, *Tulipmania: Money, Honour and Knowledge in the Dutch Golden Age* (New Haven, 2007); Paula Findlen ed., *Early Modern Things: Objects and Their Histories, 1500–1800* (Abingdon, 2013); Anne Gerritsen, Giorgio Riello eds., *The Global Lives of Things: The Material Culture of Connections in the Early Modern World* (Abingdon, 2016); Dagmar Bleichmar, Meredith Martin eds., *Objects in Motion in the Early Modern World*, Special Issue Art History (September 2015); Lia Markey, *Imagining the Americas in Medici Florence* (Pennsylvania, 2016); Giorgio Riello, Anne Gerritsen, Zoltan Biedermann eds., *Global Gifts: The Material Culture of Diplomacy in Early Modern Eurasia* (Cambridge, 2017); Beverly Lemire, *Global Trade and the Transformation of Consumer Cultures: The Material World Remade, c.1500–1820* (Cambridge, 2018). For a pioneering article on Dürer see Dagmar Eichberger, 'Naturalia and artefacta: Dürer's nature drawings and early collecting', in Dagmar Eichberger, Charles Zika eds., *Dürer and His Culture* (Cambridge, 1998), 13–37; for a pioneering article on Philipp Hainhofer see Renate Pieper, 'The Upper German Trade in Art and Curiosities before the Thirty Years' War', in Michael North, David Ormrod eds., *Art Markets in Europe, 1400–1800* (Aldershot, 1998), 93–103.

famous men turned into Renaissance obsessions and marketing tools. Reflecting the influence of these strategies, one of Dürer's scholarly friends wrote that the artist's ghost visited his bedside and whispered: 'Send on my name in writing to fame everlasting and add the words to be read on my tomb'.[10]

The Renaissance was an age in which markets created culture and culture created markets on a new global scale. This interpretation differs from those who understand its history principally through an account of artists gaining confidence through learned ideas as they collaborated with humanist scholars in Italian or German cities. The understanding of mercantile practices and mindsets has become integral to the history of Renaissance art.[11] Nor should such a story focus on painting and sculpture alone—on what began to be exclusively defined from the nineteenth century as 'Western fine art'.[12] Many like Dürer fought hard to argue that painting should be accepted among the liberal arts rather than be classified among the lower mechanical arts. More and more artists therefore used signatures and painted from life—humans, of course, but also animals, minerals, and plants, to claim that through imitating nature, they were brought closer to understanding God's designs directly, rather than through mathematical abstraction via numbers and shapes as espoused by university trained scholars.[13]

Increased travel and global expansion furthered contemporaries' engagement with nature and an interest in getting empirical facts right. Moreover, the political contexts of art appreciation mattered intensely as visual culture was ever more firmly embedded in national and international politics, not least through the increased importance of diplomatic gifts and practices of claiming secular power through the display of artistic achievements in architecture, through fashion and collections. Rulers, in turn, became interested in ingenious ideas promising commercial profit. While Frederick III only regarded an ostrich egg as treasure if it was exquisitely mounted in goldsmiths' work, other collectors valued unadorned natural rarities.[14]

[10] Ashcroft, *Dürer*, vol. 2, 902, Eobanus Hessus.

[11] Peter N. Miller, *Peiresc's Mediterranean World* (Cambridge Mass., 2015), 19. See, for instance, the contributions by Freist, Keblusek, Nybog, and Siebenhüner in Michael North ed., *Kultureller Austausch* (Cologne, 2009); Marika Keblusek, 'Mercator Sapiens: Merchants as Cultural Entrepreneurs', in Marika Keblusek, Badeloch Vera Noldus eds., *Double Agents: Cultural and Political Brokerage in Early Modern Europe* (Leiden, 2011), 95–111, here 109; Inger Leemans, Anne Goldgar eds., *Early Modern Knowledge Societies as Affective Economies* (Abingdon, 2020); Dániel Margócsy, *Commercial Visions: Science, Trade, and Visual Culture in the Dutch Golden Age* (Chicago, 2014); Smith, Findlen eds., *Merchants and Marvels*; Harold J. Cook, *Matters of Exchange: Commerce, Medicine and Science in the Dutch Golden Age* (New Haven, 2007).

[12] For a magisterial overview see Thomas DaCosta Kaufmann, *Court, Cloister & City: The Art and Culture of Central Europe 1450–1800* (London 1995)—contrast this approach with Martin Warnke, *Geschichte der deutschen Kunst: Spätmittelalter und Frühe Neuzeit 1400–1750* (Munich, 1999), which solely focuses on fine art, print culture, and architecture.

[13] See the important work of Pamela H. Smith, *The Body of the Artisan. Art and Experience in the Scientific Revolution* (Chicago, 2004).

[14] See the formulation in the classic account by Lorraine Daston and Katharine Park, *Wonder and the Order of Nature 1150–1750* (New York, 1998), 68, and 86 to discuss change and different types of collectors, an account that has replaced Julius Schlosser's notion that there existed national geographies of collecting, see also the recent overview provided in Thomas DaCosta Kaufmann ed., *Julius von Schlosser, Art and Curiosity Cabinets of the*

By the end of his lifetime, Dürer himself was at the avant-garde of an age of global trade that ushered in a new fascination with natural rarities and art collecting demonstrated in cabinets of curiosities. Some encompassed thousands of items, amassed from all over the world and across time, celebrating the rare and strange over the common and known. Such rarities stimulated Dürer's curiosity, erudition, and view of the world as much as they enabled him to cultivate relationships with rulers, merchants, and scholars to win him further prestige. Attitudes towards nature and its study fundamentally changed at this time, and Dürer was one of the artists leading the way by promoting new attention to detailed observation. As a result, the demand for natural specimens surged and so did the investigation into their utility. [1.4]

The interest in natural curiosities and objects of exquisite craftsmanship meant that the arts in Germany did not decline with the rise of Protestantism. New tastes emerged with the Reformation from the 1520s. The period saw global expansion, attacks on art by iconoclasts, the growth of printing and education, and the rise of fashion. All these factors created an extraordinary period of rapid change to which Dürer and other German makers after him responded.

The magnitude and speed of these changes moreover explains why, even for an artist of Dürer's quality, it appears as anything but a foregone conclusion that we should remember his name and visit museums to revere his paintings. For many collectors, rarities became all the rage. Stacked up in museums, these can just look bizarre to us, while we have been educated to know how to respond to paintings. This book extends an invitation to look at these tastes anthropologically, to understand visual dispositions and an engagement with materials as alien, but illuminating, to get to a society's core.[15] Hence the second part of this book looks at a merchant and his interests in the arts during the pivotal second half of the sixteenth century, when Germany emerged as a society divided into Protestants and Catholics, its population grew, and statecraft became more sophisticated. Hans Fugger (1531–98), one of the richest men in the world, was a collector and purveyor of novelties. Whereas Heller commissioned art because he was worried for his salvation, Hans Fugger was a confident Catholic in an age of religious renewal.

Fugger has left us thousands of letters, although only one of them mentions Dürer's name. They tell us *just why* other types of objects became so attractive, and what cultural ideas and visions were attached to them. Private zoos, aviaries, and cabinets of curiosities perhaps seem fanciful to us today. Why did anyone care about, and pay so much for elks, canaries, coral, Turkish shoes or dead birds of paradise? Moreover, Fugger spent enormous amounts of money on novel consumer goods, and especially on dress. To us, much of this is amusing in its ostentatiousness. Horses were this man's

Late Renaissance: A Contribution to the History of Collecting (Los Angeles, 2021), 1–54, and Jeffrey Chipps Smith, *Kunstkammer: Early Modern Art and Curiosity Cabinets in the Holy Roman Empire* (London, 2022), published after this book had gone into production.

[15] This approach develops the work of Michael Baxandall, see esp. his *The Limewood Sculptors of Renaissance Germany* (New Haven, 1981), here p.143 and *Painting and Experience in Fifteenth-Century Italy* (Oxford, 1972).

Fig. 1.4　Portrait of Ferrante Imperato's Museum, 1672. Ferrante Imperato, Historia naturale… In questa seconda impressione aggiontovi da Gio[vanni] Maria alcune annotationi alle piante nel libro vigesimo ottavo, 2nd edn. (Venice, 1672), unpaginated insert. Courtesy of the Wellcome Library/Creative Commons Attribution only licence cc by 4.0.

Ferraris, although with age, he needed more gently moving and tolerant breeds. Fugger once even dyed his horse with saffron to create an impression of greater opulence.

Fugger's letters allow us to track how trade links, processes of state formation, and new tastes foregrounded the role of such objects in market-orientated behaviour. They tell us about his relationship with the Catholic court of Bavaria as it turned itself into a powerhouse of collecting in its bid to become a key player in German politics. By the 1580s, Munich housed one of the grandest cabinets of curiosities in Europe. At this point, it contained thousands of objects, but very few Dürers, and these were not displayed prominently.

Nothing in Duke Maximilian I's childhood primed him to become obsessed with buying up Dürer's altar paintings. International merchants and financiers like Fugger, with their connections to Iberia and the Atlantic world, in addition to the Mediterranean, Eastern European, Ottoman, and Baltic worlds, were important intermediaries who helped to shape a broader conception of the arts at court. Apart from an interest in objects, such merchants laboriously sourced medicines and novel foods, including the

12 *Ulinka Rublack*

beautiful cauliflower, to strengthen and delight the body and senses in an increasingly competitive age, one that experienced booms and busts.

During one such boom, Dürer's fortunes suddenly changed. He became one of the first 'big bucks' artists in the world. In a phenomenon often referred to as the 'Dürer Renaissance', several collectors from the 1580s onwards began chasing his paintings and paid thousands of florins for them.[16] Led by the Emperor Rudolph II, they systematically emptied all the churches of Dürer's scarce altar paintings. One coup followed another. Heller's altarpiece in Frankfurt turned out to be one of the Dürers most hard to acquire. Not satisfied with his cabinet of curiosities, Duke Maximilian of Bavaria became the most insistent, and finally successful, bidder. The duke was a member of the Wittelsbach dynasty which had long turned art into one cornerstone of their claim for political leadership in the Holy Roman Empire. Within Maximilian's lifetime, two inventories listed this altarpiece as prime possession among the fine collection built up by him and three previous generations of Wittelsbach dukes.

We know much about the rise of Renaissance art as part of the rise of luxury consumption in Italy and the Netherlands. Yet German research has only recently begun to fully address the shape of the art market throughout the sixteenth century and into the age of the Thirty Years' War (1618–48)—and it was during this latter part of the period that Dürer's standing as an internationally recognized painter was confirmed. The history of German culture in this period has traditionally focused on the heights of humanism and on Luther's breakthrough at the beginning—a dynamic culture of debate that 'gradually faded away' through struggles among Catholics and Protestants, leading to insular divisions among Germany's many territorial states. It can seem like a cultural story that ends with the literary revival of Goethe's time, while little of significance happened around 1600.[17]

The interpretation advanced in *Dürer's Lost Masterpiece* demonstrates how the history of material culture changes this account by highlighting the role of makers, merchants, and ruling elites as cultural innovators. I want to understand what meanings they gave to pigments, new fashions or flowers, and how the particular properties of materials—including colours, shells, or silks—manifested their meaning in this world.[18] By 1618, several of Europe's most important collections and gardens—from Catholic Vienna and Eichstätt to Protestant Heidelberg and Dresden—were located in the German lands. Across its geography, a great influx of Protestant refugees from Flanders and France, as well as Sephardic Jews, settled as merchants and expert craftspeople in cities

[16] An overview of the critical discussion of this notion and investigations are offered by Andrea Bubenik, *Reframing Albrecht Dürer: The Appropriation of Art, 1528–1700* (Abingdon, 2013) and Anja Grebe, *Dürer: Die Geschichte seines Ruhms* (Petersberg, 2013); see also the important catalogue Giulia Bartrum ed., *Albrecht Dürer and His Legacy: The Graphic Work of a Renaissance Artist* (London, 2002).

[17] For this critical account see Joachim Whaley, *Germany and the Holy Roman Empire*, vol. 1 (Oxford, 2012), 9–10; for a new appraisal of German history as part of global history writing see the roundtable discussion 'Globalizing Early Modern German History', *German History*, 31/3 (2013), 366–82.

[18] This approach develops the work of Michael Baxandall, see esp. his *The Limewood Sculptors of Renaissance Germany* (New Haven 1981), here p.143.

Introduction 13

including Frankfurt, Hanau, Frankental, Glücksstadt, Freudenstadt, and Nuremberg. They infused this society with dynamism. Several of these towns were newly created. Male and female urban collectors grew in number and ambition. Rulers from the German south to its far north ambitiously planned artistic and architectural projects and were more closely connected to each other through efforts of governance and diplomacy in a country divided by faiths.

The third part of this book shows how European arts and societies transformed by examining one of the first successful art agents. Philipp Hainhofer (1578–1647) was a new type of Protestant luxury merchant. He acted internationally as professional art agent for courts, including the Catholic court of Bavaria. Hainhofer coordinated entire teams of Augsburg's luxury craftsmen over decades to produce cabinets of curiosities as single pieces of furniture filled with hundreds of exquisite rarities. Nowadays his creations feature in the glitziest of art books. They represent the best of the best in that age, and encapsulate its philosophical and spiritual programme to reveal the wonders of art and nature pushing the boundaries of perception and categorization of distinctions between both. [1.5]

An abundance of surviving artefacts and written sources allows us to fully chart Hainhofer's achievements.[19] His cabinets adorned stately rooms from Florence and Vienna to Uppsala, and he was keen to find a client in the Americas. A mediator, aesthete, and trader of rare energy and vision, his activities underline the fact that significant collections were shaped by cultural entrepreneurs like him and emerging global markets for rarities, rather than by a programmatic vision of art that exclusively privileged sculptures, paintings, and prints for aesthetic enjoyment. For example, supplies of shells from Indonesia opened up when the Dutch East India Company was founded in 1602. These shells certainly fascinated Hainhofer and others, as much as paintings, through a profound experience of colours, textures, and an interest in their geometry inspired by Dürer's theoretical writings. Shells showed God as creator at play.[20] As empires grew, cabinets of curiosities, and the forms of scientific knowledge as well as aesthetic, political, and religious ideas interlinked with them, would continue to shape seventeenth- and eighteenth-century engagements with the arts.

This development ran parallel to the full emergence and greater international integration of the market for collecting pictures and rarities. Art, politics, and religion intertwined in new ways.[21] Maximilian of Bavaria's hunt for Dürer's altarpiece

[19] Massimo Litzi, *Cabinets of Curiosities* (Taschen, 2020); for an excellent study see Michael Wenzel, *Philipp Hainhofer: Handeln mit Kunst und Politik* (Berlin, 2020); see also Hans-Olof Boström, 'Philipp Hainhofer – Seine Kunstkammer und seine Kunstschränke', in Andreas Grote ed., *Macrocosmos in Microcosmos. Die Welt in der Stube: Zur Geschichte des Sammelns 1450 bis 1800* (Opladen, 1994), 555–80.

[20] For recent in-depth explorations see Henrike Haug, *imitatio—artificium: Goldschmiedekunst und Naturbetrachtung im 16. Jahrhundert* (Cologne, 2021), esp. 195–322; Marisa Anne Bass, Anne Goldgar, Hanneke Grootenboer, Claudia Swan eds., *Conchophilia: Shells, Art, and Curiosity in Early Modern Europe* (Princeton, 2021).

[21] For pioneering studies of cultural politics and religion in the period before and after 1600 see Howard Louthan, *The Quest for Compromise: Peacemakers in Counter-Reformation Vienna* (Cambridge, 1997) and Claudia Swan, *Rarities of these Lands: Art, Trade, and Diplomacy in the Dutch Republic* (Princeton, 2021). The importance of

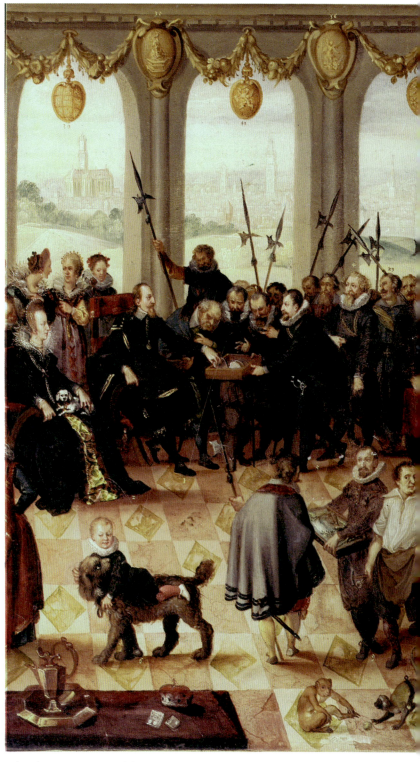

Fig. 1.5 Anton Mozart, c.1615/6, The Presentation of the Pomeranian Cabinet, oil on wood, 39.5 × 45.4 cm. Kunstgewerbemuseum Berlin, bpk/Kunstgewerbemuseum, SMB/Saturia Linke. The art agent Philipp Hainhofer in 1617 presents his first cabinet to the Duke and Duchess of Pomerania in Stettin, who are seated in the background; a large team of Augsburg artists involved in assembling it parade in the foreground and the cabinet is displayed on a table at the centre of the image.

commissioned by Heller tells us much about the meanings this painting took on a full century after its creation. The painting's aesthetic qualities and commercial appeal played important roles. Its subject was equally important. The Heller altarpiece depicted the Virgin Mary and fitted Maximilian's ideas to the core. Dürer had painted his Mary a decade before the Protestant Reformation shook Germany. Nuremberg became one of the most important cities to turn Lutheran in defiance of the Habsburg Emperors. Yet one century later, Maximilian spearheaded a movement that turned the Virgin Mary into a triumphant symbol of the militant Catholic Reform he championed across the Holy Roman Empire—in Germany, Austria, and Bohemia. As the Thirty Years' War broke out in 1618, Dürer's painting for Heller was finally hung in Munich, soon to be sheltered as soldiers in the service of Lutheran Swedes looted ducal collections. Dürer imagined that his painting would forever remain in Frankfurt's church for art connoisseurs from everywhere to admire. Yet in this age of change, religious subjects became the most ideologically loaded and contentious of all. The Protestant Reformation changed what subjects could be displayed in churches or owned, making pre-Reformation masters available to the art market on an unprecedented scale. Catholic collectors sought out religious art from Protestant churches and collections, and offered Catholic churches to replace masterpieces with copies.

The Thirty Years' War pitted states against each other enriching their collections through plunder. Expensive rarities circulated as diplomatic gifts to bargain for protection. The war also created a market of its own. As in any war, this market was made for profiteers who still had cash to offer to those forced to sell. It furthered an unparalleled fluidity in the art market, and the making and unmaking of European collections. As a result, our history of Dürer and German art and society during the Renaissance and early Baroque periods ends in London. It was here that the great collector Thomas Howard, Earl of Arundel, operated to buy works by Dürer as well as the library of his closest friend Willibald Pirckheimer. Much of it remains in London today.

This book sets out to describe the influence merchants wielded, how it changed over time, and how it played out in different arenas through different types of actors, such as the patron, the long-distance merchant, or the professional art agent as broker. These relationships helped to shape how commerce in art itself was given value, by whom, why, and how. My book is built around the biography of a lost Renaissance masterpiece: the altarpiece commissioned from Dürer by the merchant Heller, and the astonishing story of how it was made and valued before the Reformation, and how it became enmeshed in the drive of the Bavarian rulers to assert themselves, as Germany became the European country most riven by warfare in the name of religion. To tell the story of one of the best painters of all times and his forgotten masterpiece offers a surprising narrative about culture, politics, and society in Germany and Europe across a formative period when the arts expanded in scope and significance across the world.

Maximilian's devotion also means that we cannot detect a linear shift from images that were valued for cultic reasons to the mere aesthetic value of images.

It also allows us to get closer to Dürer, the legend and the man. Like many German children, I first encountered Dürer by facing a 500-piece jigsaw puzzle. Next, I was taken to Nuremberg to visit his house. I stuck a black-and-white postcard of it in an album. I saw images of *The Great Turf* and *The Hare*. At the beginning of this project, a British art critic asked me whether I liked Dürer's work. I remember thinking that, growing up in West Germany after the great anniversary celebrations of his four hundredth birthday in 1971, *not* liking Dürer had never been an option. The extraordinary appropriation and commercialization of Dürer's work in every possible direction accelerated then and never stopped—today you can even buy a playmobil figure of bearded master Albrecht with his palette.[22] All the same, as a child I never actually learnt much about him as a man in his time. Visiting the Dürer house as an adult today might not do much to change this. The display is a brilliant piece of German post-war museology telling you mostly about what we can *not* know about the functions of particular rooms rather than allowing you to speculate or taking you into Dürer's world. It defies mythologies of the German genius artist to rightly insist on our scrutiny of sources that question the fabrication of historical accounts. Dürer left a greater range of personal written records than almost any other sixteenth-century artist. But these have not been made accessible in modern German. His voice can easily seem lost.

Dürer's writings reveal more about his inner life than those of any other Northern Renaissance artist. His letters are a treasure trove. Dürer often continues to be discussed in terms of his graphic work, but a close reading of the letters reveals how important painting was for him, and how it related to key tenets of natural philosophy and religion at the time. This in turn tells us about humanism in new ways—as rooted in an immersion in practical experiments and medical care rather than merely in a world of the mind. I argue that Dürer's engagement with the materiality of painting, the pigments or oils, resonated with intellectual currents of the time.[23] Through Dürer's writings, we learn about the importance of other material, embodied aspects of life: his sexual fantasies or his enjoyment of food delicacies. They take us into his inner emotional world, telling us about what made him angry and manipulative. It was not just in his artistic life that he allowed himself to be driven by pleasure and break with conventions. He

[22] For an excellent discussion of twentieth-century commemorations of Dürer in East and West Germany see Campbell Hutchinson, *Dürer*, 187–206; and Paul Münch, 'Changing German perceptions of the historical role of Albrecht Dürer', in Dagmar Eichberger, Charles Zika eds., *Dürer and His Culture* (Cambridge 1998), 181–99, here esp. 196; for the nineteenth century see Jeffrey Chipps Smith, *Albrecht Dürer and the Embodiment of Genius: Decorating Museums in the Nineteenth Century* (Philadelphia, 2020).

[23] My approach thus significantly contrasts, for example, with Erwin Panofsky's approach to humanism in, *The Life and Art of Albrecht Dürer*, with a new introduction by Jeffrey Chipps Smith (Princeton, 2005) or Schauerte, *Dürer*, 19, who privileges a discussion of the graphic work, as Dürer in his view only responded to the intellectual currents of his time in his 1500 self-portrait and his Four Apostles. For a balanced introduction to Dürer as a painter and printer in English see Jeffrey Chipps Smith, *Dürer* (London, 2012).

loved humour, could be ironic about himself, and terribly sarcastic about others. He could become both calculating and compromised. Dürer was drawn to Lutheran ideas, but chose to ignore the reformers' attack on long-distance merchants as the cause of growing inequality. His imagination, dreams, and deep spirituality fed him with some of the most powerful images of horror and hope; and yet for decades he was also obsessively bogged down in calculating the correct proportions of hundreds of body types. Dürer laboured away to finally produce a book that few considered to be of any practical value. His deepest friendships supported his work, but were sometimes fraught by social distance and jealousy among men. The artist liked to gamble and adored shopping, but constantly worried about spending. Still, in contrast to his Wittenberg contemporary Lucas Cranach, Dürer never built up a large workshop to make money by standardizing his designs and having them copied in a highly efficient factory style.

Above all, these sources tell us the story of an extraordinarily imaginative artist who fought to be as independent and as recognized as possible and therefore often felt under social pressure. Although he stood out through his clothing and creativity, he liked to get on with people rather than cause scandal. That is why his fiery letters to Heller mark such an exception. He remained a dutiful son to his mother, a loyal brother, friend, and husband. Dürer conformed to the politics of Nuremberg's council and was keen to serve, and gain privileges from, ruling elites. Perhaps in part because Dürer had offended his old father by deciding not to follow in his footsteps, but more tangibly because he lacked substantial formal schooling, his fears of enmity and rejection remained immense throughout his life. So did his commitment to disseminate his learning and passion for the arts and crafts to other makers.

This was as radical then as it is now. Dürer wanted creative making in different areas to be valued in society and be as skilled as possible. His work opens a unique window on what it meant emotionally to live at the avant-garde of a modernizing world and to fight for the value of art and art theory. None of the issues he struggled with have gone away—the relationship of art and art theory to politics and commerce, the recognition of the arts and crafts, the question of fair value and price, and the role of aesthetics in society. His life is full of questions for our time. To many of those looking at his daring self-portraits, Dürer appears just arrogant. Yet the man I encountered in his letters and other writings was as conflicted and challenging as many makers in his age or our own.

PART ONE

Letters to Heller

CHAPTER 1

What Few Can Do

In late August 1507, the Frankfurt merchant Jakob Heller unfolded a letter. He had commissioned a prestigious altarpiece from the Nuremberg master Albrecht Dürer, and recently enquired about its progress. In neat writing, Dürer politely explained to his wealthy patron why he had not even started the job:

> First, my willing service to you, dear Mr Heller. I was delighted to receive your kind letter. But please be aware that until now I have been afflicted with a long bout of fever, so that for several weeks I have been prevented from working on Duke Frederick of Saxony's commission, to my great disadvantage. Now, however, his work is after all getting finished, for it is more than half done. So be patient about your altarpiece, which, as soon as I get this work finished to the satisfaction of the above-mentioned Prince, I will at once set myself diligently to paint, as I have promised you when you were here.

Dürer went on to update the Frankfurt merchant on these preparations—a carpenter had already skilfully prepared the wooden panel:

> And although I have not yet begun on the panel, I have got it from the carpenter and have already paid for it with the money you gave me. He would not knock anything off the price, though I thought that it was more than he deserved. I have given it to a preparer who has whitened it and coloured it[1] and will gild it next week. Up to now I have not wanted to accept an advance on that, until I begin painting the panel, which, please God, will be my next job after the Prince's commission.

Dürer explained the pressure he felt under, as Frederick the Wise (1463–1525) had insisted on his full commitment to his commission. Measuring almost 1 metre by 90 centimetres in height, Dürer's *Martyrdom of the Ten Thousand* for this powerful Saxon duke was, by contemporary standards, a large oil painting on panel. Dürer created a Renaissance masterpiece, with the bodies of Christian martyrs rendered in perfect proportion, to gruesomely resonate with the duke's collection of relics such as the bones

[1] der hat sie geweist, geferbet, und wird sie die ander wochen vergulten…, in Hans Rupprich ed., *Dürer: Schriftlicher Nachlass* (Berlin, 1956), vol. 1, p.64, and for the entire passage. Excellent translations can be found in William Martin Conway, *Literary Remains of Albrecht Dürer*, with transcripts from the British Museum manuscripts, and notes upon them by Lina Eckenstein (Cambridge, 1889), and especially in Jeffrey Ashcroft, *Albrecht Dürer: Documentary Biography*, 2 vols (New Haven, 2017). Ashcroft presents a state-of-the-art edition of Dürer's writings and writings about Dürer which follows Rupprich closely while also critically engaging with him.

and teeth of martyrs and saints that were annually on show at the church in Wittenberg castle. Its lifelike evocation of suffering stimulated fervent prayers. The church housed sixteen altars in total, and a pamphlet advertising Wittenberg's newly founded university to prospective students in 1508 promised those praying in front of any of these altars one hundred days of remission of their sins once their soul roasted in the fires of purgatory. Dürer had painted an aid for salvation. Writing to Heller, the artist explained that in order to avoid feeling overwhelmed and depressed by work on such demanding commissions, he had decided to focus on just one major painting at a time: 'It is just that I do not like to take on too much at one time, so as not to be weighed down. The Prince too will not be kept waiting, as he would be if I were to paint his and your pictures at the same time, as I had intended.'[2]

Dürer's panel for Heller measured nearly two metres in height and well over a metre in width. For its size alone, it would have been a commanding presence on the ground floor of Dürer's Gothic townhouse, as it was left waiting for him to begin work on. Matt white and probably smelling of rabbit glue that had been applied to it, these planks of smoothed wood, carefully joined up to just the right tension, inspired the artist into dreaming of what a great piece the finished altarpiece would be: 'But console yourself with the knowledge that, so far as God permits and to the best of my ability, I will yet according to my power make something that not many people are capable of. Now many good nights to you. Given at Nuremberg on Augustine's day, 1507.'[3]

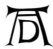

Albrecht Dürer is now overwhelmingly remembered through his astonishing woodcuts and engravings, as a 'master of the black line', as well as the inventor of serial self-portraits. His altar paintings have become less well known. Yet in the Renaissance, winged altar paintings were the obvious public artworks to paint—they were prestigious and artists could charge more for them. A growing number of merchants, as members of newly rich urban elites, commissioned them. Before the age of museums, churches were the most exciting contemporary art spaces which practitioners and connoisseurs travelled to see. Dürer's learned friends would have told him about a history of Germany just published by Jakob Wimpfeling in 1505. The Alsatian scholar praised German artistic achievements, noting how greatly Martin Schongauer (c.1445–91) was admired by artists and makers: 'In the church of St Martin and St Francis in

[2] 'uf das ich nicht verdrossen werde'—translated by Ashcroft, *Dürer*, as 'overwhelmed' and Conway, *Dürer*, as 'then I become wearied'; here, I have chosen 'weighed down' to convey the emotional resonance of *verdrossen*.

[3] Dürer writes 'nit viel leuth können machen'—which both Conway and Ashcroft translate as 'not many men'. Yet 'leuth' is not defined by gender, and Dürer might have included in this description expert female makers such as embroiderers, whose art was greatly admired. For the pamphlet see Edgar Reinke ed., *The Dialogus of Andreas Meinhardi: A Utopian Description of Wittenberg and its University, 1508* (Ann Arbor, 1986), 254–5.

Colmar there are to be found pictures painted by his hand to which artists themselves eagerly flock to copy and imitate them.' Wimpfeling knew of Dürer and mentioned him immediately after lauding Schongauer—but only his engraved prints and their diffusion in Italy.[4]

When Dürer took on Heller's commission he must have wanted to enhance his reputation, and create an outstanding altarpiece that would be both remembered by fellow artists and widely visited, placed as it was at a crossroad of European trade and learning. Frankfurt was situated closer to the Netherlands than his hometown of Nuremberg, and artists from Flanders set the pace of Europe's art world alongside the Italians. Business and crafts people as much as scholars and printers from Europe regularly visited Frankfurt because of its fair, which took place in the spring and autumn. According to a contemporary rhyme everything was on offer there: 'What people desire, whether big or small, can be found in you or not at all.'[5]

Dürer had just placed an altar painting in another trading centre of his world, in the Venetian church of San Bartolomeo di Rialto, which by the mid-century ranked among the city's artistic works of note, alongside Titian's masterpieces or the bronze horses of St Mark's.[6] The extraordinary end of Dürer's letter confirms that he regarded himself as on a par with both past and current masters, and was competing for future fame as one among a group of the best of the best. He knew that such hierarchies framed how an eager patron regarded him. Who, then, was Wimpfeling to think that 'no one' other than Schongauer could 'ever' fashion anything more 'delightful and elegant'? Hence Dürer's astonishing promise to Heller: 'so far as God permits and to the best of my ability, I will yet according to my power make something that not many people are capable of'. If given the right conditions, time and God's help, he would excel, and create a monument of devotion for a rich man that would survive for centuries to come.

This complicity between the artist and the merchant in their mutual wish to be remembered would yield its returns. Altar paintings for the right clients in the right churches were strategically important, instrumental in increasing demand for an artist's work and commanding higher prices, as well as shaping an artistic legacy. The Heller altarpiece was among Dürer's most significant and spiritually inspiring commissions, and one of only ten altarpieces he ever painted. Right into the seventeenth century, it continued to be a key sight in the Frankfurt church, and was one of Dürer's best-known works.[7]

[4] Rupprich, *Nachlass*, vol. 1, 290, fn.6 for the translation of 'imagines' as relating to the graphic work, in contrast to the translation by Schauerte, *Dürer*, 142.

[5] 'Wasz mench begert in grosz und kleyn/Find man by dir in der gemeyn', translated in Miriam Hall Kirch, 'Art, Collecting and Display in the Sixteenth-Century Patrician House in Frankfurt am Main', in Kirch, Münch, and Stewart eds., *Crossroads: Frankfurt am Main as Market for Northern Art 1500–1800* (Petersberg, 2019), 78–103.

[6] Jeffrey Chipps Smith, *Dürer* (London, 2012), 165.

[7] Bernhard Decker, *Dürer und Grünewald. Der Frankfurter Heller-Altar: Rahmenbedingungen der Altarmalerei*, Frankfurt am Main 1996, p.5; for a recent discussion see also Robert Brennan, 'The Art Exhibition between Cult and the Market: The Case of Dürer's Heller Altarpiece', *Res* 67/8 (2016/7), 111–26.

26 Ulinka Rublack

Yet Dürer executed only one further altarpiece after Heller's. He painted it for a marginal, newly built chapel in his native Nuremberg, and accepted the commission while finishing Heller's piece. Why did Dürer not seek, or accept, any commission for prestigious altarpieces after 1511, or indeed for the remaining eighteen years of his career? Surely they would have internationalized his fame alongside his prints?[8] Many of the clues that provide an answer to this question lie in the eight further letters Dürer eventually exchanged with Heller, revealing the kind of relationship an artist as ambitious as he was could develop with a merchant patron of this kind. Mutually frustrated and furious, both men paid a price. For Dürer, the emotional toll was bound up with the essence of what it meant for him to be a maker, and therefore what it meant to live.

[8] He might have also completed another altar painting in Stendal, in 1511, but this seems unlikely, Schmid, *Dürer als Unternehmer*, 311, and for a detailed discussion of which paintings Dürer executed after 1511. Commissions for altar paintings continued to be plentiful during the next decade and were taken on by Hans Suess von Kulmbach, who probably had been in Dürer's workshop during the painting of the Heller altarpiece, 341–3. For a detailed description of the Heller correspondence see Schmid, *Dürer*, 345–67 and Heike Sahm, *Dürers kleinere Texte: Konventionen als Spielraum für Individualität* (Tübingen, 2002).

CHAPTER 2

Herr Jakob Heller

Imagine Jakob Heller as a small astute businessman energetically entering a room wearing a black cloak with a big round leather purse hanging from his belt. Money had made this man. Heller was born into a Frankfurt family that descended from a well-off shoemaker first documented in 1384. Over the next generations, the family gained ever greater wealth through its involvement in trade, suitably celebrated in the acquisition of a coat of arms depicting three gleaming coins of the currency that became known as 'Heller'. This coin belonged to one of three currencies accepted as reliable at the Frankfurt fairs. The Hellers' name and fortune signified money, and it was clear that they had accumulated masses of it. The Heller was the lowest reliable currency and passed through everyone's hands: around 1500, one gulden equalled two hundred *Pfennig* and four hundred *Heller*. Jakob's father traded linen from Westphalia in exchange for fine fabrics, spices, and other luxuries from Venice, and invested his money carefully. He owned much land, 560 sheep, and six horses, as well as townhouses in Frankfurt, some of which stood empty except for the time when they were rented out to foreign merchants during the fairs.[1] With the upswing of the fair came the need for finance—and wealthy Frankfurt families, such as Heller's, increased their riches through prudent lending. In 1495, a Nuremberg visitor to the city observed: 'There is a collegiate church there, and several monasteries, and God's worship is excellent, and the people are clever at making money.'[2]

Born around 1460, Heller was just over a decade older than Dürer. After studying liberal arts in Cologne during his early youth, he had entered his family's world of business and had joined merchant companies with his own capital by 1487. Trade in cloth and their devout Catholicism tied the Hellers to Italy. Jakob's uncle acted as a consul for the Foundation of German merchants in Venice in 1500, and Jakob himself travelled in Italy, not least to visit Rome in the jubilee year in which the Vatican granted a universal pardon for sins. One of his brothers lived in Venice, and died there around this time,

[1] Friedrich Bothe, *Das Testament des Grosskaufmanns Jakob Heller vom Jahre 1519: Ein Beitrag zur Charakteristik der bürgerlichen Vermögen und der bürgerlichen Kultur am Ausgange des Mittelalters*, Archiv für Frankfurts Geschichte und Kunst (9/1907), 345–50; Otto Cornill, *Jakob Heller und Albrecht Dürer: Ein Beitrag zur Sitten-und Kunstgeschichte des Alten Frankfurt am Main um 1500* (Frankfurt am Main, Verein für Geschichte und Alterthumskunde zu Frankfurt am Main, 1871), 2; Alexander Dietz, *Frankfurter Handelsgeschichte*, vol. 1 (Glashütten: Auvermann Verlag, 1970), 62.

[2] *Dr Hieronymus Münzer's Itinerary and the Discovery of Guinea*, transl. and ed. by James Firth (London, 2014), 237.

which makes it more than likely that Jakob himself would have known the city and its splendid churches, palaces, and buoyant trade around the Rialto bridge.[3]

Despite the fact that he only corresponded in his West Central German dialect, Heller became one of Frankfurt's important men as the sixteenth century began, having acquired great wealth as a merchant and banker. As he reached his late forties he commissioned the foremost contemporary artists Dürer and Matthias Grünewald to commemorate himself and his wife. About 10,000 citizens lived in Frankfurt. Heller was involved in several trading companies, served as senior mayor of his city twice, in 1501 and 1513, and he repeatedly represented Frankfurt at imperial political summits and in diplomatic missions. He was among the city's most charitable citizens. His wife Katharina, whom he married around the age of twenty-five in 1482, belonged to the enormously wealthy and reputable patrician family of the von Melem. As Katharina's father had settled in Frankfurt relatively recently, her marriage to Heller helped to bolster the Melem's local prestige and privileges. Her dowry exceeded the sum Jakob's father gave the couple by fifty per cent, in addition to which Melem financed the wedding festivities.[4] The couple owned houses, fields, meadows, and vineyards in the region, leasing many of them. Katharina's money paid for the acquisition of the 'Nuremberg Court', a complex of stalls, cellars, and lodgings situated right next to her parents' house. This was where Jakob and Katharina lived, and welcomed emperors, including Frederick III, as well as Nuremberg merchants who were visiting the famous Frankfurt fair. The building's spacious lodgings annually yielded a rental income of at least 600 florins just through short-term lets during the fair. Half of this sum the Hellers donated to poor citizens during winter.[5] A glass window they commissioned confidently depicts an angel holding the couple's joint coat of arms—three Heller coins and the von Melems' bright red crab. [2.1]

Jakob and Katharina hence lived in an important European city, which since 1480 had also become a centre of the book trade. Most books were printed in Latin and served an international market; the city's location on the river Main facilitated such trade as books were shipped in barrels on boats onto the Rhine. Still, in Johannes Cochläus's 1512 'Brief Description of Germany', Frankfurt, and the river Main, did not even receive full descriptive sentences. The work of a young humanist looking for local promotion, it described Nuremberg as the centre not just of Germany but also of all Europe.[6]

Yet in a speedily commercializing world offering a greater range of goods, the Frankfurt fairs created new markets and meeting places, financial and political power.

[3] Bothe, *Testament*, 363, 351.

[4] Michael Matthäus, 'Hamman von Holzhausen, Jakob Heller, and Claus Stalburg: Drei Ratsherren, Schöffen und Bürgermeister der frühen Reformationszeit', in *Frankfurter Stadtoberhäupter vom 14. Jahrhundert bis 1946* (Frankfurt 2012: Societäts Verlag), 70; Bothe, *Testament*, 358.

[5] Bothe, *Testament*, 396–7, 361, 373.

[6] Johannes Cochlaeus, *Brevis Germanie Descriptio* (1512), ed. Karl Langosch, Darmstadt: Wissenschaftliche Buchgesellschaft 1960, 74–5, 68–9, 144–5.

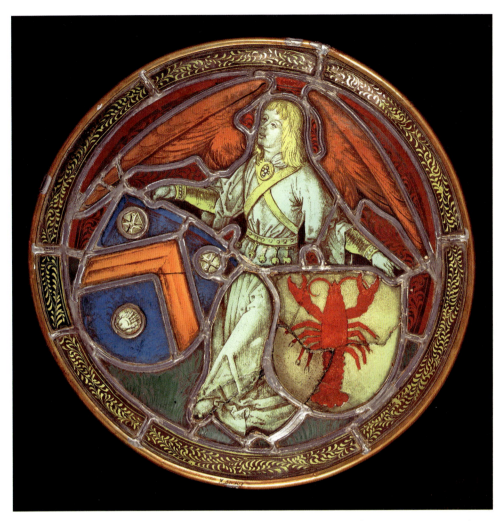

Fig. 2.1 Circular stained glass, an angel holding the Heller and von Melem arms. © Historisches Museum Frankfurt, Fotograf: Uwe Dettmar.

The Hellers were well connected and knew how to meticulously organize their involvement in business, politics, contemporary art, charity, and churches. Jakob became both popular during the years when he commissioned Dürer—serving eight times as head of the all-important Frankfurt society of marksmen—and more powerful: he had overseen the quality of local fustian textiles and woollens since 1508.[7] Now in their late forties, the couple donated money to several religious orders, and in 1509 commissioned large sandstone sculptures depicting the crucifixion for the graveyard of Frankfurt's cathedral where Katharina's parents were buried. Jakob and Katharina cared for their own and their ancestors' souls through religious art. The inscription on the sculptures

[7] Matthäus, 'Drei Ratsherren', 86–7.

reads: 'In the year 1509, Jakob Heller and Katharina von Molheim, a married couple who live in the Nuremberg Court, had this image of the crucifixion mounted to praise the victorious Jesus Christ, for themselves and their parents, so that God shall give grace to the living and eternal peace to the dead, Amen.' Added to this was a quotation from the Revelations of St John 1, v5: 'He has washed us clean from sin with his blood', a choice which underlines how the Reformation would soon evolve into a strong strand within contemporary devotion that focused on Christ and his purifying blood. Anxiety about the afterlife could be assuaged by believing in Jesus's death for mankind.[8]

Still, Jakob and Katharina also venerated female and male saints and the Virgin Mary. A further inscription reveals that Heller and his wife kept a large piece of wood believed to have been taken from Christ's cross, and several relics of female and male saints, in a metal box. They were blessed by the auxiliary bishop of Mainz, who served one of Germany's most powerful clergymen in the nearby city. As potent ritual, this blessing was believed to charge and activate the sacrality of holy things, allowing it to release its power among the laity.[9] The Hellers adopted such rituals and sacred possessions to safeguard their souls' eternal lives as they approached old age. In 1514, they donated a precious illuminated bible to the Dominicans, and during the same year helped to finance the noted artist Jörg Ratgeb to decorate Frankfurt's Carmelite monastery with the largest cycle of frescoes ever carried out north of the Alps.

Local goldsmiths, too, would have known Jakob and Katharina well. Their rich collection of silver contained countless devotional objects they would have touched and used in prayers, such as crucifixes and fragrant rosary beads. The couple believed in the efficacy of good works. When he made his will in 1519, Jakob noted that much of their jewellery, silver, grain, and money was to be sold to benefit charities; 100 florins Katharina had left 'to honour God' was to be used to buy grey cloth, a cartload of wood, shoes, and some bread for needy people and to provide them with alms.[10] A Frankfurt chronicler commemorated Heller as a 'singular benefactor of the church and poor'.[11]

In his will, Jakob Heller even left money to hire an honourable man as pilgrim who was to impersonate him—wearing Heller's old clothes, but fitted with new shoes with double soles. This 'reputable' man would have needed the good shoes, for he was instructed to speed down to Rome with a pilgrim's customary walking stick and return to Frankfurt via Loreto and Venice in no more than fifteen weeks, while daily reciting thirty Paternosters, three Ave Marias, and three times the Creed to commemorate Jakob, Katharina, and both their parents. The itinerary was carefully calculated, and meticulously specified the days on which toll stations were to be reached, and the exact price to be paid for wax candles which were to be lit in particular churches. Nothing was left to chance. In Rome, a priest was to accompany the stand-in pilgrim. If the

[8] Cornill, *Heller*, 45.

[9] C.W. Bynum, 'Epilogue', in Ivanic, Laven, Morrall eds., *Religious Materiality in the Early Modern World* (Amsterdam, 2019) 247–56, here 252.

[10] Bothe, *Testament*, 397, 381–7.

[11] *Quellen zur Frankfurter Geschichte*, vol. 1, Joannes latomus, 110.

priest testified that he prayed with true devotion, Heller made provision that the pilgrim would be paid a bonus. A second pilgrim was dispatched to Cologne in order to present one of Heller's golden rings to the cathedral. From the evidence of other wills, Frankfurters rarely made such provisions.[12] The degree of precision in the will was unusual, too, and reveals the mental habits of a merchant who kept the constant risks and uncertainties of long-distance trade at bay through the close monitoring of his correspondence. The Hellers sought control, in life as well as death.

Yet Jakob and Katharina had no children. They shared this fate with Dürer, who, as a man well into his thirties at the time of working on Heller's altarpiece, would similarly have known that he and his wife Agnes were infertile. This rendered the question of who would remember both patron and painter far more acutely. Urban patrician and bourgeois families at this time began to care greatly about genealogy, preserving their memory and honour. Emperor Maximilian I used the new medium of print to commemorate his deeds and told German elites, rather shockingly, that whoever failed to create a memory during their lifetime would instantly be forgotten after death. Heller knew Maximilian I through his visits to Frankfurt, and would have been aware of his efforts to commemorate and promote the honour of the Habsburg dynasty through the work of the best contemporary artists. Members of Katharina's family eventually commissioned one of the most precious genealogical books of the sixteenth century, for which artists created detailed illuminations of family members in their specific costume, their spouses, and descendants.[13] Such family books included those who entered convents and monasteries or followed clerical careers without leaving legitimate children. It represented those who had died young and single. But a couple who had remained childless stood out, like a tree that did not bear fruit, a marriage which had not been blessed.

For Jakob Heller, compiling a genealogy was pointless. His parents had sixteen children, ten of whom had died early. None of their remaining sons had any children. Heller thus knew that the entire male line of his family would end with him.[14] Even though he was the oldest son, all of his other siblings had already died by the time he commissioned Dürer, except for a sister who had entered a convent. In his will of 1519, Jakob named four children of his oldest sister Agnes as heirs—three of them men.[15] Other patrons in similar positions conveyed a sense of sadness mixed with responsibility as they were the 'last of their family', *ultimus familiae*, in carefully constructed bequests.[16]

[12] Bothe, *Testament*, 383; for a comparative analysis of wills see Miriam Hall Kirch, 'Faith Embodied: Jacob Heller, Catharina von Melmen, and their Altarpiece', in Catherine Ingersoll, Alisa McCusker, Jessica Weiss eds., *Imagery and Ingenuity in Early Modern Europe: Essays in Honor of Jeffrey Chipps Smith* (Turnhout, 2018), 191–200.

[13] The Melemsche Hausbuch is thought to have begun in 1550, see Harry Gerber ed., *Das Melemsche Hausbuch: Bilder vom Leben und Brauch eines Frankfurter Geschlechts im 15. bis 17. Jahrhundert* (Frankfurt am Main, 1938); for the importance of this memory culture for Dürer see Schauerte, *Dürer*, 12–13.

[14] Bothe, *Testament*, 351.

[15] Bothe, *Testament*, 380.

[16] Several examples are discussed in Wolfgang Schmid, 'Jakob Heller – ein Frankfurter Stifter und Auftraggeber', in Cat. *Grünewald und seine Zeit* (Karlsruhe, 2008), 13–14.

Katharina must have lived through years of hope and disappointment as she tried to conceive. A woman of her background would have been invited to countless parties when her peers were resting and merrily chatting with women friends as they recovered from the ordeal of giving birth—a period called 'lying in'. There would have been endless baptisms and requests to act as godparent. Relatives and friends from further afield would have inquired in letters over many years about whether there was any news of conception. Katharina would have prayed daily to specific saints and the Virgin Mary to bless her womb, she would have lit candles at their altars, and tried out numerous recipes to help, such as placing ill-smelling mud poultices on her belly. Each time her period came, she is likely to have felt distraught. [2.2]

Katharina lived in a world in which children, rather than old people, dominated, and knowledge about pregnancy and childbirth circulated in print to honour, for the first time, the labour of women as mothers. Eucharius Rösslin, the author of Europe's first bestselling book on childbirth and child health, served as Frankfurt's long-standing civic doctor and, based on local experience, compiled his writings between 1508 and 1512. A pharmacist by training, Rösslin reassured women that much could be done to lessen their pain in childbirth: 'I've given you ladies enough advice, On how you'll come to recognize, Labor with ease and much less pain, Just take to heart what I have penned.' His recipes to treat new-born babies, who had died in such high numbers at this time, provided numerous alternatives even for common problems such as constipation. They ranged from rare ingredients, such as ground elephant tusks, to the most common treatments available to all: 'Take butter and put it in a nutshell and bind it on the navel. One should also rub and smear its body with butter.'[17] Anxious mothers collected many of these recipes and experimented with novel ingredients. Rösslin did not however mention problems with conception. He wrote in an age of high fertility rates, when most women's childbearing lasted over one or two decades, or even three for elite women who typically married during their teens. Katharina must have often felt lonely in her plight, a failure as a woman, and, despite all her privilege, punished by God. [2.3]

Like other men in his position, Heller discovered that he was fertile through affairs. How would this have impacted on his relationship with Katharina? We know from letters written by the fourteenth-century Prato cloth merchant Datini, for example, that he fathered illegitimate children and then expected his infertile wife Margherita to find wet nurses for them. He caused her emotional torment. An otherwise resourceful woman, Margherita Datini was dragged into a deep sense of shame for not being able to conceive heirs. She became self-destructive and felt that she was only good enough

[17] Eucharius Rösslin, *When Midwifery Became the Male Physician's Province: The Sixteenth Century Handbook The Rose Garden for Pregnant Women and Midwives, Newly Englished*, transl. by Wendy Arons (London, 1994), 36, 103.

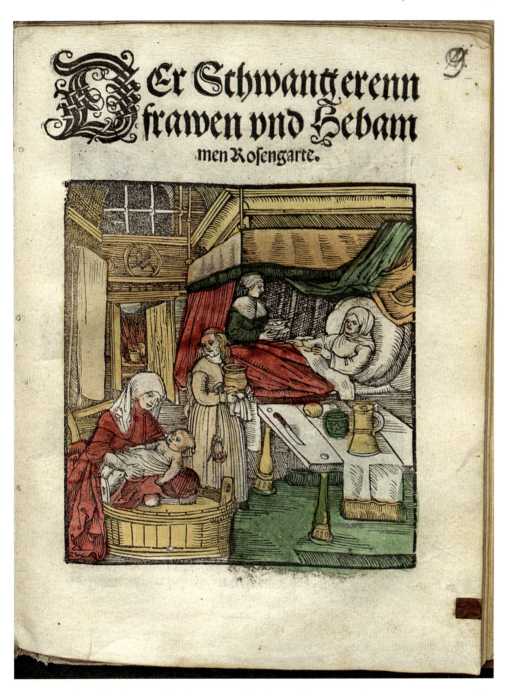

Fig. 2.2 Coloured title page of Eucharius Rösslin's bestselling treatise for pregnant women and midwives, Der Schwangerenn frawen und Hebammen Rosengarten, 1513. Bavarian State Library, Munich, CC BY-NC-SA 4.0, public domain.

34 Ulinka Rublack

Fig. 2.3 Institut für Stadtgeschichte Frankfurt am Main, Best. S1-1004-08 (Holzhausen-Archive). Depiction of Jakob Heller and Katharina von Melem in the Melemsches housebook, sixteenth century. This depiction of Jakob and Katharina in the Melem's family book of honour depicts them without descendants. Both of them hold on to their coat of arms and a rosary to underline their status and piety.

to deal with filth. Replies to her husband repeatedly battle with self-loathing, which suggests that he expressed no empathy for her or cared for her emotional needs.[18]

[18] Margherita Datini, *Letters to Francesco Datini*, transl. and ed. by Carolyn James and Antonio Pagliaro (Toronto, 2012), see, for instance, 283. These responses were typical for the time and into the sixteenth century, see Regina Toepfer, *Kinderlosigkeit. Ersehnte, verweigerte und bereute Elternschaft im Mittelalter* (Stuttgart, 2020).

We have no idea when Heller began having affairs. In April 1518, the merchant crudely joked in a letter to Dürer's friend Willibald Pirckheimer in Nuremberg that he probably suffered ill-health because it had pleased him more to 'kneel over women and unmarried maids' than to kneel down in church. Aged sixty, Heller fathered an illegitimate boy in Cologne and bribed local canons to baptize him. Despite his physical decline and ailments, Jakob was determined to have a good time in the city he had known so well since his student days, when he might first have visited its brothels.[19] The trip to Cologne was Jakob's last fling, taken just after he had resigned from Frankfurt's town council in 1517, after pointing out that he had served on it for thirty-four years, but was now aged around sixty and no longer able to physically manage his duties as he would like to.[20]

Heller might have consoled himself with the knowledge that suffering through afflictions, such as an infertile marriage or illnesses, might benefit one in heaven. Life on earth was temporal. The Dominican church would simply house his mortal remains. Yet, unusually for Frankfurters at the time, Jakob's will repeatedly referred to his sinfulness.[21] This explains why the merchant did so much to ensure that his own and Katharina's souls would be saved from the pains of purgatory. The force of people's prayers in front of his altar and priestly masses in daily rituals of remembrance deeply mattered in this quest. The Hellers' many benefactions for Frankfurt's Dominican church secured them the right to an 'eternal burial' in a privileged spot—immediately to the right as one entered the church through its west portal, in a space dedicated to St Thomas of Aquinas, the Dominican patron saint and scholar. Jakob's paternal grandparents already lay buried in this church and thus in the select company of some of Frankfurt's wealthiest patricians and aristocrats.

Frankfurt's Dominican monastery had been founded in the thirteenth century, was dedicated to the memory of the Virgin Mary and counted the great mystic Master Eckhart amongst its priors. Around 1500, its community was made up of about thirty-five monks and further lay brothers whose many tasks included praying for the dead. Prior Johann von Wilnau (d. 1516) presided over the monastery with great stability for forty years and ensured discipline. During this time, the number of notable tombs for patrician families and fine artworks rapidly grew. Holbein the Elder finished the churches' high altar in 1501, working *in situ* with his brother and assistants to deliver a composition packed with figures and the drama of Christ's crucifixion and resurrection. Several gifted Rhenish masters completed side altars. The monastery's cloisters were lined with coats of arms of Frankfurt's leading families, including many of the Heller dynasty.[22]

Jakob took care of his own arrangements for 'my altar', as he put it, by agreeing a contract with the Dominicans in 1513. Confirming these arrangements, he drew up his

[19] Dieter Wuttke ed., *Willibald Pirckheimers Briefwechsel*, vol. 3 (Munich, 1989), 309–10; 317–18.

[20] Matthäus, 'Ratsherren', 93.

[21] Hall Kirch, 'Faith Embroidered', 198.

[22] Heinrich Hubert Koch, *Das Dominikanerkloster zu Frankfurt am Main. 13. bis 16. Jahrhundert* (Freiburg, Herder, 1892), 99–105, 119–20, Heinrich Weiszäcker, *Die Kunstschätze des ehemaligen Dominikanerklosters in Frankfurt a. M.: nach den archivalischen Quellen* (Munich, 1923), 25, 149; Klaus-Bernward Springer, *Die Deutschen Dominikaner in Widerstand und Anpassung während der Reformationszeit* (Berlin, 2009), 51–2.

will after Katharina had perished four months after his spirited spring visit to Cologne in 1518.[23] Whether he had managed to hide his illegitimate child from her, or caused terrible upset, remains unknown. But we do know that, as early as November 1518, the merchant wrote another letter to the Nuremberg humanist Willibald Pirckheimer, a man well known for his sexual bravado. Heller mentioned Katharina's passing away, adding that this would require him to remain a chaste widower for a while. However, he had recently started taking an aphrodisiac in the evenings. This turned out to be a home-made concoction with an ingredient sourced through the merchants' trade: sweets made with pine nuts. Jakob had received them from the wife of Hans IV Imhoff, one of Nuremberg's most important patricians, merchants, and art lovers, who had evidently tried to cheer him up. A woman of noble background, she had tried and tested them on her ageing husband, who was Heller's contemporary and approaching his sixties. She supplied stimulants. Heller instantly wrote to Imhoff in order to request a big box of these sweets. One of them made him instantly dream about 'virgin Deyltey'—the woman he had sex with in Cologne, and whom Pirckheimer likewise seemed to know. In writing his letter, Heller began to wonder whether 'virgin' Deyltey had survived a recent outbreak of the plague in Cologne.[24]

Whatever the case, in 1519 Heller once more attended to the care of his own and Katharina's souls by instructing a notary that his and Katharina's most precious velvet gowns should be donated to monasteries and confraternities in Frankfurt and its wider region, in order to be turned into precious vestments for clerics celebrating mass and praying for them. Each was to be embroidered with a cross and the couple's coat of arms at the centre.[25] Heller in addition left 120 florins to the Dominican monastery to buy new red velvet, 'the best and most beautiful, so that a vestment be made in the most precious and costly manner'. Embroiderers were to place St Jacob and St Catherine, the couple's name saints, alongside their coat of arms and to use the hundreds of pearls his wife had possessed in jewellery.[26] Such pearls would have been used for elaborate raised embroidery which lent great depth to each scene. The monastery was to keep the vestments 'for eternity'. This was an important safety clause, as Heller knew well that the Dominicans might otherwise sell them in times of need or repurpose the beads.[27] [2.4a–c]

Dürer was initially meant to receive 130 florins for painting the central panel of Heller's altarpiece in the church adjacent to the convent. This sum included the costs of

[23] Weiszäcker, *Kunstschätze*, 144.
[24] *Pirckheimers Briefwechsel*, vol. 3, 563a, 429, 431.
[25] Bothe, *Testament*, 393; Schmid, *Stifter*, 428–9.
[26] Schmid, *Stifter*, 431.
[27] Schmid, *Stifter*, 431.

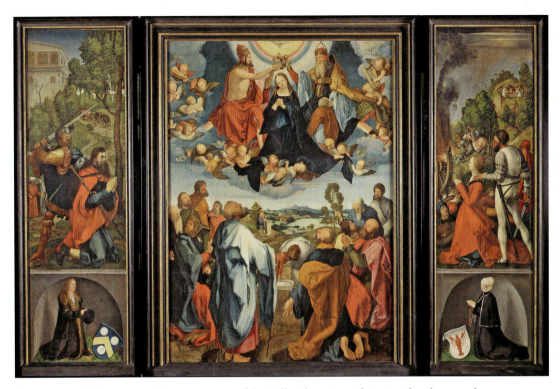

Figs. 2.4a–c Early seventeenth-century copy of the Heller altarpiece, Jobst Harrich, oil on panel, 189 × 138 cm, 1614: a. whole view, b. Dürer's central panel, c. detail of Dürer's figure. © Historisches Museum Frankfurt, Photos: Horst Ziegenfusz.

all materials. No clause precluded Heller selling his panel—which means that its potential saleability was perhaps calculated as a bonus for the Dominicans. But for the time being, the altarpiece was part of a larger complex designed to commemorate Jakob and Katharina, and which Heller planned in every detail. 114 florins were to pay for his funeral, the same amount as he had spent on his wife's. An epitaph which had long been finished and inscribed was to be placed on Jakob's and Katharina's grave in front of the altar, noting his date of death; above the altar a mural painting of the Last Judgement depicting hell, and Heller's cuirass and shield were to be hung beneath it.[28] For decades, voices supporting reform among the Franciscans had battled against donors who wanted their coats of arms embroidered onto vestments or armour hung up in churches, but the Frankfurt Dominicans accepted Heller's demands as part of a traditional package of pious commemoration.[29]

[28] Schmid, *Stifter*, 431.
[29] For the Dominican reform campaign see Martial Staub, 'Zwischen Denkmal und Dokument: Nürnberger Geschlechterbücher und das Wissen von der Vergangenheit', in M. Staub, Klaus A. Vogel eds., *Wissen und Gesellschaft in Nürnberg um 1500* (Wiesbaden, 1999), 98.

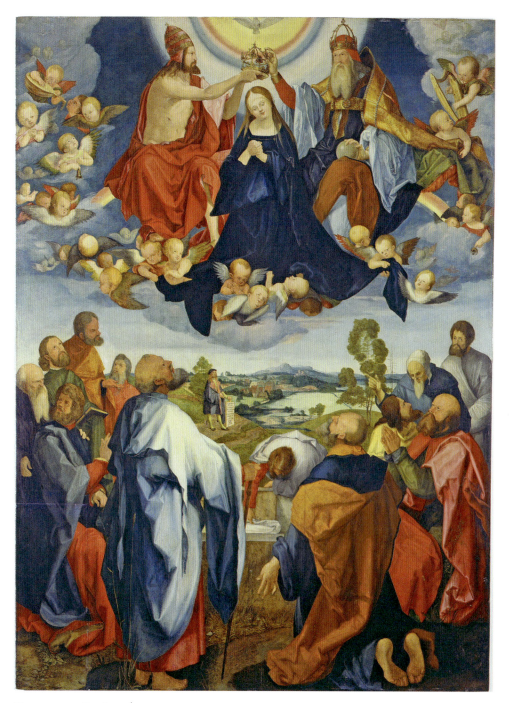

Figs. 2.4a–c Continued

Figs. 2.4a–c Continued

40 Ulinka Rublack

These bequests gained significance and prominence through rituals activating their sacrality. In front of the altarpiece each Sunday, prayers were to be uttered for the couple in front of the altar, every Monday there would be a requiem, on Tuesdays a mass to honour St Anne and Mary, on Wednesdays a mass to honour the Holy Trinity, Thursdays commemorated Corpus Christi, Fridays the Sorrows of Christ and Saturdays Mary. In addition, each anniversary of Heller's death would be honoured with a special mass during Advent in front of the altar and Heller left money for the convent to eat fish on that day. Five singing masses would be performed in the course of each year. An iron grid with a silver-vessel to light blessed candles was placed over the altar. Each of the candles was to weigh half a pound, and an oil lamp was to burn at the altar in perpetuity. For twenty years, Heller and his family were to be included in prayers following every single sermon. The merchant donated 830 florins to the monastery during his lifetime and left another 400 florins when he died, alongside two precious illustrated manuscripts containing the bible as well as other theological and scientific manuscripts and printed books from his library.[30]

This sum nicely matched the substantial amount of 1,200 florins he left for a special charity. Heller identified a small house that could serve as temporary day shelter. Poor Frankfurt citizens would be able to warm themselves up in a ground floor chamber with an iron stove during the harshest winter months, between 1 November and 22 February, or for a maximum of two additional weeks, in case the weather continued to be very cold. People were to be admitted at 'half an hour into the day', asked to leave between 11 a.m. and 1 p.m., and then allowed to return. A married couple living on the first floor would serve as resident caretakers to buy coals and wood, clean after the poor had left, and make sure that nobody had sex. Everyone had to pray daily for Jakob and Katharina before being told to leave again in the early evening.[31]

None of these concerns and provisions made Heller very different from other local men of his class, except in one respect. He was the only Frankfurt citizen to ever commission and receive a Dürer.[32] The inventories of elite families in the city list extraordinary amounts of jewellery, silverware, clothes as well as tapestry—a few books but only very occasionally small portraits of a couple or an image of the Virgin painted on canvas that might have just been pinned up without a frame.[33] Dürer and his fellow artists had to find ways of convincing these wealthy German burghers to see the point of buying paintings for their homes or for churches.

The fact that the Heller altarpiece was a Dürer would not have been lost on anyone. In order to ensure the preservation of his own memory and make clear that he had executed everything by his own artful hand, Dürer did something that no painter had

[30] Schmid, *Stifter*, 432–3.

[31] Bothe, *Testament*, 373; Schmid, *Stifter*, 427; Koch, *Dominikanerkloster*, 37.

[32] Schmid, *Stifter*, 436.

[33] Friedrich Bothe, *Frankfurter Patriziervermögen im 16. Jahrhundert. Ein Beitrag zur Charakteristik der bürgerlichen Vermögen und der bürgerlichen Kultur* (Berlin, 1908) and M. Hall Kirch, 'Art, Collecting and Display in the Sixteenth-Century Patrician House in Frankfurt am Main', in Kirch, Münch, Stewart eds., *Crossroads*, 78–103.

ever done before. He placed an image of himself right in the middle of the panel, as a lean, isolated figure in a landscape, a figure nobody would have expected to see when looking up from the monumental apostles in the foreground to gaze at the Virgin Mary's ascension and coronation. Dürer inserted his figure just left of centre, and below Mary and Jesus, to ensure that any viewer's gaze was directed to just this spot. By contemporary standards, there were not many figures in this painting. It would have looked surprisingly empty, inviting close encounter with what there was to see. This self-portrait made a claim for the panel to commemorate Dürer's art as much as for it to constitute a cultic object in memory of the Hellers and the queen of heaven. It was an unparalleled move.

CHAPTER 3

Dürer's Revenge

Impossible to miss, Dürer stands in the middle distance of the Heller altarpiece, dressed like a fine man of fashionable comportment. This look contrasted with the humble tunic he chose to portray his father in, or the simple clothing even the celebrated Italian artist Michelangelo adopted. Their clothes stressed the honesty of pious makers, whereas Dürer styled himself as a creative, inventive artist who deserved to be treated like a gentleman. Nuremberg's citizens were keen dressers. We know that in 1514, even a servant wore fashionably tight leg garments made in yellow, having borrowed money from his master in order to purchase them.[1] Blue colours and faded, brownish reds, known as 'liver-colour', were popular in the city, while cod-pieces—padded mock erect phalluses—were attached to the flap of hose to parade men's virility. [3.1]

Painting, architecture, and sculpture often dominate our sense of the Renaissance. Yet this cultural movement also became visible to many through a new world of fashion. In daily life, dress possessed immediate visual appeal and increasingly offered choice. Everyone was attentive to new hues of colours created by novel dyes. Tailoring was transformed by new materials, cutting and sewing techniques. Shrewd merchants created wider markets for innovations and chic accessories.

Was this fun or foolish? Sebastian Brant's 1494 *Ship of Fools* humorously lamented:

> Of Innovations
>
> An erstwhile quite disgraceful thing
> Now has a plain, familiar ring:
> An honour 'twas a beard to grow,
> Effeminate dandies now say no!
> Smear apish grease on face and hair
> And leave the neck entirely bare,
> …
>
> Vile sulphur, resin curl their hair,
> An egg white's added too with care,
> …

[1] The fabric was 'Futtertuch', normally used as lining; Jutta Zander-Seidel, *Textiler Hausrat: Kleidung und Haustextilien in Nürnberg von 1500–1650* (Munich, 1990), 182.

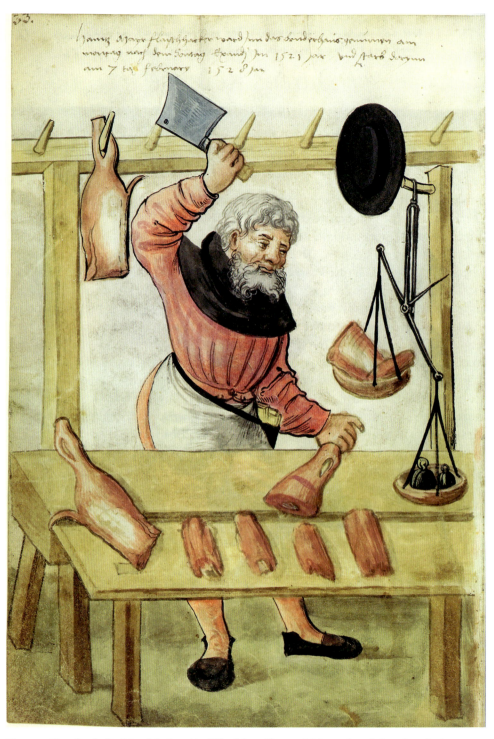

Fig. 3.1 Hausbuch der Mendelschen Zwölfbrüderstiftung. A Nuremberg's butcher during Dürer's lifetime, dressed in fashionable 'liver-colour', Stadtbibliothek im Bildungscampus Nürnberg, Amb. 279.2°, f. 17v.

Their number (of lice) now would wax untold,
Since modern clothes have many a fold,
Coat, bodice, slipper, also skirts,
Boots, hose, and shoes and even shirts
…
Shame German nation, be decried!
What nature would conceal and hide,
You bare it, make a public show,
'Twill lead to evil, lead to woe,
And then grow worse and harm your name.

As a young journeyman in Basel, Dürer worked on woodcuts for Brant's bestselling publication. [3.2] He began to earn more money during his twenties, loved elaborate, expertly dyed fashions on his well-proportioned body, and was careful not to put on weight to demonstrate his moderation. Humanist friends commented on his 'good looks'. They told him that his physical grace was a sign of God's special calling of a superior artist. Furthermore, Dürer noted somewhat obsessively in 1508 that any boy to be taken on as one of his apprentices needed first to have his body and limbs measured 'with full details'.[2] Dürer's appearance would have been noted, and he understood its power.

Nuremberg, as a Renaissance city, can be seen as a backdrop to his presentation of self. Its spaces were constructed and socially engineered because urban embellishment signalled good government. A practical example of this approach was the labour-intensive cobbling of the market square begun in 1494. It took sixteen men thirteen weeks to complete, after which no-one risked sinking into mud when it rained. As part of the same cleansing of the urban environment, 1,300 beggars were driven out of Nuremberg's New Gate.[3] A year later Dürer's friend, Conrad Celtis, a celebrated humanist who lived in the city at this time, finished his treatise on the splendours of the city, with the aim of countering Italian prejudices against Germany as barbarian.

Johannes Cochläus took over this brief. In 1511, he provided the most systematic geographical overview of German lands to date and argued that Christianization had civilized the nation. Nuremberg encapsulated Germany's new leadership through thriving commerce and solid governance. Its thirteen churches, nine convents, and artful buildings resonated with the 'vigor of ingenuity' among its best minds— foremost among them Albrecht Dürer. Cochläus painted an idealized picture of 'very beautiful' merchants gathering at the marketplace, with their 'bodily shape, tallness and precious clothing' as they displayed themselves next to Nuremberg's *Schöne Brunnen*—the mid-fourteenth-century pyramidal fountain decorated with many artfully imagined and worked sculptures that cascaded abundant water. The cascading

[2] Ashcroft, *Dürer*, vol. 2, 910; vol. 1, 246.
[3] As related by the chronicler Heinrich Deichsler, in Karl Hegel ed., *Die Chroniken der fränkischen Städte: Nürnberg* (Leipzig, 1874), vol. 5, 580.

Fig. 3.2 Woodcut for the Ship of Fools, published by Sebastian Brant, Basel, 1494, public domain. This woodcut shows a fool holding up a mirror to a young man of fashion.

water was not just for aesthetic pleasure but also for practical use. In actual fact, the fountain had become so dilapidated that Dürer was sent out to inspect it in May 1511.

In terms of Nuremberg's social composition, Cochläus outlined that there were three social classes. Old elite families, called patricians, stood at the top; next came merchants; everyone else belonged to the *plebs*.[4] Others divided Nuremberg's citizens into five groups by distinguishing between patricians and the wealthy traders in charge of politics in the city's Inner Council as first and second group, middling merchants who belonged to the group of three hundred men in the Great Council as third group, and a fourth group of shop keepers and craftsmen, while low income groups such as day-labourers ranked at the bottom.[5] Nuremberg's Inner council had abolished guilds from 1348, and during the fifteenth century the influence of merchants on its politics and society had steadily grown. The Inner Council's oversight of governance could be as punctilious as prescribing the measurements of the tips of shoes in order to control sumptuousness.[6]

Sumptuary controls made dress even more important. It mapped out a route to social ascent. Hence Dürer used clothing as a way to stand out aesthetically and bolster his claim that he and his fellow artists were superior to common folk and craftsmen. Dürer and his family traded his work internationally, and clothes helped to make him look like a cosmopolitan merchant. Dürer had cultivated his contacts in Italy for some time. From 1497, the artist had paid peddlers to distribute his woodcuts and engravings in German and Italian towns 'for the highest possible price', although this system eventually turned out to be too fraught with risk. From 1506, his wife Agnes and mother Barbara set up stalls at Nuremberg's annual Imperial Relics Fair—a perfect event from which to sell religious prints—as well as in nearby Augsburg and Ingolstadt. Barbara was addressed as *Goldschmiedin*—the feminized form of goldsmith. Agnes joined merchants from Nuremberg on their carts to travel to Frankfurt's fairs. She stayed for weeks at a time to sell print series, such as the *Apocalypse*, alongside single sheets of her husband's woodcuts or engravings, and kept accounts. Just as in any other artisan workshop, theirs was a joint business which provided her with independence and status. Like many other middling Nuremberg citizens at the time, the Dürers were keen to live more comfortably by investing in trade; they produced for markets and speculated a little. Nuremberg craftspeople sought out opportunities that a capitalizing economy offered rather than aiming to just get by.[7]

This was an acquisitive time, spurred on by an age of imperial expansion into the 'lands of gold'. A terrestrial globe by Martin Behaim was displayed in the ground floor

[4] Cochlaeus, *Brevis*, 82–3, 84–5; Ashcroft, *Dürer*, vol. 1, 335–6.

[5] Hildegard Weiss, *Lebenshaltung und Vermögensbildung des mittleren Bürgertums: Studien zur Sozial- und Wirtschaftsgeschichte der Reichsstadt Nürnberg zwischen 1400–1600* (Munich, 1980), 34–5.

[6] Weiss, *Lebenshaltung*, 165.

[7] Weiss, *Lebenshaltung*, documents this extensively; and Dürer's own father's investment in mining is a very good example of these types of investment.

of Nuremberg's town hall and instrument makers perfected navigational tools. Everyone in Nuremberg would have known about the fleet of three ships financed, at enormous expense, by local, Augsburg, Florentine, and Genoese merchants in 1505. In partnership with the Portuguese crown, these ships sailed to the East Indies. They returned, laden with luxury goods, just as Dürer finished working on the Heller altarpiece in 1509. That same year saw the publication of the bestselling tale of Fortunatus. It told the story of a young Cypriot who tried to restore the wealth his father had wasted. Eventually he met Lady Luck. She asked him to choose between wealth, wisdom, strength, beauty, health, and a long life. Fortunatus chose riches. He received a magic purse that forever produced coins in the right currency, as well as a wishing-hat enabling him to fly to wherever he wanted. In contrast to traditional morality tales, Fortunatus knew how to conduct himself wisely as a rich man. Money did not corrupt him, although he misjudged his children, who turned out to be lazy, greedy, and immoral. Woodcuts depicting Fortunatus happily flying round Europe, India, and Egypt with his wishing-hat were popular. It was a captivating tale for this new age.[8]

The global spice trade fuelled Nuremberg's riches, and clothes flaunted them. For example one of the city's spice merchants owned eleven coats valued together at over two hundred florins, while a patrician from the Löffelholz family in 1506 was able to choose between a green, brown, and two yellow gowns before leaving his house, one of them made entirely from velvet.[9] For the Heller altarpiece, Dürer depicted himself wearing slashed black shoes, and tight yellow hose to adorn his elegant legs, a finely tailored and slashed white doublet for his upper body with matching breeches. Over these garments he wore a remarkable blue coat. It was fashionably designed while its blue colour was associated with the apostles and the Virgin. The right sleeve differed in construction from the left to highlight a love of variety and thought which had gone into its creation. All this indicated his aspiration to rank, further reflected in his fresh enthusiasm for the expensive clothes he had recently bought in Venice or had brought with him to the city. 'My French coat, coat and brown tunic', he told Pirckheimer in autumn 1506, 'send you warm greetings'. Fancy clothes were no meagre things for him, they spoke of longed-for success and expressed the type of man he wanted to be. His new Venetian friends impressed him as gentlemen—he described them as congenial, 'intelligent, well-educated, good lute-players or pipers, knowledgeable in painting and of noble spirit, true paragons'. Shopping around the clothes stalls, he selected quality fabrics like those they wore. 'If only I had my woollen cloth back!', he despondently penned to his friend Pirckheimer after a fire, 'six houses are ablaze…and woollen cloth I bought just yesterday for eight ducats has gone up in flames'.[10]

[8] See the discussion in Sandra Richter, *Eine Weltgeschichte der deutschsprachigen Literatur* (Munich 2019), 47–51.
[9] Zander-Seidel, *Textiler Hausrat*, 160.
[10] Ashcroft, *Dürer*, vol. 1, 163 (with adaptation), 139, 142, 167.

An integral part of Dürer's carefully curated look was his long and immaculately curled hair. As Brant suggests, ingredients such as sulphur, resin, and egg white aided both men and a new type of woman to achieve this look. Agnes wore her hair in long braids when the artist met her, just like single German girls were meant to. From later depictions of her it appears that she kept her hair tightly bound below a headdress as a married women, following conventional customs of her time. Agnes must have spent more time helping her husband to get his hair dressed than her own. In fact, just as he was working on Hell's altarpiece in 1509, Dürer described himself for the first time, quite deliberately and self-consciously, as a 'hairy, bearded painter'. Yet this was no mere fashionable pose; it signalled that he felt bold enough to experiment, and his challenges went beyond the visual arts, such as writing poetry, a genre through which humanists attempted to train reason and civility by describing emotional choices.[11] He defended himself against those who reminded him of the proverb 'shoemaker, stick to thy last'. Dürer was trying to unleash all his creative potential, and his long hair functioned as a reflection of feelings. We can imagine that a habit of Dürer would have been throwing it around to dramatize his emotions, or greasing it to emphasize his grace. It would have accentuated his movements as he bent down to inspect work, or stood up from kneeling in church, except for those times when he shoved his locks under a tight hairnet. To know Dürer meant knowing a man who kept arranging his hair.

In Venice, Dürer bought a bestselling Italian book on love that shows how hair defined gentility or coarseness, and a notion of liberty for women yet unknown in Germany. It was all about how much effort you put into the look—in fact, hairstyles were closely linked to explorations of ornament, calligraphic flourishes, and geometry. Ringlets expressed a fascination with spiral figures. The *Hypnerotomachia Poliphili*, one of the period's most influential erotic texts published in Venice in 1499, was probably written by the monk Francesco Colonna. It leads us into the period's intense sensitivity towards hair, and thus towards an understanding of how hairstyles became such an important visual experience. They were devices to tell stories or live one's life. Colonna lavished prose on the nymphs' gentle curls, knots, and twists, crisped hair wound into tight ringlets, curled ringlets made with 'art and artistry'. Floating hair 'deliciously inconstant in gentle breezes', hair moving in 'beautiful waves' past 'firm, fresh buttocks', and 'lasciviously loosened washed hair' were vividly set out before readers. At this time it was more usual to perfume and powder hair than wash it. Colonna celebrated the 'utmost smoothness of two tresses' as much as the glossy, lustrous intensity of blonde, red, or coal-black hair.[12] Such passages prepared readers for the emotional

[11] On this wider theme see, most recently, Julia Saviello, *Verlockungen: Haare in der Kunst der Frühen Neuzeit* (Berlin, 2017), 123–45; Koerner, *Self-Portraiture*.

[12] *Francesco Colonna: Hypnerotomachia Poliphili: The Strife of Love in a Dream*, transl. by Joscelyn Godwin (London, 1999), 332–3.

50 *Ulinka Rublack*

fever pitch of encountering two executioners, characterized by coarse clothing, peasant gestures, and their 'long thick hair' that appeared 'goat-like', 'greasy and filthy, grizzled with black and grey', signalling their corrupt human nature.[13]

Dürer's hairstyle was a means to show that his imagination was divinely inspired, which is why he portrayed himself as early as 1500 as a dignified artist, created in the image of Christ. He wore long hair, in the same hazelnut brown colour as Jesus's was believed to have been, a look he artfully updated with blond highlights. How he styled his own hair, as well as the care he routinely bestowed on the depiction of hair and fur in his portraits, right up to the end of his life, were part of the essence of his singular painterly style. It displayed his precise, super-fine, cleverly conceived, and endlessly patient brushwork, worthy of one with a goldsmith's background. Admiring the Heller altarpiece, the art critic Carel von Mander recorded in 1577: 'Everything is painted in a very clean and fine manner, the hair, for instance, is very sharply drawn and worked into curls through *well thought* brushstrokes in the manner which can sometimes be seen on his best engravings.'[14]

On the Heller altarpiece, a black bonnet distinguished Dürer from the group of bare-headed apostles. So did other accessories: a long sword, and leather gloves so tight they would need to be peeled off like skin, a ring on his right thumb, and a bracelet or string of rosary beads on his left arm. Dürer's right hand points to a tall canvas framed with simple wood which reached from the ground to his hips and was supported by his left hand. Elegant Roman letters in Latin spelt out that he, Albertus Dürer, German, had made the panel after Christmas 1509. A particularly large rendering of his monogram AD completed the inscription.[15]

During these years, Dürer was creating something of what we might call today a 'selfie' habit to market himself and attract attention. For some, this habit resulted from the artist's 'piety and narcissism' mixed with a peculiar form of 'fetishistic self-possession' that responded to 'larger spiritual, aesthetic and economic problems'.[16] Dürer had painted three self-portraits in oil before the age of twenty-eight—the age that signalled his full maturity. All of these he kept at home. His final self-portrait from 1500 had been painted without a commission, just like the other two, but with extraordinary care, and thus perhaps as a gift for a loyal client such as Frederick the Wise, or to entice clients visiting his studio to commission their own portrait. At the time, nobody

[13] *Hypnerotomachia Poliphili*, 405.

[14] Cited in Decker, *Helleraltar*, 117: 'Alles ist sehr sauber und fein gemalt, die Haare z.B. sind sehr scharf gezogen und mit geistreichen Pinselstrichen zu Locken gestaltet, wie man es manchmal auf seinen vortrefflichen Stichen sehen kann.'

[15] For this new emphasis in research on very gradual success as well as failure rather than a breakthrough through the Apocalypse prints, for instance, and the use of the logo, see Schauerte, *Dürer*, 102.

[16] Koerner, *Self-Portraiture*, 186.

appears to have offered to buy a Dürer *as* Dürer. This might explain why he painted no further autonomous self-portrait.[17]

Even more startlingly, however, from 1500 onwards Dürer started adding his figure to his most prestigious commissions. In 1503–5, Dürer included a full-sized portrait of himself as a drummer accompanying a piper on one of the side panels of an altarpiece (executed most likely for Frederick the Wise's castle church in Wittenberg). In 1506, he put himself in the far-right background of his Venetian altar painting, standing tall among a group of German lay people celebrating the Feast of the Rosary. More daringly, in the 1508 altarpiece depicting the *Martyrdom of the Ten Thousand* for Frederick the Wise, Dürer placed himself, together with his recently deceased friend Conrad Celtis, right in the centre of the panel, and probably decided to do so spontaneously at the end. Dürer used a device he had seen in the paintings by the Venetian master Giovanni Bellini. He held up pieces of paper inscribed with Gothic script, with a brief identification in Latin—'Albertus Durer, German, made this in 1508', or, in the case of the *Feast of the Rose Garlands* painting, 'Albrecht Dürer, a German, produced this in the span of five months AD', although there exists a slight possibility that the latter may have been added posthumously.[18]

Yet the Heller altarpiece remains the only painting in which Dürer depicted himself as detached figure, unmissable, with a panel providing credits larger than a shop sign. He repeated this feat in the final altar painting he would ever complete, the Landauer Altarpiece, in 1511, but positioned himself far more modestly in the lower right-hand corner of the panel, clearly separated from the Christian story the altar brought to life.

Most German artists and makers at this time still did not sign their work, not only because it was seen to result from collaboration in a workshop but also because they were restricted by a sense of modesty or viewed it as a form of advertising they did not need.[19] Some included their portraits among groups of devout people, but likewise never identified themselves by name. Adam Kraft and Peter Vischer of Nuremberg created sculptures of themselves in the Nuremberg churches of St Sebald and St Lorenz, but these did not bear their names. Makers occasionally signed master works—Christian Cloit, the exceptional caster of large church bells in Cologne, for instance, but the inscription also recorded that he was liable for repairs and alterations. Hans Baldung Grien showed Dürer's influence on him when in 1507 he depicted himself as watching

[17] This is based on new research, see Schauerte, *Dürer*, 16, 109–14, with an emphasis on the importance of a non-linear perspective on Dürer's biography.

[18] A painting of Eve finished after Christmas 1507 included a small framed canvas with a Gothic inscription and Dürer's monogram, an adaptation from his famous engraving in 1504, where the framed canvas hangs from the branch Adam clutches and shows that Dürer's art can breathe life into figures just like God breathed life into them from clay, Chipps Smith, *Dürer*, 142.

[19] Schmid, *Stifter und Auftraggeber*, 298–9.

 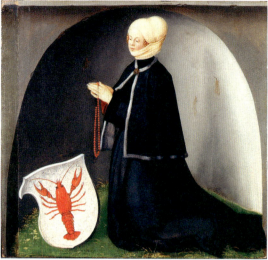

Fig. 3.3　Jakob Heller and Katharina Melem as donors, part of the altarpiece commissioned from Dürer. © Historisches Museum Frankfurt, Photo: Horst Ziegenfusz.

the martyrdom of St Sebastian, right behind the naked saint, clad in green—the colour being a pun on his name.[20]

Still, Dürer's combination of a self-portrait and self-centred inscription was unique, and the Heller altarpiece remained the most blatant of these interventions in the history of religious art. It showed off the graceful proportions of his full-length body, and Dürer's expertise as mathematically trained painter who understood beautiful proportions geometrically. The portrayal of Jakob Heller and Katharina as donors, below the central panel, was entirely formulaic. They were depicted against the backdrop of a grey, narrow space, which suggested that they awaited salvation. Heller looked a youthful, wealthy, but anxiously humble and pious man, whose shoulder-long hair was not well combed and fell on a broad fur collar decorating a voluminous, precious gown. These small panels would have been painted by someone helping Dürer at the time, most likely his younger brother Hans. There was no reason to look at this kneeling merchant or his wife twice. They were rendered as subsidiary, generic figures of true devotion. [3.3]

This portrayal stood in complete contrast, for instance, to the choice made by Claus Stalburg, Frankfurt's richest man at the beginning of the sixteenth century. Stalburg was somewhat younger than Heller and resided in the city's most sumptuous new-built Gothic villa. Sole heir to his father's merchant capital, he lived as a rentier with his wife Margaretha vom Rhein, who hailed from one of Frankfurt's patrician families and bore

[20] The altar painting that is likely to have negotiated the fear of dying from syphilis, with which Ernest II, the immensely powerful archbishop of Magdeburg and Frederick the Wise's brother, had been afflicted for years, Birgit Ulrike Münch, 'Praying against Pox: New Reflections on Dürer's Jabach Altarpiece', in Debra Cashin et al. eds., *The Primacy of the Image in Northern European Art, 1400–1700*, essays in honor of Larry Silver (Leiden, 2018), 256–68.

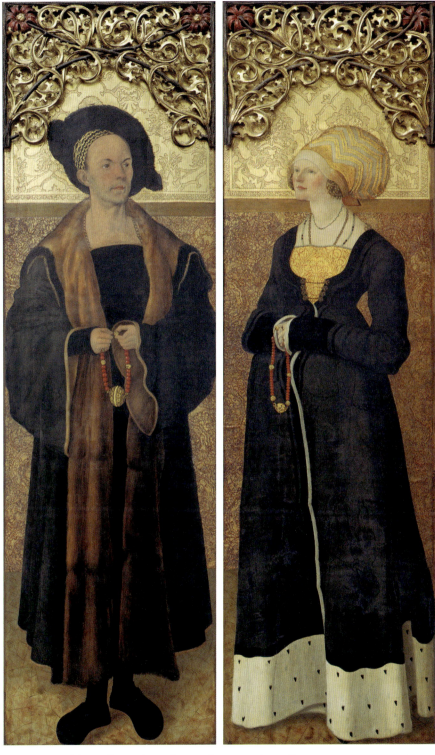

Fig. 3.4 Master of the Stalburg altar, Claus and Margarethe Stalburg, 1504, 188 × 56 cm, mixed technique on fir wood, Städel Museum, Frankfurt am Main, public domain. Stalburg's gown is lined as well as trimmed with fur, which underlines his wealth. The central panel of the altarpiece depicts a crucifixion scene.

54 *Ulinka Rublack*

him fourteen children.[21] One year before his election as junior mayor in 1505, Stalburg and Rhein had commissioned an altarpiece with wings, gleaming with gold leaf that depicted each of them standing upright, nearly life-size and in floor-length gowns. Frau von Rhein shows off precious ermine fur trimmings and clothing made from gold thread—the most conspicuous consumption there was. [3.4]

Katharina's and Jakob's modesty about their place in society and their trust in contemporary artists allowed Dürer to make himself central. No contract or contract drawing exists for the Heller altarpiece, but it is quite unthinkable that Jakob would have known of Dürer's plans to include himself in precisely this way.

Dürer's unusual decision to depict himself so prominently in the Heller altarpiece surely resulted from his desire to competitively market himself to those who lived in or visited Frankfurt. It reflected his radical claim that true artists should be honoured as men of dignity and distinction. The tense relationship that he and Heller were soon to develop further magnified the emotional connection Dürer formed with this painting. Indeed, the figure's central position suggests that this self-portrayal might have been an act of revenge.

[21] Alexander Dietz, *Frankfurter Handelsgeschichte*, vol. 1 (Frankfurt am Main, 1910), 285–6.

CHAPTER 4

A Trio of Unconventional Friends

It is crucial to consider therefore who Dürer was as he undertook Heller's commission, and the extent to which unconventional friendships with humanists shaped him. They inspired his ambition and were underpinned by pleasure in experiment and transgression which stood in tension to the morally steadfast ideals of the burgher family he was born into.

Like many people at the time, Dürer carefully curated his own memory and, at the end of his life, turned the notes left by his father into a short family chronicle. The story began with his paternal grandfather, a goldsmith who lived in a small Hungarian town. He and his wife had four children, one girl and three boys. Two of these boys followed their father's trade. One of them was Dürer's father. Born around 1427, he eventually left Hungary as an apprentice to find work in Germany and the Netherlands. Finally settling in Nuremberg, Dürer's father worked for twelve years in Master Holper's workshop, whose family had been goldsmiths since 1387. When Holper died, he took over the workshop and finally, aged forty, became a master in his own right. For Dürer's father, life as a mature immigrant craftsman went wonderfully to plan. The Holper's daughter Barbara (b. 1452), whom he had known since she was three years old, was betrothed to him in 1467 when she was fifteen. Marrying a Nuremberg maiden from within the craft helped Dürer's father to gain recognition as an independent master and to be entrusted with civic office later in life. Although so unequal in age, their marriage was blessed. Barbara bore her first child aged sixteen, and, up to the age of forty, seventeen further children. It is remarkable that she did not die in childbirth, like many other women who married young and were fertile for well over twenty years. The couple prospered financially, managed a shop at the main market square from 1468 and from 1480 another shop at the town hall. They invested in Germany's burgeoning silver mining industry, although their son in retrospect would stress his parent's humbleness, and the fact that they had 'little indeed'.[1]

[1] Ashcroft, *Dürer*, vol. 1, 35; for important discussions of the genres of self-writing and Dürer's texts see Heike Sahm, *Dürers kleinere Texte: Konventionen als Spielraum für Individualität* (Tübingen, 2002); for an extensive discussion see also Schmid, *Dürer als Unternehmer*, here 39. For an instructive overview of middle-class investment in the mining industry by Nuremberg citizens at the time see Hildegard Weiss, *Lebenshaltung und Vermögensbildung* (Munich, 1980), 64–70.

56 *Ulinka Rublack*

Albrecht was Barbara's second son and born when she was nineteen. By the time she gave birth to her last child, Albrecht had left home to travel as a journeyman west to Colmar and down south to Basle. His previous life with his parents would have been marked by him overhearing them having sex at night, by Barbara's periods of pregnancy, the home births, periods of recovery as she lay in, and baptisms. Yet when Albrecht's father died in his seventies in 1502, only three of his seventeen children were alive. Albrecht was aged thirty-one, and his brother Endres eighteen, while Hans, the youngest, was only aged twelve, so that his mother still worried about him. Hans and their widowed mother now came to live and work with Albrecht, until Barbara died, old and very ill, in 1514.[2]

Dürer's household was thus an extended one when he painted the Heller altarpiece, and he was keenly aware of his need to support his kin. Hans never married, and Endres, a goldsmith, had no children of his own. Despite his mother's almost constant state of pregnancy, there would be no further descendants. Dürer would not have been able to foresee this when he painted for Heller, but he would have known that it was unlikely that he himself would have any legitimate children and that his family might possibly die out. There was no son to take over a workshop and receive the knowledge he could hand down. In contemporary humoral terms, this would have inclined him to think that he lacked generative heat, tending to emotional dispositions such as melancholia that needed balancing. He is likely to have felt a sense of loss as well as of heightened singularity, which his humanist milieu in any case encouraged through its commemoration of famous men and women. All fed into an urge to preserve his legacy through his works and writing. [4.1]

Dürer's career had at first evolved slowly by the standards of the time. As we have seen, he most likely enjoyed only basic schooling and trained with his father as a goldsmith before deciding that painting pleased him more. Dürer was therefore next apprenticed to the large workshop Michael Wolgemut ran in Nuremberg, where he learned both to paint for large commissions such as altarpieces and to make drawings on woodcuts for ambitious projects in print. Wolgemut collaborated with Dürer's godfather Anton Koberger, a successful printer who descended from a local family of bakers. Koberger's approach to printing was mostly cautious and commercially calculating, as a result of which he made so much money that he married a patrician girl in 1492. He published the *Nuremberg Chronicle* one year later, became rich enough to close his shop in 1504 and be invited to patrician dances from 1506.[3] Because Dürer spent several years wandering after his apprenticeship, he was already aged twenty-three by the time he returned home. Most of his peers would have already worked locally for years. Just as his aspiring parents had arranged for him, Dürer married Agnes Frey,

[2] For the chronicle and footnotes on the children see Ashcroft, *Dürer*, vol. 1, 31–41.
[3] See the myth-busting account of Christoph Reske, 'The Printer Anton Koberger and his Printing Shop', *Gutenberg Jahrbuch* (2001), 98–103.

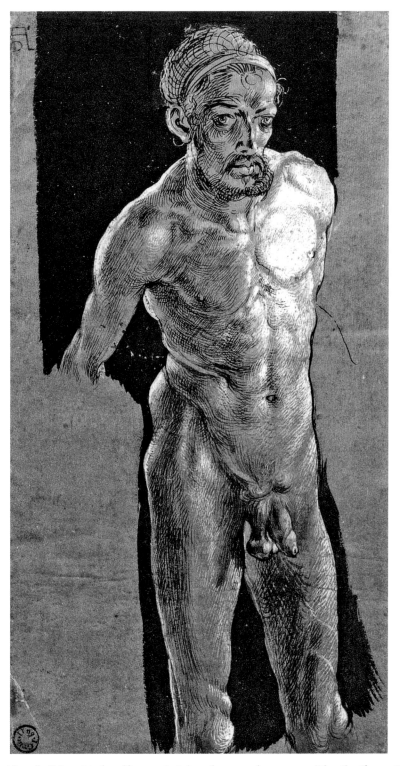

Fig. 4.1 Albrecht Dürer, Nude self-portrait, ink and watercolour, c.1509, Klassikstiftung, Weimar, Wikimedia Commons, public domain. This nude self-portrait carefully observes the genitals, casting a large shadow.

whose mother belonged to Nuremberg's patriciate, and soon after travelled south towards, or even into, Italy for several months.

By 1498, Dürer had confidently published the *Apocalypse* as a bound series of fifteen woodcuts—the first book ever created and printed by an artist. During the same year, he painted his second self-portrait in oil, in which—aged twenty-six—he truly looked like an international gentleman. Some prints Dürer created around this time, such as the *Men in a Bath-House*, were similarly unique, experimental, or highly emotive, inviting his audience to spend time with them. He used vendors to market them internationally. It was at this time that Dürer became a close friend of Conrad Celtis, a humanist firing up young Germans about excelling through endless effort and true learning. Just like Koberger, he exuded the energy of a self-made Renaissance man. A vinter's son who had risen through restless industry, Celtis denigrated everyone daunted by the prospect of mastering classical languages as sloths. After all, Cato the Elder had taken up learning Greek aged eighty to improve his Latin rhetoric. Why, he challenged young students, wouldn't you?[4] The matter was politically urgent. Celtis thought that Germans had the right character to unite classical learning with true Christian belief in order to assert themselves as a nation. Nuremberg's learned elite joined Celtis in defending the importance of subjects cherished during antiquity, such as topography or zoology. Dürer's 1502 watercolour of *The Hare* hence marks one of his first contributions to this renewed passion for the study of animals based on empirical observation of all divinely created nature. Perfectly recreating the fur of a hare was an exercise in Christian humanism. Dürer's costume studies responded to Celtis's calls to describe the manners of people all over the globe. Studying Vitruvius led Dürer to theoretically conceptualize the beauty of geometric proportions in human bodies. His final self-standing self-portrait in oil, aged twenty-eight, emulated the perfect, harmonious proportions of Christ's face in his own, claiming his special grace as a male painter able to minutely imitate ordered nature. Executed around the same time, his *Witch Riding Backwards* conversely represented the horrors of disorder in a world ruled by the devil and women as his dark, sexually lusting allies to destroy everything living.

All through his twenties and early thirties, Dürer created occasional altarpieces, the first of which was commissioned by the local Paumgartner family around 1498. From December 1505, just over a decade after his first trip towards or across the Alps, Dürer worked in Venice for about eleven months on the *Feast of the Rose Garlands* altarpiece and later visited Bologna. He was one of four hundred Nuremberg men who are known to have worked in Venice between 1400 and 1530, most of whom were connected to

[4] Conrad Celtis, *Panegyris ad duces Bavariae*, transl. and ed. by Joachim Gruber (Wiesbaden, 2003), 35.

merchant trades.[5] Dürer arrived back in his home city just in time to celebrate carnival, in February 1507. Aged thirty-six, Dürer wanted to assert himself in Germany as an artist who had just celebrated real international success with his painting rather than with his prints. More than ever, he now strove for recognition as the best of the best, so that every major piece of work he accepted became supercharged with his own expectations and fantasies of future fame. Meanwhile, he had spotted his first grey hair in Venice, which he jokingly attributed to his fears of poverty and stress over work: 'But nothing annoys me more', he told Pirckheimer, 'than when they say you are growing handsome whereas I'm getting ugly. It's enough to drive me mad. I've just spotted a grey hair. What's made it grow is sheer poverty and the way I stress myself.'[6] Like many men of his time, Dürer was intensely self-observing, acutely aware of the signs of an ageing body and ill-health. As he travelled to Italy, he also escaped the plague, leaving his family and local life behind.

His humanist friends, too, were deeply attentive to their bodies, illness, ageing, and looks, so much so that they corresponded about recipes for hair dye. Willibald Pirckheimer was only five months older than Dürer, but his grey hairs would certainly not have been thought to result from financial worry. He belonged to Nuremberg's patrician class, albeit not to the town's very oldest patrician families. His father and grandfather had already been well-known humanists who had studied in Italy. The family likewise cherished both his grandmother and his oldest sister, the abbess Caritas, for their humanist learning. Pirckheimer grew up in nearby Eichstätt, and aged nineteen studied for almost six years in Padua and Pavia, where he left behind an Italian courtesan grieving for *Bilibaldo Allemano*. The relationship was a measure of how much he sought to blend into high Italian culture during the foundational years of his early to mid-twenties—his male friends were distinguished young Italian aristocrats excited about developing humanism as a cultural movement. The future lawyer, superb Greek scholar and civic diplomat would keep the courtesan's final letter, passionately assuring him that she would not be able to live without him and asking him to preserve his single and pristine love.[7] On his return from Italy, Willibald moved to Nuremberg when he married Crescentia, a patrician woman aged twenty-five, as arranged by their families. The couple had four daughters in nine years, until Crescentia tragically died of complications in childbirth in 1504, their baby boy perishing as well. As he approached his mid-thirties, Pirckheimer decided to explore again feelings of love and enjoy sexual freedom. In a very long and passionate German love poem he wrote for a woman, he repeatedly addressed her as his 'peasant bride' and 'doll', echoing the exact phrases used

[5] Bettina Pfotenhauer, *Nürnberg und Venedig im Austausch: Menschen, Güter und Wissen an der Wende vom Mittelalter zur Neuzeit* (Regensburg, 2016), esp. 234.

[6] Ashcroft, *Dürer*, vol. 1, 163.

[7] Emile Reicke ed., *Willibald Pirckheimers Briefwechsel*, vol. 1 (Munich, 1940), 26–7. For biographical information see Emil Reicke, *Willibald Pirckheimer: Leben, Familie, Persönlichkeit*, (Jena, n.d.).

60 Ulinka Rublack

by the courtesan from his Paduan student days: 'his body, soul and life' were 'completely devoted' to her. Such rhetoric, he must have thought, was sure to make an impression.[8]

Pirckheimer never remarried. Writing from Venice, Dürer teased him about bragging about his affairs since his student days: 'My dear fellow, there are so god-awful many Italians here who look exactly like you, I can't imagine how that comes about'; or: 'It seems to me that you stink of whores so badly that I can smell you here, and people tell me, when you go after women, you pretend you're no more than twenty-five'. Sexual boasting was a way to compete with male peers and emotionally manage ageing; it was also part of a jocular culture full of sexual ambivalence in which women who entered affairs could be honoured as much as denigrated as whores. In the same letter Dürer sent greetings to 'canon Lorenz and our pretty lady-friends'.[9]

Nuremberg ran its civic brothel at full capacity during this time. Its twenty-three sex workers were meant to satisfy the demands of single men before marriage. They were careful to protect their legal status, although after 1496 they lost their privilege to take part in dances in the town hall, as in Frederick III's time. Nuremberg's brothel workers, however, entertained clients by dancing to music and gambling; they would have been well and sensuously dressed. Their key fight was against uncontrolled prostitution. For example, at the end of November 1505, while Dürer was travelling to Venice, the mayor of Nuremberg received a visit from eight prostitutes complaining that a secret brothel had opened up to welcome young men day and night. They asked for permission to storm it and attack the procuress, to which the mayor agreed. The whores pushed through the doors, destroyed the ovens and all the glass windows, horribly beating up the old procuress and taking away with them what they could.[10] At this time Pirckheimer was most likely cultivating his own amorous liaisons with local women, and perhaps with men, at home, which to upright people would have made his dealings all the more circumspect. He employed a widowed housekeeper, who did not live on the premises.[11]

A far bulkier and taller man than Dürer, who was never afraid of creating conflict, Pirckheimer in his youth had been an extrovert who enjoyed Italian songs as well as dancing, and probably owned a small organ or keyboard at home. Their close friend canon Lorenz Behaim in nearby Bamberg joked that he was jealous about missing his 'revelling' with Pirckheimer and Dürer in the great 'bacchanalia' they inspired during the carnival season in 1507, adding that he likewise preferred young women to old matrons. Nuremberg's carnival season began around the 6 January and lasted into

[8] *Pirckheimers Briefwechsel*, vol. 1, 392–402, here 397, 'Meyn leyb, gut und leben/Ist, frau, in dem gewalte deyn'.

[9] Ashcroft, vol. 1, 159–60; for an insightful discussion see Lyndal Roper, 'Tokens of Affection: The Meaning of Love in Sixteenth-Century Germany', in Eichberger/Zika eds., *Dürer and his Culture*, (Cambridge, 1998), 143–63, here esp.155; and for sensitive readings of the correspondence see Thomas Noll, 'Albrecht Dürer and Willibald Pirckheimer. Facetten einer Freundschaft in Briefen und Bildnissen', in Franz Fuchs ed., *Willibald Pirckheimer und sein Umfeld* (Wiesbaden, 2014), 9–56, and Sahm, *Dürers kleinere Texte*, 60–83.

[10] *Chroniken der fränkischen Städte, Nürnberg*, vol. 4., 695–6.

[11] This is implied by *Pirckheimers Briefwechsel*, vol. 1, 443, fn.35. On the role of prostitutes in carnival plays see Beatrice von Lüpke, *Nürnberger Fasnachtsspiele und städtische Ordnung* (Tübingen, 2017), 181–90.

A Trio of Unconventional Friends 61

February or early March.[12] As early as 20 January 1507, one Würzburg canon wrote to Pirckheimer that the carnival hindered him from any serious pursuits and that he was drinking far too much to be able to comment on a treatise the humanist had sent.[13] Informal gatherings and mummeries culminated in organized festivities. In 1506, the carnival processions had been especially 'precious', including a large ship with sails manned by a foolish devil that was destroyed by fire.[14] Carnival plays spiced with obscenities entertained crowds; both patricians and butchers appeared in fancy dress to stage the famous *Schembartlauf* indigenous to the city. By 1507, these festivities included performances of Italian ballets. Pirckheimer was at the vanguard of a cultural movement that would successfully merge traditions from classical antiquity and Italian tastes with German culture through the genres of satire and comedy.

Canon Behaim was himself descended from a family of Behaim gun- and bell-casters. After obtaining a doctorate in Italy, he had lived in Rome for more than twenty-two years, serving Alexander VI as Senior Bombardier (*Oberster Geschützmeister*) at his sexually licentious court. Following the Pope's death in 1503, Behaim had only recently returned to Germany. Dancing had been a notable past-time at the Vatican, so that Behaim sent new *bassadanza* tunes to Pirckheimer. A blend of scholarly passions, including astrology, and applied empirical interests, such as engineering and chemistry, turned Behaim into a Renaissance man of a kind. The Borgia thought him knowledgeable about poisons. By 1507, when Dürer took on Heller's commission, the canon had just fought off a paternity claim; in 1514, he asked Pirckheimer to intercede for him before Nuremberg's council on behalf of an unhappily married wealthy woman engaged in a public, long-term adulterous affair.[15] As a man who had just turned fifty, canon Behaim was happy to counsel his much younger friends on how to dye their hair, with recipes that lasted for six to seven months until new root growth appeared.[16]

Pirckheimer cultivated his attractiveness and novel gender roles by carefully choosing his outfits. As a young man he had asked his Italian mistress to send gold-worked gloves. Later, an Italian correspondent repeatedly sourced fine clothing for him, including a doublet made in a Lyonese style. He wrote to Pirckheimer in September 1506: 'I am sending you two pairs of leather shoes in the current French fashion and one pair from velvet, which you can use for masquerades, or when you visit a lover.'[17] Pirckheimer's inventory records a leopard skin imported from Africa among his clothes, and a Turkish gown.[18] His unconventional lifestyle even encouraged a lowly local woman

[12] *Pirckheimers Briefwechsel*, vol. 1, 485, and Ashcroft, vol. 1, 185.

[13] *Pirckheimers Briefwechsel*, vol. 3, 277, Behaim is also known as Beheim.

[14] *Chroniken*, vol. 4, 698.

[15] *Pirckheimers Briefwechsel*, vol. 2, 450–3, Dorothea Hallerin.

[16] *Pirckheimers Briefwechsel*, vol. 1, 291.

[17] *Pirckheimers Briefwechsel*, vol. 1, 333, 429; see also Rudolf Schmitz, 'Der Anteil des Renaissance-Humanismus an der Entwicklung von Arzneibüchern und Pharmakopüen', in Fritz Krafft, Dieter Wuttke eds., *Das Verhältnis der Humanisten zum Buch* (Boppard 1977), 227–43.

[18] Horst Pohl, *Willibald Imhoff: Enkel und Erbe Willibald Pirckheimers* (Nuremberg, 1992), 20.

who had been disowned and expelled from the city for prostitution and procuring to beg him in a long letter of 1510 to intercede for her. Yet Nuremberg's orderly and 'upright citizens', its *Biedermänner*, became increasingly critical of Pirckheimer's behaviour, culminating in a comprehensive reprimand of his conduct.[19]

For humanists such as Celtis or Pirckheimer an entire worldview was at stake. They argued that classical love poetry should be taught in Latin schools to teach morals, giving the example of the biblical *Song of Songs* which proved that pure love was foundational to belief. Traditional clergymen and citizens objected that it was impossible to merge pagan literature with Christian ideas. Love poetry inspired immorality instead of civility. They questioned whether Pirckheimer's studying of Latin and Greek helped him to control his passions.[20]

The trio of unconventional friends—Pirckheimer, Dürer, and Canon Behaim—likewise observed each other closely. When Dürer was planning to travel to England or Spain aged forty-eight in 1519 to obtain patronage, Behaim commented to Pirckheimer that the artist was 'delicately made' and no longer a young man. Behaim thought that he would simply be unable to cope with the discomfort of the journey, let alone with the weather. The most sensible thing for Albrecht and Agnes to do, he thought, was to look after each other and live a quiet life, besides which, he remarked, their lack of children meant that they did not need greater wealth.[21]

The Dürers' childlessness informed views of Dürer's body and invited comments on his life choices. Dürer's own acute sense of temporality would have furthermore been shaped by the fact that Michael Wolgemut, his teacher as painter, lived close to him as a man in his seventies. He would probably have seen Wolgemut on the street most days and would paint him aged eight-two in 1516, three years before he died. Such old age was exceptional in this period and equated to a state of childlike senility, as men thought of themselves as declining fast much earlier. Not having any children by mid-life might well have intensified this awareness of ageing and temporality for Dürer as much as for Heller.

[19] *Pirckheimers Briefwechsel*, vol. 2, 60–2. Pirckheimer was repeatedly approached for help by men and women of the lower classes—an aspect that must nuance the standard characterization of him as 'herrisch', and lead to his accusation by the council in August 1511, Pirckheimer, Briefwechsel, vol. 2, 83–99.

[20] Jörg Robert, *Konrad Celtis und das Projekt der deutschen Dichtung: Studien zur humanistischen Konstitution von Poetik, Philosophie, Nation und Ich* (Berlin, 2003).

[21] *Pirckheimers Briefwechsel*, vol. 4 (Munich,1997), 40; see also Ashcroft, *Dürer*, vol. 1, 502.

CHAPTER 5

Preparing to Paint

Dürer had known Heller for several years before 1507 and had previously painted a small altarpiece for Katharina's and Jakob's domestic devotion. Next, they probably began to talk about an altarpiece commission for the church in which the couple were to be buried, and eventually made an agreement, although this is likely not have been written down. The correspondence never refers to a written contract. Katharina, for sure, would have had her say in choosing the subject.

As Dürer's first letter to Heller stressed, life back home after returning from Venice in 1507 was frantic, and the fact that it was so cold would not have helped him to settle back comfortably. He had worried about freezing back in Nuremberg months before-hand, and we know from a local chronicle that 1508 indeed saw months without sun-light in the Franconian town.[1] Dürer came down with a fever, but still had to paint the *Martyrdom of the Ten Thousand* for Frederick the Wise. Starting in March, it would have taken him at least until the end of August to finish, based on the claims that he had made for painting the *Feast of the Rose Garlands* in Venice. Yet the claim to have finished that painting in five months was certainly a conceit to gain a reputation as a fast and therefore superior painter, comparable to the masters Pliny praised. Dürer was so keen to boast about the speed of his production that he failed to add in the time it took him to design the composition and produce sketches—at least another three months.[2]

Meanwhile the bishop of Breslau waited for a *Virgin and Child* by Dürer as well as two rectilinear pinewood panels depicting *Adam and Eve*. Each panel measured over two metres in length and eventually adorned his episcopal library as life-sized, superbly proportioned, and thus unusually naturalistic nudes. Because of their naturalism and size, Dürer's *Adam and Eve* represented a marked change to the usual array of philo-sophers, saints, and church fathers that adorned the inside of such buildings. Dürer lived with these large, unwieldy panels at the home that doubled as his studio. As we have seen, he very much felt under pressure, and, as always, wanted to get things right. Endless copying and practising was integral to his mastery. [5.1]

The Nuremberg artist was to some extent his own master and set his own pace. But he also had to make a living and satisfy clients, and his standards and expectations at

[1] *Chroniken der fränkischen Städte: Nürnberg*, vol. 5.
[2] Chipps Smith, *Dürer*, 176.

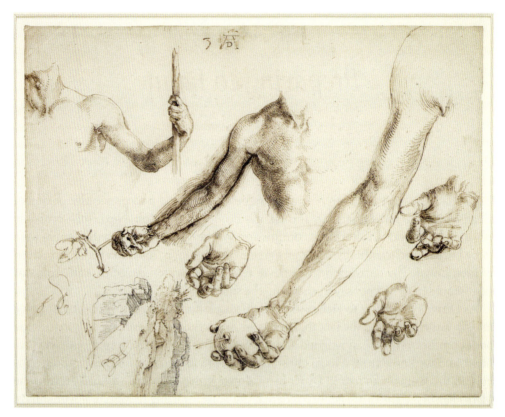

Fig. 5.1 Albrecht Dürer, Studies for his *Adam and Eve* engraving, 1504, British Museum, BM, SL,5218.181 © The Trustees of the British Museum.

this time greatly rose in relation to how he thought he should rank. He undertook the trip to Venice in order to deepen his understanding of perspective and colour, that is, the mathematical basis of painting (*disegno*) alongside the art of *colorite*, colouring and colour combinations, in which the Venetians excelled. He bought a copy of Euclid's geometry in Latin. It shows no traces of use, but its purchase documents his aspirations to engage with classical learning. Dürer changed his sense of himself, wishing to pass on his own learning in writing and print. As a Northerner, he would have been constantly aware of being regarded as a 'barbarian' or boring traditionalist 'a la antiqua' by Italians believing themselves to be more sophisticated and modern. Yet by the end of his stay Dürer finally felt approved for his painting, rather than for his prints, by some of the Italians who mattered to him.

He relished the moment when Giovanni Bellini, the master painter, had 'praised him before many nobles' and asked Dürer to paint something for him personally, for which he would pay him well for.[3] Born in c.1428, Bellini was the revered grand old master of

[3] Ashcroft, *Dürer*, vol. 1, 139.

contemporary Venetian painting, and for decades advised the Venetian Council of Ten on what art to commission and collect. Dürer was very precise in his reports from Venice back to his friend Pirckheimer, who in turn would have disseminated the news in Nuremberg. The fact that Bellini had praised Dürer in public, made a commission, and promised to pay him well for it, was proof that this had not been mere flattery, spoken in private. It showed that Bellini meant what he had said, and Dürer felt proud. In fact, Italian painters regularly formed networks of this kind among each other to help each other in gaining a reputation.[4] They increased their authority, elevated their status, and ensured better pay. No doubt as a result of Bellini's praise, Loredan, the Doge, as well as the Patriarch of Venice, had visited St Bartholome to admire the *Feast of the Rose Garlands* painting. The Doge's visit promised to secure the church's prestige and privileges; he was a connoisseur whose entire family purchased art to hang in their immense palazzi. Dürer suggested in a letter to Pirckheimer that, had he stayed in Venice, he would have acquired further lucrative commissions.

Back in Germany, the Heller commission would be, and remained, Dürer's only major post-Venetian altar painting—the Landauer altar, his final piece, was placed in the small chapel of a charitable housing complex for ageing, impoverished Nuremberg craftsmen. Matthäus Landauer had made his fortune in the copper trade. He built the charitable foundation between 1501 and 1509. In 1508, the merchant asked Dürer to sketch a painting for its chapel. It took Dürer three years to deliver the painting, for which he was paid the substantial sum of 200 florins. The scene depicts the just whom God has admitted to heaven, praying to the Holy Trinity. Landauer's beautiful young relatives, clad in shining armour and fashionable veils, mingle with characters who looked like the humble old men who worshipped in the chapel. Alongside the rich merchant donor with his shoulder-length grey hair, these craftspeople were depicted next to kings and cardinals, elevated, and made equal through true devotion. Dürer empathetically depicted one of these men as an old peasant, with a weather-worn face and ill-trimmed grey hair and beard. He wears a simple blue tunic, clasping his green felt hat with the left hand, and his flail with his right, seemingly in disbelief as the young princely figure behind him gently touches his shoulder. In a society of three orders and tight social hierarchies, this altar painting would have been deeply comforting to the small group of craftsmen worshipping in the foundation as they awaited their end. [5.2]

This was not a prestigious commission for a majestic church. In contrast to the Heller painting for the ancient Dominican church in Frankfurt, the Landauer piece was created for a truly contemporary space. Dürer proposed a new wingless format inspired by Italian altarpieces, with an exceptionally intricate, polychrome frame after his own design. He was completely in control of the entire setting. Dürer accepted the commission in 1508, alongside stained-glass windows after his designs for this newly built chapel. It was a last homage to his craftsmen peers, perhaps men like Fritz Buhler, who

[4] Michelle O'Malley, *Painting under Pressure: Fame, Reputation and Demand in Renaissance Florence* (New Haven, 2013), 4.

66 Ulinka Rublack

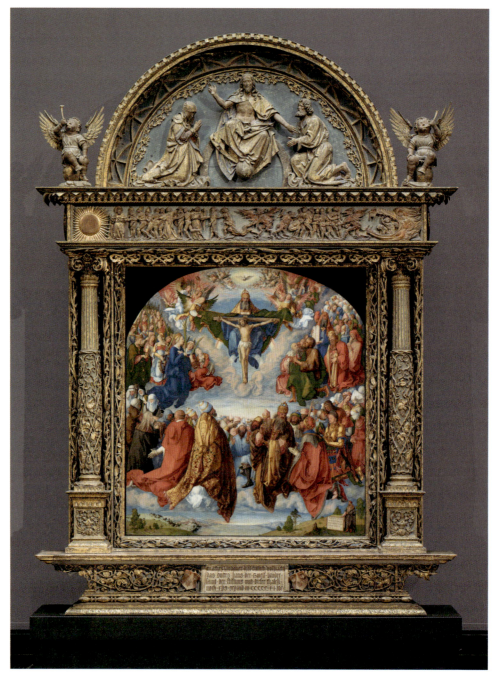

Fig. 5.2 Albrecht Dürer, Landauer Altarpiece, 1511, 135 × 123.4 cm, oil on lindenwood
© Kunsthistorisches Museum, Vienna, KHM-Museumsverband.

might have prepared the panels he painted on, and who joined the foundation in 1513, and lived there until he died eight years later. The audience for Dürer's Landauer new altarpiece were seven old craftsmen: a baker, a smith, two weavers, a cheese seller, a shoemaker, and a barrel-maker. [5.3]

For all his obsession with handsome appearances, aged men inspired Dürer over and over again, as he responded empathetically to the lived experience and true devotion reflected in their humble faces. While generating ideas for how to depict the apostles gasping at the wonder of Mary's ascension in the Heller altarpiece, for instance, Dürer included a perfect drawing of one such man. He took these preparatory drawings for the Heller altarpiece very seriously. He had started doing so in Venice, but now prepared the paper by mixing gum arabic with finely ground charcoal or chalk, and just a little water. This allowed him to paint delicate details. Yet Dürer never even mentioned to his patron the time and effort spent on them—fine brushstrokes to mark contours and delicate hatching to render facial expressions in different colours of ink and to depict the hair, drapery, and place his highlights. It was his decision to execute them in so fine a manner; as for the merchant, 'sketches' towards a final composition counted for nothing. Even in Venice, Dürer struggled with the question of how much time and labour an exceptionally fine altar painting required if it was undertaken without a workshop. This was what might gain him immortality as painter rather than as a graphic artist, and yet it took so long and was so absorbing. Did it pay well enough? While in Venice, he boasted that he had finished a mid-sized oil painting of *Christ among the Doctors* within five days. Given the painting's detail, this seems like another attempt to rival the rapid, ingenious masters of the past and present. Yet there is no doubt that he did paint this particular panel fast and there was a price for speed when painting in oil: he applied only one colour in depth and in more than one layer, as each layer needed to dry and thus delayed the whole process. Dürer even hatched some details in the faces on the base pigment.[5] A product of this kind provided him with a good enough reward and an acknowledgement of his originality. But it was the *Feast of the Rose Garlands* painting which granted him real recognition, and it was made to last.

It marked a watershed in his hard-earned career. In Nuremberg itself, the local Tucher family had been the first to commission portraits from Dürer in 1499, but these were tiny and only measured around 29 by 23 centimetres.[6] As we have seen, Dürer's two final self-portraits in oil were probably intended to show clients what he was able to achieve in portraiture.[7] Up to 1503, when Dürer finished an altar painting for the local Paumgartner family, there seem to have been no major local commissions. On the other hand, some of Dürer's uncommissioned paintings which he sought to market

[5] Chipps Smith, *Dürer*, 179.
[6] Schauerte, *Dürer*, 106.
[7] Schauerte, *Dürer*, 73–6.

Fig. 5.3 The cheese seller, Hans Thom, would have been among the first to worship in the Landauer foundation's newly built chapel containing Dürer's panel and stained glass.

gained him recognition. In 1501, an art-loving Nuremberg diplomat bought one of Dürer's panels, presumably with a religious theme, for 45 florins. He took it with him on a diplomatic mission to King Vladislav of Hungary in order to settle a deal about the town's feudal holdings, and then left it up to Nuremberg's councillors whether or not to reimburse him for the cost of the gift. The Hungarian king, he reported, had been delighted by the 'pretty, illuminated panel'—which indicates its small, handy size, easy to package up for a trip of this kind.[8]

Practical and pretty—these qualities satisfied clients but not Dürer's real ambition. Hence he faced that nagging question: was he considered as useful to German society or as a parasite? Who in his native city, or country, admired painting as a contemporary art that set itself entirely new challenges? Who even possessed the vocabulary and acuity to talk about what different artists attempted to do? At this point, there is no indication in Dürer's letters from Venice that even Pirckheimer was necessarily someone with whom he could engage in art criticism or discuss ideas for compositions. Pirckheimer, in fact, sent him endless shopping lists for other types of luxury goods—books, rings with gemstones, Turkish carpets, or crane feathers to fashionably decorate his bonnet. The humanist was a man of his time in so far that his own tastes focused on book illustrations rather than on painting—the household inventory taken on his death only listed five paintings in his house, of which the most significant one was a picture of the Virgin Mary with a candlelight attached to it. Two of the other paintings were just described as small, while the others depicted a ship and a Hercules. No artist was named.[9] This contrasted with a significant collection of over 120 types of Italian glasses he showed off in his living room. Throughout his life, Pirckheimer collected stags' antlers for mounting on walls. He thought them ingenious and tried to obtain ever larger, finer, and 'attractively shaped' ones.[10] At some point, Dürer had enough of being the humanist's personal shopper posted to Venice, and humorously signalled the end of his patience:

> You would have so many girlfriends, and if you were to have your wicked way with every one of them just once, you wouldn't get through them all in a month or longer. Note: I am grateful to you for discussing my business with my wife to such good effect, and I acknowledge how sensible you are deep down. If you were only as meek and mild as I am, you'd have all the virtues. *And I have to thank you for the good things you can do for me, if only you'll leave off buggering me about with the rings. If you don't like them, just snap their heads off and chuck them in the shithouse*....[11]

Despite this joshing, Dürer was indebted to Pirckheimer, as he relied on a loan from him to finance the trip to Venice. Dürer would have remained keenly aware of their differences in education and status. The men were almost the same age. Yet in Pirckheimer's

[8] Ashcroft, *Dürer*, vol. 1, 120–1.
[9] Pohl, *Imhoff*, 21.
[10] Ashcroft, *Dürer*, vol. 2, 931.
[11] Ashcroft, *Dürer*, vol. 1, 151–2.

home, six cushions embroidered with his coat of arms were displayed in a large reception room. There were all those stag antlers engraved with the family coat of arms decorating the walls. Books and manuscripts in Greek were piled up everywhere. The house stood on the prestigious site of Nuremberg's central market square. Pirckheimer leased properties all around the city to craftspeople, including a dyer, an ironmonger, a button-maker, and a carpenter. Dürer's own home, in comparison, which he struggled to buy, was valued at the low end of the property market. It was large, but at a noisy location next to main trading routes on which wagons rumbled with their wares.[12]

Despite these differences, the friends shared a surprising amount in the way they approached their work and this too brought them closer. For, just like Dürer, and despite all his achievements to date, the humanist was still a man on the make in his thirties. Classical scholars are often portrayed as fully accomplished once they returned from studying in Italy. In fact, Pirckheimer needed to labour exceptionally hard towards realizing his own intellectual ambitions. This was bound up with building habits. Just as Dürer advanced through endlessly copying other masters, so Pirckheimer advanced through painstaking word-by-word translations that took tremendous amounts of time. Artistic and humanist linguistic practices were built by learning through mistakes, by gradually sharpening perceptions and skills. Effortless fluency resulted from slowly built habits over many years—a free but certain hand, or a free but elegant translation that produced more powerful effects.[13]

Pirckheimer's extended studies in Italy had only provided him with the first foundations of mastering classical Greek. Immediately on his return to Nuremberg in 1495, he had been thrown into the thick of a civic career and family life. In 1502, after the death of his father, he made the radical decision to take three years off from civic politics to completely dedicate himself to his private studies of Greek and Latin. About that time, in 1501 or 1502, Pirckheimer had also met and befriended Dürer. Then in 1504, Pirckheimer's wife died and he had to take care of their daughters; despite this he tried to maintain his dedication to his translations of Greek texts ranging from Aristotle to Homer into Latin. In 1505, Pirckheimer returned to communal politics, and quickly made his mark as the city's diplomat at imperial summits. His knowledge of classical rhetoric helped him persuade his audiences, and influence political decisions in the way he thought best. Zoology, history, and geography fascinated him as subjects, and, as we have seen, Dürer became a soulmate in such pursuits. Classical satire helped to make

[12] Pohl, *Imhoff*, 21, 14–15.
[13] F. Ravaisson, *Of Habit*, transl. C. Carlisle and M. Sinclair (London, 2008), pp. 49 and 71—I owe this reference to Spike Bucklow. Dürer explicitly reflected on these connections in his theoretical writings, see Ashcroft, *Dürer*, vol. 2, 868 and 870.

Pirckheimer's encounters with traditionally minded enemies bearable. He fought for a new Latin school in Nuremberg, and dedicated enormous effort to amassing one of Europe's best libraries of books printed in Greek. Yet it would take Pirckheimer another seven years of private study and endless corrections of mistakes to finish the first draft of any publishable translation.[14] Both Pirckheimer and Dürer, in short, knew what it meant to graft.

From 1512 onwards, the friends were both to enter into the orbit of the Emperor Maximilian to collaborate more closely on artistic projects. But for now, around 1506, it was obvious that Pirckheimer was not interested in hearing about Dürer's painting in great detail. Besides responding to bawdy jokes and sending him his shopping requests, Pirckheimer seems to have asked mostly how much Dürer was getting done and selling in Venice, when he would be finished and return home. The moment he was back in Nuremberg, Canon Lorenz Behaim asked Pirckheimer to enquire about their friend's financial success. 'Greet Albrecht Dürer in my name. I'd like to know just how much money he's made', he bluntly asked in February 1507. Behaim also commissioned a composition from Germany's Apelles, but without wanting to spend too much money on it. 'I shouldn't', he pithily wrote to Pirckheimer on 19 March 1507, 'want it to become some *great* work that needs huge labours. Quite simply *un disegno*, with a certain flavour of the antique, just as I sketched out for him in my last letter.' Just as patronizingly, he then joked: 'but his beaky beard gets in his way, which I'm sure he twists and curls daily, so that it looks like an imitation of protruding boar's tusks'.[15]

Even so, Dürer shared genuine moments of emotional fragility and indecisiveness with Pirckheimer as well as his enjoyment of friendships he had finally forged in Venice. Some cultivated Italians had, he reported, 'become more and more friendly towards me as time goes by so that it does the heart good—intelligent, well-educated, good lute-players or pipers, knowledgeable in painting and of noble spirit, true paragons, and they do me much honour and provide friendship'.[16]

Often, he wished Pirckheimer was there with him. In the end, Dürer felt real pride, and trusted that his friend would share in and admire his success: 'my altar painting says it would give a ducat for you to see it, to see that it is good and has beautiful colours'.[17]

By October 1506, Dürer faced his return to Germany with trepidation. He famously adapted a proverb that in Venice he was treated as a gentleman, while at home he was a parasite. Years later, he told Nuremberg's council that the Venetian government had tried to attract him as a civic painter for a guaranteed annual salary of 200 ducats, in addition to which he most likely would have been able to take on further commissions and continue to sell his prints. In September 1506, the artist reported that 'everyone'

[14] Niklas Holzberg, *Willibald Pirckheimer: Griechischer Humanismus in Deutschland* (Munich, 1981).

[15] Ashcroft, *Dürer*, vol. 1, 187; *Pirckheimers Briefwechsel*, vol. 1, 502, my emphasis.

[16] Ashcroft, *Dürer*, vol. 1, 139.

[17] Rupprich, *Nachlass*, 55, compare Ashcroft, *Dürer*, vol. 1, 159.

said they had never seen better colouring than in his *Feast of the Rose Garlands* and that nobles and painters told him they had 'never before seen such a sublime, lovely painting'. Still, he dryly summed up: 'I have earned much praise but little profit by it.'[18]

Herein lay the problem. In Venice, Dürer most clearly began to measure his own success in terms of how fast he painted, using inscriptions to fabricate a memory about the length of time these two panels had taken him—one of them five days and the other five months. He could outdo the best of the ancient painters. Yet if Dürer cultivated the expectation that he could paint fast, this meant that he was likely to be paid a moderate fee. The letters to Heller asserted that this time, Dürer could and would not rush the altarpiece but create a truly outstanding painting. It took him two years to deliver the commission and he demanded to be paid at least in some proportion to the amount of time he had invested—about eleven to thirteen months solidly. His Frankfurt patron would be less than impressed.

In 1507, after the fasting period and Easter festivities had passed, Canon Behaim sent both Pirckheimer and Dürer a horoscope that he had cast for Albrecht. Behaim was an experienced astrologer. In the same letter, he reported on the horoscope of Cesare Borgia, the illegitimate son of his former employer Pope Alexander VI, who had been elevated from the office of bishop to cardinal aged eighteen. Behaim went on to note that after Borgia's father had been elected as Pope, he later resigned to follow an ambitious career as a military commander. Behaim followed careers with fascination. His horoscope of Dürer sized him up after his alleged Venetian triumph. 'I have cast our Albrecht's nativity for him', he reported to Pirckheimer, 'and am sending it to him too—he'll show it to you himself—and I believe I have set it up well, because everything seems to fit.' This suggests that Behaim had sent the same copy to Dürer in Latin, and anticipated that the painter would, as usual, need to consult Pirckheimer in order to translate. Latin indicated learning, but also functioned as a secret code. Behaim always wrote in Latin to Pirckheimer, signing as *Laurentius*.

> He has Leo as ascendant house, which is why he is lean; at the end of the ascendant is Fortune's Wheel, hence he is getting rich, and because Mercury is in this house, that is evidence of his genius for painting. Since moreover Mercury stands in the house of Venus, that means he is an elegant painter. And because conversely Venus is in the house of Mercury, he is an ingenious lover. However, Venus is separated from Saturn, hence they are in some sense incompatible, yet that is of no account. Because Venus is turned towards the Moon, and the latter stands in a sign which has two bodies, he desires many women; but the Moon is turned towards the Dragon's tail, signifying rapine. And because five planets stand in the Middle Heaven, his deeds and works are manifest to us all.... Since Jupiter is in the house of Substance, he will never be poor, however nothing of it shall remain. Because Jupiter in his descendent stands in Virgo, he shall have only one wife, according to Ptolemy, because the Moon is not turned towards any of the planets, indeed it is extraordinary that he has married even one wife.[19]

[18] Ashcroft, *Dürer*, vol. 1, 159, 163.
[19] Ashcroft, *Dürer*, vol. 1, 187–8; *Pirckheimers Briefwechsel*, 539–40.

The back of this letter contains a Roman recipe for a fragrant shaving soap, as well as a recipe for a mixture of Mediterranean herbs, flowers, and river water to humidify and purify a beard. Added to this was an astrological prediction that Dürer, though in the position of an inferior person and Pirckheimer's servant, would be his master.[20] Writing from Venice, Dürer himself had jokingly addressed Pirckheimer in broken Italian as 'the greatest and foremost man in the world. Your servant, the slave Albrecht Dürer, says "Hail!" to his magnificent lord Willibald Pirckheimer'—'Grandisimo primo homo di mundo', 'serfitor', and 'schiavo Alberto Dürer'.[21]

The entire horoscope and accompanying recipes are best read as a witty exchange. It concluded the running joke about the ridiculous fashion of Dürer's beard that Behaim and Pirckheimer had enjoyed ever since February 1507. Yet it also confirms the matrix of psychic preoccupations that mattered among these creative, fiercely dedicated, and unconventional middle-aged men just at the time when Dürer began to work for Heller. They attempted to negotiate values rooted in a pagan antiquity in relation to the Western Christian tradition as well as the everyday culture they were part of. They were concerned with income and status, their sexual prowess and appearances in competition with other men, and sexual freedom, in ways which might have included homosexual relationships and would have stood in tension with their deep religious beliefs. None of them wanted a wife to be their master, as Dürer once explicitly told Pirckheimer when it still seemed as if the latter might remarry. None of them produced a legitimate son as heir. Both Dürer and Pirckheimer wished to be remembered as singular men of ingenious spirit.[22] These preoccupations in turn fuelled anxieties and desires that related to social and personal hierarchies, masculinity, and intellectual as much as material ambitions. They were clearly at the front of Dürer's mind and imagination as he settled back into Nuremberg in 1507 to work on his two major commissions. Would he be able to assert himself as a painter and gentleman in Germany? He began to draft a manual on painting. Outlining the usefulness of art, it abounded with wishful thinking: 'God is honoured by it when people see how God bestows such intellect on one of His creatures, who has such art in him, and all who are wise will be gracious towards you for the sake of your art', and: 'If you are poor, through such art you may attain to great wealth and possessions'.[23] Dürer was literally thinking of poor people here, as in his other theoretical writings which he addressed to humble potters, among other craftspeople. He wanted to make his knowledge accessible in order to create a less unequal society in which crafts were valued for combining intellectual and hands-on knowledge. Dürer would not have perceived himself as poor at this stage, but expected to gain significantly more wealth. In hindsight, given these expectations and pressures, it should surprise us little that the painter came down with a fever in July.

[20] *Pirckheimers Briefwechsel*, vol. 1, 540–1; Ashcroft, *Dürer*, vol. 1, 188.
[21] Ashcroft, *Dürer*, vol. 1, 150–2.
[22] Ashcroft, *Dürer*, vol. 1, 144.
[23] Ashcroft, *Dürer*, vol. 1, 247.

CHAPTER 6

Apelles AD

Dear Herr Jakob Heller,

Be assured that in a fortnight I shall be finished with the work for Duke Frederick. After that I shall start on your commission and, as is my practice, do no other painting until it is complete. In particular I shall concentrate on painting the central panel with my own hand. But that apart, the outer panels which are to be stone-coloured have also been completely set out, and I have had them under-painted as you specified. I wish you might see my gracious lord's panel. I am quite sure it would please you. I have spent the best part of a year on it and made scant profit from it. For I shall get no more than 280 Rhenish gulden for it, and have used up pretty much every single one in expenses. That's why I say that, if I were not doing it as a special favour to you, no one would persuade me to take on anything at a fixed price. For that way, I miss out better jobs. Enclosed I sent you the measurements of the panel, length and breadth. A very good night. Given at Nuremberg on the second Sunday in Lent 1508. Albrecht Dürer.[1]

Nearly seven months passed before Heller replied to Dürer's letter quoted above—any shrewd merchant knew not to drive up the price by showing too much interest but also knew the importance of ensuring that contracts were delivered on time. The artist assured him that further preparatory work towards the commission had been completed by his workshop and he would finally start working on the central panel in April.

Since summer 1507 and throughout the winter in 1508, Heller's panel had simply been stacked up somewhere in the artist's house, the preparation with layers of underpaint protecting it from degradation in the cold. Dürer claimed that the panel for Duke Frederick the Wise of Saxony had taken him the best part of a year to paint, which was part of his strategy to argue that he did not want to paint fast but as best he could. As we have seen, this raised the issue of how and whether clients were expected to remunerate this vast increase in time, which was, after all, Dürer's choice.

In fact, Dürer now claimed that any remuneration Heller might consider would still leave him underpaid in relation to his time. How to properly carry out a major painting by his own hand without it becoming profitable kept bothering Dürer. Still, he never chose to build up a sizeable workshop, but wanted to be rewarded for his own work as Apelles AD, for his own hand, mind, and skill that bore out that special

[1] Ashcroft, *Dürer*, vol. 1, 213.

grace God had bestowed on him. Duke Frederick generously paid him 280 Rhenish florins, but Dürer remarked that despite such apparent generosity he had spent most of this sum on materials. He strategically told Heller that the painting was therefore entirely a 'special favour', especially as he was missing out on better jobs. By painting for dukes, moreover, his own value grew. Frederick III was one of the seven electors of the Holy Roman Emperor, and hence belonged to the group of Germany's most influential men. At the very least, Dürer thought that Heller should stop insisting that he complete his commission on time.

In truth, Dürer did not regard the price of Heller's altarpiece as having been set in stone. By comparing the sum Frederick the Wise paid to the meagre agreed price of 110 florins Heller had promised him, Dürer continued to negotiate for more money. He once more demonstrated his rhetorical skill by claiming that his plea was not self-interested, as even with a larger sum of money he made almost no profit from such a large commission in relation to the time and expenses involved.

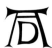

What determined a painting's value in this period? A wealth of information tells us about the Italian art market as Dürer would have experienced it through his travels. His letters to Heller suggest that he fully absorbed these rules. They shaped how he negotiated. In Italy, a general price or price range was first agreed and determined the quality of a painting in terms of the number of figures which might be included, the design, and finish. It was an outcome of the relationship between patrons and painters as well as the patron's ambition to endorse honour or magnificence via the product, or the painter's interest in attracting new patronage. As we have seen, the price of any commission also depended on how many hands were involved, that is, to what extent it was produced by a workshop or executed by a master. Key decisions about the design or execution might only be taken in the course of the process of working on a painting, once more in relation to the price agreed and the demand on an artist to fulfil other commissions.[2] In other words, in Germany as in Italy, the process remained one of negotiation and adjustment. Even compositions were not conceived as complex iconographic 'programmes' in writing. Dürer's notes accompanying a sketch for another artist to carry out an altar panel in 1510 read:

> Christ shall stand in the winepress.
> Mary shall stand on the right-hand side.
> The angel on the left.
> The canon kneels before Mary.
> Peter below.

[2] O'Malley, *Painting*, 2–3.

Someone supplied him with two biblical quotations relating to the theme of Christ in the Winepress.[3] Sketches at this stage could still be roughly indicative and omit important details. Hence Dürer's sketch for the Landauer altarpiece tellingly did not include his self-portrait, and only a fraction of the figures he finally painted. This further explains why patrons in all respects did well to stay closely in touch.

Dürer's letters show that Frederick the Wise did so very effectively from Saxony, to ensure that the artist would really just focus on finishing the *Martyrdom of the Ten Thousand* painting for him, and that Heller likewise was proactive in checking progress made. Dürer's letter written in Lent 1508 started the final process of negotiation over the real price and contents of the painting, and, in turn, how Heller perceived the value of Dürer's art. What modern economists perceive as the 'human dynamic in price formation' was therefore key to the Renaissance as a new aesthetic movement, but it was a process in which a painter's rhetorical skill and strategic thinking mattered greatly. In assuring his patron that he could make a commission something special, which few others could accomplish, Dürer's first letter had instantly introduced uniqueness as a key pricing term.[4] He had already indicated that he could make this panel a completely original one, and this implied that he would not recycle any elements he had used before. This too increased the value. Alternatively, a painter could implicitly threaten to revert to including previous motifs in case he was not happy with the price negotiations as they evolved.

The fees of painters in Rome, Florence, and Venice were common knowledge in Dürer's Italian circles and doubtlessly the subject of animated conversation between artists. It is easy to imagine that they traded tips on how to raise the price of a painting once a commission was under way.[5] For an artist engaged in negotiation it mattered mentioning that other influential people had also commissioned them, and that they were greatly in demand yet reliably committed to finishing without compromising on quality, especially if this was a crucial commission of high visibility which would increase their reputation and generate more interest. It further mattered whether artists networked with humanists who might write or talk about them. Dürer was no exception: humanists' texts, letters, and conversations typically compared contemporary to ancient painters, such as Apelles.[6] They discussed how well, elegantly, or exceptionally a painter handled proportion, perspective, the presence of figures, gestures, light, and colour, and how original he was in doing so. Eloquence translated into pay.

Another factor was whether a painter had travelled and was able to incorporate leading or innovative techniques or stylistic elements practiced elsewhere—thus some

[3] Ashcroft, *Dürer*, vol. 1, 334; for some examples of contracts from the 1510s see Baxandall, *The Limewood Sculptors of Renaissance Germany* (New Haven, 1980), 116–19.

[4] O'Malley, *Painting*, 98.

[5] O'Malley, *Painting*, 111–13.

[6] O'Malley, *Painting*, 22.

families favoured the Florentine painter Ghirlandaio's mastery of a Netherlandish style.[7] Dürer was rather unusual among German painters in travelling to Italy. He travelled not as a journeyman but as a mature artist. This made his reports of Bellini's praise even more relevant, as Pirckheimer in turn knew a wide-ranging network of people interested in art, including Erasmus, and the humanist Cochläus, who later stayed with Heller in Frankfurt. Dürer could hope that Pirckheimer would pass Bellini's praise on, while Cochläus's 1512 *Description of Germany* named Dürer as first among Nurembergs great contemporary 'artificers with true ingenuity' including the city's prized map and instrument makers. Yet he only mentioned his engravings of the *Small Passion*, finished in 1510, because 'merchants from all over Europe' bought these subtle, fine prints with their proper perspective 'for their painters' to imitate.[8]

Larger commissions of a new subject, on a new scale or in a different medium provided artists with a chance to experiment and develop as well as to demonstrate their ability to alter their styles. They needed such commissions that made them recognizable in collections as 'a Dürer' or 'a Bellini' and were different from those, often multiples, that repeated elements of previous work and usually provided a lucrative sideline. Dürer's device of putting himself in the picture with a credit line tackled this problem: he made it recognizably a work of his own and yet could experiment with new subject matters and techniques. A cunning businessman like Heller nonetheless knew that placing an altarpiece in Frankfurt would be an important commission for Dürer in terms of the location of the church and his own prestige as patron from outside Nuremberg. Both factors tended to lower the price.

Above all, it remains startling to note just how modest the fees of the majority, as well as some of the most brilliant Renaissance painters, remained. Other areas of luxury craftsmanship, such as armour or velvet-weaving, were far more lucrative, and we have observed the high prices embroiderers could command for work such as the vestments couples like the Hellers donated to churches. Within the painting trade, most fees remained relatively low once the cost of the materials was subtracted. When Dürer made his way to Italy in 1505, for instance, a confraternity in a town outside Florence commissioned Sandro Botticelli, now one of the best-known Renaissance painters, famous for his painting of the Primavera, to paint an altarpiece. Botticelli was already aged sixty. Still, he painted in oil and tempera for just over four florins per square metre, while putting his heart into a startlingly original design and time-consuming technique.[9] Fresco painting was much faster to accomplish than oil painting, and therefore paid less, so that Filippino Lippi earned not even two florins per square metre for the frescoes in the Strozzi Chapel, while the Sistine Chapel was the best-paid commission of any fresco painter at six florins per square metre. These were papal remunerations.[10]

[7] O'Malley, *Painting*, 41.
[8] Cochlaeus, *Brevis*, 88–9.
[9] O'Malley, *Painting*, 193.
[10] O'Malley, *Painting*, 105.

In 1504, by contrast, the confraternity in Perugino's birthplace asked him to lower the fee of a fresco for them—indeed, he willingly halved it to 100 florins, and modestly requested a donkey to move his equipment. It was a beautiful piece with dozens of figures, but in the end the confraternity told Perugino that they were only able to scrape together seventy-five florins after all.[11]

Many stories of how meanly artists were treated must have circulated, some of which Vasari recounted in his *Lives of Artists*, published in 1555. A famous episode relates how Donatello (d. 1466) had smashed one of his statues after a Genoese merchant, who had commissioned it, complained that it cost too much, despite the fact that the artist had worked on it for an entire year. Donatello allegedly declared, that 'the merchant had shown himself used to dealing in beans and not in statues'.[12] Leonardo around 1485 got so annoyed with his Franciscan patrons in Milan that he privately sold the altar painting of the *Virgin on the Rocks* they had commissioned. The Franciscans in turn had to convince him to execute a second one, which he finished in 1508, just as Dürer was embarking on the Heller altarpiece. Hence, the stakes for patrons could rise if they faced the most confident painters, who were really prepared to lose a commission, or to sell it on to someone else who offered them more money.

German contracts at this time broadly outlined a composition and specified costly materials. Above all, they clarified a patron's expectations by laying down which parts of a commission were to be completed up to what standard of skill and by whom. At best, this allowed a master to efficiently direct his team according to their skill and availability. At worst, such contracts equalled an overly complex and restrictive commitment. Hans Imhoff the Elder's contract for Adam Kraft in 1493 thus distinguished between less visible parts of his astonishing tabernacle at St Lorenz's church in Nuremberg, which were only to be executed with 'good craft, but not preciously in terms of workmanship'. Other parts were to be carried out with 'really good craftsmanship', while the most important parts were to be executed 'with subtle good craftsmanship', or 'with the best, artful craftsmanship and most properly' as 'most people would gaze upon' it. Other elements were permitted to be 'not as subtle, but also artful' and good in quality.[13] Kraft was only allowed to employ up to four assistants in total and obliged to remain 'constantly connected to the work and with his own body'. He was meant to finish it within three years, but was still working on it up to his death in January 1509. Imhoff, whose family grew rich from dealing with saffron, had promised the sculptor 700 florins, while carefully calculated clauses threatened to claw some of this fee back in case the work had shortcomings or was not delivered on time. Needless to say, the contract did not consider whether Kraft would immortalize himself in this

[11] O'Malley, *Painting*, 99–100.

[12] Peter Burke, *The Italian Renaissance: Culture and Society in Italy* (Cambridge, 1986), 61.

[13] Hans Huth, *Künstler und Werkstatt der Spätgotik* (Darmstadt, 1967), 120–2; see also Corine Schleif, *Donatio et Memoria: Stifter, Stiftungen und Motivationen an Beispielen aus der Lorenzkirche in Nürnberg* (Munich, 1990).

Fig. 6.1 Adam Kraft, Self-portrait of the Sculptor, Tabernacle in Nuremberg's St Laurence church
© Theo Noll/www.nuernberg.museum.

work—but Dürer would have been able to see that this was just what the celebrated sculptor had chosen to do. [6.1]

Most urban German Renaissance painters, however, earned their humble living by remaining accommodating and loyal to local clients from leading families. When the Cologne wine merchant Hermann Weinsberg (b. 1518), for instance, ordered an altarpiece from the reputable local painter Barthel Bruyn the Younger (c.1530–1607/10), he received it within seven months and it cost about 50 florins. Weinsberg noted that Bruyn's father had already painted him and his parents; he knew the artist from a young age and trusted him completely in terms of pricing arrangements and stylistic choices. Weinsberg specified which scenes Bruyn was to represent—the central panel included a crucifix, the Virgin, and St John the Evangelist alongside Weinsberg and his wife; Abraham and Moses were to be depicted on the inside of the wings, the evangelists on the outside of the wings in grisaille, and Weinsberg also specified gilding for parts of the frame. Each of these figures was to portray a specific relative, friend, or even a priest. Weinsberg's wife requested that her sister should be represented on the central panel as Mary, and her son from a previous marriage as St John the Evangelist.

The Weinsberg couple clearly valued their local painter's knowledge of the family to create a lifelike pious memory for them. In every other respect they expected him and his workshop to complete the altarpiece in the usual style, and to rely on an

iconographic programme least likely to provoke iconoclasm. They were Catholics in the age of the Renaissance and the Reformations, and in fact among the last local families to commission an altarpiece during the second half of the sixteenth century. But what they cared about most, in any case, was exactly what had mattered to German patrons since the Middle Ages: that their coats of arms and their clothes were precisely represented so as to indicate their social standing and remind onlookers to pray for their family.[14]

Urban painters, in other words, were ideally kept busy with several such commissions from local patrons on which they worked at the same time, while layers of paint on each of them dried, and they completed each panel quite quickly in order to make a living. Dürer tended to work with quickly executed underdrawings on such commissions to save time—or no underdrawings at all.[15] Yet Dürer would have been aware of the enormous prices Raphael (1483–1520) already commanded very early on in his career. It seems no accident that he sent a self-portrait to the artist in Rome in 1511—indicating that Raphael perhaps was already on his mind while he negotiated with Heller. Raphael fascinated him all his life. He later proudly inscribed a drawing of two nudes which the Italian artist had sent to him in return: 'Raffahell of Urbino, who used to be so honoured by the pope, made these nude pictures and has sent them to Albrecht Dürer in Nuremberg, to show him his hand.'[16] Given what he felt capable of achieving, Dürer might have wondered whether he might not be treated a bit more like this young man from Urbino by Heller as one of Germany's richest men. Alas, this was a dream.

[14] Wolfgang Schmid, *Kölner Renaissancekultur im Spiegel der Aufzeichnungen des Hermann Weinsberg (1518–1597)* (Cologne, 1991), 34, 96, 187. For contracts and regulations see Hans Huth, *Künstler und Werkstatt* and the discussion of his findings in Schmid, *Unternehmer*, 354–5.

[15] Schauerte, *Dürer*, 106.

[16] 'der beim papst so hoch geacht ist gewest', Schmid, *Unternehmer*, 325; Panofsky, *Dürer*, 284, argues that it would have been a work from Raphael's workshop and reveals Dürer's characteristic fantasy that it could have only been the master's own hand.

CHAPTER 7

Letter 3

The hard reality for almost all painters in German towns, rather than at courts, was that they had to make a living by producing uncommissioned and unframed works across a broad price range. These were often traded directly from workshops, in front of churches, on market stalls, and in fairs for an expanding market of middling consumers. For many makers this meant that they resorted to lower standards than they otherwise might have aspired to, to faster work, smaller formats, more repetition, more copying of motifs using prints made by other artists, more help from assistants, and greater efforts to find customers. Such developments in turn drove the ambition of superior artists, such as Dürer, to show their own hand for the best commissions as 'art'. This explains why he and other masters began to sign their work. Yet even the most advanced patrons' expectations usually stood in tension to their willingness to pay such ingenious artists appropriately in terms of their time and satisfying their desire for a better living and the recognition that wealth of their own brought.[1] Heller, in any case, kept to conventions. He was interested in the use of expensive materials for an altarpiece and excellent technique rather than in originality, and showed little understanding of how much time it took to achieve paintings at Dürer's level.

Dürer's ambition was rooted in this frustrating matrix, which is why he used his letters as an opportunity to educate the merchant about the many steps involved in the making of the altarpiece. This is what makes this correspondence so unique. Moreover, Dürer had his own milestones in mind as he took on Heller's commission. The two most significant of these were buying a house and being made a member of Nuremberg's Great Council. This was an honour extended to about three hundred male citizens rather than linked to any significant rights. Dürer's marriage to Agnes Frey, whose mother was a Rummel and thus belonged to one of the old families, even the patriciate, would have fuelled the couple's hopes to raise their status. None of the artistic trades were granted any political influence in Dürer's time. Only eight of Nuremberg's oldest crafts were represented in the Small Council which controlled artisanal production,

[1] For a full treatment see Berit Wagner, *Bilder ohne Auftraggeber: Der deutsche Kunsthandel im 15. und frühen 16. Jahrhundert* (Petersberg, 2014) and on the greater scope for innovation among court artists the classic study by Martin Warnke, *Hofkünstler: Zur Vorgeschichte des modernen Künstlers* (Cologne, 1985); for Dürer's painting in the context of Nuremberg see Peter Strieder, *Tafelmalerei in Nürnberg 1350–1550* (Königstein, 1993).

but these crafts enjoyed no voting rights. Guilds, as we have seen, had been abolished in the city for over a century. This made Nuremberg anything but the Renaissance Silicon Valley it has sometimes been presented as. Nuremberg's wealthy councillors, at the heart of which were thirty-four patrician men, firmly held the reins to uphold order. Regulations governing every detail of civic life were ever present—any house, for example, needed to measure exactly at least twenty-five feet and to neatly fall in line with others in the street.[2]

Buying a house promised to bolster Dürer's middling status—in fact most Nuremberg master craftsmen traditionally owned a home and workshop. But house prices rose steeply as the new century began. Agnes's dowry amounted to 200 florins, and while there was an inheritance from the Freys to look forward to, the couple would have received no further financial help to buy a home. It seems most likely that Dürer first rented a large house, situated next to bustling trade routes in the upper town next to the castle from 1504, when he also took in his impoverished mother and younger brother. The five-storey building had belonged to Bernhard Walther (1430–1504), an eminent astronomer, humanist, and engineer, who had just died, and was well known for having worked with the famous mathematician Regiomontanus. It was easy to reach from the town centre as one walked steeply uphill from the market square to the castle. Dürer certainly lived in this house from June 1509, when he was working most intensively for Heller.[3] Its price had risen from 150 florins in 1501 to almost twice that sum when Dürer wanted to buy it, and yet, as we have discussed, its value remained far below any house a patrician or wealthy Nuremberg merchant owned. As house prices kept inflating, Dürer not only needed to be realistic about his means but also needed to complete a purchase as soon as possible.[4]

In addition, his long-term goal was to save up sufficient capital to withstand any crisis that might overcome the family. Dürer could not afford to be an absent-minded artist casual about money or dismissing finances as a trivial matter. He seems to have kept a notebook for his expenses in Venice and constantly thought about how much he needed to provide for whom among his dependents, how to pay off debts, or what he could afford as worthwhile luxury at what point. He generously and discreetly helped his younger brother Endres, a goldsmith, when he stayed with him in Venice, exhausted from a long illness. Dürer noted to Pirckheimer in a postscript in August 1506: 'Endres is here, ..., still isn't back to full strength, and is short of money, because his long illness and debts have eaten up his reserves. I've lent him eight ducats myself. But don't tell anyone in case he gets to hear, otherwise he'd think I was betraying a confidence. I assure you, he's behaving honestly and sensibly, so that everyone wishes him well.'[5]

[2] Weiss, *Lebenshaltung*, 138–9.
[3] *Das Dürer-Haus: Neue Ergebnisse der Forschung*, 148.
[4] He paid 275 Rhenish gulden in gold coin. Weiss, *Lebenshaltung*, 138–47.
[5] Ashcroft, *Dürer*, vol. 1, 153.

Letter 3 85

Large debts were regarded as a sign of dissolute squandering, whereas the Dürers would have prided themselves on good housekeeping, for which daily accounting was vital. Dürer proclaimed this ethos in the most conventional manner when he tried writing poetry in 1510. It reveals the different voices he absorbed, including the moralistic tone with which town councillors and sermons predictably addressed common folk:

> Count one penny as precious as four.
> …
> You can save a penny as quickly
> As earning one, believe you me.
> And put your money to good purpose,
> Don't overindulge in gambling and parties.
> Shun loans and all extravagance
> And you'll come off the better for it.[6]

In the spirit of the poem Dürer decided to ditch dancing classes as overly extravagant while in Venice, despite the fact that they would have been essential to achieve graceful civility: 'Let me tell you', he wrote to Pirckheimer, after having made money at the end of his stay in the city on the lagoon, 'that I'd meant to learn to dance and went twice to the classes. Then I had to give the teacher one ducat and after that nobody was going to get me on my feet again. I would have spent everything I'd earned, and in the end still not managed a step.'[7] Fine fabric for clothing was a different matter—as we have seen he happily paid eight ducats for some lengths of woollen cloth that then burnt in a fire, and he feared that a cloak had burnt as well. 'I'm cursed with bad luck', he complained, not least because someone who owned him eight ducats—perhaps an agent who sold his prints—had scarpered. Misfortune or new obligations so easily loomed in life that it is easy to see why Dürer, after his return home, was keen to build up capital.

Might Dürer therefore have deliberately delayed the process of painting the altarpiece to open price negotiations with Heller? In responding to the artist's second letter written in March 1508, Heller had evidently assured Dürer that he, above all, wanted him to accomplish good work and would, within reason, make allowance for the time this would take. This response was a routine part of the typical push and pull in luxury production—if expert craftspeople claimed to need more time after being chased, then their patrons often relented although quality remained key. For the moment, it seemed as if Dürer had gained the upper hand.

Heller having evidently retreated from insisting on the imminent delivery of his commission assured the artist that he was, most importantly, to 'make a good job'. The artist next tried to exploit his advantage. In his third letter to his patron, written in August 1508, he was able to report that he had finally started to paint! 'Let me bring you up to date', he wrote cheerfully: 'The main panel I have set out with utmost care, taking

[6] Ashcroft, *Dürer*, vol. 2, 321.
[7] Ashcroft, *Dürer*, vol. 1, 168.

a long time over it, and it has been undercoated with two very good layers of colour, so that I am now starting to underpaint it. For I intend, once I have your approval, to underpaint some four, or five, or six times, for maximum clarity and durability, and also to paint with the finest ultramarine I can muster.' Dürer reassured Heller of his complete commitment: 'no one except him' would paint a 'single brush-stroke' on the central panel. Therefore, he would spend a lot of time on it. This underlined the absence of any workshop involvement and prepared for the inclusion of his self-portrait with the shop sign to advertise that the panel was entirely made by his own hand.

Alas, next followed the bad news. Dürer explained to Heller that the terms needed to change if this was to be a really good painting:

> I have decided to explain to you my considered opinion—that I cannot carry out your commission for the fee of 130 Rhenish gulden because of the loss I'd incur. For I shall lose a lot of money and time. However, what I agreed with you, I shall faithfully keep to. Should you not want to exceed the price we contracted, then I shall do the panel in such a way that it will still be very much better than befits the fee. But if you are prepared to pay me 200 gulden, then I shall carry it out as I originally proposed. And even if somebody offers me 400 gulden, I won't paint another such one, for I don't know I'd make a penny profit on it, given the long time it would take me. So let me know your view, and once I know, I shall take 50 florins from Imhoff. For so far I have had no advance. With that I commend myself to you.[8]

Dürer thus skilfully offered different options which seemed to give Heller the choice of a price range in relation to quality, while trying to convince him yet again that the quality in any case would exceed even the lowest payment. He indicated that even an extremely high price of 400 florins would still be unprofitable. All this put pressure on Heller to settle for a fairer price—and fair salaries had long been discussed by authors such as Thomas Aquinas as integral to religious morality.[9]

Letters are tricky sources to interpret. How can we reliably assess what was strategic and rhetorical, and what was authentic, or a mixture of the two? Towards the end of his letter, Dürer added a remarkable sentence. He professed to never enjoying anything as much as this project: 'Let me say incidentally that in all my days I have never taken up a commission which gives me as much pleasure than your panel that I'm now painting'—even though he had only begun to underpaint. If he wrote that from his heart, it might suggest that Heller's lost painting was and perhaps remained the most ambitious painting Dürer executed during his entire career. If used tactically, on the other hand, the sentence simply underlined why Heller would do well to pay up. There is good reason to assume that he operated strategically. Dürer instantly added a warning that the progress he had finally started making was about to slow down again: 'I shall do no other work until I've completely finished with it. I'm only sorry that winter will so soon be upon me, for when the days grow short, one gets so little done.' Yet the

[8] Ashcroft, *Dürer*, 214–15.

[9] For a discussion of pricing negotiations see also Anja Grebe, 'Marketing Favours: Formal and Informal Criteria for Pricing Albrecht Dürer's Works between 1500 and 1650', *Journal for Art Market Studies* 1/1 (2017), 1–15.

letter equally supports the view that Dürer was sincere. If he was now truly immersed in a process he loved, then winter with its short hours of daylight would interrupt his flow.

Dürer by now had carefully drawn preparatory sketches of the Apostles in preparation for the panel. These sheets included the *Praying Hands* that are now regarded as expressive masterpieces in their own right rather than just preparatory sketches. Most of them are dated 1508. Dürer's sensitivity to the deepest feelings in their shifting states from fear to hope was fired by Germany's vibrant devotional culture and the natural philosophy of his day. He was most immediately and dramatically in touch with his emotions when expressing his deepest fears about suffering, bodily decline, death, and salvation. The drawings captured the bodies of those able to open themselves to intense spiritual insight, and, as we have seen, were certainly not rushed. Dürer carefully chose special paper, chalks, and pencils. He described to Heller how he wanted to carefully apply layer after layer of colour on his panel. It had already been undercoated with two layers of colour, and he now asked Heller to approve the application of up to six layers of underpaint on top. 'I shall spend a great deal of time on it'—that was beyond doubt. Both painter and painting would grow during the process of production, Dürer in ambition and the painting more literally, as more and more figures were included, just as had happened with the Landauer altarpiece.

Moreover, Dürer now built up courage to devote more time to his creative and spiritual prose as well as theoretical works. He wished to express himself, prove himself part of the new pedagogical movement the humanists spearheaded, to express himself in words to be printed passing on his knowledge to many people. Because of his limited schooling, he had never learnt to structure an argument, or master different metres of prose. Ambitious writing was a real challenge for Dürer and took time. By 1509, he had tried writing spiritual poetry, despite instant ridicule from his more versatile friends, all of whom had attended university. Lazarus Spengler (1479–1534), Nuremberg's city scribe, frankly told the artist to stick with what he knew. Dürer retorted that it was good to try something new, which he did all the time.

Despite these higher ambitions, a final paragraph in the letter Dürer wrote on 24 August 1508 shows that he wanted access to Heller's Frankfurt circles to market the cheaper, uncommissioned paintings he evidently continued to turn out quickly on the side. Might Heller find a buyer for the panel painting of a Madonna he had seen in Dürer's workshop? Cold temperature could damage stock during winter. He offered it at a 'bargain' price of 25 florins, even though, he said, it was worth twice as much.[10] Yet this favourable offer might likewise have been a strategic move. A note at the end of Dürer's next letter, written in November, told Heller that the Madonna panel had already been sold to the Bishop of Breslau, for 72 florins, a 'good deal'.[11] He is likely to

[10] Ashcroft, *Dürer*, vol. 2, 215.
[11] Ashcroft, *Dürer*, vol. 2, 218.

88 Ulinka Rublack

have invented this sum.[12] By providing, or by making up, information on sales, Dürer enhanced his own worth to reflect what he perceived as Heller's own meanness, especially as he was a less prestigious client than the bishop. Dürer's letter asked Heller to increase his payment for the entire altar painting from 130 to 200 florins. The ball was now firmly in the Frankfurt merchant's court.

[12] He had to chase up the bishop in 1511 for payment, who by then claimed to have no idea what the artist 'expects for it', instructing a Nuremberg factor of the Fugger merchant company to negotiate the price and settle the payment, Ashcroft, *Dürer*, vol. 2, 337.

CHAPTER 8

Who Will See It?

Heller's letters to Dürer are not preserved, but we can piece together a broad sense of how the merchant might have replied from Heller's surviving letters to Pirckheimer. To him he wrote in his thick local dialect. [8.1]

Frankfurt, on the day of the Virgin Mary's birth, 1508.

Praise be to God.

To the honourable painter Herr Albrecht Dürer of Nuremberg. Greetings and my willing service.

We received your latest letter after St Bartholomew's Day and am pleased to note that you have started painting. My gout improves in summer, but still prevents me from travelling to Nuremberg to see for myself what progress you have made. Besides, we are preparing for the autumn fair. As regards my painting—have you obtained the best grade ultramarine? It must, as you know, be the finest you can find for the Virgin's mantle, although I hope you can get a good deal for it. Otherwise the pharmacist I frequent might help—he often trades with Antwerp. What about the azurite and the reds? They must, as agreed, be good oil colours, that stay fast and clear to delight those who will admire my altar. Only your utmost care in painting will make up for the lack of gold in the painting, which you convinced me of as being the new style to advertise your own art. Do let us know when the outer wings will be varnished. I should hope to receive the panel next spring at the latest, and take your word for it that you will now refrain from starting any other work. Devote yourself with the utmost care to the panel.

This, of course, presumes that you will keep to your word in honouring our firm agreement of the price I am to pay for your own labour, the cost of material, and time. I certainly do not wish to increase the price and pay the 200 florins you now request. I trust you do not wish to see this matter dealt with at the chamber-court. We sealed our contract with a drink in the Golden Goose in which you like to gamble at night, and a handshake. It is an orderly affair, and Imhoff will pay you 50 florins as agreed in advance. I am as well to pay Grünewald and your workshop for the wings. I shall have to send a messenger to Hans Imhoff and Pirckheimer to receive their council as to why you might dare to behave yourself so outrageously; we are in Germany, where an honourable man stands by his word, not among the welsch, among whom subtle dealings corrupt all honesty. So Dürer, Alemannus, continue your labour as true German Apelles. And herewith think of me. Iacop Heller.

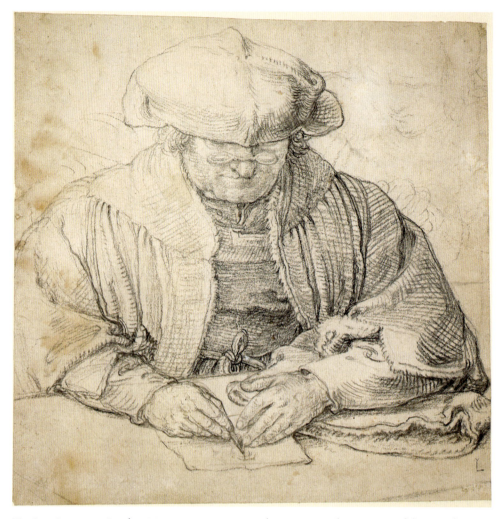

Fig. 8.1 Lucas van Leyden, Man writing, 1512, pencil on paper © The Trustees of the British Museum, London.

Like any merchant, Heller never even tried to be elegant, nor to demonstrate any particular learning, even though he had spent some years at university, knew highly educated men and, it bears repeating, chose an innovative contemporary artist to complete his altarpiece. Merchants were trained to describe goods and payments as clearly and specifically as possible, to avoid misunderstandings in long-distance trade, and they were also educated to quickly write chasing letters with ease. Miscalculations could be extremely costly, if a trading partner was not to be trusted, or the wrong type or quality of good arrived. In 1505, for instance, Ravensburg merchants bought fine wool via Genoa from Saragossa that turned out to be too high grade and costly for the German market and thus could only be sold at a lower price. 'We don't understand how this is

possible', a despondent merchant penned.[1] Merchants were also wise to fully document transactions in writing in case conflicts arose and necessitated arbitration or, in the worst case, a trial.

Dürer impatiently noted that Heller enquired repeatedly about the quality of the pigments and their price. To everyone looking at the altar, these would reveal the value of the commission and thus Heller's place in society. Medieval contracts often set out in detail what qualities of gold leaf a painter was to use to gild specific parts, as gold manifested wealth but also led to a sensual encounter with a material signifying eternity and illumination. Heller, as we have seen by comparison with the patrician Claus Stalburg, was already prepared to opt for a new kind of Renaissance modesty that laid more emphasis on showcasing artistic ingenuity.[2] As it was a painting of the Virgin Mary, Heller did not compromise on the use of ultramarine made from lapis lazuli. Lapis would provide the deepest and most stable blue, added to the rarity of the piece, profess his piety, and provide him with pleasure. Contracts often specified that ultramarine of a high cost was to be applied to depict the Virgin, and lower-cost ultramarines, or other blue pigments such as azurite, elsewhere. This in turn implied the painter's experience in judging the quality of a piece of lapis when he bought it—or the reliability of the chain of contacts he had built up reaching all the way down to the best mine in Afghanistan, which operated for only a few months a year, generating the pigment-bearing rock that was imported via the Levant to Europe.[3]

For all his readiness in opting for Dürer's radically contemporary approaches, we know that Heller became furious at this stage, or knew how to stage his fury, and did not agree to increase Dürer's pay. He would have thought carefully about how to show his anger. 'Good words don't break your teeth', a German saying went at the time, as if bad words might break them by inviting a brawl. A merchant of the Nuremberg Behaim family used this saying when advising a younger relative involved in a dispute about unpaid debts. He added that in 'foreign lands' (by which he meant anywhere beyond Nuremberg), nobody asked or cared about who he was or what family he came from. All that seemed to matter was how rich you were perceived to be—and whether you talked nicely.[4] Despite being a patrician, even Pirckheimer spent two and a half days in Nuremberg's prison in March 1507, after assaulting a man who had called him a fool to his face.[5]

Merchants relied on dependable networks to ensure that their contracts were fulfilled. Heller's strategy therefore was to first write a letter to Dürer and then, when he did not reply, to verbally complain to other people about Dürer. He complained to one of the artist's relatives as well as to his broker, Hans Imhoff, presumably when he stayed

[1] Hanns-Peter Bruchhäuser ed., *Quellen und Dokumente zur Berufsbildung deutscher Kaufleute im Mittelalter und in der frühen Neuzeit* (Cologne, 1992), 112, in a source from the Ravensburger Handelsgesellschaft, 1479, and 116.

[2] For a German example see Huth, *Künstler und Werkstatt*, 116–17.

[3] For an in-depth discussion of the challenges of processing lapis and its spiritual connotations see Spike Bucklow, *The Alchemy of Paint: Art, Science and Secrets from the Middle Ages* (London, 2009), 43–75.

[4] Bruchhäuser ed., *Quellen*, 122–5.

[5] Pirckheimer, *Briefwechsel*, 506.

92 *Ulinka Rublack*

in Frankfurt during the autumn fair. Imhoff in turn knew Pirckheimer well, and in this way Dürer would hear about Heller's accusations. Most importantly, Imhoff helped decide who was elected to Nuremberg's Great Council, which Dürer aspired to. In this way Heller tried to exert pressure on the artist.

This was an age in which public honour was integral to men's sense of themselves and it was vigorously defended. Honour systems in turn relied on informal, as well as formal, public shaming and punishment. The vast majority of those executed were robbers and thieves attracted to this thriving city. Dürer would have watched several executions during his life. These were gruesome procedures. Recent concerns about witchcraft meant that women deemed to be possessed by the devil were burnt.[6]

Next there were civil crimes. While Dürer was working on the Heller altarpiece, everyone would have seen the famous sculptor in wood Veit Stoss (before 1450–1533) walking around Nuremberg as a disdained man. Stoss had forged a signature to retrieve profits from money he had invested. Sentenced to branding on his cheeks with an iron, the chronicler sympathetically noted that the executioner did so as 'gently' as possible. On his return to the city in 1506, Stoss was able to take commissions, but it would have been unthinkable for him to have been considered for election to the Great Council. His reputation was ruined.

Honour had to be permanently maintained. In 1508, Christoph Scheurl (1481–1542), a Nuremberger just appointed as professor of law at the newly founded university of Wittenberg, praised Dürer in print as 'easy-going, humane, punctilious and of utter integrity'. Heller, by contrast, appear to shame Dürer as dishonest, unreliable, and unreasonable in his claims.[7]

In response, the freelance artist Dürer was prompted to send the longest letter he had written so far, in defence of his honour. Writing to Heller on 4 November 1508, he set out why he needed to be fairly paid to cover even his living costs while working on the commission:[8]

> Dear Herr Jakob Heller,
>
> Recently I wrote you a letter expressing my intention honestly and in all innocence, and you complained angrily to my relative, and were heard to say that I was going back on my word. Since then I have also received from Hans Imhoff your reply to the same effect, at which I take justified offence, given my previous letter. For you accuse me of not keeping my promise to you. Everybody will acquit me of that, for I reckon I behave fairly towards other honest people.... What I agreed to was to paint for you something that not many men can.

Dürer reiterated that he only asked for higher pay as he had begun to devote such painstaking care to the commission. Once the panel was finished, he was sure that 'all who know about art will be delighted by it'. It was a work for connoisseurs, and Heller would

[6] *Chroniken*, vol. 5, 693–5.
[7] On Scheurl see Ashcroft, *Dürer*, vol. 1, 229.
[8] Ashcroft, *Dürer*, vol. 1, 217.

agree that he had never seen anything more beautiful. This made the deal seem so unfair: 'It will be valued at 300 florins if not more. I wouldn't take three times the money promised to paint another one like it. For I am losing time and money and earning your ingratitude.'

Dürer appears to wonder why he was even doing such work—and yet he did want to establish himself as the second Apelles through this Frankfurt commission for centuries to come. Yet working at this level of skill meant, Dürer argued, that he could not see himself 'painting the centre panel from start to finish in less than thirteen months. I shall do not other work until it's ready, even though that is to my great detriment.' He challenged the merchant audaciously: 'For what do you imagine my living costs are? … And so, dear Herr Jakob Heller, my letter is not as totally out of order as you believe.'[9]

Moreover, he was able to buy ultramarine more cheaply than Heller would have managed through his suppliers. Dürer judged that the merchant would have needed to pay over 100 florins just for the pigment. So 130 florins in total really was nothing. Was this just a rhetorical exaggeration? How were things valued in Nuremberg at the time? We know that the wealthy patrician Anton Tucher (1458–1524), for instance, provided his maidservant Berblen with 3½ florins to buy a coat in 1509. Hans, his house servant, received 2 Rhenish florins to buy a doublet and hose, while a civic corn labourer earned as much in twenty-three days of work. Hans received a further 10 florins in 1511 to buy clothes for his wedding, and Berbel 4 florins to buy red fabric for a dress four years later. Hans earned 7 and Berbel less than 4 florins a year, which explains why occasional gifts for clothes supplemented low salaries. Women not only were paid less but also received less. Yet neither Hans nor Berbel, of course, needed to keep a household of their own— they would have been young and needed to make savings towards one.[10]

Dürer was older, a master, and had to keep his small household afloat, including, at this time, a few journeymen and servants. In 1508, we know that a journeyman received 1 florin per week when working on a commission elsewhere.[11] Dürer's monthly average income from the Heller altarpiece would have amounted to about 18 florins, supplemented by the sale of prints and cheaper works. He aimed much higher, ideally for about 26 florins per month for an exceptional painting he had worked on solidly.[12] This was little in comparison to a successful merchant's profits, which explains why he challenged Heller to imagine being in his situation: 'For what do you imagine my living costs are? To pay my upkeep you wouldn't get away with 200 fl.'[13]

The Nuremberg artist now adjusted the merchant's expectations. He would not be able to work with his utmost care for such a low salary, and had never promised to do so. Even with 'great care I can scarcely paint one face in half a year'. Writing in November

[9] Ashcroft, *Dürer*, vol. 1, 217.

[10] Valentin Groebner, *Ökonomie ohne Haus. Zum Wirtschaften armer Leute in Nürnberg am Ende des 15. Jahrhunderts*, Göttingen 1993, 154–5, 156; for an extensive discussion see Weiss, *Lebenshaltung*.

[11] Schmid, *Unternehmer*, 344, for the altar in Schwäbisch Gmünd.

[12] Schmid, *Unternehmer*, 358.

[13] Ashcroft, *Dürer*, vol. 1, 217.

1508, Dürer thus assured Heller: 'now the panel has roughly 100 faces, not counting drapery and landscape and other things on it'. This might have been the underdrawing, or far more likely a sketch on a piece of paper, and retrospectively confirms how little Dürer might have actually started to paint. It seems as if Dürer decided in 1509 to reduce the number of figures on the panel. For the moment, he still told Heller that there would be a hundred figures on his altar, as his ambition for the composition had grown. The *Feast of the Rose Garlands*, the *Martyrdom of the Ten Thousand* as well as the *Landauer Altar* abounded with figures. Altarpieces such as Holbein the Elder's for Frankfurt's Dominican church were completely crammed with them, as their number likewise reflected an artist's pay and patron's wealth.

After returning from Venice, Dürer generally lightly outlined contour lines on all of his paintings, as we have seen, or used no underdrawing at all.[14] This kept his commitment to a design much more flexible. Short hours of daylight in December slowed him down. Indeed, his letter indicated that he now felt ambivalent about his initial ambition for the composition: 'the panel has nearly one-hundred faces without costumes and landscapes and other things which are in it. Nothing like this has ever been heard of for an altar-painting. Who will see it?'.[15] Encouraged by the merchant's seemingly committed letter in the summer, Dürer had planned to create something exceptionally ambitious, and yet now wondered whether such an effort would even pay off in money as much as in its impact.

In the light of Heller not paying for more time, the Nuremberg artist now announced that he would paint with 'good or special care', keep to the initial agreement, and make sure nobody would be able to reproach him for breaking his word. He tried ending in a conciliatory manner, and promised that he had not tried to ignore Heller's last letter. Once the panel was finished and the merchant had actually seen it he felt sure that 'everything will be better between us'. All the same, it was still going to be 'a lot of work and won't get any less'.[16]

As we have seen, Dürer's figure at the centre of the final altarpiece included a shop sign on which he announced that he had 'made' the painting, that is completed it, after Christmas 1509. By then, Dürer must have just wanted to get rid of the commission, and he must have decided on an obvious, but radical, solution as the new year began. Instead of one hundred figures, there were to be the twelve apostles in the foreground. He placed Mary, Christ, and God in the centre, and surrounded them with just over twenty

[14] Katherine Crawford Luber, 'Dürer as Painter', in Larry Silver, Jeffrey Chipps Smith eds., *The Essential Dürer* (Philadelphia, 2010), 66–7.
[15] Rupperich, *Nachlass*, 68.
[16] Ashcroft, *Dürer*, vol. 1, 218.

faces of putti, which would not take long to paint, and the apostles. Finally, he added his self-portrait. In total, there were sixteen full-sized figures. For anyone living in Frankfurt in 1509, the minimalism of this composition in an altar painting would have been startling, and it allowed Dürer to finish it more quickly. In negotiating its completion with Heller he had seen how far he could push a merchant in Renaissance Germany. Was he able to achieve 300 or even 400 florins for a painting for which he was prepared to give almost everything in terms of his technique, which tested the limits of his ability and declared his position among the best of all painters, perhaps for all times? The answer turned out to be 'no'.

From this fraught, embattled process resulted one of the most innovative and focused designs displayed in a European church at the time. Nobody would take this altar painting as starting point for a simple retelling of the story of the Virgin's ascension. The apostles are portrayed as onlookers vividly engaged in the spiritually intense experience of a moment. This resonated with contemporary calls for a 'modern devotion' that moved hearts. By introducing a landscape background into this iconography, Dürer moreover suggested that the faithful could experience revelation anywhere.[17]

Dürer certainly was not a cool-headed merchant, or vengeful. He still experienced pleasure in successfully producing a challenging piece, and repeatedly stressed that he could only dedicate himself completely to one such task at a time, although this of course also enhanced a painting's value. Dürer's 'selfies' might appear arrogant or even just a marketing ploy today. Yet, as we have seen, Dürer never painted a large self-portrait after 1500, and stopped doing altarpieces in 1511. His self-portrait on the Heller altarpiece hence could be seen as signalling a man who largely worked independently and who wanted to be recognized and remembered for his art. The panel invited lasting devotion for the artist, as much as religious devotion. This is what makes it so modern for a time in which even tour guides of excellent princely collections never mentioned an artist's name but simply related a painting's subject and its moral lessons. Dürer's decisions about how he painted an altarpiece were also an expression of his creative bond with these works, which he formed over time and which encapsulated his hopes about what they might become, and for what humans might be able to create. Dürer acutely felt the loss of ancient knowledge and longed for what there was to come—his whole sense of himself as a contemporary maker was inspired by that classical past and visions of future creativity revealed to him even in dreams. 'I myself', Dürer still penned in 1513, 'think very little of my art. . . . If it were only possible, by God, that I could now see future great artists' work and art, those who are not yet born. Often, I see great art and good things when I sleep.'[18] Visions of truly great artwork engaged Dürer's senses, his creativity, and his mind. It hurt when they were checked by reality.

[17] Compare the interpretation by Decker, *Helleraltar*.
[18] Ashcroft, *Dürer* vol. 1, 380, Footnote 11 and text.

CHAPTER 9

Oil and Pigment

Throughout the correspondence with Heller, Dürer drew attention to painting as material process. He educated this merchant about the art of making an oil painting from start to finish, and how long different aspects took. Impatience would never pay off. Dürer wanted Heller to appreciate not just the expense of particular colour pigments but also the entire practice of painting as a skilful and time-consuming practice, which in turn he hoped would educate his patron about what was to be regarded as a fair price. 'I feel my own way forward from one day to the next' was how he described his growing understanding of rendering proportions and perspective.[1] Consistency, purity, and technical precision mattered and this in turn depended on a deep knowledge of tools, instruments, his body, and materials.

Dürer knew why a superior artist as craftsman needed to understand about materials such as oil with his senses, nose, and hands in intricate ways. He talked surprisingly little about the ideas for his composition as it evolved—patrons like Heller in any case expected to communicate about materials, costs, and deadlines. Linking Dürer predominantly to a text-based humanist culture of his time therefore overlooks the fact that the artist as a painter liaised with carpenters and joiners, sourced pigments, oils, and other ingredients alongside special brushes in order to paint as finely as possible. Dürer listened to the sound of grinding azurite or ochre, had chalk on his fingers and smelt of paint, oils, resin, varnish, or turpentine which he sometimes sprayed onto wet glazes to blend colours or used to add textures by working with his fingers. Most of his paintings up to 1505 have been x-rayed and show just how physical his relation to them was—his finger prints are scattered all over them, as Dürer sometimes preferred fingers to brushes for stippling effects on hardening layers of glazes. He used the balls of his hands to spread paint or achieve special atmospheric effects through subtle shading. The range and quality of his techniques leave no doubt that Dürer could be as ambitious and successful as a painter as he was as a printmaker.[2] Dürer depicted his own hands typically as immaculate or gloved, but in truth they were likely to show the marks of materials that were hard to scrub off and his intense work with burins. The artist

[1] Ashcroft, *Dürer*, vol. 2, 711.
[2] Bruno Heimberg, 'Zur Maltechnik Albrecht Dürers', in Gisela Goldberg, Bruno Heimberg, Martin Schawe eds., *Albrecht Dürer: Die Gemälde der Alten Pinakothek* (Munich, 1998), 32–54.

might have been drawn to wearing gloves as much as possible in public to hide the work of his hand and avoid denigration for it. Yet in truth this was an age in which many began to see why the work of the mind and the hand were best joined up. Immersion in how materials smelt and felt would have advanced Dürer's discernment, because he learnt through experiment how they smelt better or right, or displayed the appropriate texture, as runny or dense, or glossy or matt in the best way. All of this was part of empirical experience that linked to an understanding of causes—of why materials worked the way they did and how they might therefore be manipulated to do other things in new ways. Dürer would have reflected on whether using wood from vines to heat materials—like many doctors did—might help to purify them and unlock a particular character.[3] Such procedures could temper ingredients in their hot or cold, dry or moist qualities, that was thought to underlay everything living. These qualities in turn had an effect on viewers, as encountering an image was perceived as an embodied process that moved their emotions. For the Renaissance was not an age of a 'rationalisation of sight' through the reception of scientific perspective that distanced idealized observers from the world as object. As we have seen with Heller, religious objects and images were still regarded as filled with sacred power. Devotion could make them literally come alive, or activate their spiritual benefits to help the mind, body, and soul of those praying in front of them. In German art, naturalism and geometry were used to manipulate visual perception in order to intensify 'the emotional and moralising features of visual representation' by implicating onlookers ever more intensely.[4] This emotional connection in part continued to be achieved through the use of materials associated with active properties. A balance of fiery colours, such as red, with areas of blue could thus enhance a sanguine temperament. These ideas were linked to a surge in fascination with alchemy and hence chemical investigation into the mysteries of nature. Indeed, alchemy so enthused Nuremberg burghers that, by the end of the fifteenth century, the council tried to restrict their domestic experiments.[5] These attempted to unlock the virtues and powers inherent in natural materials as they were affected by changes in place and time.

Dürer's knowledge of the properties of pigments and oils in these ways would have made for a coherent body of knowledge and thus a conceptual practice. It was anything but a *non-intellectual counterpart* to 'true' artistry through new compositional ideas.[6]

[3] For a reflection on these sources of heat see Erich König ed., *Konrad Peutingers Briefwechsel* (Munich, 1923), 492.

[4] On sight see Bob Scribner, 'Ways of Seeing in the Age of Dürer', in Eichberger/Zika eds., *Dürer and His Culture*, 93–117, here 97. The important material component of this process is at the heart of Spike Bucklow's work, see *Alchemy*.

[5] Joachim Tölle, *Alchemie und Poesie: Deutsche Alchemiker in Dichtungen des 15. bis 17. Jahrhunderts* (Berlin, 2013).

[6] The failure to sufficiently acknowledge Dürer as painter is bound up with the legacy of understanding his practice as non-intellectual, see, for instance, the discussion in Raymond Klibansky, Erwin Panofsky, Fritz Saxl, *Saturn und Melancholy: Studies in the History of Natural Philosophy, Religion and Art* (London, 1964), 342.

Practice was intellectual because it drew on observation and advanced experiments that tested and developed the 'hidden' nature of these organic components as they emerged through the forces they interacted with, such as cosmic influences. It was widely believed that light, moisture and astral rays emanated from the heavens. They activated vital forces in materials. None of this was about traditional, routinized, artisanal knowledge one learnt in an apprenticeship and was simply followed for the rest of one's life. At best, it was linked to a culture of Renaissance craftsmanship deeply committed to a mindset of growth. It recognized the benefit of learning through new knowledge, mistakes, and tremendous effort. Trials tested the properties and behaviour of materials, and this in turn formed 'taxonomies and hypotheses' about which materials would perform best or how they could be pushed on and manipulated to imitate the properties of other materials.[7]

Dürer, as painter in this sense, was no genius above practice; he wanted to be recognized as excelling *through* practice. His practices as a painter were linked to how he wanted his choice of colours to affect people's souls. Colours derived from minerals, earths, shells, or residues of fabric dye. Much knowledge lay in choosing and processing these judiciously to unlock the beauty and secrets which lay hidden inside these types of matter. Dürer needs to be rematerialized, and the Heller correspondence enables us to do this. Artisanal work and alchemical thinking were integral to his artistic and intellectual milieu.

This similarly applies to strands of scholarly 'high' culture, as both Dürer's and Pirckheimer's correspondence bear out. Humanism, as we have seen, was not just a text-based intellectual world that happened in the mind and intellectually focused on form and composition as style. None of these scholars led disembodied lives of the mind. They imbibed the classical preoccupation with the care of the soul as linked to the care of the body. This attuned them to physical and mental conditions and changes in pronounced ways. Erasmus of Rotterdam (1466–1536) would probably have told you within minutes of meeting him how he had felt about his 'stone' that morning, or his gout in the evenings. A classical writer like Pliny the Elder (23/4–79), from whom we know most about Greek artists, had himself been eminently interested in the arts of making. He set out, for example, how the painter Pausias had worked on a large painting representing the *Immolation of an Ox* that used shades in an ingenious way to convey the size of the beast even though he depicted it in a front-facing position.[8] A passion for the ancients could seamlessly merge with an interest in furthering new practical knowledge in fields ranging from what we think of as chemistry and medicine to mastering perspective or engineering. In the Renaissance, chemistry, metallurgy, and medicine were all part of a fascination with chemical knowledge that enquired into how manual labour could be ennobled and transformed to benefit mankind after the Fall.

Alchemical interests brought scholars and artisans closer together because they combined the study of texts with hands-on work. As he had trained as a goldsmith and

[7] Pamela H. Smith, 'The Matter of Ideas in the Working of Metals in Early Modern Europe', in ead, Anderson, Dunlop eds., *The Matter of Art: Materials, Practices, Cultural logics c.1250–1750* (Manchester, 2000), 42–67.

[8] J.J. Pollitt, *The Art of Ancient Greece: Sources and Documents* (Cambridge, 1990), 165.

had interests in medal-making and sculpture, Dürer was likely to have kept in touch with metallurgical experiments. Canon Lorenz Behaim, the mutual friend of Dürer and Pirckheimer, firmly counted amongst those deeply interested not only in astrology but also in alchemical transformations, furthering knowledge through the sharing of recipes. In 1506, two decades before books by German authors included medical recipes for *aurum potabile*, for instance, Canon Behaim drew on his time as papal servant at the Vatican to pass on four detailed recipes about drinkable gold to Pirckheimer. Many of their ingredients were Mediterranean, and the description required specific techniques and equipment to best distil them, thus furthering chemical expertise.[9] He owned a whole alchemical recipe collection that he kept studying and enriching in order to establish, for instance, how copper could be whitewashed.[10]

Pirckheimer, and those in his circle, moreover constantly cared for each other through new medicines they not only just theoretically explored but also laboriously sourced, concocted, and shared. Such activity was bound up with empirical knowledge about plants and beliefs in their divinely bestowed potency. Handbooks written in the vernacular began to explore distilling to produce curative quintessences of great purity in order to combat bodily corruption and decay. Hieronymus Brunschwig's bestselling work on distilling was the first to be published in Europe, in 1500. Just like Rösslin's book on gynaecology, it was quickly translated into English. Such treatises were of wide interest, as few pharmacies existed and almost everyone made at least some of their own medicines. Meanwhile, well-known Nuremberg pharmacists could be highly esteemed for their expert knowledge, and some were elected as members of the Great Council, although they worked with their hands.[11]

A publication that particularly gripped Germany and Nuremberg circles in Dürer's time was the *Three Books on Life*, published in 1489 by Marsilio Ficino (1433–99). Ten German translations were published between 1505 and 1537, woodcut illustrations adding to their appeal. Translators and owners clearly linked this voluminous treatise to alchemical knowledge.[12] The books popularized humoral psychology and its relation to astrology by reflecting on how to balance humours and temperament. Saturn, for instance, was held to govern the humour of melancholic people who were cold and dry; by contrast, those who were hot and dry were governed by the planet Mars and assigned a choleric temperament. Ficino's first book specifically addressed learned people, while book three explored astrology. Intellectuals, he asserted, needed special health advice as they worked most intensely with the 'animal spirit': they, 'more than

[9] See, for instance, Pirckheimers Briefwechsel, vol. 1, 290–1, 374–8, 403–4; vol. 3, 34–5. See also Rudolf Schmitz, 'Der Anteil des Renaissance-Humanismus an der Entwicklung von Arzneibüchern und Pharmakopüen', in Krafft, Wuttke, Humanisten, 27–243.

[10] *Pirckheimers Briefwechsel*, vol. 3, 34–5.

[11] Tillmann Taape, 'Distilling Reliable Remedies: Hieronymus Brunschwig's Liber de arte distillandi (1500) between Alchemical Learning and Craft Practice', Ambix 61 (2014), 236–56; Hannah Murphy, *A New Order of Medicine: The Rise of Physicians in Reformation Nuremberg* (Philadelphia, 2019).

[12] This interest was marked in contrast to other European countries, see Marsilio Ficino, *Three Books in Life: A Critical Edition and Translation*, Carol V Kaske, John R. Clark (Binghampton, 1989), 12, 53. On interest in Nuremberg see Holzberg, *Pirckheimer*, 51–3.

anyone', he thought, needed 'select pure and luminous air, odours, and music'.[13] Green, he explained, refreshed this animal spirit. Potable gold revitalized old men; so (just as ancient physicians recommended) did pine nuts by increasing moisture.[14]

Ficino opened up a world of transformative recipes and instructions with his eminently practical philosophy addressed at a learned audience. How could a man's spirit be made 'solar'? Dürer's own depictions of the classical sun god Apollo reflected the way in which alchemical thinking celebrated solar energies by associating it with gold, as the noblest and everlasting metal, and with male generative powers.[15] Ficino explained at length how to achieve such radiant energy: compound suitable substances (ranging from animal organs to plants and ground gems) in sunlight, 'put on Solar clothes and live in, look at, smell, imagine, think about, and desire Solar things'.[16] Eating saffron helped too. Solar clothes were 'blazing yellows, pure golds, and lighter purple colours'. 'Indeed', Ficino explained, 'any colours, if they are fresh or at least pertain to silk, are more stellar.' Watery, yellowish colours, by contrast, harboured the properties of the moon.[17]

Ficino had first trained as a physician, then became a priest, and subsequently directed Cosimo de Medici's Platonic Academy. He was part of a lively culture of experiment, scholarly discussion, and global trade radiating out of fifteenth-century Florence. Humanists such as Ficino enquired into the effects of substances and were fascinated by the power of images. They sought to harness their power to protect mankind from evil. His third book on life explained that he had 'personally seen a gem at Florence imported from India, where it was dug out of the head of a dragon, round in the shape of a coin, inscribed by nature with very many points in a row like stars, which when doused by vinegar moved a little in a straight line, then at a slant, and soon began going around, until the vapour of the vinegar dispersed'. Vinegar was categorized as a sharp, fiery substance that, as in this case, could literally move other matter. If used in the wrong way, it was corrosive and damaging; if used for the right purposes, it could help to heal and preserve.[18] Ficino believed that whoever wore this stone as an amulet and frequently doused it with vinegar or strong wine could probably borrow some of the power of that Indian dragon by preserving it. Daemonic powers, in other words, might be harnessed to a good end. Celestial influences too were imbued in gems and metals, while wooden images had little force.[19]

The cumulative effect of reading all three of Ficino's books on life opened up troubling questions about how Christian and classical ideas could be reconciled as one delved

[13] Ficino, *Books*, 223.

[14] Ficino, *Books*, 195, 190–1.

[15] Larry Silver, Pamela H. Smith, 'Splendor in the Grass: The Powers of Nature and Art in the Age of Dürer', in *Merchants and Marvels*, 29–62, here 41.

[16] Ficino, *Books*, 311–13.

[17] Ficino, *Books*, 297.

[18] Spike Bucklow, *The Riddle of the Image: The Secret Science of Medieval Art* (London, 2014), 31–41.

[19] Ficino, *Books*, 317, 309.

more deeply into their mysteries. Yet for most readers, Ficino's *Three Books on Life* would have simply provided eminently practical advice on how to strengthen one's nature in ways that responded to commonplace views of the four temperaments. Its empowering message was that temperaments did not equal a fixed fate to be endured but could be understood and manipulated to achieve a long, healthy, and pleasurable life. Whatever one's age, a combination of music, matter that conserved the power of astral rays, food, drink, odours, drugs, clothes, cosmological knowledge, mathematical numbers, and visual experiences could be used to positively balance feelings.

This Renaissance science of life thus encouraged vigilance as much as experiment in relation to everyday practices. Pirckheimer knew Ficino intimately, battled on to translate classical medical texts, and increasingly acted as a physician. He began to regularly pass on not only recipes but actual pills he had manufactured, enquiring about their intake and effects, and also about reliable treatments for a host of diseases. Behaim in turn contributed his expertise on therapeutic astrology.[20]

Exchanges about these types of knowledge particularly interested Dürer's circle at the time he was working on the Heller altarpiece. In 1508, for instance, Pirckheimer received a letter from a barber he had met in Nördlingen two years earlier, while escaping from a plague that ravaged Nuremberg at the time. Writing in broad German dialect, this man requested 'dear hern tocter Birkamer' to send him a recipe for a particular type of plaster as well as three measures of a substance called *Mercurium suplymatum*. He had heard that pharmacists at Nuremberg's Our Lady's church sold it for less than half the price of his local pharmacy. Another surviving letter shows that the scholar and barber mutually exchanged recipes.[21] They discussed ingredients and 'secrets' about their preparation with pharmacists, who made or dealt with a broad range of substances, including pigments. Pirckheimer owned a German manuscript with twelve pages of technical writings and recipes, to which he added secrets about how to polish precious stones with chalk, resin, or other substances.[22]

Canon Behaim frequently wrote about recipes from 1508. By now, he had stopped joking about Dürer's beard, and never failed to send greetings to Albert, or 'our Albert', as well as of course to some of Pirckheimer's lady friends. Pirckheimer requested advice on skincare for one of them. Cosmetics could be dangerous because of the harmful effects of toxic ingredients such as quicksilver, and yet the Italian Renaissance spread beauty ideals such as white skin 'resembling lilies' and cheeks as 'flesh-pink roses' through portraits and poetry.[23] In October 1508, Behaim recalled a recipe he had obtained in Naples, and then sent details of an entire treatment regime that would, as he wrote, switching to Italian, 'fa la pelle Bella'—make the skin beautiful. He added two recipes a doctor in Rome had recommended to a woman against facial blotches or acne.[24]

[20] See, for example, *Pirckheimers Briefwechsel*, vol. 3, 58–9, 114–15; vol. 4, 167, 206–8.

[21] *Pirckheimers Briefwechsel*, vol. 2, 12–14.

[22] *Pirckheimers Briefwechsel*, vol. 1, 346, fn.14.

[23] Patricia Phillippy, *Painting Women: Cosmetics, Canvases and Early Modern Culture* (Baltimore, 2006), here 5–7.

[24] *Pirckheimers Briefwechsel*, vol. 2, 36–40.

All this shows how seriously any of these requests for information about cosmetics were taken, and to what extent they were a conduit for knowledge that travelled across wide social and spatial geographies. In June 1509, as Dürer was trying to finish his altarpiece, Behaim confirmed receipt of a recipe to make sugar and wine spirit. He described at length a procedure to make highly acidic mercury with its awful-smelling fumes, asked Pirckheimer for a solution of mercury, and reported on further complex chemical experiments. Most of Behaim's long letter was taken up with these questions, which made evident that he and Pirckheimer seriously experimented at home with a wide range of chemical and vegetable substances as well as with distilling equipment, and provided medical advice for others.[25] Behaim's next letter enquired about the uses of a small oven, wondering whether alchemically achieved gold would ever illuminate the men—that is, transform them into solar states.[26] In 1511, the canon still wished to see such an oven and made further references to Pirckheimer's distilling. Next, he probably went to stay in Nuremberg for an extended period with Pirckheimer, sending to one of his old lady friends a recipe against the 'stone', after his return. Dürer then stayed with Behaim in Bamberg in April 1512. By now, they were discussing recipes supplied by Hans Imhoff's wife, the patrician woman who evidently made her reputation as an active medic. She especially recommended a range of honeys in specific colours to treat and prevent diseases. That spring, Behaim's letters mostly dealt with recipes, alongside his interests in politics, classical literature, astrology, and sexually available women.[27] Hence, after Dürer had returned to Nuremberg, re-established himself, and was painting for Heller, these exchanges around chemical and medicinal knowledge, observation, and experiments began to increase in depth. Exchanging secrets about substances such as mercury affirmed bonds of trust among these friends, as they were known to be potential poisons, and their interest in them could easily have been misconstrued. Secrets needed to be in the right hands.

The trio's interest in treating skin diseases and mercury cures moreover related to the devastating experience of syphilis as a new disease that swept through Europe from 1494 onwards. Pirckheimer discussed challenging new authors such as Paracelsus (c.1493/4–1541). 'Human commerce in fleshly lusts', Paracelsus wrote, had never been as it was now.[28] Syphilis, known as 'French pox', was seen to derive from a range of causes, including sexual intercourse. It was frequently treated with mercury cures before *guaiacum* wood began to be used more commonly from 1518. Conrad Celtis died from syphilis in 1508, having suffered from it for many years, while Dürer himself feared

[25] For Pirckheimer's recommendation to take mercury as cure see *Briefwechsel*, vol. 1, 452. N.4.
[26] *Pirckheimers Briefwechsel*, vol. 2, 44–51.
[27] For the latter see in particular, *Pirckheimers Briefwechsel*, vol. 2, 450–3; for chemical interests see 113–19, 139–48.
[28] Cit. in Bruce Moran, *Paracelsus: An Alchemical Life* (London, 2018), 57.

being afflicted when he was in Venice. 'I know of nothing I fear more at the present', he confessed in August 1506, 'everyone has it, some folk it eats completely away until they die.'[29] These fears preceded his trip—Dürer's self-portrait in the Jabach altarpiece was, in fact, based on an image in a popular broadsheet that provided a prayer against *Malafranzosa*.[30] Pirckheimer had received a recent treatise including a recipe for a guajak cure that had been translated from Spanish to German in April 1519.[31] Such anxieties formed a counterpart to their interest in aphrodisiac plants and substances. Dürer himself held *eryngium* in his hand when he painted his first self-portrait in oil aged twenty-two, in anticipation of being betrothed to eighteen-year-old Agnes. The plant was known as *Mannstreu* and thus associated with male fidelity, but also known as an aphrodisiac. Dürer bought pine nuts later in life, perhaps for the same reason that Imhoff was given them by his wife, for sexual stimulation. His nature studies meticulously observed many plants commonly used for medicinal purposes and inspired the emerging genre of herbals based on close empirical observation.

When Pirckheimer's belongings were inventoried after his death, they included 'lots of small boxes and glasses, many of which with powders and medicine, soaps and pills and such like'; though not described in detail, their presence provides further evidence of his pharmaceutical activities.[32] Many women in Pirckheimer's and Dürer's circles would likewise have known how to best grow, harvest and source, grind, mix, and blend a host of ingredients, for both either domestic or professional use. Transforming animal, plant, and mineral materials, for the benefit of health through a good diet or medicine, to achieve beauty and fastness of dyes, as well as for painting, meant being in touch with regeneration and creation. When staying with Behaim, Dürer talked to his female cook, who would have been knowledgeable about how to best cater for his dietary needs, and Behaim's sister was among Pirckheimer's lady friends.

Convents were also places where practical knowledge was cultivated. Several of Pirckheimer's sisters served as learned and notable abbesses, and three of his daughters took the veil. They often sought his medical advice, recipes, and drugs.[33] For example Pirckheimer's sister Eufemia, a Benedictine nun in the convent of Bergen, frequently wrote to her brother in order to benefit from his and Dürer's material knowledge and their access to specific materials. As in other convents, the Bergen nuns were constantly engaged in embroidery and painting devotional scenes. Their motifs in turn came alive to many of them in visions, their emotions deepening as they touched, held, kissed, or intensely gazed at them. It was this spiritual relationship, rather than the rationalization of sight, that made them strive for naturalistic depictions and colours. Once more we can see just how devotion played a role in fostering Renaissance ideas.

In Bergen, one nun was appointed as 'painter'. She was provided with time and resources to practise. In 1524, this 'sister painter' asked Pirckheimer how to apply yellow

[29] Ashcroft, *Dürer*, vol. 1, 152.

[30] Birgit Ulrike Münch, 'Praying against the Pox'.

[31] *Pirckheimers Briefwechsel*, vol. 4, 47.

[32] Pohl, *Imhoff*, 25.

[33] See also Reicke, *Pirckheimer*, 92–3.

colour on cheap prints. How could she get her pigments right? She had tried two different ingredients—ground yellow pearls and yellow lead—but both failed to achieve good results, even though she knew that these materials worked for others. Everything depended on the particular composition of materials. Knowing that Dürer had access to a high-quality gold colour, she wrote to her brother Willibald: 'we could really use some ground gold—you bought some for us once that isn't the right thing; but the stuff Dürer sent here, that was exceedingly beautiful, and sister painter says to do her a great favour and get another lot out of Dürer for her'.[34]

The nuns next tried out 'aurum pigment', a golden pigment that Dürer seems to have recommended. They also tried to achieve a durable copper-green that would not tarnish. In short, Eufemia's sister Sabina wished: 'if only I could have Dürer here for a fortnight so he could give Sister Painter some lessons'.[35] By 1527, Eufemia had written to Willibald Pirckheimer in order to let him know that they had received Dürer's book on art and measurement. Yet 'sister painter' confidently judged that 'her art' was 'accurate enough without it'. In fact, 'she had no use for it'. What she really wanted to improve was her colour-making. She knew that Pirckheimer by now possessed technical hands-on knowledge, and was familiar with exchanging information about materials that actually worked, for example when paint clogged up or failed to combine. Pirckheimer's sister told him that 'sister painter' would 'like a little really nice blue for when she is doing something fancy, as she is well capable of, so that the colour enhances it. She has tried out the Spanish green, which you taught her to add a drop of vinegar and lily sap to. But she can't make it work and it doesn't adhere. Particularly as she is painting it on, the colour doesn't end up looking nice and thin. You need to teach us all about these things.'

The letter conveyed a maker's pleasure in the alchemy of material qualities as they combined—when the paint turned out well because it had the right tone and was of the right density for a particular surface. Some weeks later, Eufemia, herself a keen painter, added another request, which underlines the persistence of the nun in making materials work for a range of projects:

> Sister Painter has asked me to ask you to buy more brushes. The last ones pleased her greatly. Reverend Mother will be happy to pay for them. Also we beg you tell us how to paint on cloth—we would like to make banners for the church. Sister Painter has tried it out on small pieces, but painting onto cloth just won't turn out right for her, in particular the gold looks coarse, because the oil keeps bleeding from the colour. We daren't ask a painter—they never tell us the right reason. I am quite sure that you know about it as well as any painter…

Pirckheimer sent this query on to Dürer, who in turn shared the secret: depending on the colour, prime the cloth with chalk or charcoal.[36]

[34] Ashcroft, *Dürer*, vol. 1, 728.
[35] Ashcroft, *Dürer*, vol. 1, 730.
[36] Ashcroft, *Dürer*, vol. 1, 824–5.

As Dürer was completing the Heller altarpiece in 1508–9, he worked on his manual on the art of painting. Its entire magic, he explained, lay in the process and experience: 'No one believes, unless he is engaged in it, that art is so rich in pleasures. Great joy is to be had from it.'[37] You had to do it! This made it difficult to convey just how enriching this process could be. Dürer never wrote anything like this about the process of making woodcuts or engravings. After all, he had stopped training as a goldsmith because he wanted to experience this *pleasure* of painting—immersing himself in materials and forces that lent lifelikeness and presence to the subject in order to transmit its affective essence to an audience. That is what he wanted to achieve in the Heller altarpiece.

Dürer would have kept many recipes secret. This absence of written records has made it even easier to forget his tacit knowledge and expertise as a painter—in fact, it has been assumed that he bought all his painting materials from a pharmacist.[38] However, a recently discovered manuscript shows that Dürer cherished his own collection of craft secrets given to him by a cousin. It included advice on how to write with gold, how to soften glass with a ram's blood, sharp vinegar, and plantain leaves. It included detailed instructions on how to imprint leaves, flowers, and their stems on paper to aid naturalistic observation. The manuscript also contained advice on how to mix paint so that it would capture the complexion of the young, neither too red or too white. It was a treasure trove replete with new interests, material techniques and ingredients, including those for Venetian glass.[39] So, of course, Dürer thought materially as he set himself challenges in painting. He rigorously recommended working with purified nut oil, for instance, when handling ultramarine.[40] Nut oil tends to age better than linseed oil, as it prevents the dulling of the blue which is most sensitive to discolouration.

Artists like Dürer used oil paint mostly on wooden panels and canvas. Wood had to be chosen in terms of its type, thickness, and chemical quality. If its planks were cut from parts of the tree with branches, then the hole this created by knots falling out might need to be filled with fabric to make painting over it less bumpy. Resin deposits or cracks likewise interfered with a smooth surface and paint. The central panel of the Heller altarpiece measured *c*.189 by 138 centimetres, a size which might require at least six planks of wood to be joined. A linen canvas likewise could be rough or bumpy— everything depended on how fine the linen had been hand-spun and how it was then woven.[41] Next, the properties of oil proved crucial.[42] A range of different oils—

[37] Ashcroft, *Dürer*, vol. 1, 247.
[38] Andreas Nurmester, Christoph Krekel, 'Von Dürers Farben', in Goldberg et al. eds., *Dürer*, 54–101.
[39] Christina Sauer, 'Eine kunsttechnologische Handschrift aus dem Besitz Albrecht Dürers', *Dürer Forschungen*, vol. 2 (Nuremberg, 2009), 275–97.
[40] Ashcroft, *Dürer*, vol. 1, 388.
[41] Schauerte, *Dürer*, 39.
[42] Ann-Sophie Lehmann, 'Das Medium als Mediator: Eine Materialtheorie für (Öl-)Bilder', *ZÄK* 57/1, 2012, 69–89.

mostly walnut and linseed oils—were experimented with for different effects, so that conservators are still trying to understand whether van Eyck, for instance, additionally used aetheric oils or particular proteins.[43] Every painter's challenge was how to achieve special effects—how to paint a dead person with veracity, or to render light, shade, or colour in vivid ways to give a subject reality.

Medical recipes likewise relied on knowledge about oils and their best preparation. In 1509, as we have seen, Dürer began to write poetry and defended himself against ridicule from his younger humanist friend Lazarus Spengler, a neighbour who had just been appointed as Nuremberg's city scribe in 1507 after returning from Leipzig university. Dürer claimed his right to develop their skills and experiment in different fields. At the end of a burlesque poem, he suddenly proclaimed that he also set his sights on making medicine. He was a 'new quack' with 'painter's medicine' to help people achieve a 'ripe-old age' up to a hundred years:

> It's not just writing I would learn,
> I have my eyes on medicine too.
> It will be wondrous to behold
> How Painter's medicine sorts you out.
> So hear what this new quack prescribes
> As perfect stuff to boost your health:
> A tiny drop of pure leach-brine (an alkali, UR)
> Apply twice daily to sore eyes.
> And if you want the sharpest hearing,
> Drip almond oil in both your ears.
>[44]

Even in German, this poem reads terribly. Dürer was not a gifted poet. Yet what matters is that Dürer thought of this analogy of a painter as a physician, connecting the handling of paint with the handling of remedies. It was personified in St Luke, the patron saint of all artists as well as doctors and surgeons.[45]

Dürer recorded a lengthy recipe to make a 'precious, tried and tested oil' to heal wounds, as complex as any for paint. Five different herbs were ground and mixed with olive oil to form a sap. The description of the required measurements were simple, but more detailed instructions related to the next step in the preparation. The sap had to be poured into a pan and put on gleaming coals. In order to judge whether the proper temperature had been reached, some of the heated mixture was then dripped onto the fire. If it sparkled, the mixture needed to seethe for longer. At this point, the recipe advised to 'deal diligently' with the mixture—such processes needed attention to carefully register chemical reactions. The perfect cooling down process was described as 'properly' or 'cleanly', which presumably relates to the importance of making sure no

[43] Lehmann, 'Medium', 79.

[44] Ashcroft, *Dürer*, vol. 1, 287.

[45] For a further reading see Mitchell B. Merback, *Perfection's Therapy: An Essay on Albrecht Dürer* (New York, 2017), 225–7.

108 Ulinka Rublack

dust or dirt, or insects, entered the mixture as well as emphasizing due care. Finally, a 'beautiful glass' had to be chosen that was narrow at the top so that a glass funnel could be placed on top of it. A 'beautiful' double linen cloth helped to filter the mixture, and the glass was then sealed with wax mixed with mastic—a resin obtained from Mediterranean mastic trees—'so it will lose no strength, and when it is new, it is green, and the more it ages, the whiter and better it is'. Dürer treated this recipe as a potent secret. He affirmed its power by a change in writing style that evoked the mystery of such transformations. They surpassed human reason and therefore demanded humility:

> Keep this oil secret
> And in great honour, for
> You have nothing more secret
> To treat wounds on the earth …

For whenever a person was wounded, the oil could be heated up to as high a temperature as tolerable and applied directly before bandaging. The recipe promised: 'You will be surprised by its healing power' (*Heilsamkeit*).[46]

Working with materials meant unlocking spiritual secrets for the benefit of society. Dürer shared his ethos with the aim of creating lasting and spiritually powerful works with reputable craftspeople in Nuremberg and elsewhere. Any master of his craft equated honesty with great effort that led to quality and furthered redemption. Dürer was no proto-Lutheran when he painted the Heller altarpiece. Despite the crucible of ideas that humanism exposed him to, his religious practices were firmly rooted in traditions he had been brought up with as a child. Just like Jakob and Katharina, he believed deeply in good works, the importance of God-fearing conduct in daily life to avoid hell and purgatory, in earthly penance, in saints, and the efficacy of prayers to them. He and his family worshipped at St Sebald's church, presumably several times a week; and his mother was a deeply devout woman. Pirckheimer, as we have seen, strongly supported his sisters' and daughters' spiritual lives and career paths in convents; Dürer knew and respected them as nuns.

Germany's culture of intensely pious devotion constantly received new stimuli. In 1507, for instance, the Nuremberg sculptor Adam Kraft set up seven sacrament houses commemorating the crucifixion that led all the way from the Tiergärtnertor to devotional sites outside town.[47] Mary's intercessory power seemed supreme. At St Sebald, masses commemorated the Virgin every Saturday, and the chaplain and boys sang hymns in her honour, and everyone attending was granted an indulgence of fifty days. If the day of attendance was one of the many feast days devoted to the Virgin then the indulgence was greater, one hundred days off time in purgatory. At this time

[46] Rupprich, *Nachlass*, 217–18.
[47] *Des Johann Neudörfer Schreib-und Rechenmeisters zu Nürnberg: Nachrichten von Künstlern und Werkleuten daselbst aus dem Jahre 1547*, ed. by Andreas Gulden (Hamburg, 1828), 8.

confraternities devoted to the Queen of Heaven had begun to multiply in German cities, and many believers individually recited rosaries to gain indulgences too.[48]

Ulrich Pinder (fl. 1489–1509) belonged to Nuremberg's enterprising Christian humanists. A wealthy physician who had served Frederick the Wise, he bought his own printing press to issue medical books and devotional literature. Both addressed a large middling audience who had attended Latin schools and anxiously cared for their body, mind, and soul. In the same way that his fellow physician Hartmann Schedel (1440–1515) had made images central to the *Nuremberg Chronicle*, Pinder believed in the power of woodcuts for his publications. They invited further contemplation, worked for those who were not as literate, and could be therapeutic through spiritual edification. In 1505 and 1507, Dürer and artists close to him supplied hundreds of woodcuts to illustrate two books issued by Pinder—one on the life of the Virgin Mary, and the other a mirror of Christ's passion.[49]

All of this inspired Dürer to experiment further with how his personal voice might offer spiritual guidance. As he painted for Heller, the artist produced a text entitled *The Seven Daily Times of Prayer* that could be interlinked with illustrations in an *Engraved Passion*, which he had been working on from 1507. In 1510, he combined simple devotional texts and images in a cheap broadsheet. Dürer's final verses on this broadsheet reveal his spiritual voice:

> And so let all who would die well,
> With eager gladness do good works
> And set their trust in God alone,
> Then they can never suffer shame.
> Never will God desert them,
> But bring them to his heavenly host.
> Albrecht Dürer gives this advice.
> Would God that I might live by it!
> Gladly let us all pray for that,
> Hoping God grants us his mercy.[50]

Painting Mary's Assumption and Coronation in bold and lasting colours for Heller therefore both challenged and inspired him to master his materials and techniques in an exceptional manner, to lend vivacity and lifelikeness to what his contemporaries considered a deeply reassuring, joyful message. Most paintings of the Virgin focused on

[48] Bridget Heal, *The Cult of the Virgin Mary in Early Modern Germany: Protestant and Catholic Piety, 1500–1648* (Cambridge, 2007).
[49] Merback, *Perfection's*, 29.
[50] Ashcroft, *Dürer*, vol. 1, 310.

her sorrow upon the death of her son. Yet Pinder's 1505 chapter on the Assumption reflected ideas that must have echoed in sermons across Nuremberg and influenced Dürer. It set out that, bathed in miraculous light, Christ had come to greet his mother with great joy and placed her on a glorious throne next to himself. She was there for young and old, and people of every profession, to intercede for them. Whoever truly turned to her would not be damned. Pinder's text was so successful that it was translated into English, engulfing readers in its deeply comforting, fortifying prose:

> O thou gloriouse Lady, what may I say more? Who so laboreth to considre and declare the immensitie and hudghnes of thy grace and glory: his tonge faileth, his wit wanteth, and his reason can nat com therto. For as all sayntes in heuyn by thy glorification be inestimably beautified and gladded: so al creatures vpon erth be vnspeakably exalted by the same glorificacion. For as god by his power / creatynge and makyng al creatures, is the father and lord ouer al: so our blessyd Lady / by her merites repayryng all thynges: is the mother and Lady of all. And as almyghtie god the father dyd generate of his owne godlie substance his eterne son, by whome he hath gyuen lyfe and begynnyng to all thynges: so blessyd Mary conceyuyd and bare hym of her owne body / which restored all thynges vnto the beautie and fayrnes of theyr fyrste condicion. And as there is no thyng made or hath his beyng, but by the son of god: so ther is no thynge condempned forsaken or put to etarnall dampnacion, but that person whome Christe absolueth frome her sauiour, or whome she dothe nat fauoure or defende. Who is he that consi|derynge these thynges with a ryght sense or wit and a pure hert, may fully know or perceyue thexcellency of this Lady / by whom the world is erecte and raysed vp with vnspeakable grace: from so great a fall and decay? Therfore we leauyng tho thynges that can nat be searched and knowen by our naturall reason: let vs la|bour to opteyn by prayers that we may deserue to get that in hol|som and fruyteful effecte: which we can nat perceiue by our vnder standyng. Hereby we may perceiue that it is vnpossible that any person shuld be dampned: that is truly turned to her, and whome, she fauoreth and beholdeth.[51]

By 1509, Nuremberg citizens like Dürer still prayed that Mary was a well and fountain of joy in all their sorrows and troubles, leading them to the ineffable joys of eternal life in heaven.

The artist would have tried to make this experience of joy and solace come alive in his painting of the Virgin for Jakob and Katharina, and anxious at times perhaps, just like himself and Agnes his wife, about whether their childlessness was their punishment by God. Compared to other wills in Frankfurt, as we have seen, Heller's clearly was unusual in referring repeatedly to his sinfulness.[52] Deeply beholding an image transformed believers, bringing them closer to the divine and offering a cathartic sense of salvation. In accepting to paint the Heller altarpiece, Dürer would have wished to reflect both his own devotion and offer spiritual comfort. In the Landauer altarpiece, he depicted the faithful, as Erwin Panofsky put it, as already 'accepted among the beatified', although its separate frame still depicted God's Last Judgement that sends humans

[51] Ulrich Pinder, *The myrrour or glasse of Christes passion* (London, 1534), 118.
[52] Kirch Hall, 'Heller', 198.

either to heaven or hell.[53] The artist could become a healer of souls—in fact, Dürer had 'cultivated a unique sensibility for discerning and "attending to" the particular needs of audiences he addressed'. Through religious subjects, he offered 'care and consolation to himself, to his patrons and friends, and then to the extended human family united under Christ'.[54] As I have shown, this message was not only linked to motifs, such as Mary as Queen of Heaven, but also bound up with how he handled the raw materials in the painting.

Following Dürer's process thus means recognizing that the meaning and effects of images partly related to their materials, to how they were processed and used to create meaning in art. As we have seen, an artist would have worked with materials through a dialogue with them, which responded to the ways in which particular properties enabled possibilities or resisted them, to how they behaved and acted, and to how these properties were loaded with cultural meaning. Matter, makers, and tools merged as an artefact evolved. This shines a different light on Dürer's point that he could not work on other commissions simultaneously so as not to be weighed down at the same time. It was as if a major project demanded its own temporality and the complete attention and devotion of a maker. Making a complex painting meant to involve oneself in a mutual process with matter; matter was not just a 'backdrop for human action' but an agent and influence.[55] After his stay in Venice, Dürer wanted his own colours to leave their imprint on human souls to demonstrate what art could do.

[53] Cit. in Merback, *Pefection's*, 251.
[54] Merback, *Perfection's*, 254.
[55] Lehmann, 'Medium', 83.

CHAPTER 10

Colour

As if caught in a triangle, Dürer's religious beliefs and spiritual intentions as an artist thus uneasily coexisted with his feelings towards a client and the commercial mindset of an aspiring Nuremberg craftsman. Bitterly, he kept pondering whether a man like Heller was ever going to understand what painting involved at the highest level, and why this trade should be profitable for its makers.

Because Dürer had requested Heller's patience in November 1508 (not least for having to paint one hundred figures on the panel), the merchant resolved to write only after a further three months. In response, on the 21 March 1509, Dürer replied that he hoped to finish his work by May, claiming to have concentrated hard on the commission for an entire year. Heller had evidently worried once more about whether Dürer was taking on other commissions, and also whether he was using the best colours. 'I have applied much effort to this one and only piece of work', Dürer wearily affirmed. He added: 'There is not much that I feel able to tell you about it, except that I am confident that you will see for yourself how much trouble I have devoted to it.' He assured Heller that he would not find more beautiful colours *anywhere*. For it was not just the pigments, it was his handling of them that made the colours so beautiful. Reflecting on this subject, Dürer felt frustrated again about how unfair the terms of this commission had turned out to be, and thus repeated: 'For I'm putting such hard work and long hours into it, even though it is unprofitable and takes up all my time.'

In August 1508, Dürer had made the base layers of underpaint in colour crucial to his most concrete and substantial price negotiations yet. By November, he addressed the merchant in more intimate terms—'Dear Herr Jacob!'—and asked for Heller's approval to allow, and fund, techniques to ensure that the main panel, entirely the work of Dürer's hand, would be made to last for as long as possible. Heller presumably realized that oil paintings deteriorated over time, and that the variable climate of a church and an altar close to its entrance did not bode well for the durability of Dürer's panel, even if the outer wings, when closed, protected it for part of the year. As noted previously, both men were concerned with eternalizing their memory—Dürer to ensure his lasting fame and Heller to ensure his eternal salvation. If the painting needed to be restored, it would no longer be a pure impression of Dürer's hand. Hence Dürer assured Heller that he had set out the main panel 'with utmost care' and that no one except him would

even add a single stroke to it. It had been 'undercoated with two very good layers of colour' so that Dürer could now start the process of further building up layers of colour.

Only the effort to patiently apply layer after layer of high-quality oil paint, while being in perfect control of each part of the composition, ensured a painting's exceptional quality. For example, painting a grape in a still life, a genre soon to become so popular, required at least six layers of paint to achieve a naturalistic effect. The tone of each layer needed to be freshly mixed up on a palette numerous times, as paint was difficult to store. Dry pigments were kept in shells or animal horns, and pre-made wet paints in airtight walnut-sized pig bladders, either tied closed with a removable peg stopper or just pricked with a thorn and squeezed. This was crucial to avoid the colour from changing, for every time an artist returned to his painting, the colour tone needed to be consistent to avoid lighter blotches and irregular patches. Each layer moreover required a different drying time that also depended on a room's changing humidity levels and temperature.

Ultramarine on its own was an exceptionally slow drier. A painter therefore needed to be able to envisage compositions as slowly emergent layers and remain attentive to when best to return to particular parts. Much of this process would have been stressful—we must by no means imagine painting to have been a relaxing activity since any mistake might produce irreversible results. Pure ultramarine needed to be laid on thickly, for example, as it was translucent in quality and any layer beneath would otherwise influence its colour. Hence ultramarine was often mixed with opaque lead white, which improved the drying time, and the paint's concealing power, making it much easier to handle. This in addition produced a texture which prevented the paint from cracking later. But it obviously lightened the colour tone.

Pure ultramarine on its own, which Heller wanted Dürer to use for the Virgin Mary, tends to 'produce a rather granular paint' which was harder to work.[1] Dürer sometimes chose to apply a thin layer of it over a layer of azurite mixed with ultramarine, but working with these two layers increased the drying time.[2] A key area of worry, and thus of knowledge, was how to make colours that would not fade or alter their tone easily. Yellow lake, for instance, derived from textiles dyed yellow using plants that tended to be fugitive over time. For greens, verdigris was achieved chemically by making copper react with the right type of vinegar. This resulted in a blue crust that turned turquoise when ground down. A painter hence had to paint with this colour in anticipation of it turning green on the panel after one month—an effect that was far stronger in oil than in other media.[3] Only intricate techniques such as these produced what Dürer thought were not just beautiful but 'sublime' colours that deceived the eye into thinking an object was real, and also retained the 'character' of each colour.

[1] Paul Taylor, *Condition: The Ageing of Art* (London, 2015), 148.
[2] Burmester, Krekel, 'Farben', in Goldberg et al. eds., *Dürer*, 75.
[3] Taylor, *Condition*, 141.

Dürer had to reflect on how to distil advice on this process for his manual on painting. This was pioneering for the time. Cennino Cennini's practical late fourteenth-century handbook only circulated in Italian, while Alberti, whose treatise on art Dürer knew, said nothing about how to make colour. The subject immediately proved complex to communicate. 'If you wish to paint in the sublime manner', Dürer began, 'keep (*your colours*) firmly apart.' He followed with lengthy instructions on how, and when, to introduce shading. Any flaw revealed that the subject had not been done 'justice'. Shading with the wrong colour resulted in the loss of a colour's character: 'At all events, no colour must forfeit its essential character', Dürer summed up. This respect for a colour's nature left him wrestling with the challenge posed of how to depict new types of silk that were woven from two colours to achieve a shimmering *changeant* effect or how to represent the nature of particular colours in dark settings.[4] He abandoned the manual.

Painting colour was made more difficult by advances in high-end textile arts. Alongside mastering perspective depicting silks posed the greatest challenge of the time. 'More than anything', Paul Hills concludes for Venetian painters and their patrons in the world Dürer would have experienced, 'it was the dress they wore and touched—their camouflage and sign of distinction—that (they) became cognitively attuned to colour texture, to *colorite*.'[5] Renaissance dress created new colour worlds.

One of the ways to achieve colour effects in Venetian painting during the age of Bellini was to use a wide range of lakes. Lakes were the dried and filtered residues of dyestuffs and metals extracted from dyeing vessels, or from boiling a dyed fabric in an alkaline solution. Yellow lake, for example, was used as glaze over blue azurite to achieve green used in landscapes and modify hue.[6] In painting, as in dyes, the labour required to achieve effects was considerable. Take orange, which only began to be used as a colour term in the late fifteenth century, and as orange trees began to be planted in northern Italian cities like Venice. It featured in maiolica about 1470. When Bellini painted St Peter in an orange mantle he had first applied lead white as a primer, which with its high refractive index over gesso reflected the light back on to the successive layers of colour to brighten them: first a khaki underpaint made of lead white, possibly yellow lake and some black; next a mix of orpiment and realgar; finally a thin orange-brown glaze, and for darker areas a rich brown blended with red earth, umber, and some orange-brown glaze.[7] Around the same time, violet, mauve, aubergine, and purple came into their own and fully different from blues and reds, for instance through violet lakes.

This Venetian commitment to bring out the best colours throws further light on Dürer's proposition to Heller, when he was at his most ambitious: 'For I intend, once I have your approval, to underpaint some four, or five, or six times, for maximum purity,

[4] Ashcroft, *Dürer*, vol. 1, 386–7.
[5] Paul Hills, *Venetian Colour: Marble, Mosaic, Painting and Glass, 1250–1550* (New Haven, 1999), 185.
[6] Hills, *Venetian Colour*, 141.
[7] Hills, *Venetian Colour*, 146–7.

clarity[8] and durability', as well as to use the best ultramarine. These layers of underpaint were needed to ensure that the final layer of colour reflected the light in the best way. In contrast to Italy, the use of ultramarine was rare in Germany where it was impossible to buy. However, one of the reasons for the lack of ultramarine in German painting was the availability of such excellent-quality azurite, 'German blue', from German copper mines. The best painters and preparers converted a supposedly second-rate material into a first-rate colour. Highly processed azurite could be practically indistinguishable from ultramarine. The use of ultramarine nonetheless explains, as we have seen earlier, why Dürer and Heller could make an instant material claim to brilliance and wealth through its use—especially as Dürer was able to source high-quality ultramarine through an exchange in kind.[9] He referred to his painting of Mary similarly as 'purely' or 'properly' made, as *reinlich*—as a quality which Heller could trust in.[10] *Reinlich* and *beständig* hence functioned as a pricing term, but, as the artist explained, this was because they were intimately bound up with his particular techniques of preparation, his material knowledge and willingness to invest time in working to high standards. In these ways, he gained authority and hoped for fair remuneration, just as any other maker. A seamstress could work sloppily or *reinlich* in the art of her stitching. Fine suede leather when insufficiently prepared could simply dissolve in rain and thus be *unbeständig*. For these reasons, Dürer had laid out two options for Heller—he could either pay another 80 florins for superior technical qualities and materials or confirm the agreed price of 130 florins. The proposed increase in price hence did not refer to Dürer's *ars* in the sense of ideas in composition but *techne*, his techniques to ensure greater memory.

Materials and techniques were in these ways bound up with Dürer's ideas of how to ensure his fame. The inscription on his self-portrait of 1500 recorded that he had painted it himself with his 'own', 'immortal' colours, and this meant that his material techniques enabled him to make his image endure. He tried out using the same four pigments as Pliny reported of Apelles and their variations—white, ochre yellow, red and black.[11] Dürer's black seems to have been made from burnt peach stones, while he sourced high-quality ochre from Armenia.[12] When writing to Heller he was most enthusiastic about his use of the 'best', 'most beautiful colours', and assured his patron that he would be 'unable to find more beautiful ones elsewhere'.

[8] I have added purity to Ashcroft's translation of clarity, see Rupprich, *Nachlass*, 66, Ashcroft, *Dürer*, 214. The term for durability is *Bestendigkeit*.

[9] On the rare use of ultramarine in Germany see Schmid, *Unternehmer*, 356.

[10] Rupprich, *Nachlass*, 215; on 'reinlich', 'vleissig', 'subtil', 'maisterlich', 'kunstlich', 'Wohl gemacht', and 'werklich' as pricing terms see Schmid, *Unternehmer*, 356–7.

[11] Saviello, *Verlockungen*, 137.

[12] Burmester, Krekel, 'Dürer's Farben', in Goldberg et al. eds., *Dürer*, 81–3.

Venice, in other words, had not sent Dürer back with new allegorical or mythical themes he had wished to explore but a love of colour and the knowledge of how to best make them. His colour was not 'made', he affirmed, in the usual way. He assured Heller: 'I want you to know that I take the most beautiful colours which I can get.'[13] As ultramarine was a rare pigment sourced in Afghanistan, its market value fluctuated more than that of other pigments. After Heller failed to reply to Dürer's attempt to secure 200 florins and instead started smearing his reputation, the Nuremberg artist wrote: 'You often refer, when you write, to materials! Were you to have bought 1 lb of ultramarine, you would have scarcely got it for 100 florins. For I can't buy a beautiful ounce of it for under ten or twelve ducats.'[14] Writing on 21 March 1509, Dürer very plausibly claimed to have spent 20 ducats—25 florins—on just the solid ultramarine he used—another testimony to his dedication, high standards, and honesty. By contrast, he had spent only 5 florins on materials for the *Feast of the Rose Garlands*. Dürer used 28 per cent of the total sum he was eventually paid by Heller on pigments, in addition to which he paid for other materials and of course the frame, carpenters, and assistants.[15] He judged the painting to be worth 400 florins. Still, he had made up his mind to complete the commission: 'for the sake of my reputation and yours we get to the end of it, for it is going to be seen by many well versed in art'. The small angel faces, he informed Heller, still needed to be painted in.

Yet, by November, Dürer had clearly decided on the much more minimal composition. He added a note of cautious defiance to the merchant, without making his new design explicit: 'It is going to be seen', he imagined in March 1509, and just six months away from finishing, 'by many artists, who will perhaps give you their opinion as to whether it's a master's work or terrible.' He instantly ridiculed potential critics who were not themselves makers: 'I think perhaps as well, it may not please some art connoisseurs—(*Kunstreichen*)—who would prefer a panel for peasants (*Bauern-tafel*) instead.' In a different translation, this sentence reads: 'It may not please certain art connoisseurs who would prefer a village altar instead. That does not bother me. The praise I look for only comes from experts.'[16]

Dürer intriguingly criticized some of the taste-makers of his period, and very likely their preference for a Germanic style in handling colour and expression. Their judgement, he affirmed, 'does not bother me. The praise I look for only comes from knowledgeable people.... And if you see it and then don't like it, I'll keep the panel for myself. For I've had people pleading with me to put it on sale and paint another one for you.' He stressed how much he hoped Heller would be pleased with the final result and thus esteem his 'great', rather than simply good, care and diligence.[17] He had achieved rich

[13] Rupprich, *Nachlass*, 67.

[14] Rupprich, *Nachlass*, 68, compare Ashcroft, *Dürer*, vol. 1, 217.

[15] Rupprich, *Nachlass*, 217 and 223. See also Schmid, *Unternehmer*, on the comparison of the 28 per cent spent as four times as much as on the *Feast of the Rose Garlands*, 359.

[16] Rupprich, *Nachlass*, 69.

[17] 'under den verstendigen', Rupprich, *Nachlass*, 69; Aschcroft, *Dürer*, 220–1.

colours and modulated them subtly to lend fabrics, for instance, real physicality. Then, as in the final stages of any of his ambitious paintings, Dürer focused on each coloured area with complete virtuosity through his honed skills as an exceptional draughtsman. He placed highlights, and on the Heller altarpiece would surely have loved finishing the different beard styles of the Apostles, with the tiniest of brushes. Some of Dürer's brushwork used to characterize eyelashes or eyebrows is so fine that only a magnifying glass makes it visible.[18] As with the famous hare that he executed in watercolours in 1502, Dürer made such choices whenever he wanted to show other artists what could be achieved, to be copied and revered. At the time, this type of investment in a watercolour would have been seen as crazy.

[18] Burmester, Krekel, 'Dürer's Farben', 49.

CHAPTER 11

Delivering

May 1509 came and went, and no painting arrived at Heller's house in Frankfurt. In turn, the merchant wrote to Hans Imhoff. He regretted the entire commission and wanted to forget about this annoying business. Dürer could keep his painting for as long as he wished.

As Imhoff relayed the news to Dürer, the artist seems to have likewise become furious, incensed that Heller had once more tried to damage his reputation and dignity by not writing to him directly. How could he suggest cancelling the commission after all his effort, and without even seeing the painting?

In his most striking move to date, Dürer offered to call everything off. Mustering his pride, he resolved to see Imhoff in order to return the 100 florins he had received as an advance, only to find that Imhoff was wise enough not accept them without Heller's instruction. Dürer knew the customs of contract law—he understood that he was obliged to pay back *some* of Heller's investment if he did not fulfil his contract mid-way. He showed his disdain for this mean merchant by offering to return almost the entire payment.[1] Yes, he would happily keep that nearly finished painting, and sell it for more!

The relationship between the artist and the merchant was at breaking point. There is no evidence from his entire career to suggest that anything of this kind ever happened to Dürer before or after. The first week of July 1509 is likely to have been the time when he finally made up his mind never to comply with similar terms and conditions again. He hated being rushed and his patron's endless suspicion that he was taking on other major projects. 'It may be', he angrily wrote on the 10 July 1509, 'that I might have long since finished it, had I been willing to hurry it. But my thoroughness was meant to please you and win praise for myself. If it has turned out otherwise, I am sorry.'

He demanded that Heller instruct Imhoff, or anyone else, to accept the advance which he wanted to return. His letter closed by wishing the merchant 'the best of all times'. This was a gesture of a final goodbye full of subliminal anger.[2]

The timing could not have been worse. Dürer needed money. Just four days later, on the 14 July, he finally signed a contract to purchase the large house at the Tiergärtnertor he already seems to have been living in. It cost 'two hundred and seventy-five Rhenish

[1] Ashcroft, *Dürer*, vol. 1, 222.
[2] Ashcroft, *Dürer*, vol. 1, 221–2.

120 *Ulinka Rublack*

gulden in gold coin', in addition to which he had to pay an annual ground rent of 8 florins to the rich Tucher family and 'twenty-two old pounds' to a church foundation. He instantly liberated himself from this latter burden with a payment of 78 florins.[3]

Heller's response flew back, and so did Dürer's reply. Meanwhile Imhoff came to talk to the artist, telling him that he was obliged to fulfil the commission. Heller had not actually written in any legally binding way that he wanted to withdraw the commission. On the 24 July 1509, Dürer thus told the Heller that the painting would finally be packed off and offered to him, but under one condition: it would definitely cost 200 florins—70 florins more than it had been contracted for. If Heller did not intend to pay this sum after viewing it, he was to return the painting. Dürer would easily sell it for 300 florins. The painter justified his demand by constructing a narrative about how all this confusion had come about—but also confessed that he, frankly, had struggled to work out Heller's intentions regarding how significant a commission he wanted the painting to be. Still, he summed up: 'at the urging of Hans Imhoff, I acknowledge that you did commission the picture from me and that I had rather it was set up in Frankfurt than anywhere else'.

The way Dürer now saw things, he had initially planned to finish the painting in half a year, but then, in the course of the correspondence, he had felt encouraged by Heller to work at a more ambitious level, and had also wanted to serve him well. This implies that Dürer had originally budgeted for six month's work at a fee of just under 22 florins. He now estimated that he had spent twelve months to complete the altarpiece, and, as we have seen, to have used up 25 florins of ultramarine alone. As the reference to the one hundred figures in November 1508 makes clear, Dürer no doubt seems to have fully concentrated on the panel only in 1509, as the hours of daylight increased. Yet he had carried out preparations, including the masterful sketches, and creatively engaged with the commission, many months before.

Writing in July, Dürer once more wanted Imhoff to formally act as intermediary in this conflict. He asked Heller to inform Imhoff of whether or not he accepted this offer. The painting was finished; he would send it off once he heard back from Imhoff. In ending the letter, Dürer aggressively affirmed how absurd this rich merchant's behaviour seemed: 'I hope that you will not look to cause me serious loss over and above this, because that's something you need even less than I. Therewith at your disposal and command.'[4]

Dürer delivered the carefully packaged altarpiece to Hans Imhoff in late August 1509. By now, the men had arranged that Dürer would receive 100 florins on top of the initial advance straightaway. Dürer's accompanying letter was bitter and long. It restated that even at this price he was making a loss of at least 100 florins. In fact, someone had already offered 300 florins. His market price was going up and up. Georg Thurzo—a rich merchant and relative of the bishop of Breslau—had just offered him 400 florins

[3] Ashcroft, *Dürer*, vol. 1, 257–61.
[4] Ashcroft, *Dürer*, vol. 1, 223.

for a *Madonnna in a Landscape*. The bishop's patronage, in other words, was working better for him than the connection with Heller. Even so, Dürer 'had turned' Thurzo 'down flat' . Even such a large sum of money would reduce him to 'beggary'.

In other words, Heller, by implication, had made him destitute. Still, he wanted to retain his friendship and to keep 'this picture in Frankfurt rather than in any other place in Germany'. Dürer understood that Heller continued to feel unhappy about having been forced to pay 100 florins more than agreed. The artist once more tried to explain himself in the simplest terms by appealing to common fairness: 'My confidence in you makes me hope that if I promised to paint you something for 10 florins, and this then cost me 20 florins, you would not wish to see me lose by it.' Would Heller appreciate this?

If we believe Dürer, the Heller panel was indeed one of the best paintings, if not the best, he ever made. He reiterated what this meant in terms of technique, effort and time—'you can't hurry real pernickety stuff' and: 'I put all my skill into it, as you will see, and it's painted with the finest colours I was able to get. It is underpainted, over-painted, and fine-finished with good quality ultramarine, five or six times over. And even after the final coat I went over it again twice more, so that it would last a long time.'

The artist put moral pressure on his patron. In the coming year, Dürer announced that he would need to make up for his financial loss by turning out one 'ordinary picture' after another—a whole pile of them—'that nobody will believe it possible for one man to do it' and return to making engravings. 'That's the way to make money': if he had created and sold new engravings during the time he spent on Heller's altarpiece, he would have earned 1,000 florins.[5] This underlined his ability to paint good quality and 'a Dürer' at speed if he needed to, or to use the new medium of print to further his profit and behave like a merchant himself. For Heller, by contrast, he had given his time in abundance, his originality, and soul.

Dürer's letter of late August contained a series of instructions for Heller, in addition to advising him about the need to possibly revarnish the panel in a couple of years. The first protective edging supplied by a carpenter had been rough work. Hence, Dürer had commissioned a new type of temporary protective frame which cost over 6 florins, but without fitting hinges on it, as Heller had not specified a frame. 'It would be really good', Dürer continued, 'for you to have the battens screwed on so that the panel doesn't split. Let the panel hang forward by two or three little fingers so that shine (i.e. from candles, UR) does not interfere with seeing it well.... And when it is set up, make sure you are there yourself to prevent it getting damaged. Take care of it with diligence, because you will hear from your painters and others from elsewhere how it is made.'[6]

Writing in 1509, in a time full of fears about the looming apocalypse, Dürer astonishingly envisaged us today as his audience, 500 years later. 'I'm sure that you will keep it clean', he told Heller, 'so that it will stay fresh and unmarked for five-hundred years. For

[5] Ashcroft, *Dürer*, vol. 1, 225.

[6] Rupprich, *Nachlass*, 73, and in partial distinction to Ashcroft, *Dürer*, vol. 1, 225, who translates the final part, for instance, as 'how well it's been painted' when Dürer writes 'wie es gemacht'.

it is not painted as people usually paint.' Hence, he admonished, 'make sure that it will be kept clean, that it will not be touched and no holy water will be splashed on it'.[7]

Most strikingly, this deep engagement with temporality led him to experiment with varnish. His letter to Heller contained instructions for the aftercare of his panel, rather than the entire altar. If Dürer was to stay in Frankfurt during the next three years, Heller was to ensure that his panel would be especially taken down so that he himself could check whether the oil paint had dried sufficiently. He would apply a final varnish, 'with a special varnish which only I can make'. Such a treatment extended its life for a full hundred years. It was crucial that no one other than Dürer should use varnish on it, because, he wrote, 'all other varnishes are yellow and they will ruin the panel. If a thing I've spent more than a year painting were to be ruined, I myself would be upset.'[8]

This means that the artist used varnish to maximize the deep luminosity of his colours and wanted them to be preserved as purely as possible.[9] A painting, Dürer taught his patron over and over again, was not a dead thing but an organic entity, a mixture of plant, mineral, and animal parts (as gesso typically contained animal glue, and black could be made from bones) which interacted with its environment in a continual and precarious process. His techniques did everything to avoid its drying out and dullness, all of which would reduce the affective import of the scene he wanted to set before the beholder with vivacity and brilliance.

Dürer's worries about exterior damage were not unfounded. Temperatures in churches were unstable and freezing during winter months. Worms could damage wood. Clergy or visitors could be careless. For example, Hermann Weinsberg had to take back his altarpiece for repairs to Barthel Bruyn's Cologne workshop after sixteen years, noting that boys had scratched it and that it had also been damaged by bell-ringing ropes. He expected Bruyn to charge but little for these repairs, as if they were still his responsibility, as a result of which the painter kept the panel for six years, argued that the damage had been externally caused, and thought of ever new excuses for delay in taking any action.[10] Public art in churches, in short, was vulnerable to decay, so much so that Weinsberg's female relatives once told him to look after a cycle depicting the legend of St Jacob better. The women offered their help in repainting the faces and got neighbours along to finish the work within one week.[11] In a bourgeois home, too,

[7] Rupprich, *Nachlass*, 72.

[8] 'war mir selbsten laid', Rupprich, *Nachlass*, 73; for the entire passage compare Ashford, Dürer, vol. 1, 225—I understand the passage on the drying of the panel differently to him.

[9] Burmester, Krekel, 'Dürer's Farben', 49.

[10] Schmid, *Kölner Renaissancekultur*, 29–30.

[11] Schmid, *Kölner Renaissancekultur*, 45.

oil paintings and portraits in a main chamber were cleaned up as the household was prepared for feast days when everything had to look beautiful and pleasing.[12]

Dürer cleverly indicated in advance what type of professional repairs he would feel responsible for in order to avoid future conflicts and costs, but also to ensure that his work would continue to look as good as possible. The varnish mattered to him as it sealed off the work of his hand, and protected it from amateurish intervention. Good varnish also meant that the painting continued to look 'fresh', as inventories would note, and thus as contemporary, authentic, and exciting as possible. Fresh glossiness, rather than a yellowing screen which altered the colours, was a quality derived from the use of the right materials. Heller hence needed to be 'diligent' in caring for the panel, just as Dürer, as he repeatedly stressed, had been diligent, *fleissig*, in painting it. Once more, these terms indicated reliable, honest, knowledgeable craftsmanship which was attentive to material properties as they changed, in addition to which Dürer added his secret recipe for varnish to preserve the deepest and longest-lasting colours.

Was Dürer haunted by expectations of perfection—a condition that might have made him prone to melancholy? The evidence from the Heller letters affirms not only his ambition but also a firm sense of rootedness in an artisanal taxonomy of degrees of effort, skill, and value. Over time, through learning and habit, he had become confident about his handling of colour and, presumably, composition. He was able to distance himself from criticism. 'I am sure', he asserted, 'nobody will criticize it, unless to annoy me. And I firmly believe it will please you.'

This expression of confidence rhetorically also served to protect Dürer—it implied that Heller in turn would be either ignorant or indignant if he was displeased. Moreover, in providing all the instructions about how the panel was to be cared for and set up as a great artwork, Dürer made it almost impossible for the merchant and his wife to reject what they were about to receive. He had made, above all, a spiritual painting which would last, testify to his skill, and further his fame. Dürer hence closed his letter by anticipating the praise Heller would receive from local painters and those from far away. He reminded the merchant of his meanness by telling him to send Agnes a gratuity, as artists' wives customarily received for their part in managing the practical running of the studio. Dürer rudely suggested that Heller was too mean to observe etiquette and needed to be told to give her a tip. 'With that I commend myself to you. Read this for its sense not its style, for it was written in haste. Dated Nuremberg on the Sunday after St Bartholomew's Day 1509. Albrecht Dürer.'[13]

Imhoff would have taken the large panel, still smelling of fresh paint and varnish, to Frankfurt, along with his other wares, as he travelled to the fair in early September, riding on a big wooden cart, breaking the journey at inns at least twice overnight. After unloading at the Nuremberg courtyard, servants would have taken the packaging

[12] As Weinsberg notes before Easter 1583: 'Disse zeit hat man jarlichs die camer am hoff zu Weinsberch hubsch mit sinen . . . gezeirt und die olifarben tafflen uffgesclagen und die contrafits tafflin rein gemacht, das es lustich in der camer war', which implies that women were involved in such cleaning, Schmid, *Kölner Renaissancekultur*, 89.

[13] Ashcroft, *Dürer*, vol. 1, 224–6.

off the panel. It was wise of Dürer to have added a provisional frame in order to present it to its best advantage and as art. Painted planks of wood on their own were set to disappoint.

That autumn 1509 Jakob and Katharina would have seen the colours for the first time—that sea of ultramarine, and the full composition. Unexpectedly, there stood Dürer with his shop sign in Latin in the middle distance: 'Albertus Durer the German was making this in the year since the Virgin gave birth 1509', which annoyingly seemed to confirm that he had carried out most of the work in 1509, and that the panel commemorated his art rather than them.

In addition to the central panel with its focus on the fear and awe of the Apostles as they recognized Mary's coronation, Dürer's workshop delivered the inner wings with their modest depictions of Jakob and Katharina, matched by dramatic scenes of their patron saints being beheaded. The outer wings represented grisaille—'stone-coloured' paintings of Thomas Aquinas, St Christopher, St Peter and St Paul, and the Three Magi. The artist Matthias Grünewald (c.1470–1528) seems to have provided two further wings and a canopy. Hinges turned the wings of the altarpiece in such a manner that different proportions of the side panel, as well as the contrasts between the intense colours and colourless grisaille, created a highly dynamic visual field. Dürer's panel was the first ever German painting that skilfully connected a landscape with figures with a heavenly scene through the use of central perspective. The miracle of Mary's elevation into heaven, as we have seen, affirmed a new bond between a gracious God and humankind. It was a visionary scene in which passionately devoted Apostles witnessed Mary, supported by the little angels, ascending into heaven and into eternity.[14]

The way in which Dürer handled colours was fundamental to stressing this link between heaven and earth, especially through his use of blue, white, red, and orange as colours which are repeated and hence unite the figures. The composition further accented the visionary nature of this scene, distinguishing it from altarpieces that attempted to create an immediate presence. Dürer's altarpiece led into mysteries of Christianity so as to inspire more inward and sincere devotion.[15] At the same time, Dürer's self-portrait drew attention to this as an authored artwork. He wanted to be known for it. Dürer wanted people to think about his artistry, first and, second, about the Hellers as patrons who had enabled him to create his art.

[14] Decker's entire discussion convincingly focuses on a reconstruction of how the parts would have worked together, *Helleraltar*; see also the discussion in Panofsky, *Dürer*, 122–5.

[15] Decker, *Helleraltar*, 86. For a critique of Decker's arguments in relation to Grünewald and Dürer being involved at the same time from the beginning and the significance of the frame see Schmid, *Unternehmer*, 352.

Whatever Jakob and Katharina may have thought about Dürer's conceit, they kept the painting. They put up with the lack of figures, but were not minded to add to the 230 florins that Dürer had extracted from them. In the end, Imhoff returned from Frankfurt with some fabric as a gift for Agnes, and 2 florins for Dürer's younger brother Hans, who had been involved with the whole commission. Only 2 florins! Imhoff also carried a letter from Heller, in which he enquired how the panel might be embellished, presumably with a proper frame.

By 12 October, Dürer felt able to very briefly respond to a letter from Heller, writing that he was 'glad to hear' that Heller was pleased (if clearly not ecstatic) and satisfied with the price. He sent a sketch for possible embellishments, though not without reminding the merchant for a final time that the painting was a bargain and at least worth 100 florins more. He therefore expected to retain Heller's 'friendly support' in his 'part of the world', that is, the Frankfurt region. The artist ironically thanked him for 'all the honour you have done me'. He wished Heller 'happiness'. This would be the end of any correspondence the merchant kept, stowed away, and left to his inheritors.[16]

The knowledge we have of the evolution of the Heller altarpiece suggests that in Venice Dürer must have decided that the best artists, given their diligence and unique ability, should expect to live like gentlemen and make a profit. Money reflected the value assigned to artistic genius, and he had learnt in Italy that some of the best painters achieved a premium in path-breaking ways.[17] He had also acquired matching rhetorical skills crucial to effective bargaining. In deploying such strategies artists could attempt to shape new conventions about what created economic value in their society. Dürer hence argued less in terms of alleged poverty or need, and more in terms of his ingenuity and skills, to request fair compensation for the rarity of what he produced through a great investment of time, diligence, material worth, knowledge, experiment, and emotion. This is what makes his correspondence unique: Dürer had fought a historical battle to assert the value of art. Heller had proved stronger. Scarred and angry, Dürer moved on, abandoning altarpieces to create commercially viable works.

[16] Ashcroft, *Dürer*, vol. 1, 226–7.

[17] For a discussion see Margot and Rudolf Wittkower, *Born under Saturn: The Character and Conduct of Artists* (New York, 2007), 263.

CHAPTER 12

Journey to the Netherlands

On the 12 July 1520, Agnes and Albrecht Dürer packed their bags in Nuremberg and set off with their maidservant to travel to the Netherlands. Their first major stop was Bamberg, where they visited the nearby church of *Vierzehnheiligen*. A local shepherd had twice experienced visions of a child accompanied by fourteen other children, who requested a chapel to be built for them to rest and help the needy. News of the shepherd's visions spread quickly and miracles were said to have occurred. A maidservant visiting the site recovered from an illness. By 1448, a chapel had been built, to which thousands of people flocked in wonder and devotion. The site encapsulated that intensified devotional fervour that had been building up throughout Germany since the late Middle Ages, and which now fired lay people's involvement in the Reformation movements.

Agnes and Albrecht may have prayed for health and protection during their long journey. Dürer was about to turn fifty and beginning to feel his age. He still wore his hair in long curls but knew that it did not grow as much as it had; he was sanguine about the fact that his hands would lose their dexterity, and his eyesight was already failing.[1] They intended to finance the trip by selling, or exchanging, prints and paintings they carried with them, for which they would have needed to pay custom duties in all towns through which they passed on their river journey through the German lands. Bamberg's Bishop Georg, whom Dürer had portrayed not long since, invited the artist to dine with him, and issued a pass exempting the Dürers from many of these duties. And so, the couple happily boarded a boat that would take them from Bamberg to Frankfurt am Main.

A Frankfurt stopover would have presented the perfect opportunity to reconnect with Heller and his altar painting. The couple had ample time to meet Heller, as they allowed for a stay of one day and two nights. However, this is all Dürer recorded in his diary: 'Then we came to Frankfurt and there too I showed my pass and was allowed through. I spent 6 silver pence and 1 ½ hellers, and I gave the lads 2 silver pence, and overnight cost me 6 silver pence. Herr Jakob Heller sent wine to my lodgings.'[2]

[1] Ashcroft, *Dürer*, vol. 1, 536.
[2] Ashcroft, *Dürer*, vol. 1, 552.

Historians often assume that Dürer would have visited his patron, staying in the Hellers' Nuremberg courtyard complex, but this entry makes this seem less than likely.[3] Dürer loved food, and his diary would subsequently note a host of personal welcomes with wine or fine dinners. He was keen to record dinners as a mark of honour. Since the diary also recorded income and outgoings, he kept track of invitations that saved on cash expenditure. The moment he reached Antwerp, for example, the artist noted: 'I took lodgings with Jobst Planckfelt, and that same evening Bernhard Stecher, factor to the Fuggers, invited me to an excellent meal, though my wife ate at the hostelry.'[4] Nothing of that kind of hospitality, it appears, came from Heller—with or without Agnes. A gift of wine was a customary honour awarded to visitors; the merchant would have seemed extremely rude in not recognizing Dürer's stay at all. In all likelihood then the Dürers drank Heller's wine, paid for lodgings and food, boarded another boat, and moved on.

It remains hard to tell whether Dürer would have even wished to see his masterpiece from eleven years ago. Many things had come to pass in his own life since then. Just as he had hoped, his financial affairs had gone well. After his election as a member of the Great City Council in 1509, the artist had begun investing money through the city government with guaranteed interest. His presence on the Great Council made it easier for him to proclaim his new status as a learned artist and to lobby for privileges. Most importantly, within three years, Nuremberg's council agreed to legally protect Dürer's monogram 'AD' as copyright mark.

This was more relevant than ever. In 1511, Dürer published four books of new prints, the second edition of the *Apocalypse*, his *Large* and *Small Passions*, and the *Life of the Virgin*, alongside compilations of previous ones, aimed at elites as much as middling classes.[5] All of the images in them dealt with religious themes. However, Dürer did not repeat this format, which suggests that he might have miscalculated his market.[6] In addition, he worked hard on his educational works on painting for Germans, which he eventually aspired to print. His puzzling, daring, and extraordinarily skilled 'master print' engravings (*Knight, Death and Devil*, *St Jerome*, *Melencolia I*), made in 1513 and 1514, document Dürer's attempts to creatively manage the ideals and anxieties of his age. From at least 1512, he provided heraldic woodcuts for elite families to both earn money and further his international connections.[7]

Most significantly, from the same year onwards, Pirckheimer and Dürer worked for Emperor Maximilian I, a ruler obsessed with projecting the honour of the recently powerful Habsburg dynasty by visualizing genealogies, wars, and his own interest in

[3] Cornill, *Heller*, 40.
[4] Ashcroft, *Dürer*, vol. 1, 554.
[5] For an extensive discussion see Schmid, *Unternehmer*, 399–401.
[6] Schauerte, *Dürer*, 161.
[7] See the important discussion in Schmid, *Unternehmer*, 433–49.

hands-on knowledge. Maximilian I made a point of depicting himself in conversation with skilled metalworkers at court producing lighter but robust armour for him, and he championed print as a German invention full of opportunities. Dürer contributed to designs for monumental tomb sculptures of the Habsburgs, the printed *Triumphal Chariot* and *Triumphal Arch*, as well as hieroglyphic, instrument, and horoscope prints, as the Emperor was also interested in astrology and the arcane.[8]

Dürer thus by no means operated as a completely free-spirited urban artist, independent from those who held religious and political power. His social ambition entwined with political service, first in Nuremberg, and then for the Emperor. Serving Maximilian I paid off. In 1515, he granted Dürer an annual payment of 100 florins in lieu of these repeated commissions, roughly equivalent to the income of a university professor at the time. This payment was made via Nuremberg's council. In addition, Dürer's regular income from selling his art amounted to around 150 florins a year—three times more than a local master builder's salary.[9]

All the same, thinking about money could still propel Dürer into feeling bitter and unrewarded. Being self-employed kept him financially insecure. Maximilian I's death in January 1519 alarmed him. Nuremberg's council did not wish to renew its annual payment to Dürer without his successor Charles V's agreement. The immediate reason for Dürer's trip to the Netherlands was to confirm his privilege with Charles V's advisors as soon as possible. Charles V and his entourage were making their way from Spain to the Netherlands and from there to his coronation in Aachen before returning home via Antwerp. Dürer hoped to be able to socialize with the young Burgundian and to likewise gain patronage and diplomatic help via his aunt, Margaret of Austria. As regent of the Netherlands, she had assumed the role of young Charles's mother from when he was aged seven. A woman widowed from the age of twenty-three, and determined to remain unmarried, Margaret had turned her court in Mechelen into a centre of politics as much as of contemporary culture and collecting.

Dürer hoped that Margaret might buy some of his work, and, it seems, even thought about painting a new altarpiece of the Virgin Mary for her.[10] This was because, just as he approached the age of fifty and his allowance from Maximilian I had vanished, his ability to market prints in Frankfurt declined too. In February 1520, Prince Elector Albrecht of Brandenburg rescued him from 'financial difficulty'. By April that year, Cochläus told Pirckheimer that he had discussed Dürer's *St Jerome* and the *Melencolia* with the mayor of Frankfurt. They had 'much to say to one another about them'. Cochläus was astonished that Dürer's 'prints are so rarely to be found here', whereas Lucas van Leyden's prints were 'there in abundance at this year's trade-fair'.[11] Lucas van Leyden was around twenty-six and an outstanding artist burgeoning with talent and ideas.

[8] For a magnificent overview see Larry Silver, *Marketing Maximilian: The Visual Ideology of a Holy Roman Emperor* (Princeton, 2008).

[9] Schmid, *Unternehmer*, and Schauerte, *Dürer*, 180.

[10] See new research by Stijn Alsteens, 'Dürer's Virgin and Child with Saints of 1520–1: An Archducal Commission?', in S. Foister, P. v.d. Brink eds., *Dürer's Journeys: Travels of a Renaissance Artist* (New Haven, 2021), 129–45.

[11] *Pirckheimers Briefwechsel*, vol. 4, 214–15; Ashcroft, *Dürer*, vol. 1, 536, 540.

Netherlandish traders would have taken his latest prints with them to the fair. Towards the end of his trip, Dürer would meet this young Dutchman in his prime and pay dearly to obtain his work. He embodied the next generation of stellar artists, while Dürer came to reckon with his physical decline.

In 1520, moreover, the artist's thoughts turned towards finally publishing his *Instructions on Measurements* and *Four Books of Human Proportion*, on which he had worked for over ten years without any pay. Nor was it obvious that this would be a profitable venture. It was one thing for his friend Pirckheimer to prepare books for publication, and quite another for a freelance artist to pursue such demanding projects built around many woodcuts—some of them fold-outs, and thus tricky to print. To make matters worse, fears haunted Dürer every time he took up his quill to draft a preface that summed up his intentions and ambitions for the *Four Books*. He kept crossing out multiple drafts over the years. Pirckheimer kept correcting his texts as assiduously as he worked on his own. Dürer employed a ghost writer to help him find the right words, but this unleashed further unease. He deliberated over just a few pages. It was as if the attack on his poetry in 1509 had left the artist deeply insecure about disseminating his writings.

Since then, the drive towards lay learning and pedagogy in the German lands had become politically ever more charged. Martin Luther's fame and notoriety had spread from Wittenberg in 1517. The Pope declared him a heretic in 1520. That same year saw the publication of his three major treatises addressing the German nobility and wider populace. Dürer was part of a Nuremberg circle whose members discussed evangelical ideas, but his own views were in transition. The artist had been impressed by Johann Staupitz (*c*.1460–1524), Luther's own confessor, who had delivered his first sermon in Nuremberg in 1512. In Advent 1516, he tackled the subject of salvation. Dürer noted the sermon from memory, and this radical message stuck in his mind: 'Everyone into whom Christ enters is born again and lives in Christ. Therefore, all things are good things to Christ.'[12]

This was reassuring. The time was rife with astrological prophecies that the world was about to end. Luther began to publish incessantly. By 1520, Dürer owned over twenty works by this Saxon professor of divinity, who was about to face Charles V at the Diet of Worms and to fully develop his radical theology. Six early publications by Luther dealt with the subjects of God's law, sin, and penance, speaking to people's deepest fears about salvation and the pains of purgatory. Title pages on prints Dürer saw at bookstalls endlessly repeated images he knew from church: devils vigorously drove the damned to hell as they were separated from the godly at the Last Judgement. Rome capitalized on these fears by selling indulgences as prime insurance against purgatory; Dürer's patron Albrecht of Brandenburg functioned as a broker and had been elected as cardinal in 1518. Yet Luther's 1520 treatise on the 'Babylonian Captivity' argued that the Roman Church was in fact an institution from hell. The papacy was the 'Antichrist'—an

[12] Ashcroft, *Dürer*, vol. 1, 466.

ally of Satan. The only way forward was an 'evangelical' faith, centred on the belief in the biblical message of the death of Jesus Christ to save mankind.

Dürer wrote in February 1520, reading Luther, 'rescued him from deep anguish'.[13] Luther told him that belief in Christ's suffering for humans and God's grace was all he needed to believe in, but also that humans were so sinful by nature that Christ could never be born and live in them. Luther was leaving medieval mysticism and Staupitz's ideas behind. Believers remained sinners; after Adam and Eve's fall from paradise there was no way for anyone to 'make all things good things', as Staupitz held. The confident message of Dürer's self-portrait from 1500 suddenly appeared to be in question if humans remained so flawed and could never prove themselves better through good works. Dürer owned several of Luther's sermons on how to contemplate Christ's suffering and gain spiritual comfort through the words of psalms and the Lord's Prayer. Even so, paying to see a confessor to redeem sins still formed part of Albrecht's and Agnes's life in Antwerp.

Germany's Reformation movements quickly evolved into different strands of evangelical beliefs, but were united in empowering common readers. Translations, cheap broadsheets, pamphlets, and sermons printed in German changed the market for publications on religious subjects that had traditionally only been aimed at the clergy and scholars able to read Latin. The evangelical message often appeared to be that anyone reading the Bible could also trust in their interpretation of it to challenge centuries of tradition. Some of these short publications attracted readers with eye-catching woodcuts and a compilation of biblical quotations to bolster their point.[14] By 1523, cobblers keen to debate biblical passages confidently stood up in churches. As peasants and burghers across Germany began to revolt in 1525, Dürer would argue that learned people and the authorities needed to fight such disorder and take the lead.

Still, by addressing stonemasons and potters in his own writings, Dürer still followed the radical humanist goal to educate laypeople by connecting their skill with theoretical insights. Potters in fact copied many motifs from prints and paintings onto clay sculptures, pastry moulds, or oven tiles, to market them at pilgrimage sites and market stalls. He wanted them to become more bourgeois, like him, by gaining recognition and doing better financially. Equally importantly, Dürer told elites that their expertise in judging art was void unless they gained practical knowledge. Presenting his views in a clear, systematic way remained challenging. His drafts as much as the final versions of his dedicatory epistle for the 1525 treatise on measurement manifested a polyphony of voices within the artist and rooted in the turbulence of his age. His battles with these voices reflected religious, humanist, and commercial mindsets that often proved paradoxical. As the German Reformation radicalized debates, weaving these ideas together

[13] Ashcroft, *Dürer*, vol. 1, 535.

[14] On Dürer's book collection see Martin Brecht ed., Gottfried G. Knodel, *Dürers Luther-Bücher: Ein Beitrag zur Dürer-Biographie* (Gütersloh, 2012); Ashcroft, *Dürer*, vol. 1, 533–4; for examples of contemporary printing see Germanisches Nationalmuseum Nürnberg ed., *Ohn' Ablass von Rom kann man wohl selig warden: Streitschriften und Flugblätter der Frühen Reformationszeit* (Nördlingen, 1983).

132 Ulinka Rublack

was increasingly impossible. Dürer began to fear 'reproach . . . for having revealed this hidden secret art and set it before the common man'. He dedicated the *Instruction on Measurement* to Pirckheimer, whose authority he relied on to act as a protective shield.[15] [12.1]

While Dürer remained passionate about drawing, painting, and printmaking, the expansion of the Atlantic trade and Iberian conquests flooded Europe with ever more alluring rarities. These trumped everything else in wonder. In 1518, a report was made of young Nuremberg merchants having sent back home Indian rapiers, nuts, precious stones or miniature ships crafted from mother-of-pearl, exotic woods, parrots and fruits as well as fabrics from India. Dürer would have seen them decorating houses or have heard them being talked about. One merchant called Pock left Lisbon in April 1520 to travel to India and serve the German Hirschvogel and Herwart merchants as factor—selling their wares and buying Indian goods, especially spices and precious stones, for them. Pock would be the Hirschvogel's third factor in India since 1505. Dürer was more than likely to have met the previous factors when they returned home to Nuremberg, Ulrich Imhoff in 1506, and Lazarus Nürnberger in 1518.[16]

The Portuguese State of India had been founded in 1505. As a result, the Portuguese royal agents the Dürers met in Antwerp were connoisseurs of a new kind. They turned out to be among the most exciting friends they had made during this trip and were enthused by what they sourced and sold. They repeatedly treated Agnes to gifts. Merchants, as well as humanists or craftspeople, formed Dürer's milieu. Antwerp's connections with the Mediterranean trade were strong—it was the northern centre of the Atlantic trade with Africa and the Americas. Soon after his arrival in the city, a Genoese silk merchant and a Portuguese factor invited Dürer for a meal. He was served by African slaves, and he reflected on their proportions and beauty, executing charcoal drawings of a black man and woman who had been given Christian names.

This world of exotic merchant commodities drew the artist in like a vortex—they were bound up with new knowledge, colour sensations, and tastes. João Brandão, agent for the king of Portugal in Antwerp from 1514, generously sent the Dürers candy and other sweets as well as 'a lot of sugar-canes just as they were harvested' on the island of Madeira. Next, Brandão invited him to a dinner and presented the Dürers with three precious Chinese porcelain bowls.[17] Just before this dinner invitation, Dürer had travelled to Brussels with his new Genoese merchant friend, who had given him a 'hat made of plaited alder bast' as artistic rarity. Dürer would have told Brandão about the astonishing things he had seen in Brussels, which the Spanish conquistador Cortés had just sent back to Charles V 'from the new land of Gold' to justify his bloody conquest of Mexico. He felt that 'nothing' had 'ever' delighted *his* heart as

[15] Ashcroft, *Dürer*, vol. 2, 705.
[16] Christa Schaper, *Die Hirschvogel von Nürnberg und ihr Handelshaus* (Nuremberg, 1973), 226–9.
[17] Ashcroft, *Dürer*, vol. 1, 559.

Journey to the Netherlands 133

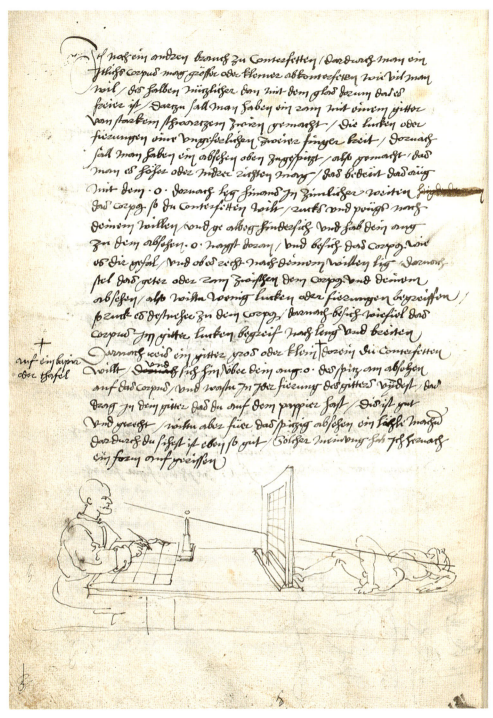

Fig. 12.1 Albrecht Dürer, Instructions on Measurement, 1525, copy with his own additions. Dürer's annotations correcting the instructions on his perspective machine—in the posthumous printed edition, the male mannequin-like figure was turned into a voluptuous, naturalistic female nude, Bavarian State Library, Sign 4° L.impr.c.n.mss.119, 17, and 200, public domain.

much the feather costumes, weapons, feather-shield and bed coverings manufactured so ingeniously by Aztecs.[18]

This was an extraordinary admission, as Dürer had long been fascinated by feathers in his painting, and he clearly had an eye for the careful work of the native Aztec feather workers. It was a specialized craft. Mexican *amantecas* knotted thousands of tiny, soft, and translucent feather tufts onto a supporting fabric to make cloaks or shields, with enormous manual dexterity and patience not dissimilar to the artist's best efforts at engraving. He valued the whole treasure at the immense sum of 100,000 florins—fifty times or more valuable than anything he had ever done. Dürer typically observed masterful art with a generous eye, and these rarities completely awed him.

They fitted into the range of new objects that Antwerp merchants made accessible to Albrecht and Agnes. Brandão's secretary Rodrigo Fernandes de Almada had already given Agnes a small green parakeet, for which she bought a cage. Upon hearing Dürer's response to native feather work, Rodrigo instantly gave him 'a number of feathers from Calicut'—a term that geographically designated anything from Asia or Africa.[19]

Albrecht, Agnes, and these merchants and state officials hence thrived on the same fascination for rarities. They collected some and consumed others, or passed them on. In spring 1521, Rodrigo thus presented the artist with 'a musk-ball, as cut out of a musk-deer, also a quarter pound of peaches, another box of quince electuary and a large box full of sugar', followed by two 'Calicut cloths, one of silk, and also an embroidered cap, a green jug with myrobalan plums, and a branch from the cedar tree'. Did the Dürers choose to trade with some of these Portuguese gifts of sweets, or give them to friends back in Nuremberg? Otherwise, Albrecht, Agnes, and their maidservant would have soon felt their teeth ache, for Brandão also sent 'two large, pure white sugar-loaves, a dish full of glazed sweets, two green pots of candied sugar', as well as four ells of black silk.[20] Further gifts included 'Indian nuts', parrots, and 'six big coconuts, a really pretty coral and two large Portuguese coins, one weighing 10 ducats'. In return for these rarities, Dürer finished a beautiful painting of St Jerome for Rodrigo in oil, measuring 60 by 48.5 centimetres. On show in Lisbon today, the panel remains a testimony to Dürer, the painter, who with all his extraordinary skill wanted to do his best for a generous merchant client.

Encountering the greatest Netherlandish artists, past and present, inspired Dürer to once again produce an outstanding painting. He met artists employed at Margaret's artistically discerning and forward-looking court. Dürer knew that she and her staff rigorously assessed artistic quality, reflected in the wording of the inventories kept in French. Their more varied vocabulary testified to a growing interest in art criticism as much as expert commercial valuation. The inventories distinguished between works

[18] Ashcroft, *Dürer*, vol. 1, 560.
[19] Ashcroft, *Dürer*, vol. 1, 559, 561.
[20] Ashcroft, *Dürer*, vol. 1, 575.

that were 'really exquisite' or just 'very good', 'very beautifully worked', and 'extremely well made' or 'well done'. 'Fort bien fait!—brilliantly done!', or 'exquis' were the reactions Dürer most likely coveted.[21] 'Exquisite' corresponded to what he himself thought of work being *künstlich*; and costly in monetary terms primarily because it was made so skillfully rather than because of the materials used.

Dürer bought three pairs of spectacles during this trip. These visual aids clearly stimulated his observation. He found a ninety-three-year-old man with an immense white beard in one of Antwerp's alleys. Was he willing to be a model? The man was in good spirit, and happy to earn a coin. Dürer executed at least four preparatory drawings. Jerome's carefully arranged beard turned into a masterpiece of meticulous detail, which Dürer evidently enjoyed executing as his trademark accomplishment. In autumn, Dürer had sourced a new type of red pigment, keeping up his interest in contemporary advances and experiments. He recorded: 'Master Dietrich, glass-painter, sent me the red colour that you find in Antwerp in the new bricks.'[22] The energy radiating from the saint's large light red coat contrasts with his wrinkled skin and heavy posture as he sits over his manuscripts and points to a large skull. This was not a remote saint in his study but a challenging religious figure with astonishing immediacy which involved onlookers in questions about the role of scripture and the centrality of Christ to their faith. Art could mediate piety, morality, and self-knowledge. To thank Dürer, Rodrigo Fernandes de Almada put no less than one ducat into Dürer's maid's hand after she brought over the panel, still sticky with fresh paint.[23] Within a matter of months, Antwerp's busy paint workshops had copied and adapted the design. [12.2]

Dürer kept adjusting to new religious ideas while fully enjoying the pleasures of life. In addition to the Portuguese in Antwerp, there were local officials, Fugger factors and Nuremberg merchants whom Dürer knew well, who were also turning into collectors of small-scale exotic items so abundantly traded in Antwerp. 'I ate with Treasurer Lorenz Sterk', Dürer for instance noted in spring 1521, 'who gave me an ivory whistle and a beautiful piece of porcelain, and I responded with a complete set of prints.'[24] Before leaving, Dürer set off to buy gifts for his Nuremberg friends—his purchases included ten big pine cones filled with kernels, gloves, fabrics, and for Pirckheimer 'a large cap, an expensive buffalo-horn writing-set, a silver emperor, a pound of pistachios, and three sugar cones'. He bought for himself camlet cloth, a tortoise, and met with a friend who gave him an Indian bag made out of fish skin and 'two Indian fencers' gloves'.[25]

The stay in Antwerp and journey to the Netherlands heralds Dürer's move into the new age of collections as cabinets of curiosities, powered by merchants involved in the Atlantic trade. They fed new intellectual tastes and were thus integral to Dürer's artistic milieu. While Dürer and many of his friends were urban collectors of these curiosities,

[21] Eichberger, *Handeln*, 363–4.

[22] Ashcroft, *Dürer*, vol. 1, 562.

[23] Ashcroft, *Dürer*, vol. 1, 576; see also Astrid Harth, Maximiliaan P.J. Martens, 'Albrecht Dürer's Iconic Image of Saint Jerome; Making, Meaning and Reception', in Foister, Brink eds., *Dürer's Journeys*, 253–65.

[24] Ashcroft, *Dürer*, vol. 1, 575.

[25] Ashcroft, *Dürer*, vol. 1, 576. The word used for bag might instead indicate a shield.

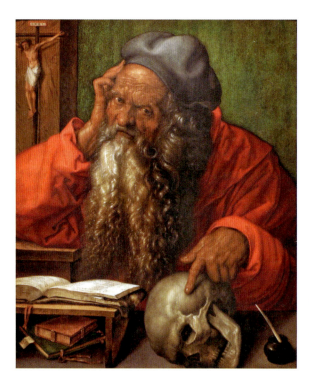

Fig. 12.2 Albrecht Dürer, St Jerome in His Study, oil on panel, 1521, 60 cm × 48 cm, Museum Nacional de Arte Antiga, Lisbon, CC-BY 3.0 Foto: Sailko.

the flourishing of this new type of collection was linked not only to contacts with merchants but also to the political power of Iberian Empires.

Margaret of Austria stood at the intersection of this world. Born in 1480 as a daughter of Emperor Maximilian and Mary of Burgundy, she was a confident forty-year-old by the time Dürer visited her, whose court pioneered in showcasing national styles of craftsmanship in the age of Habsburg expansion. Her assembly of around 132 natural and man-made rarities was made to participate in the diversity of the world rather than to systematically study it. Her library in Mechelen exhibited over seventy objects from the Americas and constituted one of the largest and earliest collections created for display. Among them was a Mexican feather cloak with 367 gold coins, which were significantly not melted down for their bullion value.[26] Her inventory shows that six further Mexican feather cloaks were closely examined and assessed for their craftsmanship, as one of the borders was described as 'very well made'.[27] Margaret's inventory catalogues rugs, tableware, or precious furniture as 'à la mode d'Espaigne',

[26] Dagmar Eichberger, *Leben mit Kunst, Wirken durch Kunst: Sammelwesen und Hofkunst unter Margarete von Österreich, Regentin der Niederlande* (Turnhout, 2002), 430, 418, 180, 362. On women as Habsburg collectors see Sabine Haag, Dagmar Eichberger, Annemarie Jordan Gschwend eds., *Frauen, Kunst und Macht: Drei Frauen aus dem Hause Habsburg* (Innsbruck 2018); see also idem., 'Art and Entrepreneurship: Dürer's Encounters with Margaret of Austria and His Network at the Imperial Court', in Foister, Brink eds., *Dürer's Journey's*: Travels of a Renaissance Artist (London, 2021), 119–27.

[27] Eichberger, *Leben mit Kunst*, 181.

Journey to the Netherlands 137

'Turquie', 'd'Italie', just as the Mexican works were classified as 'à la mode du païs'. Margaret's interest in these objects hence 'clearly exceeded dynastic and material interests' and pointed to 'a growing awareness of foreign cultures and their artistic achievement' gained from imperial politics to stimulate Habsburg traditions in turn. Her paintings likewise showcased different styles and types of technical mastery.[28] She was among the first collectors to exhibit undecorated exotic shells alongside an immense variety of red and white coral in her garden room. She displayed a dead bird of paradise, and the 'very large tooth of a wild boar of the sea'. These rare 'natural' artefacts were shown alongside man-made things without creating any hierarchical distinction.[29]

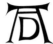

Dürer wished to serve Margaret. When he went to her court he presented her with a complete set of his prints and executed two paintings on parchment depicting her father Maximilian with 'utmost care'; but she 'disliked' his 'Emperor so much' that he took it away again.[30] He estimated having given her work worth 30 gulden. The artist's financial summary would be bitter: he had lost out during his trip to the Netherlands, and 'quite especially with Lady Margareta for in return for what I presented to her and made for her has given me nothing'.[31]

This negative account in terms of finance, of course, partly resulted from his own love of non-necessities that he thought fitting for his needs. Dürer's circumstances had changed from the period when he had worked for Heller and received larger payments for major, time-consuming commissions after some time and in instalments. In fact, Dürer's diary is an astonishing record that reveals the importance of small-scale quotidian trading for artists, much of which still happened in kind. Affordable, movable art immersed Dürer in the fluidity and excitement of a marketplace full of fleeting opportunities, which he recorded in great detail. He could decide whom to charge with relatively standardized prices for his prints, quick portraits drawn in charcoal, and small canvases with religious themes. This generated the cash flow that allowed him to make choices about which goods or utilities to acquire and what to sell off quickly in order to keep afloat. As small coinage easily lost value, quickly executed works of art and reproductions offered enormous flexibility for Dürer to immerse himself in relationships and commercial transactions. The artist was able to satisfy his pleasure, say, in a pair of gloves, or even two pairs of them, either to keep or to gift to others. He bought braided shoelaces, costly meerkats, a little tortoise, expensive elk horns to grind down as medicine, lots of gloves, fabric, purses, fish skins—hundreds of things within just a few months.

[28] Eichberger, *Leben mit Kunst*, 353–4, 421.
[29] Eichberger, *Leben*, 400–3, 422–3, 425–6.
[30] Ashcroft, *Dürer*, vol. 1, 584.
[31] Ashcroft, *Dürer*, vol. 1, 563, 586.

138 *Ulinka Rublack*

Consider just one small passage from his diary and account book, which captures some of these transactions covering just four days in Antwerp, Trinity Sunday to Corpus Christi, from 26 to 30 May 1521:

> Master Konrad has given me fine razors for shaving, so in return I gave this little old man a Life of the Virgin. I made a charcoal drawing of Jan, the goldsmith from Brussels, and one of his wife. Sold prints for two gulden. Note: Master Jan the goldsmith gave me 2 Philip gulden for doing the design for his seal and two portraits. I have given Jan the goldsmith the Veronica I painted in oils and the Adam and Eve which Franz did, in return for a jacinth and an agate with a Lucretia engraved in it. Each of us estimated his part of the bargain at 14 gulden.

The list of transactions went on:

> In addition, I traded a complete set of prints for a ring and six small jewels. Each valued his contribution at 7 gulden. Paid 14 stuivers for two pairs of gloves. Paid 2 stuivers for two small boxes. Cashed 2 Philip gulden. I sketched three times Christ led away to Cavalry and twice the Mount of Olives using five half sheets. I sketched three heads in black and white on grey paper. For the Englishman I did his coat of arms in colour and he paid me 1 gulden. As well I have at various times done many designs and other such things to oblige people here, and for most of my work I have had no payment. Andreas of Cracow gave me 1 Philip gulden for a shield and children's heads. Exchanged 1 gulden for cash. Paid 2 stuivers for brooms.[32]

Brooms? Agnes was equipping a makeshift household for herself and the maid: the purchase of brooms was followed by a washtub, bellows, wood for cooking, and a washing-up bowl. The brooms cost half as much as one of Dürer's *Adam and Eve* engravings. During the entire trip, he only sold or exchanged five of these. A monk charged the equivalent of two Adam and Eve prints just for listening to Agnes's confession. Selling prints to earn hard coins of durable metal contents was far from easy. A local art dealer paid 4 florins for *sixteen* of Dürer's small Passion series—each of which was a bound volume of thirty-seven images.

Dürer needed 11 *florins each month* to pay his rent. At least his landlord bought an oil painting of Mary for 2 florins. With exchanges in kind, Dürer at best struck a fair bargain; at worst, he gained nothing, or stuff that needed to be traded straight on by Agnes. Once he received 100 oysters—what was he to do with them? How could the couple ensure that they only received things they actually needed?

As business was only partly monetized, Dürer designed, drew, and painted pretty much non-stop to make money and trade in kind, and to network. Gambling earned and lost him money. He enjoyed a drink and getting to know international elites gathered in the city. He noted 160 shared meals in his diary, and consistently received more gifts from local elites than he gave in return.[33] Never blasé, Germany's Apelles was

[32] Ashcroft, *Dürer*, vol. 2, 583.

[33] Dagmar Hirschfelder, 'Bildniszeichnungen als Tauschobjekte und Freundschaftsgaben: Dürers Strategien der Beziehungspflege in den Niederlanden', *Wallraf-Richartz-Jahrbuch* 74 (2013), 107–36, 38.

ready to serve those wanting a coat of arms, or a seal, a quick portrait, measurements for dress, or even a house designed by him. Despite the recognition he had won from so many for his best art, Dürer was clearly in the habit of making himself useful in all directions. A sociable man, he became acquainted with gunsmiths and glassworkers, goldsmiths and fellow engravers. While in the Netherlands, such restless small-scale activities earned him at least an additional 260 florins. He recorded selling 120 portraits in the diary—in reality there must have been even more. Portraits and religious prints sold best. The Danish king wanted to briefly sit for a portrait—Dürer drew a sketch and worked it up into an oil painting for which he earned 30 florins. He traded his art in kind whenever possible, adjusting its value accordingly. Even so, just before leaving, Dürer needed to request a loan of 100 golden florins from one of the Imhoff merchants.[34]

Dürer's diary ended recording his arrival with Agnes in Cologne, in July 1521. He seems to have planned one more complex composition depicting the *Enthroned Virgin and Child with Saints and Angels* in 1521—most likely an altarpiece he proposed to Margaret of Austria, but chose to never execute. Andreas Karlstadt (1486–1541), Luther's senior colleague at Wittenberg's divinity faculty, sent him a pamphlet warning that evangelicals could fiercely contest any religious art. Karlstadt thought paintings and sculptures fostered idolatry, and detracted from the biblical message of salvation. Luther's theology minimized the role of Mary. The Bible did not praise her as queen of heaven or as a divine female figure. As far as Luther was concerned, she was not to be prayed to at all.

At home, Dürer unpacked all his curiosities and arranged them in a new type of collection, the sort that from now on would exercise immense fascination for European lovers of art.[35] As the weather turned cold in Nuremberg, he would have worn an exquisite new coat made in Antwerp. Its soft camlet fabric had cost him 14½ gulden, and thirty-four pieces of black Spanish fur 10 gulden. It boasted decorative velvet trimmings and silk lace stitched with silk thread, so that the making costs for the furrier and tailor added more than another gulden. Probably the last Dürer ever bought, this coat was bound to make an impression.

In fact, spending on a coat of exquisite international craftsmanship might have been a habit of his to mark the transition back to Nuremberg from a place where his work and luxury goods were highly esteemed. He had probably done so before on leaving Venice—he might have depicted himself wearing it on Heller's altar. The quest for coats ran alongside his quest for recognition, distinguishing the tone of Dürer's diary from similar works.[36] Putting on a fine coat supported Dürer's mental stability as he faced his return. It turned him into the cosmopolitan gentlemen he so wanted to be as a son of Nuremberg, and the German Apelles.

[34] Gerd Unverfehrt, *Da sah ich viel köstliche Dinge: Albrecht Dürers Reise in die Niederlande* (Göttingen, 2007), 217–20; Chipps Smith, *Dürer*, 293–5; Schmid, *Dürer als Unternehmer*, 474–80.

[35] Jeffrey Chipps-Smith, 'Albrecht Dürer as Collector', *Renaissance Quarterly*, 64 (1) (2011), 1–49, here 37.

[36] See the analysis in Sahm, *Dürers kleinere Texte*, 182–4.

CHAPTER 13

Becoming Lutheran

Jakob Heller did not survive that winter. He died on the 28 January 1522, leaving an estate worth 20,000 florins and no dependants. As a court scribe and witnesses worked their way through an empty, cold, and dark wintery home to take the inventory, they found 365 gold florins, a thick red purse and a yellow purse full of coins. There were endless amounts of rings, jewellery, and devotional objects, such as coral paternosters, many of which would have belonged to Katharina.[1] To whom was all their wealth to go? Their families had fought this out well in advance. Just one year earlier, the new prior of the Dominican monastery had helped to mediate between them. Katharina had left 3,000 florins to Jakob, while 5,611 florins of her original wealth were to go to her brother and sister in order to remain in the hands of the Melem family. Once Heller had died, his heirs were therefore to return the jewellery, vineyards, and houses in Frankfurt that Katharina had owned. They were also to pay interest on further income from renting lodgings in the Nuremberg court, and make a series of additional large cash payments.[2]

The Melems clearly saw no reason why Jakob's family should further profit from her wealth. Katharina not only limited what was passed on to Jakob in her will. She also must have had her say on the final frame for their altarpiece. It was decorated with four coats of arms—Jakob's and her own as well as those of their mothers, Katharina Blum and Margaretha Dorfelder.[3] The altarpiece hence honoured and commemorated mothers as life-giving. Katharina's infertility had ended this maternal genealogy, and yet she would have put all her trust in Mary's pleading with God to recognize this as a sufficient punishment for any sins.

Heller had spent his final years battling illness—in March 1518, he sent Pirckheimer a letter because that they had not heard from each other for a long time. He seemed bored, noting at the outset that 'he had nothing much to report' and felt compelled to complain of his ailments all the time, though he hoped his health would improve during the summer. The merchant next asked Pirckheimer for some informal information about how Nuremberg creditors dealt with insolvent debtors in Erfurt, whom he had

[1] Bothe, *Testament*, 399–401.
[2] Stadtarchiv Frankfurt, Vergleich 10.6.1521.
[3] Cornill, *Jacob Heller*, 173.

likewise lent money.[4] Pirckheimer replied and sent a recipe, for which Heller thanked him in April. This was the moment when he crudely joked that his illness probably resulted not just from being aged sixty but also from having had too much sex. Might this, he asked, likewise explain Pirckheimer's ailments?

Pirckheimer's love life, however, had settled down with age and chronic gout. Behaim now simply sent greetings to Pirckheimer's housekeeper and to Dürer in his letters. Gone were the times when sexual allusions or jokes helped men to establish intimacy with him. Heller just hadn't understood this. [13.1]

As ever, Pirckheimer was busy with ambitious scholarly projects. He prepared a Greek and Latin edition of Ptolemy's *Geography* that would reflect his views on the expansion of geographical knowledge since antiquity. Pirckheimer was furthermore involved in battles to defend the importance of Hebrew scholarship against antisemitic Dominicans. Pirckheimer thus used the contact with Heller to enquire whether the Dominicans had published any attack against him at the latest fair. Heller's life and memory revolved around Frankfurt's fairs: 'There has been more folk at this mass than in 3 or 4 fairs', he reported in 1518, adding that nature had appeared 'greener' than during the past seven spring fairs. Yet he would not have picked up on Latin debates and offered no information.[5]

By May 1518, Heller had told Pirckheimer in coded words about his illegitimate son, and had asked whether Pirckheimer and his circle knew anything about the Emperor's negotiation with Franz von Sickingen (1481–1523). Von Sickingen, the robber knight, was turning into an explosive character in German politics. He mobilized knights to side with the common people to challenge the growing importance of the state and cities governed by wealthy merchant elites. The knight provided an evangelical message of his own to fight in a new age of commerce and state-building. In von Sickingen's view, monopolistic merchants and merchant companies were already part of a huge network 'in which are caught coins and letters of credit, spices, mining operations in silver, gold, tin, lead, brass, copper, and whatever can be made by compounding the four elements.' He lamented: 'The ordinary man never sees a penny of the enormous profits'. Should common men not be free to engage in trade as they wished? In that case, we 'might not then have', Sickingen chided, 'quite so large an import trade in pomegranates, lemons, capers, olives, silk, velvet and camel-hair cloth (for the purchase of which our own hard-earned money and goods have been flowing out of our country, leaving us destitute), but we would manage to live just the same, eating our own native products'.

Merchants controlled princes, as their loans financed wars and courtly luxury. In short, a new society was needed, built on justice, godliness, and a return to German sustainable, upright simplicity rather than new-fangled tastes for Indian spices and foreign clothes of the kind Dürer loved.

[4] *Pirckheimers Briefwechsel*, vol. 4, 518–19.
[5] *Pirckheimers Briefwechsel*, vol. 3, 309–10.

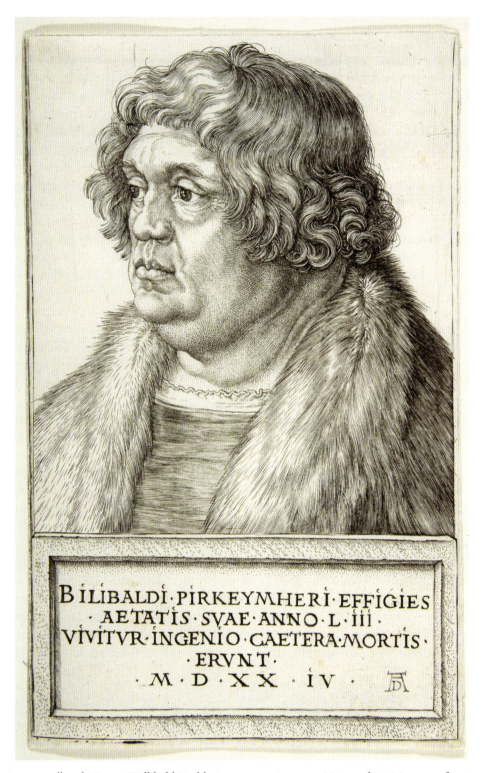

Fig. 13.1 Albrecht Dürer, Willibald Pirckheimer, engraving, 1524. Metropolitan Museum of Art, New York, public domain. Dürer completed this engraving of his exact contemporary Willibald Pirckheimer aged 53 in 1524—the year in which Nuremberg supported the Lutheran Reformation and the friends divided in their views. The engraving radically rejects the role of art to provide idealized portraits.

144 Ulinka Rublack

Dürer's consumption of oysters, sugar, and parmesan cheese in Antwerp, and his camel-hair coat worn to impress fellow councillors back home, placed him on the far side of this militant evangelical strand.[6] The Reformation movements were fast turning into a crucible melding traditionalist and radical ideas in a call for a reform of religion, society, the economy, and politics. Luther and others repeatedly attacked Jacob Fugger (1459–1525), the notoriously profit-seeking merchant of Augsburg whose family had made its wealth in textiles. As we have seen, Dürer socialized with his Antwerp factors, and had portrayed Fugger in 1518. Reform writers now rekindled views that merchandise was 'unclean' because it led to luxury, greed, and deception by driving up prices and increasing social inequality. Poor people suffered. It was 'a grave danger for one's soul', Johann Agricola (1494–1566) would write, 'to be a merchant or shopkeeper', unless commerce was kept within reasonable profit margins.[7]

Heller clearly turned nervous about revolts against merchants, and his own life was changing. He had withdrawn from active politics by absenting himself from council sessions in early 1518; Katharina was buried in the Dominican church in August that year. An ageing widower, he felt more isolated. In November, he complained again that he had not heard back from Pirckheimer for a long time and their old friendship seemed to have completely cooled off. He repeated his concerns about the greater militancy of robber knights and their followers, and now told Pirckheimer about his dreams of his Cologne lover Virgin Deyltey after taking the pine nuts.[8]

Heller never asked, spoke about, or greeted Dürer. Nor, as I have argued, is it likely that he wished to see the artist in person, and whom he would in any case have to face every single time he looked at the altar painting. He remained hospitable to those he liked or needed. In February 1520, Cochläus reported that Heller had invited him for a meal. Having returned from tutoring Pirckheimer's nephews in Italy, the Nuremberg humanist had just settled in Frankfurt as deacon of the *Liebfrauen* convent with his mother, who managed his household.[9] Frankfurt lacked highly educated humanist circles, but men like Heller tried to follow some of their current discussions.

It is easy to guess what subjects the two men might have talked about when they met during the coming months. By 1519, Heller's former colleagues Claus Stalburg and Hamman von Holzhausen had used their influence in the city council to support the foundation of Frankfurt's first Latin school for patrician sons. Its director, appointed in autumn 1520, was a Lutheran who supported the Reformation movement through public lectures. Just like Erasmus, doyen of humanists, Cochläus would soon attack

[6] 'A Dialogue Spoken by Franz von Sickingen at the Gates of Heaven with St Peter and the Knight Saint George (1523)', in Gerald Strauss transl. and ed., *Manifestations of Discontent in Germany on the Eve of the Reformation* (Bloomington, 1971), 177–9. See also Christine R. Johnson, *The German Discovery of the World: Renaissance Encounters with the Strange and Marvellous* (Charlottesville, 2008); Alix Cooper, *Inventing the Indigenous: Local Knowledge and Natural History in Early Modern* Europe (Cambridge, 2007); Peter Hess, *Resisting Pluralization and Globalization in German Culture, 1490–1540: Visions of a Nation in Decline* (Berlin, 2020).

[7] Strauss ed., *Manifestations*, 'From Johann Agricola's Commentaries on German Proverbs in 1528', 119.

[8] *Pirckheimers Briefwechsel*, vol. 3, 428–9.

[9] *Pirckheimers Briefwechsel*, vol. 4, 180, 192.

Luther's theology in order to try and limit its impact. He already knew that Ulrich von Hutten (1488–1523) was about to publish several explosive dialogues at the spring fair criticizing the papacy and Dominican attempts to confiscate Hebrew books and scholarship. A 1521 treatise by von Hutten presented a compilation of his inflammatory pamphlets and a frontispiece designed by the artist Baldung Grien. It presents soldiers as agents of God's anger to fight in the name of Luther and Hutten against the corrupt Catholic church. Von Hutten's agitation for Luther merged with nationalist fervour to endorse German liberty and values of honesty and simplicity. This impressed some of Frankfurt's leading patricians. Frankfurt belonged to the many German cities in which a local bishop claimed political power and privileges, ensuring that the urban Reformation would become a vehicle to strengthen the council's oligarchy.[10]

It was a time of unprecedented transition, in which many German secular rulers and aristocrats likewise put together grievances for Charles V as new Emperor to consider. Bishops behaved like secular lords, they claimed, while Rome often awarded such lucrative German benefices to unworthy persons, to 'gunners, falconers, bakers, donkey drivers, stable grooms', who did not know a word of German. The reference to such male employees implied that homosexuality ruled the Vatican and led to absurd rewards. Furthermore, the grievances echoed complaints against the sale of indulgences, charges for pilgrimages, weekly tributes levied on artisans, and many other ways in which Roman greed burdened common folk through threats of the horrors of purgatory.[11] The first political summit Charles V attended in the German lands after his coronation began in January 1521, in Worms. By then, the 'Luther affair' in the German lands was spiralling out of control. Hostility to Jews as alleged usurers, who extracted money from the poor, was rife and further fuelled the reform movement. Worms had a distinguished Jewish community, and Frankfurt counted 250 Jewish inhabitants in 1520, forced to settle in tightly crammed houses just behind the Dominican monastery. [13.2]

On 14 April 1521, Luther stopped in Frankfurt for one night on his way to Worms. He deeply impressed leading patricians sympathetic to him, including Hamman von Holzhausen, and he visited Wilhelm Nesen and his Latin school—Frankfurt's first independent school not overseen by the clergy. Nesen was to turn into a fervent Lutheran and leave to study in Wittenberg in 1523. Until then, he tried enthusing patrician sons and their parents. Holzhausen and Stalburg supported Frankfurt's first evangelical preachers in March 1522. This was despite the fear that Charles V as Catholic Emperor in return might withdraw the city's privilege to hold its fairs, or even its status as an imperial city. Heller's funeral in the Dominican church took place just weeks before Nesen's appointment, on the 27 January 1522.[12] The merchant left the Dominicans 400 florins in addition to the 830 florins he had given them earlier, which the monastery

[10] Sigrid Jahns, *Frankfurt, Reformation und Schmalkaldischer Bund: Die Reformations-, Reich- und Bündnispolitik der Reichsstadt Frankfurt am Main 1525–1536* (Frankfurt, 1976), 32.

[11] Strauss, *Discontents*, 52–63, here 54.

[12] *Frankfurter Stadtoberhäupter*, 94–5.

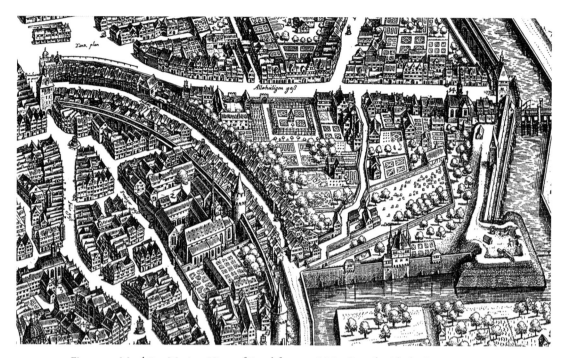

Fig. 13.2 Matthäus Merian, View of Frankfurt am Main, Detail with the Dominican monastery and the Jewish ghetto. Frankfurt Historisches Museum © Historisches Museum Frankfurt, Fotograf: Horst Ziegenfusz. This map shows Frankfurt's Dominican monastery, church and cloisters, and next to it just behind the city walls, the curved Judengasse.

had invested in turn. In April 1523, the monastery confirmed its duties in caring for the souls of Jakob, Katharina, and their parents.[13]

Just at this time, Frankfurt's reformation movement broadened out from patricians to the wider populace. Suburbs began to refuse paying the tithe and demanded preachers who could read and interpret the biblical message. From 1523, in Frankfurt itself, Catholic preachers and a new evangelical preacher used their respective sermons to attack each other's theologies. The council remained divided and worried about how to preserve public order and recognize the Emperor's order of July 1524 to strictly obey the edict of Worms. Charles V insisted that Lutheran writings, for instance, were not to be sold. Yet evangelical works fuelled the book trade at the Frankfurt fair. By the end of 1524, Frankfurt's council was so worried about revolts that it told the principal evangelical preacher to stop giving services.

This exacerbated resentment.[14] Across many parts of the German lands, peasants and burghers were beginning to rise in one of the greatest popular revolts in European history: the German Peasants' War. They attacked the economic power and privileges of monastic houses such as that of the Frankfurt Dominicans because they lived off

[13] Stadtarchiv Frankfurt, Rep. 529, 4.4.1524.
[14] Jahns, *Frankfurt*, 33–9.

investing bequests in land and thus determined the agrarian economy, while paying few or no communal taxes. The Reformation's empowerment of lay people, and opposition to the Catholic church, furthered movements towards the wider political participation of citizens. Protest spread like wildfire. Frankfurt's guilds organized themselves so well that their forty-six articles of complaints, presented in April 1525, were printed immediately to diffuse the urban revolt south and as far north as Münster. 'God the Almighty', guildsmen claimed, had sent the 'spirit of truth' into the 'hearts of many'. It was time to obey God above all and stop coercive practices. They wanted skilled and upright people as town councillors rather than those from old families and the newly wealthy. Concubines and whores were to be driven out.

Had he still been alive, Heller would have particularly stumbled over article 14: legacies and alms endowments were to be paid into a 'common chest which has been ordained for the honour of God in order to feed the poor'. Masses to commemorate the dead were to be abolished.[15] Everything about Heller's bequests—even his winter shelter for the poor—suddenly appeared ill conceived and unpleasing to God. On Easter Monday 1525, evangelical radicals started attacking Frankfurt's convents.

Back in Nuremberg, two craftsmen were publicly executed in July 1524 simply because they had criticized the town's increased taxation of wine in a year of acute price rises, and done so in drastic language threatening to stir uproar and rebellion against the wealthy, to whom Dürer now firmly belonged. Nuremberg's hangman beheaded both men to deter anyone else from opposing the council. The council claimed that it alone stood for order, wisdom, and safety. Reform ideas voiced by peasants and artisans principally criticized payments and dues, and the privileges of clergy who were exempt from them. The council dismissed these voices as *ungeschickt*—the same word as untalented, to suggest that these people were uneducated and uncouth. This loaded any discussions with anxiety about the total overturn and collapse of society.

Still, by May 1525, the council had agreed to substantial concessions in relation to the demands raised by those living in its large territory. It increased social equality. This was now the only way to avert an attack on Nuremberg by the armies of peasants that had gained great strength in the Franconian region.[16] Despite this clever settlement, Dürer so feared that such a rebellion might trigger the Apocalypse that on the morning of 8 June 1525 he woke up with a terrible nightmare. Torrential storms and flooding rain lashed him. He trembled all over. It is not surprising that during the same year, Dürer published his *Instructions on Measurement* criticizing radical iconoclasts: For 'any Christian', he wrote, 'it is as likely to be drawn into superstition by a painting or sculpture

[15] Tom Scott, Bob Scribner eds., *The German Peasant's War. A History in Documents* (New Jersey, 1991), 172–3.
[16] Günter Vogler, *Nürnberg 1524/5* (Berlin, 1982), 110–17, 131–233.

as a decent man into murder simply because he carries a weapon at his side. That must truly be an ignorant man who would pray to painting, wood or stone. Indeed, a painting promotes betterment rather than injury if it is fashioned well, honestly, and with art.'[17]

Dürer yet again dedicated the treatise to Pirckheimer as a 'lover of all arts' who had inspired 'pruning' uneducated people, just as if they were wild trees. Learned men needed to provide directions to improve society. Pirckheimer had come to firmly oppose the radicalism of the Reformation movements and Luther's theology. Dürer echoed the foundational evangelical contention that we 'must be obedient to God rather than to men' that also opened the Frankfurt articles.

Just as in his art, he ever more strongly believed in the importance of conceptual order and expert guidance. Insight grew from a tutored mind. This allowed visualizing religious truths as much as it prevented worshipping an object in cultic ways. Yet Dürer did not spell out with any clarity as to why religious images were needed and what they were meant to do in this brand-new world of Lutheran beliefs and practices, to which Nuremberg committed itself in a series of steps, and the first among the major German cities to do so, from March 1525. He translated humanist sarcasm into a visual pun in order to ridicule the rebellious peasants who claimed victimhood after their military defeat against Charles V's troops, when 10,000 of them had perished. Just like Luther and his fellow councillors, Dürer supported basic civic values and obedience to secular authorities, including the Nuremberg magistrates' expulsion of three young artists with radical religious ideas in that decisive year of 1525. Spiritualists, based on a mixture of reading the Bible and experiencing such visions, disturbed the civil peace of Nuremberg by claiming that God had given complete authority to their ideas.

Dürer, as we have seen, had once been inspired by Staupitz's mystical and hermetic thinking. The *Discourse on Aesthetics* accompanying his *Four Books on Human Proportion* (1528) suggests that a godly artist revealed 'the form of a thing' as a 'new creature' formed in 'his heart' after years of copying. A secret treasure eventually yielded fruit. Just how this transition happened remained a mystifying process. Yet the difference between Dürer's thought and that of the religious spiritualists lay in his argument that sense perception could not be trusted. Years of copying and studying prepared for a transformation into that new creature. Dürer hence must have regarded his own practice of endlessly estimating the right proportions for different body types as part of a religious practice: God's measurements could be trusted, and the artist never measured actual nude models. He calculated from experience what proportions would seem to be correct.[18] He prized humility, learning, and technique in an age filled with instantly confident prophets: 'your ability', he told them, 'is impotent compared with God's creativity'.[19]

[17] Ashcroft, *Dürer*, vol. 2, 767, 777.

[18] Berthold Hinz, *Albrecht Dürer—Supplement zur 'Menschlichen Proportion'. Die Dresdner Handschrift (1523): Mit einem Katalog der Handzeichnungen, herausgegeben, kommentiert und in heutiges Deutsch übertragen* (Berlin, 2016).

[19] Ashcroft, *Dürer*, vol. 2, 879; Panofsky's discussion of the theoretical writings in his *Dürer*, 242–84, remains foundational.

Manifestos calling for an equal society based on common property and brotherly love as a form of social bond would have truly alarmed Dürer. Agnes had inherited a considerable amount of money after her father had died two years earlier, including two silver goblets valued at over 100 florins each. She had also kept her father's shares in metal mines. Dürer profitably invested 1,000 florins in 1524. As he turned 55, following the turbulence of the Peasant Wars, the couple might have finally felt financially secure. In 1528, he would leave an inheritance of nearly 7,000 florins, which placed him among Nuremberg's one hundred richest citizens.[20]

Even so, the uncertainties of the time were hard to take. Becoming a Lutheran would have alienated Dürer from much of a lifetime's work. As he kept trying out new eyeglasses to combat the onslaught of old age, Dürer started redoing designs, rather than reprinting previous work, and created astonishingly intimate, immediate, and unidealized portraits of those he cared about, Pirckheimer among them.

In 1526, Dürer presented Nuremberg's council with his final oil paintings on a religious subject, to display in the town hall where they would be safer than in any church and serve as a 'memorial to him', as he frankly wrote. This was now his legacy. Monumental in size, these panels depicted John the Evangelist, Mark, Peter, and Paul in a flat style to warn against sectarians. Biblical quotations below the images explained this, pioneering a new Lutheran conception of art. Dürer made himself useful as a painter in new times. He politically endorsed the magistrate's message against sectarians, visually imprinting it on people's hearts and minds. As *Genannter* and member of the Great Council, he would have been present at the assembly that decided to introduce Lutheranism in Nuremberg; he followed this directive even though he realized its potential threat to the arts.[21]

Dürer knew that the council in turn would play by the rules: they judged his gift as 'skilfully painted' and renumerated him with 100 florins, a particularly generous honorarium of 12 florins for Agnes and a tip for the servant.[22] This not only was a pleasing outcome but also documents that the market for religious subjects must have been at a low point and that the value of the artist's painting had not significantly risen in twenty years. In 1527, Dürer tried further to prove the usefulness of his art by dedicating a treatise on fortification to Ferdinand of Austria, Charles V's brother, who ennobled men for outstanding service to the Habsburgs in the German lands. It would not have been unusual for a man such as Dürer to harbour the hope that he might be ennobled.

[20] Ashcroft, *Dürer*, vol. 2, 718–19; Schmid, *Dürer als Unternehmer*, on his strategy to secure a financial investment via Nuremberg's council in 1524, 492–9.

[21] Karl Arndt, Bernd Moeller, *Albrecht Dürers 'Vier Apostel': Eine kirchen- und kunsthistorische Untersuchung* (Heidelberg, 2003).

[22] Ashcroft, *Dürer*, vol. 2, 816–29.

By 1523, he had cut his own coat of arms and used it on some of his work. He had even trimmed his hair to one third of its former length and stopped having it curled, as the modern Habsburg look favoured straight short haircuts for men. A final portrait of Dürer suggests that he might even have allowed himself to go grey. [13.3]

While Dürer worked through new constellations of patronage, strained relationships, and became involved in divisive debates in Nuremberg right up to his death in 1528, the speed of change in Frankfurt slowed down. Support from rulers and the Bishop of Mainz helped the council to reassert its oligarchical power. However, Frankfurt's council also agreed to employ two evangelical preachers. Both were influenced by the Swiss Reformation, which mandated against any use of images for worship.

Despite this, Frankfurt's religious paintings and statues remained in place until divergent views clashed during Christmas 1532. Iconoclastic attacks followed, in the course of which rebels used holy oils as shoe polish, removed church paintings, and profaned the high altar by seating children and women on it. If the council would not abolish Catholic masses in the city, then women and children would do so.[23] This was meant to horrify patricians by suggesting that ignorant folk might take control.

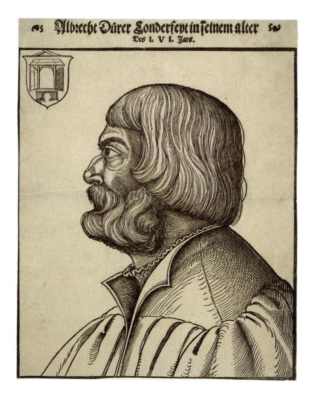

Fig. 13.3 Attributed to Eberhard Schön, Dürer as an old man with his coat of arms, woodcut, c.1538. Metropolitan Museum, New York, public domain.

[23] Jahns, *Frankfurt*, 213–14.

The council agreed to prohibit Catholic masses, and the city joined the Protestant Schmalkaldic League in 1536.[24] Altars and 'other vexed images' were now banned.

What happened to Jakob and Katharina's altarpiece and the masses to commemorate them? After attempting to secularize the Dominican monastery and its possessions, the council agreed in 1544 to wait until the last of the monks had died. Four years later, the monastery recovered its right to admit novices and maintain masses after the Schmalkaldic League's defeat. Yet the Dominican's financial wealth from donations of land and money in return for their care of souls dwindled, and its position in the Protestant city remained precarious.

One source of income for the few remaining elderly monks inhabiting the monastery was the opening up of Dürer's altarpiece. Dürer himself paid to study and admire great altar paintings in the Netherlands—every connoisseur was prepared to make such small payments, as the wings of altarpieces were closed for most of the year. In dire straights, Frankfurt's Dominican brothers now catered for those who visited their chapel to view Dürer's art. By 1555, the year in which Vasari's *Lives of Artists* was published in Italy, the Heller's altarpiece had even acquired a panel with a Latin inscription: 'If Appelles had seen this panel's figures, I think he would have been stunned by Albert's cultivated hands and ceded the palm, surpassed by the new art.'[25] Dürer's masterpiece proved him a German Super Apelles of the 'arte nova'.

Perhaps Philipp Melanchthon (1497–1560) devised this caption when he stayed in Frankfurt in 1539. Melanchthon was Wittenberg's most important reformer next to Luther. One of his students recalled Melanchthon telling the class: 'At Frankfurt am Main is Dürer's most sublime painting which depicts the Assumption of the Virgin Mary embellished with little flowers'—referring to the flower ornaments on the frame.[26] Usually, Lutherans talked strictly about Dürer to praise the simplicity of his final works, and would no longer have venerated the subject matter of the Heller altarpiece. Decades later, it would be Catholic collectors who negotiated with Frankfurt's Dominicans to sell their Dürer.

[24] *Frankfurter Stadtoberhäupter*, 96–8.

[25] As reported by Joachim Camerarius, for a detailed discussion see Brennan, 'Art exhibition'.

[26] Ashcroft, *Dürer*, vol. 2, 1029. He and Dürer became close when he advised the Nuremberg council on the curriculum for Protestant schools.

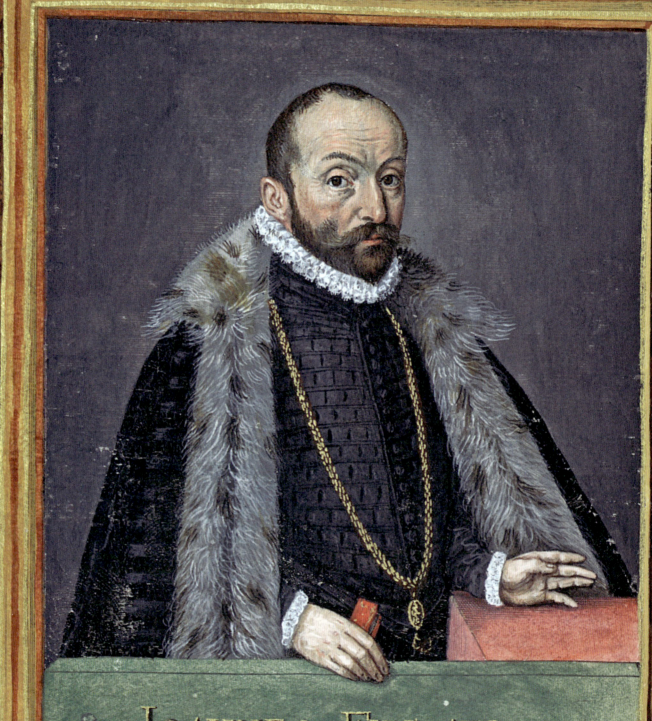

PART TWO

Tastemakers

CHAPTER 14

Hans Fugger and the Age of Curiosity

Was Dürer destined to become one of Germany's most famous artists? Several factors explain why, despite everything Dürer had done to turn himself into an Apelles, his legacy as a painter in his own age was far from guaranteed. He had had no son to teach his art. His brother Endres inherited 'all his precious colours'—that is, his pigments—as well as the copper plates and woodblocks, from which Endres and Agnes Dürer continued to print.[1] Dürer's visibility as a painter remained relatively low. His links to Nuremberg's council had enabled him to install a number of works in the city hall and to decorate its walls. Nuremberg continued to claim its status as the most excellent German city through the achievements of local artists. This mattered because the Lutheran city still occasionally hosted political summits in the German lands. Yet the last Imperial Diet to be held in Nuremberg took place in 1542, after which Augsburg and Regensburg overtook it as centres of imperial politics, and the goldsmiths of Augsburg turned their city into a leading centre of international arts. As for Nuremberg, there is no record of any visitor ever mentioning having made his way to the chapel for impoverished craftsmen founded by Landauer to see Dürer's final altarpiece. A number of Dürer's works hung in the church in Wittenberg castle, but the small Lutheran university town was not located on any trade routes. It mostly drew in the sons of middle-class Lutherans, destined to become low-paid pastors in rural communities rather than enterprising collectors. The church of St Bartholomew in Venice, where Dürer's *Feast of the Rose Garlands* hung, was principally used by German merchants. Venetian churches and foundations abounded with exciting art, not least in utterly different contemporary styles of masters such as Tintoretto from the late 1540s.

Visiting the Heller altarpiece in Frankfurt required a special trip to the city's dwindling Dominican monastery at the edge of the Lutheran city. Dürer's portraits and other paintings, such as his Adam and Eve, were mostly in private collections and largely inaccessible or not necessarily even known about. Above all, as we have seen, Dürer had produced few complex, time-consuming compositions. Paintings he had

[1] *Johann Neudörffers Nachrichten von den vornehmsten Künstlern und Werkleuten so innerhalb hundert Jahren in Nürnberg gelebt haben 1546: nebst Fortsetzung von Andreas Gulden 1660* (Nuremberg, 1828), 38.

produced quickly would have deteriorated fast. Vasari's 1550 edition of *The Life of the Painters* hardly mentions the artist, and a revised 1568 edition merely noted Dürer's engravings in an entry on 'Marcantonio Raimondi and other engravers'. His stature as Apelles in the annals of art history was cut down to size.

Dürer's work as a printer certainly continued to be esteemed over the following decades—but prints were typically kept in thick albums rather than displayed and framed, and bought in bulk. Johann Neudörffer (1497–1563), a Nuremberg calligrapher and mathematician, noted around 1550 that it was impossible to buy any of Dürer's woodcuts and engravings, 'of which there are many', for less than 9 florins, as if they were already overpriced.[2] In 1574, Willibald Imhoff (1519–80), a Nuremberg patrician who inherited much of Pirckheimer's collection and bought Dürer's work, valued a large crucifixion scene painted by the artist in oil at just 80 florins, and Dürer's self-portrait as a young man, now in the Louvre's Northern Renaissance Gallery, a mere 4 florins.[3] Dürer's commercial value therefore had hardly risen since the artist had unsuccessfully challenged Heller to pay him 300 florins for the central section of his altarpiece. Painting in general continued to be valued modestly in Germany, although it was beginning to gain in prestige in relation to a body of art theory, the so-called *Kunstbüchlein*, that valued its distinctive ability to imaginatively tell stories through mathematically accomplished compositions. Elites might exceptionally spend more on larger and complex pieces by the most noted painters, as well as of course on antiquities and medals— but the normal expectation remained to pay below around 10 florins for most paintings for the domestic interior.

Moreover, there was no consensus about Dürer's uniqueness even among German or even specifically Nuremberg artists. When Johann Neudörffer started gathering brief notes on Nuremberg's greatest past and present 'artificers' in 1547 for his *Kunstbüchlein*, he mentions Dürer, but not as the first among them nor does he even laud him as an Apelles. Yet the men had known each other well. Neudörffer had completed Dürer's last painting, *The Four Apostles*, by supplying an explanatory biblical text in perfect calligraphy beneath each panel. As we have seen, Dürer donated the painting to Nuremberg's Lutheran city council in 1526 in order to warn them against 'false' prophets among Protestant religious radicals. Even though the artist claimed to have put more work into it than any other painting, and skilfully expressed the characters by aligning them with different temperaments, these panels ultimately remained flat, didactic, monumental, lacked immediacy, and were technically straightforward. Neudörffer does mention Dürer's pleasure in painting landscapes, people, and towns. Among his output, he listed 'a work' in Venice, the Landauer altarpiece, and portraits for high-ranking people. He referred to Dürer's theoretical works, of course, and the fact that Nuremberg's Inner Council liked his 'wise and pleasant' talk so much that they treated

[2] *Neudörffers Nachrichten*, 37.

[3] Horst Pohl, *Willibald Imhoff. Enkel und Erbe Willibald Pirckheimers* (Nuremberg, 1992), 193, 235, 299.

him 'as if he had been one of them'.[4] This ambiguously implied that the artist's rhetorical skills had enabled him to network beyond his rank—his talk had got him places and allowed him to make profitable investments. Alongside Dürer, Neudörffer profiled the work of stonemasons, clockmakers, goldsmiths, bell-makers, illuminators, and other makers, many of whom had likewise been honoured through their election to Nuremberg's Great Council. Dürer's profile merged far more into a group portrait than he would have liked.

As for himself, Neudörffer was particularly excited about the subtle work carried out by contemporary masters in metal or wood. They carved lifelike miniature mosquitos, for instance, or life-cast plants and insects. Among them, the goldsmith Wenzel Jamnitzer (1508–85) excelled. Born when Dürer was working on the Heller altar, Jamnitzer lived a long life. As Nuremberg craftsman, he succeeded Dürer in fame for decades during the second half of the sixteenth century and, in the judgement of many, would eclipse him. Jamnitzer worked for different Protestant and Catholic courts of the highest rank, commanding enormous prices for his unrivalled art that matched the elite's growing taste for lifelike observation and an interest in alchemical transformation and regeneration. The city of Nuremberg deployed some of his work as diplomatic gifts. Jamnitzer also wrote theoretical works. His work exuded contemporary, innovative, mathematically informed, and utterly rare subtlety for a new clientele, that was easily displayed and admired at eye-level in the round.[5] [14.1]

An Age of Wonder

Tastes were changing. The period after Dürer's death saw the true rise of the age of collecting for cabinets of arts and rarities in German lands, a movement which Margaret of Austria and Dürer himself had pioneered as avant-garde. Some sixteenth-century courts housed these ever larger collections in dedicated buildings. They usually combined a wide geographical and thematic range of man-made and natural objects and were on display for select visitors only. By 1600, they had become *de rigueur* for any art-loving court or major merchant. The taste for these collections tied together merchants who purchased artefacts and the courts who desired them ever closer. Rarities from far away were mostly available through commerce; no court artist could create them. The Habsburgs moreover sourced some items as political tribute or gifts through their Empire that newly stretched to the Americas, and European courts disseminated them further as diplomatic gifts. But many items had to be bought via connections to merchants or dedicated art agents, which meant that more money than ever before was spent on global arts and *naturalia*. The whole enterprise of collecting could bring

[4] *Neudörffers Nachrichten*, 'als were er ein Rhatsfreund mit Ihnen gewest', 37.

[5] For a reflection of these types of work by urban craftsmen for courts and the recognition they gained see Andrew Morrall, 'Urban Craftsmen and the Courts in Sixteenth-Century Germany', Dagmar Eichberger, Philippe Lorentz, Andreas Tacke eds., *The Artist between Court and City (1300–1600)* (Petersberg, 2017), 220–45.

158 Ulinka Rublack

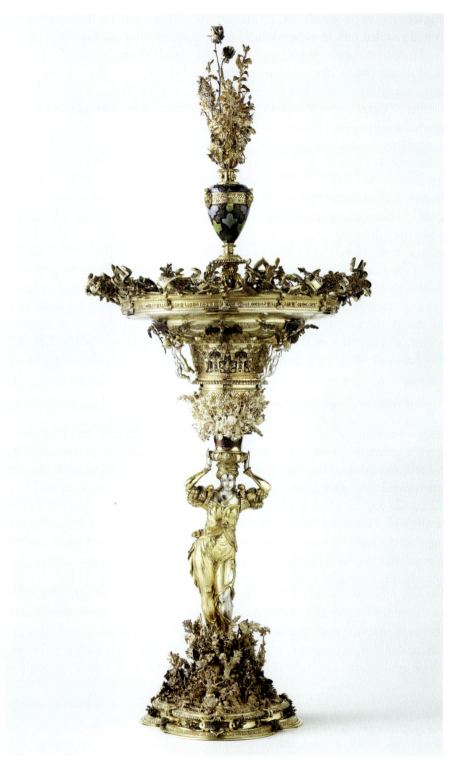

Fig. 14.1 Wenzel Jamnitzer, Merkelsche table ornament in silver with life casts of plants, insects, snakes, and lizards as an ode to Mother Earth (in the centre) and all it brings forth, Nuremberg 1549, 100 × 46 cm, Rijksmuseum, Amsterdam.

ambitious courts to the brink of collapse with debts, and hence tied them even further to money-lending merchants. Merchants in their turn shared this taste and were keen to secure their ennoblement or marriage alliances with the aristocracy, through their own, and supply of other, collections.

The relationship of many merchants to art had thus fundamentally changed since Heller's day. While Heller defined the age of the deeply devout patron, keen to commemorate him- or herself through vestments embellished with their coats of arms, a major painting or sculpture commission for a local church in ways that were broadly specified, the new urban elites often operated in a different way. The merchant might still act as patron like Heller, but typically he or she also actively sourced and co-produced a wide range of artefacts. For this they engaged in extensive communication. In order to buy an item, merchants had to gain special knowledge about their merchandise, working together with international craftspeople to create objects both in the current style and responding to detailed specifications relating to quality. Instead of focusing on church art, some of these collections had far wider religious and political ambitions: to mirror God's evolving macrocosm of everything he had created within the microcosm of a majestic collection. This ambition had the power to rebuild theories of wise governance. A wide-ranging collection of natural and man-made artefacts promised to lend its owners and visitors unique knowledge about the world. Showcasing technical skills or material properties from around the globe moreover had utilitarian aims. Such technologies had the power to inspire growers, hunters, and makers at home to imitate and appropriate them and eventually diversify and strengthen the home economy. Collecting could be legitimized as governmental prudence to justify the effort and expense involved.[6] In turn, commerce in collections also legitimized the role of merchants in new ways. While they had often been negatively portrayed as money-grabbing and self-interested, these practices allowed merchants to increasingly project themselves as positively connecting countries and furnishing knowledge for courts or even for their nation.

Museums of Useful Wonder

In the generation following Dürer's, the activities of one merchant son more than any other characterized this period of change. Samuel Quiccheberg (pronounced *Quickelberg*, 1529–67) had grown up for much of his youth as a religious migrant from Antwerp in Lutheran Nuremberg. He studied at both Protestant and Catholic universities in the German lands, and served Protestant and Catholic patrons alike as doctor and as scholar. After the Peace of Augsburg in 1555, Germany divided into Protestant and Catholic territories whose entire populations were required to follow their rulers' faith. Councils in the leading imperial cities had decided on the faith to be adopted in

[6] Mark A. Meadow, 'Introduction', in idem and Bruce Robertson eds., *The First Treatise on Museums: Samuel Quiccheberg's Inscriptiones 1565* (Los Angeles, 2013), 25–30.

their domains, unless the Emperor intervened. Some cities, such as Augsburg, allowed both Lutherans and Catholics to practise their religion. Meanwhile, after the Council of Trent had ended in 1563, several rulers actively supported the Catholic Renewal.

Quiccheberg was among those who began to champion wide-ranging interests in the arts in order to avoid narrow confessional allegiances. Since 1559, he researched genealogy and heraldry for Albrecht V of Bavaria (r. 1550–79), travelled widely, and became ever more interested in contemporary collections.[7] Albrecht V turned into one of Germany's foremost princely patrons of the arts. His goal was to position the Wittelsbach dynasty at the centre of German imperial politics. Close to his castle in the centre of Munich, Albrecht V began, in 1563, to build the largest cabinet of art (*Kunstkammer*) of his time; in 1565 he declared nineteen valuable pieces he had commissioned for his collection of jewellery and goldsmithing as inalienable treasures. In 1568, he began building a separate large space for his numerous antiquities and statues, and soon after, he founded a court library.[8]

In order to secure his position with Albrecht V, Quiccheberg composed what is now known as the first treatise on museums, completed two years before he died prematurely in 1567. Entering a cabinet promised an exciting experience that was different from viewing paintings in castle galleries, listening to a guide explaining classical myths or dynastic genealogies at length. Quiccheberg's short book set out a pioneering, practical agenda for how to build up and order a collection that allowed for learning from artefacts of all kinds in order to be 'stimulated to imagine' and to 'investigate' new things. Instead of a stuffy museum in which a mass of objects gathered dust or were distanced from visitors in cases, Quiccheberg envisaged an animating display theatre alongside a 'research and development centre' encompassing workshops, a chemical laboratory, and a pharmacy, complemented by a library.[9] These collections were unlike today's museums in that they served as flexible reservoirs for owners from which to extract items as gifts. Objects were handled rather than merely exhibited. Quiccheberg's titlepage advertised the importance of such hands-on knowledge as key to rapid learning: 'It is recommended that these things be brought together here in the theatre so that by their frequent viewing and handling one might quickly, easily, and confidently be able to acquire a unique knowledge and admirable understanding of things. Authored by Samuel Quiccheberg from the Low Countries.'[10]

Quiccheberg's treatise only briefly mentions that 'the most outstanding painters' in Germany should be honoured in the Bavarian collection of paintings that had been

[7] On Quiccheberg's biography see Meadow, Robertson eds., *The First Treatise*, 7–12.

[8] For the best overview in English see Lorenz Seelig, 'The Munich Kunstkammer, 1565–1807', in Arthur McGregor, Oliver Impey eds., *The Origins of Museums: The Cabinet of Curiosities in Sixteenth- and Seventeenth-Century Europe* (Oxford, 2017), 76–7, and Katharina Pilaski Kaliardos, *The Munich Kunstkammer: Art, Nature, and the Representation of Knowledge in Courtly Contexts* (Tübingen, 2013), esp. 1–88; see also Dirk Jacob Jansen, *Jacopo Strada and Cultural Patronage at the Imperial Court: The Antique as Innovation* (Leiden, 2018).

[9] Mark A. Meadow, 'Introduction', in *The First Treatise*, 29–30.

[10] *The First Treatise*, 61.

assembled mostly by Albrecht V's father Wilhelm IV (1493–1550). While Quiccheberg noted that Albrecht V's sons had inherited a fondness for eminent paintings, it was clear that Albrecht V himself did not passionately care for them in terms of their painterly style.[11] In fact, by the time his cabinet was installed in Munich's first Renaissance building and opened to visitors in 1578, many of the paintings had been hung so high that they were difficult to see. Only two of Dürer paintings were on show—one of them a naked Lucretia in the act of committing suicide, acquired by Albrecht V's father. The panel was not prominently displayed and the guides did not draw attention to it; most visitors would simply have missed it. Many recently acquired paintings were not added because of their aesthetic merit but as historically relevant or unusual—they depicted men and women of influence, or wondrous animals, alongside court fools, as curiosities, including a simpleton named 'Anton Leiniger Pum Pum', or one 'Stupid Elsa', who had served Anne of Bohemia (1503–47).[12] Albrecht V's father had already begun collecting portraits of famous rulers, popes, and cardinals, and this tradition would be energetically continued. Painting in this way continued to serve more as a document than as a work of art in its own right.

Quiccheberg's treatise radically imagined that paintings of different genres should be combined and displayed without any fixed order or hierarchy distinguishing them. He adapted the concept of the altarpiece with its closed and open wings to propose a surprising, revolving mode of display. Visitors were invited to actively discover and engage with the panels, that were constantly shifted by attendants. A multitude of maps, watercolour paintings of plans and vistas, or even animals, replaced the religious scene at the centre of an altarpiece:

> But the theatres or collections that I am presenting to princes will be able to have on their walls on all sides double doors of the proper size so that panels of all kinds can be extended; these doors may be opened, as it is the customary set up in the case of altarpieces, so they reveal two or three new facets. Thus, in the interior there will be some class of objects such as statues and oil paintings; in the middle perhaps there will be maps, cities, animals, and the like, or other simple pictures of expeditions or vistas, painted on canvas in watercolours. In that way, any viewer, any time, might wander around and view the outer paintings and then, returning to his starting point, find a new facet, with some attendant meanwhile having shifted the doors of the walls.[13]

This was an astonishingly unprejudiced proposition: perceptions were free to endlessly shift and refresh themselves, rather than focus on defining a canon that culminated in the achievement of specific master artists or on privileging types of visual expression

[11] *The First Treatise*, 85; for an assessment of Albrecht's collection of paintings that is anxious to avoid anachronisms see Peter Diemer, 'Wenig ergiebig für die Alte Pinakothek? Die Gemälde der Kunstkammer', in Dorothea Diemer et al. eds., *Die Münchner Kunstkammer*, vol. 3 (Munich, 2008), 125–224.

[12] Diemer et al. eds., *Kunstkammer*, vol. 2, 887, No. 2968.

[13] *The First Treatise*, 89. He added: 'And so also for the rest of the paintings. Unless it should be considered preferable to draw curtains and veils around these, which I myself would not do, unless the textiles contained something suitable for the theatre or something learned.'

162 *Ulinka Rublack*

such as depictions of Christian subjects. Hence it opened up the inclusion of extra-European art. This concept of a cabinet rooted in an ever-changing present, ideally suited, and reflected, contemporary attitudes to the display of fashions and ways of making.

Another of Quiccheberg's inspirations for such displays built on his frequent visits to German artisans. Their toolboxes fascinated him. Many of these artisans, he noted, had developed a system of single portable cases and chests in which a multitude of instruments were beautifully organized without rubbing against each other. These German toolboxes had either 'outward opening double doors or folding panels', and were so admired that the Augsburg merchant Anton Meuting had transported several of them 'all the way to Spain' for princes and counts.[14] Both altarpieces and toolboxes combined mechanisms of unfolding as a means of revelation as much as for spatial compactness. These features would soon lead to the development of cabinets of curiosities as one single, highly complex piece of furniture with secret compartments, of the kind Philipp Hainhofer (1578–1647) excelled in. Yet for the moment, most objects to be acquired for art cabinets were grouped and laid out on large tables as well as hung up on panels, ceilings, and walls.

Quiccheberg's treatise by no means functioned as a blueprint for Albrecht V and his wife Anna of Austria's collections. Yet it captures the new excitement about a broad range of arts in this period, their role in governance and in political thought. While in 1557 the Bavarian State Council lamented that merchants drove Albrecht V and other rulers into the 'acquisition of various strange luxuries' for their own collections and financed courtly 'splendour and luxury' that drained state finances, Quiccheberg defended the immense 'wisdom and utility in administering the state' that could be gained from studying the 'images and objects that we are prescribing'.[15] Assembling a cabinet of the arts, he argued, was by no means the same as hording expensive luxuries in a treasury. Some of its contents, such as minerals from mining regions, were decidedly mundane.

Quiccheberg left no doubt that ethnological rarities were integral to the acquisition of knowledge about foreign craftsmanship. He therefore was keen to assemble 'ingenious objects worthy of admiration either owing to their rarity or to the distance of space or time from their point of origin. These are principally tiny and rather elegant, in fact, unless something larger might also on occasion be able to lead us to an understanding of foreign customs and craftsmanship'.[16]

An interest in technical accomplishments in crafts including weaving and sewing supported such a cosmopolitan outlook. 'Inscription 10' hence instructed the seeking out of dress made from diverse materials, and dolls, which showed how garments were displayed on a body: 'Foreign garb, such as those belonging to Indians, Arabs, Turks,

[14] *The First Treatise*, 83.
[15] Mark Meadow, 'Introduction', in *The First Treatise*, 4–5.
[16] *The First Treatise*, 64.

and the more exotic people. Some made from the feathers of parrots, from the weaver's loom, or from some marvellous textile or diversely sewn leather. In addition, miniature garments of foreign peoples, like the garments of dolls, for the purpose of distinguishing the dress of young women, widows, wives, and the like.'[17]

Such ideas also drew on the interests and international connections of ruling women, among them Archduchess Anna of Austria (1528–79). Anna was a daughter of the future Holy Roman Emperor Ferdinand I (1503–64) and his wife Anna of Bohemia and Hungary—her Habsburg pedigree could not have been more distinguished, and the alliance was a great achievement for the Wittelsbach dynasty. She had grown up as her parents built up their art cabinet and pleasure gardens in Vienna and started turning the city into an artistic centre. Aged seventeen in 1546 when she married, Anna was soon noted for her state-of-the-art pharmaceutical laboratory in Munich's new castle, where medicines and cures were developed for poor and rich alike. She further distinguished herself as a lover of natural knowledge through her immense aviary which contained many species of birds.[18] Quiccheberg was particularly inspired by the extensive collections of dolls—'figures in their hundreds', as he explained—amassed by Anna and Albrecht V of Bavaria's daughters, as well as girls at the court of Baden, which displayed fashionable elite dress. Women exchanged these dolls to study 'foreign garments' and the jewellery of 'distant people' in 'fine detail'.[19] [14.2]

Fashion dolls in Europe began to provide an expansive source of knowledge about novel and different fashions beyond cultural boundaries.[20] They presented three-dimensional, up-to-date information on how particular aspects of appearance were styled, while the collection of a great number of dolls for study purposes suggested that the Bavarian courtly ladies treated them as a creative resource, using them in discussions with their craftsmen and -women to innovate. Albrecht V's daughter Maria hence took her dolls to Austria when she married, and it would be wrong to see them as simply linked to childhood play. Courtly entertainments with masques became far more numerous during this period, and offered possibilities to try out unusual, globally eclectic styles. For example the dukes of Bavaria collected the emerging genre of manuscripts and books, which illustrated hundreds of costumes from around the world to inspire them.[21] The textile industry was one of Europe's most dynamic sectors, and extraordinary amounts of money were spent on the finest silks or best linens. Trying out materials and styles through collectors' objects hence offered great opportunities to

[17] *The First Treatise*, 69.

[18] *The First Treatise*, 76–7. On Vienna and the arts under the guidance of Jacopo Strada see Howard Louthan, *The Quest for Compromise: Peacemakers in Counter-Reformation Vienna* (Cambridge, 1997), 24–48; on the gardens see Hilda Lietzmann, *Irdische Paradiese: Beispiele höfischer Gartenkunst in der 1. Hälfte des 16. Jahrhunderts* (Munich, 2007), 37–66.

[19] *The First Treatise*, 84.

[20] See the discussion in Evelyn Welch, 'Introduction', in idem ed., *Fashioning the Early Modern: Dress, Textiles and Innovation in Europe 1500–1800* (Oxford, 2017), 14–18.

[21] See, for example, Berndt Ph. Baader, *Der Bayerische Renaissancehof Herzog Wilhelms V (1568–1579)* (Leipzig, 1943), 65.

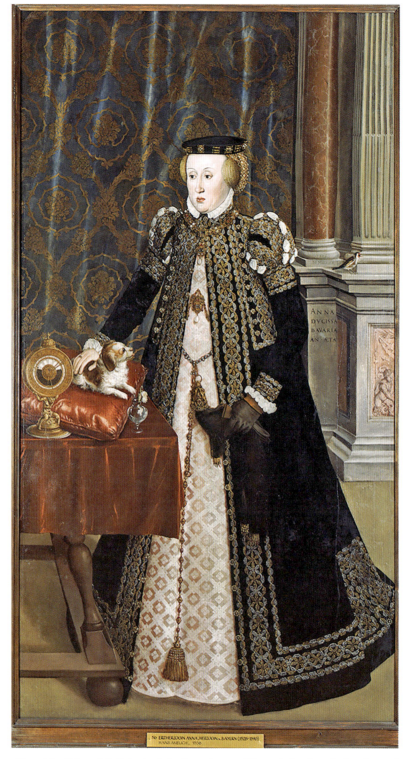

Fig. 14.2 Hans Muelich or Mielich, *Archduchess Anna of Bavaria (1528–90), daughter of Ferdinand I, Holy Roman Emperor*, oil on canvas, 1556, 211 × 111 cm, Vienna, Kunsthistorisches Museum Neue Galerie, KHM-Museumsverband.

generate ideas to imitate or adapt techniques from elsewhere. European feather-working, for instance, greatly expanded as an entire crafts sector during the sixteenth century as a result of a fascination with American, Persian, and Ottoman styles.[22]

It therefore made sense to elite men and women in this period to regard dress as a human achievement reflecting technological advances, idiosyncrasies, and customs of civilizations, as preserving memory and opening up innovation. This included footwear—another sector that changed beyond recognition in Germany during the sixteenth century. The ideal of elegance from the late fourteenth to the mid-fifteenth century had been the narrow, flat, elongated Gothic shoe with sharp pointed toes stuffed with moss for men and women, which created its own demands for walking and interacting with others. A range of decorative techniques, such as elaborate openwork patterns, incising, and engraving began to be used from the fourteenth century. Drawstring shoes were commonly worn for comfort.[23] [14.3]

In the early sixteenth century, the so-called *Hornschuh* became the ideal of German and Swiss elegance. It took the form of a leather shoe with very narrow rims over the sides and front of the foot, on which leg garments were often directly fastened.[24] Dürer made his own pattern drawings in the 1520s for his shoemaker specifying the cut with a high back and very flat double soles. He requested the decoration (*zier*) to be pressed into the wet leather on the toe and the leather strap.

People clearly appreciated footwear for its materials, details, and skilled construction. The first inventory of Munich's cabinet of curiosities made in 1598 listed the following items in one room:

> A large...man's shoe worn by Anthoni Frangipan.
>
> Two men's soles from white leather, stuck together in numerous ways, which are to be bound on the foot with white and black laces.
>
> A pair of Muscovite slippers, with white hemp laces and soles, as well as overshoes.
>
> A pair of shoes, also with laces, as the above mentioned slippers.
>
> A pair of old, small leather slippers, which are to be tied over the foot, and have brass below the toe.
>
> A rather old small pair of women's slippers.
>
> Another Muscovite pair of shoes, soles and overshoes, made from wooden branches or roots.
>
> Another pair of this type of shoe, the soles made from vines, the upper woven from laced thread.

[22] Ulinka Rublack, 'Befeathering the European: Feathers as Matter in the Material Renaissance', *American Historical Review* (March, 2021), 19–53.

[23] Francis Grew, Margarethe de Neergaard, *Medieval Finds from Excavations in London: 2, Shoes and Patterns* (Woodbridge, 2001).

[24] Sigrid Müller-Christensen, *Die männliche Mode in der süddeutschen Renaissance* (Berlin, 1934), 53–5.

166　*Ulinka Rublack*

Fig. 14.3　Albrecht Dürer, Ill-assorted couple, the man wearing fashionable elongated shoes with wooden overshoes. Engraving, 15 × 14 cm, *c*.1495. Metropolitan Museum, New York, public domain.

> A single man's shoe, also threaded.
>
> Two pairs of wooden shoes, one of them with a pointed toe, the overshoes threaded from straw.
>
> High Spanish women's slippers made from gilded leather.[25]

[25] Johann Baptist Fickler, *Das Inventar der Münchner herzoglichen Kunstkammer von 1598*, ed. by Peter Diemer (Munich, 2004), 66–7; Diemer et al., *Kunstkammer*, vol. 1, 158–60, see also 512 for shoes from Lappland and 520 for Chinese women's shoes.

The Munich cabinet even contained the cordovan leather boot taken from the Lutheran Duke John Frederick of Saxony when he had been captured by the Catholics in 1547.[26] It was preserved, among other textile and leather items, including a velvet beret decorated with swan feathers worn by Albrecht V's mother and a mourning hat which had belonged to his father. There were also velvet shoes lined with cordovan leather, a large pair of gloves, and, more mysteriously, a cap to make oneself invisible.[27]

This mixture of items with an historical provenance, together with ethnographic items and tools that supported an interest in applied knowledge and design made these collections stimulating for a wide variety of collectors. German artists, urban artisans, and pharmacists, Quiccheberg noted, had already developed significant and varied collections of artefacts and instruments through far-reaching networks of exchange. In fact, it worried him that, 'goldsmiths, painters, sculptors, and others who are more or less unlearned' in Augsburg might surpass his own knowledge. The Catholic Marina Pfister (d. *c*.1561) was one of these Augsburg collectors, a most 'honourable lady' who, of 'her own initiative', Quiccheberg stressed, assembled a 'very extensive collection of technical tools and instruments of turners, carpenters, painters, mathematicians, and musicians—the broad benefits of which have even continued after her death, as long as there have been those eager to imitate her'.[28] Pfister's father was involved with salt-trading and she had married a patrician. Up to her death in 1561, she collected contemporary small bronzes, tools, and instruments, including musical instruments, as well as modelling and casting objects with her own hands. These activities gained Marina Pfister such respect that the Munich *Kunstkammer* housed a portrait of her.[29]

Bone collecting likewise lent itself to practical applications that benefited society. Quiccheberg prized lifelike animal casts of 'lizards, snakes, fish, frogs, crabs, insects' and shells because the study of bones and skeletons had recently assisted in the manufacture of prostheses for mutilated people.[30] Further tangible benefits included the building of cheaper prototypes through the study of materials as well as the propagating of new edible plants and medicines from foreign seeds, such as the tomato.[31] Whereas a man like Canon Behaim in Dürer's time had tried to match written recipes with available drugs in hands-on experiments, Quiccheberg argued that learning from ordered, systematic collections of materials and artefacts likewise inspired ideas and furthered applied knowledge.

Many subjects they related to were not yet taught at university. 'Within my first year in Augsburg', the merchant's son noted, 'I was inspired and attracted, in far more areas than I attended to before, by the instruments of Cyprian Schaller, the gold assayer, and

[26] For an extensive discussion of this item see Fickler, *Inventar*, 76–8.

[27] Fickler, *Inventar*, 120–1.

[28] *The First Treatise*, 100.

[29] Fickler, *Inventar*, 877–8.

[30] *The First Treatise*, 66.

[31] *The First Treatise*, 80.

Johann Schümberger, the goldsmith.'[32] Models of machines and constructions were displayed so that 'better ones' would be invented.[33] Glazes and oils, the work of weavers and embroiderers, as well as anything indicating 'foreign customs and craftsmanship' were just as crucial.[34] Germany hence was no backwater of the arts in the age following Dürer—it thrived through collections.

The Fugger

Augsburg and the Fugger merchants were at the central node of this future-orientated world of knowledge and experiment. Quiccheberg even lauded the Fugger for fostering talent and inspiring creations which in future might outshine the achievements of the ancient Romans.[35] Indeed, such merchants could inspire rulers to sponsor collections of objects in order to 'enhance the refinement of the entire world' as sophisticated products and instruments were developed and traded.[36] Quiccheberg operated as an ideal broker between the two worlds of the merchants and the court.

He knew the Fugger family well. They descended from a humble migrant weaver who had arrived in the south German city of Augsburg in 1367.[37] By the mid-fifteenth century, this weaver's sons ranked the fifth wealthiest in the city. A family company, the Fugger invested in burgeoning mining businesses and the textile trade. As their capital rose further, they involved themselves in high finance, lending money to Europe's most powerful rulers, the papacy, and Habsburg Emperors. From 1512, Jakob Fugger (1459–1525), known to everyone as 'Fugger the Rich', headed the firm and, as we have seen, was targeted by religious reformers criticizing this new age of global empires, international trade, and luxury. Jakob granted credit not just in cash but also financed armies and luxury goods for elites. Financial power and political loyalty brought social ascent. The Emperor ennobled him. The family now paid out large dowries to marry daughters off to impoverished aristocrats and accumulated land in the Augsburg region. As territorial lords, they furnished their castles handsomely and threw lavish entertainments. Meanwhile, the company's head office remained rooted in Augsburg. Jakob lived in a large central complex of urban palaces, hosting the Emperor and other dignitaries.[38]

Yet just like Heller or Dürer, Jakob Fugger conceived no legitimate children with his wife. When he died in 1525, his nephew Anton thus succeeded him as the company's

[32] *The First Treatise*, 82.

[33] *The First Treatise*, 63.

[34] *The First Treatise*, 64.

[35] *The First Treatise*, a reference to Johannes Fugger, which Meadow believes does refer to Hans, 99.

[36] *The First Treatise*, 81.

[37] An excellent, up-to-date account is provided by Mark Häberlein, *Die Fugger. Geschichte einer Augsburger Familie (1367–1650)* (Stuttgart, 2006) translated as *The Fuggers of Augsburg: Pursuing Wealth and Honor in Renaissance Germany* (Charlottesville, 2012).

[38] Benjamin Scheller, *Memoria an der Zeitenwende: Die Stifung Jakob Fuggers des Reichen vor und während der Reformation (ca.1505–1555)* (Berlin, 2004).

director, staying in command until 1560. Anton lived through the long, troubled period of the Reformation which finally turned Augsburg into a divided city inhabited by Lutherans and Catholics after the religious settlements of the Peace of Augsburg in 1555.

For Quiccheberg, meeting Anton Fugger when he was barely twenty years old had been formative. Fugger's support enabled him to matriculate as a student at the Catholic university of Ingolstadt. Their ties remained intimate. Quiccheberg first tutored Anton's son Jakob at university and then served Anton himself as his physician for three years between 1555 and 1557. Quiccheberg moved on in June 1557 to help Anton's nephew Hans Jakob Fugger to order his immense family library.

However the Fugger company faced a crippling financial crisis caused by a collapse of the Habsburg's credit repayments. When Anton Fugger died in 1560, he was thus deeply worried about the future of his mighty firm. He doubted that his sons or nephew Hans Jakob were competent enough to succeed him. By 1563, the debts of the Spanish Crown alone amounted to three million ducats.[39] Anton was right to worry about his nephew. A deeply scholarly man, Hans Jakob filed for bankruptcy in that very year to end his life employed by Albrecht V of Bavaria. In Munich he joined Quiccheberg, who had already gained employment at the court in 1559.[40] Albrecht acquired Hans Jakob's immense library as well as coins and antiquities he had inherited from his father, the merchant Raimund Fugger.

Although Hans Jakob had lost nearly everything, he exerted considerable influence at the Munich court as he helped Albrecht V to extend what had once been the Fugger family's unrivalled collection. Between 1563 and 1567, both Quiccheberg and Hans Jakob Fugger, as deeply learned merchant sons, provided a practical and programmatic vision for collecting at the Munich court. Their thinking most likely informed Albrecht V's decisions from 1563 to lay the groundwork for major buildings that would house his collections. This was pioneering at the time, four years earlier than the beginning of the now famous collection in Castle Ambras and decades before the equally famous collection of Rudolph II in Prague gained shape. The Lutheran elector of Saxony in Dresden had started a collection by 1560.

After Hans Jakob left Augsburg for Munich, the Fugger company was directed by Anton's two sons, Marx (1529–97), the first born, and his brother Hans (1531–98). They hated their cousin for decimating the Fuggers' collections and leaving enormous debts for them to sort out. Their acumen for business far exceeded their father's expectations. Marx restructured the firm. He dissolved a number of branch offices, pooled the company's resources in Tyrol with other Augsburg firms, and concentrated financial investments in Austria, the Netherlands, and Spain. As the Habsburgs remained

[39] Häberlein, *Fugger*, 98; Hermann Kellenbenz, 'Anton Fugger (1493–1560)', in *Lebensbilder aus dem Bayerischen-Schwaben*, vol. 11 (Weißenhorn, 1976), 46–124; Johannes Burckhardt ed., *Anton Fugger (1493–1560). Vorträge und Dokumentation zum fünfhundertjährigen Jubiläum* (Weißenhorn, 1994).

[40] For an account of his life in English see Mark A. Meadow, 'Hans Jakob Fugger and the Origins of the Wunderkammer', in Pamela H. Smith, Paula Findlen eds., *Merchants & Marvels. Commerce, Science, and Art in Early Modern Europe* (New York, 2002), 182–200.

heavily indebted to the Fugger, they leased lands from the Spanish chivalric orders to the company in 1562. This proved to be to the Fugger brothers' greatest luck, as they included the mercury mines of Almadén.[41] Mercury was essential in the separation of silver from lead, essential in making coinage and in constant demand at Mexican silver mines. These mines were soon to yield extraordinary profits.

Intensified global trade and profits derived from Spanish America contributed to the revival of the Fugger fortunes. Marx led the company up to his death in 1597, and Hans died only a year later. The brothers never rivalled each other for influence—not only because Marx was two years older but also because he was far more learned in traditional ways. Whereas Hans avoided practising his Latin and never wrote anything other than matter-of-fact letters, Marx found time to translate several religious authors from Latin into German, seriously collected antique coins and medals with scholarly interest, published a voluminous treatise on horses, and systematically built up his library. Hans directed the company's affairs when his brother was on vacation, and reliably reported about any matters that needed to be discussed or solved. Yet most of the year, Hans's principal occupation was to forge and secure networks, source prestigious goods to assert his nobility and to circulate political information in return for protection and favours, as well as to negotiate credit. Hans Fugger exhibited many of the best traits of merchants, which made them so influential in this age: he had access to wide-ranging information and all kinds of luxury objects, got things done, and displayed common sense through a focused, precise, and practical mind. Around 4,700 of his letters relating to the management of the company's family and foreign relations survive.[42] They provide a unique glimpse into the universe of a sixteenth-century merchant financier. [43]

Quiccheberg left no doubt about the Fugger's legacy. His treatise ended a lengthy discussion of their formidable involvement in art and collecting by stating that it had 'befallen' to Hans Fugger 'in particular to be recognized as having offered himself as the most generous patron for the foremost talents everywhere'. Hans and his brother Marx, alongside two cousins 'sponsored many craftsmen in devising new things, with a similar enthusiasm for images and sculptures of genius, for furniture or remarkable workmanship, and for precious vases and such objects that, having been produced in

[41] Häberlein, *Fugger*, 97–111; Carolin Spranger, *Der Metall-und Versorgungshandel der Fugger in Schwaz in Tirol 1560–1575 zwischen Krisen und Konflikten* (Augsburg, 2007).

[42] For this characterization of merchants see Peter N. Miller, *Pereisc's Mediterranean World*, 340–1. This also explains why Fugger as a consumer was happy to invest in a number of prestigious art commissions even at a financially difficult time, Christl Karnehm, 'Die Korrespondenz Hans Fuggers: Adressaten und Themen' in Johannes Burkhardt, Franz Karg eds., *Die Welt des Hans Fugger (1531–1598)* (Augsburg, 2007), 33; Mark Häberlein, 'Geschenke und Geschäfte. Die Fugger und die Praxis des Schenkens im 16. Jahrhundert', in Wolfgang E.J. Weber, Regina Dauser eds., *Faszinierende Frühneuzeit. Festschrift für Johannes Burckhardt zum 65. Geburtstag* (Berlin, 2008), 135–49.

[43] *Die Korrespondenz Hans Fuggers von 1566 bis 1594. Regesten der Kopierbücher aus dem Fuggerarchiv*, ed. by Christl Karnehm, 3 vols (Munich, 2003). For a geographically wide-ranging exploration of the phenomenon see Christina M. Anderson ed., *Early Modern Merchants as Collectors* (Abingdon, 2017).

that flourishing age of ours, posterity will greatly admire, perhaps even more than it will esteem the ancient Romans'.[44]

By lauding the new generations of the Fuggers in Augsburg, Quiccheberg most likely hoped to create career options for himself. He also kept hinting that his treatise was a very preliminary sketch and one that he was planning to elaborate upon in a future book, lauding Germany's leading collectors. This future treatise was aimed at writing the 'history of our time' through their story. Everything he laid out made clear what an inspiring account of German achievements among cultured citizens, noblemen and ruling families it promised to be.

This was an age in which Germans often endorsed a persistent stereotype of themselves as a rough nation. Marx Fugger's own treatise on horses, for instance, started with despondent reflections about the state of Germany in this vein. Dürer and Pirckheimer saw their pursuit of collecting, acquiring, and discussing objects as an intellectual as much as an emotional practice that offered the potential to change a civilization like Germany's. How did Quiccheberg then position Nuremberg's contribution to this new age of knowledge through collecting? Given his hopes for continued employment at the staunchly Catholic Munich court or by the Catholic Fugger, Quiccheberg avoided any detailed discussion of this Lutheran city as much as he could. He simply listed names of collectors and their key assets, such as Willibald Imhoff's coin collection. There was no mention of his Dürers. Of course, Quiccheberg conceded, there were distinguished patrons of 'every kind of craft, commerce, and study' in this city and 'such versatile inventors of new objects and devices necessary for every life'. Among these inventors, he specifically mentioned Johann Neudörffer and his son (for devising geometrical models and mathematical instruments) as well as Wenzel Jamnitzer. But this discussion already seemed too fraught in view of his current Catholic patrons. 'If there were space to speak about these craftsmen', he quickly added, 'one would immediately have to turn to others throughout the cities of the empire and talk at length about Munich's sculptors, clock makers, swordsmiths, and esteemed makers of cannons and other such weaponry, whose works are heralded with the highest acclaim in the most distant foreign lands.'[45]

The memory of Nuremberg's greatness and the achievement of Dürer were easy to overwrite in this *history of the present*. The Fugger could be championed as knowledgeable merchants for this new age, working together with artisans as well as the Munich court.

[44] *The First Treatise*, 99.
[45] *The First Treatise*, 101–2.

CHAPTER 15

Hans Fugger's Taste for Painting

Yet Hans Fugger was not a man who usually sought out rarity and innovation through the medium of painting. He only mentioned Dürer once in his thousands of letters. It was not for a lack of exposure. This was the age of the later Renaissance. Hans Fugger's stay in Italy as a student overlapped with Michelangelo's lifetime (1475–1564). As a young man, Hans would have seen Titian working in his father's house during the last Imperial Diet held by Charles V. Abundant resources had been deployed on his education in languages, manners, and taste. Born in 1531, Hans had left Augsburg aged eleven and been sent to Austria, Italy, Paris, and Flanders, guided by tutors of excellent repute. After studying in Padua, he had visited Spain in his mid-twenties and then spent time at Ferdinand I's Viennese court. Between autumn 1557 and spring 1560, he worked in the Fuggers' Antwerp office during the worst of the debt crisis caused by Spain's state bankruptcy. He returned home aged twenty-nine, the year in which his father Anton died. Following the carefully laid-out plan to further increase the family's power, he married Elisabeth Nothafft von Weißenstein, whose family belonged to the imperial nobility. Elisabeth had been a lady-in-waiting for Anna of Austria, the Habsburg born duchess of Bavaria and Germany's highest-ranking consort.

This alliance strengthened Hans Fugger's ties to the Munich court, where the wedding itself took place. Through their continuous presence at court, young ladies-in-waiting such as Elisabeth built considerable social capital through meeting influential people, acquiring tastes, as much as a way of life. This included mastery of etiquette and comportment, such as 'wearing apparel, as best become her', and also a familiarity with political affairs and arguments. As high-ranking duchesses they kept themselves extremely well informed and used their own dynastic relations to conduct politics through letter writing, visits, entertainments, and festivities.[1] Anna's pedigree as a high-born Habsburg princess meant that her presence elevated courtly life; the alliance itself was a great coup for a newly strengthened Wittelsbach dynasty that in 1505 had united its upper and lower Bavarian territories which had long been divided between two lines of the family. Appointments of ladies-in-waiting were in turn part of the ruling couple's joint strategy to cultivate patronage among the Bavarian nobility. While

[1] Nadine Akkerman, Birgit Houben, 'Introduction', in idem eds., *The Politics of Female Households: Ladies-in-waiting across Early Modern Europe* (Leiden, 2014), 1–27, here 16.

current affairs would have been a topic of conversation among Duchess Anna and her ladies-in-waiting, Elisabeth would have also gathered advanced medical and technological knowledge. She would have learnt about new drugs and recipes, the latest luxury goods, current music, literature and arts, dances and entertainments. Each day, moreover, maidens at court absorbed lessons in household management and the politics of distinction. Every lady-in-waiting had a small portrait painted of her. These hung in a separate chamber, on view for inspection by eligible men. A lady's ultimate goal was to present herself appealingly and create a good name for herself in order to marry a man of fitting social status and increase her family's resources.[2]

Elisabeth certainly accomplished the latter. For over twenty years, Elisabeth and Hans Fugger lived in the family's Augsburg town palaces.[3] Hans had inherited the rear part of these houses towards the central *Zeughaus* market, while his older brother Marx naturally resided in the privileged front.[4] Here, they continued the company's tradition of receiving or accommodating high-ranking visitors, most notably emperors. As soon as Hans Fugger acquired his home he started to rebuild the rear courtyard and buildings in the latest style. With his grand-uncle Jakob, he pioneered the introduction of Italian styles to Augsburg, including the spearheading of a new fashion for glazed terracotta sculpture that imitated marble. He was the first in German lands to employ Friedrich Sustris (*c.*1540–99), a young artist who had been trained by Vasari in Florence when decorating the Medici's Palazzo Vecchio. This commission would nonetheless remain Hans Fugger's only commitment to costly, innovative painting. Sustris carried out frescos in two large rooms used to display Fugger's collections. They also pioneered in Germany the inclusion of erudite grotesques on walls and ceilings, executed in light and bright colours especially sourced from Venice. Sustris decorated enormous rooms over two floors at the heart of Hans Fugger's palace that were used for receptions in the same style. Sustris started working on the commission in 1566—just after Hans had visited Florence in 1565 as a guest of the Medici on the occasion of the wedding of Francesco Medici to Joanna of Austria.[5] Hans had been a particularly welcome guest at this grand event, as his father had once granted Cosimo I Medici an enormous credit payment which Marx had been keen to recover. Hans and Marx extended a new loan to Francesco in 1566.[6]

[2] On the Bavarian custom of commissioning such paintings see *The First Treatise*, 77; on the careers of ladies-in-waiting in such contexts see Katrin Keller, 'Ladies-in-Waiting at the Imperial Court of Vienna from 1550 to 1700: Structures, Responsibilities and Career Patterns', in Akkerman, Houben, eds., *Politics of Female Households* (Leiden, 2014), 77–97, here 90.

[3] Regina Dauser, *Informationskultur und Beziehungswissen—das Korrespondenznetz Hans Fuggers (1531–1598)* (Tübingen, 2008), 287. A Lutheran by birth, Elisabeth converted to Catholicism to marry a Fugger.

[4] Sylvia Wölfle, *Die Kunstpatronage der Fugger 1560–1618* (Augsburg, 2009), 104–34; Dorothea Diemer, 'Hans Fuggers Sammlungskabinette', in Renate Eikelmann ed., *'lautenschlagen lernen und ieben'. Die Fugger und die Musik. Anton Fugger zum 500. Geburtstag* (Augsburg, 1993), 13–40.

[5] Wölfle, *Kunstpatronage*, 126–33.

[6] See Wölfle, *Kunstpatronage*, for the most extensive discussion of castle Kirchheim, 133–213.

Unlike the Medici, the Fuggers never used their noble title in public, and Hans cautiously kept an arsenal of canons and weapons to defend the Augsburg palaces should there be any popular revolt against his newly rich and staunchly Catholic family. Around eighty per cent of the city's population was Protestant, and many of the craftspeople were poor. The Fuggers kept strategically marrying old nobility and buying up land. Just as the Augsburg house was finished, Hans Fugger received his share of the territories the family had begun to accumulate in order to bolster their status as landed nobility, despite their livelihood as urban merchants. From 1575 onwards, Hans poured enormous sums into the building of a new castle for one of his sons in one of these territories as well as on buildings in Schmiechen, an estate with fertile land. Most ambitiously, Hans Fugger spent over 166,000 florins between 1578 and 1585 to build his own castle on an estate he developed in Kirchheim—a beautifully situated territory with views of the Bavarian Alps where he enjoyed his summers. Defensive structures were vital, as peasants had attacked and looted the old family castle during the Peasants' War in 1525. Castle Kirchheim was finished in 1583, and the main features of the interior decorations by 1585, in time for a visit by Albrecht V of Bavaria's son and successor, Wilhelm V of Bavaria. The castle's modern highlight was the still celebrated *Zedernsaal* (the Cedar hall), created by Augsburg's best marquetery maker, made with intarsia from different types of globally sourced rare woods. Wood panelling covered most walls, while an 'Italian chamber' featured the finest leather wallpaper. It had cost 350 florins in materials alone. Rare collectors' objects filled three large rooms. A monumental fountain decorated the courtyard, featuring erotically entwined sculptures of Mars and Venus as a symbol of peace through the triumph of love. By 1587, a full-length marble tomb sculpture of Fugger dressed as a knight was finished for the chapel after seven years of planning. Two years later, Hans declared Kirchheim castle inalienable in his will; it was to commemorate him in perpetuity as a member of the imperial nobility on Bavarian territory, loyal to the Habsburgs and inspired by the art of the Medici.

All this documents Hans's determination to gain prestige by demonstrating aesthetic leadership through innovative building, sculpture, frescos, and woodworking techniques. All the same, his interest in paintings would only ever go so far.[7] Had Dürer still been alive, Fugger most likely would not have employed him. The commercialization of painting had hardly progressed, or even declined, in Augsburg. After Augsburg's noted portraitist Christoph Amberger died in 1562, no leading figure replaced him. The Reformation minimized demand for religious art. Depictions of the Virgin Mary, for instance, almost disappeared from Augsburg's Protestant churches. For many decades, Catholics in Augsburg trod carefully with any new commissions so as not to provoke iconoclasm.[8]

[7] See the comprehensively revisionist assessment by Dorothea Diemer, 'Hans Fugger und die Kunst', in Burkhardt, Karg eds., *Die Welt*, 165–76.

[8] Bridget Heal, *The Cult of the Virgin Mary in Early Modern Germany: Protestant and Catholic Piety, 1500–1648* (Cambridge University Press, 2007), 130–5.

Despite his wealth and connoisseurship, Marx Fugger likewise commissioned few contemporary religious and portrait paintings. A small altar for his domestic chapel depicted the coronation of the Virgin, just as in the Heller altar, but the piece was entirely sculpted from wood and stylistically imitated late Gothic art.[9] Old German paintings meanwhile decreased in value. When pursuing two panels depicting Adam and Eve by a German artist on Wilhelm V's behalf in 1575, Marx thus noted that any Italian work cost three times the price. Because the original buyer had paid 200 florins for the panels, his widow at first did not want to sell them for less than 170. She offered her Adam and Eve to a friend for 100 florins if he promised to personally keep them. Having received this information, Marx managed to negotiate the woman's offer down to 140 florins.[10] German painting looked a bad investment.

To acquire paintings that matched an aristocratic lifestyle and promised to keep their value, Hans Fugger needed to look to artists elsewhere. For example, take his exchanges about Pauwels Franck (1540–96), a painter influenced by Tintoretto who owned a workshop in Venice, where he was known as Paolo Fiammingo—'Paul the Flemish'. Hans Fugger worked with two generations of the Ott family who were merchants and financiers of German origin, based in the city on the lagoon. Brokering art was only a marginal side business for them, but they suggested Fiammingo's work to Hans.[11] Hence, on 23 July 1580, as he sought to decorate the upper floors of his newly built castle in Kirchheim, Hans Fugger confirmed that he was happy to acquire three of Fiammingo's paintings, the 'Triumph of the Sea' and 'The Triumph of Earth', which depicted 'a triumphal chariot with two lions', as well as the 'Triumph of Air' with 'various birds'. A final price needed to be agreed. If Fiammingo had set out a more ambitious intellectual programme, it was clearly lost on Fugger. The merchant frankly admitted that he could not understand the details he had been told about this 'Triumph del Aria decorated with various birds gliding in the air and then the Triumph de Focco with various kinds of metal'. What mattered to him was that this was a representation of the four elements on four separate panels of the size he wanted. Whatever the case, he instructed the Otts to acquire them.[12]

Hans was too practically minded to discuss inventive ideas with painters—generating ideas, in his view, was precisely their job. Just like Heller, however, he certainly valued evidence of diligent, proper, careful technique. One month after receiving the 'Triumph of the Sea', Hans Fugger reported that it pleased him. While he noted that he would enjoy more paintings of this kind, he also urged not to hasten the delivery of the rest of the cycle. Fiammingo was told to use the ample time he had been given to execute the

[9] Wölfle, *Kunstpatronage*, 55–7; on the more significant altar painting for the Andreas chapel on the passion see 91–4.

[10] Wölffle, *Kunstpatronage*, 20–2, 34.

[11] Sibylle Backmann, 'Kunstagenten oder Kaufleute? Die Firma Ott im Kunsthandel zwischen Oberdeutschland und Venedig', in Klaus Bergdolt, Jochen Brüning ed., *Kunst und ihre Auftraggeber im 16. Jahrhundert: Venedig und Augsburg im Vergleich* (Berlin, 1997), 175–97.

[12] Karnehm, *Korrespondenz*, II.1, n.1658, p.722.

panels with great 'diligence'. For Fugger, allowing 'ample' time meant completing the whole cycle within a few months. How many figures were painted on a painting and how varied they were continued to serve as evidence of the time a painter had spent and how much money a patron invested. This explains why Fiammingo and Ott stressed the inclusion of a great variety of exotic birds, to which the theme of four elements ideally lent itself. It moreover appealed to men such as Fugger who made a fortune from minerals and also laboriously sourced exotic birds, such as ostriches from Africa, or birds from the Americas, for zoos.

When Fiammingo and his workshop had finished the next two paintings in late October, the artist wrote a long letter to Hans Fugger in which he described further possible commissions. Yet Fugger now told Ott his agent that he was not keen on buying paintings over such a geographical distance. However, if Ott, and his cousin and artistic advisor Malipiero, liked them, he would take them. He received the 'Triumph of Air' in February, simply noting that he liked it well.[13] All of the series he ordered from Fiammingo for his palace in Kirchheim—'The Four Elements', 'Four Ages', 'Five Senses', 'Four Parts of the World' and 'Seven Planets'—showcased his interest in knowledge about the micro- and macrocosm, civilization, perception, and change.[14] Identically sized at 160 x 280 centimetres, they served as a backdrop on corridors in one of the upper floors of Kirchheim Castle which were not pannelled with wood and, it seems, led to rooms which displayed Fugger's cabinet of curiosities. Still, gilded deer heads with antlers served as more prominent wall decorations throughout the castle.[15] [15.1]

How much Fiammingo had been paid since July is not recorded, but when Hans Fugger contracted the Nuremberg portrait painter Nicola Nicolaj Juvenal in 1581, it was agreed that he would receive between 100 to 120 florins to stay in Augsburg for five to six months, in addition to free lodging and food for himself and a son who helped mixing paints and carried out other preparatory work.[16] Juvenal earned 5 florins per week. How do these prices compare? A Nuremberg maid at around the same time would be paid 6 florins annually in addition to food, clothing, and lodging, and a male servant twice as much. In 1577, Duke Albrecht of Bavaria paid half a florin for a fine watercolour of a spear that formed part of the imperial treasure, while an oil panel with 'well depicted trees'—perhaps by Albrecht Altdorfer—cost 4 florins in Nuremberg. Two pieces by Dürer—presumably woodcuts—were not even valued at a quarter of a florin. Guiccardini's brand-new Latin description of the Netherlands cost nearly 1½ florins.[17]

In his negotiations with painters, Hans Fugger was thus certainly mindful of market prices, reliability, and his own reputation. He increasingly insisted on contractual

[13] Karnehm, *Korrespondenz*, II.1, n.1772, p.772; n.1848, p.812.

[14] Andrew John Martin, 'Hans Fugger und die Zyklen des Paolo Fiammingos', in Burkhardt, Karg eds., *Die Welt des Hans Fugger*, 204.

[15] Maurice Sass, *Physiologien der Bilder: Naturmagische Felder frühneuzeitlichen Verstehens von Kunst* (Berlin, 2016), esp. 88–91; Georg Lill, *Hans Fugger (1531–98) und die Kunst* (Leipzig, 1908), 125–6.

[16] Karnehm, *Korrespondenz*, II.1, n.1824, p.799.

[17] *Willibald Imhoff, Enkel und Erbe Willibald Pirckheimers*, ed. Hans Pohl (Nuremberg, 1992), 261.

Fig. 15.1 Paolo Fiammingo and his Workshop, The Element of Water, oil on canvas, 1596, public domain.

settlements to avoid complications and conflict, and so as not to waste his time. 'Politeness and Cortesia' in the French style were not to his taste, Hans Fugger declared. Whenever he wanted a new employee his criteria were crystal-clear: they needed to be Catholic, pious, hard-working, quick, clean, and honest. He liked using the proverb 'an image can't be carved from any wood'. It reflected not only Hans Fugger's general belief in astrology but also his notion of talent—young scribes in the company evidently needed to be good linguists and be swift at copy-writing. Personal characteristics, he thought, manifested themselves during adolescence. Still, bad morals could erode honourable people, making them increasingly rough through drinking and whoring, and thus unsuitable to do business with.[18]

Just like Heller, Hans Fugger revealed himself as a shrewd merchant through keeping a sharp eye on people and enjoying a sense that he never paid over price. He liked getting things done. If they took too long, as with the major project of Sustris's fresco decorations for his house in Augsburg between 1569 and 1575, he felt unhappy. Hans Fugger indeed began to wish he had not even started on it. Expenses of around 10,000 florins across six years made him painfully 'feel his wallet', especially through the high

[18] Karnehm, *Korrespondenz*, II.1, n.1624, p.217; n. 318, p.139; n.1732, p.393; n.1751, p.761; n.1786, p.780; n.1788, p.780; n.1624, p.704.

salaries the painters Sustris and his companion Ponzano commanded—38 and 23 florins per month. Friedrich Sustris in fact unnerved him. He was a superior, a 'sharp' painter who nonetheless made slow progress, who liked going for walks and enjoyed leisure. Hans credited himself for working busily with 'unsparing diligence'; the contrast could not have been greater. Dealing with Sustris, he despaired, was akin to riding on a laggard horse.[19] After five years, Hans Fugger therefore employed a notary to set up a contract which agreed a very final sum that painters would be paid on delivery of their work. This would also be the last time he employed such a highly skilled painter.[20] For the altarpiece in the chapel of Castle Kirchheim, he contracted Wilhelm V of Bavaria's court painter for the modest sum of 150 florins to depict Mary's Assumption. This was despite the fact that the church was designated as his family's perpetual mausoleum.[21] By the 1580s, Hans Fugger relied on a small circle of artists he felt he could trust—not least in relation to their ideas about pricing.

Problems with transport, on the other hand, with which any merchant was familiar, were usually dealt with in good grace. When a consignment of caps and shirts arrived in disarray, Hans Fugger wished, he mildly informed his Antwerp agent, 'to receive goods undamaged', despite the argument that the carrier always packed them this way.[22] When a load of antiques, on the other hand, suffered breakage on its way from Venice, Hans told the Ott agents to take better care of packing, but, in response to their additional explanations, concluded that further considerations were useless and the damage simply needed to be repaired. He estimated that he needed a skilled Italian sculptor to spend one month in Augsburg, and asked Ott to negotiate pay and offer free food and lodgings. Hans was particularly pleased when the twenty-four-year-old Gerolamo Campagna arrived in 1574 without speaking a word of German and wanted to get the job done quickly. Campagna, a supremely talented sculptor who soon rose to fame, did in fact finish this task in just under a month and left Fugger so happy that he might have been paid in excess of the agreed fee. He used white marble from Innsbruck, and it is doubtful, following such a thorough restoration, that much of the original would in fact have remained 'visible' at all. Fellow sculptors rejected such jobs as cobblers' work.[23] Fugger did not mind. Campagna excitedly promised to create sculptures for Fugger in the future, with marble and other types of stone that even Fugger would have found difficult to source.[24]

Yet the merchant only once tried to follow up on Campagna's offer, uneasy about the fact that the artist would be able to exploit his lack of access to such materials in order

[19] On Fugger's appreciation by his brother Marx, see Karg in Burkardt and idem ed., *Die Welt des Hans Fugger*, 133: 'embsiger arbait und ungespartem fleiss'; Karnehm, *Korrespondenz*, III.1, n.496, p.624 for an appreciation of his 'sharp, beautiful work'; and Susan Maxwell, 'A Marriage', 722.

[20] Lill, *Hans Fugger*, 64–5.

[21] Lill, *Hans Fugger*, 149.

[22] Karnehm, *Korrespondenz*, III.1, n.623, p.274.

[23] Lill, *Hans Fugger*, 169.

[24] Karnehm, *Korrespondenz*, II.1, n.27, p.14; n.118, p.58, n.172, p.77.

180 *Ulinka Rublack*

to negotiate a high price.[25] Any expectation of seriously high prices for art, without much room for making deals, generally turned the merchant off.[26] In 1580, Hans Fugger moreover strictly told his Venetian agent that he did not require any sacred art, and did not wish to spend much money on pieces for sale by a local painter who had just died, probably a follower of Titian.[27] Inventive Italian approaches to religious themes easily caused misunderstandings in Germany. Hans Fugger wanted these subjects to be handled in an easily recognizable Catholic manner whenever necessary, and otherwise preferred new subjects of a more general kind. Moreover, the possession of contemporary Italian art did not confer much prestige on a patron in Fugger's circles—in fact, Duke Albrecht of Bayern, who ruled from 1550 until 1579, was 'hardly interested' in it or in contemporary Italian sculpture. Albrecht V did not spend much on court painters, nor did he employ many foreign painters. This Bavarian duke invested most of all in jewellery, antiquities, and his burgeoning cabinet of curiosities.[28] When in 1577 Albrecht V bought contemporary Netherlandish paintings he felt so uncertain about judging their quality that he consulted his son Wilhelm. Wilhelm replied that one of the painters appeared 'unspeakably industrious and very patient', and his work merited a place in the cabinet. Yet both father and son felt that they could only judge whether his 'art' matched his industry if he appeared at court.[29]

While Wilhelm was therefore keen to observe an artist at work, Hans was happy to save expenses by having them work remotely. In 1582, Hans Fugger therefore asked Juvenal to paint family portraits from his workshop in Nuremberg. When the painter requested the actual gown Fugger's sister-in-law was to be depicted in, Hans quickly replied that she was ill and also that it did not matter much as clothing changed every day. These portraits would have been commissioned to commemorate the family's elevation to the rank of Imperial Counts.[30]

This comparatively low-key approach to paintings contrasted with the considerable energy Hans Fugger invested in chasing up people for projects that interested him. Writing such letters steadily filled many of Fugger's hours. From 1574 onwards, he passionately collected medals of popes and wrote countless letters in pursuit of them. His collection, he noted, would be as rare and original as collections of medals of all emperors, which were currently very sought after. In fact, he hoped that it would end up being unique. Still, achieving a complete set of these medals mattered more than the question of who had made them and whether the medals were originals or imperfect copies—Hans employed local masters to work them up.

Such a collection most clearly represented his staunchly Catholic loyalties in a bi-confessional city during the period of the Catholic Renewal, to which he gave all

[25] Karnehm, *Korrespondenz*, II.1., n.528, p.220.
[26] Wölfle, *Kunstpatronage*, 211.
[27] Karnehm, *Korrespondenz*, II.1, n.1601.
[28] Dorothea Diemer, *Hubert Gerhard und Carlo di Cesare*, vol. 1 (Berlin, 2004), 49.
[29] Baader, *Renaissancehof*, 272.
[30] Lill, *Hans Fugger*, 134.

his support. Middlemen worked on his behalf and were well rewarded. His international information networks came into play, as also a merchant's ability to hear about and quickly respond to good opportunities. Auctions were among these. One of his former servants chased up missing medals in Rome when a cardinal's possessions were sold. Hans Fugger also kept track of competitors. Once he was told about a Netherlandish collector already in possession of 'pretty copies' of all popes, he nervously tried to find out the man's name.[31] Owning such a rare, special, complete, and very up-to-date collection of historical and contemporary relevance conferred tremendous prestige.

Yet the spectrum of prestigious goods was wide. As Dürer's own penchant for food delicacies showed, they were also coveted consumable commodities. A typical letter Hans Fugger sent to Venice reveals that, in the same sentence, he was equally concerned about the arrival of a portrait as well as two Parmesan cheeses and a *Salami di Cremona*.[32] His next letter repeated a request for 'good and fresh' ginger, sourced via Cologne and Antwerp. A barrel of 13½ pounds of it was to be shipped.[33] Two of Fiammingo's paintings arrived with truffles and asparagus seeds,[34] and another was sent all the way across the Alps—Fugger briefly referenced its weighty subject, 'The Age of Iron', and then immediately noted that the basket with *Salzizani* sausages had also arrived.[35] Any canvas would have travelled from Venice rolled up, sticky, smelling of fresh paint and varnish—in comparison to sausages, one might concede that it was not an obviously attractive item to be unpacked.

In fact, food and clothing expressed Fugger's idea of aesthetic leadership just as successfully, if not more so, than paintings by integrating international styles. They were integral to cultural developments at the time. For while Fugger loved meat, he also knew how to abstain from it in style. Some of his most taxing requests to the Venice agents concerned fresh fish as rarities from the Mediterranean during the period of Catholic fasting in Lent. He asked for sea spiders, crabs and sea urchins, caviar and gold bream. He once gorged on such delicacies, which had arrived 'almost' rather than truly fresh, and came down with food poisoning. He decided in future to abstain from them.[36] He then requested Ott in Venice to source marinated preserved fish, ordering fresh fish during cold Februarys only. By 1581, for instance, Hans Fugger joyfully reported that three types of fish had arrived still fresh. Elisabeth had liked the sea spiders so much that she now preferred them to any other fish, whereas previously she had never wanted them. He would be very grateful indeed if Ott could source further sea spiders before the weather turned warmer.[37] Hans Fugger's considerable energy helped

[31] Karnehm, *Korrespondenz*, II.1, n.1465, p.625.
[32] Karnehm, *Korrespondenz*, II.1, n.1935, pp.598–9.
[33] Karnehm, *Korrespondenz*, II.1, n.1938, pp.856–7.
[34] Karnehm, *Korrespondenz*, II.1, n.1772, pp.772–3.
[35] Karnehm, *Korrespondenz*, II.1, n.1942, p.859.
[36] Karnehm, *Korrespondenz*, II.1, n.1488, p.636.
[37] Karnehm, *Korrespondenz*, II.1, n.1870, pp.823–4.

182 *Ulinka Rublack*

to turn Augsburg into a cosmopolitan culinary centre with access to delicacies, and refined cooks and pastry-makers able to serve princely tables across the country.

Hans Fugger's letters therefore reflected daily conversations with cooks, servants, gardeners, pharmacists, and craftspeople. On many days, the Fugger kitchen, as in any other more major household, would have buzzed with attempts to cook *gentilezza*— more elegant food, if possible, prepared with newly discovered vegetables and spices. Hans's letters probably record the earliest potatoes grown and turkeys raised in Germany.[38] He employed a French gardener to look after flowers, but likewise sought out refined vegetable and herb gardeners to produce *gentilezza* and not just German fare. In 1561, the Fugger gardens displayed some of the first tulips imported from the Levant to be spotted anywhere in Europe, whereas Dutch merchants still mistook bulbs for onions in 1583, and it took another decade for serious Dutch tulip gardening to begin.[39] All of this required a great deal of attention and wide-ranging networks; in May 1577, Hans Fugger acknowledged the receipt of one pound weight of cauliflower seeds from his agent in Genoa. Having tried them out, alas, they did not look right.[40] He—and in all likelihood Elisabeth—moreover were extremely interested in creating new medicines from the latest ingredients shipped from China or Peru. Their Augsburg home contained a pharmacy next to the kitchen, and they developed a garden close to the city to use for relaxing entertainments and to cultivate a wide range of plants, many of them medicinal. This mattered not least because roots from different parts of the globe were increasingly marketed, and New World drugs that promised miraculous cures were profitable to the Fugger company. Iberian accounts of American plants highlighted guaiacum and sarsaparilla as potent cures and antidotes to syphilis. They presented the New World and its native peoples as a source of powerful medicines.[41] Yet in order to identify variants of drugs and their properties, merchants needed to access indigenous information about them, which remained difficult, or try them out and cultivate plants for careful comparison. Trying drugs out meant moving out of one's comfort zone. Information in books usually lagged behind newly available goods often disseminated through the Jesuits' growing global networks. The questions were many. Were marketed drugs authentic, powerful, and efficacious, and was it true that Bezoar stones from New Spain were better than those from the Portuguese 'Isles'? Were the Peruvian stones simply to be taken in larger quantities? Did they cohere with humoral theories about diet, even if they tasted bitter and caused heat, but were meant to dispel fever?[42] Hans Fugger liked to be in control of what medicine he took. We know that he once instructed one of his servants to go to a pharmacy to oversee the mixing of a medicine

[38] Karnehm, *Korrespondenz*, III.1, pp.31–2.

[39] Anne Goldgar, *Tulipmania; Money, Honor, and Knowledge in the Dutch Golden Age* (Chicago, 2007), 32–5.

[40] Karnehm, *Korrespondenz*, II.1, n.1106, p.480.

[41] Stefanie Gänger, *A Singular Remedy: Cinchona across the Atlantic World, 1751–1820* (Cambridge, 2021), 51.

[42] See also Dauser; on Bezoar stones, Karnehm, *Korrespondenz*, II.1, n.1648, pp.717–18; and the wider medical debates Alisha Rankin, *The Poison Trials: Wonder Drugs, Experiment, and the Battle for Authority in Renaissance Science* (Chicago, 2021).

that he had been prescribed by an Italian specialist. He enclosed the recipe. Everything needed to be properly done.[43] Unlike his older brother Marx, Hans Fugger was emphatically not a scholar, or a *mercator sapiens*, a 'knowledgeable merchant'. He did not attempt to mix humanist learning with new knowledge gained through trading networks. Although Hans Fugger occasionally engaged with new books, he was above all a practical, hands-on man. His idea of learning was based on doing, comparing, and experimenting. He did not look much to the past, and the achievements of past painters such as Dürer, for instance, but lived for the present and future.

Tailors and seamstresses worked in Hans and Elisabeth Fugger's home, as well as able spinners who span the fine flax and raw silk that the couple imported via Antwerp or Venice. They carefully chose different qualities and quantities of flax to purchase and once kept samples from Antwerp to compare them with the products that were eventually delivered. They noted that samples often promised better quality than the order delivered.[44] Hans Fugger witnessed how long it took and how much skill was involved in turning such delicate fibres into the finest regular threads before they could even be woven or sewn. He knew about the qualities of materials, with a schooled eye and keen sense of touch needed to evaluate them.

On their farm, Elisabeth deftly devoted herself to breeding animals of all kinds, including Italian hens and a whole herd of Swiss cows; the latter soon perished because the grass was so different to that of their native land. Fugger endlessly experimented with animal breeding and propagation, proudly sending the Bishop of Brixen two new types of swans the couple had raised, alongside instructions for what sort of nesting they required.[45] No detail was too precise. In June 1577, Hans Fugger instructed a caretaker of his farm to make sure that an Italian hen he was sending, alongside a cockerel, should be mated in the cool of a morning, the hen then to sit on up to fifteen eggs, while a maidservant was to observe her closely in the hope of chicks emerging.[46]

Making, growing, breeding, and trying new plants, and animals, as well as experimenting with materials proved integral to the active lifestyle with which a refined Renaissance merchant identified, and which connected him with novelties across the globe. This opened up trade, spread 'improvement', and developed civilizations. But such active engagements and experiences also had personal meanings. Focused activity was seen as vital for health. An active life kept the senses vigorous and expanded the intellect, as it ensured the right amount of body heat and vitality.[47] Colours were still seen to imbue specific kinds of vitality. Hans Fugger hence tried to source a specific 'subtle and burning' red to colour a wall to animate guests at dances; it was mixed by a

[43] Karnehm, *Korrespondenz*, II.1. n.1940, p.858.

[44] Karnehm, *Korrespondenz*, III.1, n.615, p.271.

[45] Karnehm, *Korrespondenz*, II.1, n.1104, p.479.

[46] All of this involved the couple in success and failure—the enormous sculptures for the fountain in Kirchheim would take ten years from the planning stage to complete and cost over 10,000 florins, and were completely out of the ordinary north of the Alps, Wölfle, *Kunstpatronage*, 174.

[47] Sandra Cavallo, Tessa Storey, *Healthy Living in Late Renaissance Italy* (New Haven, 2013), 184–5.

widow in the Bavarian town of Landshut.[48] Wonderful meals, drinking fine wine, listening to birdsong in gardens, smelling scents, seeing delightful sights, and wearing clothes in lovely colours, enjoying expensive horses, hunting dogs, and sporting were among the pursuits which were increasingly seen to resonate with the life of an active merchant as an elite gentleman. Medical writers opined that such activities put 'a man in a state of readiness for his business dealings'. Scholars and merchants particularly needed to cultivate them in order to cope with the highly competitive environment surrounding them.[49]

[48] Karnehm, *Korrespondenz*, III.1, n.400, p.174.
[49] Cavallo/Storey, *Healthy Living*, 184–5.

CHAPTER 16

In Style!

Yet Hans Fugger's letters suggest that efforts to acquire and optimize some of these goods were so tiresome that exhaustion might have countered their benefits. Chief among them were fine leather shoes and leather wallcoverings. Leather has not often been written about as a 'Renaissance material' and art, yet the demand for leather developed significantly in this period and so did the craft skills associated with its processing during the sixteenth century.

Leather wallcovering was a major new decorative product for which only the best leather and specialized, international craftsmen sufficed. Techniques of gilding leather wallcovering had been developed in the Ottoman Empire and North Africa, and had been advanced in Moorish Spain; they were subsequently adapted in Northern Italy, Flanders, and France. Calf-, goat-, or sheep-skin was prepared and covered with thin sheets of silver leaf. After further steps, a design was stamped, printed, or painted onto the leather, and sometimes layers of colour were added at this stage or the leather could be embossed with metal plates. Finally, yellow varnish was applied to simulate gold. Customers received their leather wallcovering in standard pieces measuring *c*.75 × 65 centimetres which needed to be sewn rather than glued together. Leather was valued for its cleanliness, and sixteenth century advances in painting and stamping techniques were spectacular. No paintings were hung on leather wallcoverings—rather, it replaced them to stunning effect. Gilding produced a sparkling, vibrant luminosity, and hence the sensation that a room glowed with gold and silver. Stamped moresque patterns provided a most appealing sense of texture and tactility. These effects were difficult to achieve with any other wallcovering material, and the same techniques were used to furnish chairs, settees, beds, and cover cushions.[1] Coats of arms, mottoes, and ornaments could be easily applied, and all these possibilities ensured the extraordinary success of this product. In Spain, Cordoba and its Moorish craftsmen stood at the centre of this trade up to their expulsion in 1610, producing around ten thousand pieces of leather wallcoverings annually.[2]

[1] Günter Gall, *Leder im Europäischen Kunsthandwerk* (Braunschweig, 1965).

[2] For instance, nineteen masters were paid to make 10,490 panels in gold and green for Philipp III, while the Vatican ordered 14,500 panels between 1608 and 1609 Waterer, *Spanish Leather*, 49.

Venice possessed seventy golden leather (*cuoi d'oro*) workshops during the sixteenth century and integrated distinctive oriental techniques, which made leather one of the republic's most significant export items.[3] Even so, Hans Fugger's acquisition of leather wallcovering from Venice initially proved a slow and costly process punctuated by failures. Hans Fugger's commissions, through his Venice agent David Ott, endlessly tested his patience. He had begun his enquiries in 1572, with the firm intention of acquiring gilded leather wallcoverings with grotesque or flower patterns for six to eight rooms in his Augsburg home. The sheets were costly and had to be paid for in advance, thus requiring high capital investment and considerable trust. As their execution depended on specific weather conditions, they took a long time to complete, while the standardization of measurements and leather surfaces was difficult to achieve. [16.1]

Hans Fugger knew that Duke Albrecht V employed a workman from Verona, along with three journeymen, to fit his leather wallcoverings. He nonetheless decided to order his own directly from Venice to achieve an even higher quality, especially as the patterns he received struck him as more impressive than those he had seen at the Munich court.[4] He insisted that a journeymen needed to be dispatched from Venice with the finished wallcovering.[5] The first load had arrived by August 1572, but was damaged by water, badly sewn, and did not correspond to the specified measurements or the beautiful pattern agreed. Hans Fugger feared they would look horrible when mounted.[6] Nobody in Augsburg was able to repair the water damage—the successful transporting of this luxury good completely relied on expert craftsmen travelling over the Alps.[7]

As Hans Fugger awaited the rest of the delivery, the wallcoverings turned into something he felt he needed 'urgently' in order to accommodate his honourable guests appropriately.[8] After sending ten reminders, Hans Fugger admitted that while he had 'always thought of local craftsmen as useless, now he realised that they were no better elsewhere'.[9] He resented the money he had paid in advance, and these difficulties put considerable strain on his relationship with the Ott agency.[10] Moreover, the first part of the order from Venice arrived with pieces of paper glued to the leather because the varnish had not completely dried when it had been packed. In fact they were nearly ruined.[11] Hans Fugger had ordered it for eight rooms, and the cost of just the final two loads of wallcovering amounted to the significant sum of over 314 florins.[12]

Hans Fugger decided that he needed access to the expert craftsmen at the Munich court after all. He discovered a new wallcovering-maker from Treviso in Italy who

[3] Anna Contadini, 'Middle Eastern Objects', in Ajmar-Wollheim/Dennis eds., *At Home in Renaissance Italy* (London, 2006), 319.

[4] Karnehm, *Korrespondenz*, III.1, n.705, p.312; n.658, p.289.

[5] Karnehm, *Korrespondenz*, III.1 n.721, p.318.

[6] Karnehm, *Korrespondenz*, III.1, n.834, p.364; n.837, p.365.

[7] Karnehm, *Korrespondenz*, III.1, n.848, p.371.

[8] Karnehm, *Korrespondenz*, III. 1, n.897, p.393, n.1149, p.505.

[9] Karnehm, *Korrespondenz*, III.1, n.1045, p.457.

[10] Karnehm, *Korrespondenz*, III.1, n.1174, p.513.

[11] Karnehm, *Korrespondenz*, III.1, n.994, p.435.

[12] Lill, *Hans Fugger*, 45.

Fig. 16.1 A sheet of Italian leather wallcovering, with pomegranate motifs, *c.*1560, 66 × 59 cm, Museumslandschaft Hessen Kassel, Deutsches Tapetenmuseum, Foto: Gabriele Bößert. This wallpaper transposes common motifs used on velvet to leather.

worked for Duke Albrecht and for the Archduke Ferdinand of Tyrol. By securing a well-connected wealthy man as godparent to one of the craftsman's children, Hans Fugger was able to secure his time and expertise to fit his new Italian leather wallcovering, appropriately in the rooms in which Albrecht V would reside when visiting Augsburg.[13] The craftsman started working once the weather had turned warmer, but predictably found the measurements of the Venetian leather inaccurate. He convinced Hans Fugger

[13] Karnehm, *Korrespondenz*, II.1, n.347, p.151; n.354, p.154.

that he would be able to produce superior leather panels, with which Fugger now planned to decorate ever more rooms.[14]

Leather was used for an astonishing range of products, ranging from gilded wallcoverings, cases, bags, book-bindings, furniture, cushions, shields, and saddles to fashion items including belts, gloves, doublets, hose, caps, and footwear. As we have seen, some leather working skills became embedded in local craft traditions across Europe through cultural exchanges with Moorish makers. Colonial trade increased the supply of raw materials through imports from the Hispanic Caribbean economy, where the decimation of the local population provided colonists with large pastures on which to graze the cattle whose hides provided the leather. As early as 1548, individual ranchers owned up to 42,000 heads of cattle.[15] By 1580, the merchant Simón Ruiz recorded the arrival of 75,000 hides on just one vessel from New Spain, which had shared their journey across the seas with cochineal dyestuff, linen, and silk.[16] Illegal trade far outweighed legal trade. Spanish leather, which early modern records frequently mention, was thus a global agglomerate rather than just a local quality product. Its name hid these global origins, despite the fact that hides had become significant in the economy of the Caribbean islands.

Clever city councils actively sought out those skilled in the leather and other luxury crafts. Since Dürer's visit, for instance, Antwerp had continued to turn into a booming centre of Atlantic trade, so much so that by 1549 it could be regarded as 'the metropolis of the world'.[17] Numerous new luxury industries had been introduced by the middle of the century, several of them of foreign origin.[18] A foreign shoemaker named Martin Gaillard was allowed to settle and was provided with a house and workshops near the horse market in c.1530–40 to introduce the fabrication of Cordovan leather; his successor Jean van Tricht was granted similar privileges.[19] Italians founded ateliers for glazed pottery, glass, crystal, and mirrors so productive that just one of them produced 11,000 mirrors a year in 1549.[20] These trades further specialized in a number of existing luxury and artistic crafts supplying an international market and led a Frenchman to complain that only 'superfluous, useless, fragile and pernicious' goods were manufactured in the

[14] Karnehm, *Korrespondenz*, II.1, n.360, p.155; n.372, pp.163–4; n.588, p.248.

[15] Frank Moya Pons, *History of the Caribbean: Plantations, Trade and War in the Atlantic World* (Princeton, 2007), 33–4. Various official documents mention annual illegal exports from particular places ranging between 50,000 and 80,000 hides by the last third of the sixteenth century.

[16] *Lettres marchandes échangées entre Florence et Medina del Campo*, ed. by F. Ruiz Martín (Paris, 1965), 55. On data for significant North African and Carribean imports to France from the seventeenth century onwards see Olga Willmer, *The Sun King's Atlantic: Drugs, Demons and Dyestuffs in the Atlantic World, 1670–1740* (Leiden, 2017), 84.

[17] In a contemporary foreigner's description see Peter Burke, *Antwerp: A Metropolis in Comparative Perspective* (Antwerp, 1993), 9.

[18] Hans Vlieghe, 'The Fine and Decorative Arts in Antwerp's Golden Age', in Patrick O'Brien et al. eds., *Urban Achievement in Early Modern Europe: Golden Ages in Antwerp, Amsterdam and London* (Cambridge, 2001), 185.

[19] J.A. Goris, *Étude sur les colonies marchandes méridionales (portugais, espagnols, italiens) à Anvers de 1488 à 1567. Contribution à l'histoire des débuts du capitalisme moderne* (Louvain, 1925), 27.

[20] Herman van der Wee, *The Growth of the Antwerp Market and the European Economy (Fourteenth–Sixteenth Centuries)*, vol. II (Louvain, 1963), 188, building on Goris, *Étude*.

city.[21] Learned people would have noted that this plagiarized Augustine's discussion of 'ars' in his *City of God*. The church father objected that, despite its many merits, 'ars' was 'superfluous, perilous, and pernicious' in focusing on worldly goods instead of spiritual transcendence.[22]

Shoes

Yet men of ambition, whether in Italy, Spain, the Netherlands, or Germany, used leather for home decorations and dress to convey their ideals of politics, manhood, and morality.[23] A persistent theme in Hans Fugger's correspondence over a number of years was his struggle to have well-fitting leather shoes in Spanish and Italian styles made for him in Antwerp.[24] Like other fashion items, perfect shoes of a particular kind constituted a visual act which displayed new materials and technologies.[25] For Hans Fugger they were no less complex and time-consuming to acquire than some paintings, and just like paintings they were returned if they did not please in style or fit in size.

Hans Fugger coveted fashionable shoes amongst Antwerp's new luxury fare. On 27 April 1568, he sent a letter to his Antwerp office agent Hans Keller with a pattern of a shoe for his wife and asked for several pairs to be made in this style.[26] These had already arrived by the 8 June; however, while fitting in length, they were too wide at the toe. The shoemaker was requested to make them smaller.[27] Later that month, Fugger wrote to Keller again, this time to order six pairs of white ornamented 'Porsequine' shoes, as he had 'used up' his old ones.

The term *Porsequine* referenced Moorish traditions which had first become fashionable among Spanish aristocrats during the late fifteenth century and were now adopted by international elites. These Moorish shoes and boots were called *Borceguíes*. They were prestigious goods because of their association with superior equestrian skills and the nobility of those who wore them. Riding demonstrated sovereignty and defined social identities. In Spain, sixteenth-century aristocrats and other Christian elites hence took to dressing up in Moorish attire to ride in light armour *a la jineta* in the so-called game of canes. This was a popular and highly prestigious tournament associated with Moorish equestrianism, requiring fast manoeuvres and speed. Only a short stirrup was used, which required great bodily control. Moorish attire was often handed out to

[21] Wee, *Growth*, 187, fn.248: 'bifferies et choses superflues, inutiles, dommageables et pernicieuses'.

[22] See Douglas Biow, *On the Importance of Being an Individual in Renaissance Italy: Men, Their Professions and Their Beards* (Philadelphia, 2015), 31.

[23] Elizabeth Currie, *Fashion and Masculinity in Renaissance Florence* (London, 2016), 12.

[24] This material was first used selectively by Saskia Durian-Ress, *Schuhe. Vom späten Mittelalter bis zur Gegenwart* (Munich, 1991).

[25] Ulinka Rublack, *Dressing Up: Cultural Identity in Renaissance Europe* (Oxford, 2010), 238–41.

[26] Karnehm, *Korrespondenz*, II.1, n.220, p.98.

[27] Karnehm, *Korrespondenz*, II.1, n.226, p.100.

Fig. 16.2 One of a pair of *Porsequine* shoes, leather, c.1590–1600, Spanish (?), length 22 cm, width 6.5 cm, height 7 cm, Bavarian National Museum, Munich, I 7–44.

participants and established their elite status.[28] *Borceguíe*-style buskins were made from soft, light-weight Cordovan leather. They varied in length, but were exceptionally tightly fitted to the foot and leg, and usually decorated with ornamental openwork in the Iberian Muslim tradition. [16.2]

Such elegant but durable openwork on paper-thin leather proved extremely difficult to achieve, not least in fit. Techniques employed by specialized Muslim and Iberian makers needed to be translated. Yet Hans Fugger was impatient to adopt this style. He ordered one or two pairs of these *Porsequines* from Antwerp via the fastest and most reliable postal service, the weekly *Ordinaripost*, which took six days from Antwerp via Brussels to Augsburg. As for the decoration, he provided precise instructions: these shoes were not to be slashed with long cuts in the front but pinked with very short incisions. Otherwise they split after a short period of usage, which looked really bad—'*übel*'.[29] In further letters to Keller, written in June and July 1568, Hans Fugger mentioned that he was waiting for these shoes to arrive, and had only received one pair for his

[28] See Javier Irigoyen-Garcia, *Moors Dressed as Moors: Clothing, Social Distinction, and Ethnicity in Early Modern Iberia* (Toronto, 2017), 8, 46–8.

[29] Karnehm, *Korrespondenz*, II.1, n.238, p.105, and the full quote in Dürian-Rees, *Schuhe*, p.20; on the postal service see Dauser, *Informationskultur*, 126.

wife.[30] Because of the dangerous roads frequented by robbers he expressed further worries about whether the second pair of the shoes he had ordered for his wife were on their way from Antwerp, while renewing equally lengthy efforts to acquire one or two Indonesian parrots via Lisbon.[31] Despite these difficult conditions, all the shoes had arrived by early September.[32]

Writing in late October to Keller, Hans Fugger noted that as 'winter was on the doorstep' he needed three or four pairs of shoes made from good, strong leather. He wanted them black on the outside and white on the inside, with double soles, one of them turned inside and the other outside, as the Antwerp shoemakers knew 'how to make them with great elasticity' —'geschmeidig'. These shoes were not to be slashed, and to be made wider, so that he could wear thicker hose with them. If possible, they should be sent as fast as possible.[33]

When they arrived in the middle of November, however, Fugger was greatly disappointed. The shoes did not fit. The leather was too thick and the boot too narrow. He asked the shoemaker to considerably widen those which had not yet been sent, and to use the right leather for them, otherwise he would be unable to wear them.[34] One month later, Hans Fugger had received new and fitting models, even though this time he found them lacking in elegance. It was just beginning to be terribly cold, yet Fugger surprisingly requested a further pair of shoes with small pinked perforations.[35] In May 1569, he asked for two pairs of black *Porsequines* made from smooth leather, one of them with double soles. They were to be made from good elastic leather, not 'broken through' in any way, as well as being 'wide and comfortable to put on'.[36] He acknowledged their safe arrival in June, while taking the opportunity to request fabric that needed to be sourced from Granada to make coats in the manner of Spanish women.[37] Two further pairs of shoes were ordered in July; these were to be slightly narrower at the front of the foot and to have lighter soles.[38]

In the coming years, Hans Fugger ordered shoes which had neither slashed decoration nor ribbons for tying, in black as well as white, and, if possible, made from the smoothest leather available in Antwerp. These were ordered along with canary birds, a lark, and parrots, as well as diamonds and a paternoster, tablecloths, handkerchiefs, and shirts.[39]

[30] Karnehm, *Korrespondenz*, II.1, n.245, p.108; n.255, p.112; n.268, p.118.
[31] Karnehm, *Korrespondenz*, II.1, n.275, p.122; n.288, p.127.
[32] Karnehm, *Korrespondenz*, II.1, n.300, p.132.
[33] Karnehm, *Korrespondenz*, II.1, n.311, p.136.
[34] Karnehm, *Korrespondenz*, II.1, n.320, p.139; n.321, p.140.
[35] Karnehm, *Korrespondenz*, II.1, n.333, p.146.
[36] Karnehm, *Korrespondenz*, II.1, n.434, p.188.
[37] Karnehm, *Korrespondenz*, II.1, n.446, p.192.
[38] Karnehm, *Korrespondenz*, II.1, n.456, p. 197.
[39] Karnehm, *Korrespondenz*, II.1, n.519, p.224; n.524, p.227; n.535. 231; n.551, p.239; n.556, p.241; n.623, p.274; n.631, 277.

192 *Ulinka Rublack*

Footwear became a design item of great interest during the sixteenth century. Ladies' shoes were only partly visible under floor-length dresses worn at the time.[40] This perhaps explains the allure attached to feet and shoes in that erotic bestseller Dürer had looked at, the *Hypnerotomachia Poliphili*, or *The Strife of Love in a Dream*. Its description of the nymph's footwear feasted on details of luxurious, subtle, and inventive craftsmanship to create an atmosphere in which sophisticated making fed the senses as much as the mind:

> Some of them had their little feet shod with purple boots…magnificently decorated with precious stones and laced with gold and silk. Some, with voluptuous vanity, had clothed their bare feet with scarlet silk slippers. Many were shod with half-boots of gilded leather embossed with many elegantly executed reliefs. Quite a number wore sandals of pink leather with gilded eyelets, exquisitely adorned with moon-shapes or recurved openings, while from the sole came thongs that made the most novel and amazing ties, tongues and straps that could ever be described, of blue-grey silk and gold filaments, knotted around the plump ankle with such beautiful and graceful entanglements as the mind could ever conceive.[41]

While women concealed their legs and knees, men displayed their legs at least from below the knee, and their shape fundamentally constituted masculinity, beauty, and rank.[42] Men's footwear thus was exceptionally prominent in everyday life and was further highlighted by the new genre of full-length portraiture. Cosimo I de Medici (1519–74) owned at least sixty pairs of boots, half of which were made of cordovan leather. In 1562, aged twenty-one, his son Francesco de Medici owned two hundred pairs of shoes, mules, long and short boots, including thirty pairs of fine, short boots, which were often white and pinked.[43] Fugger would have admired a selection of these at Francesco's wedding.

He moreover shared his own passion for shoes with Duke Albrecht V's son, the youthful crown prince Wilhelm of Bavaria (1548–1626, r. 1579–97). In 1572, Fugger advised the crown prince to buy twenty pairs of Italian ladies' shoes from Genoa and sent Wilhelm a pattern he had brought home from Italy many years earlier to show how beautifully slippers and shoes were perforated in Rome. This confirms that supreme, courtly elegance was associated with Spanish as well as Italian shoes, typically ornamented through cuts in their material. Knowledgeable merchants such as

[40] That such fashions became equally important for urban elites is documented by an extant shoe similar to Pl.16.2 which was used by one Margareta Völker of Nuremberg at her wedding in 1594, *Germanisches Nationalmuseum Nuremberg*, Inv. T.44.

[41] Francesco Colonna, *Hypnerotomachia Poliphili, The Strife of Love in a Dream*, transl. Joscelyn Godwin (London, 1999), 334; this is one of many passages describing footwear.

[42] Rublack, *Dressing Up*, 18.

[43] Between 1563 and 1565, Francesco received a further twenty-five pairs of knee-high boots from just one shoemaker, many of them of white cordovan leather, see Roberta Orsi Landini, *Moda a Firenze 1540–1580: Cosimo I de Medici's Style* (Florence, 2011), 34, 162–3. See also Jutta Bäumel, June Swann, 'Die Schuhsamlung der Dresdner Rüstkammer: Ein Überblick über die Geschichte und deren Bestand', *Zeitschrift für Waffen-und Kostümkunde* (1996), 3–34.

Hans Fugger functioned as key figures in 'cultural transfer—as distributors not only of cultural artefacts and products throughout Europe, but also of people, ideas and taste'.[44]

In providing practical advice on fashionable ready-wear, Hans Fugger took care to warn Wilhelm that any shoes from Genoa would take a long time to arrive.[45] He himself continued to order from Antwerp, despite the fact that in May 1572, for instance, he found another pair of white *Porsequine* boots too uncomfortable to wear as they did not reach his knee and were too short around the lower thighs.[46] In August that year, he was waiting for two pairs of white shoes.[47] When he received them three weeks later, he told the agent that they fitted, but that in future he needed stronger leather at the front as this part of the shoe broke easily when it got wet.[48] This underlines Hans Fugger's preference for delicate as well as reasonably durable craftsmanship; shoes for him were not disposable commodities. The agent acted as intermediary between client and craftsman to pass on such expectations, information about what happened to objects in use, and suggestions about how to customize and improve them.

In October and the following March, May, and June more pairs of white *Porsequines* were ordered or finally arrived; and those for the summer were meant to be particularly smooth at the front of the foot because Hans Fugger wore lighter linen socks with them.[49] This requirement for smooth leather became even more acute for elite men wearing costly silk stockings, usually ordered from Italy, to extend their use. Riding boots, by contrast, had to be made wide enough to allow for boot hose to protect stockings from waxed leather. Thinking ahead to winter, Fugger in October once more began to consider solutions on how to protect his winter shoes. As he was mourning a family relative, he needed two pairs of black shoes, but open at the side, to be laced and with a single sole. Yet to make them more durable he asked for a pair of slippers to wear as overshoes, '*Pantoffeln a la Portuguesa*', which he would order more of if he liked them. He also noted that he had seen that Spaniards had black boots made 'à la gineta', referencing once again the Moorish riding style practised by Spanish noblemen in the game of canes.

Hans Fugger had seen these lightweight shoes with single soles and models which were also worn with slippers as overshoes. He assumed that his shoemaker would know about these Iberian models. He requested a pattern for the overshoe, even though he imagined they might be somewhat 'wide and not smooth' to wear, but useful for periods of mourning and winter.[50] In November, however, he instructed his new Antwerp agent, Philipp Römer, not to send overshoes, as they would be damaged by

[44] Marika Keblusek, 'Mercator Sapiens: Merchants as Cultural Entrepreneurs', in Marika Keblusek, Badeloch Vera Noldus eds., *Double Agents: Cultural and Political Brokerage in Early Modern Europe* (Leiden, 2011), 95–111, and for the quotation idem, 'The Embassy of Art: Diplomats as Cultural Brokers', in the same volume, 25.

[45] Karnehm, *Korrespondenz*, II.1, n.639, p.280.

[46] Karnehm, *Korrespondenz*, II.1, n.753, p.329.

[47] Karnehm, *Korrespondenz*, II.1, n.808, p.254.

[48] Karnehm, *Korrespondenz*, II.1, n.828, p.363.

[49] 'Leinwand', Karnehm, *Korrespondenz*, II.1, n.1018, p. 445.

[50] Karnehm, *Korrespondenz*, II.1, n.1184, p.518.

194 Ulinka Rublack

the postal service; he would have them made locally.[51] By 24 November, Fugger feared that the shoes themselves might not arrive before the end of winter.[52]

Yet the shoes which finally arrived from Antwerp in early December proved a complete disaster. Fugger complained that the leather was bad, the craftsmanship hasty (*Huderwerck*), and they disintegrated after first use. They had been far too narrow over the knee, so that he had hardly been able to take them on and off. He asked for wider shoes, better leather and laces, with single soles. They were to be delicately perforated with a pattern, but not to be *zerflaischt,* sliced up, like these. In addition, he requested two pairs of shoes without patterns and single soles from Moroccan leather, just like the ones he had bought before.[53]

The perennial problem was dirt, which spoilt fashionable white shoes. Augsburg, like most cities, was only partly paved, while urban shoe- and stocking-cleaners had not yet developed as a profession. This was true for most European cities. Hans Fugger's contemporary Felix Platter thus experienced complete embarrassment when he took a girl to a ball while studying in Montpellier during the 1550s: when walking past a dung heap, he regretfully noted, 'wishing to give her the best side of the street, unhappily I put my foot in the mud and splashed her from head to toe with filthy water. I was quite confused and dismayed when a friend who was with us went ahead and announced that I had offered holy water to my fiancée'.[54]

Equally, there was the question of what to wear while residing on estates in the even muddier countryside. Waterproof shoes had not yet been invented. Pattens with a wooden base had been designed in the Middle Ages to deal with such problems, but were now deemed too common. In 1575, Hans Fugger recalled having seen Crown Prince Wilhelm in overshoes with double soles, and Fugger himself preferred to wear such a model over simple white shoes, in preference to the high Iberian-style slippers. He asked a middleman at Crown Prince Wilhelm's court whether the ducal shoemaker might make up some of these overshoes for Fugger when he had time.[55] He deemed the matter sufficiently important for him to request this favour.

Indeed, Hans knew that Wilhelm's Milan agent Prospero Visconti had just facilitated the appointment of a young Italian shoemaker called Battista Canobio in November 1573 at the Munich court. Visconti recommended Canobi as a virtuoso craftsman, '*molto virtuoso e dabbene*', so that Canobi's multiple requests for special conditions concerning

[51] Karnehm, *Korrespondenz*, II.1, n.1217, p.532.

[52] Karnehm, *Korrespondenz*, II.1, n.1225, p.537.

[53] Karnehm, *Korrespondenz*, II.1, n.1236, p.542. By the end of the month, better shoes had arrived, though he was still waiting for those to be worn with overshoes, n.1251, p.549. In 1574, he requested two pairs of white, slashed (*zerhackten*) Porsequines, Karnehm, *Korrespondenz*, III.1, n.100, p.51; on 25 May, he wrote to say that he had received one pair which had slashes at the lower thigh. This was to be avoided in future because the leather was so easily damaged, II.1, n.112, p.55; in August, he asked for three pairs of white slashed shoes alongside two leather belts as he had received before, n.188, p.83.

[54] *Beloved Son Felix: The Journal of Felix Platter a Medical Student in Montpellier in the Sixteenth Century*, transl. and ed. by S. Jeanett (London, 1961), 50.

[55] Karnehm, *Korrespondenz*, II.1, n.396, p.168; with a reminder on 14.IV.1575, p.174.

his remuneration at the Munich court appeared wholly justified. Prospero also arranged for leather to be sent from Italy for Canobi to work with, including 'the kind for *borzachhini*'—for *Porsequines*.[56] The shoe collection from different parts of the world that was assembled for the cabinet of curiosities in Munich hence resonated with resourcing the most advanced contemporary design. It generated communities of shared taste and sense. These interlinked with ideas about civilized delicacy and manliness expressed through perfumes. In 1574, Prospero Visconti sent Crown Prince Wilhelm two samples of leather from which to construct a leather doublet as upper garments, one perfumed with amber and musk and the other with a scent of Spanish jasmine.[57]

Meanwhile Hans Fugger continued to order riding boots from Antwerp, which he requested to be smooth, as always, with double soles for durability, one with 'rings' at the side, the other, more urgently, without these rings,[58] as well as three to four pairs of simple shoes made from black Moroccan leather without perforations. In November 1575, he asked for three more pairs of white shoes.[59] The quality of white leather turned out to be extremely uneven,[60] but at the beginning of 1576 Hans Fugger optimistically wrote that he had heard great things about the Antwerp shoemaker Jost's young son, whose craftsmanship was said to improve daily.[61] This suggests that virtuoso international shoemakers might even have been known by name, and their skills discussed among discerning customers and agents, just as in the case of the best painters. Yet Hans Fugger by now also affirmed that he did not want his shoes to be too artful in ornamentation. He requested further white, pinked *Porsequines*, which were to be made as knee boots but not to be pinked in cross patterns over the lower thighs and shins. [16.3]

Hans Fugger feared that pinking made them break easily and moreover looked too 'flirtatious'. He was now aged forty-five, which for contemporaries signalled the beginning of old age rather than mid-life.[62] Moreover, trade via Flanders was becoming increasingly difficult. In response to the success of Calvinism in the Low Countries from 1566, the Duke of Alba (1507–82) launched his 'Spanish Fury'. Mechelen and other cities were violently sacked. Hans Fugger was appalled by how Spanish forces conducted themselves. Troops brutally plundered Antwerp, forcing the Fuggers to close their office and shift more business to Cologne. It was as if their own loans to the Spanish Crown had helped to finance a drawn-out war that now hurt their own business. To add insult to injury, his orders for shoes were jeopardized as no sustained peace was in sight. The white ornamented shoes he ordered in July 1577 were the last for a long

[56] H. Simonsfeld ed., *Mailänder Briefe zur bayerischen und allgemeinen Geschichte des 16. Jahrhunderts* (Munich,1902), 315, 317–18, 530.

[57] Simonsfeld, *Mailänder Briefe*, 330.

[58] Karnehm, *Korrespondenz*, II.1, n.440, p.185, with a reminder on 24.V.1575, p.199, and further reminders on 7.VI.1575, p.206 and 29.VI.1575, p.218. The first pair had arrived by July 1575, p.228.

[59] Karnehm, *Korrespondenz*, II.1, n.509, pp.212–13; n.645, p.283.

[60] Karnehm, *Korrespondenz*, II.1, n.684, p.300.

[61] Karnehm, *Korrespondenz*, II.1, n.701, p.306.

[62] Karnehm, *Korrespondenz*, II.1, n.809, p.351.

Fig. 16.3 Page from Hans Weigel, Trachtenbuch, Nuremberg 1577. An Italian courtier with tight, elegant Porsequine boots, pinked in a pattern Fugger associated with a flirtatious disposition. © The Master and Fellows of Trinity College, Cambridge.

while, and came with a sack of canary bird seeds, decorative trimmings for shirts, and instructions to watch the price of sugar.[63] The next letter about Hans Fugger's *Porsequines* was sent to Cologne after a gap of six years, in 1583. It concerned an experiment, and, alas, the *Porsequine* boots that resulted were too tight around the knee.[64] He ordered further pairs from Cologne in the following year, as well as a damask tablecloth, knowing full well how difficult it was to find safe routes to deliver goods.[65]

Most of Hans Fugger's other instructions about his clothing, and hence how he constructed his appearance, are lost because he would have talked personally to local tailors and other craftspeople. This makes a letter Hans Fugger wrote from his country estates to an Augsburg servant especially rare. Writing in November 1576, he confirmed receipt of several patterns of silk fabric and reported that the one wrapped in paper pleased him most. He returned it with the instruction to 'sew the doublet'—the upper garment—with this silk 'at the front and all around'. The buttons were to be made half from this silk fabric and half with gold thread, in the manner he 'himself had told Master Georg, the tailor'. This level of involvement and visual awareness seems truly remarkable for a man uninterested in discussing paintings.

Hans Fugger's shoes were not ready-made but emerged from a collaborative craft and design effort between him, his agent, and the shoemakers. The emotional core of craftsmanship lay in tolerating high levels of frustration, pushing the capacity of materials and new methods of doing things with them. Hans Fugger spurred innovation by picking up on particular fashions he had observed, while also furthering product refinement through feedback on how these shoes behaved when used. Footwear was exchanged through postal services and payments, and he valued it as an important part of his wardrobe, to withstand different weather conditions, to observe etiquette in mourning customs, to signal elegant sophistication, and simply to walk in comfort.

Up to the late 1570s, Hans Fugger looked for yet further specialization that his Augsburg tanners and shoemakers were able to provide. Spanish leather was mostly shipped from Antwerp to Cologne and North Germany.[66] Hans Fugger thus provides us with an example of one South German international customer hoping to source both high-quality material and manufacture via Antwerp. His most persistent concerns were with suppleness and softness, which one contemporary likened to silk, as well as with the visibility of whiteness and the delicacy of perforations in the *Porsequine* style associated with the equestrian Spanish-Moorish fashion. Pinking and slashing techniques aggressively tested the structure of materials. Yet this dramatic texturing on a delicate surface appealed to both sight and touch. On cloth, every slash or hole would need to be sewn at the edges to avoid fraying. In fine leather shoes, this was far more difficult to achieve because of their great propensity to crack, loose shape, or disintegrate.

[63] Karnehm, *Korrespondenz*, II.1, n.1137, p.491. On the closure of the office see Häberlein, *Die Fugger*, 103.

[64] Karnehm, *Korrespondenz*, II.11, n.2409, p.1091; n.2424, p.1099.

[65] Karnehm, *Korrespondenz*, II.11, n.2447, pp.1109–10.

[66] Donald J. Harreld, *High Germans in the Low Countries: German Merchants and Commerce in Golden Age Antwerp* (Leiden, 2004), 167–8.

Footwear might also immediately fall apart in rainwater if the leather had not been sufficiently fed with fats and oils after immersing the leather in salt and alum. Just like human skin, well-fed leather gleamed rather than appeared dry and dull. Feeding was a sort of sophisticated cosmetic treatment for animal skins. Just as in facial cosmetics, innovative work with Spanish leather depended on great experience of ingredients and what they were 'apt and good for', relying on complex chemical balances and experiments with collagen.[67]

Italian and Spanish styles mattered most to the Fugger family as a means to demonstrate its loyalty to the Habsburg Emperors who had ennobled them. From 1576, Hans's aim was to gain the support of the newly elected, twenty-four-year-old Emperor Rudolph II (1552–1612). He and his brother wanted to be elevated to the rank of an imperial count and lord—and thus placed higher than imperial knights. This would lend them social recognition of a type unprecedented for the heirs of a humble weaver. Rudolph II of course would join the list of Marx's and Hans's significant creditors.[68] In addition, as we have seen, the Fugger brothers were closely connected to the Bavarian court, which stood at the forefront of a Catholic cultural renewal in the German lands and received regular payments from the Spanish Habsburg king Philip II.[69] These political and confessional associations further explain why a man like Hans Fugger invested so much time, thought, and money in his choice of finely worked footwear, why he needed so many pairs of shoes, and why he carefully monitored developments in overshoes. Through the lens of anthropology, we can see that different types of materials and objects derived much of their meaning from how they functioned in a network of social relations. As he walked the streets, his Spanish leather shoes functioned as another means of claiming imperial nobility in ways which had specific connections to the Fuggers' trade links, fashion knowledge, politics, and the Catholic faith. It made Hans Fugger behave and feel in specific ways. Leather was one of the materials which was newly valued in this period and crafted in particular ways to command visual attention. The material associations of soft leather with tactility and smoothness animated the notion of the contoured muscular body; it was a second skin that signalled and controlled manhood as much as indicating sophistication. The association of a *Porsequine* design with superior equestrianism created further cultural associations. All this helps explain the social and emotional work a specific material or object could animate in the context of its time, and why it proved more vital to Hans Fugger than painting.

Stylish dress was one of the most effective statements of status for imperial noblemen. It also constituted immense material value. After Hans Fugger's relative Georg

[67] For Paracelsus' discussion of what materials were 'apt and good for' see Baxandall, *The Limewood Sculptors of Renaissance Germany* (New Haven, 1980), 48.

[68] Stefan Grüner, *Mit Sitz und Stimme. Die Erlangung der Reichsstandschaft durch die Familie Fugger auf dem Augsburger Reichsstag von 1582* (Augsburg, 2017).

[69] Philipp's extensive German network, especially dense between 1560 and 1580, has been documented by Friedrich Edelmayer, *Söldner und Pensionäre. Das Netzwerk Philipps II. im Heiligen Römischen Reich* (Munich, 2002).

Fugger died in Augsburg in 1572, two furriers and one tailor, a beret maker, and a smith carefully valued his dress and weapons. The total value of Georg's wardrobe, excluding jewellery, exceeded 4,000 florins. Only expert craftsmen knew how to separate a wardrobe of this kind into lots of equal value, to be distributed among Georg Fugger's five sons.[70]

[70] Beatrix Bastl, *Das Tagebuch des Philipp Eduard Fugger (1560–1569) als Quelle zur Fuggergeschichte: Edition und Darstellung* (Tübingen, 1987), 334–55, 374–9.

CHAPTER 17

Spending on Style

If Dürer's journal shows us how artists could behave more like merchants, the Fugger sources therefore show how discerning merchant families might be involved artistically as they co-designed innovative art through their bespoke commissions. Headwear was as important an accessory as footwear in creating an impressive visual display. Just as in the case of fine cordovan leather and Moorish traditions, the prominence of feathers in fashion was an innovative Renaissance craft stimulated by cultural exchange with the Ottoman world and with the Americas. In 1480, few Europeans were depicted wearing feathers, yet within decades they became prestigious accessories, indispensable to the achievement of a military as well as an elegant look. Dürer, as we have seen, belonged to the first generation of Europeans fascinated by the natural colours of birds and the dexterity of American feather workers. Dyeing feathers in multiple colours and crafting them into intricate shapes turned into a major sixteenth-century European fashion trend shaped by male as much as female taste communities.

Crafting feathers held many challenges. Although their chemistry was similar to hair, the materiality of feathers was unique within the early modern world: Europeans were struck by the lightness, softness, stability, looser or denser structure, movement, lustrousness, translucency, colour intensity or patterns intrinsic to many types of feathers. There was much knowledge needed to work them. A long peacock feather required different techniques to craft compared with that of an ostrich feather, or the light, flowing head plumes of an egret heron, or the tiny feathers of hummingbirds. Each could be manipulated by makers and wearers through bleaching and specialized dyeing techniques, cutting, gluing, or layering, starching, stitching, and straightening. Some arrangements looked voluminous and sculptural, others purposefully negligent. Each generated emotional effects.[1]

Hans Fugger's thoughts thus naturally turned to feathers and hats as he prepared for his entry to the Diet of Regensburg, which would elect Rudolph II to succeed his father Maximilian II as Holy Roman Emperor in 1576. He ordered twelve 'Saxon hats from clean wool' at the soonest for his servants, adding they 'must be of the new fashion (*new Manier*), the brim a bit smaller and a bit lower over the head, just as it now tends to be

[1] Rublack, 'Befeathering the European'; see also Stefan Hanß, 'Making Featherwork in Early Modern Europe', in S. Burghartz, L. Burkart, C. Göttler & U. Rublack eds., *Materialized Identities: Objects, Affects and Effects in Early Modern Culture, 1450–1750* (Amsterdam, 2021), 137–185.

made'.[2] The hats came in different colours and were to be adorned with feathers, a style Hans Fugger associated with the courageous, as well as disciplined, spirit of horse-riding—he enjoyed them looking *reiterisch*. In November, he personally inspected a delivery of two hundred loose black ostrich plumes and two samples of bound panaches in the 'current Saxon manner' that came in from Nuremberg. Writing to his servant in 1576, he furthermore requested a small hat made from grey cloth, and in a postscript added that the servant was to ask the hat-maker whether he would be able to craft the hat in the same manner as seen on 'Ilsung', an imperial official he knew well. He would await a report on this matter.

Finally, Hans Fugger ordered matching leg garments. His tailor was to be sent a sample of the grey cloth, ideally an identical or similar fabric to match the hat that might need to be sourced at the Frankfurt fair.[3] This confirms the considerable efforts that were made to create unified ensembles for men. Expert tailors needed to be aware of, and be able to imitate, what was worn by other elite men, and to source the right materials through national and global supply chains. Parrot feathers were sourced from the Americas, the finest heron feathers from the Ottoman Empire, and ostrich feathers from Northern Africa, where indigenous populations skilfully hunted wild birds in challenging natural environments.

During the 1560s, Augsburg's and Nuremberg's cultures and economies were shaped by the interaction among merchants and aristocrats such as Hans Fugger, who imported such luxury goods, rulers such as the Wittelsbach who employed some of Europe's foremost artisans at their courts to process them, local artisans, and an entire network of collectors, agents, and connoisseurs, who saw materials used in global artefacts and encouraged cross-cultural learning. This fusion was unique to globalized cities at the nodes of trade and was characterized by cultural brokerage, craftsmanship, and fashion-conscious male and female clienteles. In the new specialized craft of feather-making, Nuremberg retained an edge over Augsburg, because specialized feather-makers had successfully developed their trade in the city since Dürer's time. Hans Fugger hence wrote a letter in November 1575 to his Nuremberg agent to let him know that no Augsburg maker was able to bind feathers as well as the samples he had been sent from Nuremberg. He requested twenty-four full feather panaches from Nuremberg to be delivered within ten days at most.[4] Each panache required about twenty ostrich plumes, as multiple layers of feathers were stitched together to create a luxurious, sensuous feel. The 'new manner' in a fashionable Saxon style mattered so greatly that on the 17 November Hans Fugger returned an unsatisfactory batch of feathers offered to him from Munich.[5] Over the years, he sent patterns for hats he wanted to have made and accessorized, received soft Saxon hats from Leipzig via Nuremberg, and each time noted

[2] Karnehm, *Korrespondenz*, II.1, n.689, p.302.
[3] Karnehm, *Korrespondenz*, II.1, n.944, p.414–15.
[4] Karnehm, *Korrespondenz*, II.1, n.598, p.262.
[5] Karnehm, *Korrespondenz*, II.1, n.589, p.249; n.618, p.260.

how much their feathers pleased him.[6] In January 1578, he likewise enthused about the 'incredibly beautiful and delicate' material of further Nuremberg hats he was sent.[7]

High-quality plumes from the Ottoman world used for male headwear ranked among the most exquisite rarities which were particularly difficult to source. Even for Hans Fugger, procuring them could turn into a guilty pleasure. In January 1585, he wrote to David Ott in Venice, remembering that he had once sent a panache of heron feathers to him, which in their length and beauty had not been perfect. He would be pleased, Fugger noted, to receive eighty to one hundred of the 'really long, delicate and beautiful' ones. Some were traded via Constantinople to Hungary and used by Turks as payment to liberate prisoners. However, Fugger thought it impossible to obtain these, as they were bought by 'great lords at courts for gold'.

The merchant's desire for such feathers led him to write to his agent in Vienna, adding that he did so secretly, as such a luxurious expense stretched his current means.[8] Meanwhile Ott had sent feathers by early March—though Fugger was not happy that they cost three times more than he thought they were worth. Still, he would keep them because they were so difficult to source.[9] During the same month, he received a further fifty-nine heron feathers via Vienna, and as these were 'longer and more beautiful' than those available in Augsburg or Venice, the agent was requested to source more.[10]

Fugger's greatest coup was brokered by a close friend in, or with connections to, Hungary. He sent Fugger sixty heron feathers equalling the sum of 110 florins which an imprisoned Ottoman had used as ransom. Fugger told his Venetian agent that these were the most beautiful heron feathers he had ever seen, longer, thicker, and more perfect, so that each one of them surpassed three of the inferior feathers Ott had sourced in Venice.[11] Their rarity as much as their sensuous materiality conferred distinction. Fugger thus notified Ott in Venice that he now possessed sufficient feathers, while repeatedly instructing his Viennese agent to source more of the long, full, beautiful plumes, even if these were expensive.[12]

The Challenge of Fashion Innovation

Hans Fugger's exhaustion engendered by keeping up with innovations in fashion nonetheless emerges in a prolonged exchange about the making of headwear for his daughters. He promptly wrote to his agent Hans Frick in February 1578, after the Antwerp office had closed in December 1577 and he had settled in Cologne. Burgundian

[6] Karnehm, *Korrespondenz*, II.1, n.704, p.307; n.1790, p.781; n.1796, p.784; n.1903, p.839.

[7] Karnehm, *Korrespondenz*, II.1, n.1277, p.547, 'über die massen schön und zart'.

[8] 'dan ich schem mich des Bettels', Karnehm, *Korrespondenz*, II.11, n.2695, p.1231; n.2694, p.1230.

[9] Karnehm, *Korrespondenz*, II.11, n.2720, p.1242.

[10] Karnehm, *Korrespondenz*, II.11, n.2731, p.1248.

[11] Karnehm, *Korrespondenz*, II.11, n.2720, p.1242.

[12] In July, he bought some for 182 florins, Karnehm, *Korrespondenz*, II.11, n.2731, p.1248; n.2772, p.1266; n.2823, p.1288.

hairstyles, Hans Fugger reported, were currently in fashion among local women. Hair was no longer curled but worn in a style called a 'Spanish cap', alternatively known as 'French' cap. In order to achieve this style, the girls required trimmings which were actually made from human hair to wear across the forehead. Fugger explained that he assumed that this Spanish *Mutz* was likewise fashionable in the Netherlands. He requested patterns for his daughters in order to 'replicate with their own hair'.[13] Essentially, these were wigs for women that had just been invented and for which no noun existed. They were strong enough to be decorated with permanently attached jewellery. [17.1]

One month later, Hans Fugger was pleased to note that Frick had ordered these Spanish caps in Antwerp via Cologne. Their arrival in April disappointed the family. Hans now detailed that his daughters could only use one style that had been sent, namely one made from curly hair—presumably that matched their own hair. They also wanted the type of wig (he explained without being able to use the word) that was worn on top of natural hair, was two fingers high, and did not break or damage their hair. This fashion, he reported, had been introduced in the German lands by Christina of Denmark (1521–90), Crown Prince Wilhelm of Bavaria's mother-in-law. It was fashionable among many noble ladies, but in different variations rather than 'in one manner'. The best thing about this style, Hans noted with some enthusiasm, was that it 'conserved' a woman's natural hair. It therefore linked to contemporary understandings of the body, beauty, and health. A key concern was to regulate temperature around the head to benefit well-being. Hans repeated his request to be sent a design for these wig-like hairpieces from Antwerp, as his daughters were reluctant to send some of their own hair across to Antwerp, and also because he would be able to find local craftspeople able to follow instructions.[14]

Christina was a remarkable trendsetter at the Munich court. Born in 1521, she had governed Lorraine between 1545 and 1552, had been claimant to the throne of Denmark, Norway, and Sweden, and in 1578 claimed sovereignty of Tortona. Tortona was a city with a small profitable territory near Milan, enfiefed to Christina many years previously by her first husband, Francis II, Duke of Milan. After marrying her daughter Renata of Lorraine to Crown Prince Wilhelm in 1568, Christina had herself spent seven years in Bavaria, much of it in a castle near Augsburg. She regularly socialized with the Fugger. Her ambitions were greater than ending her days as a mother-in-law attached to a foreign court which had begun to run into ever greater debt. Historians of Bavaria have characterized Christina as an old, ill-tempered, and imposing woman, while equally highlighting how much Albrecht V valued her political advice.[15] She was accustomed to being an influencer. Fashion innovation was one of the ways in which ruling women

[13] Karnehm, *Korrespondenz*, III.1, n.1292, p.553.
[14] Karnehm, *Korrespondenz*, III.1, n.1320, p.564.
[15] Baader, *Renaissancehof*, 134–7.

Fig. 17.1. Franz Pourbus the Younger, Margherita Gonzaga (1591–1632), Duchess of Mantua, c.1601, oil on canvas. 93 × 69 cm. Gonzaga is wearing a hairpiece like the *Mutz* sought after by the Fugger ladies. Metropolitan Museum of Art, New York, public domain.

206 *Ulinka Rublack*

of any age could demonstrate their power and influence if they spearheaded cosmopolitan styles which were then emulated by others.[16]

This is borne out by the inventories of Duchess Jacobe of Jülich-Cleve-Berg (1558–97). A daughter of Mechthild of Bavaria, Jacobe had been orphaned aged eleven and as a result was educated at the Munich court during the 1570s, when Christina's influence, through the dissemination of cosmopolitan styles, was marked. In 1585, the Munich court married Jacobe off with luxurious clothes, jewellery, and art objects, while never paying the promised cash part of the dowry. An inventory of her belongings in 1593 records forty-one items of costly caps and wigs alone. One was crafted 'from white hair, diamonds, rubies and pearls' and valued at the significant sum of 270 imperial thaler. Several other wigs boasted different hair colours and attached fashion jewellery including a red coral turtle, and possibly American indigenous work described as an 'Indian rose in silver'. Jacobe likewise owned the type of hairpiece the Fugger daughters were after—and here the *Mutz* was described as a 'bulge of hair'.[17] For all this splendour, Jacobe paid a high price. Her husband was heir to the strategically important Protestant duchy Jülich-Cleve-Berg, but mentally severely troubled. He broke down, leaving Jacobe to face hostilities at the court, which led to her murder.

Meanwhile back in 1578, Hans Fugger was finding it exceptionally challenging to source this type of hairpiece. After more than three months' effort, he still struggled to make his agent Frick understand what exactly it was he was after. He frankly admitted that after reading the latest letter from his agent and his discourse about the 'Spanish Mutz', he had gained the impression that they were talking at cross purposes. He once again tried to explain exactly how his daughters wore this accessory and the fact that this was the preferred manner for women from Lorraine and others keen to cultivate female decorousness. As Christina had left castle Friedberg after 1575, it had become impossible for the Fugger daughters to source the hairpieces. For this reason, Hans explained, it had occurred to him that 'Netherlandish ladies' might also be fashionable, recollecting that they certainly had been during his Antwerp years. If Frick was unable to succeed, Fugger would need to try to source the hairpieces directly in Lorraine. Meanwhile, the fashion had already diffused among further social groups, so much so that single women wore them and not just high-born ladies.[18] Their exchange on the matter ended here.

In 1579, Hans Fugger's daughter Maria Jacobäa was sixteen, and about to be married to her cousin Octavian. This was an extremely important alliance for the Fuggers because the groom belonged to a line of the Fugger family with which there had been repeated tensions. Each marriageable child was precious. Hans and Elisabeth had fifteen children, only five of whom reached adulthood. Maria Jacobäa herself would die in childbirth aged twenty-six in 1588, leaving behind five children. An inventory

[16] Evelyn Welch,'Art on the Edge: Hair and Hands in Renaissance Italy', *Renaissance Studies* (2009), 241–68.

[17] Monica Kurzel-Runtschneider, *Glanzvolles Elend: Die Inventare der Herzogin Jacobe von Jülich-Kleve-Berg (1558-1597)* (Vienna, 1993), 208–11.

[18] Karnehm, *Korrespondenz*, III.1, n.1340, p.573.

of her wardrobe further underlines how important 'dressing the head' had become for fashionable aristocratic women in the orbit of the Munich court. It records four hats, thirteen berets, thirteen coifs, nine worked from gold thread and four made of black silk, as well as some pieces crafted from coloured glass. Maria Jacobäa possessed no less than forty-three pieces of fabric in different colours to wrap around her hair, six artificial braids in different colours as well as other hair extensions to increase volume or length. She owned two items of headwear made from hair, and one Spanish *Mutz* wig, as well as a 'whole headdress with feathers from a bird of paradise' and a detachable crown of crafted flowers, made in Milan.[19] Hans Fugger had not hesitated to mobilize his network of international agents to acquire feathers for his daughters' bonnets from Milan, Mantua, and Antwerp.[20] Such adornments materialized their noted cosmopolitan appearances, which gained the Fugger women an entry of their own in Jost Amman's *Frauentrachtenbuch* published in 1586, the first costume book to focus exclusively on female dress.[21] Well into the seventeenth century, women were judged in terms of how well 'gemutzt und geputzt' they were—ingenious headwear defined their look and dignity.

Paintings continued to be just one category of Renaissance artefact among many, and not the most expensive by far. The European Renaissance, moreover, is easily presented in terms of its accomplished splendour preserved through some exceptional artefacts which have survived in collections. Yet contemporaries such as Hans Fugger devoted time to conversations with makers to discuss innovations, samples, special requirements, and the skills, costs, and time involved. They co-produced visual displays that mattered enormously in both everyday life and for special occasions, some of which were captured in portraits. Such conversations mutually built visual and material understanding and skills. Concrete information was not always easy to replicate in letters, and this drove on the need to provide specialized, detailed descriptive language and pattern drawings to avoid disappointment. This high degree of involvement created attachments that easily exceeded those linked to paintings that arrived in a finished state from artists whom clients often had never met, let alone observed in a studio.

The women of the Fugger family were consistently keener on bespoke innovation in fashionable goods than in paintings. Both were understood as crafted objects to be evaluated according to similar criteria: they were not to look roughly or hastily made but carefully and properly done. They insisted on these values. Hans, for example, rejected a belt from Antwerp because its decorative stitches were not sewn neatly enough and the buckle was insufficiently smooth.[22] Rather than paintings, precious silver belts, which could be unscrewed open and filled with scented medical balms, were sent as prestigious gifts for weddings, and so thoughtfully chosen that

[19] Martha Schad, *Die Frauen des Hauses Fugger: Mit sanfter Macht zum Weltruhm* (München, 2003), 73, 69.

[20] Karnehm, *Korrespondenz*, II.1, n.702, p.307, n.708,9, p.309; n.728, p.318.

[21] Jost Amman, *Frauentrachtenbuch* (Frankfurt am Main, 1986), n.p., 'Ein Jungfrau auss der Fugger Geschlecht', pictured here with a Venetian-style fan and costly Italian low-cut dress.

[22] Karnehm, *Korrespondenz*, II.1, n.211, p.94.

208 *Ulinka Rublack*

Fugger once even asked a high-ranking relative how her daughter had received the one he had sent her.[23]

This underlines the fact that goods were carefully inspected for quality and manufacture, sometimes across a range of materials from costly to cheap, or, in the case of precious metals, to ensure that no fake materials had been used. When unmarried women began to decorate headwear during the mourning period with fashionable metal chains, for instance, Hans Fugger asked his Antwerp agents to send him all the available models for him and his wife to choose from.[24] He also ordered necklaces from Antwerp. In 1575, he noted unhappily that a silver one which had arrived looked totally different from the sample which had been worked with gold, silver, and pearls. Hans Fugger's decision on whether to buy or not depended on the price, and this indicates that the price was not fixed.[25] Each step in the purchase of such goods was negotiated, and required further communication in which his wife and sometimes his daughters were likely to be involved.

By December 1575, for instance, Hans Fugger received necklaces worked with gold, silver, iron, and pearls but then decided that he wanted them without any silver content, as he thought the material did not work well with pearls. He ordered two other necklaces of the same length, made from just gold, iron, and pearls.[26] As these were imitated and became fashionable, the Fuggers' requests stimulated further product diversification. In March 1576, Hans reported that a niece had asked him for the type of black necklaces which were worn in Lent with black clothing. He instructed his agent to send four more pairs, 'delicate and pretty but different in their make'.[27] Fugger insisted on the high quality of manufacture and kept monitoring it. Later that month he thanked his agent for another necklace that had arrived but requested a further 'two or three of the fine and subtle type', noting that the last that had been sent was not according to 'everyone's taste'.[28] Such value judgement related to his material literacy and helped him to optimize products, as when in 1569 Hans Fugger rejected a sample of raw silk from Venice, requesting it to be spun 'somewhat more subtly' to please him better.[29] This required knowledge and experience of what qualities could be achieved in luxury products and was important as subtlety bestowed virtue on the owner. High-quality material was usually key for Hans Fugger, and he retained wish lists for years. In December 1570, for instance, he requested six *'bisottas'* of sable fur of the same quality he had previously been sent in order to both lengthen his fur coat and make it more

[23] Karnehem, *Korrespondenz*, II.1, n.726, pp.317–18; n.768, p.336.

[24] Karnehm, *Korrespondenz*, II.1, n.409, p.173.

[25] Karnehm, *Korrespondenz*, II.1, n.572, p.239.

[26] Karnehm, *Korrespondenz*, II.1, n.684, p.300; for a discussion of Hans Fugger's involvement with jewellery, such as these necklaces, see also Kim Siebenhüner, *Die Spur der Juwelen: Materielle Kultur und transkontinentale Verbindungen zwischen Indien und Europa in der Frühen Neuzeit* (Cologne, 2018), 241–88.

[27] Karnehm, *Korrespondenz*, II.1, n.747, p.327.

[28] Karnehm, *Korrespondenz*, II.1, n.770, p.337.

[29] Karnehm, *Korrespondenz*, II.1, n.390, p.166.

impressive.[30] By January, he had accepted that such sable furs were impossible to source at this time and instructed his agent not to look for them that winter. Yet he had not entirely given up his quest, as in 1574 and 1579, he hoped he might finally source this quality of sable fur through the Frankfurt spring fair.[31]

Investing in Things

A successful merchant patiently waited for the right opportunities and kept records of what had unsuccessfully been ordered and when. He left an organized paper trail. Good book-keeping skills were integral to monitor spending. Hans Fugger employed a servant to keep track of daily household expenses and produce annual statements. He advised others that the only way not to loose track of payments was to daily monitor outgoings and chase up bills. Just like Heller, Fugger rooted his life in commercial discipline. He did not delay tasks, had a clear sense of spending limits for particular types of items, and enjoyed achieving a 'profitable deal' (*gueten khauf*). He held that any successful merchant needed to be known for his moderation and control. He would never, Fugger insisted, want to be thought of by others as someone willing to spend more than 200–300 *scudi* (Italian silver coins) on a horse.[32] After attending a sumptuous wedding of the Count of Fürstenberg, he commented disapprovingly that their style was not for him, for he wished to 'live within his means one year so that he would have something to eat in the next one'. With a wife such as the one the count had taken, he noted, a husband needed a very large purse indeed.[33]

The Spanish debt crisis had taught Hans Fugger to realistically assess assets. He passed on cool-headed advice to aristocratic or ruling widows who were left with insufficient means, telling them what to sell off, and how to adapt to their changed circumstances. The Fuggers were also aware that conspicuous consumption nourished jealousy and thus needed to be reflected on. As for himself, Hans Fugger was a master in prudently staggering major expenditure. Costly building works for his Augsburg home as well as for his castles were systematically carried out in succession.

Such an overview was necessary because, even in 1562 at the beginning of his married life, annual outgoings of 1,062 florins on his household expenditure exceeded his income of 1,014 florins. Only one of Hans Fugger's household accounts survives. It dates to just this year, when Elisabeth was already pregnant with their first child, and Hans took care of his two younger sisters, both of whom lived in his house and were of a marriageable age. Hence, he paid Munich court's tailor 13 florins to obtain two fashionable farthingales in the Spanish style for them. Two black velvet caps lined with fur cost 4 florins. By far the greatest expense was lavished on eighty-four gold buttons at a

[30] Karnehm, *Korrespondenz*, II.1, n.491, p.206.
[31] Karnehm, *Korrespondenz*, II.1, n.224, p.100; n.1459, p.623.
[32] Karnehm, *Korrespondenz*, II.1, n.808, p.351.
[33] Karnehm, *Korrespondenz*, II.1, n.1393, p.597.

210 *Ulinka Rublack*

staggering cost of 153 florins, a disproportionate extravagance.[34] Hans spent far more on his younger sisters' attire than on his own and that of his wife—55 and 70 florins, respectively. Expenditure grew as Elisabeth assumed her role as mistress of the household. She ordered large quantities of high-quality linen from Munich, bought more locally, and also saw to it that furniture and fittings in the rooms reserved for women were maintained.[35] These items amounted to another 159 florins. The accounts name expert craftspeople all of whom were well remunerated for their skills, for example: 'paid Erasmus Eckher embroiderer 12 florins, 42 crowns for embroidering two trims on brown and yellow atlas silk', or, 'paid Anna Sighart 17 florins, 39 crowns for six coifs and spun gold and silver for Hans Fugger's gowns'.[36] The couple's annual expenditure on domestic servants at this time, by contrast, amounted to a mere 16 florins, including their dress. In time, Hans Fugger's total income grew, so that he was able to spend an average of 60,000 florins annually between 1574 and 1597 and, exceptionally, 243,000 florins in 1589, when his oldest sons married. This sum also included the acquisition of further land and extensive building work as he constructed Castle Kirchheim.[37]

Hans Fugger's exceptional means can be compared to the wealthy Nuremberg patrician and collector Willibald Imhoff (1519–80) whose family, as we have seen, had grown rich by trading saffron. Imhoff resided in one of Nuremberg's finest houses, in which he hosted princes and other dignitaries. His household accounts underline how significantly not only marriageable girls but also maturing sons added to expenses. We know through surviving letters that parents attempted to control their children's spending through stern speeches and regular reprimands. Even so, Imhoff repeatedly noted cases of extraordinarily conspicuous consumption in his personal account book—as when his son Wilboldt spent 84 florins on a sword in Lyon to complete his outfit as a groom, while an enormous payment of 459 florins went to another son who lived abroad in 1578. Each time, Imhoff penned: 'may God forgive him'.[38] During the 1570s, his total annual outgoings amounted to around 2,300 florins.

Such expenditure included prospective purchasing—as in 1576 when a piece of velvet was bought 'for a future bride' for just 10 florins. Mending and maintaining helped reduce new expenditure. Imhoff thus had a portrait of himself reddened and refreshed. Two of his oil panels were cleaned by exposing them to sunlight and 'washed' for 3 florins. His wife spent 14 florins on the repair of her silver girdle which she had received for her wedding.[39] Even top elites such as the Imhoffs moreover capped expenses by buying some quality clothes second-hand, and bought dress across a defined spectrum of value. Expenditure on headwear for the Imhoffs thus ranged between 1 florin and

[34] Christl Karnehm, 'Eine private Haushaltsrechnung des jungen Familienvaters Hans Fugger vom März 1562', in Burkhardt, Karg eds., *Die Welt des Hans Fugger*, 93.

[35] Karnehm, 'Eine private Hausrechnung', 95.

[36] Karnehm, 'Eine private Hausrechnung', 92, 93.

[37] Wölfle, *Kunstpatronage*, esp. 315.

[38] Pohl, *Willibald Imhoff*, 192, 277.

[39] Karnehm, *Korrespondenz*, II.1, n.205, p.91; n. 269, p.118.

7 florins, and only once amounted to 24 florins. Any regular expenditure was allocated a similar sum each year. Imhoff's wife thus spent around 75 florins on her own dress every year—just as Elisabeth Fugger had after her wedding in 1562. Investments in painting and engraving, by contrast, were categorized as extraordinary and thus could dramatically fluctuate, for example from between 132 florins in 1572 to a mere 4 florins in 1576, probably because Wilboldt's extravagant spending on his sword that year needed to be taken into account.[40] Still, while the purchase of paintings as collectors' items could be reined in, the Imhoffs' annual expenditure on dress for the entire family never fell below around 400 florins and often considerably exceeded this amount, although most items would decrease in value over time.

Investing in Dürer

An elite family's appearances thus amounted to a visual performance that was carefully considered and by far surpassed even a serious collector's annual investment in art. As we have seen, Imhoff deemed his most precious Dürer painting as worth only 80 florins—the epitaph dating from 1500 which depicted the crucifixion and had hung in Nuremberg's Dominican church before the Reformation. This precisely matched the value of Imhoff's best silken gowns, lined with good marten fur. He possessed a pair of these gowns estimated to be worth 161 florins.[41] Among his Italian paintings, he judged his Bordone to be worth 50 florins, having initially bought it for 36, and a Titian worth 20 florins.[42]

While objects such as silver goblets held their bullion value which was retrievable, Imhoff had painfully learnt that the same was not true for paintings or books. In 1573, as he approached his mid-fifties, Imhoff decided to list and value his entire collection. He valued Willibald Pirckheimer's splendid library of Greek and Roman writings at 800 florins, only to comment that nobody in Nuremberg would actually pay as much for it and the books were worth far more.[43] Alongside books, Imhoff had inherited valuable coins and antique busts from amongst Pirckheimer's possessions.[44] He regarded his collection as an investment, but did not want it to be scattered and lose value: he urged his children not to start selling single pieces or allowing for casts from coins and medals to be made.[45] He noted: 'I have experienced best what these items cost me.' Imhoff was careful to explain to his children which items he had inherited and how he had enriched his collection. For some years he had regularly and obsessively acquired objects from Lyon or Venice. He justified his collecting passion by adding that he had seen people in Lyon make real profit through dealing in art. As his family had grown,

[40] Pohl, *Imhoff*, 205, 235, 261.
[41] Pohl, *Imhoff*, 311.
[42] Pohl, *Imhoff*, 301.
[43] Pohl, *Imhoff*, 44.
[44] Pohl, *Imhoff*, 2.
[45] Pohl, *Imhoff*, 71–2.

he had planned to sell his collection at an imperial diet in Nuremberg. Nuremberg, as we have seen however, had not been chosen to hold such an international summit since 1543. There had been no opportunity for his grand sale. Imhoff honestly admitted to having lost opportunities to make gains on some items.

In addition, he had been a victim of fraud. Someone had sold him a painting which he thought was a Dürer for 36 florins, but the monogram turned out to be a fake, and its value was reduced to 16 florins; he had paid 80 florins for a painting from Dürer's workshop when 'its art' now appeared worth only 12 florins. None of the other paintings which he had bought as Dürers had gone up in value since he had acquired them. A Salvator, for instance, for which he had paid 30 florins, would at best sell for just that price, and he expected an authentic watercolour portrait of Emperor Maximilian I by Dürer to realize 8 florins. Imhoff valued portraits of Dürer's parents at 10 florins each, but expected the master's landscapes in watercolours to fetch 1 or 2 florins. 'Foreign painters and artists' visiting Imhoff had told him to send his best album with many editions of engravings and woodcuts printed by the artist to 'the Netherlands or Italy, where great Lords, who greatly revere Dürer's hand, would pay several hundred Scudi' for it. Germans no longer seemed seriously interested. Imhoff valued this precious volume of prints at 200 florins.[46] In comparison, in that same year, he spent 109 florins just on dress for his three girls, without there being any demands of a special occasion.[47]

When Imhoff died seven years later, in 1580, local valuations for his exceptional collection of panels by Dürer, and many volumes of the artist's graphic works, had not gone up in price.[48] Duke Albrecht V of Bavaria and his wife Anna had stayed in his home twice, in 1570 and 1576, but their interest seemed to focus on coins and jewellery.[49] His heirs might have felt bitterly that Imhoff's family connection to Willibald Pirckheimer and Pirckheimer's friendship with Dürer had lured him into the wrong type of collecting. He justified himself as an introvert: he did not enjoy society 'or other joys' but continued to 'entertain' himself as 'a melancholic' person with collecting, although this seemed unprofitable.[50] And so it was that for many observers at the time, Hans Fugger's commitment to an active life, up-to-date styles, rarities, and courtly networks would have seemed wise. As we have seen, they led him to aesthetic preferences and investments in luxury goods other than panel paintings.

[46] Pohl, *Imhoff*, 80–4.
[47] Pohl, *Imhoff*, 216–17.
[48] Pohl, *Imhoff*, 298–305; the value of his entire collection of paintings, engravings, and watercolours was estimated to be worth 1494 florins; for a discussion see also Anja Grebe, *Dürer—Die Geschichte seines Ruhms* (Petersberg, 2013), 273–343.
[49] Lorenz Seelig, 'Die Münchner Kunstkammer', in Diemer et al. eds., *Kunstkammer*, vol. 3, 72.
[50] Pohl, *Imhoff*, 71.

CHAPTER 18

The Court of Bavaria

The dangers of lavish spending on fashion and rare curiosities among many of the elite were nonetheless plain to see. In 1575, Crown Prince Wilhelm V of Bavaria was in debt to the tune of 100,000 florins to Hans and Marx Fugger, and 200,000 florins more to other creditors.[1] Hans Fugger had known the young Wilhelm closely from at least 1562, when Wilhelm was aged fourteen. Six years later, Fugger attended his extraordinarily splendid marriage to Renata of Lorraine, which had been designed to rival recent Medici festivities. Gifts from Lorraine included a sumptuous marital bed that had cost 13,000 scudi, and jewellery worth 65,000 scudi. Crown Prince Wilhelm himself paid keen attention to detail when discussing gifts for his future wife. A passion for specifying the details of making artefacts characterized Wilhelm throughout his long life.[2]

The young couple were set up in Castle Trausnitz, overlooking the small town of Landshut to the north-east of Munich, a convenient location for guests attending imperial summits at Regensburg. Duke Albrecht of Bavaria granted the newly-weds a modest annual allowance of 15,000 florins to spend and pay for a staff of 125 men and women; their personal allowances amounted to 3,000 florins each.[3] Within a year of their wedding, Wilhelm and Renata had already spent nearly twice their annual budget and asked for payments to be omitted from account books to hide their expenses from Albrecht and his chancellors. By 1571, two hundred members of staff filled the castle with life, including those the court acquired as black people, and people of oriental origin, who were in part treated as entertaining curiosity alongside 'dwarfs' and 'fools'. Splendid events were designed to attract high-ranking visitors and facilitate Bavarian diplomacy as the Wittelsbach dynasty aspired to gain a central position in imperial politics.

Renata and Wilhelm were in their early twenties and especially loved amusing musical and theatrical entertainment. They championed Italian style comedic traditions that were seen to connect back to classical Bacchanalia. Pirckheimer, as we have seen, had pioneered the amalgamation of Italian and German dances and masquerades

[1] Mark Häberlein, Magdalena Bayreuther, *Agent und Ambassador: Der Kaufmann Anton Meuting als Vermittler zwischen Bayern und Spanien im Zeitalter Philipps II* (Augsburg, 2013), 38.

[2] Baader, *Renaissancehof*, 34, 43.

[3] Baader, *Renaissancehof*, 56; Bavarian architecture and collection in Landshut had been at the forefront of German Renaissance art, see Brigitte Langer, Katharina Heinemann eds., *'Ewig blühe Bayerns Land': Herzog Ludwig X. und die Renaissance* (Regensburg, 2009).

214 *Ulinka Rublack*

for carnival entertainments. During the 1550s and 1560s, the Commedia dell'arte turned into a professionalized art form performed independently from carnival. Its comical plots dealt with sexual desire experienced by old women and men, or among men. Stock characters in masks performed acrobatic movements, singing, and elaborate musical arrangements. Much of their text was improvised.[4]

Orlando di Lasso, the Flemish born composer (b. *c*.1530), arranged and acted in such a performance for the wedding of Wilhelm and Renata, and under his direction this new art form flourished in Munich and at the Castle Trausnitz. Lasso's main occupation, of course, was to create some of Europe's best contemporary sacred music for the Catholic court, but in addition to this he wrote polyphonic secular works for pure entertainment. Lasso and Wilhelm were closely associated throughout their lives. During his years at Castle Trausnitz, the much younger Crown Prince would exhaust his composer on the tennis court or enjoy receiving his jocular letters. In July 1572, for instance, Lasso mixed French and Latin upon his return from Landshut to Munich to pen: 'I would like to write more, but now it is as it were time for dinner to honour the cod-piece and I cannot omit visiting the low countries of my wife.' This was followed by rhymes: 'I haven't fucked for too long—and it is a natural thing, which isn't beautiful but very fun' (*c'est une chose naturelle: qui est bien bonne non pas belle*).[5]

While Wilhelm had not travelled to Italy, he was a good Latinist and was soon able to read Italian fluently. He and Renata corresponded in French. Men like the multilingual Lassus suited their ambition to cultivate a court of European significance. Wilhelm thus quickly grew into a man keen on investing in grand courtly life.[6] This involved building up and managing wide-ranging networks of favours throughout Europe, among related dynasties and the nobility. A supply of luxury goods was essential not only to serve the couple at home but also during a great number of ceremonial and diplomatic journeys in which Albrecht began to involve his son. [18.1]

The same years saw the rise of Wilhelm's near contemporary Rudolf of Habsburg to power. Born in 1552, Rudolf spent his entire teenage years at the Spanish court of Philip II, who was becoming well known as a collector of Italian and Northern European paintings, of rarities and relics that would in future shape the Golden Age of Spanish Baroque art.[7] Rudolf returned to Vienna in 1571. The following year, the twenty-year-old was crowned King of Hungary and Croatia. In 1575, he was crowned King of Bohemia, and, as we have seen, elected Holy Roman Emperor in 1576. After moving his court to Prague in 1583, Rudolf would turn into one of the period's most major collectors of artefacts and art in Northern Europe alongside the court of Bavaria.

As heir to the throne, Crown Prince Wilhelm travelled to Rudolf's coronation as King of Hungary in 1572. He had visited Prague in 1570 and attended his oldest sister

[4] Baader, *Renaissancehof*, 59.

[5] Horst Leuchtmann, *Orlando di Lasso: Briefe* (Wiesbaden, 1977) vol. 1, 36–7.

[6] Baader, *Renaissancehof*, 62–3 details Albrecht's limitations on Wilhelm's spending in 1568; on Fugger's role see 106.

[7] Jonathan Brown, 'Philip II as Art Collector and Patron', in Richard L. Kagan ed., *Spanish Cities of the Golden Age: The Views of Anton van den Wyngaerde* (Berkeley, 1989), 14–39.

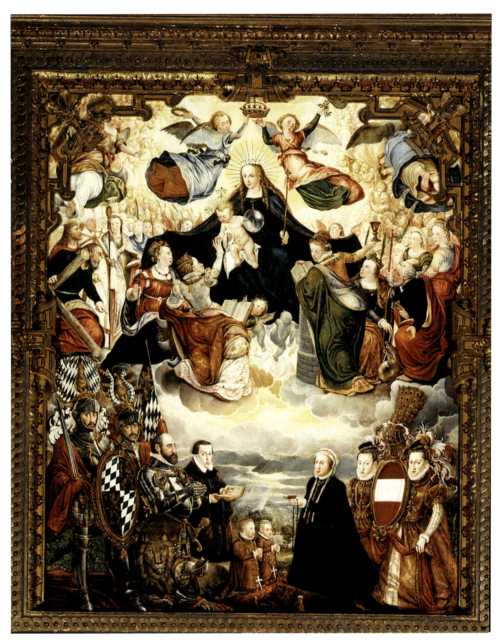

Fig. 18.1 Hans Mielich, Albrecht and Anna of Bavaria with their five descendants, Wilhelm kneeling to the left of his father, placed under the Virgin Mary's protection. Liebfrauenmünster, Ingolstadt. Photo: Georg Pfeilschifter.

Maria's strategically important wedding to her maternal uncle Charles II of Inner Austria in Vienna in 1571. During this period, his father Albrecht attempted to significantly strengthen the so-called *Landsberg Circle*, a supra-confessional defensive military circle designed to aid peace-keeping in the German lands. In 1573, Duke Albrecht requested that Renata and Wilhelm stay in Vienna and at Charles of Austria's new court

in Graz to maintain good connections with the Habsburgs. Wilhelm was valued for infusing gatherings with good humour and fun, but he also began to increasingly take over political duties from his ageing father, who exuded somberness and exhaustion in the years before his death in 1579.[8] From 1576 onwards, Castle Trausnitz was rebuilt in Renaissance style. Friedrich Sustris decorated its main ceremonial rooms with an iconographic programme, in the style of Vasari's decorations in the Palazzo Vecchio, to celebrate the Wittelsbach dynasty's magnificence, virtue, and faith.[9]

This also explains why Wilhelm and Renata hosted a 'princely table', covered with delicacies, built up a zoo and aviary with exotic animals and birds, and carefully curated their appearances. Renata, who had ten children, was less able to travel and hence had every interest in turning Castle Trausnitz into a satisfying courtly environment. In 1569, just one bill for textiles amounted to 720 florins. The couple tried to cut costs without looking cheap. Whenever possible, they used Italian gold trimmings that were sewn onto garments to replace embroidery.[10] They employed Spanish, French, and German tailors to be in style. Albrecht worked with secretaries, even when writing to his son. Wilhelm, by contrast, tirelessly managed an immense volume of detailed correspondence with agents and brokers, such as Hans Fugger, which allowed him to discuss prices and designs in detail.

Diplomatic gifts between courts promised to reduce expenditure on rarities. In 1572, Francesco de Medici boasted that he had chosen rarities for Albrecht from a recent delivery from the New World to his new port of Livorno. Francesco was married to Anne of Austria's younger sister, and thus was Albrecht's brother-in-law. Couriers carried these American rarities over the Alps. They included parrots, exotic mice and their food, Mexican feather-mosaics as well as a Mexican 'idol' described in the following manner: 'it looked like a human', and was 'composed of different chosen seeds made in Mexico where people not only worship but also sacrifice human beings' to such spirits.[11]

As Philip II of Spain regarded the court of Bavaria as a crucial ally in the Habsburg's German lands, the Wittelbachs could likewise expect their gifts. After some prompting, Anton Meuting—the Augsburg merchant whom Quiccheberg mentioned as taking German toolboxes to Spain—duly arrived in 1573 bearing costly silks and other luxuries from the Spanish court. He carefully advised on how to share them out. Boxes were filled with 'black perfumed gloves, silks and fabrics worked with gold-thread' as well as 'well tasting' patisseries for Albrecht and Wilhelm, but, it was stated explicitly, not for the ladies.[12] The scene of a Bavarian duke and his son unpacking a box filled with gloves and sweets encapsulates a German Renaissance we have lost sight of—a cultural movement filled with excitement about subtlety in food and decorative arts in which

[8] Baader, *Renaissancehof*, 107–33.

[9] Maxwell, Susan, 'A Marriage Commemorated in the Stairway of Fools', *The Sixteenth Century Journal*, 36/3 (2005), 717–41.

[10] Baader, *Renaissancehof*, 108–9.

[11] Lia Markey, *Imagining the Americas in Medici Florence* (Pennsylvania, PA, 2016), 49.

[12] Häberlein, Bayreuther, *Agent und Ambassador*, 125.

items of dress, sugary concoctions, or materials such as the finest fibres and leather played a key part.[13]

Brokers were essential. Hungarian noblemen were often willing to source horses for Wilhelm.[14] Other middlemen did everything in their powers to see to orders of male ostriches with their striking black plumage for the zoo. In Milan, two men of the Visconti family sourced astonishing artefacts crafted from corals or crystal and other artefacts from local craftspeople and across the Italian peninsula. Hans Fugger quickly became a close ally in these pursuits, and the Fugger company paid for Wilhelm's expenses incurred in Milan.

At the height of Wilhelm's spending, Fugger's life buzzed with requests from him which he was meant to source. Hans kept stimulating them. Was this calculated behaviour, despite the mounting impossibility that Fugger would ever see any of his loans returned? Managing credit and repayments was his profession—he endlessly declined requests for loans or put pressure on debtors. As a merchant and financier, Hans Fugger knew how to maximize prospects to achieve profits or at least the repayment of a loan. In relation to Wilhelm, Fugger nonetheless encouraged behaviour which secretly ran up hopeless debts over years, created friction with his father Duke Albrecht, and meant that Bavaria's tax-paying population, as well as Fugger himself, ultimately had to foot much of the bill.

It was in Hans Fugger's strategic interest to secure Wilhelm's favour as he would in the future rule Bavaria. He closely followed any news about Duke Albrecht's ailments up to his death in 1579. We have seen that Hans Fugger and his family relied on access to virtuoso craftsmen at court to maintain an up-to-date style. He occasionally used his connections to the Munich court to advance men linked to his own patronage network.[15] Both Hans and Wilhelm moreover bonded over their support of Jesuits in an age of reform.

Equally importantly, Wilhelm appeared the best ally against the hated cousin of Marx and Hans, Hans Jakob, who had risen high in Duke Albrecht's court and only died in 1575. The Fugger brothers knew that they might be asked to pay their cousin's outstanding debts from the period when Hans Jakob had bankrupted the company. They were unwilling to make any concessions. Wilhelm's secret debt shielded them from these demands, and Wilhelm must have understood that he could therefore run them up as he wished. The materials and artefacts about which Wilhelm and Hans corresponded drove the dynamic of their relationship for long periods between 1569 and 1574, in the early years of life at Trausnitz and up to Hans Jakob's death, when Hans Fugger's correspondence revolved almost entirely around supplies for Wilhelm. A shared passion for things interlocked their interests and desires.

[13] There are many examples—for a letter in which he drove the agent on to ensure an even more delicate quality than a sample provided, see Karnehm, *Korrespondenz*, II.1, n.507, p.212.

[14] Baader, *Renaissancehof*, 93–4.

[15] For an extensive discussion see Dauser, *Informationskultur*, 368–79, 399–400, who mostly argued that Fugger's behaviour was functional in relation to social capital formation, but also concedes that he walked a tightrope and that his behaviour remains puzzling; for an extensive account of the debt crisis and Albrecht's response see Baader, *Renaissanchof*, 149–76.

CHAPTER 19

The Flow of Things

As cultural leadership expressed itself through appearances, it is not surprising that textiles featured prominently among goods employed to enhance them. Hans Fugger wrote to senior court officials who mediated requests, yet much of this correspondence went back and forth directly between him and Crown Prince Wilhelm. Increasingly, his tone was one of hurried excitement. Take an exchange about hosiery in 1569. In April, Hans Fugger acted on Wilhelm's request to buy silk stockings from Venice for the composer Troiano and the ducal antiquarian Stoppio. As a man 'likewise wearing silk stockings', Hans Fugger advised Wilhelm that much better ones were made in the Netherlands. They were more expensive but also much more beautiful and durable. He would be ready to order them at any time.[1] Hans repeated this offer eight days later.[2] This was a sign of the times—the international textile trade was growing increasingly competitive, further stimulating demand for fashionable goods, not least through information supplied by merchants and agents to clients.[3]

Wilhelm, however, was impulsive. A young man addicted to fast games of tennis, he did not plan in advance. In October, Hans therefore acknowledged a letter from Wilhelm which had included a sample of velvet and instructions to send a pair of silk stockings as soon as possible. Given the urgency, Hans looked at what stockings were available from local knitters and sent a pair of crimson red stockings woven from beautiful Spanish silk. Hans judged them as very close to the sample in quality. The pair cost 12 crowns and could be returned if they were not to Wilhelm's liking. Hans Fugger moreover informed the prince that it would take three months to source a really beautiful pair from elsewhere. They would be very expensive but of higher quality. He returned the sample of velvet.[4]

On receipt Wilhelm immediately tried these Augsburg stockings on, but found them too tight and short. Fugger therefore promised to order stockings from Venice via the next fast postal service and immediately sent his own servant to Wilhelm's court to retrieve the sample in time to be able to include it. The servant returned with two of

[1] Karnehm, *Korrespondenz*, III.1, n.414, p.180.
[2] Karnehm, *Korrespondenz*, III.1, n.417, p.181.
[3] Currie, *Fashion and Masculinity in Renaissance Clothing*, 68.
[4] Karnehm, *Korrespondenz*, III.1, n.483, p.208, from GHA, Korr.Akten 607.

220 Ulinka Rublack

Wilhelm's current stockings to ensure correct measurements, and Hans wrote another letter to confirm that the request had been processed, although he warned that it might take time as 'these were unusual colours, which are not to be found everywhere'. He promised to send the stockings as soon as they arrived.[5]

New dye tones consistently excited Hans Fugger and his circle. Demand for them spurred dyers to engage in skilful chemical experiments based on experience and new ingredients. It was the easiest way for elites to distinguish themselves through fashion, and mirrored their passion for diverse, strange colours in novel plants. In 1584, Hans Fugger wrote to the Spanish merchant Simon Ruiz to ask whether he could source the seeds or seedlings of some Latin American flowers in varied and rare colours from the park of the Escorial: '*de qolores varios y raras*'.[6] The Visconti agents wrote to Wilhelm from Milan to offer ten silks 'in the new colours', ranging from ash to morello red colour, reporting with excitement in the next letter that 'the silk has now dyed' (*la seta e finite di tingere*). Ribbons were sent in diverse colours; these short pieces of fabric were exempt from sumptuary legislation and ideal for dyers to experiment with.[7] Italians led the market. In 1577, Hans Fugger expressly wrote to his Nuremberg agent because he had heard that two of the Italian merchants residing in the city offered damask and atlas silks in a range of 'foreign, strange' colours, and requested a selection of five dyes and their prices.[8]

Yet why did Wilhelm, one of Germany's most politically important princes, personally concern himself with matters of hosiery? A glance into Cosimo I de Medici's Florentine wardrobe can help answer this question. Cosimo I was greatly interested in fashion innovation, and keen, for instance, to adopt new types of breeches that could be quickly undone as he suffered from bouts of diarrhoea. The relative importance of his tailor, who supplied the breeches, is reflected in his pay, 12 scudi a month; in comparison his painter Bronzino received only a little more.[9] Stockings had been made traditionally from woollen cloth.[10] The sixteenth-century knitting revolution made it possible to produce far smoother stockings with intricate stitches of superfine threads on four needles in the round, which provided an improved fit. Such technologies of knitting in the round had also been developed for berets which were knitted rather than felted, requiring advanced skills in mathematical calculation, spatial imaging, and manual coordination. Cosimo I's first such knitted woollen stockings came from Germany in 1544, followed six years later with silk stockings from Spain and Naples. Naples was famous for producing particularly fine, regular, 'subtle' silk threads, dyed in different colours. In 1575, Hans Fugger sent Duke Wilhelm a bill for 340 florins and his father a

[5] Karnehm, *Korrespondenz*, III.1, ns.483–5, pp.208–9.

[6] Hans Pohl, *Die Portugiesen in Antwerpen: Geschichte einer Minderheit* (Stuttgart, 1977), 331.

[7] Simonsfeld, *Mailänder Briefe*, 312–13, 374.

[8] This turned out to be a misunderstanding and the fabrics showed new patterns rather than 'foreign, strange' colours, Karnehm, *Korrespondenz*, II.1, n.1248, p.536; n.1260, 541.

[9] Currie, *Fashion and Masculinity*, 73.

[10] Orsi Landini, *Moda*, 91–2.

bill for 818 florins for Neapolitan silk thread alone.[11] Hans Fugger kept Wilhelm up to date about which colour tones could be ordered via his Italian correspondents. These new dyes were discussed in the latest Italian books of secrets.[12] Knitted hosiery manufacturing required large quantities of thread, and was a 'product innovation that transformed the clothing markets, creating a European fashion'. In Italy, the leading centre of production, stockings were knitted as ready-to-wear products and were made across a wide spectrum of quality, design, and colours. Children were employed in large numbers alongside men and women to knit woollen stockings in Mantua, Verona, and Padua, while silk stockings were knitted in Milan, Naples, Genoa, Lucca, and Turin.[13]

Silk stockings quickly gained such popularity that Cosimo I revised the sumptuary laws in 1562 to prohibit the wearing of them. He himself owned fifty pairs of silk stockings, mostly in black, but including a wide range of colours, while his son Francesco owned sixty-eight pairs sewn onto a wide range of coloured leather or felt soles, by 1565.[14] Men's stockings reached over the knee, which explains why Wilhelm might have found his too short. Yet, just as with fine shoes, the fit remained tricky—Hans Fugger once rejected a pair of silk stockings from Antwerp as they were 'far too long' and he always bound his stockings below the knee.[15] Linen understockings were used beneath silk stockings to keep them clean for longer and to reduce the need for washing as well as to add warmth. Some of them were even fur-lined.[16]

Alongside stockings, Hans Fugger also negotiated the quality of delicate devotional objects, looked for rare 'Indian' rabbits, and sourced designs, props, and theatre costumes for Wilhelm's entertainments. He did not stint on expense, assuring Wilhelm that two women's hats he had sent a pattern for could be made locally in 'the most beautiful way with silver, gold and pearls'. No Augsburg master, on the other hand, felt confident enough to craft the passementerie trimmings in various colours that Wilhelm had sent samples of. Hans Fugger promised to send them to Venice and make sure that Wilhelm received some before his trip to the imperial court in Vienna. If time allowed, he might also try sourcing them in Milan.[17]

So rushed were some of Wilhelm's and Renata's requests that Hans Fugger, while working hard to ensure fast turnovers, reminded them of the German proverb that 'good things take their time'. Their lists became longer and not only demanded attention but also provided an education in innovative craft knowledge available at the

[11] Karnehm, *Korrespondenz*, II.1, n.669, p.294; n.676, p.296.

[12] Karnehm, *Korrespondenz*, II.1, n.1090, p.473.

[13] Andrea Caracausi, 'Beaten Children and Women's Work in Early Modern Italy', *Past & Present*, 222 (2014), 95–128.

[14] Orsi Landini, *Moda*, 91.

[15] Karnehm, *Korrespondenz*, III.1, n.629; p.277.

[16] Orsi Landini, *Moda*, 90.

[17] Karnehm, *Korrespondenz*, II.1, n.550, p.239; n. 557, p.242, with the indication that the hats were made for women. On Fugger's uses of the term 'Indian' see Anna Grasskamp, 'Unpacking Foreign Ingenuity: The German Conquest of Artful Objects with "Indian" Provenance', in R.J. Oosterhoff et al. eds., *Ingenuity in the Making: Matter and Technique in Early Modern Europe* (Pittsburgh, 2021), 203–18.

222 Ulinka Rublack

Bavarian court. For example paternosters requested from Antwerp were to be made with hollow beads, so lighter to carry and pray with, and they were to be damascened with gold and silver on the outside.[18] In August 1571, Hans acknowledged another of Wilhelm's letters which had arrived including a 'thorough tutorial' relating to coral. These instructions were to be forwarded to Fugger's Genoese agent. The flurry of requests continued. Flags for the trumpeters, he explained, would arrive alongside the hats within two days. A glass lantern was just about to be completed; the altar would be ordered now. A silver bell would also be finished this week. Hans Fugger received constant updates from craftspeople busy with Wilhelm's order. Six ells of fabric, he reported, had just been woven. On the other hand, he had decided not to request coral from Tripoli, as the place belonged to 'heathens', and current warfare made trade impossible.[19] Preparations for the battle of Lepanto in October were afoot, affecting trade with the Levant.

Amidst this buzz of activity, a servant on horseback now delivered an urgent letter from Ferdinand, Wilhelm's younger brother, with another request. As the brothers were about to attend Maria's Viennese wedding, Ferdinand requested natural, rather than dyed black, ostrich feathers from Algeria for his headwear.[20] Hans Fugger replied instantly to say that he was sending the feathers, but that it had been impossible to find anything other than brown, and not even white ones to dye.

Settling Accounts

Hans Fugger remained at his most accommodating in relation to the question of how the luxury items Wilhelm requested were to be paid for. When settling accounts for the two hats, for instance, he offered to either bill them to Duke Albrecht or simply put them on Wilhelm's private account with the Fugger.[21] Through the use of this private account, he began to connive in hiding Wilhelm's considerable expenses which by far exceeded the allowance Albrecht had granted his son. For instance, when beautiful Italian armour, diamonds, and meercats had arrived for Wilhelm by early October 1571, Hans Fugger told his messenger to tell everyone that the animals were a present for the Crown Prince so as to hide the expense. Because the price of diamonds was currently low in Antwerp, Fugger nonetheless encouraged Wilhelm to buy more of them.[22]

He put up with receiving little in return. Agents at this time could either be formally employed by courts to deliver political news and source luxury goods in return for an annual allowance, or they served a court voluntarily in the hope of being rewarded with favours while trying at the least to recuperate their expenditure incurred on a court's

[18] Karnehm, *Korrespondenz*, II.1, n.556, p.241.

[19] Karnehm, *Korrespondenz*, II.1, n.557, p.242.

[20] Karnehm, *Korrespondenz*, II.1, n.561, p.244.

[21] Karnehm, *Korrespondenz*, II.1, n.564, p.245. For an in-depth analysis of the financial dealings of Fugger and Wilhelm, and specific consideration of the so-called Ciurletta affair see also Hilda Lietzmann, 'Der Briefwechsel Hans Fuggers mit Wilhelm von Bayern', *Zeitschrift für Bayerische Landesgeschichte* 66/2, (2003), 435–59.

[22] Karnehm, *Korrespondenz*, II.1, ns.561–79, pp.244–53.

behalf. Recovering payments was always difficult, but in Wilhelm's case it became an increasingly illusionary pursuit for Hans. He charged the customary six per cent interest for any agreed credit, but not for purchasing goods on Wilhelm's behalf. Hans Fugger placed several relatives and members of his own network in Munich or other courts connected to the Wittelsbachs' sphere of influence. The strong Habsburg connections of the Bavarian court would have mattered tremendously to him. Wilhelm's Habsburg mother Anna led a very long life at court, and he used her influence to keep forging these connections. To a man like Hans Fugger, who had risen from being a merchant financier to a nobleman, such strong connections to the Habsburgs mattered because they were bound up with his ambition for yet further advancement in rank within the Holy Roman Empire. Furthermore, a strong network provided both backing in relation to all of the Fuggers' creditors and some political influence beneficial to their trade. Still, it would have been a matter of courtesy for Wilhelm to repay Fugger's efforts in some form. And while Wilhelm kept promising him a Turkish horse for his services, he used every means to keep stressing how difficult this currently was to find and how much effort he devoted to the task.[23]

Hans Fugger became nervous as the secret dealings between him and the Crown Prince became increasingly difficult to conceal.[24] On 12 October 1571, he told an impatient prince that further Italian objects, including the prized coral artefacts, were ready to be transported in four heavy chests across the Alps. Carriers would fasten them 'to their neck' as they traversed paths made slippery by wet weather. Fugger had not yet quite the courage to give orders for this to happen, as he wondered how to keep the delivery of these goods secret. He was worried about making mistakes, and that these fragile, precious artefacts might break.[25] All the same, by November Hans had confirmed that the enormous sum of 1,200 crowns for the items sent from Genoa—such as the coral—would be added to Wilhelm's account.[26]

Hans next informed Wilhelm about his large order of rabbits, including a badly tasting Indian variety, costing 5 florins a pair.[27] Wilhelm intended to breed from these rabbits, taking nine females and two males whose fur was of yellow and red in colour. Hans also promised thirty to forty coal-black ones.[28] Fugger offered cautious advice. The entire investment might be lost. He had himself tried to settle many interesting rabbit species in the moat at Kirchheim Castle, only for polecats to feast on them.

Records in the Wittelsbach archive reveal that Hans Fugger did not arrange for copies of all of his letters, or perhaps was so busy writing to Wilhelm that there was simply no

[23] Karnehm, *Korrespondenz*, II.1, n.583, pp.254–5; n. 591, p.259.
[24] On the secrecy of these exchanges see also Baader, *Renaissancehof*, 133, fn.45.
[25] Karnehm, *Korrespondenz*, III.1, n.584, p.256; n.586, p.257.
[26] Karnehm, *Korrespondenz*, III.1, n.608, p.266.
[27] Karnehm, *Korrespondenz*, III.1, n.586, p.257.
[28] Karnehm, *Korrespondenz*, III.1, n.593, p.259; n.597, p.261; n.598, p.262.

time.[29] To give an idea of the volume of correspondence between them, we can refer to three letters that survive, written in Hans's own hand, on a single day, 17 November 1571. With one of them he sent long-awaited, extremely costly church vestments, another concerned a bespoke order for a helmet made by one of Augsburg's renowned goldsmiths. The final letter written that same day advised that Barbara Khandyn, an Augsburg silver dealer, would send her husband to the Munich court within eight days. Her husband would contact Wilhelm and show him rare drinking vessels. Fugger enclosed a list of them and assured the prince that they had not been shown to anyone else.[30]

These clandestine dealings kept rare things exclusive for Wilhelm, and avoided the need for his father Albrecht's consent. One week later, Hans confirmed that he would send Wilhelm a credit payment of 7,000 florins. He forwarded news about a crystal cross, a small altar, a new edition of a mass book, and an enquiry about the quality of embroideries for vestments.[31] By December, their relationship had become so close that Wilhelm too began to write in his own hand, and apologized when he sometimes still dictated letters to his trusted secretary.[32] In January 1572, Hans wrote that letter advising that twenty pairs of ladies' shoes would be best sourced via Genoa, and sent a pattern for perforated slippers he had brought home many years ago from Rome, to advise that the Genoese shoes were perforated in 'just the same manner and much more beautifully still'.[33] The male quest to achieve aesthetic magnificence naturally included objects to enhance the appearance of women in the family and at court.

It was in 1573, however, that Hans became more aware of the full extent of the debts Wilhelm had incurred from other merchants. As a result, he began to restrain the lavishness of his patron's orders. Reviewing designs for Spanish blankets for mules (*reposteros*) that Wilhelm had ordered, Hans Fugger instructed his Antwerp agent Römer to find an able tapestry maker and ask him to send a budget for work that would be carried out with 'good colours' and even more beautifully than in the sketch. However, he also underlined that no silk should be used and not much silver and gold thread, but only wool.[34] When Wilhelm sent his silk embroiderer to survey silks woven with gold and silver threads for clothes, Hans reported to the Crown Prince that his servant had accompanied the ducal embroiderer to look at these silks 'all morning', but found little appropriate. He advised that what the Augsburg merchants had to offer was both limited and far too expensive. It would be better to source them in Italy to save costs.[35]

In Milan, Prospero and his cousin Gasparo Visconti were employed to locate textiles, feathers, and hats, as well as animals and artwork, for the Crown Prince—and Marx and

[29] Christl Karnehm, 'Die Korrespondenz des Hans Fugger: Adressaten und Themen', in Burkhardt/Karg eds., *Die Welt*, 22.

[30] Karnehm, *Korrespondenz*, III.1, n.611, p.268.

[31] Karnehm, *Korrespondenz*, III.1, n.269, p.119.

[32] Karnehm, *Korrespondenz*, III.1, n.616, p.271.

[33] Karnehm, *Korrespondenz*, III.1, n.639, p.280.

[34] Karnehm, *Korrespondenz*, II.1, n.163, p.73–4.

[35] Karnehm, *Korrespondenz*, II.1, n.155, p.71.

Hans Fugger regularly had to foot bills amounting to over 10,000 florins per annum.[36] Prospero reported on innovative products that would look good but save costs—in 1573, for instance, he sent Wilhelm samples of yellow linen printed with gold. He informed him of a whole range of prices in relation to different specifications and colours, and emphasized that this technique was quick to carry out.[37] Courts and aristocrats everywhere struggled with financing conspicuous consumption, as a result of which craftspeople developed a broader spectrum of more affordable goods imitating the most refined luxuries with particular skill. This spearheaded innovation, as the attempt to save on costly embroidery also developed techniques to print on silks.

Hans Fugger mostly remained understanding of Wilhelm's needs. During June 1574, he oversaw the transport of, and paid for the delivery costs for, a heavy chest weighing 83 pounds, sent by an Italian friend of the agent Stoppio. Hans Fugger lent Wilhelm 3,000 scudi, assuring him that he would not ask to be repaid any time soon. Hans moreover ordered no less than 4,000 leather tennis balls as well as ten racquets for Wilhelm from Antwerp. By July, Hans had sent gold thread for embroidery while offering to keep up his attempts to source silver thread.[38] In August, he forwarded five American curiosities sold by Katharina Fleckheimer, an Augsburg trader whose husband managed the Marseille trade with the Levant and also had connections to the Atlantic trade.[39]

Hans's and Wilhelm's exchanges remained intense and tied to common passions. A total of 335 copies of letters Hans wrote to Wilhelm between 1568 and 1594 survive, though many more would have been sent. Renata of Lorraine likewise wrote to Hans independently, and in June 1574 asked for a woman's paternoster from an Augsburg silver dealer for the relatively cheap sum of 8 florins. Hans assured her of his services.[40] In July, she sent her gardener and two letters with questions about plants. Hans immediately took this gardener to see the gardens of his brother and the local bishop. Despite containing a great variety of flowers and herbs they were unable to find what Renata was looking for—it was not the right season. Hans related that, just like Renata, both he and his brother had been unsuccessful in growing cauliflower that year. The seeds for the most beautiful specimen had come in from Cyprus, but were now not possible to purchase as the island was in Ottoman hands.[41] The tone of the correspondence, in other words, remained intimate for the time being, and related to resources, networks, knowledge, shared experiences, and political news. [19.1]

[36] Baader, *Renaissancehof*, 97, fn.183.
[37] Simonsfeld, *Mailänder Briefe*, 311.
[38] Karnehm, *Korrespondenz*, II.1, n.107, p.53; n.123, p.60; n.131, p.63.
[39] Karnehm, *Korrespondenz*, II.1, n.182, p.81; n.194, p.86; n. 203, p.91.
[40] Karnehm, *Korrespondenz*, II.1, n.51, p.28; n.148, p.69.
[41] Karnehm, *Korrespondenz*, II.1, n.136, p.65. On the Landshut garden and connections to the Fugger see Hilda Lietzmann, *Der Landshuter Renaissancegarten Herzog Wilhelms V. von Bayern: Ein Beitrag zur Garten-und Kulturgeschichte der Frühen Neuzeit* (Munich, 2001), esp. 97–108.

Fig. 19.1 Hans Fugger, a coloured plate in the publication Fuggerorum et Fuggerarum Imagines, 1619, Bavarian State Library, License: http://creativecommons.org/licenses/by-nc-sa/4.0/deed.de; page 75 v.

By the end of June 1574, Hans even toyed with the idea of accompanying Wilhelm on a trip to Italy, which the prince had still never visited. For Fugger, this trip would have offered an opportunity to easily gain access to the most privileged treatment at leading courts.[42] Cosimo I had died in April 1574, and was succeeded by his son Francesco, who was deeply interested in furthering the arts and crafts through a wide range of dedicated workshops at his court. Journeys of this kind, however, were notoriously expensive. Unsurprisingly, Wilhelm had to stay put. Hans Fugger continued reporting on particular expenditures. For example, in regard to the Spanish blankets for the mules, he requested that Wilhelm agree to a price per ell for cloth using light-fast, high-quality dyes and the setting up of the pattern on the weaving loom to commission them.[43] This would have ensured their longer use. He still kept stimulating Wilhelm's desire to consume—informing him in August 1574, for instance, that he was travelling to Graz for three weeks so that any orders for purchases could still be placed by Wednesday night.[44] On the same day, Hans requested that Wilhelm's secretary place an order for six women's beaver hats with his servant in his absence.[45] Wilhelm personally opened each of Fugger's letters in order to hide the extent of his spending from his father.

Winter 1574 brought the usual hurried request for rare and special family Christmas gifts—Hans assured the prince that although he had 'searched the whole town of Augsburg' talking to numerous craftspeople in search of suitable presents, none could be found. His willingness to do the duke's bidding, even in the most difficult circumstances, both dramatized his devoted service and was demonstrative of the typical way agents secured favours in return. Prospero Visconti for example once reported that he had successfully sourced an object after 'a thousand conversations'.[46] Then Hans Fugger made a suggestion for an appropriate seasonal present: a chess set worked in precious material. An Augsburg woman dealer offered one made in ivory from India or Africa for 200 florins, and Hans hoped that she might not request instant payment. Unfortunately she made it clear that the actual owner would tolerate no delay, so that Hans once more offered to pay and assign the bill to Wilhelm's personal account with him.[47]

Was Hans Fugger using mere rhetoric in claiming that he personally visited the workshops of Augsburg makers, some of them poor, rather than deputizing the task? In all likelihood not. Fugger dealt directly with specialized craftspeople and through conversations and negotiations determined exactly how diligently things were crafted, embellished, or repaired, whether a maker was flexible and skilful enough to innovate technically or in design, the appropriate time-scale of commissions, their material and labour costs as well as the character of makers. He contributed his own ideas, assessing,

[42] Karnehm, *Korrespondenz*, II.1, n.152, p.70.
[43] Karnehm, *Korrespondenz*, II.1, n.163, p.73.
[44] Karnehm, *Korrespondenz*, II.1, n.203, p.91.
[45] Karnehm, *Korrespondenz*, II.1, n.204, p.91.
[46] Simonsfeld, *Mailänder Briefe*, 215.
[47] Karnehm, *Korrespondenz*, II.1, n.260, p.115; n.266, p.117.

228 *Ulinka Rublack*

for instance, what might be the best materials for clocks to be sent to Ottoman sultans—wood, silver, or gilded—as well as the clock's most interesting mechanisms. This meant that he kept up to date with advances in mechanics. He also advised on new models of display cabinets containing many secret drawers of the kind Philipp Hainhofer would soon perfect.[48] Personal involvement and connoisseurship guaranteed the best outcome for the acquisition of luxuries, as he could form his own judgement of what challenges, materials, and skills were involved, and which urgent demands needed to be prioritized. Sometimes this necessitated a higher price and the involvement of further craftsmen. For example, Hans only managed to satisfy an urgent order for two guns for a shooting competition Wilhelm was to participate in by increasing their price from 28 to 33 florins.[49]

Yet given Wilhelm's multiple requests, many of them urgent, Hans of course at times had to use servants to fulfil all the demands made of him. In December 1571, he let the prince know that he had sent someone to enquire how the master carpenter working with ebony was progressing. Dark ebony hardwood was only beginning to be sourced in larger quantities from Africa at the time. The carpenter had told Fugger that he was finishing work for Duke Albrecht. But now he had time to start on a number of Wilhelm's orders.[50] Wilhelm remained on the case. He sent deer antlers as a gift to Marx and Hans and within a week requested further news on his order. Hans Fugger reported that the master worked very slowly but promised to speed up, although Hans added that he, in fact, would have chosen another craftsman altogether.[51] This emphasized his personal knowledge of not just what makers were able to achieve but how they did so—such knowledge depended on an agent's local presence and presumably a whole network of informants.

The year 1574 ended with great hope that Francesco Medici might offer Wilhelm a very significant loan. In addition, Hans Fugger was much involved in plans to build a Jesuit college in Augsburg and was therefore keen to maintain Wilhelm's support. Moreover, an extremely unpleasant trial about the settlement of Hans Jakob Fugger's debts was just coming to an end. While their cousin was employed by Duke Albrecht, Marx and Hans continued cultivating Wilhelm's favour. On 9 December, Hans accepted, without demur, Wilhelm's request to add 250 French gold crowns to his unpaid account.

The returns for Hans Fugger's service to Wilhelm meanwhile were still insignificant at best—some meat might be delivered to his door following a hunt. It was not until November 1574 that Hans Fugger finally received the long-promised beautiful Turkish horse from Wilhelm. In a letter dated 9 December, he took courage to report that this horse threw off every rider and puzzled his extremely experienced staff. Could Wilhelm, Hans Fugger cunningly asked via the prince's secretary, and without, he added, wishing

[48] Karnehm, *Korrespondenz*, II.1, n. 894, p.389; n.1506, p.645; n.1651, p.719 on the importance on seeking out inventive masters.

[49] Karnehm, *Korrespondenz*, II.1, n.30, p.16.

[50] Karnehm, *Korrespondenz*, II.1, n.619, p.260.

[51] Kanrhem, *Korrespondenz*, II.1, n.624, p.262.

to insult the Crown Prince, send Joan Pedro Ginarra, Munich's courtly stablemaster, so that he could attempt to train it in Augsburg?[52] This, of course, made it evident that Wilhelm had purposefully sent a gift that merely looked expensive but in fact would become a burden on Fugger's own funds. Hans's dealings and connoisseurship were based on the ability to discern true quality—whether in animal breeds, plant varieties, or a dish of crystal. Their engagement with an evolving world of goods gave them honour; it turned him into a man lauded as a true patron of the arts to advance civilization in the German lands.

[52] Karnehm, *Korrespondenz*, II.1, n.291, p.127.

CHAPTER 20

The Debt Crisis Implodes

In 1575, Wilhelm's financial crisis came to a head. Duke Albrecht V of Bavaria strictly instructed his son to keep to the agreed annual budget. Wilhelm had to drastically reduce his staff and expenditure. In March 1575, he told Gasparo Visconti not to send fashionable or costly velvet for Renata's ladies-in-waiting but only 'the worst and cheapest'. The language he chose speaks for itself. Yet the agents, as well as the silk merchants and weavers they relied on, had their own honour and aesthetic judgement to defend. Gasparo responded promptly: If Wilhelm wanted to order velvet ormesin, which faded away quickly, it would still be pricey and cost 1 scudo and 20 soldi. Because the quality was low and the price relatively high, it was not an honourable product for him to purchase. Moreover, if Wilhelm's secretary had alerted him earlier that this fabric would be used for the ladies-in-waiting he would have advised on alternatives. He very much wished the ladies to look 'beautiful and pleasing to the eye' (*bello et vistoso*), but understood that Wilhelm did not wish to spend much money on them. Gasparo explained that he felt that he had reached an age at which he discerned quality closely, recognized the true value of things, and wanted to please the prince.[1] What possibilities did Visconti have in mind? One year later, he offered Wilhelm crimson-coloured velvet in imitation of highly expensive real crimson, stressing that it was 'pretty and good and good value' (*bello et bono et bon merchato*).[2] A commitment to aesthetic beauty rather than merely making money was integral to Visconti's experience of pleasure, and reputation, in merchandise.

Meanwhile, Duke Albrecht requested full information from the Fuggers about Wilhelm's accounts, reprimanded them for secretly extending loans, and forbade any further credit. By March 1575, Marx and Hans feared that this provided their hated cousin Hans Jakob with an easy opportunity for intrigues. Hans therefore refused a new request from Wilhelm to satisfy demands by the Kraffter textile merchants for 1,000 florins. The Kraffters were a Lutheran Augsburg company. They extended credits to Wilhelm for purchasing costly Italian silks and other precious fabrics they and others traded with over three decades. They might very well have been the firm to which Wilhelm had sent his embroiderer with Fugger's servant to look through fabrics worked

[1] Simonsfeld, *Mailänder Briefe*, 348.
[2] Simonsfeld, *Mailänder Briefe*, 370.

232 Ulinka Rublack

with costly metal thread. Fugger's staunch Catholicism meant that he would not in any case have been keen to keep financing local Lutherans, especially as he and Marx had already paid 5,000 florins two years earlier to the Kraffter silk merchants to cover Wilhelm's debts.[3]

Hans remained interested in accessing new styles invented by skilled courtly craftsmen. In April, he offered to pay in cash if the shoemaker could make galoshes and overshoes identical to those Wilhelm wore.[4] He also dealt with an old order Duke Albrecht had placed with him to buy fine silk, which was difficult to fulfil. This signalled that Hans wanted to retain the duke's support by making an exceptional effort. Rulers used their power through manipulative frameworks couched in a language of emotion. Any ruler's affection was presented as a labile state, and through the idiom of temperatures. It turned hot or cold, and thus had to be maintained, for otherwise it might boil or freeze. If that happened, a person was cut off from the court. Demonstrating effort avoided any cooling off, while any special effort might even renew a ruler's favour and 'grace'.

Hence any purchasing process that required a lot of effort generated value. As he gathered information about the four green and black silk samples that Albrecht had forwarded, Hans found out that this was rare material indeed, and only manufactured in Spain. Yet it was possible to source a supply in a quality that was even a little finer and lighter. This *buratto de seda* was only available in black, but Hans promised the duke that he would deploy his servant to ensure that a green silk fabric was custom-made, while attempting to secure a delivery via Naples rather than Genoa to speed things up.[5] Although Anton Meuting, the Wittelsbach's agent in Spain, had been able to source thirty-six pounds' weight of precious silk threads in different colours from Granada for Albrecht and Anna in 1573, times had changed.[6] [20.1]

As seen in the case of leatherwork described earlier, this points to the great achievements and aesthetic influence of Moorish craftsmanship in Europe. It was first threatened by, and then lost through, Catholic Spain's ethnic-cleansing campaigns. Up to the mid-sixteenth century, Granada had been the Morisco 'kingdom of silk', as the fine but durable quality of its threads, as well as the quality of its dyes, were famous from Europe to Asia. Mulberry trees grew under ideal conditions in the Sierra Nevada mountains where women workers fed silkworms, extracted their cocoons under even temperatures, and spun their filaments with extraordinary skill. In 1548, Pedro de Medina reported that women—almost all of them Moriscos—operated three hundred spinning wheels in Granada itself. One fifth of the entire population was employed in silk manufacturing. Threads and weaves were sold on the city's silk market. Yet when the Moriscos were expelled from the city in 1571, only Christian weavers and spinners remained. Up to the final expulsion of all Moriscos from Spain between 1609 and 1614,

[3] Karnehm, *Korrespondenz*, II.1, n.382, p.163; Häberlein, Bayreuther, *Agent und Ambassador*, 43–5.
[4] Karnehm, *Korrespondenz*, II.1, n.396, p.168.
[5] Karnehm, *Korrespondenz*, II.1, n.422, p.179.
[6] Häberlein, Bayreuther, *Agent und Ambassador*, 205.

Fig. 20.1 Silk curtain, fifteenth century, Granada. Metropolitan Museum of Art, New York, public domain.

some of this workforce migrated to Murcia and Valencia to produce raw silk in this finest quality that continued to surpass Italian competition.[7] In attempting to fulfil Albrecht's orders, Hans Fugger thus told his agent in Spain in 1575 to buy silks 'in Granada, or wherever else one can find them'. He knew that the quality of silk had already declined, through the war against the Moriscos, but urged Miller to track the best quality even for a high price.[8] Scarcity drove up prices. In order to source Albrecht's orders to his satisfaction, Hans Fugger therefore needed to invest significantly into searching for information through his Iberian agents, who in turn needed to carefully assess price, quality, and transaction costs in a changing market and arrange for suitable and safe transport. Such foreign demand for Morisco skill in turn secured the livelihoods of female growers and makers as well as weavers and dyers up to their expulsion from Spain to Africa.

Despite these efforts, the flow of Wilhelm's requests and letters, and occasional requests by Albrecht, ceased. In May 1575, Fugger affirmed that these were difficult, wearing times for Wilhelm and that everything had to be done not to offend the ageing Albrecht.[9] He assured Wilhelm's younger brother Ferdinand of his services in the usual manner—Ferdinand had requested jewellery in the shape of three forget-me-nots and three other flowers for his 'beloved wet-nurse'. Hans Fugger reported that he had immediately spent the whole morning with local goldsmiths and finally found one who would craft them the following week for 4 florins each piece.[10] Twenty-four florins in total—these were insignificant sums given the Bavarian court's former habits of expenditure, and, in the end, Hans Fugger even managed to negotiate the price down to 18.[11] Wilhelm only wrote with requests in June—he asked for apple and pear trees for his new pleasure gardens in Landshut, as well as a transfer of 25 gold crowns to a man in Venice and 30 florins to someone else. These sums, likewise, were too small for Hans Fugger not to oblige.[12]

When Wilhelm followed with further requests soon after, Hans pleaded with him to understand his own difficult situation.[13] By July that year, and only aged twenty-seven, Wilhelm had broken down with worry and exhaustion.[14] This meant that Marx and Hans required Duke Albrecht's support more than ever. Their cousin Hans Jakob died in the same month. The Emperor and Duke Albrecht both approached Hans with the expectation that the Fugger would pay 100,000 ducats to satisfy Hans Jakob's creditors in order to 'save' their relative's 'honour'. At the end of October, Hans travelled to Munich to see Duke Albrecht in person. He argued why this request was entirely misplaced and recounted the scene to his brother in detail. In Albrecht's view, the

[7] Elizabeth Nutting, 'Making a Living in Silk: Women's Work in Islamic and Christian Granada, Spain, 1400–1571', *Journal of Women's History*, 30/1 (2018), 12–34.

[8] Karnehm, *Korrespondenz*, II.1, n.166, p.75.

[9] Karnehm, *Korrespondenz*, II.1, n.456, p.191.

[10] Karnehm, *Korrespondenz*, II.1, n.469, p.196.

[11] Karnehm, *Korrespondenz*, II.1, n.484, p.203.

[12] Karnehm, *Korrespondenz*, II.1, n.515, p.215.

[13] Karnehm, *Korrespondenz*, II.1, n.532, p.221.

[14] Baader, *Renaissancehof*, 175.

'Fugger were famous for their fortune in the entire Empire' and God had endowed them with sufficient means. Hans retorted: 'The goose, gracious Lord, is not as fat as it is made out to be'. With customary directness, he told the duke that his brother Marx as head of the Fugger company had been adamant, Marx would rather be quartered alive than pay off Hans Jakob's debts.

Hans's speech was a triumph. Albrecht, on conferring with the Emperor, accepted that he could not insist on the Fugger brothers' obligation to settle any of their cousin's debts. Upon this assurance, Hans bowed himself out of the stately room in which he had been received. This, he thought, would be an end to the troublesome matter.[15] The Fuggers had played their cards cunningly: Wilhelm's and Albrecht's own debts limited their power to pursue settlements any further, should the Emperor insist.

In October 1575, Wilhelm admitted Hans Fugger into his entourage during the Imperial Diet in Regensburg—a further step towards his ultimate goal to be elected as an imperial count.[16] By November, therefore, Hans was happy to cautiously resume his service for Wilhelm. He had agreed to add 800 florins to Wilhelm's debts on the assumption that they would be paid off through a Florentine creditor.[17] Fugger told the prince that he had finally found a woman who expertly crafted silken flowers in the manner he had been interested in. He could send a sample and a price. He was moreover happy to source, via Antwerp, entertaining French books Wilhelm and Renata desired. At the same time, both Hans and Elisabeth Fugger responded with some trepidation to Wilhelm's request for dolls as presents for Saint Nicholas Day (6 December), which in any case arrived on Fugger's desk in November, far too late for him to fulfil.

Hans Fugger once again faithfully assured Wilhelm that he had been 'running around all day' in Augsburg without finding anything suitable that was ready-made. The craftspeople promised that something could be made in time but wanted the duke's assurance that he would then actually pay for the dolls. Fugger added: 'the people here are almost poor'. They could not take on such a commission if there was any risk that they might be forced to sell the dolls on the open market, if Wilhelm did not pay. He added as postscript that he had received four dolls, with price labels attached, which he was sending with the letter. The commission could be finished before the celebrations in just the manner the duke wished. The dolls, therefore, were treated as another bespoke commission. Specialized seamstresses would have been involved in their making because, as we have noted in Quiccheberg's treatise, their fashionable attire mattered. Fugger added that similar dolls had been displayed with great success at the duke of Württemberg's wedding celebrations on 7 November and that beautiful dolls were being brought to Augsburg for sale from elsewhere. As Hans Fugger was absent from Augsburg in early December, Elisabeth eventually sent on the finished dolls. She requested them to be paid for at the soonest, underlining how poor their makers were.[18]

[15] Karnehm, *Korrespondenz*, II.1, n.643, p.279.
[16] Baader, *Renaissancehof*, 200.
[17] Karnehm, *Korrespondenz*, II.1, n.654, p.286.
[18] Karnehm, *Korrespondenz*, II.1, n.654, p.286.

236 *Ulinka Rublack*

This signalled that the Fuggers no longer intended to settle the bill as a matter of course, and in any case they had already offered their services in obtaining such goods without any charges. Other members of the Munich court kept the Fuggers busy as well: Hans told Albrecht's sixty-eight-year-old mother that he had spent a whole week looking for a St. Nicholas gift for Albrecht locally, but without success, except for one opportunity which he would report on.[19] The opportunity turned out to be rare stones for the ducal cabinet of curiosities, sold by the Herwarts, a Lutheran company. It was about to go bankrupt the following year. Bankruptcies multiplied in Augsburg at this time, as both the Spanish and French monarchies defaulted on their debts, the output of major mining areas declined, warfare in France and the Netherlands cut off South German merchants from important markets, and Flemish and Italian firms expanded their activities in central Europe.[20] Augsburg's city council passed three ordinances between 1564 and 1580 to regulate the settling of bankruptcy cases and fraudulent behaviour. As he already felt under considerable financial strain, Herwart even offered to sell his entire collection for 200 florins rather than just four or five of its specimens. Fugger advised that it would be too risky to send the collection back and forth for inspection, lest the stones might get damaged.[21] Anton Meuting bought Herwart's extraordinary Augsburg mansion after the firm collapsed, boasting to Duke Albrecht that he now wanted to govern it like 'a real Spaniard' and Catholic.[22]

In hard times Augsburg makers were particularly aware of the fact that Wilhelm delayed payments and was heavily in debt. Craftspeople did their best to resist being negotiated down by merchants. Some makers stopped producing unless they received a firm order and seem to have put pressure on Hans Fugger to convey their circumstances. Hans was receptive to their plight, but also had to shoulder insults and aggression from them if items that had been sent to the Munich court were left unpaid beyond twelve days.[23] Thus, when Hans sent Wilhelm 'a bush of silken flowers' crafted partly from real and partly from fake gold and silver, he emphasized that the woman who made these was poor and it would be unfair to even ask her for samples without placing a proper order.[24] The matter rested here.

From now on, Wilhelm rarely wrote with requests. His staff at Trausnitz was reduced, and the castle's ensemble of musicians much curtailed. Lassus, the composer, tried to keep his head above water. In July 1576, Lassus wrote to Wilhelm: 'I love to be joyous and crazy, once a year, that only lasts twelve months, so that the great melancholy does not go to my head. To live well and happily makes a good man who lives a long life. Let's live

[19] Karnehm, *Korrespondenz*, II.1, n.665, p.287.

[20] Mark Häberlein, 'Production, Trade and Finance', in B. Ann Tlusty, Mark Häberlein eds., *A Companion to Late Medieval and Early Modern Augsburg* (Leiden, 2020), 114.

[21] Karnehm, *Korrespondenz*, II.1, n.672, p.295. These negotiations apparently came to nothing.

[22] Häberlein, Bayreuther, *Agent und Ambassador*, 205.

[23] Karnehm, *Korrespondenz*, II.11, n.2822, p.1288.

[24] Karnehm, *Korrespondenz*, II.1, n.676, p.295.

then and play ball!', referring to his tennis matches with the Crown Prince.[25] Hans Fugger reported that Albrecht had strictly instructed himself and Marx not to extend any credit to Wilhelm, who had not written to them for three months. He feared that the duke's 'affection and gracious will towards us' had definitely 'cooled down'.[26]

Even so, expenditure continued to realize the Wittelsbach ambition for imperial power, even if craftspeople themselves had to foot the bill. Valentin Drausch, Wilhelm's exceptional goldsmith, was owed over 17,000 florins just for work he had carried out between 1576 and 1579. Wilhelm, however, not only withheld these payments but also kept money Drausch's own father had given him to support the struggling artisan.[27] Ambitious pleasure gardens at Castle Trausnitz only began to be planted from 1575 onwards, while Sustris and his team carried out wall decorations inside the castle and also, it seems, for the aviaries. The grand-duke of Tuscany sent his grotto designs to inspire a grotto at Trausnitz, and shells and hand-stones were rapidly sourced.[28] Wilhelm excitedly began to cast plants and animals himself. As we have seen, such creative processes generated an understanding of the principles of material and spiritual transformation that were associated with good rule. Annual expenses for the gardens quickly amounted to over 4,000 florins. Albrecht in this case was so impressed by his son's vision that he requested him to oversee similar works at Castle Dachau.[29]

In December 1576, Hans frankly told Bishop Ernst of Bavaria, Wilhelm's younger brother, that the Fugger company was short of money and needed to solve its own financial problems.[30] For Ernst's planned feast—a 'respectable conviviality'—however, Fugger assured him that he would be able to source Indian turkey, 'as much as needed', two or more pheasants, as many force-fed capons as needed, and other wild fowl, alongside salted anchovies, Spanish salted olives, green lime and lemons as well as larger lemons, the *Pomeranzen*.[31] Such luxurious sociability centred around a 'princely table' filled with delicacies, even in the most difficult of times was a good investment.

The Wittelsbach dynasty had fought hard for Ernst to be appointed Archbishop of Cologne. Through great diplomatic efforts, Ernst first accumulated bishoprics in Hildesheim and Lüttich, and finally Münster, in the north of Germany, despite the fact that he had shown little promise as a cleric. Success in systematically promoting him marked a further turning point for the family's power as a Catholic force in the politics of the Holy Roman Empire.

Cologne was the politically most significant bishopric the Wittelsbachs managed to secure for him. Cologne had proven a dangerously fragile centre of German confessional

[25] Leuchtmann, *Lassus*, vol. 1, 204–5, 17.7.1576.

[26] Karnehm, *Korrespondenz*, II.1, 801.

[27] Baader, *Renaissancehof*, 256.

[28] Baader, *Renaissancehof*, 301.

[29] On casting see Susan Maxwell, 'The Pursuit of Art and Pleasure in the Secret Grotto of Wilhelm V of Bavaria', *Renaissance Quarterly*, 61/2 (2008), 414–62, here 458; Baader, *Renaissancehof*, 299.

[30] Karnehm, *Korrespondenz*, II.1, n.1011.

[31] Karnehm, *Korrespondenz*, II.1, n.1009.

politics and trade. The Archbishop of Cologne was one of the seven electors of the Emperor, and thus not only among the most powerful and internationally recognized men but also extremely wealthy. Ernst's election was secured in 1583; and the Fuggers spent 20,000 florins to support him. Five years of warfare against Protestant forces backing the deposed Archbishop Truchsess von Waldburg, who had converted to Lutheranism, ensued. Bavarian and Spanish forces fought against Protestant armies in these 'Cologne Wars'. For the first time since the Peace of Augsburg had been agreed in 1555, confessional conflict in the German lands was resolved through violence, capital, and foreign armies—with substantial help from the Fuggers to aid the Wittelsbachs' claims to power, the process of re-Catholicizing the German lands, and safe trading for them.

Personal requests made to Hans Fugger meanwhile continued to focus on his access to specialized artisans at Wilhelm's court. Despite the fact that 1576 was the first year in a long time that Wilhelm had not requested his service for St Nicholas presents, Hans in December humbly asked whether Renata's French or Italian tailor might be dispatched to Augsburg just for one day to make 'no more than one dress' for each of his two daughters.[32] Hans Fugger had every reason to ask for such favours. By April 1577, Hans calculated that Wilhelm's debts amounted to 106,278 florins. Given Albrecht's strict command and the Fuggers' own need to keep their property together in hard times, he claimed to be sincerely unable to extend further credit.[33] In May 1577, Wilhelm therefore requested that Hans might visit for one or two days in order to privately discuss matters which could not be 'entrusted to the pen'—most likely requests for further credit for himself or others. When Wilhelm's debt crisis became critical, craftspeople and agents everywhere in the luxury trades feared for their pay. The fallout was immense, and it was Hans Fugger who had to deal with debtors whose livelihoods were destroyed and who were left so mentally disturbed that they had to be assigned a guardian.[34] Anton Meuting told Wilhelm in 1577 that a Spanish leatherworker who gilded saddles impressed with Wilhelm's coat of arms had not yet received any payment. The craftsman pleaded that Hans Fugger intervene in God's name, for otherwise he might 'sadly sink into utmost misery'.[35] By 1579, Meuting himself was so indebted that he had to sell the Augsburg mansion he had acquired only eleven years earlier from Herwart to start satisfying his own creditors.[36] Just like the Fuggers, Meuting had had to finance goods for the Bavarian court out of his own pocket without ever being repaid. Meuting ended his life attempting to avoid further financial damage—during his last trip to Spain in 1591, he desperately told Duke Wilhelm that 600 ducats would not suffice to pay for the luxury goods he had requested, which included furs, 'unicorn horns', perfumed gloves,

[32] Karnehm, *Korrespondenz*, II.1, n.1014, p.442.
[33] Karnehm, *Korrespondenz*, II.1, n.1083, p.470.
[34] Karnehm, *Korrespondenz*, II.1, n.836, p.363.
[35] Häberlein, Bayreuther, *Agent und Ambassador*, 161.
[36] Häberlein, Bayreuther, *Agent und Ambassador*, 117, 163.

and cordovan leather for shoes. Yet he still sent on silk stockings.[37] Prospero Visconti permitted Wilhelm to delay repayment of expenses until April 1577. From then on, he tried to keep in touch by relaying political information, without receiving any future significant orders for many years. In 1582, his brother Gasparo asked why they had not received any commissions for such a long time.[38] Evidently, Hans Fugger no longer footed these Milanese bills. In 1578, when Orlando di Lasso told Wilhelm that he needed to be paid his salary, he cautiously added that he did not want to trouble the Fuggers but rather receive the money in Landshut or Venice.[39]

Hans Fugger thus had every reason to come up with plausible excuses to avoid a private meeting with Wilhelm in which he might be asked for further loans. Yet he assured the duke of his company for a visit of the influential Habsburg duke Charles of Inner Austria, who in turn would grace the most exclusive of his own banquets in Augsburg.[40] The much hoped-for Medici credit had not materialized—in fact, the agent who had sought to broker the arrangements had turned out to be a reckless fraudster. Wilhelm's prospects of satisfying his creditors became more illusionary than ever.

Hans Fugger's relationship to the court hence shifted during the debt crisis and after his cousin's death. He denied services and set conditions. For example, once, before leaving to visit Wilhelm, Hans Fugger wrote to him with apparent regret that he was unable to help him to source leather wall coverings. He explained that he only possessed those Wilhelm had already seen in Augsburg, which could 'not be accommodated to another room, or be sent over land'.[41] Wilhelm tried so ruthlessly cut back on some costs that he requested Fugger to take down his wall coverings for him. Wilhelm moreover had just ordered an indoor tennis court from Innsbruck which was taken apart so as to understand its construction, and then returned, rather than paid for.[42] Hans Fugger watched Bavarian achievements with a mixture of admiration and jealousy. One year later, he ordered another 525 pieces of leather wall covering for himself from Treviso, even though he admitted to his agent in Spain that the company's trade activities had declined steadily. He and his brother needed to cut costs if they wanted to avoid the same fate as their cousins. They attempted to use the Wittelsbachs' influence to get Philip II of Spain to repay his debts.[43] Wilhelm and Marx were getting older and had their children to look after, who in any case caused them all sorts of concerns. Just like his uncle Anton, Hans Fugger never believed that their descent or education would ensure their good character and success.

In December 1577, Fugger obliged by mediating another of Wilhelm's requests for St Nicholas presents—rarities for his father at a value of 200–300 florins or 'a little

[37] Häberlein, Bayreuther, *Agent und Ambassador*, 204.
[38] Simonsfeld, *Mailänder Briefe*, 380, 452.
[39] Leuchtmann, *Lasso*, vol. 2, 216–17.
[40] Karnehm, *Korrespondenz*, II.1, n.1102, p.478, 1103; Grüner, *Sitz und Stimme*, 171–81.
[41] Karnehm, *Korrespondenz*, II.1, n.1125, p.487.
[42] Baader, *Renaissancehof*, 71.
[43] Lill, *Hans Fugger*, 45; Karnehm, *Korrespondenz*, II.1, n.1359, p.581 and n.143, p.67 on his sons.

more' via the Ott agents in Venice, and a Turkish horse for 200 florins for his brother Ferdinand via Vienna.[44] He sourced an engraved agate cameo from Venice that the Crown Prince returned, which Hans decided to keep himself in order not to further inconvenience his Venetian agent.[45] A female relative at the Munich court was given a reel made of silver. It was both highly decorative and functional, as it was used to wind threads of the finest materials. Hans Fugger was fascinated by his conversation with one of the three specialized artisans involved in its manufacture, who explained that his casting and finishing techniques involved a great loss of silver. Given the amount of work and the cost of the material, which was carefully itemized in a separate entry, Fugger reported that the high price of 150 florins for this reel seemed entirely justified, and that the master goldsmith was a pious, good man who would serve Wilhelm reliably in future.[46] At the same time, Hans Fugger reported that he had spoken to Konrad Roth, an Augsburg merchant who had just become a key player in the European pepper trade via Lisbon and owned a 'curiously strange beautiful' Indian crane. Fugger wanted to see whether he might sell the bird, or at least let Wilhelm see it. He also negotiated for rarities from the collection of the recently deceased Count Ulrich of Montfort on Wilhelm's behalf. By this point Wilhelm owed the Fuggers a further 6,000 florins.

[44] Karnehm, *Korrespondenz*, II.1, ns.1182, 1183, pp.510–11.
[45] Karnehm, *Korrespondenz*, II.1, n.1253, p.538.
[46] Karnehm, *Korrespondenz*, II.1, n.532, p.221.

CHAPTER 21

Wilhelm V, Duke of Bavaria

When Duke Albrecht died, and Wilhelm finally assumed rule as Duke of Bavaria in October 1579, the total debts of the Wittelsbachs with the Fuggers amounted to 616,000 florins.[1] Wilhelm in addition had accumulated debts from countless other merchants as well as agents, aristocrats, the Bavarian estates, and numerous cities—each of whom claimed not just interest in return but also privileges for a lifetime. The estates represented Bavaria's largely agricultural population, and in the end peasants and small craftspeople paid for a good part of the courtly cabinet they would never see through increased taxation.

Yet Wilhelm V of Bavaria was positioned as a cultural leader of magnitude not just in the German lands but also across the whole of Europe and even the world. By May 1579, the Munich cabinet of curiosities and art was mostly complete; it had taken over fifteen years of work, and was one of the earliest of its type.[2] Architecturally, it stood out as Munich's first Renaissance building. Visitors admired a large, arcaded modern building with four wings and five-metre-high ceilings for the art cabinet's second floor. Its longest northern side measured about forty-five metres; each of the floors measured about seven metres in width. This was not a cramped or makeshift space, as in the case of some other cabinets of curiosities; it was purpose-made to show off a carefully arranged collection on tables and in porticos. Large windows ensured that items could be properly viewed by daylight. An elevated passageway connected the art collection with the castle. This meant that there was no need for high-ranking visitors to pass through the lower courtyard, where they might sniff horse dung from the ducal stables that were located at ground level or lose their breath as they mounted the staircase leading to the second floor. [21.1]

From 1578 onwards, guests came to visit. The collection was more widely accessible than many other courtly cabinets. Prospero Visconti spent two days in the collection, marvelling that the art cabinet was unique in 'tota Europa'. Braun and Hogenberg's 1588 edition of *The Cities of the World* informed visitors that they would always find something novel to admire in it. By 1598, an inventory of the cabinet's collection listed over 6,000 objects (excluding more than 7,000 coins and an enormous doll's house), displayed on

[1] Baader, *Renaissancehof*, 215.
[2] Seelig, 'Munich Kunstkammer', in McGregor/Impey eds, *Origins*, 85.

Fig. 21.1 Braun and Hogenberg's contemporary depiction of Munich. Georg Hoefnagel, 1586, public domain. Wikimedia Commons.

about sixty large tables, on panels, in drawers, or hung from the wall, including a crocodile measuring over five metres in length.[3] A 30-square-metre large detailed printed map of Bavaria's united territory, dating from 1563, hung in the court library. All of this signalled the triumph of state power. While Quiccheberg still regarded Germany's urban merchants as leaders in collecting rarities, the Munich art cabinet finally dwarfed any of their possessions in scale. Munich became a destination for aristocrats travelling across Europe to encounter the might of the Wittelsbachs. Emperor Rudolph would have visited the important collection in 1582, when he stayed at the court for several days. [21.2]

When the collection opened, its scope, contents, and some of its messages nonetheless became more challenging to control. Foreign visitors were eager to leave their mark to advertise their relationship with the court. Small gifts, in any case, were expected as a kind of entry charge for those who were shown around. The more personal they were, the more likely they were to stay in the collection rather than be redirected as gifts. Prospero Visconti in 1578 thus sent a cap that had belonged to Giangalezzo Maria Sforza Visconti, sixth duke of Milan (1476–94). It related to his family history and also fitted in with the collection's group of antique textiles worn by previous rulers.[4]

[3] Seelig, 'Munich Kunstkammer', in MacGregor/Impey eds., *Origins*.
[4] Simonsfeld, *Mailänder Briefe*, 518.

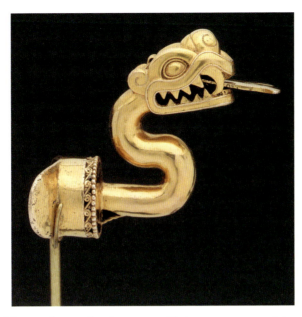

Fig. 21.2 Serpent labret with articulated tongue, gold, Aztec, 1300–1521, 6.67 × 4.45 × 6.67 cm, Metropolitan Museum of Art, New York, public domain. An example of exceptional gold smithery of the Aztecs that was sent to Europe and often melted down, but sometimes preserved as here, as a rarity in art cabinets.

Hans Fugger's first visit to the art cabinet that he had helped to finance and assemble most likely dates to 1579. Wilhelm had become ruler, and the new cabinet building finally was properly set up. An inventory of the cabinet lists two small portraits measuring c.29 × 21 centimetres that depict Marx and Hans Fugger, dated 1578 and 1579. An identically sized portrait of Hans's wife Elisabeth was executed by the same painter, at the same time, to remain in the Fuggers' private collection. Hans and Marx might have taken these portable portrayals, that only cost a few florins, with them as gifts when they visited. They nonetheless made sure that the painter included their names, so as not to be forgotten like the sitters of so many portraits that surrounded theirs on the walls of the cabinet, however elevated their status had been. Johann Baptist Fickler later faced the task of creating his inventory in 1598. A 'king of Spain, as we can see from the order of the golden fleece around his neck and his clothes', Fickler guessed as he set out to describe item 2,778; or, for item 2,781, 'on the tenth pilaster', two of the 'same panels with the portraits of two Netherlandish princely ladies'. Marx Fugger's portrait hung next to 'a true likeness of a man and a woman in old German dress'. All of these paintings presumably had been acquired by Wilhelm's grandfather. Although Fickler was a highly learned man, he did not think it necessary to trace the details of the objects further. Marx and Hans's small portraits hung surrounded by a series of Dutch ladies in regional costumes, a portrait of the humanist Erasmus and of the Protestant John Frederick

of Saxony, as well as a portrait of St Bernhard of Siena. Even in 1598 this hanging made little sense.[5]

While the Munich collection was by far the most encyclopaedic among the early art and curiosity cabinets, it also evolved idiosyncratically during Wilhelm's reign and was never built up systematically across all areas of the arts. Yet its collection of rarities from outside Europe was astonishingly rich—by 1598, 'exotic', crafted artefacts already numbered 930 in total. They were grouped according to size and usually mixed with European objects, displayed on forty-three panels and fifty to sixty tables. They represented all known continents, including ninety pieces from the Americas and 120 from Africa. 240 objects originated from East Asia, including many pieces of fragile Chinese porcelain that naturally appealed to the Wittelsbachs as their hereditary colours were blue and white.[6] By contrast, the collection of scientific instruments and naturalia was limited in number, although a straw-stuffed elephant gifted to Albrecht V in 1572 (following an epic voyage from India via Lisbon to the court of Emperor Maximilian II in Vienna) particularly impressed visitors.[7] As we have seen, many objects were included because they possessed historical and political relevance—such as a portrait series of important people. This included a portrait of Dürer which was placed on the wall over the street entrance to the cabinet which provided access to more common visitors. There were also items of dress worn by significant people, and other memorabilia linked to the Wittelsbachs' past, or documenting their political influence and connections.[8] Michelangelo's portrait served to remember him as the 'most famous Italian painter'; yet few Italian paintings were included in the collection. Paintings by old German masters such as Cranach the Elder were usually referenced by subject, while the artists' names largely remained unrecorded at the time of the acquisition and were forgotten.[9] All this underlines just how much the Munich art cabinet differed in outlook from Quiccheberg's ideal of a collection that would enable connoisseurs to compare master painters with each other in order to designate one of them as an Apelles, and overall systematically benefit the development of new knowledge as a matter of political prudence.

All the same, this was not just a collection of courtly luxuries to only demonstrate power. Specific object groups bore out the contemporary fascination with technical or decorative accomplishments in different arts across the world to stimulate the crafts, industry, and trade. This connected to pioneering contemporary initiatives to increase a state's economic resources through planned mercantile policies, for instance by scaling up textile manufacturing. By 1585, for instance, 140 weavers in the South German town of Calw already worked under state protection rather than as members of a guild.

[5] Diemer et al. eds., *Kunstkammer*, vol. 2, 821–5.

[6] Elke Bujok, 'Ethnographica in der Münchner Kunstkammer', in Diemer et al. eds., *Kunstkammer*, vol. 3, 311–20.

[7] Diemer et al. eds., *Kunstkammer*, 1045–6.

[8] Seelig, 'Kunstkammer', in Diemer et al. eds., *Kunstkammer*; for Dürer see ibid., vol. 2, 2887, 2969.

[9] Diemer, 'Gemälde', in idem et al. eds., *Kunstkammer*, 151.

Figures for the beginning of the seventeenth century reveal that Bavaria gained a trade surplus of 185,000 florins through exporting cloth. Textiles were generally at the heart of trade in this period.

Moreover, a cabinet such as the one in Munich had the potential to stimulate entrepreneurial interests in global trade. The Portuguese crown had ceded its monopoly on the import of Asian spices in 1570; in 1576, it offered Upper German merchants the entire contract to market Asian spices across Europe. South German merchants saw new opportunities to involve themselves in colonial ventures, and the Wittelsbachs might have hoped to profit from any successes through credits. In 1576, Fugger's creditor Konrad Roth of Augsburg indeed grabbed the opportunity of a European contract to market East Indian pepper and send equipment and materials for Portuguese ships worth 60,000 ducats. In 1578—and thus amidst the new financial crisis—he partnered with Italian and Portuguese merchants to secure a contract for buying Indian spices. By 1579–80, Roth successfully interested the powerful Lutheran duke August of Saxony (1553–86) in founding a 'Thuringian company'. It secured Leipzig a monopoly for trading pepper in Eastern Europe and into Russia.

The art cabinet in Dresden art contained far more tools and scientific instruments than the cabinet in Munich, reflecting plans to increase Leipzig's importance as an international trading city, which included instituting an exchange bank. By 1586, members of the Welser and Fugger families (though not Marx and Hans, who rightly judged the Welser too close to bankruptcy) likewise began to invest in the Asian contract and installed their own representative at Goa. Between 1586 and 1591, these merchants sent eleven ships to India via Lisbon and marketed much of the pepper that arrived via Amsterdam, Lübeck, Danzig, and Hamburg. Alongside pepper, returning ships brought back drugs, plants, silk and cotton fabrics.[10] The opening of the Munich cabinet thus connected with a new phase of German and European interest in colonial empires that now engulfed Catholics as much as Protestants, sparking off a new wave of European trading wars in the fight for political power. Between 1577 and 1580, there were reports on the Englishman Francis Drake who had circumnavigated the globe to challenge the Spanish on behalf of the Virgin Queen Elizabeth I.[11]

The textile collection within the Munich cabinet would certainly have offered merchants and rulers an opportunity to display and develop their practical knowledge. Take the collection of eighteen 'oriental' textiles acquired by Ludwig Welser. Welser hailed from this leading merchant family but he had first served as military commander in Tunis and then served at the Munich court. Textiles he had brought back from Tunis ranged from expensive to cheap materials, to enable focused study. Fickler clearly understood the pieces as specimens of textile arts when he

[10] Roth was bankrupt by 1580, feigned suicide, and fled to Lisbon, Häberlein, *Fugger*, 113–15.

[11] In 1589 he captured sixty ships of the Hanse. Rudolph II prohibited English trade in Germany in 1597; in response, Elizabeth I closed down the Hanse merchants' Steelyard in London, Götz Freiherr von Pölnitz, *Fugger und Hanse: Ein hundertjähriges Ringen um Ostsee und Nordsee* (Tübingen, 1953), 128–9.

compiled his inventory, each of which had been collected to show how different materials could be skilfully transformed into things. They were kept in purpose-made drawers below a square table next to a window. The table itself displayed mathematical and astronomical instruments. This context presented oriental textiles as objects of knowledge to study. The collection also included a 'big, wide royal night gown from blue velvet, with wide golden trimmings'; 'another such night-gown from red damask, with golden borders', and then 'another such gown from delicate linen, with dyed silk trimmings'. Other gowns he had sourced in Tunis were made from taffeta, 'pure linen', cotton, rough fustian—a mixture of linen and cotton, 'delicate cotton and linen', all the way down to 'poor linen'. Fickler carefully itemized some of them as demonstrating particular sewing techniques.[12]

We can therefore qualify the view that the Munich cabinet only housed curiosities and valuable items of fine craftsmanship which exemplified the 'taste' of individual merchants, traders, or conquistadors. Just as in the cabinet's selection of shoes, Welser's oriental textiles revealed an interest in technique and materials across the entire spectrum of quality rather than just his own aesthetic taste. In the drawers of the table next to it, visitors found a further extraordinary collection of twenty-six oriental textiles, ranging from Turkish and Persian rugs made in different techniques to several types of fine linen veils and large decorative handkerchiefs. Finally, they could study a spectacular long table rug woven in vibrant colours. Half of it was fringed with green, red, and blue parrot feathers. This might well have been an experimental, hybrid piece that merged Mesoamerican feather-crafting with weaving techniques from other traditions.[13]

The cabinet thus exemplifies a period in which textiles were highly valued as a trade item, reflecting new German as much as European colonial and mercantile opportunities. Painting was not yet unquestionably privileged as a liberal art over 'applied' crafts. Arts and crafts were still regarded as twin sisters. Ingenuity was not just attributed to painting, and the mathematical skills imbued in mentally computing complex weaving or embroidery patterns were widely recognized. As I have shown, this matched the world of Wilhelm V in which merchant-agents as well as financiers such as the Fuggers inhabited. Hans Fugger and Wilhelm V were closely in touch with innovative knowledge circulating across the globe and used in the manufacture fine textiles, deep or novel colours, or cheaper imitations that were nonetheless visually impressive—they paid vast amounts for goods of this kind, investigated them, wore them, talked to their tailors or shoemakers, and observed them on others. Hans and Marx Fugger risked large amounts of money by granting an enterprising global merchant like Roth a credit of over 80,000 florins.[14] It is therefore perfectly possible that investors in colonial ventures would have visited the cabinet with its rich ethnographic holdings, alongside its

[12] Diemer et al. eds., *Kunstkammer*, vol. 1, 593–5.
[13] Diemer et al. eds., *Kunstkammer*, vol. 1, 4; vol. 2. 578–82.
[14] Grüner, *Mit Sitz und Stimme*, 31.

zoo and aviary with exotic species, which, just like Roth with his Indian crane, they might have contributed to. The collection stimulated global awareness. Court artisans ranging from goldsmiths to shoemakers, from painters to feather-makers and tailors had access to the cabinet to learn from Chinese scroll paintings, Aztec gold rings and feather headdresses, or Ottoman heeled shoes.

At the same time, it is evident that Wilhelm V was not a ruler to roll out pioneering mercantile policies. Hans Fugger was not interested in systematically investing in, or lobbying for, the advancement of the quality of *common* local crafts. Their love of rare, secret, exclusive commodities and craft processes was politically self-serving. This separated them from Dürer's commitment to make technical knowledge available as a pathway to social mobility and by treating it as a public good.

While Wilhelm ruled as Duke of Bavaria, a host of makers and agents continued to skilfully advertise their exclusive wares to him. They communicate their excitement about new knowledge, unique artefacts and rare antiquities, and the duke must have constantly struggled to resist buying them all. In 1579, Battista de Negrone Viale, the Genoese craftsman who had long supplied the court with exquisite Christian and mythological scenes worked into Sicilian coral, offered a new work with a subject 'that had never been made' before, crafted from mother-of-pearl and coral. In addition, he offered forty to fifty snails and other types of *naturalia* from the sea, of the kind usually sourced from India. These were perfect from which to craft drinking vessels.[15] During the same year, Wilhelm received the offer of a 'beautiful, whole, tested and exceptional unicorn', which in effect would have been a narwal horn.[16] In November that same year, a Nuremberg embroiderer offered Wilhelm an image of Christ's nativity worked in silk for 20 thaler.[17] In 1580, Alessandro Tossignani from Bologna told the duke that he had learnt the secret of how imitation coral was coloured. Furthermore, he had obtained a most exquisite antiquity. Great cunning had allowed him to obtain a bowl used 145 years ago by a king of Tunis. It would be perfect, he thought, for Wilhelm's art cabinet; it was made from a unique and hitherto unknown material, and it was extremely precious and rare.[18] This notion of cunning used in the purchasing process created value in itself. It also avoided uncomfortable details implicit in merchant sourcing, making the buyer complicit in the process—whose property had this piece been, and who had been taken advantage of and in what way to gain it? Was Tossignani's cunning demonstrated through his knowledge of the true value of the piece and its provenance, or did he create it through particular networks? Had someone actually paid for this antiquity or had it perhaps been looted in Tunis?

[15] Jacob Stockbauer, *Die Kunstbestrebungen am Bayerischen Hofe unter Herzog Albert V. und seinem Nachfolger Wilhelm V. Nach den im K. Reichsarchiv Vorhandenen Correspondenzacten* (Munich, 1874), 111.

[16] Stockbauer, *Kunstbestrebungen*, 116.

[17] Stockbauer, *Kunstbestrebungen*, 119.

[18] Stockbauer, *Kunstbestrebungen*, 107.

248 Ulinka Rublack

Inspired by the wealth of all these materials, antiquities, creatures, and creations, Wilhelm's own collecting during the years of his rule continued at speed and in the face of ever greater financial debt. He prepared to renew his request for a Medici loan. In 1581, the duke hence sent a *carrozza della cucina* over the Alps for Ferdinando de Medici. This was a kitchen carriage suitable for travel, complete with a fully functional oven, copper pots and pans—a gift that was greatly welcomed as an example of German invention in engineering.[19] In return, Wilhelm asked for seashells, stones, and instructions on how to manufacture glistening glass icicles for a new grotto he was planning in Munich. These were promptly delivered, and Friedrich Sustris, who had remained at the Bavarian court as artistic director for his entire career, began to paint these shells with the most expensive colourants available, including saffron and brazilwood imported from Venice.[20] Wilhelm's grotto courtyard was inspired by Italian models and completed between 1582 and 1589—the same period in which the Boboli grotto was built for the Medici.[21] This intimate courtyard, at the heart of Munich's ducal palace, was decorated with scenes from Ovid's Metamorphoses and featured a mural of Arachne's challenge to Minerva, the goddess of weaving. An allegory of the visual arts, she was depicted together with murals of poetry and music as her sister arts.[22] During his reign, Wilhelm's spending on fine textiles continued to incur astronomical debts. The Lutheran Kraffter merchants from Augsburg provided Wilhelm with 27,000 florins to buy textiles at the 1582 Frankfurt spring fair.[23] This was to prepare for Emperor Rudolph II's visit to the court and the Imperial Diet in July. Hans Fugger informed Wilhelm in May that Venetian red crimson velvet of the best quality cost 4 to 5 ducats. He was told to order 300 ells of it and 60 ells of cheaper crimson atlas silks.[24] In 1586, Wilhelm requested over 17,000 florins from Hans and Marx Fugger to buy textiles. Years earlier he had assured their maturing sons the honour of including them in the Wittelsbach entourage for diplomatically important journeys.[25]

From 1583 onwards, as the Medici granted credit, Wilhelm's priorities above all focused on building the largest Jesuit church north of the Alps—St Michael in Munich. The archangel St Michael had been turned into a symbol of militant Catholicization driven by the Empire and the Bavarian state, so much so that the entire façade was covered with statues of Wittelsbach dukes who had fought for

[19] Hilda Lietzmann, *Valentin Drausch und Herzog Wilhelm V. von Bayern: Ein Edelsteinschneider der Spätrenaissance und sein Auftraggeber* (Berlin, 1998), 117; in 1583, Wilhelm requested another loan of 150.000 florins that Francesco granted; Suzanne B. Butters, 'The Uses and Abuses of Gifts in the World of Ferdinando De' Medici (1549–1609)', *I Tatti Studies in the Italian Renaissance* (11/2007), 243–354, here 301.

[20] Ursula Haller, *Das Einnahmen- und Ausgabenbuch des Wolfgang Pronner: die Aufzeichnungen des 'Verwalters der Malerei' Herzog Wilhelms V. von Bayern als Quelle zu Herkunft, Handel und Verwendung von Künstlermaterialien im ausgehenden 16. Jahrhundert* (Munich, 2005), 39.

[21] Maxwell, *Grotto*, 429.

[22] Maxwell, *Grotto*, 429–30.

[23] Häberlein, Bayreuther, *Agent und Ambassador*, 39.

[24] Karnehm, *Korrespondenz*, II.11, n.2139, p.957.

[25] Karnehm, *Korrespondenz*, II.1, n.834, p.362; Häberlein, Bayreuther, *Agent und Ambassador*, 39.

Catholicism, as well as of Wilhelm himself with a model of his new church.[26] As Wilhelm sought to spur on the Catholic Renewal, his own and his wife Renata's pious practices had become ever more demonstrative and integral to their lives. Once a week, a chronicler noted, Wilhelm now castigated himself and wore penitential dress underneath his silken clothes—a hair-shirt and breeches woven from the toughest hemp, roughest wool, and hair from humans, dogs, and horses.[27] Two passageways linked his castle to the Carmelite and Jesuit monasteries. Marian feasts became ever more important, as the Wittelsbachs believed that the Virgin Mary's intercession would be crucial to obtain God's help in warfare against heretics. The Magnificat and litanies as sung petitions to evoke Mary's intercession became a cornerstone of religious music. Music for Corpus Christi processions became so elaborate that trained musicians rehearsed their performance for weeks in advance.[28] Munich's religious processions were staged as splendidly and as sensuously evocative as possible. Wilhelm even instructed both Prospero Visconti and Hans Fugger to source fresh Italian palm leaves from the area of St Remo, where they were best, in time for Palm Sunday 1581. The procession mimetically evoked the entry of Jesus into Jerusalem, accompanied by scents derived from burnt olive wood. At short notice, Hans Fugger was told to order wigs and beards via Venice for masked characters in the Corpus Christi processions. He promised to have them sent straight to Munich with several couriers if necessary, rather than via Augsburg via the usual route for Italian deliveries. It irritated him that this hasty demand meant that they were vastly overpriced and of low quality.[29]

Before Easter, the period of penance following the excesses of carnival, was taken so seriously that Hans Fugger kept reminding Renata of Lorraine to discipline his fool Randel who entertained her in Munich. Fugger's fool Randel was a uniquely talented man who was for decades much in demand by Renata, Wilhelm, and his mother Anna, although he had once involved himself in a bloody fight with Anna's dwarf.[30] Discipline meant abstinence from alcohol, which he loved, and physical castigation, especially as Fugger felt that age made Randel even more foolish. This drove Randel to exclaim that he liked neither rods nor whips, and rather wanted to become a Lutheran.[31]

Fugger was alarmed. He believed that humans needed periods of penance to pray for God's mercy just as they needed air to breathe. Fools as figures of excess and licence embodied the need for humans to be cleansed from sins. Hans assured a correspondent

[26] Jeffrey Chipps Smith, *Sensuous Worship: Jesuits and the Art of the Early Catholic Reformation in Germany* (Princeton, 2002).

[27] The couple's penitential clothes survive, Reinhold Baumstark ed., *Rom in Bayern: Kunst und Spiritualität der ersten Jesuiten* (Munich, 1997), 353–4.

[28] Alexander J. Fisher, *Music, Piety, and Propaganda: The Soundscapes of Counter-Reformation Bavaria* (Oxford, 2014) 44–5, 106, 255–6.

[29] Simonsfeld, *Mailänder Briefe*, 521; Karnehm, *Korrespondenz*, II.1, p.831; n.1946, p.861; n.1952, p.864.

[30] Karnehm, *Korrespondenz*, II.1, n.1652, p.719.

[31] Karnehm, *Korrespondenz*, II.1, n.1877, p.827; n.1899, p.837; II.11, n.925, p.402.

in 1575 that his appetite for illicit sex had already burned off. Remembering the past, he referred to a beautiful Regensburg prostitute named 'Bird of Paradise', whom they both knew from attending political summits.[32] In 1581, Hans started to seriously cut back on his own alcohol intake, not only during Lent but also throughout the year, to benefit his 'soul'. He had tried to stop drinking too much wine for years, as he found wine from Southern Germany too sour and those from Cyprus too strong. Munich's ducal councillor Erasmus Fend now urged him to completely abstain from wine in favour of beer and, most importantly, to adhere to a limited daily intake. Fend drove a veritable campaign to improve German morals by fighting against the excessive consumption of alcohol—a long-standing ambition of many Germans that gained renewed energy in Catholic reform circles. Self-imposed limits displayed the ability to control one's passions through reason.

This underlines the fact that early modern merchants like Fugger cannot be understood solely as Renaissance men who calculated the reduction of transaction costs to optimize supply, rationally decided over prices, and were emotionally numb. They lived in a time which provided much guidance on the question of how the world was to be experienced sensorially—in their relation to sight, smell, sound, and touch—and emotionally, not least through a new emphasis on health preservation. Objects, drinks, drugs, or food were therefore implicated in moral and not just in social self-formation. The Fugger and their material communities hence 'played a key role in the emergence of new types of knowing tied to the world of the senses', imbued 'with virtue and morality'.[33] Their consumer demand and relation to matter corresponded to, and further explored, understandings of the body, passions, and the soul as Catholic reforms were finally implemented.

Fugger in turn proudly related that his new diet consisted of drinking just over one litre and a half of beer in the morning and the same at night. However, he confessed that it was only possible to follow this lifestyle if he stayed at home. When in company, it remained customary for men to copiously drink to each other's health in multiple rounds. Still, he was happy to generally keep to Fend's rules for greater godliness and a reform of German morals, although he felt unable to completely forsake wine.[34] From the age of fifty, Fugger also took carriages more often, and preferred slower horses of medium height that suited his size, were easy to ride, and alleviated his back pain when he hunted ducks or rode long distances. After his wife's death in the middle of the Imperial Diet in 1582, when the couple had moved out of their palace temporarily to make space for Emperor Rudolph, he admitted feeling like an 'old mare, unable to move forwards well'.[35] Cures with 'china-bark' improved some of his ailments, and the

[32] Karnehm, *Korrespondenz*, II.1, n.587, p.249; n.623, p.262.
[33] Joanna Woodall, 'In Pursuit of Virtue', in *Nederlands Kunsthistorisch Jaarboek (NKJ)/Netherlands Yearbook for History of Art* (54/2003), 6–25.
[34] Karnehm, *Korrespondenz*, II.1, n.1827, p.801; n.1840, p.807.
[35] Karnehm, *Korrespondenz*, II.11, n.2255, p.1010.

housekeepers managed his daily affairs. Aged fifty-two, he had no desire to remarry, as stepchildren would reduce his children's inheritance and threaten the future of the company. Besides, he thought that given his middling age he would only be able to attract fat women, whether they were young or old.[36] Fugger kept slim, and he certainly kept in style as a widower and as newly elected imperial count after the 1582 imperial summit. In 1583, he bought a leopard fur and tails of sable for well over 1,000 florins. In 1586, he decided to have the four horses of his carriage dyed with saffron—but which turned out a little too bright yellow.[37] Saffron colour was esteemed for its warm, animating glow and, as we have seen, associated with a solar spirit. Prices for it had doubled in the second half of the sixteenth century, so that saffron belonged to the most expensive colourants ever bought at Wilhelm's court, and valued alongside ultramarine.[38]

Hans Fugger might have taken some of his decisions with the help of lists, in which case these included during the next months:

eating my morning porridge without saffron in future to save costs;

looking for a new horse, as one of the four saffron-coloured horses to draw my carriage has perished;

commissioning Alexander Colin to complete the marble tomb sculpture of himself as knight in armour within six to eight months;

ask Ott to choose items from the list of Persian and Turkish rarities for sale in Venice I have annotated.[39]

Yet, all in all, after losing his wife, Hans Fugger quickly recovered the mental speed and energy so vital to a merchant's ability to competitively buy goods in a period of intense political and religious turmoil.

In 1581, he happily told Wilhelm that Augsburg's Jesuit College Saint Salvator was nearly ready to start educating young men. Lutherans, led by the professor of theology Müller, had just finished building St Anne College, which Fugger thought a Lutheran 'synagogue'.[40] Jesuits felt they faced an uphill struggle. Petrus Canisius (1521–97), the influential Jesuit priest, lamented in 1583 that the Germans as a nation were given to drink and overeating, and that they were independent and proud but cold in spirit and somewhat rough in their thought and judgement.[41] These were traditional stereotypes, but he judged the success of Protestantism to be a result of this national problem. Fervent, sensuous devotion was seen to not come naturally to this nation, which explains why evocative materials, artefacts, images, spaces such as newly built hermitages and staged performances were given such prominence in order to achieve religious

[36] Karnehm, *Korrespondenz*, II.11, n.2269, p.1015–16.
[37] Karnehm, *Korrespondenz*, II.11, n.2418, p.1095; II.11, pp.1359, 2969.
[38] Haller, *Das Einnahmen- und Ausgabenbuch*, 146.
[39] This fictive list is based on information in Karnehm, *Korrespondenz*, III.1, n.2969, p.1359; n.3011, p.1378.
[40] Karnehm, *Korrespondenz*, II.1, n.1923, p.849.
[41] Baumstark ed., *Rom in Bayern*, 47.

affects. Music played a major role in them. Hans Fugger was obliged to source a 'moor' for one of these Corpus Christi processions to make it more affecting for the audience. The 'moor' he found was an elderly black man employed by Augsburg's civic guard, who had served many years in the Spanish wars in the Netherlands.[42] Hans Fugger and Wilhelm were at one in their commitment to the Jesuits. Their mission was to grow, as much as to defend, true Catholic devotion in the world and the nation in order to refine Germany as a civilization. Indeed, Fugger feared that Augsburg would deteriorate into a 'dive' if the Lutherans gained the upper-hand in governing the city; and he let it be known that in such a case he would move away.[43]

After decades of peaceful co-existence, the atmosphere between Protestants and Catholics turned explosive in 1583. Catholics now controlled twenty-six of forty-five seats in Augsburg's small council, and Marx Fugger had acted as mayor since 1576. Hence, most councillors decided to introduce an adjusted calendar proposed by Pope Gregory in the previous year. Many Catholic territories and nations had already adopted it, and, it was argued, would benefit trading. In turn, the Lutheran preacher Müller vehemently attacked merchants, councillors, and Jesuits as children of the devil. Protestants kept to the old calendar, so that Catholics in Augsburg started to work and worship on different days of the week to them. In March 1584, Emperor Ferdinand I requested 1,000 soldiers to be hired to keep the city under control; in June, Protestants revolted in their thousands. About 3,000 disaffected Protestants eventually left Augsburg after the Imperial Chamber Court ordered the expulsion of Müller.

Alongside the Cologne Wars (1583–88), the tensions in Augsburg showed how the achievements of the 1555 Peace of Augsburg could become fragile in the German lands. Hans Fugger told a commission tasked with inquiring into the background of these disturbances that they were motivated by poverty and rebelliousness rather than by any truly religious sentiment. As in the Peasants' War, religious motives mixed with a wider vision of ethical politics. Once again, the Fuggers came under attack. A patrician called David Weiss picked up on arguments against the Fuggers as he gave evidence for the inquiry, and he provided detailed information: everyone earning an income of over 150,000 florins was meant to pay 600 gold florins in tax to the city, and yet the entire Fugger clan was known to pay only 2,000 gold florins. Instead of paying sufficient tax, they bought local houses, only to then tear them down and create pleasure gardens. This made it harder for poor people to find anywhere to live. The new Jesuit College the Fuggers had substantially helped to finance and promote had also created tensions.[44]

[42] Karnehm, *Korrespondenz*, II.11, n.2500, p.1137.

[43] Häberlein, *Die Fugger*, 185.

[44] Bernd Roeck, *Eine Stadt in Krieg und Frieden: Studien zur Geschichte der Reichsstadt Augsburg zwischen Kalenderstreit und Parität*, vol. 1 (Göttingen, 1989), 125–37, here esp. 136, and for an analysis of declining incomes since 1558 for middling people see 158–60.

All this helps to explain why Hans Fugger himself never showed any interest in furthering the conditions of Augsburg's fustian weavers, who made up much of its impoverished and overwhelmingly Protestant workforce. These weavers overproduced cheap mixtures of cotton and flax yarn that were exported across Europe and globally, but now faced stiff competition from central German producers, the English, and the Dutch. By 1610, the weavers' craft ballooned in size to become ten times larger than any other craft; 2,000 weavers turned out 400,000 pieces of fustian a year, although half of them worked just on one single loom in their workshop, and many received public alms.[45] Hans Fugger would have regarded these weavers as part of the Protestant rabble, ready to ruin a city. In his own territories, Hans tightly controlled the appointment of able priests and their conduct. Discipline, international commerce, and a renewed, sensuous Catholicism aligned with his vision of Germany's development as an advanced civilization.

As Duke of Bavaria, Wilhelm would need to navigate severe challenges in the years to come. In May 1590, the church tower of St Michael collapsed and seriously damaged part of the church's interior. It was said to be a symbol of Wittelsbach power and the Counter-Reformation. St Michael was revered as the protective spirit of the German lands. Fickler was among those who feared that the devil had told an army of witches to destroy the church. Undeterred, and with Sustris's help, it was decided to finish and inaugurate one section of the church by October, and to accept the Vatican's offer to send an Italian architect to help build another cupola.

The next disaster beckoned when Wilhelm, during that same October, decided to house and greatly encourage Marco Bragandino, a Cyprus-born alchemist. In his patronage of alchemy Wilhelm sought to turn his court into a scientific centre as part of his state-building mission, and as an initiative was typical of German courts at the time. As we have seen, since the beginning of the century, humanists and artisans had begun to promote alchemy as chemistry that promised to transmute materials for health purposes, to invent or improve material artefacts. Now, alchemy in addition was seen as a possible means to consolidate state finances through the production of gold. Bragandino promised to cure Wilhelm's chronic headaches and to draw the 'soul of gold' from jewellery that he had requested from the duke. He then sold on these valuable treasures. In April 1591, Bragandino was decapitated for fraud in Munich, carrying a rope coloured with gold leaf around his neck. A horrified crowd watched the executioner failing to cut through his neck in one go and then butcher the man.[46]

Despite such setbacks, Wilhelm's acquisitive energies continued unchecked. As we have seen, from 1581 Hans Fugger was prepared to once again shoulder some large debt payments for him, not least to increase the size of his territories in Bavarian land that he received in exchange. Moreover, Fend helped by reminding Wilhelm to put pressure

[45] Häberlein, 'Production', in idem and Tlusty eds., *Companion Augsburg*.

[46] Ivo Striedinger, *Der Goldmacher Marco Bragadino. Archivkundliche Studie zur Kulturgeschichte des 16. Jahrhunderts* (Munich, 1928).

on Philip II to repay the Spanish Crown's debts.[47] This was an interlocking system of finance—pressuring Philip II aided the Fuggers in continuing to draw considerable profit from the Spanish mercury mines on land that was leased to them; and it enabled them to grant further credit to Wilhelm. Hans Fugger himself had finished his castle at Kirchheim, with its 375-square-metre-wide festive hall, by 1585, though few visitors made the trip to see it. From around 1590, Wilhelm acquired many newly sourced relics, rebuilt the Munich *Antiquarium*, and constructed a new palace for himself and Renata. By 1596, the palace was ready to move into; in 1597, the completion of St Michael's church was celebrated with an exceptional performance of a Jesuit drama to honour the archangel Michael. It lasted for eight hours, involved nine hundred actors, technical effects, and lavish staging, for which enormous amounts of paint had been used.[48] Wilhelm's precious relic collection included an unusual number of skulls from saints which were encased in tight, lavishly embroidered silk masks and decorated with a wreath of fresh flowers. They were placed on velvet cushions to be kissed by the devout.

It did not take long for Wilhelm's finances to yet again verge on bankruptcy. By 1588, the duke admitted to his estates that he had accrued 1,900,000 florins of debt.[49] In 1594, he appointed his nineteen-year-old son Maximilian as co-ruler of Bavaria, agreeing to hand over to him four years later by abdicating. Duke Maximilian I of Bavaria chose a path of austerity over further debts and dependencies. He immediately reduced spending at court and defined new priorities. Two decades later, Dürer's Heller altarpiece would top his wish list.

Hans Fugger died in 1594, only a few years after his brother Marx, leaving Maximilian with heirs from both sides of the family to satisfy. In that same year Philip II of Spain passed away. In Inner Austria, Maria of Styria's son Ferdinand started a militant campaign against Protestants to advance the Catholic Renewal. And it was now that seven provinces of the Netherlands, which had broken away from the South to create the Dutch Republic, surged in power, to turn, alongside Britain and Sweden, into a Protestant sea-trading nation.

[47] Karnehm, *Korrespondenz*, II.1, n.1937, p.856. In 1585, Hans offered a loan of 10,000 for one year with five per cent of interest to the small town of Mering, n.2713, p.1238.

[48] Haller, *Pronner*, 69.

[49] Spindler, *Handbuch*, vol. 2, 361.

PART THREE

Dürer and the Global Commerce of Art

CHAPTER 22

The Lives of Northern Painters

Ever since the publication of Vasari's *Lives of Artists*, a fuller account of the Northern painters was waiting to be written. The man to do so was Carel van Mander (1548–1606), a Flemish painter and writer of Protestant faith. Van Mander dedicated an entire volume of his wide-ranging history of art to Flemish, Dutch, and German painters. This story begins with Jan van Eyck (1390–1441), a fellow countryman mythically turned into the inventor of oil painting. Vasari had foregrounded achievements in *disegno*—painterly style, ideas, and form—over how painters handled their materials. As any composition in oil could be endlessly changed, Vasari and Italian art critic Giovan Paolo Lomazzo (1538–92) ambivalently characterized oil painting as an effeminate technique. It suited youths and women rather than mature men. Fresco painting was fully masculine because any execution was finite and it required boldness.

Van Mander by contrast proposed that Northern art differed from Italian art by taking nature as its guide in recreating its colours. Nature was 'the mother and nurse of painting'. He told the story of van Eyck like a fairy tale to show that Northern excellence was rooted in the observation of natural colours and in technical knowledge through chemical experimentation, in persistent research on colour making, varnishes, and methods of distilling. Such painting triumphed through understanding mundane substances, such as the properties of nut or flaxseed oil when combined with pigments. No one before van Eyck had achieved the same lustrousness. In fact, van Mander chided, Italian visitors to fifteenth-century Flemish churches had been sniffing the strong smells of these early oil panels in vain, attempting to understand the secret of their paint. Northern art excelled through technical knowledge, optical effects, patience, a prolonged process of improvement in the process of painting in oil. Through oil they achieved sharpness, specificity, immediacy, the perfect mimicry of rarities as much as the ordinary, and thus accomplished descriptive proficiency to stimulate perception.[1] Looking at such oil paintings shaped a viewer's senses, emotions, and mind. For instance, only an artist able to create glowing colours,

[1] Carel van Mander, *Das Leben der niederländischen und deutschen Maler*, transl. Hanns Floerke (Worms, 1991), 24–6; Walter S. Melion, *Shaping the Netherlandish Canon: Karel van Mander's Schilder-Boeck* (Chicago, 1991), here esp. 90–1 and 132–3, 140–1; Christine Göttler, 'Yellow, Vermilion, and Gold: Colour in Karel van Mander's Schilder-Boeck', in Susanna Burghartz et al. eds., *Materialized Identities: Objects and Affects* (Amsterdam, 2021), 233–73.

260 Ulinka Rublack

he claimed, truly animated the body of a naked Bathsheba in lifelike ways so that it moved the viewer.[2]

All this made van Eyck sound like a man of the new empirical sciences which had gained increasing recognition during van Mander's time. Ever more city dwellers owned paintings, collected curiosities, and gardened with exotic plants. Alchemical laboratories attracted unparalleled interest and state sponsorship. Astronomy advanced through empirical observation based on powerful lenses. Printing was hailed as a German invention that had made the circulation of knowledge across society possible.

Jan van der Straet (1523–1605) hence celebrated a whole series of inventions and discoveries that had transformed European society in his *Nova Reperta*, a bestselling series of fine prints issued between 1580 and 1600. One depicts van Eyck as the man who had discovered oil painting. It includes two mature craftsmen standing to the right of the painter's workshop carefully blending ground pigments and oil with a glass muller. [22.1] In real life they would know just when their consistency sounded, smelt, and looked right, producing tiny samples of paint ready to be stored in shells. Filtered oils in glass bottles sit on the windowsill for sunlight to thicken and bleach them. Another print in the series shows a sophisticated chemical laboratory in which book learning and practical experience mutually inform each other.[3]

From such a vantage point, Northern art was indeed rooted in the observation of material properties and ever new experiments to better understand the principles of nature and her four elements—earth, air, fire, and water. Aesthetics and the history of art were bound to this evolving understanding of working with matter, and matter was not comprehended in Aristotelian terms as female, inferior to form, and something to master. It was to be respected, explored, and worked *with* through the senses as much as the intellect.

This approach to art also served to construct a Protestant aesthetic after the age of iconoclasm, as it focused less on a painting's religious subject and how its expression intensified specific cultic practices of worship. Van Mander certainly stressed the importance of an artist's ability to comprehend any theme with his mind and soul, to diligently work on fine details, to capture movement and integrate original motifs as well as to add a great number of faces with an infinite variety of expressions. Yet he kept emphasizing the importance of colourmaking to lend a work timeless quality. He thus compared van Eyck's depiction of drapery in the Ghent altarpiece to Dürer's way of handling 'folding fabric', and continued: 'the colours blue, red and purpure are eternal and so beautiful that they seem to have been freshly applied'.[4]

[2] Mander, *Leben*, 393–4, on Frans Badens; Maurice Sass, *Physiologien der Bilder: Naturmagische Felder frühneuzeitlichen Verstehens von Kunst* (Berlin, 2016), 277–302.

[3] For an in-depth discussion see Lucy Davis, 'Renaissance Inventions: Van Eyck's Workshop as Site of Discovery and Transformation in Jan van der Straet's *Nova Reperta*', *Nederlands Kunsthistorisch Jaarbook*, 59 (2009), 222–47.

[4] Mander, *Leben*, 29.

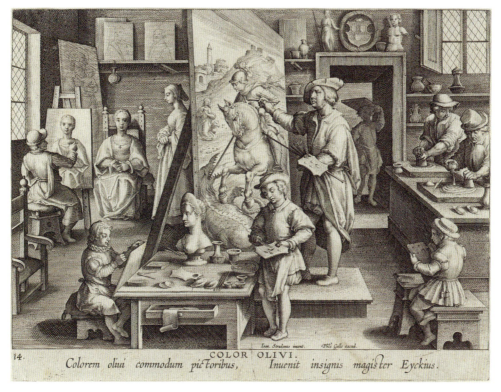

Fig. 22.1 Jan van der Straet, 'Color Olivi' from the Nova Reperta series, engraving, c.1580–1600. The Metropolitan Museum of Art, New York. The Elisha Whittelsey Collection, The Elisha Whittelsey Fund, 1949, public domain.

Van Mander enthused that many formidable achievements by Northern painters were recent and ongoing. In fact, van Mander championed the idea that the year 1600 hailed a new Golden Age for Dutch cities like Haarlem and Amsterdam, to which he, like many Flemish painters, had relocated in search of religious tolerance after Antwerp had fallen to the Spanish in 1585. He hoped for an exchange of ideas with other men and women of knowledge in the Dutch Republic, and for a good income. Van Mander's opening biography of van Eyck as founding father of the Northern arts thus contained another distinct element absent from Vasari's discussions. Whereas Vasari's artists were principally defined by their service to courts and the Catholic Church, van Mander lauded the merchant city as the motor for artistic production. Van Eyck, he related, had moved to Bruges because merchants from many nations traded in the city and it overflowed in riches. The Italian textile merchant Arnolfini, of course, commissioned a portrait of himself and his wife from van Eyck. 'Art', van Mander concluded, 'likes to live where there is wealth, from which she hopes to receive abundant rewards.'[5]

[5] Mander, *Leben*, 24.

As the Dutch Republic emerged as a heavily urbanized trading nation, van Mander witnessed an art market which was principally flourishing through the patronage of merchants. There were few opportunities for artists to seek aristocratic and princely patronage. At the same time, Mander made it clear that the best artists could aspire to be eventually honoured and admired by rulers. The Duke of Burgundy had appointed Jan van Eyck as a secret councillor. Bruges' merchants had sent his panels to rulers abroad, and Philip II of Spain's investment in a high-quality copy of the Ghent altarpiece enshrined van Eyck's lasting fame. It had taken Michael Coxcie, Mary of Hungary's court painter, between one and two years to complete the copy. Only azurite sourced from Hungarian mines via Venice had sufficed to replicate its powerful blue colour.

In drawing attention to copying as a mark of a painter's prestige, van Mander's account was influenced by two developments which stimulated the art market that had emerged since Vasari had written in the mid-sixteenth century: first, high-quality copies of major altar pieces and other master paintings were becoming prestigious. These copies retailed for up to half of the price of the original. At the same time, this development increased anxieties about whether painters delivered originals or copies, as a result of which mechanisms to certify a painting's authenticity and a painter's name and verifiable signature became ever more important. A rapidly growing international art market relied on brokers with comprehensive art expertise and on legal mechanisms that locally certified contemporary pieces as originals immediately after their production.[6] Second, original Flemish altarpieces which had been protected from iconoclasts were now marketed. Both factors contributed to a third, and astonishing, phenomenon: leading art lovers now began to directly negotiate with convents, monasteries, and churches to enquire whether they might accept a high-quality copy in return for selling them the originals.

Mary of Hungary (1505–58) appears to have started this new practice of copying entire altarpieces and even replacing originals. In 1548, Mary negotiated to replace Rogier van der Weyden's *Descent from the Cross* with a copy by her excellent court painter Coxcie. After her nephew Philip II of Spain inherited this original painting, he in turn employed Coxcie full-time for two years in Ghent, from 1557 to 1558, in order to complete that exact copy of van Eyck's Ghent altarpiece which van Mander mentions. In the aftermath of iconoclastic attacks in Flanders during the 1560s and 1570s, art lovers, many of whom were merchants, scouted out new opportunities to buy paintings that had formerly hung in churches. Maerten van Heermskerk's Alkmaar altarpiece, for instance, had been removed by the local authorities to protect it from iconoclasm in 1572. It was sold to merchants in 1581, who in turn sold the altarpiece

[6] For an informative article see Caecilie Weissert, 'Bewundern und Betrügen. Original, Reproduktion, Kopie und Fälschung in den Niederlanden im 16. und 17. Jahrhunderts', in Birgit Ulrike Münch et al. eds., *Fälschung—Plagiat—Kopie. Künstlerische Praktiken in der Vormoderne* (Petersberg, 2014), 98–109, esp. 104–5. For a new study of this phenomenon, which was published after this book manuscript was completed, see Antonia Putzger, *Kult und Kunst – Kopie und Original: Altarbilder von Rogier van der Weyden, Jan van Eyck und Albrecht Dürer in ihrer frühneuzeitlichen Rezeption* (Berlin, 2021).

to John III of Sweden. The king gifted it to Linköping Cathedral, as it depicted scenes from Christ's passion and crucifixion in ways entirely compatible with Lutheran attitudes to religious art.

Suddenly, copying originals in churches and in convents to enrich courtly collections became common. For example, in the same year the Alkmaar altarpiece was sold, the widowed Empress Maria of Austria requested Hans Fugger to arrange for a painter to copy *The Life of St Ursula* from a Dominican convent. Fugger obliged. Abraham de Hel removed the panel from the convent and propped it up in his study, to start on a copy on canvas that was to earn him 127 florins. Next, Maria cancelled the commission, presumably because she had decided to move to Spain. This left Fugger to negotiate for a payment of 15 florins to compensate de Hel for his work to date.[7]

These developments were linked to the fact that European demand for old master paintings was growing. Emperor Rudolph II, a son of Maria, fuelled this trend for Northern paintings. As Rudolph II planned an art gallery in Prague separate from his cabinet of curiosities, his foremost goal became to acquire authentic masterpieces that were notoriously rare and exquisite. Dürer ranked highest on his list. In 1585, Rudolph II successfully negotiated with the Nuremberg council to extract the Landauer altarpiece from the foundation's chapel. He paid 700 Rhenish florins for Dürer's masterpiece. Rudolph II's approach to negotiations was new. Dismissing the frame Dürer had conceived as integral to the piece, he had a copy of the painting made and took the original to Prague. A functioning altar—and the chapel's only one—turned into a piece of art devoid of any religious context.

By 1588, Rudolph II owned several other notable Dürers he had mostly bought from Hans Imhoff's estate in Nuremberg. Alongside the best Flemish, Italian, and Spanish masters, Dürer's paintings helped to represent the German school in his exquisite collection. Maximilian I of Bavaria visited Rudolph II's court for a week as a twenty-year-old in 1593, and he would have seen some of his collection. If he had seen the plans for the art gallery, they would have deeply impressed him. [22.2]

When he became Elector of Bavaria five years later, Maximilian I too set his eyes on hunting down Dürers. Rudolph II, Maximilian I, and a small group of other major collectors thus did their best to negotiate exclusive deals with institutions and to cream off Dürers, Breughels, and other master painters from the market. From 1607 onwards, Maximilian I housed these paintings in his *Kammergalerie*, a new space built for him and, at times, very select guests in his company, to admire them. Above all, this was a deeply personal space, adjacent to his bedroom, from where an opening allowed him to see through to the gallery. In its early years, it primarily housed portraits of rulers of the Wittelsbach dynasty and about thirty master paintings. Maximilian I carefully supervised the compilation of the gallery's inventories, and a proper catalogue which listed

[7] Karnehm, *Korrespondenz*, II.1, n.1971, p.872; n.1822, p.798.

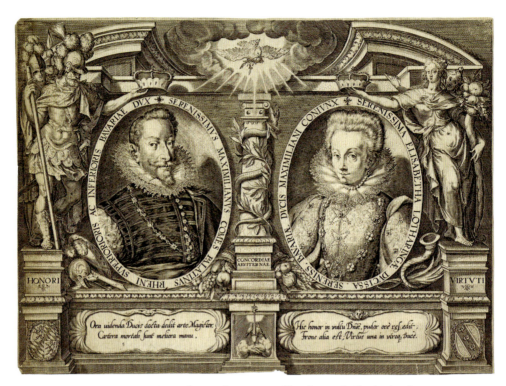

Fig. 22.2 Dominic Custos, Maximilian I of Bavaria and his first wife Elisabeth of Lorraine as youthful rulers of Bavaria, engraving. © The Trustees of the British Museum.

measurements and often materials, as well as available information about the artist and the picture's provenance.[8]

During the first part of his reign, this Bavarian ruler was the first collector to predominantly focus on the 'Old German School'—paintings that by now were often around one hundred years old. This was in clear preference to most contemporary art. Maximilian I liked old masters because he thought their painting style was 'clean'—and he liked seeing them in a neat, curated environment that allowed for pious, meditative contemplation. Overly artistic Italian paintings of sacred subjects often approached their theme with stylistic liberties that had already offended Hans Fugger. Early pieces by Dürer, by contrast, represented a purer type of pre-Reformation art and a time when German Christians had been unified in their faith.

Pre-Reformation art suggested the importance of continuity as Maximilian I tried ever more aggressively to advance Catholicism in the German nation. After a series of

[8] Dorothea Diemer and Peter Diemer, 'Zuflucht der Musen?: Die Hofsammlungen der bayerischen Wittelsbacher im sechzehnten und siebzehnten Jahrhundert', in Alois Schmid ed., *Die Hofbibliothek zu München unter den Herzögen Wilhelm V. und Maximilian I.* (Munich, 2015) 37–59; for an overview see also Dieter Albrecht, *Maximilian I. von Bayern 1573–1651* (Munich, 1998), 249–84.

conflicts from 1606, Maximilian I obtained Emperor Rudolph II's permission to send troops to the bi-confessional city of Donauwörth in December 1607. He annexed and re-Catholized the town. To many, this new Bavarian ruler seemed unscrupulous given the delicate balance of peace that German territories and the city were attempting to maintain.

Van Mander fuelled this renewed interest in Dürer's painting by providing the longest biography yet of the Nuremberg artist. It mythically presented Dürer as a thoroughly German painter who had never been to Italy or seen the wonders of classical Greece. Dürer had brought light to German art where there had been darkness. The artist had been learned and thus the Holy Roman Emperor Maximilian I treated him like a nobleman, able to bear his own coat of arms. Van Mander attempted to list Dürer's artistic (*kunstreiche*) paintings. He was pleased to note two of them in Rudolph II's new gallery because this honoured Northern painters.

Van Mander next described a 'very beautiful artful painting by Albrecht' still in a Frankfurt monastery. This, of course, was the Heller altarpiece. Dürer, he explained, had painted in a 'very clean and proper manner', with 'mindful' brushwork, especially in depicting the hair with his customary display of virtuosity. Common people, the Protestant art critic alleged, adored the naked feet of the kneeling apostle, so much so that there had been suggestions to cut out this small part of the panel. 'It is almost unbelievable and strange', van Mander commented, how 'much money the monks make through opening up this altar'. The monks received tips and presents from 'great lords, merchants, travellers and lovers of art'.[9] To anyone reading van Mander's book, this would have implied that the Dominicans might never want to sell such a source of spiritual inspiration. Yet it made equally clear that the monks had already become used to the Heller altarpiece being treated as an artwork and source of revenue. Might they be open to a deal?

[9] Mander, *Leben*, 59.

CHAPTER 23

The Art Agent

During the 1605 spring fair, a young Lutheran textile merchant from Augsburg called Philipp Hainhofer (1578–1647) made his way to Frankfurt's Dominicans in order to see Dürer's altarpiece. He read Dutch and was keenly interested in new publications and art. It is perfectly possible that reading van Mander's treatise had led him to make his way to the monastery.

Hainhofer received a guided tour by one of the few remaining Dominican brothers in the Protestant city. He left unimpressed by the monastery itself. To him, it looked like 'an old Franconian bad building'. 'Old Franconian' was a term Hainhofer often used to indicate that a building looked Gothic and outdated, sometimes even 'melancholic' in style.[1] Contemporary architecture excited him far more. But he knew what to look out for in this Dominican church. It has, he enthused,

> a really wonderful, beautiful altarpiece made by Albrecht Dürer, which is closed, and is only open for feast days or when foreign people desire to see it opened. It is the Virgin Mary's ascension to heaven made with beautiful, lively colors in the year 1509. It looks completely fresh, as if it had been painted today. A Frankfurt citizen named Jacob Heller commissioned it in his memory for the church, next to his tomb, and these are the words written down beneath the painting: If Apelles had seen this panel's figures, I think he would have been stunned by Albert's cultivated hands and ceded the palm, surpassed by the new art.[2] [23.1]

Characteristically, Hainhofer as a Lutheran merchant focused on Dürer's technical achievements in colour. Much experimentation had obviously gone into creating their durable intensity and 'freshness'. The notion of vivacity linked to ancient rhetorical ideas of how to succeed in making a subject relevant. Hainhofer's appreciation similarly turned on this sensation of its aliveness. And for Hainhofer as for van Mander, aliveness was a consequence of artistic techniques mastered by the German Apelles to enduringly affect the soul.

During these years, Hainhofer was in his twenties and slowly turning himself into an international art agent. In fact, his life and abundant writings provide us with

[1] Anne Langenkamp, *Philipp Hainhofers Münchner Reisebeschreibungen: Eine kritische Ausgabe* (D.Phil. dissertation, Berlin, 1990), 43.

[2] HAB Cod. Guelf. 60.21 Aug. 8°, 171v–172r, my emphasis.

Fig. 23.1 After Albrecht Dürer, a copy, probably in a seventeenth-century hand, of the figure of the artist depicted in the middle distance of his painting 'The Coronation of the Virgin', the central panel of the Heller altarpiece of 1509, pen and brown ink, 18.2 × 10 cm © The Trustees of the British Museum.

exceptional detail on how seventeenth-century entrepreneurs like him created competitive commercial markets for goods ranging from polar bear skins to paintings. Visiting the Munich cabinet of curiosities in 1603 had changed his life. It inspired him to become a global art dealer who shaped courtly collections. In 1606, Hainhofer would meet the former duke Wilhelm of Bavaria, who kept on eagerly contacting new merchants and middlemen to commission and collect for his dynasty and faith. Munich's collection kept growing not just through diplomatic gifts but through such acquisitions. By 1611, Hainhofer went on a secret mission as a diplomat in the service of the Wittelsbachs. Soon after, he met Maximilian I, and knew him personally during the years when the Bavarian duke sought to acquire the Heller altarpiece.

Hainhofer's success demonstrates the resilience of Augsburg merchants as the shape of the world economy shifted and how it was interwoven with new functions of art in society and politics. He offered specialized services by brokering all types of arts and natural exotica in an age of accelerated state sformation and confessional tension. In this new world after 1600, his trade legitimated itself as a medium of diplomacy and politics. He worked for courts of different confessions across Germany, from Bavaria to the Baltic Sea, and internationally, arguing that he sought to unite them through their interest in the arts. Yet working for different courts allowed him to strategically create competition for goods amongst them. It linked to his marketing strategies; first establish common tastes and then create a successful commercial market for goods. He worked with a team of craftsmen he had assembled—who supplied everything, ranging from trick purses for entertainment to super-expensive cabinets filled with rarities—only to subsequently drive up prices amongst his clients through their rivalry about items he advertised as entirely exceptional and unsurpassed. Men like Hainhofer typically started out as textile merchants for courts and elites, knew several modern languages well, enjoyed excellent access to cultural and political information, and easily conversed with Catholics and Protestants. His identity as a 'knowledgeable', multi-confessional and modern merchant with connections to the ascendant English and Dutch made Hainhofer a very different type from Hans Fugger, the merchant banker. Merchant agents like Hainhofer turned into art lovers as they responded to the growing demand for art and rarities from distant markets and shared the fascination with ever new curiosities, while also acting as political diplomats and secret agents. In fact, education, taste, and the ability to behave and communicate as 'gentilhuomo' now mattered more than noble descent in the appointment of a diplomat. Hainhofer's duties veered between supplying general political information, like many merchants in well-connected centres of news, to dealing with sensitive information in his role as Lutheran intelligencer for several Protestant courts to influence decisions.[3] Many of his activities as intelligence

[3] Michael Wenzel, *Philipp Hainhofer: Handeln mit Kunst und Politik* (Berlin, 2020), 86–7, 103.

gatherer remain elusive, but he seems to have only rarely encoded information. In fact, he was so good at his job that he left few traces and was recommended to the British King as a spy.

Hainhofer became the most influential among merchant agents as new intermediaries in the art market in the German lands and turned into an artistic creator of international reach. From 1610 onwards, he perfected the art cabinet as a single exquisite piece of furniture to behold, learn, and gain pleasure from, filled with hundreds of rarities and marketed to courts ranging from Poland and Italy to Britain. These cabinets were the most luxurious, most high-end object ensembles available in Europe, and were poised to turn into global products. Hainhofer confidently thought that one of them would be perfect for an 'Indian prince' and was cognizant of the fact that in 1617 Maximilian I sent a smaller cabinet to impress the Chinese Emperor Wanli. A Hainhofer cabinet truly was an object of wonder and itself an absolute rarity. Its compartments and complicated veneers in hard stones and exotic woods took years to make and assemble. Its production depended on merchants who ensured the ready flow of high-quality global raw materials into the city, such as African gold and black ebony wood, or American silver, as well as craftspeople with exceptional technological know-how and an appetite for experiment. It fed off rich currents of information about the latest developments in natural philosophy, including fields such as optics and instrument making, the latest books and developments across the arts. Hainhofer coordinated as much as inspired these efforts. The agent coordinated a team of around thirty exceptional luxury craftspeople in Augsburg who worked in different media and across them, constantly pushing them on to do their best, to acquire new skills, generate innovative designs, instruments, and techniques as well as to pick up novel artefacts for study. Augsburg's compact geography helped these exchanges, as did the fact that most of these highly skilled craftspeople in the luxury sector were highly mobile and in demand as they travelled to courts and cities for site specific commissions, received international clients and requests for specifications that spurred innovation. Hainhofer marketed the cabinets in several languages and supplied detailed guidance on how their mini-collections, precision instruments, entertaining games, and mini-pharmacies were to be accessed through intricate mechanisms and closed drawers, and how they were to be intellectually understood as much as experienced through the senses, body, and emotions. Its minerals were to enact their power, medicines were to be imbibed and the flasks to be refilled, the games to be played and the contents of secret drawers to be unlocked and reflected on over and over again. They transcended narrow concerns of the everyday or embellished them in exciting ways. Fine instruments to shave and trim beards matched technological advances with aesthetic elegance, as a pair of silver scissors turned into a tool of civility. Automata played spiritual music. These cabinets were intended as steady companions, to involve owners in uplifting practices of usage that reshaped their relationship to human existence, to spirituality and health.

Philipp Hainhofer, in other words, turned into a cultural entrepreneur and merchant creator of theatres of knowledge, the senses, of wisdom and wit.[4] [23.2]

Hainhofer's career shows that the phenomenon often described as the 'Dürer Renaissance' needs to be situated within these developments in the market for luxuries. While some leading collectors developed a taste for old Northern master paintings, this happened in tandem with the innovative production and marketing of other arts and a flourishing culture of curiosities fuelled by mercantile trade. The taste for old Northern masters was merely added on. The new type of merchant agent was able to act as a knowledgeable lover of *all* arts, who moreover saw it as his mission to spread civilization and concord in an age of confessional tension. Prominent in the Netherlands since the 1590s, the word *liefhebber* followed the older German term of the *Kunstliebhaber*, and such art loving as practice linked to a distinct persona, ethos, and group identity. Hainhofer was at the forefront of this European-wide cultural movement to boost refinement and an informed curiosity as a way of relating to the world. Art lovers endorsed a passionate approach to the discovery of ever greater natural variety and wonder in human arts and crafts. Their exchanges aimed to build civility, trust, and beneficial feelings to mediate or overcome political and religious divisions. Lovers were men and women of discernment and sensibility, who knew how to evaluate not just paintings and curiosities and take great pleasure from them but scents, flowers, lace, or feats of mechanical invention—in fact, all fine and ingenious things in life. They were people of skill and sociability, for they would talk about their admiration for particular pieces in detail, would travel to widen their knowledge, and, when they met, would take their time to explore objects and exchange aesthetic views. Their ties of 'friendship' enabled the sharing of quality copies of the best and newest art and architecture, of the latest medicines, or the most valuable curiosities. The movement was built on the idea of an expansive network of brokerage, integrating different parts of Europe into an art market of global reach.

The idea was central to van Mander, who unsurprisingly linked these learned and affective practices to commercial acumen. He left no doubt that any art collection was a financial investment, and that visitors were to take time not only to value objects aesthetically but also to calculate their material value and marvel at both.[5] Yet, as we have

[4] For a short but informed summary see Joachim Lüdtke, *Die Lautenbücher Philipp Hainhofers (1578–1647)* (Göttingen, 1999); for the assessment of Hainhofer as merchant-creator see also Wenzel, *Handeln*; and Hans-Olof Boström, *Det underbara skåpet: Philipp Hainhofer och Gustav II Adolfs konstskåp* (Stockholm, 2001), 305–20; Bernd Roeck, 'Philipp Hainhofer. Unternehmer in Sachen Kunst', in Louis Carlen, Gabriel Imboden eds., *Kräfte der Wirtschaft. Unternehmergestalten des Alpenraums im 17. Jahrhundert* (Brig, 1992), 9–54.

[5] Claudia Swan, 'Liefhebberij: A Market Sensibility', in Leemans, Goldgar eds., *Early Modern Knowledge Societies*, 141–64.

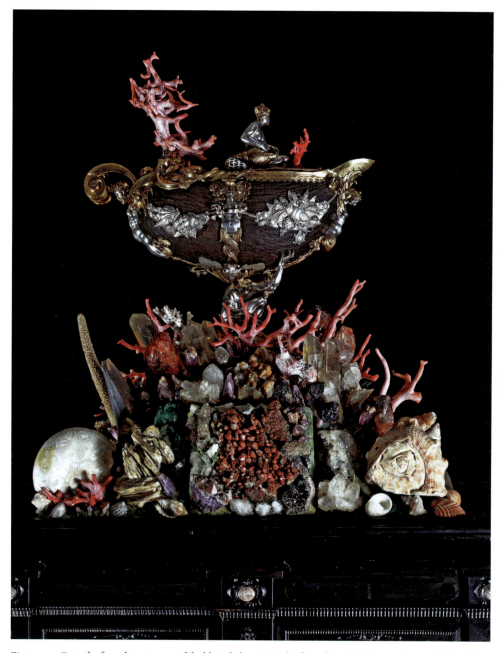

Fig. 23.2 Detail of a cabinet, assembled by Philipp Hainhofer, after 1617. Gustavianum, Uppsala. © Photo: Massimo Listri. Cabinet with abundant minerals, shells, gemstones, coral, and a coconut created by Hainhofer and his team of makers. It displays their fascination with the vast natural history of the seas and oceans that was being discovered, to supersede a focus on the ordered world model of 'four continents'.

seen, this led to compromises as men like Hainhofer came to serve several courts and were renumerated as secret agents. The cultural movement of art lovers promised to connect aesthetes across religious beliefs and great distances. Yet, in reality, as it was driven on by merchants, it competitively pitched interested parties against one another for profit.[6] It was linked to a rhetoric of connection and openness, but shot through with an aesthetics that similarly prized the discovery of hidden, exclusive things, the ownership of which marked a person out in their singular rank. Hence men like Hainhofer would frequently decide whom to privilege in offering a singular rarity object first, and for a higher price, and keep such dealings secret from other clients. Ever-increasing competitiveness in more interconnected art markets had the potential to reshape courtly and urban collecting. In the Dutch city of Haarlem, for instance, bourgeois art lovers during the 1630s were interested in painting, but even more riveted by rare varieties of tulip bulbs and paid extraordinary amounts of money just to get hold of them.[7] As we have seen earlier in this book, these developments were linked to the habits merchants, in these ever more commercialized societies, soaked up with their education—looking for profits by generating desires for things, or seeking out something 'strange' because it could be marketed as expensive. They were intimately linked to specific material communities with shared aesthetic values, emotional practices, and personal relations. The 'loving' of art lovers was an emotional and sensuous practice involving researching into, handling, and talking about things, in obtaining, using, and sharing them with those who instantly turned into 'friends' who shared the same predilection.

And so it was that the Lutheran merchant Hainhofer would forever be nostalgic about the time when, as a young man, he had first met Wilhelm V, the former duke of Catholic Bavaria. Everything in his upbringing had prepared him for this meeting.

[6] See also Michael Wenzel, *Handeln*, pp.35–7; Howard Louthan provides a discussion of the importance of the arts for irenicism at the Viennese court until the 1580s in his *The Quest for Compromise: Peacemakers in Counter-Reformation Vienna* (Cambridge, 1997), but the movement was broader and lived on.

[7] Anne Goldgar, *Tulipmania: Money, Honor, and Knowledge in the Dutch Golden Age* (Chicago, 2017).

CHAPTER 24

Becoming Philipp Hainhofer

Hainhofer was born into a merchant family that had settled in Augsburg during the late fifteenth century, and hence the same period when the Fuggers rose to unprecedented power. His grandfather increased the family's wealth and reputation so much so that Emperor Charles V in 1544 granted his family the right to bear a coat of arms. Both his sons dealt in silk, velvets, and other Italian luxuries and were involved in the copper trade. This was lucrative business. After Philipp's father Melchior married Barbara, the fourteen-year-old daughter of Augsburg's influential Hörmann merchant family, the couple moved into the very house Anton Meuting, the Munich court's agent in Spain, had been forced to sell.

Philipp was one of the youngest of fifteen children Barbara raised. She gave birth to him in 1578—a memorable year for the family, when Emperor Rudolph II permitted Melchior to use a more elaborate coat of arms. This most likely rewarded Melchior for advancing credits and would serve as road map for the family's aspirations: merchants could gain in status by being admitted to their city's patriciate or by serving the Emperor and rulers connected to the Habsburgs. Philipp would not have remembered much about his father though, who died in 1583, when he was aged five. For the Hainhofers, this was a year of great trouble and upheaval. Barbara, a committed Lutheran, followed Protestant pastors expelled from Augsburg as confessional tension rose. Until he was a teenager, Philipp thus grew up in nearby Ulm, a much smaller Lutheran city that had embraced the Reformation early on, provided good schooling and was famous for the high spire of its minster. Only his oldest brother Christoph remained in Augsburg to continue working in the family firm. The city kept growing from around 35,000 inhabitants in the 1530s to about 45,000 in 1618—crammed into an almost identical number of houses. Over 8,000 Augsburgers by now were poor weavers.[1]

Philipp Hainhofer too was destined to be a merchant. He was born into an age in which merchants asserted the benefits of commerce for the common weal with ever greater confidence. Well-educated merchants studied classical and medieval literature to defend their contribution to the progress of civilization. From 1599, Augsburg's

[1] HAB Cod. Guelf. 60.22 Aug. 4°, 165rv, on the confusion of dates and possible readings see also Lüdtke, *Lautenbücher*, 12; on the size of Augsburg's population see Häberlein, Tlusty, *Companion*, 'Urban Topography', 27. Nearly half of these inhabitants had few or no assets.

principal street even featured a mercury fountain celebrating merchant power as foundation of good government. Commerce, Hainhofer thus proposed to a younger relative in 1604, 'was an honourable and useful trade which kept the whole world running'. No one needed to be ashamed of this profession as dishonourable work. In fact, many people were of the view that one could rather do 'without scholars and soldiers than without merchants'. Their labour not only nurtured other professions but also led to 'trade with many foreign and barbarian people' as well as to 'acquaintance' and 'friendship with great Lords'. Plato, after all, had financed an Egyptian journey with money he had made by trading oil. Current rulers knew how to further commerce.[2] Politics, in short, needed to recognize the power of merchants and hence they deserved to be rewarded in status. Gaining cultivated knowledge prepared a merchant for such 'friendship' with great rulers. This involved learning appropriate lessons from antiquity, such as Plutarch's posthumous account of Plato as an honourable merchant, learning languages, manners, and about a wide range of cultures through travelling, reading, and conversation.

Hainhofer showed early promise. He was a talented linguist, and eager to learn. In 1594, aged sixteen, he wrote to his brother Christoph in Italian. Soon, Philipp rode through Bavaria, diligently noting down information about its shrines and cities in Latin, German, and Italian. He went to study in Padua, together with his younger brother Hieronymus and their tutor, the Tübingen graduate Hieronymus Bechler. Bechler was only eight years his senior, and would help Philipp to forge connections and succeed over his entire life. Leaving Padua and Siena after two years of university studies, the three young men visited leading Italian towns, from Venice to Bologna, Ferrara, and Lucca. They made their way down to Rome for a packed six days of sightseeing, and from there went further south on to Naples. In his pocket-sized book, Philipp noted Roman monuments, old inscriptions, churches and their interiors, shrines, and relics.

Yet this was not just an historical tour. Hainhofer imbibed classical learning in conjunction with contemporary customs. His education was designed to build up that store of cultural and political experiences alongside Latin maxims that were to serve for the rest of one's life, if only to mark historical change. In Naples, for instance, the young men enjoyed themselves by adopting a custom of well-off citizens. They paid to be carried around on 'beautifully furnished chairs'. Decades later, he would recall the experience of having been carried around in these litters when he recognized similar ones being used at the Innsbruck and Munich courts. Hainhofer referenced Suetonius on Caesar's hostility to private luxury, only to next relate that those Neapolitans who were being carried about in their lavish litters opined that 'Caesar is no longer alive nor reborn'.

[2] HAB Cod. Guelf 17.24 Aug. 4°, 240v, 243v–244v. On this subject for a later period see also Francesca Trivellato, *The Promise and Peril of Credit: What a Forgotten Legend about Jews and Finance Tells Us about the Making of European Commercial Society* (Princeton, 2019), 91–124.

The budding merchant agreed with such anti-Ciceronian views: this was a different world, and not one in which to slavishly emulate antiquity.[3] All his life Philipp Hainhofer was keenly interested in contemporary buildings, such as the new and magnificent Jesuit church in Rome dating from 1575. He noted the 1569 inscription on the Roman palace of the Inquisition. He looked at hospitals and herb gardens with the latest global arrivals of medical plants and animals, new noble palaces, or the Medici gardens in Pratolino near Florence. It was here that Hainhofer encountered an abundance of coral, shells, and snails amidst the sprouting fountains and water automata of the grotto described by Montaigne just a decade earlier. In Florence itself, he witnessed the making of fine furniture with inset hardstones in the duke's dedicated workshop, the *Galleria dei Lavori*, founded in 1588.[4] The trip would shape him for the rest of his life.

On his return from Southern Italy, Hainhofer stayed in Pietro Boccardi's house to study in Siena for a final six months. Boccardi was a scholar who served excellent wine, was entertaining, and elegant in his speech. The air in Siena was good, Hainhofer would later enthuse, and the Italian spoken here was the best anywhere. Moreover, the grand-duke of Tuscany was happy to tolerate Protestants. It was crucial not to appear like a heathen, the merchant later advised a young relative. The best thing to do was to drop by one or two churches on Sundays or special religious feast days in order to 'stand in them for a while', complete a prayer, and leave. Sometimes one might listen to church music, or even take communion. Finally, it was wise to befriend one or two understanding *Padri* to converse about matters of religion.[5] This experience prepared Hainhofer well for future visits to the Bavarian court. In larger gatherings, he would feel entirely comfortable with being taken for a Catholic when he was not, and this enabled him to eavesdrop on politically sensitive conversations.

[3] Christian Häutle ed., 'Die Reisen des Augsburgers Philipp Hainhofer nach Eichstätt, München und Regensburg in den Jahren 1611, 1612 und 1613/Hainhofers Reisen nach München und Neuburg a.D. in den Jahren 1613, 1614 und 1636', in *Zeitschrift des Historischen Vereins für Schwaben und Neuburg*, 8 (1881), 1–316, here 280.

[4] HAB Cod. Guelf. 60.22 Aug. 4°, 231v–232.

[5] He singled out Don Franco Bifferi, a Carmelite and Professor of Italian in Siena, HAB Cod. Guelf. 17.24 Aug. 4°, 203r, 242v.

CHAPTER 25

Networks for Success

Philipp thus returned to Germany with great experiences and with a love of Italian—he wrote to his tutor Bechler and even his brothers in this language for the rest of his life. He also returned with a carefully kept friendship album. An obvious goal for any student like Hainhofer was to become friendly with other young men, especially of high-born merchant, patrician, and noble heritage, all of whom were likely to occupy future positions of importance and wealth. The friendship album, or *Album Amicorum*, communicated this closeness and growing network of support. German-speaking students hence customarily paid to have their coats of arms, or even an artistic image, painted on a page and personally added a motto and dedication. Many of these *alba* were neglected and show mostly empty pages, but Hainhofer would turn his album, and those he later commissioned, into his principal tool to forge and document connections on behalf of himself and his patrons. Whenever possible, he nudged men or women to commission exquisite miniature paintings for these *alba*, and to carefully reflect on their technique and contents. Lifelike depictions of exotic flowers, birds, and shells in all their variety and decorative richness already fascinated him as student. They communicated new types of discernment and aesthetic ideals, and the entire *alba* documented the tastes that formed a community of friends. In Italy, then, Hainhofer learnt to collect contemporary images and inscriptions infused with a language of affection among like-minded art lovers to network for success. As his career took off, he compiled the most precious sheets into a grand album as a showpiece and took it with him whenever he visited political gatherings. Its success was astonishing, granting him access to the highest-ranking women and men. Ducal couples and even a Habsburg Emperor and Empress borrowed and poured over it for days, enabling him in turn to acquire further prestigious entries from dignitaries and offer them his wares. It tied the notion of art-loving friendship to his acquisition strategy as much as to his true belief in the power of visual and material worlds. [25.1]

Next, he moved on to the thriving city of Cologne that profited so much from trade with the Dutch Republic that had been founded in 1581. Jacques Honthius, his new tutor, taught Hainhofer French and Dutch as well as more of the technical knowledge a merchant required. In addition, this prepared Hainhofer for a further aspect of an intelligent merchant's career. Hieronymus Hörmann, his maternal uncle, served the French

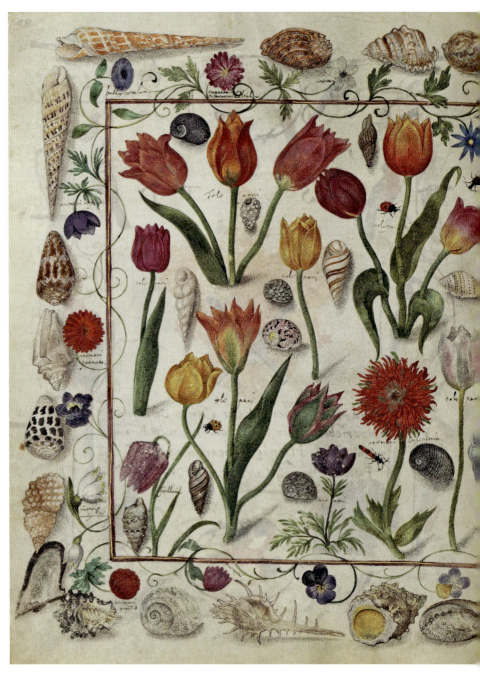

Fig. 25.1 Double page from Philipp Hainhofer's large friendship album. Exquisite miniatures of flowers, insects, and shells, most likely acquired in Italy. © Herzog August Bibliothek Wolfenbüttel, https://diglib.hab.de/mss/355-noviss-8f/start.htm.

Networks for Success 281

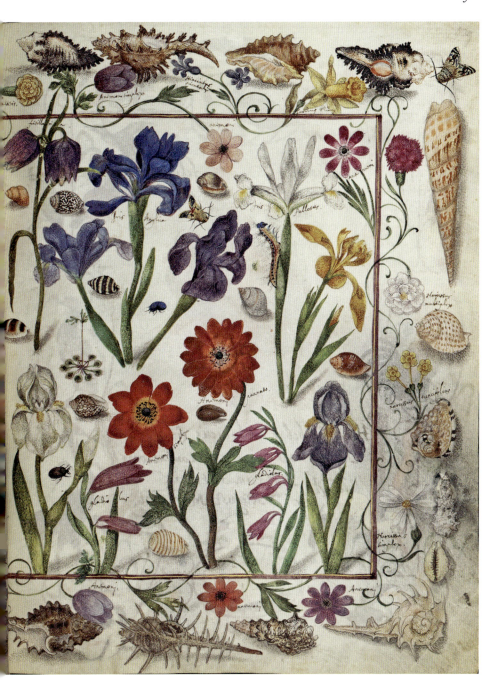

Crown and in particular the French ambassador for the Protestant German Imperial Estates (the *Reichsstände*) as secret agent.[1] By learning French, Philipp prepared to follow in his footsteps, which principally meant furthering the Catholic French kingdom's plans to cooperate with Protestant princes in an anti-Habsburg alliance in order to control the balance of power in Europe and bolster its own ascendency. Other members of the Hainhofer family were naturally involved in providing intelligence as well; listening to conversations, watching, eavesdropping at court, reporting rumours as '*l'on dit*', gathering and evaluating news, anonymizing the most sensitive information.

Merchants in this way had come to frequently broker political information, and it worked in Hainhofer's favour that he operated from a bi-confessional city that made it appear natural that he should wish to trade and interact with Catholics and Protestants alike. Augsburg additionally was at the node of international news and postal channels. This meant that Hainhofer was trained to collect copies of the handwritten reports as well as broadsheets on German and European political affairs that flooded into the city. He might have also been secretly trained in how to intercept letters. Just like Hainhofer and his uncle, merchants thus were increasingly hired as (meagerly) paid secret agents of one or several rulers at this time, and would go to great lengths in either circulating news or sourcing sensitive written and verbal information, some of which they might present in numerical, alphabetical, or thematic codes. Thematic codes often reflected quotidian merchandising: one of Sir Francis Walsingham's spies for Elizabeth I of England in the 1580s, for instance, used 'words such as fabric "patterns", "parcells", "stuff", and "warres" to code his messages regarding preparations for an invasion of Scotland'.[2] Cryptology based on alphabets of different world languages turned into an intellectually capacious field in Hainhofer's time, inspiring projects to define one language for all mankind.

But there was more to Hainhofer's life than studying languages. Having taken up lute playing in Italy, Philipp passionately loved music, and begged Christoph to allow him to continue studying the instrument with a French master. He had begun to ambitiously collect and annotate a wide range of European songs and dances, performed on the newest types of instruments. In future years, his musicianship would enable him to perfect polyphonic musical automata for his cabinets, to converse with noted music lovers such as Wilhelm of Bavaria, and to work together with composers in writing new music to laud his patrons. His tuition abruptly ended in 1597 when Cologne was badly hit by the plague. Honthius moved to Amsterdam and took his pupils with him. [25.2]

This was a well-considered choice. Amsterdam was emerging as Europe's newest global trading and finance hub. Map-making flourished, encouraging as much as benefitting from the expansion of trade. Attempting to trade with China via a Northeast

[1] For an extensive discussion see Wenzel, *Handeln*, 91–100.

[2] Nadine Akkerman, *Invisible Agents: Women and Espionage in Seventeenth-Century Britain* (Oxford 2019), 32; for Hörman's and Hainhofer's activities as agents see Wenzel, *Handeln*, 91–9.

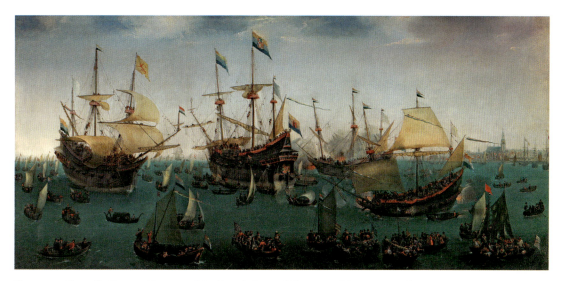

Fig. 25.2 Cornelis Vroom, Return of the Dutch Second Voyage to Nusantara, oil on canvas, 1599, Rijksmuseum, Amsterdam, public domain.

passage by sea, Dutch crews began sailing into the Artic Ocean along the Siberian coast in 1594, only to be stranded in the midst of ice, facing polar bears. Other merchants set off south in 1595, reaching Java via the Cape of Good Hope in 1596, to return to Amsterdam in 1597. Their successes against Spanish and Portuguese competitors emboldened them. In March 1598, Hainhofer thus reported on the great excitement in Amsterdam as the second Dutch ship was prepared to sail to the East Indies and high-ranking men were expected to watch it depart. In 1602, the Hainhofer company swiftly invested over 3,000 florins in the newly founded Dutch East India Company—a joint-stock company powered by international merchants that traded with India and South-East Asia with a starting capital of 6.5 million florins, promising dividends of between fifteen and a half to fifty per cent. By 1608, forty Dutch ships and 5,000 men were in Asia. Hopes were high for such ships laden with silver to return with tradeable textiles, spices, and porcelain as well as with plants, animals, and novel objects to expand European knowledge about the globe.[3] Scholars mingled with merchants as the ships came in, eager to lay their hands and eyes on goods, and to communicate their knowledge to patrons and rulers to gain financial backing (for book projects in the case of scholars) and prestige. Ships from West Africa laden with exotica already returned regularly to Dutch ports, and the Baltic trade boomed. Dutch envoys brokered trade deals with the Ottomans, the Russians, and the Swedes. Alongside negotiating for supplies of gunpowder in exchange for grain, they took rarities with them as gifts, and returned with novel curiosities in

[3] HAB Cod. Guelf. 17.24 Aug. 4°, 110r and Wenzel, *Handeln*, 24. On the culture of excitement in relation to such goods at this time see Goldgar, *Tulipmania*, 35–40; C.R. Boxer, *The Dutch Seaborne Empire, 1600–1800* (London, 1973), 26, 49–52.

return. The Dutch colonial empire grew by waging warfare and by participating in long-established Asian networks that connected India, China, Japan, and Indonesia, producing cane sugar in the West Indies and shipping slaves from Africa to the Americas. Amsterdam's first bank of exchange opened for business in 1609, and its stock exchange in 1617, each facilitating the management of risky long-distance maritime trading. 'It was', as a recent historian sums up, 'through negotiations with foreign powers and through violence against natives and at sea that Dutch officials at home and those abroad who supported their endeavours secured trade goods' and their 'place on the world stage'. In the formative years of the Republic, Dutch diplomacy with the Ottomans as much as with the French was significantly lubricated through the gifts of Indian gemstones, featherwork, or shells. Rarities shaped political power.[4]

Dutch cities were governed by wealthy merchant oligarchies and they prospered. Like other visitors, Hainhofer found that Amsterdam during the late 1590s was bursting at its seams with people. It seemed cramped. The city expanded westwards only in 1609. Many inhabitants were religious migrants from the South as well as Christianized Jews from Iberia. To educated men, Amsterdam at this point still seemed short of sights, especially as Hainhofer had been trained to methodically visit and record any city's notable buildings, monuments, and classical inscriptions. These humanist taxonomies failed to accommodate the shell or tulip. He disparagingly noted: 'If it did not have the water, it would have not a lot that was special, apart from many decorous gardens in contrast to Cologne, especially nice flowers.' Everything seemed very expensive.[5]

While judging his spoken Dutch at first too poor to talk to many locals, Hainhofer continued to read avidly, and later recalled that at night-time he had read through a French edition of *Plutarch's Lives* in so small a print that his eyes became sore and he feared that he would turn blind.[6] In the mornings, he worked with the German merchant Hans Hung to learn more about trade, while in the afternoons he continued to study his two further modern languages. For his leisure, he would talk to Marie, one of Honthius's daughters, about books he had read in Dutch and French while she sewed. On Sundays, she would tell him about a sermon she had listened to or read the Old Testament out in Dutch for him. When Christoph was told that they were in love, Philipp assured him that all their dealings had been honourable, so as to help him progress in these languages.[7] He was destined to become a merchant and not to marry Marie but an Augsburg woman from a Lutheran merchant family of suitable wealth. And so, by October 1598, and after he had visited a number of Dutch cities, it was time for this young man to return home via the booming Baltic seaport of Hamburg, ready to start working in the family firm.[8]

[4] Claudia Swan, *Rarities of these Lands: Art, Trade, and Diplomacy in the Dutch Republic* (Princeton, 2021), 17, 29, 86. For an important argument for the role of merchants in furthering scientific debates rather than consensus see Dániel Margócsy, *Commercial Visions: Science, Trade, and Visual Culture in the Dutch Golden Age* (Chicago, 2014).

[5] HAB Cod. Guelf. 17.24 Aug. 4°, 120v.

[6] HAB Cod. Guelf. 17.23 Aug. 4°, 327r. Finally, a Portuguese medic had told him a 'secret' recipe that healed him.

[7] HAB Cod. Guelf. 17.24 Aug. 4°, 103v–105v.

[8] HAB Cod. Guelf. 17.24 Aug. 4°, 204v, 230v, 8.4.1604. He diligently kept writing to Honthius in French, with regards for demoiselle Marie.

Back in Augsburg, Philipp would write letters for his pious mother. Barbara had returned to the city after the Emperor had contractually defined and approved the terms for appointing Lutheran pastors in 1591. She was now too old and ill to write, and Philipp looked after some special requests, such as sourcing bulbs of 'fire-red, red and pink' carnations for a relative. He sent his best wishes for their flourishing so that the 'country will be made happy through God's work and contemplate on it'.[9] The Hainhofer family would have regarded nature as God's book, full of benefits for the soul through colours and designs he had playfully created around the globe. While Hainhofer would have regularly attended his Lutheran church, he also enjoyed local festivities in his youth on the local wine market, and English comedians, freaks, or exotic animals that frequently entertained Augsburgers on market days or during the two annual fairs.[10] In 1597, for example, a man from Savoy displayed 'live animals with extra feet, half a "dragon's head"; a tiger pelt; a fish with two mouths; the jawbone of a giant whale' and other natural curiosities that stimulated those fascinated by portents or wonders.[11]

The city's musical life flourished—the latest instruments and printed music from German as well as Italian composers were available to buy in abundance. Hainhofer began to collect European religious hymns and secular songs, practising his penmanship in assembling beautiful manuscripts. Some of the profane music emotionally managed the experience of single people engaged in courtship. While the tunes were charming, their contents might celebrate female assertiveness to preserve a woman's chastity up to her wedding day. One popular piece recounted the story of a man who wanted to enter the house of his beloved on condition that he would swear faithfulness. The man refused. He was nonetheless allowed in, only to be tied up by the woman's sister and thrown out of the window onto cobbled stones, suffering broken ribs and head injuries.[12]

Weddings turned into boisterous, sensuous affairs as they celebrated a couple's release from restrained encounters. Hainhofer's diary noted the many weddings in the Upper Swabian region he attended, with their 'different types of music' and dances often lasting up to three o'clock in the morning over several days, their good food, copious drinking, and up to sixty guests whom he had never met before, many of whom were women. It was at such weddings that German men, who sat next to each other at meals, would eventually throw off all formalities to affirm their brotherhood. Philipp minutely described details of these feasts as if to prepare for his own.[13]

And so, in September 1601, Hainhofer wrote to friends near and far to announce his engagement to Regina, 'much loved honourable daughter of the Honourable Herrn Georg Ulrich Waiblinger'. He married her the following month, noting everything down in a separate wedding diary, his *Hochzeitsbüchlein*. Regina was related to his mother's family and his marriage to her greatly increased Hainhofer's wealth. While lower-class men and women had to save money and wait before they were able

[9] HAB Cod. Guelf. 17.24 Aug. 4°, 169r; on the mediation of the 1583 crisis by 1591 see Roeck, *Eine Stadt*, 179.

[10] HAB Cod. Guelf. 17.24 Aug. 4°, for instance 144v–145r.

[11] B. Ann Tlusty, 'Sociability and Leisure', in Tlusty, Häberlein eds, *Companion*, 314–41, here 323.

[12] Lüdtke, *Lautenbücher*, 188–9.

[13] HAB Cod. Guelf. 60.21 Aug. 8°, 123r–126v.

to marry in their late twenties, Philipp formed a household aged twenty-one. His wife naturally helped him, for instance by dictating German correspondence to their scribes.[14]

Attending weddings continued to punctuate their lives. At a Regensburg wedding, the dance was meant to be at the town hall, yet many of the men, Hainhofer among them, were too drunk by midday to move from the inn where they had eaten in. Hence it was decided to stay put and dance there, right into the night.[15] During fine seasons, the newly-weds began visits to the gardens of notable people in countryside. The couple's first child was born in 1604—a daughter who died soon after her baptism. In December that year, Philipp's mother died after two years of suffering. When he later commemorated Barbara in a carefully executed book of honour for the entire Hainhofer family, the merchant fictionally made up that she had been a virgin for twenty-one years, married for twenty-one years, and a widow for exactly twenty-one years. This harmony was taken to reveal God's providence and sanctify her pious Lutheran life. Hainhofer agreed that Luther had led believers away from the blindness of the Roman papacy.[16] [25.3]

Every spring and autumn Hainhofer now travelled to the Frankfurt fair with several of his Augsburg male peers or their Italian partners, wearing green bands of taffeta around their neck to signal belonging. It was easy to get lost in the city. Frankfurt's population had risen from c.10,000 inhabitants in Heller's time to about 18,000 by 1600. Many Protestant refugees from the Low Countries and France now lived and profitably traded here, and Frankfurt's Jewish community had likewise grown in size and significance. Printing flourished, and the number of urban collectors rose.[17] The Lutheran city had turned into a European centre of finance and business: around one hundred silk merchants permanently resided in Frankfurt, to be joined by dozens of silk merchants from Europe for every fair. The Hainhofer company was among eighteen silk merchants just from Augsburg who regularly visited the fair between 1595 and 1611. Stiff competition mixed with the buzz surrounding an enormous variety of available wares, sold from about 500 to 600 showrooms in the city's vaults and 460 stalls set up on the streets and squares.[18] Hainhofer travelled to Frankfurt up through Franconia and back via Württemberg.[19] He produced written records of his life, not

[14] 'the Edlen und Ehrenvästen Herrn Georg Ulrich Waiblingers vielgeliebten Erndochter', HAB Cod. Guelf. 17.24 Aug. 4°, 180r; for such a letter in 1602 see 196v–197r. His younger brother Hieronymus married only one year later.

[15] HAB Cod. Guelf. 60.21 Aug. 8°, 156r, he asked God for forgiveness.

[16] His mother had in fact been widowed for nineteen years, *Stammbuch*, 127.

[17] Jochen Sander, *Die Welt im BILDnis: Porträts, Sammler und Sammlungen in Frankfurt von der Renaissance bis zur Aufklärung* (Giessen, 2020).

[18] Alexander Dietz, *Frankfurter Handelsgeschichte*, vol. 1 (Frankfurt am Main, 1910), 80–2; vol. 2, 43, 309–19.

[19] HAB Cod. Guelf. 60.21 Aug. 8°, 122r.

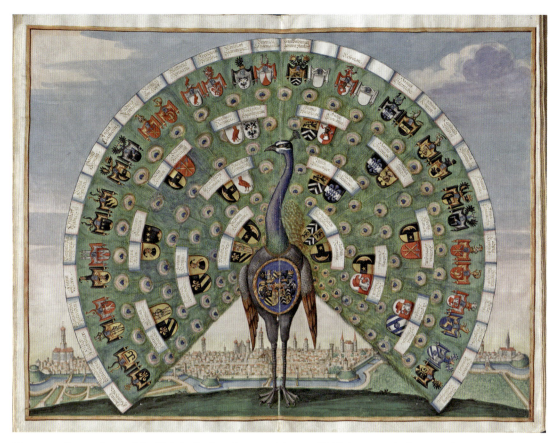

Fig. 25.3 Geneaology of the Hainhofer Family, 1629, Ahnentafel Philipp Hainhofers, Ratsherr zu Augsburg, Bavarian State Library, public domain. Hainhofer's elaborate commission of a genealogy attempted to visualize the nobility of his Augsburg merchant family. An idealized view of the city surrounded by the river Lech serves as backdrop. He was primed for this enterprise not least by helping to work on the Fuggers' genealogy as young man.

just through letters but through these diaries, friendship albums, and entry-books that would serve his memory and any biography that was to be written. He chronicled important new connections, which widened his personal as much as professional network and in 1602 left his friendship album with the notable painter Martin von Falckenburg after the fair, for the artist to embellish it with two further entries.[20] Locally too Hainhofer's reputation was fast on the rise, culminating in his election to Augsburg's Great Council in 1605.[21]

[20] HAB, Cod.Guelf., 17.24 Aug. 4°, 108v.
[21] HAB, Cod. Guelf.60.21 Aug. 8°, 173r-174r.

CHAPTER 26

Visiting Wilhelm's Court

To further widen his horizons, Hainhofer acquainted himself with the leading courts and cities. In 1603, Munich's splendour astonished him, especially the grandeur of St Michael, the Jesuit church Wilhelm V had built. A wooden sculpture of Christ on the Cross at the church's altar struck him as a 'remarkably beautiful piece of art', so delicate as 'if it were still alive'. The richness of the vestments with their shimmering goldthreads overwhelmed him. He noted precious gold and silver vessels and lights—'everything is gold upon gold, one does have eyes enough to see!'.

Next, he visited the court's grand cabinet of curiosities.[1] Hainhofer's notes confirm that visitors received a quick tour by the cabinet's keeper. Even so, the Duc de Rohan only remembered a single piece from his visit in 1599 when writing up his memories four decades later: it is 'impossible', he justified himself, to remember 'all these different things one has seen'.[2] By contrast to such aristocrats, Hainhofer used his merchant eye and training to immediately produce notes and an account that would serve his memory—in fact the only proper account to survive that any visitor ever left. This was despite the fact that the cabinet's guide selected items of particular material value to impress guests. Like others, Hainhofer thus noted the extensive collection of coral objects that the Fuggers and the Viscontis had helped to procure, said to be worth 100,000 Augsburg ducats. Antique coins, he was told, valued another 30,000 ducats. Hainhofer noted mirrors with complex inlays and some miniature jewellery. Next, the guide led him to a display of American idols. One was a *zemi* figure which the Taíno people in the Caribbean islands regarded as the embodiment of supernatural powers and deities. The guide thus reinforced racialized religious anxiety. He frightened Hainhofer by telling him that these were living oracles through which the devil had spoken to heathens. 'God protect us from this devil', Philipp noted. Lutheranism credited the devil with tremendous power and presence, which explains why Hainhofer worried whether these items were truly safe to behold if the devil's power worked through them elsewhere.[3]

[1] HAB Cod. Guelf. 60.21 Aug. 8°, 130v–131rv, 'ein trefflich schön kunststück nach dem leben'.

[2] Willibald Sauerländer ed., *Die Münchner Kunstkammer* (Munich, 2008), vol. 3, 368.

[3] Dorothea Diemer et al. eds., *Münchner Kunstkammer*, vol. 1, 539–40; see also Christine Göttler, '"Idols from India": The Visual Discernment of Space and Time', in Christine Göttler, Mia M. Mochizuki eds., *The Nomadic Object: The Challenge of World for Early Modern Religious Art* (Leiden, 2018), 49; Maria Effinger et al. eds., *Götterbilder und Götzenbilder in der Frühen Neuzeit: Europas Blick auf fremde Religionen* (Heidelberg, 2012).

This was a dramatic highpoint of the visit, followed by information about other exotic objects. Material mimesis drew Hainhofer's interest, and he investigated an image that appeared to be sewn from silk rather than created from dyed parrot feathers. The guide furthermore drew attention to the remarkable provenance of several pieces or to their subject, including the sword used by Francis I when Charles V had captured him at Pavia. The goal of this tour clearly was to impress and entertain visitors with a selection of different types of objects which showcased the court's wealth as well as access to historically and culturally relevant man-made and natural objects. Hainhofer mentioned 'beautiful Turkish and Indian clothes for masques and feather-clothes', foreign weapons, 'large crocodiles' that hung from the ceiling, the 'large stuffed elephant', and different fish as well as 'strange sea shells'. Finally, he noted the portraits of fools at the entrance and, high up on a wall, portraits of rulers and other notable figures, many of whom were connected to the house of Bavaria.

Remarkably, Hainhofer then cast his eyes around to spot two paintings that hung up high on the walls. Both depicted a nude Lucretia. 'One of them', he noted, 'is extremely artful and beautiful, as if it was alive.'[4] Hainhofer recognized the quality of this work—almost certainly the collection's exceptionally sensuous Dürer. Yet the guide mentioned no artist by name; they did not yet sufficiently matter at this point in time.

It was from this 1603 visit to the Munich art cabinet onwards that Hainhofer himself decided to project himself as a lover of art. Such an art lover needed himself to be a collector first of all, and Hainhofer's own *studiolo* in the Augsburg home was ready by 1605 for others to admire and buy rarities from. It functioned as a private showroom, which meant that access to it was exclusive to those Hainhofer admitted as possible clients or simply as knowledgeable.[5] An art lover moreover required excellent observational skills—a practised eye—and material knowledge which he continually kept sharpening in relation to new objects and through discussion about them with artists, artisans, and other collectors. As a result of his knowledge, Hainhofer could thus propose new experiments to makers that were both novel in design and materials. Sometimes, the material solution could be a function of the design, but often an exploration of material properties and their embellishment drove experimentation. Workshops and private collections functioned as privileged spaces within which to discuss such matters of art. They were linked to the merchant's experience of attractively displaying wares on temporary stalls, such as those at the Frankfurt fairs, stimulating comparison and conversation. Just as Hainhofer had learnt to compare merchandise at shops and fairs, he now compared courts and collections.

[4] Sauerländer ed., *Kunstkammer*, vol. 3, 369.
[5] For the expression 'showroom' see Wenzel, *Handeln*, 25.

CHAPTER 27

Trading Silks and a Fragile Career

Later in 1603, Hainhofer visited the Heidelberg court on his way to the Frankfurt autumn fair, where the sale of silks went 'pretty well'. His main business for now was selling a wide range of precious fabrics made in Italy. As for any merchant, a crucial part of his education was mastering accounting, different currencies, weights, and conversion rates. It involved scouting opportunities to achieve the best price for quality. But, above all, this was an education in material discernment. In relation to silks this meant, as he wrote, getting to know different qualities of fabrics, *'connoscere la seta et drapi'*, with a reliable a silk merchant.[1] Although no portrait of Hainhofer as a young man exists, it is easy to imagine that he would have been immaculately dressed in silks sold by his family which were appropriate to his standing and cultural role, exuding new standards of delicacy and discernment, just like so many of the Protestant Dutchmen he met at the fairs, clad in elegant lace collars and silk satins. [27.1]

As we have seen, this period witnessed an explosion in Tuscan silk production across a wide range of fabrics, dyes, and patterns. Precious damasks from Genoa and Lucca, imitation velvets from Venice, Bolognese silk-satin, Florentine and Modenese velvets were all on offer at the Frankfurt fairs. Each Italian city specialized in particular techniques and kept innovating. In 1602, Hainhofer noted comprehensive information on this merchandise, explaining that in Lucca, for instance, 'different types of silk fabric are made, oper and operine of smooth velvet, a fiochetti, fiochoni, mandole, mandoline, a tronchetti, a ramagi, a caccia', and so the list went on. These varieties partly related to the fact that the silk-satin ground was in one colour and the velvet pile in another. Some used a medley of different colours, while others were distinguished by 'long hair alla francese'—a longer pile. Just as in Fugger's time, 'common colours' lowered the price, and the quality and depth of the dye obviously mattered. Just as with paintings, the best dyes needed to look 'beautifully fresh' to create vivid, animating, lustrous effects. This was equally true for blacks, which no textile merchant wanted to look dull, as if the fabric was woollen.

'For the velvets', Hainhofer learnt that one needed 'to observe that they are nicely drenched in colour, and that the colour covers well, so that one cannot see through to

[1] HAB Cod. Guelf. 17.24 Aug. 4°, 222, 227r.

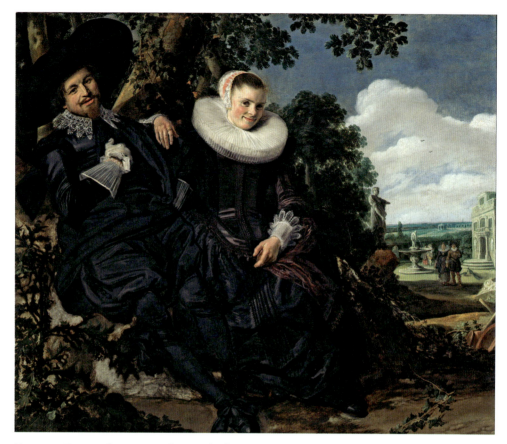

Fig. 27.1 Franz Hals, Portrait of Isaac Abrahamszoon Massa (1586–1643) and his wife, oil on canvas, 1622. Rijksmuseum, Amsterdam, public domain. Massa was the son of a textile merchant. He became a key Dutch diplomat in Russia and dealt in grain. Note his subtle lace collar of an up-to-date pattern, matched by delicately woven, almost transparent, linen cuffs.

the bottom, and that they are not blotchy or uneven with stripes, and the fabrics have beautiful fresh ends and are selvedged' to avoid fraying.[2] Seventeen different types of colouring were on offer for those cheaper *ormesin* velvets from Lucca alone.[3] Florentine silk-satin distinguished itself through its particularly beautiful sheen.

Judgement was not just a matter of sight. Discernment was also mediated by touch, and the term Hainhofer used here was '*angriffig*'. Fabrics needed to feel right to the touch—and this implied that a merchant felt the quality of the weave. A merchant had to make sure, for instance, that silk-satin from Lucca, was not made 'too tightly' (*zu stern oder zu vast*). The weave had to have the right tension in order to be used to create dress or furnishings in the best way, and it also had to be even. In addition, it mattered that no

[2] HAB Cod. Guelf. 23.34 Aug. 4°, 124r.
[3] HAB Cod. Guelf. 23.34 Aug. 4°, 129r.

lime water (*Leimwasser*) had been used to strengthen the yarn and quicken the pace of weaving because this damaged the fabric by causing it to wrinkle. Damasks, which, as Hainhofer noted, required far more time to weave than any other fabric, needed to be 'fine to the touch and full in the hand, without creating folds, and not have too much water, and once the water is dried they become limp'.[4] Adulterations needed to be identified. Sea-silk, a product of molluscs harvested in the Mediterranean, made for bad fabric. Environmental conditions mattered too and changed with seasons because silk absorbed water: 'Fabrics that have been woven in winter and cold and humid climates are not as good as that those which have been made in summer.'[5]

The perceptual worlds into which Hainhofer had been educated hence particularly valued sheen, smoothness, regular textures, freshness as well as colour variety, richness, and innovation. They related to luxury fabrics that took an extremely long time to make and required particular conditions. They depended on keen artisanal cognition to achieve complex patterns in regular weaves and made for highly sensuous objects. Hainhofer himself needed to understand and feel how they were made in order to judge their quality. He developed his material knowledge by studying textiles precisely. Ever-increasing local diversification meant that, while in Frankfurt, he needed to keep up and be involved in looking at, feeling and discussing fabrics in an evolving process of knowledge gathering through close attention. 'All commodities are known by the senses', the Englishman Robert Lewes instructed young merchants in 1638.[6]

Yet the times for trading textiles were volatile. Hainhofer reported that 'velvets from Lucca are too expensive for Germans'—at the 1603 Frankfurt spring fair a length of red velvet crafted in the city was on offer for 85 thaler a length. This was more than twice the cost of silk-satin or damask, or Genoese velvet, which sold for around 48 thaler. Luckily, the English merchants at the fair bought copious amounts of such Genoese velvet, damasks, and silk-satin alongside the cheaper *ormesin* from Lucca in yellow and red. In March 1603, Queen Elizabeth I of England had died, the last ruler of the Tudor dynasty, and the merchants prepared for the coronation of James I of Stuart descent. Had it not been for such unexpected English demand, Hainhofer repeatedly penned, 'it would have been a terrible fair'.[7]

Even so, Germany's merchants remained extremely nervous about whether they would receive payments promised by bills of exchange. They feared third-party backers who failed to underwrite a deal. In the words of one of them, awaiting the Frankfurt fair's pay day equalled the terrors of purgatory. Frankfurt's council issued a decree to ensure greater safety which Hainhofer transcribed in his journal. In addition to these pressures, the plague broke out. The young merchant felt that he had never before lived

[4] HAB Cod. Guelf. 23.34 Aug. 4°, 127r.

[5] HAB Cod. Guelf. 23.34 Aug. 4°, 130r.

[6] Susanne Friedrich, 'Unter dem Einsatz aller Sinne. Zum ökonomischen Blick und dem Sammeln von Wissen in der Frühphase der niederländischen Ostindienkompanie (1602–ca.1650)', *Historische Anthropologie* (3/2020), 379–98, here 392.

[7] HAB Cod. Guelf. 23.34 Aug. 4°, 109r; Cod. Guelf. 60.21, 8 Aug., 122r.

294 *Ulinka Rublack*

through a more 'troubled, anxious' atmosphere than during the 1603 fair.[8] Things did not get better. Disagreements between relatives involved in the family firm added further anxiety and stress. Hainhofer looked for additional employment. He temporarily worked on a genealogical project for one of the Fuggers, and in 1604 asked Hans Christof Fugger, the imperial secretary in Prague, about the baptismal names of some women in the family, and Elisabeth Fugger's coat of arms.[9] From this time onwards too, Philipp regularly began to be plagued by headaches and vertigo.[10] At the 1605 fair, he sold cheaper Genoese velvets for a good price alongside saffron, but a drop in the value of currencies meant that 'profit was bad'.[11] The atmosphere at Frankfurt remained tense in the coming years. Many merchants feared bankruptcy and even imprisonment for debt. After another immensely stressful fair in 1606, Hainhofer judged the 1607 fair 'average', it at least having passed without any discord.[12]

[8] HAB Cod. Guelf. 60.21 Aug. 8°, 177v–181r.
[9] HAB Cod. Guelf. 17.24 Aug. 4°, 238v.
[10] HAB Cod. Guelf. 17.24 Aug. 4°, 193v.
[11] HAB Cod. Guelf. 60.21 Aug. 8°, 170v.
[12] HAB Cod. Guelf. 60.21 Aug. 8°, 205r. For one such case of a silk dealer's imprisonment in 1611 see Heinrich Bott, *Gründung und Anfänge der Neustadt Hanau 1596–1620*, vol. 2 (Marburg, 1971), 248.

CHAPTER 28

The 'Old Lord'

Despite these troubles, 1606 nevertheless turned out to be one of the high points in Hainhofer's life. One morning, at seven o'clock, a carriage arrived outside his house. Wilhelm V of Bavaria, unexpectedly visited Hainhofer to see his cabinet. Renata of Lorraine had died in 1602, and Wilhelm was now aged fifty-eight. In Augsburg, the former ruler of Bavaria stayed with Marx Fugger the Younger,—Hans's and Elisabeth's first-born son. Marx twice requested to see Hainhofer, and then announced that a visit would simply have to be possible on the next day.

Hainhofer guessed that Wilhelm of Bavaria might be accompanying him. Dressed like a Jesuit, as now was his habit, Wilhelm gave everyone the impression that he had retired to devote himself to a pious life, rather than because he could no longer face governing in a state of bankruptcy. He stayed for a full three hours looking at Hainhofer's emerging collection of curiosities. Philipp by now had been collecting for two years and was overjoyed as the former duke bought from 'my Indian things for 200 florins, and showed himself very gracious and familiar, intimate', offering 'much grace'.[1] This was Wilhelm's talent: he was able to instantly create closeness to people below his rank through a shared interest in rarities. Hainhofer, for his part, had already gained praise for his courteous speech, friendly manner as well as for his generosity in relation to noted collectors, whom he presented with gifts.[2] [28.1]

As was customary when visiting a cabinet, Wilhelm also brought a gift. He presented the young Augsburg merchant collector with two miniature doves made by an artist called Johann Schwegler. Hainhofer immediately sent these on to Hamburg to strategically connect with a merchant in the Baltic port city. 'The doves', he noted, 'are made from real feathers, the beaks from ivory.' Hainhofer boasted that many of the nobility now visited his cabinet, and would likewise consider this Hamburg merchant highly if he were happy to do Hainhofer the favour of sending rare and curious things.[3] This skilfully signalled his widening network to other merchants who had access to rarities, encouraging them to send these to Augsburg.

[1] HAB Cod. Guelf. 60.2 Aug. 2°, 200r.
[2] *Reisen und Gefangenschaft Hans Ulrich Kraffts*, ed. K.D. Haszler (Stuttgart, 1861), 426.
[3] HAB Cod. Guelf. 17.22 Aug. 4°, 88r–90v.

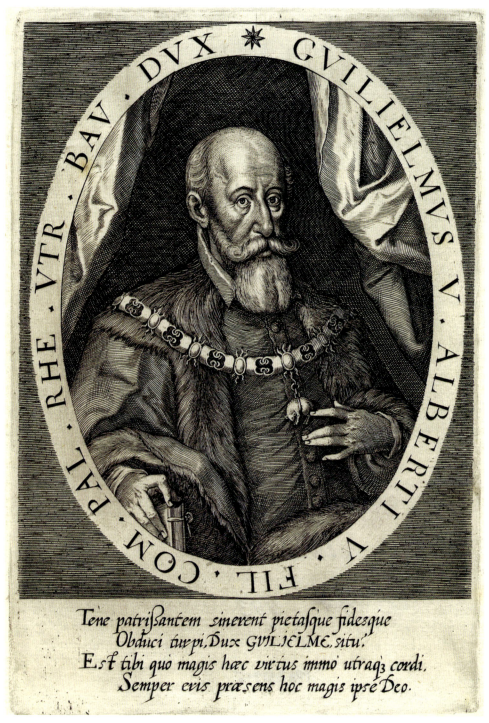

Fig. 28.1 Anon., Wilhelm V, after 1600, engraving, 17.5 × 12 cm. © The Trustees of the British Museum. The abdicated ruler Wilhelm of Bavaria as 'old Lord', pointing to his Order of the Golden Fleece.

Hainhofer soon used this personal introduction to Wilhelm of Bavaria to try to sell silk to the Munich court. It appears that he sent Wilhelm some rarity in 1607, for in July that year Wilhelm reciprocated with a small medal bearing his portrait, a *Gnadenpfennig*. Hainhofer received this with 'greatest joy' as it assured him of the former duke's 'gracious affection'. At the time he had turned thirty in 1608, Hainhofer boasted about having received 'twenty-six golden' medals from different rulers as well as other 'gracious presents'.[4] He in turn offered Wilhelm not only his own services but also those of brothers and cousins involved in the company, stressing that they possessed excellent links to the noblest merchants and port cities in Italy, Poland, England, and the Netherlands.[5] Wilhelm instantly responded, as he was trying to source four beautiful English sheep breeds and a ram for his farm.

While Hainhofer contacted a middleman in an attempt to source these animals, he also penned a letter to Maximilian I, Duke of Bavaria. Wilhelm promised to hand it on to his son with a personal recommendation.[6] Hainhofer's letter suggested that he had several times previously sent rarities to Maximilian I to offer his services but was keen to underline that his family's main trade was in Italian silks, which they sold internationally to many rulers and potentates. If Maximilian I desired silks which they did not already possess, the Hainhofer company would always be able to have them made to order. They possessed the 'right correspondence' in the right places. Hainhofer assured Maximilian I that he would always aim to obtain the duke's grace and affection rather than secure his own advantage. In short, he offered his service as a merchant who knew what serving a ruler involved.[7]

In a volatile world, rarities were mostly sourced via the Dutch, Baltic, Ottoman, and Mediterranean trade (rather than the Iberian trade) promising Hainhofer new commercial opportunities. This was not least to establish more personal connections with further art-loving courts which might buy his company's silks, or, from 1610 onwards, the expensive cabinets of curiosities he designed and commissioned. Wilhelm duly recommended the young Lutheran, writing to his son that he was 'sending a letter from a citizen of Augsburg, who, except for in terms of his religion, I think of as an honorable and intelligent young man, who is well studied and besides a tradesman, and in his house, I have seen several strange and curious things and half a cabinet of curiosities'.[8]

[4] *Reisen und Gefangenschaft*, 429.

[5] HAB Cod. Guelf. 17.22 Aug. 4°, 167v–168r.

[6] HAB Cod. Guelf. 17.22 Aug. 4°, 171v, 24.7.1607.

[7] HAB Cod. Guelf. 17.22 Aug. 4°, 170v.

[8] 'Schick Euch ein Schreiben von einem burger von Augsburg, welchen ich ausser der Religion für ainen erbarn und verstendigen jungen man halte, der auch wol studirt hat und daneben ein handelsman ist, wie ich denn in seinem haus allerlei frembde und selzame sachen und ein halbe kunstcammer gesehen', Brigitte Volk-Knüttel, 'Maximilian I. von Bayern als Sammler und Auftraggeber. Seine Korrespondenz mit Philipp Hainhofer 1611–1615', in Hubert Glaser ed., *Quellen und Studien zur Kunstpolitik der Wittelsbacher vom 16. bis zum 18. Jahrhundert* (Munich, 1980), 83–128, here 84.

298 *Ulinka Rublack*

Building a successful relationship with the Munich court nonetheless relied on the permanent cultivation of more intermediary services for Wilhelm, whom everyone called the 'old Lord'. Throughout 1607 and 1608, Hainhofer continued to cultivate the former Duke of Bavaria as client for rarities. He offered to source objects more cheaply than Wilhelm was able to by acquiring them in his own name and promising not to charge over and above the tax he himself would have to pay. He also kept advertising his far-reaching networks of informants on the look-out for rarities. Regarding artwork, such as a turned ivory vessel from Antwerp or 'two old artistic (*kunstreiche*) woodcuts from the times of Emperor Maximilian I', Hainhofer advised Wilhelm on what the King of France had paid for a similar piece or whether he thought the quality of a piece suited a distinguish ruler's cabinet. He furthermore advised Wilhelm about the possible uses of precious materials, as in 'a black coral for 15 florins that can be used for a (sculpture of) St Sebastian', and provided lists of further attractive goods, including an 'old painting on a black background' for 10 florins, or an 'Indian turtle' for 6 florins, all of which he offered to send to Munich for Wilhelm to choose from.[9]

Richly illustrated books of maps and atlases were among these items. These revealed from which parts of the globe rarities arrived. After the autumn fair in Frankfurt in 1607, for instance, Hainhofer informed Wilhelm that he had purchased a copy of Mercator's *Atlas*, with its 'very beautiful' title page, and that it superseded Abraham Ortelius's famous *Theatre of the Whole World*. Mercator's *Atlas* had been published in 1595, but Ortelius's work had remained more popular. Yet this was a re-edition of Mercator that had just been issued in 1606 in Amsterdam by Jodocus Hondius, a geographer who had bought Mercator's copper plates and had himself added new maps. Even though Hondius only figured as the publisher, this was an entirely different product, and attracted enormous interest as it built on Hondius's familiarity with Francis Drake's recent English expeditions. The new atlas included all 107 maps from the 1595 edition as well as thirty-seven new maps, skilfully engraved by Hondius, of various authors. Seven maps described the Iberian peninsula, correcting the earlier omission in the *Atlas* by Mercator. Furthermore, four regional maps of Africa were included, eleven for Asia and five for America. Six new maps of European regions were also included in the atlas. Hondius added four new continent maps to the previous plates, so that the advance in cartographical knowledge became evident. Hainhofer wrote that he had acquired the atlas at a bargain price of merely 20 florins, when the tax itself usually amounted to 24 florins, and was happy to send it along.[10] In this way, he underlined his selfless service and up-to-date knowledge of the book market.

Maps were anything but neutral representations. They often projected a sense of European mastery through governance and economic profit, and drew their audience into terrifying or joyful sensations of mystery about exotic places, animals, commodities, and indigenous customs. They allowed collectors to mentally locate, as much as

[9] HAB Cod. Guelf. 17.22 Aug. 4°, 184r–184v.
[10] HAB Cod. Guelf. 17.22 Aug. 4°, 185v.

fantasize, about their rarities, and were typically marketed via Amsterdam, Antwerp, Cologne, and Frankfurt alongside globes, navigational instruments, paintings, and the emerging art cabinets.[11] [28.2]

Wilhelm soon indicated that he was keenly awaiting the delivery of some Indian objects that Hainhofer had sourced. The men had begun to regularly correspond. Philipp's brothers too were on the look-out for novelties in different locales. All of the Hainhofers vouched for the perfect condition of any item they offered to high-ranking clients. Christoph, now stationed in Danzig, thus sent a completely white 'beautiful bear skin', with 'lovely fur like a white wolf'. The white bear particularly intrigued Hainhofer, who had known the Nuremberg publisher Levinus Hulsius (c.1550–1606). Like many contemporaries, Hainhofer was very taken by Hulsius's translation of the Dutch voyage in 1596 to find the Northeast Passage to the Indies, which had left the crew stranded in artic conditions on the island of Nova Zembla when they were attacked by polar bears. Hulsius's book on the 'Indian sea-voyage', he informed Wilhelm, 'writes much about these white bears and the damage they do.' In addition to these bear skins, an Italian called Sorgi had taken with him a 'quite beautiful, completely new Indian bed which is woven from grass and suitable at least for two people and would look really good in a cabinet directly from India'.[12] Most likely he was describing an African object woven from raffia. All this communicated excitement about authentic rarities that were new to the market, new knowledge as well as the astonishing reach of Hainhofer's network. As ever, merchants sought new goods and information about them because this increased the value of them. Information allowed them to break through the indeterminacy with which many objects were described as simply being 'Indian'—that is, foreign and outside Europe.[13]

Within weeks Wilhelm responded enthusiastically and Hainhofer supplied further information about the polar bears. Just as in the case of Hans Fugger, this shows us how Wilhelm was open to be drawn into a 'community of fascination' in which new knowledge from travel reports and exotica mutually reinforced each other. Informed fascination drove the market.[14] Levinus Hulsius's popular compilations of voyages nurtured this desire. Following new Dutch publication formats, Hulsius had bought rare artefacts via the Netherlands to commission authentic woodcuts for his quarto volumes. These were entertaining to read, far cheaper and easier to handle than the elaborate large tomes produced by the de Bry brothers. Although Hulsius died in 1606, his widow printed re-editions.

[11] Berit Wagner, 'Flämische Kunst für deutsche Sammlungen: Cornelius Caymox d.Ä. (gest.1588) und andere Schildervercoopere im Frankfurter Kunsthandel', in Miriam Hall Kirch, Ulrike Münch, Alison G. Stewart eds., *Crossroads: Frankfurt am Main as Market for Northern Art 1500–1800* (Frankfurt, 2019), 104–28, here 119.

[12] HAB Cod. Guelf. 17.22 Aug. 4°, 211rv.

[13] Daniela Bleichmar, 'The Cabinet and the World: Non-European Objects in Early Modern European Collections', *Journal of the History of Collections* (2021), 435–45.

[14] Inger Leemans, 'Introduction: Knowledge—Market—Affect: Knowledge Societies as Affective Economies', in ead and Anne Goldgar eds., *Early Modern Knowledge Societies as Affective Economies* (Abingdon, 2020), 1–19.

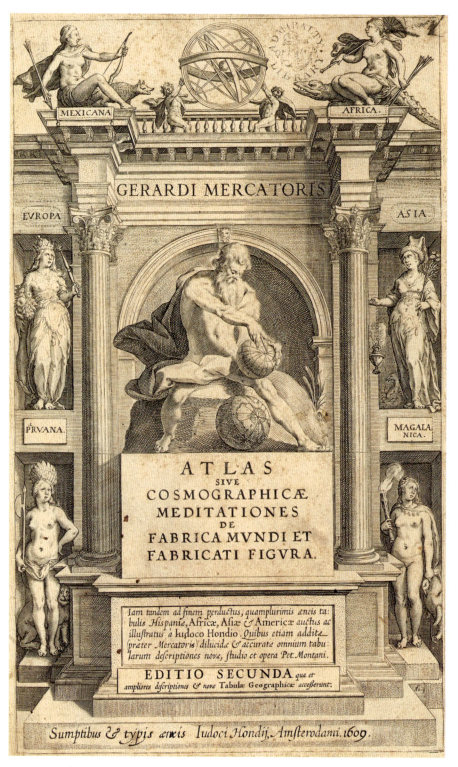

Fig. 28.2 Gerardi Mercatoris, Atlas sive Cosmographicae Meditationes […] excusum in aedibus Iudoci Hondii Amsterodami, Amsterdam, 1609. Stanford Libraries, public domain mark 1.0.

Hainhofer's response to the bear skins was clearly conditioned by the sense of adventure these publications conveyed. While paintings were aesthetically valued for imaginative story-telling, rarities equally gained in value through travel reports they were related to and which similarly stirred the imagination. On the 27 February 1608, the merchant informed Wilhelm that white bear skins cost 24 florins in Danzig. 'Outside the midnightly islands and Indies', they were extremely rarely found. He continued: 'Leoning Hulsig, who died two years ago, wrote in his voyages about these bears, how they enter the ships by night through the ice, and greatly damage those people who fall.' He offered to buy Hulsius's books for Wilhelm at the Frankfurt spring fair: 'the voyages, there are about eight or nine books, decorated with engravings, report on Indian manners and customs, and are entertaining to read, I don't think that all of them will cost more than 1 or 2 florins'. In fact, he had just been asked to buy them for a French ambassador. Hainhofer underlined that the depictions were as authentic and up to date as possible: 'what the Dutch have brought as rarities from the Indies from all their travels they have send to Hulsio to Frankfurt, and he has commissioned engravings for the voyages'.

Objects from foreign cultures carried knowledge. Hulsius kept advertising this fact to carefully build up the value of pieces and generate excitement. His 1602 edition of a short account about the *First Voyage to Oriental India which the Dutch ship that left in March 1595 and returned in August 1597* depicted the King of Galle in Ceylon and his entourage, drawing attention to different types of spears that could also be used to shoot arrows. Hulsius added to the passage: 'one of them is here in Nuremberg'.[15] An image of Javanese people depicted one man with a curved dagger. These were called *Krisses* and had a wooden or ivory hilt carved in the shape of a devil's head, represented with long curly hair and bulbous eyes. Hulsius's text comments on these daggers at length. He highlighted that his knowledge of the object was authentic: 'The depiction of the devil has been made here in Nuremberg from the shaft of an extremely beautiful Chinese dagger which the Dutch brought from Java, the blade was damascened, and was like a flame, and it had a nicely crafted hilt.'

This advertised them as collector's items, and then offered ethnographic information on Java: 'Nobody will be found there without such daggers, whether young or old, poor or rich, yes small boys aged 5 or 6, for it is a great shame not to wear one.' Hulsius continued: 'They have no religion, but worship the devil, and burn wax candles in front of him, sing and pray that he may do them no harm, because they know that the devil is bad, and God good, and harms no one, but does good to everyone, which is (why they think) one cannot worship him. This is why they have usually on their daggers (as has been mentioned before) a devil.'[16]

[15] HAB, T 82. 4 Helmst., Gerrit de Veer, *Beschreibung der dritten Reis oder Schiffahrt*, 2nd ed. (Nuremberg: Leon Hulsius, 1602), 60, Pl.54.

[16] De Veer, *Schiffahrt*, 30, 34, Pl.29.

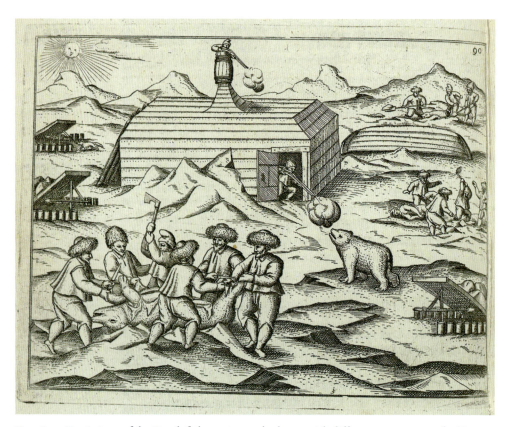

Fig. 28.3 Depictions of the Dutch fight against polar bears with different weapons on the Nova Zembla expedition that were adapted by Hulsius. Rijksmuseum, Amsterdam, public domain.

Hulsius was speaking to readers and collectors who were interested in some of the religious and cultural associations of indigenous objects. Javanese krises were feared as living idols as much as weapons. Their sharp, masterfully manufactured blade could do harm and take lives, just like the devil.[17] If anything, such information about an object's power and status in Asian culture further increased its value for Europeans.

Hulsius's edition of *The Third Voyage which the Dutch undertook around Norway, Muscovy and Tartary with the intention of finding a way to Cathay and China in 1596* was visually enormously engaging. Plates adapted by the Nuremberg artist Johann Sibmacher depicted Dutchmen clad in their thick fur caps desperately firing muskets at polar bears which were already beginning to devour some of their companions. Another showed men skinning one bear and measuring the hide (it turned out to be 12 shoes long), but the text revealed that they disliked the taste of the meat. Snow fox, they found, 'tasted as good as a rabbit' and could be hunted using traps. Their constant fighting with the ice

[17] C. Göttler, '"Indian Daggers with Idols" in the Early Modern Constcamer: Collecting, Picturing and Imagining "Exotic" Weaponry in the Netherlands and Beyond', in 'Netherlandish Art in its Global Context', ed. E. Jorink, F. Scholten, T. Weststeijn, *Netherlands Yearbook for History of Art* 66 (2016), 80–109, here 61.

bears continued. Yet successive images conveyed the Dutchmen's readiness to shoot them to protect their lives.[18] [28.3]

All this excited Hainhofer who by 1610 noted that his own cabinet contained no paintings or antiquities but Indian bowls and dishes, lots of 'adventurous things' and above all things of nature (*natürliche Gewechs*).[19] Hulsius's publications were therefore far more than dead letters. Their images and descriptions became embedded in specific social relationships among traders and collectors. They inspired emotional responses and commercialized practices amongst these collectors, which is why we might wish to use the anthropologist Alfred Gell's idea that such texts shaped an agentive 'nexus'.[20] These emotional responses inspired a mixture of enjoyment and fear associated with hunting large animals, and were linked to the dangerous but 'adventurous' explorations of novel terrains. The genre of publications about 'voyages' hence drove the kind of curiosity that helped Hainhofer to build interest in and market global products. This is further testimony to the fact that courtly collections did not just grow through diplomatic gifts, courtly patronage, and a ruler's focused requests but through the ways in which agents as bourgeois merchants created demand.[21] Hainhofer himself collected and staged his knowledge to evoke emotions of wonder and fear in his clients. In attempting to sell bear skins, Hainhofer built on some of the detail in Hulsius's publication and enriched it further with factual ethnographic information that he would have acquired from merchants active in the Baltic: 'The people of Japan, behind Sweden, make whole garments from bear skin, and fit them so well onto their bodies that they have no other opening than for the head.' Despite this skill, and the freezing cold, those encountering them had reported that these were 'completely wild and fiery people'. This enforced racial stereotypes of indigeneity. How were the skins used elsewhere? Hainhofer further reported that in Muscovy and Poland, and in parts of Germany, noble people used them instead of rugs for their open sledges and carriages, and also stored their clothes in them to ward off insects. Hence, they were prepared to pay up to 50 florins or even more for a large beautiful pure white bear skin.[22] Ethnographic information charged an object with authenticity and hence material value. It went hand in hand with a merchant's attention in grading the quality of large pieces of perfectly white skin far higher than smaller pieces that needed to be pieced together because gunshots, axes, or harpoons had irredeemably damaged a polar bear's fur. Ethnographic interest in clothes moreover

[18] De Veer, *Schiffahrt*, 38–121.

[19] Oscar Doering ed., *Des Augsburger Patriciers Beziehungen zum Herzog Philipp II. von Pommern-Stettin: Correspondenzen aus den Jahren 1610–1619* (Vienna, 1894), 10.

[20] See Warren Boutcher, *The School of Montaigne in Early Modern Europe*, 2 vols. (Oxford, 2017), here vol. 1, ch.1, vol. 2, xxxiii.

[21] Berit Wagner, 'Bürgerlicher Geschmack und höfische Sammlung. Überschneidungen im deutschen Kunsthandel und in der höfischen Kunstakquise in der Frühzeit der Kunst- und Wunderkammern', in Matthias Müller, Sascha Winter eds., *Die Stadt im Schatten des Hofes? Bürgerlich-kommunale Repräsentation in Residenzstädten des Spätmittelalters und der Frühen Neuzeit* (Ostfildern, 2020), 239–77.

[22] HAB Cod. Guelf. 17.22 Aug. 4°, 213rv. For information on clothes and the fiery nature of the Sami see de Veer, *Schiffahrt*, 1602, 29–32.

304 *Ulinka Rublack*

interlinked with European interest in identifying waterproof materials, such as seal skins, that might then be imported and adapted to withstand Northern Europe's rainy climates, or sea voyages.

Information of this kind structured what Wilhelm needed to know to appreciate the skins as useful items of value and to conceive of them as objects that could connect him to the way of life and craft technologies of a strange culture. The pricing information implied that the bear skin was another good deal the Hainhofers had to offer. This helped to cultivate a client's consumer desire—and Wilhelm was interested in the cultures of the North. An elegant Greenland kayak dating to from around 1577, made from wood and leather for an Inuit child, seems to have been added to the Munich cabinet around this time: it is the earliest preserved kayak anywhere in the world. This was ten years after the first Inuits had been abducted from the Artic and transported to Antwerp to be advertised in large broadsheets printed in Germany. In this way looted humans and their unique objects evoked new experiences in Europe, inspired further interest and added to knowledge.[23]

Hainhofer moreover let Wilhelm know that there was competition. He would be travelling to the Easter fair in Frankfurt and return via Württemberg and the Palatinate. Meanwhile, he sent various items to Munich for Wilhelm to inspect, some of which they had already discussed, and others because there was space in the chest. He whetted his appetitive by adding a 'Turkish bed' costing 24 florins, which had arrived from Jerusalem; a box of antique amber stones for 4 florins; a pair of small damascened Turkish scissors for 3 florins; a strange stone that had grown out of a plant, likewise sourced via Jerusalem; and a red Turkish hat costing 6 florins. He explained that it was used as a rain hat, and worn by Ottomans over other items of headwear when travelling.[24] [28.4]

Hainhofer found this rain hat enormously fascinating, precisely because many in his period understood the profit that could be made from commercializing waterproof fabrics. At the same time, he valued it as a true curiosity that was depicted in some printed images of Ottomans, but could be understood so much better as an actual artefact to handle. These hats were made from thick water-absorbent felt and moreover could be folded down into a neat elegant shape. This made them easy to transport, except for their length. Hainhofer included either this very rain hat or a similar one in a purpose-made drawer as, years later, he and his team of Augsburg craftsmen produced one of their most ambitious cabinets. Wilhelm was less taken with it. On 1 March, Hainhofer received a letter and 45 florins from the former duke in payment for the Indian bed, the fish sword, and the Turkish scissors. Wilhelm returned all other goods.

Live animals were far more expensive items. Exotic animals were prized diplomatic gifts and spectacles to be displayed during the Frankfurt fair—a Frankfurt chronicle

[23] See Wenzel, *Handeln*, 114; on the interest in the Inuit and the North see Christopher P. Heuer, *Into the White: The Renaissance Artic and the End of the Image* (New York, 2019), here 80–2.

[24] HAB Cod. Guelf. 17.22 Aug. 4°, 214v—two further items were included.

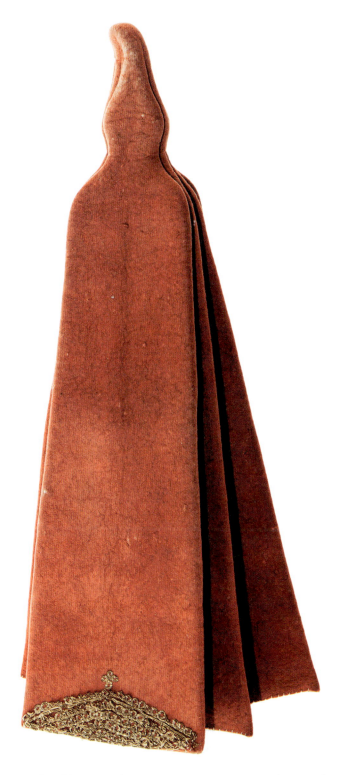

Fig. 28.4 Ottoman rain hat, felt, sixteenth century. Gustavianum, Uppsala, Uppsala university collections/Mikael Wallerstedt.

noted that as early a 1291 a lord from Norway had presented Emperor Rudolph with a white bear 'to cause great wonder'. Ostriches from 'Barbary' had been displayed in 1450 and 1577; a seal in 1609, Indian animals in 1610, and the head of a hippopotamus at the fair in 1611.[25] As Wilhelm had signalled his interest in receiving two 'rare and beautiful' reindeer via Danzig, the Hainhofers started to busily negotiate on his behalf. The dealer demanded the enormous sum of 300 thaler for an animal that was larger, he boasted, than reindeer currently owned by any other rulers. Hainhofer had hoped to purchase a pair of reindeer for 430 florins and, in order to keep the price low, pretended that he wanted to buy them for his own cabinet. This shows that one of the reasons why merchants as art lovers needed their own cabinet was to rig prices. They pretended to negotiate 'friendly' prices for themselves, even though they sourced goods on behalf of wealthy clients, or they speculated on goods which they planned to sell for a higher price later on. Prices in this period related to the relationship between specific buyers and sellers as well as to the object in question. The charged affective language art lovers cultivated could be manipulated to encourage 'friendly' deals, but sellers could also remain hard-edged when they insisted on the high value of a particular piece.

The dealer who had the pair of reindeer had also bought silk from the Hainhofer company and, the agent thought, was obliged to them, especially as he had still not paid for two lengths of extremely expensive Florentine gold brocade. Still, this dealer insisted on the reindeers' absolute rarity. As the parties could not agree on their value, negotiations got so tense that an official mediating mercantile disputes was needed to reconcile them. Hainhofer's brother Christoph finally bought the reindeer for the higher than anticipated sum of 630 florins. This still left Philip hopeful that Wilhelm would be pleased with this price and the acquisition as these rare animals were so 'strange and beautifully produced by nature'.[26]

Meanwhile, Hainhofer was preparing for Frankfurt's 1609 Easter fair. Wilhelm had ordered Hulsius's *Voyages*, which he promised to buy. Hainhofer also assured Wilhelm that he would keep asking as much as possible about rarities and obediently send reports. He highlighted that such business was made difficult by the fact that the Dutch now enjoyed a monopoly: 'they are almost the only ones to bring such rarities with them'. As a result, these Dutch merchants insisted on selling everything at the fair for cash, rather than allowing Hainhofer to first send things to Wilhelm to make his choice. Deals had to be safely concluded at the fair. Hainhofer loved the objects. Last time, he now added, the Dutch had arrived with 'different types of beautiful Indian armor, one of them for 100 Thaler, and feather dresses'. These American feather cloaks were of the highest quality, as they were those 'worn by their kings, one of which was offered for 400 Imperial florins'. He believed Wilhelm already possessed one of the feather cloaks, but not the armour, and so he promised to concentrate on acquiring such a piece.[27]

[25] Frankfurt Stadtarchiv, *Chroniken*, S5, 3, 148.
[26] HAB Cod. Guelf. 17.22 Aug. 4°, 216r. This was sent to Munich, 217v.
[27] HAB Cod. Guelf. 17.22 Aug. 4°, 216v.

On his way to the fair, Hainhofer had lunched with the collectors Dr Schad in Ulm at the *White Oxen* inn and with Hans Krafft at Geisslingen's *Golden Bear*. His fabrics sold well in Frankfurt, but there was more mistrust about bills of exchange.[28] The overall news for Wilhelm was disappointing. He had looked around for other beautiful and rare artefacts in vain.[29] However, he had also acquired some goods for himself which he was happy to send over to Wilhelm for an initial inspection: a turned ivory sphere with an engraved drinking cup for 16 thaler; an 'antique' skull, inscribed with the year 1506, costing 16 florins; four English boxes with a particular stone; 'Indian' items braided from grass and hay; small animals from Lithuania that prevented insects from attacking clothes; a nice large lead bullet; a stone bullet; Hulsius's books; a chest with 'Indian' bowls and armour for Wilhelm to choose from. He had also been told about a golden ring with a ruby available for purchase. It featured an engraved image of the Pope with his triple crown and was estimated to cost 1000 florins. Hainhofer offered to get the dealer to send it within a fortnight should Wilhelm be interested.[30] He told the dealers that they needed to arrange for transport, and he hoped that Wilhelm would simply pay for the associated costs if he returned these items.[31]

Ever busy, Hainhofer kept on acquainting himself with German towns and collections. He greatly appreciated contemporary urban architecture, such as the perfectly proportioned town houses in Stuttgart's new suburb, or houses built by Calvinist refugees in a new Leipzig suburb with a 'beautiful large square as cannot be found far and wide', as well as a project for two churches, in one of which preaching would take place in French.[32] These current developments seemed far more interesting than a church like St Sebald in Lutheran Nuremberg, where, he noted in his diary, 'they still use a lot of papist clothes and ceremonies'.[33] Frankental, a city newly built by 'the Calvinists' fascinated him too. It abounded with Flemish refugees from the Netherlands who were highly skilled artisans. They wove 'beautiful rugs and tapestries, [and] a lot of nice velvet' as well as creating 'a lot of beautiful silverwork'.[34] The work of these Flemish gold- and silversmiths who had settled in Frankental was in keen demand. Augsburg was likewise undergoing great changes. Hainhofer could see his own city modernizing architecturally and through its fountains. He was therefore particularly keen to observe new waterworks at the Heidelberg and Stuttgart courts. The Lutheran court of Württemberg, he noted during one visit to Stuttgart, invested in silk manufacturing as an innovative art, and prized fine furnishings as well as

[28] HAB Cod. Guelf. 60.21 Aug. 8°, 212v–213r.

[29] HAB Cod. Guelf. 17.22 Aug. 4°, 219r.

[30] HAB Cod. Guelf. 17.22 Aug. 4°, 219v–220r. On further complications with such buying arrangements see 221r–222r.

[31] HAB Cod. Guelf. 17.22 Aug. 4°, 219r.

[32] HAB Cod. Guelf. 60.21 Aug. 8°, 205r.

[33] HAB Cod. Guelf. 60.21 Aug. 8°, 226r.

[34] HAB Cod. Guelf. 60.21 Aug. 8°, 209r.

308 *Ulinka Rublack*

tapestries in its castle. By contrast, he noted hardly any paintings.[35] German culture was moving forward dynamically through cultural exchanges and by partaking in colonial trading, and cabinets of curiosities represented this type of exchange aesthetically.

Nuremberg too was changing. Hainhofer visited the Lutheran city in May 1609 to report on its collection to Wilhelm. Nuremberg remained the leading Lutheran South German city at the time, and, being a fellow Protestant might have facilitated Hainhofer's access to its collectors. As he left Nuremberg, he brought away a characteristic assemblage of objects. He chose two American feather objects: 'a rather wide Indian hat, made from feathers, in the manner the women wear it' as well as 'a staff made from feathers'. He paired them with 'a very clean woodcut of Adam and Eve', adding that 'many think it is Albrecht Dürer's'. If Wilhelm so desired, he would send the woodcut.[36] Dürer's work hence continued to be valued in terms of its technical qualities in relation to the material medium—in this case wood. This rare ability to work wood with such clean precision and delicacy inspired wonder and connected it to the appreciation of a finely worked feather headdress.

The first Italian merchant to knock on Hainhofer's door in Augsburg after he had returned from Nuremberg did not carry rolled-up canvas smelling of paint either. Writing to his old teacher Bechler in summer 1609, Hainhofer reported on a Venetian trader who had offered him 'white oriental balsam for 8 florins the lot, a Moschus nut, a white knitted glove embroidered with flowers, ... a beautifully embroidered velvet gown for 600 florins'. Flowers as decoration evoked fine scents that benefited health, while a piece of quality Italian velvet and embroidery visibly materialized patience, knowledge, and skill. Hainhofer's access to such quality goods mattered, as Bechler at the time sought to connect Hainhofer to the Duke of Pomerania, who intended to build up his court and collection. As this was still a secret, Hainhofer merely indicated that he would be happy to offer Turkish horses, rugs, tableware, balsam, and other goods.[37]

In September 1609, Hainhofer once more offered Wilhelm of Bavaria his service in advance of the autumn Frankfurt fair. Straight after returning to Augsburg from the fair, he followed up with another letter. This time, Hainhofer had had plenty to offer. Peter Ludwig of Amsterdam, his trusted trader in shells, had sold him two rare, beautiful, and large specimens. The de Bry brothers and Dutch dealers offered different types of pepper plants as well as a plant that appeared 'similar' to a carnation. American and Asian plants were keenly sought after in Germany as different varieties were compared to each other in exchanges between scholars, pharmacists, and gardeners in attempts to agree on German names. Further rarities from either South Asia or the Americas included 'a beautiful plant from a tree that functions as an Indian hat', a 'rather beautifully patterned and very long snake', a whole sword fish, an extraordinarily beautiful

[35] Wenzel, *Handeln*, 11.
[36] HAB Cod. Guelf. 17.22 Aug. 4°, 213r.
[37] HAB Cod. Guelf. 17.22 Aug. 4°, 223v.

'Indian' thistle, and an 'Indian' drinking vessel made from *terra sigillata* earth used by indigenous people. Hainhofer had also purchased an 'Indian' bird's nest which he held to be extraordinary because he had been told that birds were clever enough to position these nests on the most fragile plants located on wells to protect their eggs from snakes. Trade in Indonesian bird's nests as rarities began to boom at this time.[38]

Next, Hainhofer offered Wilhelm 'beautiful Indian feathers', a musical instrument, canvas, and a tablecloth worked from grass and tree leaves. His list went on. It included a beautifully spiraling shell of mother-of-pearl with blood-red sprinkles; 'the name Jesus artfully written with a pen on very delicate leaves'; a nicely scented and, it seems, stuffed rat from Lithuania that warded off insects from damaging clothes; a knitted 'Indian' skirt with wide sleeves; a beautiful large 'Indian' ring; a beautiful large 'Indian' bowl; an artistic lifelike large skull cut in ivory; 'a stone heart from a really hard stone, which in its colour and shape resembles a human heart' and an 'Indian knife, which one had to wind out of its shaft'. Among items the Dutch sourced in the East Indies was an 'Indian wreath made from the paws of a lynx' that was supplied with ethnographic information: indigenous people put these wreaths on their heads in fist fights so that their opponent would damage his hands if they wanted to deliver blows onto a head. There was also a beautiful pair of 'Indian' boots, braided slippers, and an idol with a hole from which indigenous people sometimes heard responses. Hainhofer recalled having seen several of these idols in Wilhelm's collection in 1603, and hence stressed that this idol had been truly efficacious in delivering heathen oracles. [28.5]

Hainhofer had built new networks at this Frankfurt fair. He bought most of the items from Hans Heinrich and Isaak de Bry as well as from a Dutch merchant called Jacques de Couffre, who in turn had received the goods from the aged botanist Carolus Clusius (1526–1609) and brokers who bought rarities from Dutch ships. The de Bry brothers engraved these objects in copper to integrate them in images for their pioneering print venture: dramatic, informative, edifying, and highly illustrated accounts of overseas voyages for the European book market.[39] By 1611, Nuremberg's council permitted a man with the Dutch-sounding name Johann Jannsen to set up a local stall with 'Indian wares', making them ever more accessible as consumer goods for Germans whose tastes had been shaped by travel publications.[40] Hainhofer, by contrast, stressed the exclusivity of the best items that were available to him through his personal connections and thus had not even been made available for regular sale at the fair. Instead, the de Brys and de Couffres had received him at home, and, he claimed, had only sold these items on after much effort and for considerable sums. This account, of course, was

[38] On the networked knowledge of plants in Germany see in particular Hannah Murphy, *A New Order of Medicine: The Rise of Physicians in Reformation Nuremberg* (Pittsburgh, 2019), ch.5.

[39] Michiel van Groesen, *The Representation of the Overseas World in the de Bry Collection of Voyages (1590–1634)* (Leiden, 2007); Susanna Burghartz, 'Idolatry, Market and Confession: The Global Project of the de Bry Family', in Ulinka Rublack ed., *Protestant Empires: Globalising the Protestant Reformations* (Cambridge, 2020), 140–76.

[40] Theodor Hampe, *Nürnberger Ratsverlässe, über Kunst und Künstler im Zeitalter der Spätgotik und Renaissance (1449) 1474–1618 (1633)*, (Vienna, 1904),14.10.1611, 426–7.

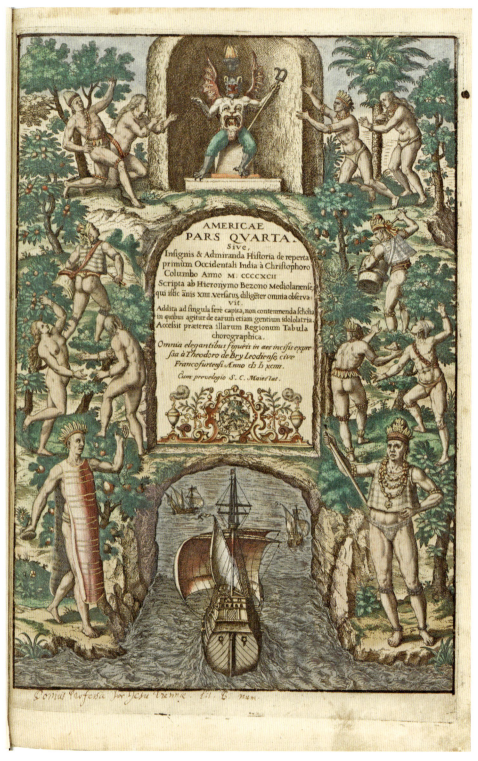

Fig. 28.5 Theodor de Bry, America, Title page, Frankfurt 1590. Courtesy of the John Carter Brown Library. De Bry's book on America was followed by accounts of 'Oriental India', capitalizing on fresh information from the Dutch and English voyages.

designed to increase the value of these items and shows just why Hainhofer targeted courts. Rulers promised a higher margin of profit for merchants able to convey the exclusivity and quality of goods that had been sourced through private sales. Johann Theodore de Bry was in the process of moving from Frankfurt to set up his printing business in Oppenheim, where he felt safe to practise his Calvinist beliefs. De Couffre lived in a new house, which Hainhofer had first visited in 1606, with a beautiful garden and a 'thesaurus of many wonderful paintings, the best in Frankfurt'.[41] Hainhofer once more presented his access to exciting rarities as linked to his ability to obtain personal favours through intimacy with fellow Protestants whose native languages of Dutch and French he spoke, and his knowledge and his negotiating skills.

To further underline his ability to distinguish truly special objects and animals from common items, Hainhofer reported that there had been much Chinese porcelain, and many meercats and parrots on offer at the fair, as well as shells but nothing particularly special except for two shells a man called Peter Ludwig had sold. This account turned into another opportunity for Hainhofer to stress his commercial talents. Ludwig had demanded no less than 150 thaler for one of these shells. The Margrave of Anspach had offered 100 florins. Ludwig decided not to sell. Hainhofer had had the nerve to wait right until the very end of the fair, at which point he picked it up for 90 florins and gave Ludwig a 'heathen coin' as a bonus. Collecting global currencies rather than merely antique coins was just becoming fashionable. He had taken both shells back with him to Augsburg to offer them exclusively to Wilhelm, though not without stressing that he could have easily sold them on to Frankfurt goldsmiths. In describing the shells, he first wrote: 'as I believe that no prince will have more beautiful ones', but then amended this to: 'as I believe that it will not be easy to find more beautiful ones'. This points to his problem: above all, the merchant did not personally know Emperor Rudolph II's grand collection, and thus could not be sure whether a piece could really be marketed as entirely unique.[42] In fact, he added that Peter Ludwig had wanted to take one of the shells to Prague but had then done Hainhofer a favour by offering it to him.

Given their extraordinary price, all this served to underline how lucky Wilhelm was to be able to rely on him, and that these shells would be prestigious rarities given that Rudolph II was likely not to own anything similar. They were good investments given the competition between leading rulers. Hainhofer added value by providing further information. His correspondent Alexander von den Berg in Amsterdam had just written to say that the King of France had instructed his representative in The Hague to look for shells. As the Dutch Stadholders had gained knowledge of this, they had bought some shells from the mayor of The Hague and given them to his representative Monsieur Jarnis as a diplomatic gift for the King. Hainhofer hence used his knowledge to socially construct the market value of *naturalia* from the Indo-Pacific—shells that

[41] HAB Cod. Guelf. 60.21 Aug. 8°, 201v. He was introduced by the mayor of Holzhausen, a suburb of Frankfurt, and lived in the Judenbuchgasse.

[42] HAB Cod. Guelf. 17.22 Aug. 4°, 226v.

312 *Ulinka Rublack*

Dutch merchants most likely had packed on their ships as their private trade, without paying the slave labour involved in harvesting them from the ocean. Sailors typically added shells to their personal baggage and sold them on at Dutch quaysides to those awaiting their return.[43] A collector's narrative of 'ownership' began with other European collectors. This narrative was underpinned by the theological concept of God as creator of these specimens for mankind to marvel at. It promoted an understanding that nature provided a free resource to showcase universalism which could be taken to Europe, where Christian connoisseurs were best equipped to appreciate it. The ways in which indigenous people preserved ecologies, gained knowledge about such *naturalia*, integrated them into their cosmologies and forms of cultural expression remained of secondary relevance or none at all.

Peter Ludwig dealt with these shells and snails alongside many Netherlandish paintings which he had brought to the fair. Otherwise, Hainhofer wrote on the 25 October, he had not seen anything strange at the Frankfurt fair which he believed Wilhelm did not already possess. He would package everything up for him to choose what he wanted to own, including a 'nice little landscape in oil' by the contemporary Dutch refugee painter Martin Falckenburg (1534–1612), whom he knew in Frankfurt, alongside three types of 'Indian' naturalia: 'a large blood stone, an English chalk stone, a nice, large eagle stone, two rather larger Indian bats, male and female, a large Indian hat from ostrich feathers, a nice Indian armour, an old ivory crucifixion of Christ, a necklace from cherry stone, 2 necklaces of horse hair, several old woodcuts, especially a neatly cut Adam and Eve'.

This was his and Wilhelm's world: there was no hierarchy between the value of a shell and a painting if they were rare. The final items on this list for Wilhelm to choose from were a Turkish dish from fishbone, the tooth of a walrus, two beautiful rare turtles, many small strange shells, and 'Indian' paper in red or white.[44]

On 4 November, Wilhelm replied and sent a messenger to Augsburg on foot to return with items he had quickly selected, and to inspect them at court. Hainhofer dispatched the man with a box that contained the following price list:

> The beautiful, rather large shell, 90 florins
> A beautiful doubled shell, 50 florins
> Another, sprinkled, mother-of-pearl shell, 20 florins
> The shell from a different type of water, 6 florins
> An Indian plant from a tree that is a hat, 12 florins
> Two Indian hats from flowers and grass, 12 florins
> An ivory beautiful skull, 24 florins
> The name Jesus on paper, 16 florins
> A whole Indian canvas from grass, 9 florins
> A beautiful foreign snake, 12 florins
> In a special box a wondrous Indian thistle, 8 florins

[43] Swan, *Rarities*, 84; for a recent exploration see Marisa Anne Bass et al eds., *Conchophilia: Shells, Art, and Curiosity in Early Modern Europe* (Princeton, 2021).

[44] HAB Cod. Guelf. 17.22 Aug. 4°, 228r.

It is rare to find such price lists for such an early period in the Dutch trade in rarities. It reveals that any differentiated terminology to classify these shells by origin and type was of little interest to Hainhofer or other collectors at this stage, although he did mention that one shell originated from a 'different water' to the Indo-Pacific ocean. He did not approach such aquatic objects to lay the ground for any systematic study of the ocean's natural history. Yet his fascination with global exploration, to empirically achieve a 'knowledge of all things', was plain. What would have mattered to Hainhofer furthermore was the general assumption that shells demonstrated God's designs through spontaneous generation as the sun enlivened the elements of the sea, turning mud into beauty. Shells could thus turn into an emblem of fecundity. Their shapes proved God a perfect, as much as a playful, geometer who created cones, spirals, and curves to inspire humans. Even so, Hainhofer also stayed true to his training as a silk merchant in focusing his attention above all on general rarity, size, and patterns. These features determined a shell's beauty and prize.

CHAPTER 29

Material Presence

Just at this time, exotic shells were becoming a marked feature of Dutch still lifes in which they are depicted as gleaming white. Goldsmiths sought to emulate Asian carving techniques that they admired on shells that entered the European market for rarities during the sixteenth century.[1] Goldsmiths likewise perfected their polishing skills. The high appreciation of sheen connected with elite valuation of polish, lustre, and light-reflecting materials, as in gems, porcelain, or fine glass and textiles such as silks and those that used metal thread. Yet the shells Hainhofer sent to Munich were matt and did not please Wilhelm. He returned two boxes and merely 8 florins in payment, enquiring how the appearance of such shells might be enhanced. Polishing them would conjure up the illusion that they were as beautiful as in the sea, lifelike, and connected to the element of water rather than dried and dulled by air. Polishing, in other words, meant working on material presence. [29.1a,b] [29.2]

Hainhofer instantly set to work. His emerging bond with Wilhelm relied not least on a shared interest in material experimentation and special effects. The Catholic Reformation in particular inspired a scientific interest in forces and movement. Hainhofer would later recall how he and the retired duke had experimented with magnets in Augsburg. This had been to find out whether magnets could be used above and below an installation of Christ's nativity so that angels crafted from iron or steel would float suspended in the air.[2] Spiritual automata engineered wonder ever more ambitiously. Wilhelm obtained a mechanical and a hydraulic sculpture of St Francis of Assisi, one of which spurted out blood from wounds.

This time, the challenge was for Hainhofer to understand the secret of polishing shells. 'I quickly', Hainhofer reported, 'asked different goldsmiths I know and two barbers whether they would be able to pull off the surface skin without doing damage by using an *Etz*-knife or *Scheid*-knife and a pumice.' The process of polishing, in other

[1] Eichberger, *Leben mit der Kunst*, 400; Anna Grasskamp, *Art and Ocean Objects of Early Modern Eurasia: Shells, Bodies, and Materiality* (Bristol, 2021).

[2] They experimented with the effect of a magnet below a surface made from a mineral stone with the sheen of mother-of-pearl, but found that a figure could only be moved if the magnet was placed below a wooden table and the figure on top, Häutle, *Reisen*, 145.

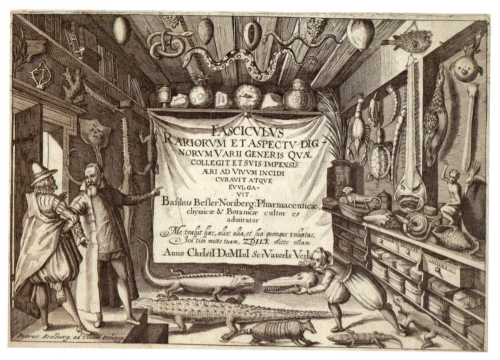

Figs. 29.1a,b Peter Isselburg, Basilius Besler, *Fasciculus rariorum et aspectu dignorum varii generis*, 1618, engraving, 18.6 × 28.2 cm. Frontispiece and image of shells, Johann Christian Senckenberg University Library Frankfurt am Main, public domain. The apothecary Basilius Besler's 1616 catalogue of his Nuremberg naturalia collection, including an Indian pearl-coloured variety 'as it is found raw', in the right corner; 29.1b in the centre a shell 'engraved' with 'Indian figures' of birds, which shows that indigenous people integrated shells into their cultural and cosmological worldviews and craftsmanship. The image reveals indigenous traditions of shell carving migrated to Europe, inspiring European goldsmiths in turn to work on smaller fragile shells. Hainhofer owned Besler's catalogue.

words, differed from the one goldsmiths applied to gemstones.[3] As all of these artisans had remained cautious, Hainhofer was going to try his luck this week with Johann Schwegler and two further artisans, Westermaier and Schweinsperger, who were 'knowledgeable in several arts'.[4] Schwegler was confident in handling feathers as fragile natural materials and happy to attempt experimentation with materials. As Hainhofer suggested, this relied on an ability to apply specialized tools, on manual dexterity as well as material knowledge that crossed different domains.

[3] Marjolijn Bol, 'Polito et Claro: The Art and Knowledge of Polishing, 1100–1500', in Michael Bycroft, Sven Dupré eds., *Gems in the Early Modern World: Materials, Knowledge and Global Trade, 1450–1800* (Basingstoke, 2018), 223–58; see also Maria-Theresia Leuker, Esther Helena Arens, Charlotte Kiessling eds., *Rumphius' Naturkunde: Zirkulation in kolonialen Wissensräumen* (Wiesbaden, 2020), 57–8.

[4] HAB Cod. Guelf. 17.22 Aug. 4°, 229v.

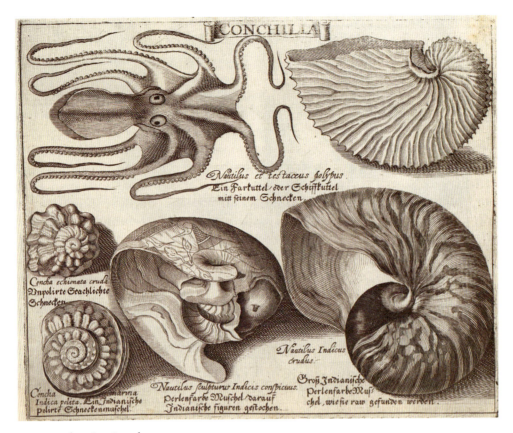

Figs. 29.1a,b Continued

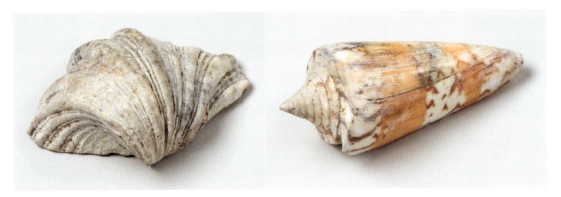

Fig. 29.2 Unpolished shells from the wreck of the VOC ship Witte Leeuw that sank en route from Bantam to Amsterdam in 1613, including the *conus marmoreus*, named after its marble effect. Rijksmuseum, Amsterdam, public domain.

Hainhofer took ten days to complete his inquiry. He found the secret, and decided to further cultivate his ties to the Bavarian court and Wilhelm's interest in buying valuable shells. Indeed, he informed Wilhelm that he had bought two more shells in the meantime that were smaller and which he was happy to send. One of them was much more beautiful and was 'filled with fine colour'. Next followed his biggest news. Peter Ludwig, the dealer from whom he had bought almost 'all of his shells and Indian goods' had taught him secretly, and in return for a meal, how the Dutch went about cleaning their shells. Hainhofer had not tried it out, but remembered its steps well. The merchant now let Wilhelm into the details of the secret: 'When the shells come out of the sea they have an ugly thick skin of coagulated and obstructing matter, but one snail more than another, just as it is proportioned and large.' To remove the skin, these shells were put into 'acid liquid for eight or fourteen days', to soften the skin. Dutchmen next used a small iron tool to take off the toughest and roughest parts of this skin at the back. Next, they applied *aqua fortis* (nitric acid or *Scheidwasser*) with a small brush or feather, following up this treatment up with many applications of fresh water to avoid the acid penetrating into the shell and creating holes. Holes could also be created if the acid was applied unevenly, or if the shells were too delicate. This entire procedure was the best to deal with rough, hard, and, the agent added with apologies for using this term in writing to Wilhelm, 'unclean' residue, implying mud and excrement. [29.3]

In sharing such knowledge of materials with a former ruler, registers of polite speech thus needed to be acknowledged and overcome. Once the shell was cleaned up in this way, large and robust specimens were rubbed with a pumice, and washed with water in regular intervals. To treat delicate shells, pumice was ground into a powder, 'and then they immerse wool or a bit of fabric in it, and see how they can best rub them until its clean'. This elaborate cleaning procedure was followed by a final step, for which leather was carefully used to polish shells until they 'shone beautifully'. Hainhofer's

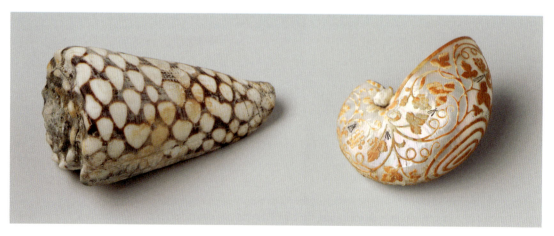

Fig. 29.3 A small, delicate nautilus shell, polished and engraved with astonishing skill as a cabinet piece with wine leaves and insects by Cornelis Bellekin, 1650–1700. Rijksmuseum, Amsterdam, public domain.

description made clear that all of these steps were the outcome of a great deal of trial and error in which the material of the shells guided the artisans in what could or could not be done. It was a painstaking process. A deep involvement with objects thus led to economies of material improvement that laboured to highlight the natural features of specimens, such as their spiralling shape and lustrousness.

Peter Ludwig's son told him that the cleaning of shells in Holland was 'a bad art, but lots of trouble', which implied that it was badly paid, took many hours, and could easily go wrong. By the end of the seventeenth century, the German shell collector Georg Eberhard Rumphius (1627–1702), appointed by the Dutch East India Company as trade overseer in the Indonesian island of Ambon, openly complained about the 'trouble and tedium one has to endure in order to clean them and make them presentable'.[5] Rumphius thought that European buyers were ignorant of this fact while Hainhofer's exchange with Wilhelm suggests otherwise. In fact, Ludwig's son detailed that the entire effort 'often led to little with some shells', especially if the nitric acid was not handled correctly.[6] Hainhofer ended his letter by once more assuring Wilhelm of his service, and affirmed that he would be delighted to find someone who could help the duke to make his shells as beautiful as Wilhelm wished.[7]

[5] Cited in Karin Leonhard, 'Shell Collecting. On 17th Century Conchology, Curiosity Cabinets and Stillife Painting', in Karl A.E. Enenkel ed., *Early modern Zoology: The Construction of Animals in Science, Literature and the Visual Arts* (Leiden, 2007), 177–214, here 210.

[6] HAB Cod. Guelf. 17.22 Aug. 4°, 229r–230r.

[7] HAB Cod. Guelf. 17.22 Aug. 4°, 229v–230v.

CHAPTER 30

Agent for the Duke of Pomerania

Hainhofer's new career thus fully took off in 1610, when he was appointed the Duke of Pomerania's agent. He immediately tried to mediate between the Lutheran ruler Philipp of Pomerania (1573–1618, r. 1606–18) and the Catholic Wilhelm of Bavaria. Their access to different kinds of goods, and desire to further develop their collections, would become central to his life over the following years.

Aged thirty-two, Hainhofer could now turn himself fully into an entrepreneur of the new European cultural movement of 'art lovers' in the German lands. In a new age of increased confessional tension, the exchanges involved took on a political dimension. Art lovers stylized themselves as virtuous elite men bridging the divide between Protestants and Catholics after the Reformations, bound together by a passion for the arts and learning as virtuous activities and a wide cultural horizon that transcended national boundaries. They distanced themselves from stereotypes of German-ness and a courtly life principally focused on hunting and drinking. Hainhofer hoped to drive German culture on through these pious, broad-minded aesthetes, profit from it, and reshape politics through the medium of the arts. Yet for the Emperor and for Bavaria, diplomacy through precious gifts of art appear to have turned into an ever more calculated strategy to lure Protestant territories such as Saxony into a position of political neutrality or to gain the support of Catholic territories. Exchanges of art functioned as part of a manipulative chess game to create 'friendship' in this politicized way and were shot through with dissimulation.

In 1611, Hainhofer thus compiled his first formal report about the relationship between the Houses of Catholic Bavaria and Lutheran Pomerania, addressed to Philipp II of Pomerania. He prepared it in beautiful handwriting as an account to be widely copied and remembered, advertising his ability as an agent. It was carefully orchestrated. Hainhofer seemed to tell a fact-based story of how this 'friendship' had developed, in which copies of letters, quotations from conversations as well as objects and images lent authenticity to his engaging account that testified to the nobility of his own soul.[1]

[1] As Montaigne put it in 1595: 'Art is but the register and accounts of the products' of well-born souls. Hence, 'prized natural productions or outward "works" in speech and action of well-born souls' were selectively registered and reviewed by means of the art of writing (as they can also be by other arts such as painting or sculpture) for future discovery and application', Boutcher, *Montaigne*, vol. 1, 106. Other public registers or chronicles

322 *Ulinka Rublack*

In the beginning was Wilhelm. Hainhofer reported that Wilhelm of Bavaria had stayed in Augsburg's Monastery of the Holy Cross for three weeks from the middle of Lent 1611 to until just after Easter—a period of intense spiritual preparation. Even so, Wilhelm had requested Hainhofer to visit him several times; on three of these occasions, the agent took care to note that they had conversed for four hours.[2] The time they spent together indicated Wilhelm's esteem for Hainhofer, his pleasure in these meetings, and the importance he gave to them. Hainhofer keenly noted down such indications of esteem, which were highly ritualized in nature and part of a courtly system signalling distinction and regard. The degree of familiarity any ruler showed a person, his trust, his gifts, and the time he spent with a person communicated a code that everyone knew how to interpret.[3]

Hainhofer's book of correspondence, however, reveals that hard-edged secret political negotiations about credits, Habsburg networks, the king of Poland, and reasons of state—'*ragione di stato*'—were already integral to these conversations. Hainhofer in this way acted as an officially appointed political diplomat on behalf of the Pomeranian court.[4] He excluded any reference to these confidential conversations from the official 'Relation' to present himself solely as an art-loving mediator between the two courts, and both rulers as solely intent on furthering peace and art. His political negotiations were normally excluded from most of the letters that were copied into the correspondence books, but there is no doubt that they formed the basis of many conversations.

The 'Relation' was designed to be copied by others and commemorate Hainhofer's achievements as a cultural diplomat. It hence told a story in the following way: Hainhofer had naturally taken the opportunity of Wilhelm's visit to Augsburg that Easter of 1611 to introduce the Lutheran Philipp II to the retired duke. The Pomeranian was 'not just a learned and extremely intelligent ruler, but also loved virtues and the arts, liked corresponding with learned and virtuous people of low and high status, read and wrote much, and was ever ready to work undauntedly'.[5] In many ways, Hainhofer suggested, the two men were alike. [30.1]

Wilhelm had never heard of the Pomeranian duke. He asked how old this duke was, of what confession, and what he looked like. Ever practical, he also wondered how Hainhofer would transport letters and other things all the way to this remote eastern Baltic region and back again if they did engage in correspondence. This account in the official Relation can be easily read as Hainhofer's attempt to characterize Wilhelm as innocent of any political strategizing.

were prepared by scribes or historians for a wide audience, while Hainhofer's more private accounts were nonetheless written and beautifully illustrated for possible wider publication. On Philipp II see Hellmuth Bethe, *Die Kunst am Hofe der pommerschen Herzöge* (Berlin, 1937), 70–106.

 [2] Häutle, *Reisen*, The reference to four-hour-long conversations, 18.

 [3] For a masterful reading of these codes see Martin Warnke, *Hofkünstler: Zur Vorgeschichte des modernen Künstlers* (Cologne, 1985), here 311 with reference to Goethe.

 [4] HAB Cod. Guelf. 17.23, 4 Aug., 13.3.1611, 308rv.

 [5] Häutle, *Reisen*, 15.

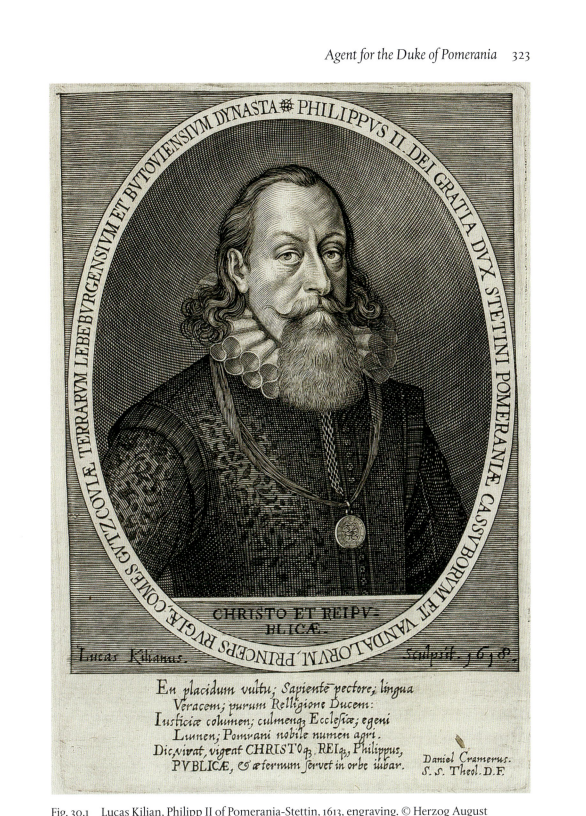

Fig. 30.1 Lucas Kilian, Philipp II of Pomerania-Stettin, 1613, engraving. © Herzog August Bibliothek, Wolfenbüttel, CC BY-SA 3.0 DE.

324 Ulinka Rublack

Hainhofer answered all these questions and showed him an image of the Pomeranian duke in gold and another one worked in amber alongside 'other beautiful golden coins and rarities' that Philipp II had sent him. His long hairstyle would have pleased Dürer, but now looked old-fashioned. Wilhelm instantly remarked on his 'long Nazarene hair' that made him look like the 'salvator', Jesus Christ, except that his beard had been cut in a German manner at the sides.

Once Wilhelm had confirmed his interest in this connection, Hainhofer presented him with two rarities which Philipp II had sent him. One of them was an enamelled crucifix from the famous workshops of Limoge, the other a gift Philipp II had received from another Lutheran ruler in the northern lands, Johann Sigismund of Brandenburg (1572–1619), who knew how to 'prepare' an elk or reindeer's horn without fire. The horn, in other words, indicated Philipp II's powerful connections to a major ruler in the region who was advancing the Protestant cause.

Ground deer horn was commonly used as a medicine, but Hainhofer believed elk horn to be far superior, and in fact nearly as potent as that of a 'unicorn'. It was believed to be particularly efficacious against weakness, fever and also used to 'drive fear from the heart' if it was prepared without fire. Johann Sigismund kept this 'mystery and mode of preparing it' completely secret. Wilhelm hence would not consign this elk horn to his cabinet. It was potent matter conducive to medical and artisanal knowledge gathering. He passed it on to his physicians at court, who would use it to good effect to cure fevers, and to his court artisans, who unsuccessfully tried to turn it into a set of dishes from—a 'Geschirrlein'—out of which healing drinks could be consumed.[6]

As usual, exchanging knowledge about recipes and health was integral to the greater intimacy that developed between Hainhofer and the old duke in these Lenten weeks. Easter fell on the 3 April in 1611. Straight after Wilhelm's departure, Hainhofer wrote to him on 9 April about a whole list of medical secrets from Italy which the retired duke had seen in a manuscript at Hainhofer's house and taken with him. The agent cautiously advised that most of these recipes had not yet been tested. He himself had successfully tried out a new recipe against toothache on 'quite a few' local people—this involved a preparation of 'fired' turpentine oil.

For himself, the agent characteristically preferred applying a far more delicate and doubtlessly better scented tincture of rosewater and rose-vinegar, as a result of which he thanked God that he had not suffered any toothache for the past two years.[7] Hainhofer would have smelt of roses most of the time, experimented with perfumes and sold them. He became known for being well scented, so much so that one ruler enquired whether he carried rosewater in his ruff, on his neck, or in his purse. In response, Hainhofer explained that he wore a yellow amber heart embellished with the portrait of Philipp II of Pomerania, as well as a necklace and a crucifix around his neck

[6] Friedrich Ludwig von Medem, 'Philipp Hainhofers Reise-Tagebuch, enthaltend Schilderungen aus Franken, Sachsen, der Mark Brandenburg und Pommern im Jahr 1617', *Baltische Studien* (2/1834), 108.

[7] HAB Cod. Guelf. 17.23 Aug. 4°, 326v.

to protect his health. In addition, he always carried a small box filled with rose-balm. The body was conceived of as porous—and scents could strengthen a man's constitution as well as indicate civility. In fact, it was a habit of Hainhofer to apply some balm on the insides of his hands and on the sides of his forehead whenever he needed emotional stamina. If anything, he might have been perfumed slightly too strongly even by the standards of the time.[8]

Just like Hans Fugger, Hainhofer accessed advanced medical knowledge in Augsburg. He conversed with medics who were keen to experiment with new knowledge from written codices and ingredients, which merchants sourced ever more globally by utilizing indigenous knowledge and technologies. His local networks were dense, and constantly grew, so much so that, in April 1611, he threw a 'stately' dinner for fifteen people when one collector visited him.[9] Spirited conversations replenished educated local elites with new knowledge, especially through the observations of apothecaries, doctors, and academic physicians. A medic called Hartmann Meyr, Hainhofer reported, had frequently used the 'composed water' described in the Italian manuscript to benefit sick and healthy people alike. Hainhofer advised Wilhelm to keep annotating this Italian *Catalogum Secretum* with further experiences and explanations—and he would then seek further information.[10] In his letter following Easter in 1611, Hainhofer felt comfortable enough to relate personal information to the duke about the sore eyes he had as young man in Amsterdam, and a secret medicine that he now passed on to Wilhelm. Ever since then, he explained, his eyes had hardly hurt.[11]

As physical and spiritual health were regarded as intertwined in this period, Hainhofer's letter to Wilhelm circled back to the theme of the connection to be forged between Bavaria and Pomerania. He offered a small crucifix that Philipp II had sent to him for his own cabinet, which he believed had been manufactured at the court. Hainhofer related it to a Latin treatise with a meditation on death, which he passed on to Wilhelm, and a verse by St Bernhard that reflected on Christ's hour of death and he quoted in Italian.[12] All this shows that during that Easter visit in 1611, the men had evidently entered into new depths of conversation and closeness on spiritual matters across their confessions. Hainhofer now sought to promote this closeness in correspondence to facilitate Wilhelm's diplomatic relations with the Pomeranians.

In his official report of these exchanges for Philipp II of Pomerania, Hainhofer noted that Wilhelm had asked whether the Pomeranian would even be interested in entering into correspondence as he no longer ruled and now lived a 'private and remote existence'. This served as a gesture of humility, but the former Bavarian ruler most likely also wanted to make it clear that the status of their exchange would differ from official

[8] Häutle, *Reisen*, 163.
[9] *Reisen und Gefangenschaft*, 428.
[10] HAB Cod. Guelf. 17.23 Aug. 4°, 327rv.
[11] HAB Cod. Guelf. 17.23 Aug. 4°, 327r.
[12] HAB Cod. Guelf. 17.23 Aug. 4°, 327v.

326 Ulinka Rublack

diplomacy. For example, he never asked what other territories Pomerania bordered on and whether he could obtain a map of it. Instead, he signalled his willingness to assemble a list of diplomatic gifts to send.[13]

Hainhofer had prepared for just this moment. Philipp II, he reported, would be particularly pleased to receive images of birds, fish, and animals which Wilhelm had assembled and the Bishop of Eichstätt likewise possessed, as well as drawings of the ducal pleasure houses in Munich, the grotto, the Belvedere, and stately rooms. He wished to copy the Bishop of Eichstätt's images of his animals and plants and use the architectural designs for the building of his own pleasure house which he had just begun.[14] A key purpose of the correspondence from both sides therefore was to access cross-confessional networks—Philipp II wanted Wilhelm's access to the Bishop of Eichstätt, and in turn offered access to Protestant princes. This was relevant not least because Wilhelm was energetically trying to retrieve relics and altars from Protestant lands.[15] But it was also relevant because both Philipp and the bishop of Eichstätt so far had retained political neutrality.

[13] For these more politically motivated questions see Häutle, *Reisen*, 211—they were posed in 1613.

[14] Häutle, *Reisen*, 16–17.

[15] Lorenz Seelig, '"Dieweil wir dann nach dergleichen Heiltumb und edlen Clainod sonder Begirde tragen": der von Herzog Wilhelm V. begründete Reliquienschatz der Jesuitenkirche St. Michael in München', in Baumstark ed., Rom in Bayern, 199–262.

CHAPTER 31

The Garden of Eichstätt

Wilhelm thus instantly wrote to Johann Konrad von Gemmingen (1561–1612), the Prince-Bishop of Eichstätt, who replied in May 1611. Von Gemmingen enjoyed understatement. He advised Wilhelm that he did not in fact own many animals and his birds were mostly common. All the same, he enclosed a proof page from one of the most ambitious book projects in the history of print. A while ago, the bishop reported, he had begun to have plants from his 'small, narrow' garden observed, drawn, copied, and then engraved in Nuremberg. He mostly acquired these plants through merchants in Antwerp, Brussels, and Amsterdam. The proof pages would turn into the celebrated *Eichstätt Garden* publication. He would happily receive a person sent on Wilhelm's behalf to look at his gardens and collections. [31.1]

And so it was that Wilhelm recommended the Lutheran Philipp Hainhofer as a 'knowledgeable man in such things and a lover, and also as knowledgeable in art' to the bishop.[1] It was the first time that Wilhelm had employed Hainhofer as an art lover on a mission that involved travelling and diplomacy. Hainhofer would see the collection of a leading German Catholic ruler in his role as agent and have his expenses paid for by the Bavarian duke. In taking this decision, Wilhelm particularly valued Hainhofer's mercantile 'dexterity' in negotiating for alternative objects in case the images of animals that Philipp II of Pomerania desired really were not to be had. All the same, the mission was intended to be secret—Hainhofer was instructed not to mention that Wilhelm was looking for diplomatic gifts, presumably least of all gifts to pass on to a Lutheran prince.[2]

Konrad von Gemmingen hailed from an old Swabian aristocratic family. Born in 1569, he had travelled extensively and in his youth had studied in England, France, and Italy. He had been consecrated in his prestigious and lucrative office as Prince-Bishop of Eichstätt in 1595, aged twenty-six. Local people attending this festive mass had been promised a letter of indulgence that would absolve them from suffering for their sins.[3] A prince-bishop acted as head of the territory and its church, and was thus one of

[1] Häutle, *Reisen*, 20–1, 'als unss in solchen sachen vertrawten und liebhabern, auch Verständigen der kunst'.

[2] Häutle, *Reisen*, 21–2—this is how I interpret the passage; on his dexterity see 22.

[3] Irene Reithmeier, *Johann Konrad von Gemmingen: Fürstbischof von Eichstätt (1593/5–1612)* (Regensburg: Pustet, 2010), 102.

Fig. 31.1 Wolfgang Kilian, Johann Konrad von Gemmingen, Prince-Bishop of Eichstätt, 1606, engraving. Missouri Botanical Garden, Peter H. Raven Library, public domain. Gemmingen resided in the Willibaldsburg.

Germany's political leaders. Yet Eichstätt's small territory was wedged in among powerful neighbours belonging to different religious camps. To the east lay Catholic Bavaria, to the west Lutheran Franconian territories. The prince-bishop needed to settle disputes over territorial rights, further consolidate his territory, and avoid siding with the Catholic League—the military union founded in July 1609, not least by Hans Fugger's

Fig. 31.2 Philipp Hainhofer, The Willibaldsburg in 1611, watercolour and ink, HAB Cod. Guelf. 23.3. Aug. 2°, fol.13v–14r © Herzog August Bibliothek Wolfenbüttel <http://diglib.hab.de/mss/23-3-aug-2f/start.htm>.

son Jakob as prince-bishop of the important diocese of Constance, but under Maximilian I of Bavaria's undisputed leadership.[4] The Catholic League had been further strengthened when powerful and wealthy rulers joined in February 1610. [31.2]

In 1608, a group of Lutheran and Calvinist cities and territories under the leadership of Frederick IV of the Palatinate had formed a Protestant Union. They felt that Maximilian I of Bavaria's annexation of Donauwörth heralded a major shift in German politics. Mechanisms to resolve conflicts at the Imperial Diet, Germany's main political summit, no longer seemed workable. Religious tensions seemed to be increasing and the Emperor partial, while Calvinism had still not been officially recognized as a legitimate faith. Maximilian I had tried to pressurize von Gemmingen to join a Catholic League ever since 1608, while avoiding the impression that his more aggressive politics

[4] Häberlein, Die Fugger, 203.

330 *Ulinka Rublack*

suited Bavarian aims above all. Still, von Gemmingen tried to avoid becoming a member of the alliance as he feared immediate retribution from his Protestant neighbours if any war broke out.[5]

The political situation stayed tense. Throughout 1610, the Union and League had assembled troops in response to rival claims for possession of the extensive and wealthy Duchy of Jülich, Cleve, and Berg. Von Gemmingen had duly mustered his own citizens and ensured they were equipped to defend the territory if needed. Meanwhile Protestants approached the wealthy ruler for loans to finance their military undertakings. Margrave Joachim Ernst of Brandenburg-Ansbach, who led the Upper-German army for the Union, promised von Gemmingen that in return for promising political neutrality he would not have to fear damage to his territory. No troops would be directed through it or quartered in houses and castles.

In November 1610, a Bavarian ambassador arrived to tell von Gemmingen that these were empty promises, and that the Protestants were out to eliminate them. Catholics needed to show unity. The burden of preventing a war, or of protecting all Catholic powers during warfare, needed to be shared. Yet von Gemmingen would not budge. It appears that he granted Joachim Ernst, as well as his fellow Lutheran Philipp Ludwig of the Palatinate, a claimant of the Jülich-Cleve territory allied to Johann Sigismund of Brandenburg, substantial loans in 1611 in order to be assured of their protection.[6]

By walking the tightrope of political neutrality, von Gemmingen decided to demonstrate his power through the display enormous wealth. In 1610, he commissioned a monstrance from Augsburg goldsmiths which Hainhofer valued at 60,000 florins. Just one of its 350 gemstones was worth 7,000 florins. The masterpiece was just about to be completed as Hainhofer visited. All this explains why Wilhelm did not immediately wish von Gemmingen to know about his contacts with a Lutheran ruler in Pomerania, and why Hainhofer would be received as a guest sent by the Munich court with utmost hospitality.

Straight after his Eichstätt mission, Hainhofer was told to see Wilhelm in person. Then, after returning to Augsburg, he carefully composed his report of the trip for Philipp II of Pomerania, in which he transcribed some of Wilhelm's letters. His talent for observation and literary description fully came to the fore in his account of von Gemmingen. No one ever composed a better portrait of a prince-bishop as an art lover during troubled times. At the same time, the report laid open the rules of the chess game of diplomacy which each of the participants knew perfectly well how to play.

On the 13 May 1611, three days after receiving Wilhelm's letter with its instructions to visit Eichstätt to scout out gifts for the Duke of Pomerania, Hainhofer thus mounted his horse to ride with a servant to the bishop's castle. After rising at 4 a.m. for the last leg of the journey, he arrived at midday, was shown to his lodgings with a view of the castle

[5] Reithmeier, *von Gemmingen*, 274–7.

[6] Reithmeier, *von Gemmingen*, 281; for Maximilian's considerations see Felix Stieve, *Briefe und Akten zur Geschichte des Dreissigjährigen Krieges*, vol. 8 (Munich, 1908), 356–7, 444–5, 558–9, 664–5.

moat full of rabbits, provided with two further servants, and treated to a sumptuous lunch served with a choice of wines from four different countries, including the Canaries. This luxury treatment reflected the rank of Wilhelm of Bavaria in whose service he had arrived. As the bishop was too unwell to receive him, Hainhofer was shown the gardens in the afternoon.

Instead of being small and narrow, there were eight sumptuous gardens in total. Each of these had its own gardener, as did four further gardens containing different types of pheasants, cranes, and other birds. The surrounding area was a building site, as von Gemmingen employed two hundred men from Italy and mountainous areas of Switzerland to break rocks. Ambition abounded. The plan was to 'completely turn around the castle' and rebuild it from this local stone, in order to then likewise 'completely turn around' the gardens and construct a precious new chapel facing the Orient. Hainhofer noted the images in these exploded rocks, with their 'fish, leaves, birds, flowers and many strange things which nature lets us see in them'. He was looking at fossils.[7]

The next morning, Hainhofer was asked to see the frail bishop, who was dressed in a gown lined with sable fur, and was only just about able to stand upright to receive him. He kissed the prince-bishop's hand and repeated Wilhelm's request for images of birds, plants, and 'other exoticorum'. Von Gemmingen repeated that he had no animals that were anything more special than those at the Munich court. Meanwhile, his plants had been sent to Nuremberg, where an apothecary who had helped him to arrange and create the garden was having them engraved in copper to 'seek his fame and profit'. Von Gemmingen would, however, faithfully show Hainhofer the little that there was to see, so that his trip was not for nothing.[8] [31.3] [31.4]

At this point, the gout-stricken fifty-year-old had to sit down, and Hainhofer stayed next to him for half an hour of conversation to provide news about Duke Wilhelm, and to hear more about the grand project of the bishop's pharmacist. The man turned out to be Basilius Besler (1561–1629), whose Nuremberg collection of *naturalia* Hainhofer had not yet seen. Each week, Besler received one or two boxes of fresh flowers from Eichstätt when they were at their best. Hainhofer wrote that about five hundred types of tulips in different colours were among them. The bishop calculated that having the *Hortus Eystettensis*, his garden in Eichstätt, engraved, would cost him 3,000 florins. He would in the end pay more than twice that amount. The total expense for producing these magnificent folio volumes would eventually amount to nearly 18,000 florins. The books were oversized, measuring more than half a metre in height, the sheets made of the largest size of paper available at the time. Sheets for a luxury edition that was to be hand-coloured were printed on even more special paper and the book cost 500 florins, so that even confirmed bibliophiles were astonished when they heard the price.

The far more affordable black-and-white edition (originally priced at 48 florins) was still stunning, showcasing the best techniques of botanical drawing and contemporary

[7] Häutle, *Reisen*, 26.
[8] Häutle, *Reisen*, 27.

332 Ulinka Rublack

Figs. 31.3 and 31.4 Depictions of rare, vibrantly coloured flowers from the bishop's *Hortus Eystettensis*, 1613, a garden planned by Basilius Besler (1561–1629) most likely together with Carolus Clusius and Joachim Camerarius, fusing advanced botanical and artistic knowledge. The *Hortus* was the first book to catalogue the plants in one single garden. Its sheets measure 57 × 46 cm. Hochschul- und Landesbibliothek RheinMain, CC-BY 4.0.

Figs. 31.3 and 31.4 Continued

engraving in alluring variety, a joint production of Nuremberg and Augsburg draftsmen, engravers, and printers who translated the coloured drawings into their art of the black line. Turning every one of the 367 pages was exhilarating and invited sustained spiritual contemplation, study, and delight. Ten per cent of these illustrated plants were Asian, some were African and American, and a third came from the Mediterranean. Many of the exotic flowers, including forty-nine varieties of tulips, had been sourced via Amsterdam. Tulips encouraged new experiments in colour variation. For the hand-coloured edition, Besler would be fastidious in his instructions to illuminators about what colour tones and hues to emulate as they applied paint onto the black-and-white images of the plants, which meant experimenting with mixing pigments in new ways. He ordered the Nuremberg master illuminist Georg Mack the Younger (active 1585–1615) to illuminate the first seventy copies of the *Hortus*, the Garden book. These now count among the most valuable early books ever printed, and only twenty-eight copies are now said to survive worldwide.[9]

Much anticipated, the garden book was published in 1613. Alas, the Bishop of Eichstätt did not live to see it; he died in November 1612. Maximilian I of Bavaria triumphed, van Gemmingen's successor would not hesitate to join the Catholic League.[10]

Hainhofer's visit of 1611 thus captured the prince-bishop's strategic vision of how to conduct politics by presenting himself as one among the movement of distinguished art lovers. The movement, and art objects as its medium, provided a language to tactically emphasize the importance of peace and friendship across confessional and national boundaries. As a result, in writing to Philipp II of Pomerania, Hainhofer was able to present his visit to Eichstätt as a complete success. It turned out that the bishop, who possessed excellent intelligence, already knew that Wilhelm of Bavaria was assembling diplomatic gifts for the Duke of Pomerania, and himself was likewise pleased to correspond with Philipp. Von Gemmingen's wish list was precise and fulfillable. Above all, the prince-bishop desired large antlers to decorate his dining hall. He also sent his clear political message of the importance of political neutrality to Pomerania—a path outside the confessional camps in which he needed further allies.

Hainhofer had seen many more of the bishop's treasures, commented on them, and quickly gained his trust. Of course, this knowledgeable young merchant appreciated the bishop's collection of embroideries and textiles, including precious Milanese velvet woven on a ground of gold thread in six colours. He looked at 'multiple drawers' filled with 'Indian mother-of-pearl shells', and six silver reliefs, part of a cycle of twelve, soon to surround a crucifix and the great altar in the dome church. They depicted themes from the coronation of the Virgin to Christ's resurrection. Some of these, Hainhofer realized, were adorned with Johann Schwegler's 'feathered animals'.[11] Through the use

[9] Nicolas Barker, *Hortus Eystettensis: The Bishop's Garden and Besler's Magnificent Book* (London, 1994); Werner Dressendörfer, Klaus Walter Littger, *Der Garten von Eichstätt* (Cologne, 1999); Klaus Walter Littger, Gernot Lorenz, Alessandro Menghini, *Basilius Besler. Hortus Eystettensis. Commentarium* (Sansepolcro, 2006).

[10] Häutle, *Reisen*, 28; Reithmeyer, von Gemmingen, 305–9.

[11] Häutle, *Reisen*, 31–2.

of real feathers, Schwegler's miniature birds combined nature and human artistry to express the wonder of God's world through mimesis. Von Gemmingen loved birds—throughout winter, they were fed on the long balcony outside his rooms. He explained that frequently over two hundred of them congregated and sang together—he would never catch them, which would lose 'his pleasure'. He kept no aviary or zoo.

Among the bishop's possessions, Hainhofer noted in passing two paintings by Cranach. Mostly, he described costly work by contemporary goldsmiths, cabinet makers, and a few painters, especially an Orpheus surrounded by many animals, such as cranes and elephants, set in a fantastical landscape, as well as two still lifes with flowers, all of them the work of the Flemish artist Roelandt Savery (1576–1639) who worked for Rudolph II in Prague and specialized in these subjects. The bishop loved these paintings and professed not to know anyone able to make a good copy. He did not wish to give them away. [31.5]

As a delegate of Wilhelm of Bavaria, Hainhofer continued to be treated in the best possible way and noted all his privileges in detail. Some meals he took on his own were served on silver plates. He took part fully in the life of this court and saw the bishop arriving in a wheelchair for an elaborate dinner during which a court fool entertained everyone with intermittent merriment.[12] Serious conversation at table turned to Germany's current rulers, to laud how greater virtue, piety, and art gradually succeeded

Fig. 31.5 Roelandt Savery, Orpheus, 1628, oil on oak, 53 × 81.5 cm. © National Gallery, London.

[12] Häutle, *Reisen*, 33.

336 *Ulinka Rublack*

over traditions of courtly excess. The diners now named rulers who were known to be learned and virtue-loving. Given Germany's hundreds of territories, this turned out to be a short list by any means. Hainhofer recorded the names as follows: Bavaria, Baden, the Palatinate, Ansbach, Pomerania, Hessen, Kassel, and the Graf von Schaumburg. Most of them were Protestant.

Von Gemmingen now enquired whether Hainhofer knew all these rulers. The Augsburg agent replied that he had only ever met and spoken to the rulers of Bavaria and Ansbach. Wilhelm of Bavaria and Philipp II of Pomerania wrote to him mostly in their own hand rather than through their scribes, and he also corresponded with Baden, Brandenburg, and the noblest French ambassadors. He now took this opportunity to assure the bishop that he would be well suited as a middleman in case von Gemmingen wished to correspond with Pomerania.

The bishop enquired with tactical hesitation whether Philipp II, an evangelical and secular ruler, would be pleased to correspond with him as a Catholic bishop and ruler? Hainhofer's reply was self-evident. Philipp II of Pomerania was a great lover of antiquities, paintings, crystal and metal images, painting and sculpture. There would be no difficulty if the letter was accompanied by a gift. Philipp II corresponded with many rulers who were not of his religion, as long as they loved peace, honour, and virtue.[13] Von Gemingen affirmed that their correspondence would concern political rather than religious matters, and that such friendly, intimate correspondence often served well in unforeseen circumstances to strengthen the common good. He immediately instructed Hainhofer to source a large crystal bowl for him to send to Pomerania. Next, the conversation at the table turned to natural phenomena: 'we talked about thunder, plants and organism, and many amusing things', in a number of languages—and Hainhofer revised one of the handwritten copies of his report to specify these languages: German, Latin, French, Italian, and Dutch. It was thus expected that those distinguished enough to be invited to the bishop's table were able to speak several modern languages, and to understand wit and allusion in them as well as the culture and politics of those countries.[14] Except for English and Spanish, Hainhofer mastered them all. His patrician background, as much as his merchant training, enabled him to flourish. [31.6]

Later that evening, Hainhofer and von Gemmingen looked at entries in the friendship album Hainhofer had brought with him to Eichstätt. Many such *alba* never quite came together. The wealthy bishop, however, trusted in Hainhofer's determination to complete a notable project worthy of art lovers and casually affirmed he would be willing to spend 'a few hundred Thaler' on an entry, if it was carried out to the design he proposed. Each of the entries, he added, needed to be 'meditated upon and contemplated' with time to full appreciate their 'art and innovation'. After noting 'art and innovation' Hainhofer added 'and industry' in a revised version of his account, as well as the fact that the bishop

[13] Häutle, *Reisen*, 36.

[14] Häutle, *Reisen*, 36; HAB Cod. Guelf. 11.22, 2 Aug., 13r. The manuscript shows Hainhofer's revisions throughout in red ink.

The Garden of Eichstätt 337

Fig. 31.6 Basilius Besler, Hortus Eystettensis, 1613, British Library, London. © British Library Board (10.Tab.29), title page. The title page of the Book of the Garden, with its depiction of paradise and plants from different parts of the world to recreate wisdom and pleasure after Adam's Fall.

338 *Ulinka Rublack*

had admired the sheer number of entries by leading rulers, remarking that nothing comparable existed in the Holy Roman Empire.[15] Just as with precious religious manuscripts, such as books of hours, the bishop was of the view that the process of looking at the album should best be stretched out over several days. One would spend only a 'while' looking at it each time to fully appreciate the experience.[16] His idea of being a lover hence linked art consumption to contemplative pleasure and legitimate leisure coherent with older monastic notions of *otium* to rejuvenate the mind and senses.

The prince-bishop nonetheless ended this conversation with one of his understated jokes: he wanted to show Hainhofer those paintings of his 'on which colors did not fade and which were painted with a different rusty brush'. As we have seen, colour degradation devalued most paintings as ultimately transient art, or one that required continuous intervention through refreshing or overpainting. Moreover, its intrinsic materials were so cheap that Maximilian I of Bavaria once vented his anger when the Nuremberg city council declined to sell him a painting allegedly by Michelangelo, writing that 'in effect this was nothing important, and only about a board covered with colours'.[17] Hans Imhoff's heirs in Nuremberg eventually would be left with a collection of worm-eaten panels or faded, worn-out watercolours.

Von Gemmingen, in sum, was characteristic of art-loving collectors at the time who still owned few paintings. Instead of leading Hainhofer to any picture gallery, his servants began clearing two tables and brought out his treasure of golden bowls, salt cellars, cups, and other items of jewellery, worth 70,000 florins, as he made sure to tell the agent. Metalwork was infinitely malleable: the bishop melted down and remade any piece he disliked. Hainhofer asked him about the making costs, to which the bishop replied that they were negligible given the fact that the value of gold rose every day. The value of gold lay in its intrinsic properties, its malleability, and resistance to decay. Hainhofer emphasized that all of this treasure was of pure gold and 'the heaviest'. He could see that lifting such items required strength. Von Gemmingen planned to leave this treasure to his successor instead of cash, as a safeguard against overspending. The next day, the bishop equally made sure to show Hainhofer his sacks of golden coins, his overflowing chests of silver, his crystal, and most precious monstrances from Augsburg makers, several of which were valued at 60,000 florins each. All of this conveyed the bishop's extraordinary wealth to the Duke of Pomerania, although Hainhofer was at pains to likewise stress his humility and endurance given his physical suffering.[18]

Art lovers were never economically naive. While exotic flowers, such as tulips, were costly and perishable, and birds likewise, the bishop knew to amass secure investments through precious metalwork and jewellery. Von Gemmingen's principle recreation,

[15] HAB Cod. Guelf. 11.22, 2 Aug., 14r.

[16] Häutle, *Reisen*, 37.

[17] Dieter Albrecht, *Maximilian I von Bayern 1573–1651* (Berlin, 1998), 258, 'in effectu um khain wichtige sach, sonder nur umb ain mit farben überstrichenes prött zu thuen'.

[18] Häutle, *Reisen*, 40.

Hainhofer would later sum up, lay in his enjoyment of gold, jewellery, flowers, birds, and large antlers.[19] Did art lovers invest to speculate? In advising on how to build up a cabinet of curiosities, Hainhofer certainly considered investment strategies for his clients from the outset. Painting had definitely become an object of speculation for those unable to invest large sums in gold and precious stones. Just as if he were advising today's serious collectors, Hainhofer hence told Philipp II of Pomerania in 1610 that 'some pieces, especially paintings by good masters and work in stone, will value twice the amount if one wants to sell them again, and the duke of Bavaria is meant to have a lot, and also the grand-duke of Tuscany, and they often pride themselves that they will be able to triple the capital they initially spent'. Indeed, Wilhelm himself had told Hainhofer just the same when visiting his cabinet.[20]

In the course of his stay in Eichstätt, Hainhofer befriended the bishop's chamber master von Werdenstein, and from then on exchanged many letters with him. The agent had impressed the bishop with his virtuous behaviour, as a true lover of art, and quite different from the traditional German courtier. Hainhofer had not taken part in *Gesundtrinken*, the custom of downing multiple large beakers of alcohol to wish a person's health, that was believed to be efficacious. Some courtiers had commented on his incapacity to drink in the evenings, so that Hainhofer apologized for his abstinence when speaking to the bishop. He told von Gemmingen that 'he rather wanted to pray a fervent Our Father to God and your grace's health and happy, peaceful government than to drink a large glass of wine'. In a revised version of this report, Hainhofer added the justification that 'drunkenness brings with it all kinds of illness, unhappiness and disaster', which he attributed to the bishop's long speech on alcohol in yet another version of his account.[21] Von Gemmingen agreed that devout prayer was preferable to godless drinking, applauded restrained rulers, and told Hainhofer that he himself had never felt better after any of these drinking rituals. He switched to Latin as he quoted the church father Augustine's views on the straight path that led from drink to sinfulness, adding that he, in fact, was now completely hostile to drink.[22] For both men, restrained drinking, as much as contemplating nature and the arts, indicated new ways of being a German.

These exchanges and agreements were part of the leaving procedures that affirmed these mutual understandings, in the course of which von Gemmingen and Hainhofer demonstrated their further acquaintance with the types of delicate taste, behaviour, and politics that befitted art lovers. At 6 a.m. on 20 May, von Gemmingen received the Augsburg agent a final time, dressed less formally than before, but still preciously, in a brown damask gown, lined with marten fur. This conveyed their intimacy and the bishop's

[19] HAB Cod. Guelf. 17.23 Aug 4°, 76r.

[20] Doering, *Hainhofer*, 7.

[21] Häutle, *Reisen*, 74; HAB Cod. Guelf. 11.22 Aug. 2°, 17v, 'denn die trunkenheit allerley krankheit, unglück und verderben mit sich bringt'.

[22] Häutle, *Reisen*, 43. Hainhofer later in his life, and in different political circumstances during the Thirty Years' War would take part in these rituals, see ibid. at the Munich court 1636, 303.

'affection'. The bishop asked a servant to once more unlock his golden desk and then took out a large golden box containing five types of balm, including 'Egyptian Lemon' balm, which alongside others was believed to strengthen the heart. He dropped some ointment onto the agent's hand and passed him a beautiful pearl necklace to admire, as well as eight further golden boxes of balm. In return Hainhofer presented his host with his 'precious rose balm'—no doubt extracted from his garden—as well as other gifts.

It was at this point that the prince-bishop explicitly outlined his policy of neutrality: his territory bordered onto Protestant and Catholic territories as well as the city of Nuremberg as a result of which he had not joined either of the Leagues that had recently been formed. He was happy to receive Protestants, wishing for 'peace and unity and good trust with everyone, and disliked to hear any talk about the destruction of peace'. In this way art-loving in an age of mounting confessional tension could become integral to a diplomatic language of irenic politics, as it symbolized a life devoted to the arts, learning, exchange and communication across territorial boundaries.[23]

Next, von Gemmingen opened further and further drawers of his cabinet containing abundant jewellery of extraordinary value and rarity, including an 'Indian ring', which Hainhofer described in detail. Afterwards he asked servants to bring beautifully embroidered cushions filled with scents, as well as other embroidery. This meant that the agent could in future advise him on what gifts were most appropriate for the duke of Pomerania and his wife, or other rulers. Hainhofer meanwhile requested a letter he might take to Wilhelm, which the bishop wrote at once, adding that he himself would be particularly glad if Hainhofer could initiate correspondence between Eichstätt and the Grand Duchy of Florence, as he already exchanged a letter every now and then with the grand duchess's brother, Archduke Ferdinand in Graz.

Finally, von Gemmingen told Hainhofer that he would be particularly pleased to receive 'beautiful, large and unusual deer antlers for his new hall', on which he would be happy to spend 1,000 thalers and also compensate the agent for his troubles. He told him to return soon, during the hunting season, upon which Hainhofer kissed his hand and bowed himself out. The agent was given lunch, he sent his servant to leave tips for members of staff, and at noon, as the castle bridge was lowered, he rode away.[24]

The bishop sent a letter and suitable diplomatic gifts to Pomerania soon after. In June 1611, Philipp II of Pomerania followed Hainhofer's advice not to send amber in return, as the agent had seen none among the bishop's possessions and therefore surmised that he would not value it. Instead, large antlers with thirty tines and a crown in which a glass of wine could be inserted were sent from Pomerania to Eichstätt, alongside a Pomeranian stallion and mare, as well as amber cameos.[25] Von Gemmingen would

[23] See also Hainhofer's presentation of Duke August of Braunschweig Wolfenbüttel as such a prince in 1636 at the Munich court, Häutle, *Reisen*, 286–8.

[24] Häutle, *Reisen*, 47–8.

[25] Häutle, *Reisen*, 52–3.

have been delighted. Hainhofer's report of the visit was full of vivid detail as it described each stage of the visit and prepared the reader for the happy ending of each party's satisfaction brought about by his art of diplomacy.

Still, on just one issue, loyalty apparently could never divide. Writing to Philipp on April 13, Hainhofer reported that Wilhelm had asked him to source paintings on religious subjects by Albrecht Dürer. Wilhelm had sent this request in his own handwriting after the Easter visit in 1611. The men had evidently touched on this topic during Wilhelm's stay. Hainhofer sensed Wilhelm's great 'desire' for Dürers, yet frankly told him that he was 'completely devoted' to serving Philipp as agent. If he were able to source anything by Dürer (as he claimed to have done every now and then in the past), it would be sent to Pomerania.[26]

[26] HAB Cod. Guelf. 17.23 Aug. 4°, 330rv, Doering, *Hainhofer*, 121.

CHAPTER 32

The Age of Maximilian I

Hainhofer rode to Munich the next morning. Upon his arrival at noon he was instructed to stay for eight days. It was the first time that the Lutheran merchant gained access to Wilhelm's court as an official visitor and saw some of the 'Neue Feste', in which his son Maximilian I now ruled.

Maximilian I, as we have seen, had succeeded his father in the face of complete state bankruptcy in 1598. A deeply religious man, just like his father, he restructured the ducal finances with astonishing speed to consolidate them by 1607. The Munich court was fully operational again. Wilhelm received Hainhofer every afternoon, dressed in his rough black woollens. The men talked about objects Hainhofer had seen in Eichstätt and about the Munich collections, they discussed the gifts for Pomerania and related matters. Four years after his first visit, there was much to see at the Munich court and the place to Hainhofer seemed like a labyrinth.

Wilhelm, 'the old Lord', resided in the 'new building'. As ever, he was full of plans. The whole place was to be rebuilt for Albrecht, his youngest son, and Wilhelm would move out of this immense space with no less than two hundred doors to smaller lodgings. For now, Hainhofer received the privilege of visiting an extraordinary grotto newly created from natural rocks and filled with life-casts of lizards, snakes, crabs, and toads. It was normally closed, as two Carthusian monks inhabited it engaged in perpetual prayer and meditation. Located in a courtyard planted with enormous fir trees next to Wilhelm's apartments in the castle, the grotto was a wilderness retreat that could be enjoyed by up to twelve princely guests seated on simple straw chairs.[1] Gardens, the pharmacy with a large rhinoceros horn that hung from the ceiling, workshops, and rooms for all the court artisans and artists were also close to Hainhofer's rooms.

Despite his Lutheranism, Hainhofer was shown the chapel Maximilian I had just built in 1607 and its most important relics. He gained access to his palace, noting a room with a long dinner table and an inbuilt musical automaton. This was the same space in which Protestant delegates had twice been welcomed earlier in 1611 in the negotiations between the Protestant Union and the Catholic League. Hainhofer described some of the paintings and decorations in Maximilian I's palace, the so-called

[1] See Christine Göttler, 'The Art of Solitude: Environments of Prayer at the Bavarian Court of Wilhelm V', *Art History*, 40/2 (April 2017), 404–29.

344 *Ulinka Rublack*

Veste, the astonishing antiquities room, a room with a painted grotto, the garden, fountains, waterworks, and a natural grotto, the nearby library with its holdings in many languages, including Japanese. Then, of course, there were the stables with the cabinet of curiosities. Hainhofer described hundreds of these objects in his report to Philipp II of Pomerania, including a waxen horse and other artefacts created by Maximilian I himself.

To see everything properly, he concluded, one needed months rather than two or three days. Even so, he had been privileged to visit the cabinet three times, especially as so many artefacts by then had been stolen from the cabinet, so foreigners were usually no longer permitted to enter.

Wilhelm Büchler, keeper of the cabinet or curiosities and Maximilian I's secretary for art, was a busy man. He told Hainhofer that he had 'enough work on his hands to keep everything clean' and was irritated that Wilhelm had allowed the agent to stay as often and as long as he liked in the cabinet, simply instructing Büchler whenever access was required. Büchler, moreover, struggled to supply the detailed elaborations on objects Hainhofer requested, and was impatient with the time his Augsburg visitor took to study some of them. Yet, in the end, the agent proudly noted in his report, Büchler had been pleased to learn from him about 'many things' which he 'did not know and understand what they were' as Hainhofer interpreted and revealed them to him ('*aussgelegt und zu erkennen gegeben*'), so that he was extremely pleased with their acquaintance. This implies that Hainhofer had told the keeper where objects might have come from, what they were made from, who might have made them, and what their function and symbolism might be.

Hainhofer's account of the cabinet listed notable items room by room without conveying any sense of a meaningful order or overarching programme other than to showcase rare, curious, and exquisite man-made and natural objects of all kinds and from all over the world. Just once, he conveyed his particular admiration for objects, while another time he became judgmental: 'on one table, shells and sea plants (*Meergewächs*)', he described, only to comment: 'but it's nothing special and I would not want to change mine for these'. Was this a response to the fact that Wilhelm in fact had returned many of the shells he had offered to him since 1606? The rest of this room contained a typical mélange of items ranging from 'a long table full of Indian clothes and feather-work' to a 'rather old'—that is, possibly antique—cast of Aristotle's face, the horns of a gazelle with an image of that same gazelle, pigs' teeth, masterworks of locksmithing, porcelain bowls and beakers, as well as a depiction of the crucifixion worked in white and red coral.[2]

After his stay at the court in May 1611, Hainhofer received his first letter from Duke Maximilian I of Bavaria in November. Even though he had not spoken to him while visiting, the agent had gained a clear impression of the ruler. On the third day of his

[2] Häutle, *Reisen*, for his positive comment see p.88, despite the fact that this was a piece of Catholic propaganda; on his critical comment relating to shells see 96.

visit, he had seen Maximilian I from afar lunching with his wife, two of his siblings, and the old court fool. The Bavarian appeared to him a tall man (even though he was not), with 'a beautiful white face and red beard'.[3] Being permitted to this ruler's table would have been out of the question. Maximilian I lodged any visitor below the rank of a prince in a large separate house called the *Gesandtenhaus*. Strict protocols and rituals operated. How often and how quickly an ambassador or agent gained access to an audience with Maximilian I, how well he was looked after, who looked after him, what kind of carriage he was given, and what kind of food and wine he was served - all of this was an indication of Maximilian I's 'affection' for the ruler an ambassador or agent was serving, and whether he could hope to complete a mission successfully.[4]

Exclusivity and tight discipline had become a hallmark of this reformed Catholic court. Instead of hosting full tables for courtiers, councillors, and guests, Maximilian I's officials handed out an allowance for members of staff, expecting them to make their own arrangements. After his father's financial debacle, Maximilian I had managed to quickly cut costs through such a 'parsimonious economy'—Hainhofer was informed that 'many 1,000 florins' were thus saved annually in order to pay off inherited debts. The duke was not inclined to support 'superfluous eating and drinking, gambling, too much hunting, tournaments and other entertainments and vanities'. The court's once exceptional musical culture was diminished.

Maximilian I focused on objectives and involved himself in the day-to-day business of governing in ways that Hainhofer clearly found astonishing: 'he reads through supplications and other documents for signage himself, corrects them himself, issues ordinances himself'. The duke personally decided on every acquisition for the court library, adding no more than around forty-five books per year, on which he spent 4,000 florins altogether during his entire thirty-two years of rule (1598–1630). He chose consistently. These books, he hoped, would facilitate new scholarship on the history of his territory and the Wittelsbach dynasty that linked to significant political claims. Key among these was Maximilian I's aim for the Bavarian line of the Wittelsbachs to join the Holy Roman Empire's seven electors through claims to the Palatinate. The electors were the most powerful men in German politics. In addition, Maximilian I argued that his entire dynasty descended from the Carolingians. He employed humanist historians to trace his descent back to Charlemagne, attempting to legitimize the claim that members of the Wittelsbach dynasty were even destined to rule as Emperors. His reading of Livy inspired him to craft the history and envisage the future of his dynasty as a series of constant successes, in linear terms.[5] He was destined to win. Just like his father,

[3] HAB Cod. Guelf. 11.22 Aug. 2°, 70r.

[4] Häutle, *Reisen*, 77.

[5] Peter und Dorothea Diemer, 'Zuflucht der Musen. Die Hofsammlungen der Bayerischen Wittelsbacher im 16. und frühen 17. Jahrhundert', in Alois Schmid ed., *Die Hofbibliothek zu München unter den Herzögen Wilhelm V. und Maximilian I.* (Munich, 2015), 54; see also Albrecht, *Maximilian I*, 274–9; Magnus Ulrich Ferber, '*Scio multos te amicos habere*': *Wissensvermittlung und Wissenssicherung im Späthumanismus am Beispiel des Epistolariums Marx Welsers d.J. (1558–1614)* (Augsburg, 2008), 62–3, 278–86.

346 Ulinka Rublack

Maximilian I spent lavishly on ambitious modern architecture once his funds had recovered—between 1611 and 1616, Hainhofer would have looked at large building sites at the Munich court. Councillors and courtiers praised Maximilian I's intelligence and judgement. Given his ambitious goals for Bavaria and commitment to renewed Catholicism, he was not a ruler to join the camp of art lovers who utilized a language of irenic neutrality. Hainhofer informed Philipp II of Pomerania that this Bavarian ruler 'frequently contemplates war, to protect his territory, and, where he is able, to extend it'. He never gifted landed property in his realm and had already enlarged it by peaceful means.[6]

Hainhofer collected basic political information and created a distinct portrait of a man. Maximilian I 'looked serious' and exuded gravity but was 'kind in speaking'. There were even 'intervals' to his somber demeanor: 'sometimes', Hainhofer reported, 'I hear, he is more fun and better tempered'. Above all, the agent observed with prefect acuity, everyone close to Maximilian I also had to *be like* him. More than anything else, this meant working 'piously and industriously'—*fromm und fleissig*. The ruler often made confession, went to church, and saw his councillors. This was Catholic, Christian rule through good example and utter 'sobriety' (*Nüchterkeit*).[7] In German, *nüchtern* means to be dry and matter-of-fact in communication, but also to be sober. Maximilian I certainly agreed that a moral character was shaped by measured alcohol intake. In a manuscript that otherwise has hardly any revisions, Hainhofer further added a comment in the margins that bore out Maximilian I's approach to discipline and morals: 'he absolutely cannot bear drunkenness, and if any servant or councilor appears drunk in front of him just once, he will be done for and all grace is extinguished'.[8] For a German court, as we have seen, this was revolutionary.

As for his recreation, Hainhofer detailed that Maximilian I spent money on beautiful horses. He also enjoyed falconry, looking at precious stones and masterpieces of goldsmithing, art and painting, and found time to himself to practise the art of turning.[9] Both Wilhelm and Maximilian I loved horses and continually accessed networks and spent large sums of money in order to source particular breeds. The number of exquisite horses they owned and showed off at grand entries during political summits, or to visitors at Munich, was essential to maintaining their image. Indeed, much of their interest in a connection with the Duke of Pomerania was built on the expectation that it would refresh their stud, which, as we have seen, was kept in large stable buildings just below the art cabinet in Munich. After dispatching diplomatic gifts for Philipp II of Pomerania, Wilhelm thus was frank enough to send this ruler a list of 'horses he currently required', as Pomerania was 'renowned for its horses and the duke in particular was said to have beautiful studs'. They were to be neither too young nor too old, about

[6] Häutle, *Reisen*, 78.
[7] Häutle, *Reisen*, 79.
[8] HAB Cod. Guelf. 11.22 Aug. 2°, 69v.
[9] Häutle, *Reisen*, 78.

five years in age, well tempered, strong, and of one colour, without many markings. Two were to be brown. In addition, he needed a beautiful stallion, not too heavy but beautiful and strong. The horses were to be transported to Augsburg as fast as possible, and in secret, so that 'nobody knows they are for me'. Much of Hainhofer's work in the following months and, indeed, years would be to ensure that Philipp II of Pomerania sent those horses, which he assured the ruler would gain him eternal praise from the Bavarians, even if they were only taken as far as Leipzig for free.[10]

The year 1612 represented another highlight in Hainhofer's life. Since 1607, he had taken over his uncle's activities as a secret informant for the French Crown; one year later, he had additionally begun to serve the margrave of Baden-Durlach after meeting him in person at the Frankfurt fair; and from 1610, of course, he had served the Duke of Pomerania, officially representing him at Emperor Matthias's entry to Nuremberg in 1612. Matthias and his wife Empress Anna kept his grandest friendship album for two full days in order to look at the miniatures and entries by high-ranking men. His contacts with Maximilian I of Bavaria likewise began to deepen. The duke first approached him in November 1611 in order to ask whether he might source beautiful, around fifty-year-old Flemish tapestries with fresh colours. Hainhofer not only immediately activated his local and international network of collectors and brokers but also took the opportunity to cultivate Maximilian I's interest in one of his cabinets. He flattered him, and in December sent a letter with a box of almonds, fruits, and strawberries made in Nuremberg—most likely from marchpane.[11] The duke graciously sent a piece of game with his next reply.

As with Wilhelm, everything suddenly seemed to flow—their letters flew back and forth between Augsburg and Munich. Both sides were knowledgeable enough to discuss a whole range of possible sources and consider the circumstances of particular owners who might sell, commenting on details of technique. Hainhofer suggested having samples of new work copied after a Persian rarity. He jumped at this opportunity with a clear sense of how he could make himself useful as an agent on matters that far surpassed the ruler's narrow request. With one letter, he thus enclosed a brand-new Italian treatise on optical refraction that provided a path-breaking discussion of the principles of the telescope that had just been invented, *De Radiis visus et lucis* by Marco Antonius de Dominis, published in Venice in 1611. Hainhofer had received it from a trusted bookseller in the city on the lagoon. His understanding of how the Bavarian duke might find these fruits of the scientific revolution appealing was apt: 'no doubt he had lenses fitted into his long shooting-guns, the Büchsen'.[12] Improved shooting mattered for hunting, but it mattered even more for warfare. The Protestant agent's letter one month later suggested that he was indeed happy to feed

[10] HAB Cod. Guelf, 17.23 Aug. 4°, 64v–66r, 72v–74vr, 233r, 269, 327r, 329r, 361v, 369r.
[11] Volk-Knüttel, 'Hainhofer', n.2, 100.
[12] Volk-Knüttel, 'Hainhofer', n.6, 102.

348 *Ulinka Rublack*

Maximilian I's desire for warfare. This time he enclosed, of his own accord, a new design of a hexagonal defensive fort which he had just received from Nuremberg.[13]

This meant that Hainhofer within one year of becoming an agent for Pomerania blurred the identity of the art lover as a man to champion irenic negotiation.[14] Above all, he went out of his way to obtain commissions and entries in his friendship album from the most high-ranking people of any confession. He transgressed rules of loyal service, which he otherwise claimed to observe, and even his own moral codes of furthering peace and political neutrality through encouraging a love of the arts. Hainhofer's note on the innovative design for forts, which soon would gain such importance in the Thirty Years' War under Maximilian I's leadership, was a calculated, well-prepared overture. He tried to connect closely to the Catholic ruler, asking for an entry in his friendship album. He used his relationship with Wilhelm to get him to intercede in this matter with his son and had recently received positive signs. Keenly aware that he and Maximilian I had never personally met, he professed his 'boldness' and hope that Maximilian I would not count it against him. Yet he added that he had already discussed the matter of Maximilian I's entry with Marx Welser, the trusted Augsburg antiquarian whom Maximilian I had enlisted as the historian of Bavaria.[15] Indeed, Welser had already suggested two suitable mottoes that might accompany Maximilian I's coat of arms alongside a superior-quality painting. It would either be a motto alluding to Bavarian history, or one about honest bellicosity. Hainhofer would see to it that the miniature painting would be a paragon by one of Germany's best painters.[16] The album was conceived as his tool to advertise his connections to high-ranking rulers so as to gain further commissions as a merchant as much as a secret agent trading political news. [32.1]

Although exchanging letters with Maximilian I followed the same rhythms of instant replies and follow-up queries that the agent was used to from Wilhelm, this new Bavarian ruler knew how to efficiently save his words. Maximilian I did not indulge in correspondence but methodically worked through it. To Hainhofer's request dated 4 February 1612 replies left Munich on the 8th and 15th of February. Hainhofer meanwhile wrote to Wilhelm on 10 February, thanking him for his brokerage in the matter of Maximilian I's entry in his friendship album. In the same letter, he assured him that he kept reminding Philipp II of Pomerania to send the horses.[17] Maximilian I confirmed that he had granted the entry, and in successive letters to Hainhofer about the order of tapestries considered the cost of gold thread that would be woven into the tapestries.[18]

[13] Volk-Knüttel, 'Hainhofer', n.7, 102.

[14] Here I divert from Wenzel, *Handeln*, 12.

[15] See Albrecht, *Maximilian I*, 278.

[16] Volk-Knüttel, 'Hainhofer', n.7, 102. The painter was Kager in Augsburg, who finished the miniature in September 1613.

[17] HAB Cod. Guelf. 17.25 Aug. 4°, 244v–246r, for an extract Düring, *Reisen*, 216.

[18] Volk-Knüttel, 'Hainhofer', nos.8,9, 102–3.

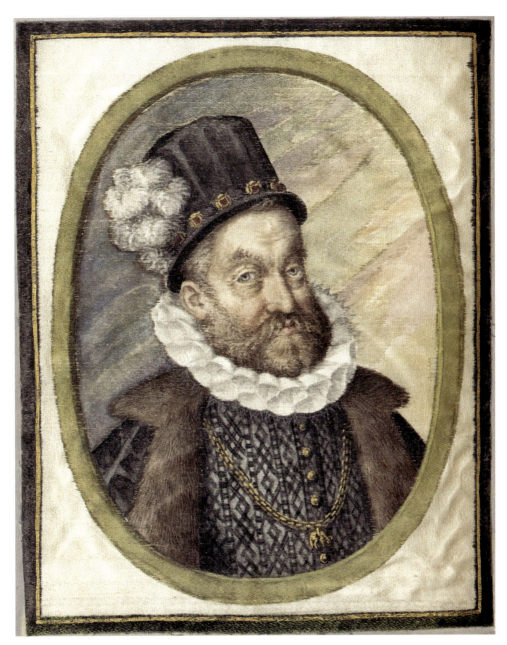

Fig. 32.1 The trophy painting on white silk satin of Emperor Rudolph II in Hainhofer's friendship album—a ruler he had never met. Entries were usually executed on parchment; the choice of silk satin as support stressed the singularity of this patron of the arts. It meant not only that it was even more difficult for the miniaturist to control the flow of colours to depict detail but also that the merging of colours could innovatively be exploited to create delicate pastel colour flows as background. © Herzog August Bibliothek Wolfenbüttel, https://diglib.hab.de/mss/355-noviss-8f/start.htm.

By late February 1612, Wilhelm moreover commissioned Hainhofer to assist in preparing, at speed, a festive wedding banquet. For three days, the merchant completely dedicated himself to this task. He relied on Maria Rauchwolf, an unmarried Augsburg woman, to prepare 'subtle' sugar-work in the shape of fruits which she claimed had great benefits for sick and healthy people alike, and which he had already sent to a summit of prince-electors in Nuremberg. He reported that artichokes and cauliflower were not to be had in this season, but spinach, radishes, or herb salads as well as marinated artichokes and asparagus, green pears, French dried plums, large hazelnuts, Indian candied fruits, some strawberries and baked marzipan that could be decorated in nice baskets, were all on offer. He would see to it that further 'strange' things would also be delivered. As his letter grew longer, Hainhofer professed that it was now close to midnight. He was sufficiently intimate with Wilhelm to offer a stream of thoughts. A suitable strange thing might be flies and insects made in marzipan by the local artisan Achilles Langenbucher. These could be hidden in napkins to entertain guests, as they were often held to be real.

In the end, thirteen men and two sledges carried all these goods from Augsburg to Munich in thick snow, and sufficiently cautiously so the sugar-work did not break.[19] To Philipp II of Pomerania, Hainhofer sent on the gossip that Maximilian I was going to marry a sister off with a substantial dowry, in order to then allocate much less to one of his three brothers, keeping his influence down—'tanto piu basso'. Wilhelm, his widowed father, was now 63. Hainhofer in the meantime anticipated the 'old Lord's' renewed stay over Lent with pleasure, looking forward to the 'many good conversations with him', and, as he would never have forgotten to add, to showing him Philipp of Pomerania's presents.[20]

In these years, Hainhofer's house became a hub for international art lovers—earls and courtiers now visited his cabinets in groups. He added a more recent interest in rare contemporary coinage to his specialization in *naturalia* from overseas.[21] By June 1612— after another of Wilhelm's Lenten visits—he began to successfully move forward Philipp II of Pomerania's request for Maximilian I and other dignitaries' entries into the duke's friendship album. He also sent on a number of unidentified panel portraits from Venice for Maximilian I, but not without first refreshing their colours. In addition, he offered new types of candied delicacies from Nuremberg, including melon, rosemary, majoram, prunes, yellow and blue violets, lemons, pistachio, rose leaves and entire roses, as well as unripe almonds.[22]

In response, Maximilian I remained courteous. He had first intended to return the candied fruits, but then merely noted that their own court pharmacists likewise produced these types, but that he had enjoyed seeing them. The quality of the Venetian paintings, he noted, was insufficient and not worth the trouble of a prince. To thank

[19] HAB Cod. Guelf. 17.25 Aug. 4°, 257r–60r, Wilhelm, 23.2.1612, 264v, to Stettin.
[20] HAB Cod. Guelf. 17.25 Aug. 4°, 264v.
[21] HAB Cod. Guelf. 17.25 Aug. 4°, 269rv.
[22] Volk-Knüttel, 'Hainhofer', no.15, 106.

Hainhofer for his services, he would send a whole deer.[23] The issue of the tapestries was dealt with, and Maximilian I clearly indicated that he did not want Hainhofer to send anything else of his own accord.

No further correspondence followed until after Hainhofer next visited the Munich court in September 1612. Ferdinand, Maximilian I's younger brother, who had just succeeded his uncle Ernst by being elected to the powerful and strategically crucial office of archbishop of Cologne and an elector of the Holy Roman Emperor, ordered 'jewelry, gold, silver, work made out of wire or crafted animals' that could be sent as gifts to cheer up a princely person during the days of blood-letting. Hainhofer obliged, sent three messengers to pass on options, and took the opportunity to discuss the selection of objects with him.

At court, Maximilian I unexpectedly appeared extremely friendly towards the Pomeranian agent and merchant. They finally met in person. Once Maximilian I had spotted Hainhofer's name on a list of guests at court, he sent Büchler to get hold of the agent. Caught by surprise, Hainhofer felt nervous. He quickly applied a strong balm of civet, amber, and musk to his hands, presumably to strengthen his head and heart, as he walked through three long rooms to enter the hall in which Maximilian I held his audiences. The ruler stood in the middle of this space. Dressed in a robe, the Bavarian duke took his hat off and offered Hainhofer his hand. Routine pleasantry was meant to make him feel comfortable: 'My Hainhofer, I am pleased to see you and to have the opportunity to make your acquaintance.' Maximilian I asserted that he had felt the agent's goodwill and hard work in all matters and encouraged him to let him know frankly about any way in which he might show favour towards him and his relations. Maximilian I hoped to see the merchant's affection and hard work continue. He was pleased to have successfully followed up Hainhofer's information about where to source the best tapestries, and asked the agent to consider him in the future, as he needed more tapestries for the new part of the palace.[24] The men talked for an hour, even as Hainhofer struggled with sneezes and coughs resulting from the strong perfumes he had applied.

Maximilian I made it clear that he still primarily wished to utilize him as a textile merchant and ordered two or three identical Turkish rugs to entirely cover a floor. They discussed the subject of old and new master paintings. Philipp II of Pomerania for his part had told Hainhofer in 1610 that he was uninterested in paintings, commenting that those in an old mass-book should be mostly admired for a painter's industry but otherwise looked outdated and quaint (*altväterlich*).[25] Maximilian I by contrast left no doubt that he judged any old master superior in 'art and understanding' to contemporary painters. He was interested to learn more about the Duke of Pomerania and hoped to see him at the next Imperial Diet. He was happy to hear about Hainhofer's cabinets on behalf of his cousin Maria Maddalena of Austria, the

[23] Volk-Knüttel, 'Hainhofer', no.16, 107.
[24] Häutle, *Reisen*, 151–2.
[25] Doering, *Hainhofer*, 66–7.

grand duchess of Florence. At the end of the conversation, he asked if there was any specific favour he might be able to grant.

The Bavarian duke thereby set the terms of their relationship for the future: just as Hainhofer had so far not been compensated for his services financially, he would not be paid in future for providing information and connections. Instead, he would continue to receive favours. Hainhofer perfectly mastered the situation. The art agent had earlier run into an old Augsburg acquaintance hoping to serve the duke in his mining endeavours—his request was immediately granted.[26]

As always, Hainhofer's lengthy account of his trips projected a sense of almost seamless successes and utter selflessness. One day, he reported that he ended up in the sole company of all three brothers, Maximilian I, Ferdinand, and Albrecht. He showed them objects which he had brought, and talked about Philipp II of Pomerania. Next, duchess Elisabeth of Lorraine herself had desired to see him. He stayed with her for an hour, and she had been particularly delighted in the design of a miniature farmyard that he had brought with him, as well as an amusing trick purse, which she wanted to give to the duke as a New Year's present. Hainhofer related that she took great care to gauge Maximilian I's moods and to make him laugh whenever he seemed melancholic at table. A mature but childless woman in her thirties, Elisabeth spoke with a thick French accent and exuded warm affection. She kept on taking off her gloves to shake Hainhofer's hand and promised an entry for his friendship album.

Hainhofer's trick purse that was so difficult to open proved an instant hit at the Bavarian court—both archbishop Ferdinand and Maximilian I requested identical purses. Hainhofer sold several other pieces for a total of 1,100 florins, he met further family members, and was constantly shown around. When Wilhelm received him again, the duke was nonetheless straightforward. Had the Pomeranian horses, he joked, frozen somewhere on their journey? Hainhofer assured him that the horses were already in Lüneburg and on their way to Stettin, from where they would doubtlessly be sent on as soon as possible. Their quality and beauty would amply compensate Wilhelm for this delay. Wilhelm impatiently requested to be informed 'by day or by night' once they had been dispatched.

All in all, everything appeared to go swimmingly for Hainhofer, even if Maximilian I had implied that he lacked competence in judging panel paintings. His friendship album attracted great interest. Archbishop Ferdinand recommended one of Hainhofer's nephews to serve in the Bishop of Bamberg's delegation to Rome. On one evening, he and Ferdinand talked until after eleven o'clock at night; Hainhofer noted in his report that this was well past any German's bedtime. As if to authenticate this astonishing fact, Hainhofer livened up his report with an anecdote. Outside the archbishop's room, the servants had fallen asleep leaving the candles burning. One of them fell against a new pair of fine French leather boots, placed on a table ready for Ferdinand to put them on

[26] Häutle, *Reisen*, 151–3.

the next morning, when he was to receive the proud Count of Vaudémont in style. Much to the archbishop's annoyance, the boots burnt.

As Hainhofer left Munich, he praised a court in which Wilhelm and Maximilian I's officials had immediately paid him for the objects he had sold during his stay, everything seemed well ordered, peaceful, calm and sober. Maximilian I worked day and night, knew how to be stern and how to reward, went to mass, accepted his subject's supplications, read them, and told a secretary how to reply. As at the beginning of their relationship, the only issue that Wilhem regretted was Hainhofer's Protestant faith.[27] The agent nonetheless had endeared himself so much that Wilhelm asked for his company at a dinner to honour Vaudémont, who hailed from the house of Lorraine and had engaged in diplomacy with Protestants. Ferdinand, the archbishop of Cologne, simply would not allow Hainhofer to leave the court for days.

Mingling with other attendants of foreign visitors in the background of the festive meals for Vaudémont that followed, at walks in the gardens or at mass, Hainhofer knew that many delegates assumed he was Catholic. Thus, they freely supplied political information on whether their rulers were likely to opt for neutrality or join the Catholic League, and what their subjects felt. Hainhofer's report for Philipp II passed on sensitive information and forecast a war in the near future, centring on a village near Cologne under the protection of the Duke of Brandenburg, a relative of Philipp II of Pomerania. It had become a bastion of Lutherans and Calvinists. He heard that Maximilian I frequently mustered his troops, ready to defend the League, and eyed the Imperial Crown.[28]

Hainhofer arrived back in Augsburg in early October 1612. Soon, mules were transporting his cabinet in a litter across the Alps for the grand duchess of Florence. Maria Maddalena (1589–1631) was a daughter of Wilhelm's sister Anna Maria of Bavaria and her maternal uncle Charles of Austria, who had married Cosimo II of Medici. Hainhofer copied her enthusiastic letter of thanks several times over and sent them to rulers he wished to cultivate as clients, and sent the original to Maximilian I, her cousin.[29] In March 1613, the duke briefly wrote that he was happy to consider commissioning a cabinet of curiosities from Hainhofer himself.

Hainhofer instantly proposed an elaborate cabinet for 5,000 to 6,000 imperial florins, the design for which had already been drawn and Marx Welser had advised on. His proposal foregrounded the elements that he thought would be attractive to the ruler and his wife and emphasized their practical utility. It would contain intriguing silver dishes to use at table, a set of games for entertainment, exquisite equipment for a man's or woman's toilette, a pharmacy, and a musical automaton. Precious materials, such as brazilwood and other 'Indian' woods, would be used, and the specific iconographic programme on the copper and stone plates would be customized in accordance to the ruler's wishes. This would be more beautiful than any other cabinet made, surpassing

[27] Häutle, *Reisen*, 165.
[28] Häutle, *Reisen*, 167–8.
[29] Doering, *Hainhofer*, 246–7.

354 *Ulinka Rublack*

the Emperor's own cabinet in beauty and comprehensiveness. Its effect would be stunning: 'everyone looking at it will estimate it to be worth an enormous amount'. Of course, he would also be happy to receive Maximilian I's instructions for a simpler and cheaper version. In sending the letter, Hainhofer included patterns of seventeen types of artificial flowers worked with pearls a local woman had requested him to offer the ruler in case he wished bunches of them for vases or to decorate altars.[30]

1613 would turn out to be the most challenging year in Hainhofer's relationship with the Duke of Pomerania, which partly explains why he needed to actively court new clients for major commissions. He was paid a modest sum annually by the Pomeranian duke for providing services in sourcing political information and art, and was meant to be paid the purchasing costs of objects that had been sent as well as payments towards the emerging cabinet of curiosities. Yet few florins had actually been sent his way, and this meant that Hainhofer himself had to fund some of the workmen who were busily constructing the Pomeranian cabinet.

Writing to Philipp of Pomerania on 20 March, he still assured him that he served no other rulers than him and Wilhelm of Bavaria with greater affection and dedication. Four other Catholic lords, including Maximilian I, often consulted him about commissions, but, Hainhofer falsely pretended, he mostly did not accept those for lack of time and only maintained such relationships to ensure better entries for his and Philipp's friendship *alba*. The agent reiterated that Philipp's cabinet would surpass that of the Emperor or any other ruler inside or outside the Empire—and yet he had just promised Maximilian I a stand-out piece in just the same terms. The problem was that Hainhofer claimed to have spent around 8,000 florins on the Pomeranian cabinet he was assembling, and urgently asked for an advance. Philipp, on the other hand, had commissioned the cabinet as son as he had taken Hainhofer into his service in 1610, and was disappointed that he had to wait for such a long time. The agent thus explained that he now deliberately had to slow the production down. He was unable to pay the artisans sufficiently out of his own pocket.[31] Hence, craftspeople had to take on additional work for other clients.

Hainhofer similarly had to keep several irons in the fire. In March, for instance, he sent the Lutheran duke of Württemberg politically sensitive information concerning the Fuggers and other political new reports in addition to a satire on the Pope, all in advance of the great Imperial Diet that was to take place in autumn 1613 in Regensburg.[32] It was particularly unfortunate that his relationship with Philipp had cooled off during this year, as he himself was to represent the Pomeranian duke as 'extra-ordinary' delegate at the Diet. His entire report of the summit for Philipp set out his excellent relations with a whole range of Catholic and Lutheran rulers. It underlined how dutifully he had

[30] Volk-Knüttel, 'Hainhofer', n.18, 108.

[31] HAB Cod. Guelf, 17.28 Aug. 4°, 26r, only very partially transcribed in Doering, *Hainhofer*, 248, and 254.

[32] HAB Cod. Guelf. 17.28 Aug. 4°, 20rv, again partially transcribed, omitting information about Hainhofer as political agent, by Doering, *Hainhofer*, 247.

represented the duke and described the inadequate behaviour of the official Pomeranian delegates, who created a fuss about the quality of their lodgings and spoke in their incomprehensible dialect for an entire evening when they met up with delegates from Mecklenburg. Hainhofer refrained from providing detail about any political information he had evidently gathered. Ever since March, when he had requested to be paid for work on the cabinet, Hainhofer had only written four brief messages to Philipp, offering him opportunities to buy books or paintings in the briefest of terms. Little was left of a natural affection between art lovers to sustain their relationship.[33]

Maximilian I, of course, had never entertained the notion of such intimacy and equality between himself and the Lutheran agent. As customary, Maximilian I dealt with the agent's proposal for a cabinet within a few days, but not without carefully considering it. He concluded that he still needed to think the issue through more thoroughly. Where Hainhofer envisaged splendour, Maximilian I feared problems with its maintenance. Characteristically, what bothered him most was whether the object would remain clean. It was beyond doubt, he explained, that silver on the outside would tarnish. He thought that one option might be to construct a large closed cover for the entire cabinet, but this would make the whole process of viewing the object cumbersome, and probably simply delay rather than prevent the tarnishing and moreover might damage the wood decorations on the exterior as it was taken on and off. He had seen the latter happen with cabinets. To judge from the cabinet made for the grand duke, Maximilian I feared that the gold that was glued onto the silver would erode and make everything look less decorous. The automaton was also likely to stop functioning, and thus, over time, cause upset rather than pleasure. The dishes were in effect useless because they lost their 'cleanliness and *politeza* (politeness)' if exposed to water or fat, and the same was true for the glass bottles with oils and distilled water in the pharmacy. If all these elements, that in the course of time would become dirty or go off, were to be taken out, not much would remain inside the cabinet.

Maximilian I did not reject the piece outright, he thought that it would be very nice to fit a table clock onto a cabinet. That would increase the functionality of the piece. Yet the same types of doubt instantly troubled him. Maximilian I's characteristic indecisiveness was as apparent as his propensity for fear, both linked to an obsession with efficiency and obsessive worry about the consequences of his actions.[34] He repeated that he needed more time to further reflect on 'how the work would be useful and not stand there for nothing, and besides remain in good order and be conserved in its primary cleanliness *(ersten Sauberkeit)*'. He also thought the price was exaggerated for such a small cabinet. Once more he told Hainhofer that he should not send any unsolicited objects, as the Munich court already possessed objects of higher quality. The duchess and her ladies-in-waiting produced more beautiful flowers than the lady from Augsburg. Indeed, they were worked in a 'cleaner', 'proper' manner, and therefore more beautiful

[33] Doering, *Hainhofer*, 249–51.
[34] Albrecht, *Maximilian I*.

in his judgement as a result.[35] This suggests that the entire court had to follow Maximilian I's high ideals of propriety that put even proud urban makers in the shade. Even objects such as artificial flowers could never be merely 'decorative'—they reflected and represented an entire system of moral value.

Hainhofer presumably took these concerns back to his artisans, noting their response. For example, images made from silver needed to be covered to prevent them tarnishing.[36] Maximilian I did not reply, and their correspondence only revived after Hainhofer had attended a wedding as Philipp's agent at the Munich court in early November. Yet he took Maximilian I's concerns on board. In sending a cabinet table a mirror to Innsbruck in 1626, he explained that this had been made without silver because it 'tarnished, needed cleaning, and looked ugly with age'. Instead, the cabinet was entirely crafted from wood, which remained beautiful as long as it was brushed or polished with a woollen cloth. He explained further that inset stones likewise had been crafted in such a way that no dust would settle on them. and they could be polished with a gentle brush. Maximilian I and his brother Ferdinand had both told him that silver work was no longer in fashion because it tarnished in an ugly way.[37]

At the wedding, he met Maximilian I in passing, who ensured that he was given a superior horse to his own from Wilhelm's stables to ride during the festivities—further evidence of the financial strain Hainhofer now faced. The agent also showed Maximilian I a precious miniature of *Orpheus*, which he liked but thought was overly expensive. Wilhelm received him for a brief, pleasant conversation.

The wedding exemplifies Bavaria's strategy to turn itself into a leading power, and to use the culture of art loving to create alliances with Protestants in order to profit from them. Aged sixty-five, the 'old Lord' reviewed the tiny group of his contemporaries—all former rulers of German lands—who were still alive. One of them was Philipp Ludwig of the Palatinate-Neuburg, the frail father of the groom, who belonged to the Wittelsbach line and was a great friend of Wilhelm, but had taken on decidedly Lutheran beliefs. The duke had raised his son Wolfgang Wilhelm as a Lutheran, but agreed for him to receive Bavarian political support for his territorial claims over the duchy of Jülich-Cleve by marrying Maximilian I's sister Magdalena. Her dowry amounted to 50,000 florins in addition to wedding expenses amounting to 30,000 florins. Yet for Maximilian I this alliance asserted a strategically important Bavarian claim over the territory. The Bavarian ruler strategized that Wolfgang Wilhelm had developed Catholic sympathies, would convert to Catholicism, and join the Catholic League. Even so, a Lutheran Catholic bi-confessional wedding was staged and tactfully handled by the staff in Munich. Priests were strictly instructed to limit dispensing incense and other 'popish' rituals. Reporting to Philipp II of Pomerania, Hainhofer was among those who did not quite understand the politics of this alliance at the time of the wedding, or simulated

[35] Volk-Knüttel, 'Hainhofer', n.19, 108.
[36] Volk-Knüttel, 'Hainhofer', n.20, 108.
[37] HAB, Cod. Guelf., 17.28 Aug. 4°, 72r, 15.4.1626, 77r, 9.5.1626.

not to understand it. In his role as an art lover and wishful diplomat, he hoped it was partly a signal for greater closeness between the confessions.[38] Philipp Ludwig died in 1614, just after his son had indeed converted to Catholicism. Controversies erupted about the legitimacy of the formerly Lutheran territories of Jülich and Berg passing onto the newly converted Wolfgang Wilhelm and the territories of Kleve, Mark, Ravensberg, and Ravenstein passing onto Johann Sigismund of Brandenburg, who in 1613 had converted to Calvinism. They galvanized a new stage of German and European decision-making that weighed up defensive against military responses. For the moment, Pomerania still retained its neutrality rather than joining the Protestant Union, but Duke Philipp instructed Hainhofer to swiftly write to Wolfgang Wilhelm's Lutheran brothers, as he had known their fathers well and intended to offer wise counsel to benefit politics in the Empire.[39]

At the end of the wedding, Wilhelm of Bavaria did not miss the opportunity to remind Hainhofer that he needed to chase and reprimand Philipp II of Pomerania for not sending the horses. It later turned out that the Bavarians, in response to such tardiness, had failed to chase their artists who were to make the entries for Philipp's friendship album. It would take until 1615 for the horses to arrive.[40] In 1613, the Wittelsbachs wondered whether Duke Philipp retained his interest in art-loving exchanges and diplomacy? This was certainly in Hainhofer's interest, not least as he himself was waiting for outstanding payments from the duke at the time. In writing to Pomerania, the agent hence took the opportunity to emphasize that great rulers needed to run their government well. He described how quickly and efficiently everything that mattered to Maximilian I was processed at the Munich court. Nor had he seen a single drunk person across the entire festivities. In fact, he inserted a whole poem against drink at this point of the report.[41] Hainhofer regained his moral voice and shape—his recent report about the Regensburg Diet had narrated an entire sequence of heavy alcohol-infused entertainments, several of which lasted until after midnight.[42] With Maximilian I, there was only order and no variation. Most importantly, he had sufficiently stabilized the court's finances to spend on art. By October 1613, his success enabled Maximilian I of Bavaria to buy Dürer's Heller altarpiece.

[38] Häutle, *Reisen*, 241. For the complex political background to Wilhelm's decision see Hans Schmidt, 'Pfalz-Neuburgs Sprung zum Niederrhein. Wolfgang Wilhelm von Pfalz-Neuburg und der Jülich-Klevische Erbfolgestreit', in H. Glaser, *Um Glauben und Reich*, 77–89.

[39] Wenzel, *Handeln*, 84.

[40] Gobiet, *Briefwechsel*, 121, n.158.; Volk-Knüttel, 'Hainhofer', n.29, 112.

[41] Häutle, *Reisen*, 239.

[42] Häutle, *Reisen*, throughout the 1613 report of the Regensburg Diet, for instance 194, 203.

CHAPTER 33

Hunting Dürer

Maximilian I of Bavaria had sought to change his father's haphazard approach to master paintings almost from the start. He scrutinized provenance and quality. From the estate of the noted collector Cardinal Granvelle (1517–86) came the pages of Emperor Maximilian I's prayer book which Dürer had decorated. Around 1600, the Bavarian ruler also bought Hans Imhoff's most major panel by Dürer, *The Lamentation of Christ*, for allegedly one of the largest prices any Dürer by then had realized: 1,000 florins.[1] By 1607, two further pieces by Dürer were noted in the collection's inventory. The cabinet's Lucretia was suitably modified to match Maximilian I's taste: Peter Candid, the court artist, was tasked with covering up her modesty and adding the figure of Cato the Younger to obliterate the painting's erotic appeal.[2]

While Maximilian I's attitude to painting was a departure for the Munich court, his energy in tracking down objects and devising ways to acquire them was as indefatigable as his father's had been. 1606 itself had been a turning point in this new hunt for Dürer paintings. As we have seen, Rudolph II managed to buy Dürer's *Feast of the Rose Garlands* altar painting from Venice and allegedly had it carried with utmost care by porters over the Alps to Prague, where it remains to this day. This was a major coup, as the authenticity of this piece was completely beyond doubt.

The Heller altarpiece too drew its suitors. In 1607, Archduke Maximilian I of Austria instructed the Frankfurt painter Frederick von Valckenborch (1566–1623) to copy the Heller altarpiece as well as Dürer's letters to Heller. The job took six months to complete and came with a significant salary of 250 imperial thaler. Emperor Rudolph II meanwhile attempted to buy Dürer's original for 10,000 florins, the Margrave of Brandenburg for 1,000 thaler. Frankfurt's Dominicans declined. For the time being, Dürer's altarpiece stayed put in Frankfurt, where the monastery so profitably kept opening its panels for visitors.

To medialize the German Apelles, the painter Rottenhammer teamed up with Augsburg's master engraver Lucas Kilian (1581–1662). [33.1] Rottenhammer had copied Dürer's self-portrait in *The Feast of the Rose Garlands*. Kilian worked with his brother Wolfgang under the tutelage of his stepfather Dominic Custos (1560–1612) in Augsburg, where

[1] Grebe, *Dürer*, 297.
[2] Goldberg, *Dürer Renaissance*, 134–5; Chipps Smith, *Dürer*, 380–1.

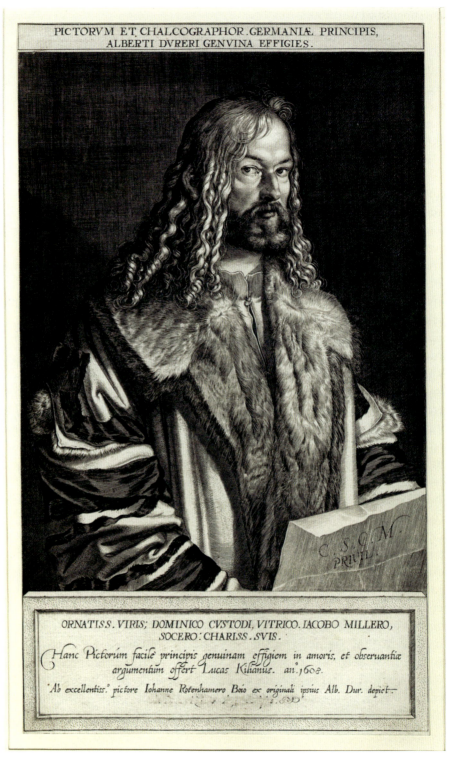

Fig. 33.1 Lukas Kilian, Portrait of Albrecht Dürer, after Rottenhammer's copy of Dürer's self-portrait from The Feast of the Rose Garlands, engraving, 34 × 20.5 cm, 1608. Wikimedia commons, public domain. A 1608 Augsburg woodcut of Dürer to target an audience of new admirers.

their distinguished workshop produced many collections of engravings portraying famous people, as well as an entire book of engravings commemorating the Fugger family. Kilian's masterful, detailed handling of the copious fur recalled Dürer's famous drawing of a rabbit and the extraordinary care Dürer had lavished on his master prints.

At this time, Dürer was regaining visibility and stature. From 1609, Wilhelm of Bavaria supported his son's passion for Dürer's depiction of religious subjects, recognized the painter's greatly increased market value and Maximilian I's rivalry with Emperor Rudolph II. The relationship Wilhelm nurtured with the church and monastery to the Holy Cross in Augsburg paid off. In just one year, he bought a depiction of the *Birth of Christ* alleged to be by Holbein the Elder from the church, and in October 1609 two Dürers from the monastery. His close relationship with the community further explains why he stayed there for weeks during Lent 1611 and why he donated expensive crucifixes and images to it.[3]

New collectors crowded into this small market. Hainhofer immediately applauded Philipp II of Pomerania's intention to build up a *Kunst- and Wunderkammer* which included old master paintings as a profitable investment. At the same time, difficulties were plain to see. Where would he source a Dürer and other old masters, or contemporary master paintings? Just three Augsburg collectors owned significant painting collections. Of these, only the medical doctor and art dealer Ferdinand Matthioli (1561–1625) possessed old masters. Rudolph II not only had paid dearly for one of Matthiol's paintings but also had needed to award him the title of a count in return. The only other two Augsburg collectors of paintings, Hans Staininger and Matthäus Hopfer, chiefly owned and bought contemporary masters and were rivals. Staininger's collection of Italian master paintings and Hopfer's collection of paintings by Titian, Rubens, and others were outstanding and already of interest for international clients.[4] Each of their pieces, Hainhofer informed the duke, were valued at several hundreds of florins, but they only sold them for twice that price. Hopfer owned no Dürer and was not too keen on the artist; he had been allowed access to the Emperor's collection after selling a painting to him and seen Dürer's *Martyrdom of the Ten Thousand*, only to report that 'a lot of work was in it', though he preferred other paintings.[5] Staininger, it turned out, only owned a single Dürer in his extensive collection, which he therefore did not wish to sell. In a letter written in September 1610, Hainhofer alluded to the fact that Wilhelm of Bavaria had

[3] Doering, *Hainhofer*, 121; yet alongside a painting by Grünewald, these would be the only old German master paintings Wilhelm bought during his very long life as a turbo-charged collector, Gisela Goldberg, 'Die Ausprägung der Dürer-Renaissance in München', *Münchner Jahrbuch der bildenden Kunst* (1980/1), 129–76, here 140.

[4] Wenzel, *Handeln*, 55–6. Hainhofer would try to sell pieces from both collections in 1627.

[5] Doering, *Hainhofer*, 52, 59–60.

recently commissioned him to acquire that Dürer—a depiction of Christ's head with the crown of thorns, offering a significant reward, but without success.[6] 'Old' Philipp Fugger, born in 1567 as a son of Marx, likewise owned 'beautiful' paintings and likewise would not sell.

Hainhofer's strategy to satisfy the Duke of Pomerania's demand thus turned out to be the following. He would scout out auctions of household possessions and private collections, especially if clueless inheritors were involved. Yet the main question remained how to track down Dürers. At this stage, collecting information was everything. In October 1610, Hainhofer thus assured Philipp II that he had 'requested different people' to seek news about who owned Dürer paintings; alas by November, the agent asserted that he was still trying to find one of Dürer's paintings, but was far from encouraging. Apart from engravings, and copies of them, few works could be found in the German lands. He had already promised a contact in Vienna a reward if he helped to release a Dürer from a collection but imagined the Emperor himself would soon find out and acquire it for himself.[7]

The stakes were high—there were too few Dürers and too many interested parties. Hainhofer, moreover, clearly understood that the Duke of Pomerania would not pay any price. He was meant to somehow find good deals on something that typically went for two or three times its original price. The task was impossible. In December 1610, he finally sent a small watercolour painting of a *Judgement of Paris* to Pomerania. Marx Welser had given it to him and the experts he involved authenticated the piece as a Dürer. He only valued it at 40 florins, so it was clearly not a major piece.[8] His chief experts and informants were the painters Rottenhammer and Kager.

Hans Rottenhammer (1564–1625) is a now largely forgotten Northern painter who nonetheless ranked among the best of his time. Born in Munich around 1564 and apprenticed at the Munich court, he lived in Italy from 1589 to 1606, specializing in the new technique of highly detailed, luminous copper paintings that exuded a rich softness in colouring. After a period of collaborative painting for cardinals and other clienteles in Rome, Rottenhammer operated a workshop in Venice, where he linked himself closely to the Ott agents. Working in Venice also meant that he was deeply knowledgeable about artists' materials and techniques, for which the city remained an innovative hub. Up to 1605, the Ott agents helped to manage the boom for paintings on copper, rather than canvas or wood, by delivering copper from the Fugger mines to Venice. Having built up strong networks that included the imperial court in

[6] Doering, *Hainhofer*, 45.
[7] Doering, *Hainhofer*, 52, 59–60.
[8] Doering, *Hainhofer*, 74, 80, 171.

Prague, for whom he sourced Venetian master paintings, Rottenhammer and his Italian wife settled in Augsburg after the Otts went bust. There he lived for another nineteen years, until his death in 1625. He continued to excel in nudes and biblical and mythological themes, supplied countless paintings for cabinets, and closely collaborated with Hainhofer as well as the Kilians, who translated many of his drawings into print. Given the demand for, and rarity of, Dürer paintings as well as their high prices, forgery was rife to upscale supply. Those at work obviously knew how to mimic Dürer's famous monogram. Rottenhammer could claim to intimately to know the master's hand as an expert copyist.

But as the Dürer hunt intensified, Rottenhammer became more difficult to control. In February 1611, Rottenhammer reported on a Dürer that could be bought in Nuremberg, but without telling Hainhofer in whose collection it was. The agent worried that he and a colleague might be engaging in contraband. They had not indicated a price yet either, and Hainhofer wondered whether it was either a painting of the Virgin Mary, or a landscape that he knew Dr Matthiol owned, and was valued at 400 thaler.[9] Greater obscurity in the art market showed its increasing significance to move wealth.

The reason for Rottenhammer's reticence was that he himself moved between the worlds of the artist, the collector, and the seller in his own right.[10] He, for instance, owned a Bernardino Licinio which he was not prepared to sell. Hainhofer nonetheless enquired whether Emperor Rudolph II might be interested in the painting for a princely sum of 300 florins. Rottenhammer was angry when the Emperor replied that he would first like to see the painting and keep it for six weeks. A proud man, Rottenhammer claimed to know for sure that the painting was authentic, especially as he himself had travelled and lived in Italy. Transport might damage the painting. Moreover, its value would drop by half should the Emperor return it.

Hainhofer, however, was keen to send the painting. Any service for the Emperor would increase his own status far more than serving the minor Duke of Pomerania. He thus went to Rottenhammer's house and sat the artist down with some wine. Rottenhammer was known to be a hard drinker. Laying aside his own hostility to drink, Hainhofer downed his glasses to convince him that sending the painting was in both their interests to further other matters with the Emperor. He promised to cover the costs of the transport at his own risk and pay Rottenhammer half a florin in food and perhaps a tip for every day in case the portrait was not returned within six weeks. The men shook hands to formally confirm this agreement. The agent in this way sourced other major artists for Emperor Rudolph II—a Palma, a Bronzino, and others, and had also recently seized the great opportunity to buy mathematical and astronomical instruments for Rudolph II. All of this was intended to 'increase the Emperor's grace,

[9] Doering, *Hainhofer*, 99–100.

[10] See Harry Schlichtenmaier, *Studien zum Werk Hans Rottenhammers des Älteren (1564–1625) Maler und Zeichner mit Werkkatalog*, Diss. Phil (Tübingen, 1988); Sophia Quach McCabe, 'Intermediaries and the Market: Hans Rottenhammer's Use of Networks in the Copper Painting Market', *Arts* (8/2019), 1–21; Wenzel, *Handeln*, 56.

364 Ulinka Rublack

so honorably achieved'.[11] Benefiting from the Emperor's grace helped to increase the agent's influence within his wider network of evolving relationships; it heightened his chances of eventually gaining access to his collection, and it certainly promised lucrative dealings. This meant that he needed to decide which paintings were likely to fetch the highest prices and could be reserved for the Emperor, and how to keep this secret from Philipp II of Pomerania as his principal patron. The top end of the art market in this way could still map on to traditional social hierarchies by rationing and reserving the best pieces and investments for the politically highest elites, especially if they were known to be connoisseurs. Cultivating oneself as an art lover, in turn, meant advancing chances to be offered better pieces by agents parcelling out rare supplies.

Next, Wilhelm of Bavaria visited during that Lenten stay in 1611, in the course of which the men seemed to become more closely connected than ever. As we have seen, Hainhofer now reported to Philipp II that he had sensed Wilhelm's great 'desire' for painting, and that the duke had taken the opportunity to write to him by hand only two days after his departure in order to ask him to source paintings by Dürer on sacred subjects. If he were able to source something by the artist, it would be sent to Pomerania.[12] The agent professed his complete loyalty.

In reality, he once more created competition and served different rulers, adding to what we might call a sense of hype. In mid-April, Hainhofer thus informed Wilhelm of Bavaria that he was going to write to his brother Christoph who had relocated from Danzig to Florence. He would specifically enquire whether Christoph knew anything about Dürer paintings that might be in collections or for sale. He noted that the Duke of Pomerania had also repeatedly written to him to acquire something by Dürer and to make sure that Hainhofer would tell him if anything by the artist's hand was seen in Nuremberg.[13]

There was no sense of loyalty in an agent, then. Hainhofer used both dukes' request for Dürer paintings to play them off against each other and bargain for his service and loyalty. Hainhofer consistently behaved like a calculating merchant through and through, fuelling competition between courts to profit himself. In 1609, for instance, he had offered Rudolph II exclusively a rare ring featured on the title page of Conrad Gessner's compilation of treatises on fossils, gems, and other natural wonders. It featured a door in the shape of a butterfly or golden bird and revealed a face when turned

[11] HAB Cod. Guelf. 17.23 Aug. 4°, 20r–29v. The Italian's wife was gravely ill and might be close to death, Hainhofer further explained, so that he needed to return at once. He was haunted by heavy dreams and a heavy heart. As the portrait was framed in wood, a case needed to be constructed to transport it safely. It was to be sent with a carriage and a man Hainhofer trusted.

[12] HAB Cod. Guelf. 17.23 Aug. 4°, 330rv, Doering, *Hainhofer*, 121.

[13] Doering, *Hainhofer*, 129.

upside down. He wrote to Rudolph II's secretary for art and antiques, the *antiquario* Fröschlin, that both Wilhelm of Bavaria and the Duke of Württemberg had repeatedly asked to sell them the ring. Gessner's book was much sought after, and a Zurich publisher had suggested that a new edition should be dedicated to Hainhofer because he owned the ring, which was in his cabinet. Hainhofer also suggested he had access to woodcuts of Charles V and his wife that were thought to be by Dürer and were even better than his *Adam and Eve* woodcut, as much more work had gone into the faces. Their safe provenance was the great connoisseur cardinal Granvelle's collection. In return for the ring and the woodcuts, the agent asked for the Emperor's entry in his friendship album.[14] Hainhofer would get what he wanted—an exquisite silk painting of the Emperor and most notable of all art lovers at the time, alongside an inscription. This entry in his album was an extraordinary coup for Hainhofer as a young man, who in the end would never even himself see the Prague court or meet Emperor Rudolph II in person.

In working together with artists, as we have seen with Rottenhammer, Hainhofer could likewise be ruthlessly calculating, and use his intimacy with them to make gains. He knew, for instance that Maximilian I's court painter Peter Candid (b. 1548) was now old, fragile, and ill. Yet Candid continued exhausting himself to serve his ruler in creating monumental tapestries. In June 1611, Hainhofer thus informed the Duke of Pomerania that old Candid was likely to be impressed by the fact that he could also serve such a mighty duke as Philipp II of Pomerania. The agent was therefore confident that he could buy something from the artist for a good price, especially if he brought a piece of linen as a gift for his wife and bought him a drink.[15]

Through the contacts he had nurtured in Ulm, the agent moreover knew that a collector called Hans Ulrich Ehinger had recently died, a man who had spent much money on art. His strategic correspondence with the family and other bourgeois collectors in Ulm paid off. Ehinger's sons and heirs, he knew, had not taken after their father. They were 'only huntsmen, who do not ask about art and virtue'. The Duke of Württemberg thus had already used the major collector and courtier Guth von Sulz as a middleman to buy 'Indian' shells from these clueless sons for 1,200 florins, which Wilhelm of Bavaria would have been willing to spend 1,500 florins on.[16] By pointing to the interest of the Dukes of Württemberg and Bavaria, Hainhofer's report thus tried to also interest the Pomeranian duke in buying the shells, in addition to which he referred to the recent diplomatic gift of 6,000 florins worth of Indian shells from the Dutch stadtholders to the King of France. Exotic shells were instrumental in establishing alliances—Hainhofer was most likely referring to the fact that French support for the Dutch truce with Spain in 1608 was facilitated by shipping the vast collection of East Indian shells assembled by the humanist and collector Abraham Gorleus to Queen Marie de Medici in Paris.[17]

[14] HAB Cod. Guelf. 17.22 Aug. 4°, 245r–247v, 13.5.1609.
[15] HAB Cod. Guelf. 17.23 Aug. 4°, 44v, 52r, 3.6.1611.
[16] Doering, *Hainhofer*, 8.
[17] Swan, *Rarities*, 152.

This was how *naturalia* made money and played its part in politics. Everyone wanted them, as Hainhofer's letter detailed. Rudolph II had just decorated an entire room with shells. By July 1610, he told Philipp II that he had already written to Ulm to ask about the remaining paintings and engravings in Ehinger's possession.[18]

Within weeks, the deal was sealed. Ehinger's heirs readily agreed to wholesale conditions. Hainhofer negotiated an asking price of 400 florins down to 350 florins, and sent the Duke of Pomerania a long list of everything that was included in the sale, with notes on each item's quality. The list included many sculptures, a fine canvas by Parmigianino, a Titian on parchment, a Holbein drawing, and a book of engravings, including works by Dürer. The agent took pains to point out how well his strategy had worked and how cheap the lot had been. He had seen Hans Imhoff's entire collection in Nuremberg, but those Dürers, he judged, 'were not available unless one wanted to pay three times over'.[19] Hainhofer also claimed to possess two miniatures by Dürer in his *album amicorum* to underline his connoisseurship.[20] Yet his annotated list from the sale once more bore out how much different sorts of objects fascinated him, which he described at greater length than paintings and sculptures. In fact, the longest entry described an entertaining yellow trick purse which could only be opened if one opened a seam in the middle by pulling from both sides.[21] Such entertaining objects, as we have seen, were a mainstay of the contents of cabinets he offered to courts.

Finally, in April 1611, a painting by Dürer seemed in sight. Hainhofer's brother Christoph wrote from Florence that he was about to be shown an extremely expensive panel by Dürer, and he sent a drawing of it soon after. However, while some artists judged it authentic, others did not.[22] By June, Hainhofer moreover had sourced an expensive landscape painting by Dürer, although he did not want to buy it without the Pomeranian duke's explicit order. He offered to try to buy it on the condition that it could be sent to Stettin for inspection and returned if it did not please, although making a bid of this kind was disadvantageous. Everyone knew that a painting did not benefit from transport and also lost in value if it was rejected as inferior or inauthentic by a knowledgeable buyer.[23]

Hainhofer in the meantime also took great pains to work on Dr Matthiol in Augsburg. It is more than likely that he scared the collector with the prospect that his inheritors might sell the collection off for little, or to the wrong people. The same worry already

[18] Doering, *Hainhofer*, 9.
[19] Doering, *Hainhofer*, 121.
[20] Doering, *Hainhofer*, 37–8.
[21] Doering, *Hainhofer*, 20–2.
[22] Doering, *Hainhofer*, 133, 137.
[23] Doering, *Hainhofer*, 149.

had motivated Hans Imhoff to construct a careful inventory with valuations, but Hainhofer was now able to use the example of Ehinger's sons in Ulm to feed Matthiol's fears that no precautions could prevent a carefully assembled treasure from being wasted by ignorance. Emotional manipulation became the mainstay of professional art agents as European markets began to heat up.

Matthiol, a man who had just turned fifty in 1611, clearly got worried. In despair, he apparently declared that he wanted to sell everything to Hainhofer for little, upon which the agent told him to send a few pieces of quality which he could send to be inspected. In turn, Matthiol sent seven paintings, three of them he held to be by Dürer. After Hainhofer's 'repeated encouragement', Matthiol was finally happy to sell this landscape as well as Dürer's portrait of Charlemagne and Emperor Sigismund. All of these 'were', as Matthiol wrote, 'originals by AD'. He drew Dürer's AD monogram in the letter, as if this acted as a further proof of authenticity and confirmed that these were 'among the best of those in my possessions'. Each of them, he claimed, was worth a minimum of 200 florins. Moreover, he was happy to have them sent to Pomerania for inspection.[24]

Yet AD could also stand for *Altdeutsch*—Old German. The portraits appeared to be copies, even if Matthiol claimed that he possessed additional written documentation by Joseph Haintzen and others to vouch for their originality.[25] On 4 April 1612, Hainhofer indeed wrote to Matthiol to let him know that the Duke of Pomerania was about to return all three of the alleged Dürers and wanted none of them.[26]

It had all been in vain. The market was too treacherous. Suspicion of forgery was rife. It was the same as with relics and antiques: demand produced forgeries. Ambitious rulers by now had honed their methods of using humanist, as much as practical, knowledge to determine the age and likely authenticity of the objects they were assessing for purchase and were ready to revere. Any additional documentation, such as an artist's original letters about a painting in a specific location, made an enormous difference to support claims to authenticity. Yet few artists ever wrote letters to their patrons, and even fewer patrons had kept them. After this debacle, Hainhofer never wrote to Philipp II about Dürer paintings again.

In any other matter that interested him, Hainhofer's persistence was a notable tool of his merchant trade. Just like Fugger, he was a master in repeatedly following up commissions, ideas, and possibilities in order to see most of them realized. Practices of 'hard-working soliciting' took up much of his time. During the week, he would visit the workshops of makers to ensure progress, and before any trip he would remind his entire team of makers of cabinets across the city, ranging from carpenters to mirror-makers, sculptors, silversmiths, locksmiths, stonemasons, bookbinders to painters and miniature makers to keep working steadily during his absence, especially to finish

[24] Doering, *Hainhofer*, 156–7.

[25] Doering, *Hainhofer*, 153–4, 173–4.

[26] Doering, *Hainhofer*, 223. Matthiol had pressured him constantly. For persistent problems of the authentication of old German paintings see Doering, *Hainhofer*, 222, when Hainhofer bought items from the Fuggers in 1612.

368 *Ulinka Rublack*

commissions that were often urgently required for a particular celebration, such as prestigious gifts for baptisms or weddings.[27] Powered by his classical education, Hainhofer's practices of soliciting were linked to the rhetorical arts of convincing a person by appealing to emotions of fear, awe, or empathy. But, as we have seen, they also linked to sensing common interests, exploiting their weaknesses, providing gifts, and creating intimate bonds and obligations among the circle of makers he worked with most closely, and that could not easily be foregone. 'Soliciting' was a merchant's way of getting things done by appealing to pragmatic needs as much as by spinning a web of client and maker relations that could variably be held together by affective ties, or simply be sustained by ruthlessness.

Yet the Bavarian dukes likewise mastered this skill and dedicated substantial amounts of their time to it. Throughout his life Wilhelm was extraordinarily skilful in soliciting wilful service. He managed a system of meticulous persistent communication by firing off multiple letters day and night to pursue his interests. This revises accounts that suggest Wilhelm's complete immersion in religion after his abdication. Maximilian I was no less persistent. As early as 1611, Hainhofer warned the Duke of Pomerania, with a real sense of shock, that both Bavarian rulers were extremely careful, efficient, and even ruthless in acquiring goods: 'when they get a thing, neither Wilhelm nor the governing duke (Maximilian I) have any peace until they hold it in their hands, and the messengers need to run day and night, and last week one of them ran himself to death and fell down in the city as soon as he had gained entry'.[28]

In 1612, the moment to approach Frankfurt's Dominicans for Maximilian I seemed right. Emperor Rudolph II, his key competitor, had died on 20 January.

[27] For an example of the latter see Häutle, *Reisen*, 271.
[28] HAB Cod. Guelf. 17.23 Aug. 4°, 64v.

CHAPTER 34

The Chase

Buying the Heller Altarpiece

The death of Emperor Rudolf as competitive collector greatly advantaged Maximilian I's chase for the Heller altarpiece. While Maximilian I pursued the Heller altarpiece, mounting confessional tensions created great nervousness in German cities. Protestants began to fear Bavaria's militancy, so much so that by 1616, the common people in Augsburg began to anonymously circulate songs predicting that Rudolph's brother and successor, Emperor Matthias, had ordered Maximilian I of Bavaria to occupy the city just as he had occupied Donauwörth in 1606.[1]

Nuremberg's council began to avert any Bavarian occupation by giving away their Dürers to the Wittelsbachs. In 1613, in fear of Bavarian occupation, the Nuremberg council agreed to offer Maximilian I Dürer's early Paumgartner altarpiece that had remained in the convent church of St Catherine ever since it had been painted around 1500. Maximilian I assured the council that it would gain a special place in his gallery but instantly ordered the overpainting of the figures depicted on the wings. Saints and a monster were turned into knights accompanied by horses. He was convinced that Dürer's memory would be best served if the artist's best pieces were to be part of his distinguished art collection, to be admired by a superior connoisseur of devout Catholic faith and accompanied if appropriate, by guests.

At the same time, Maximilian I now directed his thoughts to the Heller altarpiece in Lutheran Frankfurt. He knew that it was not only authentic but also moreover in excellent condition given its age and location. Frankfurt's Dominicans, as we have seen, had received an offer from Rudolph II to buy the original in 1596. An Augsburg agent approached the monastery's prior Johannes Kocher (1591–1618), allegedly offering an astonishing 10,000 florins for Dürer's central section of the Heller altarpiece. Kocher, a man of great dynamism, acted as the Dominican's prior between 1591 and 1625. He knew that the Dürer was the monastery's greatest asset. He had permitted the painter Valckenborch to take that copy for Maximilian I of Austria in 1607. Valckenborch also copied Dürer's letters to Heller, which the merchant's successive

[1] Roeck, *Eine Stadt*, vol. 2, 519–21.

370 *Ulinka Rublack*

inheritors in Frankfurt had preserved as important documents in relation to the value and authenticity of the panel.[2]

A list of the Dominican monastery's possessions in 1618 revealed no significant debts, some remaining treasures of relics, gold monstrances and fine vestments, recent investments in new books, and, above all, several new altars. The deacon of St Bartholomew's had donated a triptych depicting Christ's Resurrection in its central panel in 1597. In 1599, a notable Catholic family in the Lutheran city had donated a splendid altarpiece by the local painter Uffenbach. Its central panel depicted Christ's Ascension. Catholic patrons commissioned art from a Lutheran painter if they confined themselves to approved themes of Protestant belief. In addition, the Dominican church was evidently visited by Protestant art lovers as much as by Catholic ones. It might have thus been in the prior's own interest at this time to signal a break from the veneration of the monastery's rich pre-Reformation altars in order to accommodate a new situation in which it remained wise to minimize confessional hostilities.[3]

Such prudence turned into greater defiance. In 1606, the Dominican brothers consecrated two new altars—one dedicated to the Holy Cross and another to All Saints. In 1619, an altar dedicated to the Holy Trinity would follow. All this expressed the monastery's significance and endorsement of Catholic piety in the face of adversity. For Kocher, a climate of growing confessional tension in all likelihood shored up fears that he and his few remaining brothers might be expelled from the Lutheran city and the monastery repurposed. When Maximilian I approached him in 1613, soon after Emperor Rudolph II's death, Kocher might well have looked for protection from the Bavarians as a major Catholic power in the German lands.[4]

In addition, he looked for capital to plan expenditure. Elsewhere, bold art merchants began to directly approach religious orders in need of cash to rebuild convents and monasteries. For instance, in 1619, the Servite church of San Giacomo della Guidecca sold a cycle by Veronese and other paintings to the Calvinist art merchant Daniel Nijs. Nijs furthermore tried to buy a prized Titian altarpiece from the Dominican basilica of Santi Giovanni e Paolo for the enormous sum of 18,000 scudi, until the Venetian state forbade the sale under pain of death.[5]

Frankfurt's Dominicans enjoyed no protection from the city but were free from any control. This liberated them to decide what to sell, and to whom. Maximilian I knew that members of the monastery could be talked to. On 18 June 1613, Maximilian I wrote

[2] Hans van Aachen, who had worked for many years at the Munich court before moving to Prague, had evidently seen the Heller altarpiece in Frankfurt, and shrunk the composition by more than half for an altar finished in 1598 for Philipp Eduard Fugger in Augsburg. The scene was entirely set in heaven to simply depict Mary's coronation, Wölfle, *Kunstpatronage*, 237.

[3] Stadtarchiv Frankfurt, Joaquin, *Chronicon Praedicatorum 1600–1749*, Nr.299; Weiszäcker, *Dominikanerkloster*, 32–3.

[4] Weiszäcker, *Dominikanerkloster*, 155; Klaus-Bernward Springer, *Die Deutschen Dominikaner in Widerstand und Anpassung während der Reformationszeit* (Berlin, 2009), 70–6.

[5] Christina M. Anderson, *The Flemish Merchant of Venice: Daniel Nijs and the Sale of the Gonzaga Art Collection* (New Haven, 2015), 96.

to a middleman called David Kresser in order to ask whether the Nuremberg painter Jobst Harrich (1579–1617) might carry out some work for him. Harrich was a capable painter in his mid-thirties, who had just been remunerated by the city with 150 florins in March 1613 for diligently copying the entire Paumgartner altarpiece in the former convent church of St Catherine before it was sent to Maximilian I. He thus knew Dürer's hand extremely well. Otherwise, the painter had not attracted any note.[6]

Kresser reported back to Conrad Bühler, Maximilian I's secretary for art, on 11 August 1613. He had met Valckenborch and measured the drawing which the painter had taken off the altar and from which he was to base his copy. Kresser included two strings in the letter that provided this exact size, so that the remuneration for Harrich might be calculated in relation to it. Most importantly, he had asked Valckenborch how long it had taken him to paint the copy. To Kresser's surprise, this first copyist replied 'six months'. Bühler immediately marked this up for Maximilian I as he read through the letter: 'Notandum'. The art secretary intended to show Kresser's letter to Maximilian I with his own annotations in full. Kresser described how his surprise had turned into a state of shock when Valckenborch told him that Dürer's letters suggested that the master had worked no less than *thirteen months* solidly on the piece.[7] Even paying a copyist for six months was evidently far longer than Bühler had expected.

Kresser in turn persuaded Valckenborch to make a further copy of his copy of Dürer's letters to Heller, and promised not to show them to anyone else. For the Frankfurt painter, they had served as evidence for remuneration he himself could expect. Kresser enclosed these copies for Bühler, and wrote that he would enjoy reading them. 'Everything one needs to know about the panel', he promised, 'is contained in those nine letters.'

They contained inflammatory information. Kresser had no illusions. Negotiating with the Dominicans was going 'to be tough'. Dürer's letters proved beyond doubt that he had painted with 'highest diligence'. Moreover, Dürer had always wanted the panel to remain in Frankfurt, as he knew that 'many painters who were to create his eternal name' visited the city. Kresser thus recommended that it would be better if the Dominican monks did not get hold of a copy. As the letters had always remained with the Heller family and their descendants, the Dominicans in fact had never known about the painful exchange between the merchant and artist.

[6] He would die poor in 1617, see Andreas Tacke ed., 'Der Mahler Ordnung und Gebräuch in Nürmberg': Die Nürnberger Maler(zunft)bücher ergänzt durch weitere Quellen, Genealogien und Viten des 16., 17. Und 18. Jahrhunderts (Munich, 2001), 430–2.

[7] Dürer's original letters and both Valckenborch's copy and Kresser's copies of Valckenborch's copy are now lost, so that Rupprich had to rely on nineteenth-century versions.

372 Ulinka Rublack

Yet in preparing to brief Maximilian I, Bühler now entered a note that dismissed Kresser's concern that the Dominicans might find out that Dürer had absolutely wished his painting to remain in Frankfurt for other artists to study—'it's a useless worry of Kresser and clear in any case that nothing more than necessary shall be told or made known to anyone'. The Munich court was used to having access to secret information and to confidently dissimulate on this basis.

There is no evidence then that Maximilian I and his advisors used Dürer's letters to find out more about his art, his personality, and his time.[8] Rather, they treated the letters as historical documents which provided a basis to legitimate current claims and thus had to be dealt with cunningly. Just as with documents about territorial rights or historical chronicles, the past was used for present and pragmatic concerns. Bühler's annotations moreover bear out that Maximilian I expected his secretaries to work with great efficiency towards those goals he had clearly in mind.

The ruler held his art secretary in tremendous esteem for getting things done the way he wanted and incentivized his loyal service by paying large bonuses. In 1611, Bühler had received a special payment of 2,500 florins; in 1613, he would receive another 1,400 florins.[9] Bühler evidently knew how to serve Maximilian I best by keeping focused on finances. Kresser detailed that Valckenborch had received a salary of 200 thaler for his copy of the panel in 1606 and 50 as a tip on completion. Bühler immediately queried whether Valckenborch would have also received payments for food while working on the copy in the monastery, and further compared the precise value of a florin in 1606 to then.

Harrich, however, took a humble stance on the question of his salary. He promised to make a copy that would be identical to the original and asked to be paid in view of his achievements upon completion. Kresser asked Bühler for instructions on whether or not to confirm this deal, and he recommended that the wooden panel should be constructed by carpenters in Nuremberg and sent to Frankfurt. It would be best to slightly increase the width and length, as they were easy to saw off again, but Frankfurt simply did not have carpenters sufficiently competent to carry out such tasks among its artisans. Bühler approved.

When Valckenborch had carried out his work, a stage had been constructed for him in the monastery's church in front of Dürer's altarpiece so as to not take it out of its frame. Bühler—perhaps now in discussion with Maximilian I—would have none of this. 'The altar panel certainly has to be taken out and into a room so that the painter can copy it the better, especially during winter', reads the annotation. This also signalled that Maximilian I hoped that the process would get under way as soon as possible during autumn and accepted that it would take months, because he anticipated that the monastery would otherwise be unhappy with its copy and all the investment would be lost. Kresser reported that Harrich was hard-working, but that he nonetheless

[8] In contrast to Albrecht, *Maximilian I*, 258 and Bubenik, *Reframing Dürer*, 66.
[9] According to the record of payments at court, Häutle, *Reisen*, 151, fn.1.

worried that the copying would take him six months. The secretary also anticipated that the church would be too cold for Harrich to work in during winter.

Bühler once more knew what to suggest for efficiency. Kresser was to take Harrich and a fully prepared wooden panel with him when travelling from Nuremberg to the Frankfurt autumn fair. This avoided extra expense. Harrich's expenses on his way to Frankfurt would also be lessened by the fact that he travelled with Kresser's group, including his servants. The assumption was that they would share meals and beds in inns, or just sleep on the cart.

Little had changed since Dürer's time. Everything concerning pay for an artists' expenses was considered in detail, and largesse was notable only through its absence in the treatment of most of them. Harrich's prospect was somewhat grim. Kresser thought Harrich would be able to finish by the spring fair, expecting him indeed to paint through all those months with low light and bitter cold, despite the fact that his room smelling of pigments mixed with oil, egg, urine, and turpentine would be heated. Kresser assured Bühler that the panel would be well packaged and sent to Munich with the merchants leaving the fair, once more saving costs.[10]

It then turned out that Harrich could only work with oil. Dürer would have used layers of tempera underpainting, and a great many thin layers of paint with a final layer of oil paint, as a result of which his colours were bright and glowing, or, as Hainhofer put it, so vibrant and 'alive'. Harrich's copy, experts agree, 'reflects Dürer's composition', but not his 'work with materials'.[11] He tried his best to imitate Dürer's style, though his efforts are partly obscured by subsequent overpainting and the panel's deterioration.[12] The depiction of Dürer's own hand, holding his shop sign appears to have turned into a badly botched job. It was not neat or detailed, and, if anything, an embarrassment owed to rushed conditions, and especially ironic for a copyist who claimed to know Dürer's hand. Yet this execution, alongside the payment, proved sufficient. The Dominicans accepted a much inferior copy and never saw Dürer's letters to Heller. And so the masterpiece which Dürer had intended to be public art to ensure his esteem among generations of artists across hundreds of years turned into one collector's exclusive possession.

Even so, Maximilian I knew that he had to be careful. No record mentions a sale—the monastery declared the transfer a 'donation' (*Schenkung*). The Bavarian duke in turn

[10] Rupprich, *Dürer*, 62–3.
[11] Annette Pfaff, *Studien zu Dürers Heller-Altar* (Nuremberg, 1971), 37.
[12] Antonia Putzger, *Kult und Kunst—Kopie und Original: Altarbilder von Rogier van der Weyden, Jan van Eyck und Albrecht Dürer in ihrer frühneuzeitlichen Rezeption* (Berlin, 2021), 193–5. Putzger's work appeared after the completion of this book manuscript and likewise discusses Maximilian I's strategic use of copies to obtain originals.

374 *Ulinka Rublack*

used a language of affection to set out why he wished to invest 8,000 florins on the monastery's behalf. Out of this capital, 400 florins in interest (calculated at the customary five per cent) would be sent annually in perpetuity from Munich to Frankfurt's prior. Kocher had negotiated an exceptional deal, although Maximilian I might have calculated that the monastery might not exist for much longer. Yet the duke certainly requested a daily mass to be prayed for his eternal life.[13]

By early October 1614, and thus with some delay, Dürer's middle section of the Heller altarpiece arrived in Munich well packaged but with some staining. The panel was cleaned, hung up in Maximilian I's private gallery and eventually inventoried with notable pride. Dürer's Heller altarpiece was placed first in the 1627–30 inventory of Maximilian I's art objects, and the entry reads: This 'is a piece by Albrecht Dürer that is famous all-over *(weit and breit)*'. It needed no number as it was easy to recognize by its excellence. Above all, it was hailed as a trophy in the battle against other art collectors, not least the Habsburg Emperors, with whom Maximilian I rivalled and disagreed, as much as co-operated with: it had taken 'special effort and expense' to obtain the piece against the competition of 'Emperor, Kings and Potentates'. It served his ambition for the Wittelsbach dukes to join the electors of the Holy Roman Empire, or even to be considered as candidates to be elected as Emperors themselves.

The 1613 Imperial Diet, under the new leadership of Emperor Matthias, had been a disaster—and Maximilian I completely opposed the politics of compromise Matthias's chief advisor Klesl had worked out for the German lands. To Maximilian I's mind, it only helped Protestant claims to power. Imperial politics began to be seriously paralysed, 'the main actors finding themselves in the position of a fly caught in a spider's web that got further entangled in it with every move'.[14] The Habsburg Emperors had feared a Wittelsbach offensive against them under Maximilian I's leadership since the beginning of the century, and his determination to become an elector was plain. For now, much of German politics revolved around strategies to demonstrate power so as to awe opponents, as much as potential allies, and to keep them in check in order to be able to either peacefully implement political gains or achieve gains with limited warfare. Maximilian I knew that the Catholic League with its limited membership was not wealthy or powerful enough to afford any major war.[15] Just as in Italy, another polycentric polity, the building of new architecture and accumulation artefacts was a power strategy adopted by territorial rulers in the German lands. This was as true for Calvinist leaders such as Moritz of Hesse-Kassel or Frederick V of the Palatinate as for the Lutheran house of Württemberg or, of course, the Wittelsbach. On the 21 October 1614,

[13] Weiszäcker, *Dominikanerkloster*, 158. Payments continued until 1777 when a new line of the Wittelsbach dynasty took over and no longer recognized the obligation, 161, especially as the painting had burnt in 1729.

[14] Georg Schmidt, *Die Reiter der Apokalypse: Geschichte des Dreissigjährigen Kriegs* (Munich, 2018), 125.

[15] Schmidt, *Reiter*, 128–9.

Maximilian I followed up with a letter to Kresser to enquire whether Frankfurt's Dominican monastery owned any other famous paintings that might be acquired.[16]

Financial pressures on convents or monasteries and confessional changes kept on bringing forward church paintings that could be brought to the market. In 1614, for instance, Hainhofer requested his patron August of Wolfenbüttel to look out for church paintings in Berlin, as Duke Johann Sigismund of Brandenburg had surprisingly turned Calvinist. Could they be sourced for the Bavarian court, as Calvinists would not value them? He evidently forwarded instructions he had received verbally: 'it has to be only the naked paintings without ornaments and frames', and only if they were of good quality, 'because not all old paintings are artful or industrious, but often painted *stroppiatj*, of those we don't want any, but only of the very old and very industrious painters, such as Durer, his master Martin Schön, and another old one, whose name I don't recall, and especially by Quintin Masi, the old Holbein, Lucas Kronacher and painters like them'.[17]

He kept a close eye on paintings which Sigismund's Lutheran consort Anna of Prussia rescued from Calvinist iconoclasts in Brandenburg, and constantly sought information to gauge just how 'art-loving' Protestant rulers in Northern Germany and their heirs judged their interest in selling old masters.[18]

Later in his reign, Maximilian I's taste for painting diversified. Still, the new keeper of his cabinet in 1629 noted that Maximilian I continued to prefer his Dürers above everything else because of the artist's 'great industriousness'.[19] His artistic inventiveness or spiritual insight did not matter. Rottenhammer and Lucas Kilian collaborated around the centenary of Dürer's death in 1628 to commemorate the artist's character in another marketable print. It combined his early likeness from the Heller altarpiece with a later portrayal, and they used 'Work and Constancy' as the motto displayed on a table. The print lauded the artist as a man who had mastered the mathematical underpinnings of art through understanding perspective and human proportion.[20] [34.1]

As we have seen, Maximilian I identified with these principles of hard work and stoic steadiness—he and everyone around him worked with the same exacting perfection

[16] The letters to Kresser are in Bayerisches Hauptstaatsarchiv, Geheimes Staatsarchiv München, Kasten schwarz 13 223, see also Pfaff, *Studien* p.XXXVI, fn.6, and for the quotation from the inventory, Grebe, *Dürer: Die Geschichte seines Ruhms* (Petersberg, 2013), 59–60.

[17] Roland Gobiet ed., *Der Briefwechsel zwischen Philipp Hainhofer und Herzog August d.J. von Braunschweig-Lüneburg* (Munich, 1984) p.72, No., 64, 20–30.5.1614.

[18] Wenzel, *Handeln*, 58–9.

[19] Grebe, *Dürer*, 73.

[20] Perhaps the fact that the Dominican's only owned a copy was kept secret. Even though the Augsburg artists presumably knew full well that the original was now in Munich, they referred to the painting's location in Frankfurt.

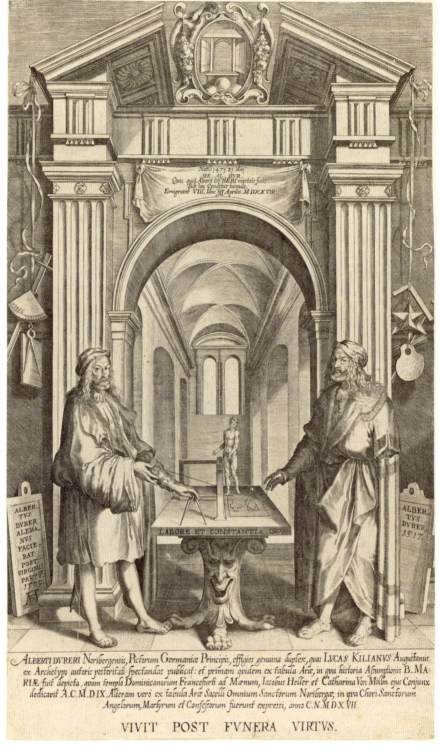

Fig. 34.1 Lucas Kilian, Alberti Dureri Noribergensis, Pictorum Germaniae Principis effigies genuina duplex, c.1628, engraving, 38 × 26.4 cm. Photograph retrieved from the Library of Congress, https://www.loc.gov/item/2015650882/. Rottenhammer's copy of Dürer's self-portrait in the Heller altar, to the left, after he must have seen the painting at the Munich court.

and tireless ambition, hoping for returns. Maximilian I prided himself on his connoisseurship that allowed him to confidently pass judgement on whether paintings offered to him were authentic or not. He had decided that acquiring paintings was no different to buying horses—'one could not really buy without seeing them'.[21] In matters of governance, the ruler often battled with anxiety and indecision, restlessly scrutinizing information. The art gallery allowed this short-sighted ruler of small stature to study his growing collection of authentic Dürers at close distance. Its purpose was not to form relationships with rulers, nobles, or travelling diplomats but to keep his master paintings an exclusive treasure for personal devotion and study.

A man given to emotional ruthlessness, if orders were not carried out to his liking, Maximilian I was furious when he was sent what he regarded as inferior paintings or forgeries. Apart from his genuine enjoyment of outstanding technique, this would have been a main reason for studying the Heller altarpiece as art—to intimately get to know the German Apelles's hand, not least in order to make the right investments in the future. When in 1630 he finally received a large panel allegedly depicting Dürer's *Birth of Christ* he furiously told the Nuremberg broker of the Imhoff family that its condition was 'terrible' and that the whole panel was an inferior copy 'worth so much that you could sell it at a flea-market'.[22]

It would nonetheless be anachronistic to characterize even Maximilian I of Bavaria as a man who solely championed modern connoisseurship based on master paintings hung up in dedicated spaces. His higher appreciation of paintings went alongside an interest in other types of art objects, since marginalized by a powerful tradition of art history focused on paintings. Alongside a Dürer, we therefore need to reconstitute forgotten names such as that of the miniature artist Johannes Schwegler, whom Wilhelm introduced to Hainhofer and whose work Hainhofer sought to reintroduce at Maximilian I's court through his disciples.

This further helps us to reconstruct tastes in an anthropological vein. Whereas we might think that Maximilian I esteemed Dürer because he was a great painter, for handling colour and spiritual expression, we have seen that Maximilian I esteemed him primarily because of the rarity of pieces and because the ruler thought he mirrored his own principles of hard work and precision. It might have been, then, that he admired parts of himself when gazing at the Heller altarpiece. At the same time, he was deeply connected to its subject matter, as worship of the Virgin Mary nearly equalled a 'state cult' under his rule. Yet for Maximilian I, as for Dürer and Heller, there might have even been more personal resonances in their particular devotion of Mary. Just as Dürer and Heller were unable to conceive children in their marriage, so Maximilian I remained childless in his long first marriage to Elisabeth of Lorraine (1574–1635). Aged respectively twenty and nineteen, the couple had married in 1595, and were approaching their mid-thirties when the Heller altarpiece was mounted opposite Maximilian I's bedroom.

[21] Quoted in Albrecht, *Maximilian I*, 255.
[22] Quoted in Grebe, *Dürer*, 73; on Maximilian I's character see Albrecht, *Maximilian I*, 1109–10.

378 *Ulinka Rublack*

Childlessness had never been a problem for the Wittelsbachs in previous generations. Maximilian I and Elisabeth would not yet have given up their hope to conceive, as fertility lasted into a woman's forties, but by 1614 they knew that they were waiting for a miracle. The emotional pressure must have seemed even more acute as Maximilian I could have hardly been more successful during these years in positioning his dynasty at the forefront of imperial politics. What would happen to all these well-laid plans if there were no descendants?

CHAPTER 35

Special Things

Hainhofer, meanwhile, kept trying to lobby the duke to buy highly accomplished miniature paintings and rare objects that mimicked the natural world. After returning from the Munich wedding in November 1613, Hainhofer thus lost no time in writing to Maximilian I. He sent the *Orpheus* painting they had previously discussed and assured him that this would be just the perfect gift for the new Emperor Matthias II or his consort Anna of Tyrol. He informed the Bavarian ruler that the couple preferred miniatures to jewellery. Here was an exquisite miniature of a traditional theme that would surpass any previous depiction. Orpheus was surrounded by no less than three hundred small and large animals, each of them painted from life. Indeed, the artist had spent two years completing it, and had even bought some of the animals himself in order to achieve a perfectly naturalistic representation from prolonged observation. Hainhofer underlined that he offered the miniature exclusively and to no one except Maximilian I, and that the ruler's brother Ferdinand had seen it. In addition, he would send one of the most beautiful landscape paintings by the Flemish painter Paul Brill (1554–1626)—Brill lived in Rome and his work had become extremely rare in the German lands. Hainhofer was thus trying to show that he could be useful in scouting the best contemporary paintings, matching Maximilian I's expertise as 'superior connoisseur and art lover of painting'—and intimated that this implied that he would understand the paintings' high price.[1]

Alongside sourcing quality paintings and diplomatic gifts for Maximilian I, Hainhofer also attempted to sell him part of a cabinet, and the kind of objects he cared for dearly. In his view, naturalistic animal miniatures, such as those in the *Orpheus* painting, complemented objects of the type Schwegler invented—they formed part of the same object-scape. He thus offered Maximilian I a small desk with three drawers in which miniature animals were kept as a perfect gift for 'a duchess's cabinet'. The cost would amount to 100 thaler.[2] [35.1] [35.2]

Maximilian I replied promptly and, as usual, negotiated hard. He would be happy to communicate further if the price for the *Orpheus* painting was lowered by half, down to 400 florins. However, some of the animals and Orpheus's hands were imperfectly

[1] Volk-Knüttel, 'Hainhofer', n.23, 109.
[2] Volk-Knüttel, 'Hainhofer', n.23, 109.

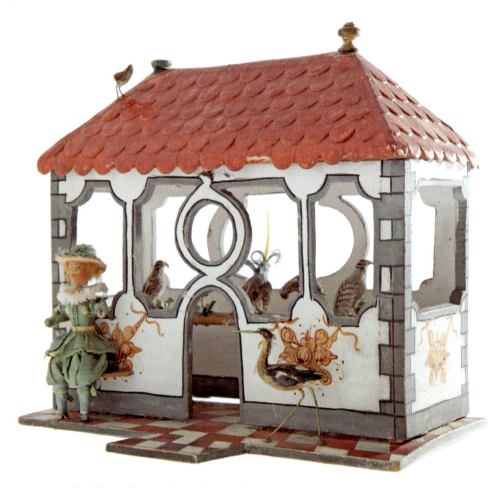

Fig. 35.1 A bird-house by or in the tradition of Johannes Schwegler in Hainhofer's Uppsala cabinet, for which all birds were created with natural feathers, leather legs, and ivory beaks as tiny miniature creatures measuring a few centimetres. The entire aviary measures 14.5 × 12.5 cm. Uppsala university collections/Mikael Wallerstedt.

depicted; Kager in Augsburg would need to correct them. He returned the miniature animals Hainhofer had sent as models for a farmyard. The ruler judged that he had previously seen some of better-quality, 'more artful' work by this master. Maximilian I nonetheless requested Hainhofer to speak to the artist in order to find out whether he would be free to undertake some work according to a specific design which he himself would supply. It would be essential that he should promise not to replicate it for anyone else without permission, for, Maximilian I stressed, 'a thing that everyone has is no longer special (*seltzam*)'.[3]

[3] Volk-Knüttel, 'Hainhofer', n.24, 109.

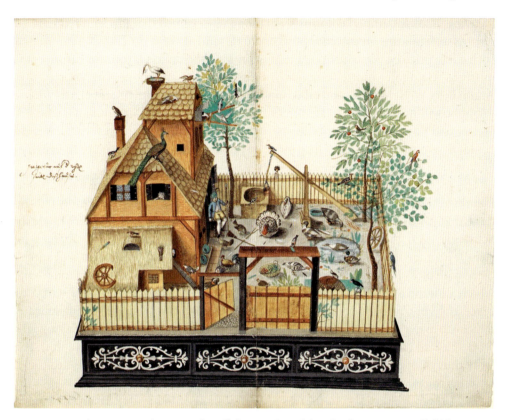

Fig. 35.2 Matthias Kager?, drawing of small farmyard model with a large variety of lifelike miniature birds, Augsburg, c.1611. Germanisches Nationalmuseum, Nuremberg. Photo: Monika Runge.

The ruler, in other words, not only looked for rarity through purchasing Dürer's Heller altarpiece at the most advantageous time but also was willing to commission work integral to the world of wonder that he himself designed. This courtly drive to keep designs and making processes exclusive through secrecy would have had very serious consequences for artisans' lives. Just like Fugger, Hainhofer inhabited an Augsburg world in which artisans, scholars, high-ranking visitors from other courts, travellers and merchants across a range of different crafts profited from knowledge sharing. Exclusivity, on the other hand, could only be guaranteed if a workshop was closed off, access controlled, or carefully zoned into areas with accessible show pieces and others that were hidden away. Yet the difficulty was that single commissions for powerful clients who demanded rarities took years to make, so that an artist was more or less condemned to labour away in solitude with this family and could only grant a specific agent full access to discuss any challenges and problems.

Hainhofer took some time to speak to the masters in response to Maximilian I's enquiry, to report back on 5 December. The miniature artist Rem was willing to sell

382 *Ulinka Rublack*

the *Orpheus* for 300 imperial florins, even though he claimed that this sum represented just his expenditure on materials. Kager would undertake corrections. Rem offered such a low price because he hoped to thereby gain the duke's favour for future commissions. Hainhofer himself implicitly harboured the same hope. He reported that Anton Felix Welser had recently died and had owned a beautiful Breughel. His widow might be willing to sell, and Hainhofer offered to scout out for Maximilian I, whether Welser had possessed further old master paintings that might interest the duke and could be sent for inspection. Once more he favoured the Bavarian rulers rather than Philipp II of Pomerania.

The second part of the agent's letter now turned to the miniature animals and identified the makers. As regards the object he had sent, Hainhofer informed the duke that it was 'not just made by one master, but two, as the birds were made by Schwegler and the three drawers depicting landscapes, fishing and midges by Achilles (Langenbucher)'. Schwegler, he continued, was 'still busy with a beautiful piece with birds for the Emperor and then a big farmyard for the duke of Pomerania, which is bound to keep him busy for another year, and I will oblige to show it to your grace and your beloved spouse'. Innovative and artistic, soft to the touch, delicate, difficult to manufacture and much in demand—these attributes commended Schwegler's work. He had created an entire scene of a bird market for Emperor Rudolph II. His work thus enjoyed the highest prestige, and Hainhofer kept pointing out his dedicated, as much as delicate, work and his ability to work out 'strange inventions'.[4]

Key among these inventions was that ambitious model of a farmyard, which Hainhofer had convinced Philipp II of Pomerania to commission alongside an art cabinet in 1610. The agent was clearly excited. It still held some challenges. The whole construction, he explained to Maximilian I, was going to be completed with a castle, a farmyard, and stables 'just as in the real countryside', and it had already taken a year to finish all the houses. The object was immensely intricate and playful—just as in a doll's house, all the hatches could be opened and peered into. At the moment, Hainhofer and his team were working out how to integrate a fountain (*spritzend wasserwerk*). He had been inspired, he flattered Maximilian I, by the mechanism designed for one of the show-food creations he had recently admired at the Munich court.[5]

So far, Hainhofer's letter had conveyed that Schwegler was still working for the Habsburg Emperors after Rudolph II's death in January 1612, and that he worked together with the artist to create true cutting-edge and cunningly engineered creations that also fitted into the Munich court culture and were bound similarly to impress visitors. This made a commission highly desirable—except that Schwegler was too busy to take it on. Hainhofer next provided greater detail on Achilles Langenbucher's situation. He was completing a commission this month and would be more than pleased to serve the

[4] F.L. von Medem ed., *Philipp Hainhofers Reisetagebuch, enthaltend Schilderungen aus Franken, Sachsen, der Mark Brandenburg und Pommern im Jahr 1617* (Stettin, 1834) 158.

[5] HAB Cod. Guelf. 17.28 Aug. 4°, for the Archbishop of Cologne and for a French client.

duke for an entirely new piece, confident that he would be able to create the birds in Schwegler's manner.[6]

Maximilian I bought the *Orpheus*, resolved to have the corrections carried out properly by his own court artists after all, and looked at Achilles Langenbucher's work. Taking advantage of the fact that his piece had not yet been returned to Augsburg, he replied to Hainhofer on 9 December that he did not judge this craftsman to be able to carry out the work he wished to commission. The ruler urged Hainhofer to talk to Schwegler in order to enquire whether he might undertake the commission in addition to his other commissions and finish it within one year.

For the first time, Maximilian I now revealed his own design: 'it is a falcon-hunt in miniature', he wrote, with fifty to sixty 'falcons and birds, each of its own special kind and different postures, in the way huntsmen alone understand and know to detail'. Huntsmen thus had evidently become interlocutors at court valued for the diversity and precision of their knowledge of the natural world which turned them into authorities in the creation of naturalistic art. The duke repeated that this design was not ever to be copied. If Schwegler was willing to carry out the work, he would be sent a drawing to work from.[7]

All this might have come as a wonderful surprise for Hainhofer and does not fit current accounts of Maximilian I as collector. His interest in different media went beyond painting, tapestry, wood turning, and jewellery. Schwegler promised that his work for the Emperor was very nearly finished—and, given his standing, it was obvious that he had privileged its execution. Schwegler's and Hainhofer's agreement to serve Maximilian I, despite the Pomeranian commission, hence shows their particular effort to cultivate the Bavarian ruler as collector who, in contrast to Philipp II of Pomerania, would instantly pay. Schwegler promised to be industrious and not to copy anything.[8]

What had started out as Hainhofer's attempt to get Maximilian I to buy a collaborative work by Langenbucher and Schwegler thus turned into a single commission for a senior artist who was already overworked. Maximilian I told Schwegler to ride to the Munich court and receive instructions from a man called Hans Krumper. In addition, the duke explained, there would need to be a lot of writing back and forth about the matter. For such detailed correspondence, he did not have sufficient time. In contrast to his father Wilhelm, Maximilian I thus prioritized and decided about the need for his involvement at different stages of an artefact's creation. He delegated. Krumper would fully inform Schwegler and also show him the live animals which he was meant to copy after the design. None of this, Maximilian I forecast ever efficiently, would take too much time.[9] Here was a new type of ruler of a modernizing state who in his confident commitment to extend grandeur constantly decided what could be centralized or had

[6] Volk-Knüttel, 'Hainhofer', n.25, 110.
[7] Volk-Knüttel, 'Hainhofer', n.27, 110–11.
[8] Volk-Knüttel, 'Hainhofer', n.27, 111.
[9] Volk-Knüttel, 'Hainhofer', n.28, 111.

to be outsourced, what could be delegated to his officials at what point, and how nonetheless to retain overall control. Amidst this drive for control, Maximilian I's ambition remained to become a knowledgeable creator of art designs. He had after all been educated amongst the curiosities which his parents had constantly assembled throughout their lives.

Schwegler rode out to the Munich court, where had worked under Wilhelm, in January 1614. He now demanded 8 florins per bird—so that the cost just for the birds in the complex piece Maximilian I envisaged would have amounted to between 400 and 480 florins. This was a significant sum. Its value equalled the annual payments for the Heller altarpiece. Maximilian I took to his pen. He had recently sent Hainhofer another piece of game as a gift in acknowledgement of his service, as well as to signal that, just like his father, he in no way intended to pay him as regular agent. Yet he required information on the market value of Schwegler's art. Did others pay Schwegler as much as this?

As always, Hainhofer knew how to oblige. He informed Maximilian I that everything depended on quality. As Maximilian I kept positioning himself as a singular and exceptionally selective connoisseur, this implied that he would want to pay within the highest price range. Schwegler, Hainhofer detailed, worked across a range of prices in terms of his 'Sauberkeit', in terms of the clean, proper perfection of each bird, its size, and the complexity of its feather-work. Small ordinary birds cost 2 to 3 florins, larger ones 4 to 5 and up to 6 florins, if he decorated them particularly beautifully. The number of colours used made a difference to the price. As for alternatives, Achilles Langenbucher was to be ruled out. He had not made any birds for a long time, but spent his time making landscapes and especially drinking. Yet there was a new possibility. Langenbucher had taught a cousin in all his arts, and this man now crafted birds, landscape, and enamel work. He was also 'a good clock-maker and a willing, good young man, who is still unmarried'. With some more practice, Hainhofer judged, he was likely to produce really good work. Hainhofer sent two of these birds to Maximilian I so he could consider whether he wished to employ the cousin in case the negotiations with Schwegler came to nothing.[10]

Instead of simply promoting Schwegler, Hainhofer after all felt obliged to serve his high-ranking client first, and to promote alternatives. Although agents helped to create a competitive market for artisans they also ran the risk of lowering prices. Maximilian I was interested at once. Within four days he replied to enquire whether this young cousin of Langenbucher thought himself capable of making somewhat bigger and more beautiful birds. He had closely inspected the miniature birds he had created, finding fault with the ways in which their eyes were made, because the material seemed less durable, much like the wax that was used for the beaks.[11]

[10] Volk-Knüttel, 'Hainhofer', n.35, 114.
[11] Volk-Knüttel, 'Hainhofer', n.36, 114.

All February, young Veit Langenbucher sat in Augsburg working on his bigger birds to try to get Maximilian I's commission. He would then be able to craft anything required, he assured the duke of Bavaria, and would charge 4 florins for a bird of any size, and 20 florins for a whole *Stöcklein*—a decorated group of them. Keen to make his mark, Langenbucher lowered Schwegler's hard-won market prices for this type of workmanship.

Hainhofer drew on his conversations with the young artist when he next conversed with the duchess of Bavaria at the Munich court. Elisabeth of Lorraine was enthusiastic about such pieces with miniature birds, and especially farmyards. It interlinked with her passion for breeding new species of 'galant', edible birds that served princely tables, were rare, and looked beautiful. In fact, she wished the entire range of her foreign poultry 'recreated ad vivam'. If Schwegler were still to undertake the falcon hunt, the agent now suggested to Maximilian I that Langenbucher would be ideal to take on a farmyard for Elisabeth. He had skilfully created the opportunity for two commissions at once.

The merchant vouched for Veit Langenbucher with increasing confidence. With practice, he would become better the longer he worked on such a commission, and able to create beautiful miniature trees and a garden.[12] Working through his incoming post as methodically as ever, Maximilian I advised within three days that he had looked at Langenbucher's work, which he was happy to return, yet still judged Schwegler's to be more naturalistic and somewhat more labour-intensive and industrious, *fleissiger*. He would take more time to consider the question of whom to choose.[13]

This was the point. For Maximilian I, *Fleiss* was a matter of character and commitment, and separate from talent and skill that were learnt and could be built up. If someone did not excel in industriousness as a young artist, he was unlikely to do so at any point in his life. As Dürer's astonishingly detailed engravings, woodcuts, and—he would have thought—the Heller altarpiece brought out, this determination had made the Nuremberg artist so different. Once again, Maximilian I most identified with exceptional industriousness alongside tidiness in execution and sought these qualities in artists. Such standards of tireless work moreover always promised great surplus value on the price any piece could command at the time it was created—these artists would invest much time of their own accord to meet their own high standards and would never ask to be rewarded in relation to their hours of work. Dürer's response to this conundrum, as we have seen, had been an investment in prints that could be reproduced while turning out lower quality, quick paintings. Schwegler too worked across a

[12] Volk-Knüttel, 'Hainhofer', n.37, 114.
[13] Volk-Knüttel, 'Hainhofer', n.38, 114.

range, and yet for the best of work he clearly needed an extraordinary amount of time that was hardly compensated for at even 8 florins a piece. His best option was to gain a large sum of money for complex pieces, and to invest it in turn upon completion. Yet by then he was likely to have created such debts that any profit was quickly swallowed. The situation for even the most exacting artists during the sixteenth as much as the seventeenth centuries hence remained extremely precarious financially, mentally, and physically, as work of such intricacy demanded immense concentration and was exhausting for the eyes.

In the meantime, Maximilian I set new tasks for Hainhofer to act on. He asked him to source large plates of lapis lazuli, to be cut and decorated with animals and landscapes in just the manner of Hainhofer's cabinet pieces. Everything seemed to go well again in their exchanges, except that Hainhofer once hastily included a treatise that he had just received from Lyon alongside calendars. Maximilian I judged the writing heretical and sent it straight to the Vatican so that it would be censured.[14] This was a committed Catholic ruler who remained principled and prompt in action to save his world.

Hainhofer continued to privilege his demands, for example his request for relics, in his new correspondence with the Lutheran Duke August of Brunswick-Lüneburg, that luckily took off in 1613 just as his relations with Philipp II declined.[15] In view of these deepening connections, Hainhofer once again took courage to offer Maximilian I unsolicited pieces. More contact offered a merchant the opportunity not only to passively react as servant but also to more actively inspire appetite and keep alert for opportunities. As any skilled merchant, and just like Hans Fugger, he remembered some old request, noted particular interests, and in addition offered a whole range of things currently available. Hainhofer hence volunteered to negotiate a tax-free delivery of Ottoman tapestries that would cover the floor, exactly what Maximilian I had been looking for some years ago. Moreover, he could send a particularly 'clean' Brueghel from Antwerp and a list of traditional cabinet pieces, including bezoar stones, an 'Indian' cabinet and 'Indian painting', clocks, embroidery, automata, and even an exquisite mirror that could be turned four ways to unfold an elaborate spiritual programme.[16]

With Wilhelm, his strategies had worked. Maximilian I by contrast declined most of these offerings with the simple phrase that he did not currently need these things. He almost exclusively defined what he wanted, and could not be influenced in his tastes. Yet Hainhofer urgently needed customers. In January 1614, he told Philipp II of Pomerania that he needed 8,087 florins for work on his cabinet so far and that 'Schwegler now has to make a falcon hunt for the lord of Bavaria, so that he also has something

[14] Volk-Knüttel, 'Hainhofer', ns.32, 33, 113.
[15] See numerous letters in Gobiet, Der Briefwechsel.
[16] Volk-Knüttel, 'Hainhofer', nn.41, 43, 44, 47, 48, 115–17.

special'.[17] In truth, no order was fixed. The Bavarian duke had never followed up on the idea of a gift of a farmyard by Langenbucher for his wife, and was unlikely to favour her idea of immortalizing her poultry in the most lifelike manner. Rather, he was likely to pay a substantial amount of money only for the falcon hunt as a far grander subject. It excited him and could easily be displayed alongside the paintings and tapestries he favoured as collector's items.

No further correspondence in this matter survives, but all of Maximilian I's following letters suggested that he increasingly sought to minimize his dependency on urban artists who set their own conditions. Artistic expertise was centralized at court. Indeed, when Hainhofer asked Maximilian I to directly approach the miniature artists in Augsburg who so delayed work on the entries for Philipp's and Hainhofer's own friendship album, the Bavarian ruler's patience broke down. Maximilian I announced that he would get the miniatures done at court. Hainhofer had not foreseen such a radical move and requested Maximilian I to retain his commission for local master miniaturists, assuring him that it would now speedily be completed.[18] In return for this renewed favour, Philipp II of Pomerania finally understood that he needed to send another gift to Bavaria. He offered Maximilian I, as someone who delighted in 'old, clean pieces', a 'cleanly painted' piece that he himself had just received. Hainhofer in addition offered the Bavarian ruler a local master's new invention. This was a cheap foldable table that could be used on military campaigns to ensure elegant dining.[19] The agent anticipated Maximilian I's future needs almost too well.

[17] Doering, *Hainhofer*, 254.
[18] Volk-Knüttel, 'Hainhofer', n.50, 188.
[19] Volk-Knüttel, 'Hainhofer', 52, 118; HAB Cod. Guelf. 17.28 Aug. 4°, 130.

CHAPTER 36

A British Spy?

In 1618, leaders of the Protestant Estates in Prague rebelled against Habsburg rule to defend religious freedom and political autonomy. As the Bohemian conflict escalated across the Empire and the Thirty Years' War broke out, Hainhofer's Lutheranism and position as an agent would finally turn into an unsurmountable problem at the Munich court. By then, Hainhofer's influence had been on the wane for some years. The agent had still sent Wilhelm eight letters between 1612 and 1617, in which he offered goods ranging from crystal to miniatures, perfumes, lapdogs, and coins, all within a limited price range. He continued to keep an account for Wilhelm, offering to add any expenditure to it without expecting immediate payment.[1] Yet there was little response. In February 1618, Wilhelm still cordially wrote to his 'dear Hainhofer' with detailed instructions on how the Bavarian miniature for Philipp II of Pomerania's album were to be carried out with precision, speed, and at low cost.[2] Hainhofer's significance as agent diminished as his patron Philipp II of Pomerania died in 1618, just months after the agents had undertaken an arduous journey north across the German lands to deliver the cabinet and the miniature farmyard. [36.1]

From now on, there was near silence. In June 1619, Hainhofer approached Maximilian I to request whether Henry Wotton, ambassador of the English King James I, might visit the Munich court accompanied by 'a prince from Holstein' to admire its exquisite art. He felt certain that Wotton could in turn be approached to source English horses and dogs for the Munich court. Either Hainhofer's memory was excellent, or he used the indices carefully compiled of all the letters he had sent and received. He remembered Wilhelm's first order, which he painfully had had to leave unfulfilled: rare English sheep breeds for the grounds of Schleissheim, his castle near Munich. Hainhofer was confident that Wotton, with whom he would further correspond in Italian to offer James I one of his cabinets, could have a word with the English King about them.[3]

Maximilian I received Wotton with great diplomacy, given that this King counted as one of Europe's most powerful Protestant men. The extent to which James I would support his son-in-law, Frederick of the Palatinate, in Bohemia at this point was decisive for

[1] HAB Cod. Guelf. 17.28 Aug. 4°, 80r, 134–135rv, 210, 213, 237, 294.
[2] Archive Greifswald, Rep 40 III 9 c/63, 3.2.1618.
[3] HAB Cod. Guelf. 17.28 Aug. 4°, 361r–362r, 531r.

Fig. 36.1 Anton Mozart, The Presentation of the Pomeranian Cabinet, c.1615. Kunstgewerbemuseum Berlin. © bpk/Kunstgewerbemuseum, SMB/Markus Hilbich. An idealized view of Hainhofer presenting the seated ducal couple of Pomerania and courtiers with the contents of the cabinet, displayed at the centre right, and most of the craftsmen involved in making it at the front.

European politics. It is doubtful that they would have talked about sheep. Wotton and his companion, Duke Joachim Ernst I of Schleswig-Holstein-Sonderburg-Plön, were on their way to a meeting of the Protestant Union in Heidelberg.

The Bavarian duke would have been able to guess that the English might wish to enlist Hainhofer as a secret agent. Wotton, in fact, had written to the English state secretary Robert Naunton in July 1618 firmly proposing that Hainhofer should be used as a spy to intercept letters exchanged between English Catholic priests in the Jesuit network and Rome. He already knew that Hainhofer was interested in serving the British King because he hoped to recruit him as a client for a cabinet. Hence, Wotton introduced the merchant in the following terms: 'there is in Augusta one Philip Hainhoffer, a Patricius of that small community'. He talked Hainhofer up as a patrician; yet the merchant only received this honour much later, after Augsburg acquired one of his grand cabinets as a present for Gustavus Adolphus of Sweden, and perhaps *in lieu* of a lowered price. Wotton continued: 'This man holds correspondence with divers Princes, and doth much desire to have some relation with the King. In *plainer language*, a pension of about one hundred pounds yearly, promising to entertain his Majesty with many

curious things. I have not with him any acquaintance by sight, but find him by his letters and by report *easy to be moulded* as we list.'[4]

Wotton planned to approach Hainhofer with this proposal in person. He arrived in Augsburg on 1 June 1619. Within seven days, Hainhofer wrote to James I agreeing to serve him as outlined by the ambassador.[5]

In August that year, Ferdinand II of Austria was deposed as king of Bohemia and crowned as ruler of the Holy Roman Empire in Frankfurt within days. The Calvinist Frederick V of the Palatinate accepted the Bohemian Crown offered to him by the Estates. On his return from Frankfurt to Vienna, Ferdinand II stopped in Munich to negotiate with his brother-in-law Maximilian I and secure the support of the Catholic League to recapture Bohemia. In return, Maximilian I would command the troops and, if successful, assume governance of the Palatinate as well as any other territories gained. Ferdinand II even promised the Bavarian ruler that he would finally gain the *Kurwürde* as one of the electors of the Emperor. By November 1620, Maximilian I had written to Pope Paul V to inform him of his leadership at the Battle of the White Mountain, just outside Prague, which God alone had won.[6]

Frederick V was deprived of the Palatinate. To many it seemed as if Emperor Ferdinand II wished to re-Catholisize the German lands—despite the fact that he had been loyally supported by the Lutheran Duke of Saxony Johann Georg I. Maximilian I's extreme focus on re-Catholisization made it increasingly impossible, even for moderate Lutherans, to envisage how a balance of politics and faith in the German lands might be retained without military confrontations and major foreign help. Between 1621 and 1623, Pope Gregor XV Ludovisi closely collaborated with Munich and with Vienna to advance the militant re-Catholisization of German lands. The Protestant Union seemed neutralized, and the Holy Roman Empire's well-honed mechanisms to stabilize a culture of religious settlement received their biggest blow.[7] So did the movement of art lovers with its claim that cultivating arts facilitated peace.

Hainhofer did not visit Munich again for years, or, as far as the evidence goes, even exchange further letters. Then, in August 1623, an eighty-five-year-old Wilhelm of Bavaria sent a brief note to the agent he had once been so intimate with. Hainhofer was cut off from the Munich court. Wilhelm would never accept any of his letters again. Their correspondence was over. The charge was that Hainhofer had corresponded with those of his faith and against the Catholics. It appeared as if he had told his Protestant friends about conversations with Wilhelm on religious matters and other issues.[8] The letter reveals what it was like to fall from a ruler's grace, to lose favour, and for relationships that had been warm and intimate to freeze.

[4] Wenzel, *Handeln*, 103, my emphasis.
[5] Wenzel, *Handeln*, 104. No evidence survives on whether James paid for any future services.
[6] Schmidt, *Reiter*, 199.
[7] Joachim Whaley, *Germany and the Holy Roman Empire* (Oxford, 2012), vol. 1, 496; Dieter Albrecht, 'Bayern und die Gegenreformation', in Glaser ed., *Um Glauben und Reich*, 13–23, here 21.
[8] HAB Cod. Guelf. 17.28 Aug. 4°, 554v, 4.8.1623.

Dawn set in as a messenger knocked on Hainhofer's door to deliver this letter. He replied at length the next day, first of all to communicate his sadness.[9] Hainhofer listed those he corresponded with, including the Emperor and Jesuits, regardless of their Catholic faith. He next suggested that he had addressed his letters to secretaries of Protestant rulers rather than exchanging ideas directly with them himself. His relationships were long-standing—he had corresponded with the Margrave of Durlach's secretary for over twenty-four years. Hainhofer, in other words, weakly claimed that he had never operated as a secret agent. Moreover, he recalled Protestant princes praising the Bavarians as good rulers—in fact, the ruler of Baden had in conversation reflected for an entire hour on this theme. Hainhofer declared that he was aware that the current situation aroused passions that incited the wrong kind of imagination through enmity in the Empire, fired by suspicion and religious zeal. He guessed that Wilhelm might specifically be upset about Hainhofer passing on his view about the children of Eduard Fortunatus, an ill-fated descendant of the house of Baden, whose marriage to a commoner led to questions about the legitimate succession claims of his children. The Imperial Chamber Court had dealt with Fortunatus's case and recently decided in September 1622 that his children were legitimate heirs to their father's territory in Baden.[10] Hainhofer admitted that he had certainly discussed the case of Fortunatus at the Diet of Regensburg in general terms in 1613, and evidently with Wilhelm. Yet it remains unclear how this would have provided him with damaging information which he might have passed on to Protestants.

The agent stressed his diplomatic achievements in creating good relations between the Grand Duke of Florence, the Vatican, and the Lutheran Margrave of Baden, so much so that they had sent each other 'pharmacies and beautiful horses'. This highlights again the prime significance of exchanging medicines and medicinal equipment and precious horse breeds as diplomatic gifts. The agent admitted to his hopes that such 'correspondence would lead to much good' by furnishing amicable relations. Only God would be able to tell why things had turned out differently. He, in any case, was a lowly private person of little understanding who had never tried to learn political secrets or had them communicated to him. In any case, he now confided, he had felt physically unwell for several years, as a result of which most of his letters had been drafted by scribes and he would merely read them over. Hence, none of it was secretive. Reputable witnesses would be able to corroborate that he had never written about anything that could be damaging. In ways not untypical for an agent, it was as if he fully believed in a persona he had created for himself, and indeed in part truthfully inhabited. As a diplomat, Hainhofer would continue to converse with high-ranking men from all confessions at political summits or courts, and as merchant and art lover he would receive all of them in his collector's cabinet and write to them during the rest of his life and the entire period of the Thirty Years' War.

[9] HAB Cod. Guelf. 17.28 Aug. 4°, 555r–560v, 11.8.1623.
[10] Johann Jakob Moser, *Teutsches Staats-Recht*, vol. 19 (Nuremberg, 1737), 107.

Hainhofer professed that his entire aim was to benefit his children and friends, and to serve others, which is why he so far had been 'loved' for his integrity and faithful service. He thus hoped he would not now be judged by his faith as he had always avoided confessional divisions. In Augsburg, he had given charitably to sick and deserving people of both Catholic and Protestant faiths. Not a single person, Hainhofer emotionally vowed, would be able to say that he had taken pleasure in the Bohemian troubles and the Palatine coronation in 1618. Even in his exchanges with the Duke of Pomerania he had only referred in the most summary way to his conversations with Wilhelm on matters of religion.

As he went on writing the letter, Hainhofer regained his confidence. He knew that he had been 'loved and held in honor by everyone' because he so skilfully handled talking to bishops and rulers of both confessions. When visiting Augsburg, such high-ranking persons visited his house first of all. Countless potentates had seen his collection. In the end, therefore, Hainhofer pleaded for Wilhelm to drop all his suspicions. As for himself, Hainhofer offered to continue their relationship with affection.[11] No reply is preserved, or indeed likely to have been written.

All the same, Hainhofer would recall encounters between Wilhelm and his brother Ferdinand for the rest of his life. He depicted their relationships as based on mutual trust, curiosity, and pleasure. He had loved their experiments as art lovers. In September 1623, he wrote to Duke August of Brunswick about mechanisms for show food and specifically of how he had created entertaining apples out of which water gushed. Wilhelm and Ferdinand had wanted them to be made from silver, but as they were made from base metal soldered with lead, they could not be silvered.[12] These were memories that stretched back more than ten years and thus to a time which in retrospect appeared to have been a 'golden age' of his correspondence with Wilhelm and Philipp II of Pomerania.[13] He would have remembered that day when Wilhelm arrived in a carriage outside of his house, brought him Schwegler's dove as a gift, and bought so many of his Indian rarities, followed by the period in which Wilhelm had employed him as envoy at Eichstätt and diplomat with Pomerania. At some point, Wilhelm had given Hainhofer miniature portraits of himself and his wife Renata as a present. The agent included them in one of his cabinets to display his connections to art lovers of rank.

The merchant's connection with Wilhelm as an eminent art lover at a court of great political power had made his career. For years, Wilhelm had trusted in gaining from his service. Then, on 26 February 1626, Hainhofer simply reported to his new patron August of Brunswick Wolfenbüttel: 'Duke Wilhelm of Bavaria died on the 7th, and was buried the 18th in Munich's Jesuit church (which, alongside the Jesuit College, he had built, and in the choir a beautiful castrum doloris was set up).'[14] Aged eighty-eight, Wilhelm of Bavaria was dead.

[11] HAB Cod. Guelf. 17.28 Aug. 4°, 559r.
[12] Gobiet, *Briefwechsel*, 400.
[13] Gobiet, *Briefwechsel*, 770.
[14] Gobiet, *Briefwechsel*, 467. NSAW 1 Alt 22 N 177d, fol.11r–12v.

Effigies ALBERTE tuæ DVRERE iuuentæ, Ars si se, genium, moresq́ referre valeret,
Sed non Virtutum, talis in Orbe viget; Clarior ulla tuâ non foret effigies.

L. Lancelottus I.

ipse Albertus Wenceslaus Hollar Bohemus fecit, ex Collectione Arundeliana, Aº 1645. Antverpiæ.

PART FOUR

Shopping for Dürer in the Thirty Years' War

CHAPTER 37

Art and Life in a Time of Crisis

Europe had turned into a continent in turmoil. Augsburg, the bi-confessional city, was to be fully re-Catholicized, and Lutherans like Hainhofer lost their civic positions. By 1635, the population growth of the last decade had been wiped out, shrinking the size of the population from around 45,000 to 16,432 inhabitants—12,017 of them Protestants and 4,415 Catholics.[1] While warfare affected German regions unequally, the Thirty Years' War reshaped the fortunes of southern trading cities such as Augsburg for decades. It repeatedly brought Hainhofer's flourishing international agency to the brink of bankruptcy. As early as 1622, Hainhofer reported to Duke August of Wolfenbüttel about the effects of the inflation crisis: 'every day here many hundreds of people queue for bread in front of the bakers' shops, and run around the city crying, several have already died and there are five children dead from hunger this week, with their pacifiers still in their mouths'.[2] A plague disastrously hit the city in 1627–28.

In March 1629, Emperor Ferdinand II enforced the Edict of Restitution, demanding the return of all church property secularized by Protestants since 1552. Lutherans were no longer permitted to attend services in Lutheran communities outside the city and poor Protestants were excluded from charity. About 1,000 imperial soldiers were stationed in the city to forestall any uprising.[3] Ferdinand II even commanded that the Feast of the Conception of the Virgin Mary was to be observed by all citizens, regardless of their faith, as the Virgin's intercessions had helped win this war. For Maximilian I as for the Habsburg Emperors, Mary became the *Generalissima* of their armies, her image embellishing the banners of troops. In this ever more charged atmosphere, it is perfectly likely that Maximilian I of Bavaria would have prayed for military success to Dürer's altarpiece in his private gallery rather than appreciating it strictly as an art connoisseur or as a man still hoping for a descendant. His infertile wife Elisabeth of Lorraine had entered her late fifties.[4]

[1] Barbara Rajkay, 'Urban Topography, Population, Visual Representations', in Tlusty, Häberlein eds., *Companion Augsburg*, 20–45, here 27.

[2] Jill Bepler, 'Vicissitudo Temporum: Some Sidelights on Book Collecting in the Thirty Years' War', *The Sixteenth Century Journal*, 32/4 (Winter, 2001), 953–8, here 963, fn.46.

[3] Andreas Flurschütz da Cruz, 'The Experience of War', in Tlusty, Häberlein eds., *Companion Augsburg*, 342–66, here 325.

[4] Maximilian I, however, soon remarried after her death in 1635, and fathered several children with Maria Anna of Austria.

398 *Ulinka Rublack*

In Augsburg, Protestants refused this cult of Mary. In 1630, one of the weavers read out a mock confession which ridiculed Catholics for holding the Virgin in higher regard 'than the Son of God himself'. He also refused to have his children baptized in the Catholic faith.[5] Augsburg's Protestants invested all their hopes in the Swedish King Gustavus Adolphus. Under his leadership, Sweden had further risen as a superpower, eager to extend its influence in the Baltic Sea, in Poland, Russia, and in Africa. Even moderate Lutheran territories, such as the Electorates of Brandenburg and of Saxony, embraced Gustavus Adolphus, who landed on the Baltic coast in July 1630 and defeated the Catholic League at the battle of Breitenfeld in September 1631. Augsburg willingly surrendered to the Lutheran leader as 'God's angel' in April 1632. Catholic clergy were forced out of the city. A new council presented Gustavus Adolphus with a magnificent Hainhofer cabinet. Gustavus and others, including his wife Maria Eleonora of Brandenburg, spent days engaging with it. Hainhofer was now elevated to the rank of a patrician and instantly offered his diplomatic service to the Swedish king by stressing that he had loyally served the French Crown for thirty years.[6]

France did not support the Wittelsbachs at this crucial juncture, as Maximilian I had hoped. Just like the papacy, Cardinal Richelieu calculated that they would benefit more from the weakening of Habsburg politics. Europe's big players readjusted the Continent's balance of power as political demands triumphed over the vision of a united counter-Reformation front. At this stage, the costs for the Wittelsbachs seemed too minor to matter, and it was obvious that Maximilian I too had furthered the power of Catholicism to significantly advance the power of his dynasty in imperial politics.[7]

As Gustavus Adolphus and his troops marched onto Munich in May 1632, Maximilian I escaped from his palace. Alas, the Swedish King died in the battle of Lützen that winter. In September 1634, the Protestant Union lost a decisive battle in the South German town of Nördlingen. Augsburg was besieged by imperial and Bavarian troops ending its occupation by the Swedes. Citizens, and Protestants in particular, were burdened with further tax increases and additional contributions to quarter imperial troops. Prices for wood and food once more rose exponentially. As the Catholic League triumphed in 1634, bakers had hardly any grain to bake with at all.

By January 1635, a local chronicler noted that soldiers in towns desperately shot dogs and cats for food, and even dead bodies had been devoured. 'Even the most noble lords', another chronicler noted, were reduced to eating their porridge without lard. Long gone were the times when Hans Fugger decided to moderately not eat his morning porridge spiced with saffron. Hainhofer noted: 'we in Augsburg ate all sorts of unusual food...from dogs, cats, rats, horses and even dead cattle and the dust (of milled grain) that remained in the mills'.[8] Elsewhere, a woman was said to have 'killed

[5] Heal, *The Cult of the Virgin Mary*, 152–3, 136–40, 148–206.

[6] Wenzel, *Handeln*, 99; Gobiet, *Briefwechsel*, 361 provides Hainhofer's extensive account of his family's status and the fact that his mother's family kept landed properties.

[7] Dieter Albrecht, 'Bayern und die Gegenreformation', in Glaser ed., *Um Glauben und Reich*, 21.

[8] Häutle, *Reisen*, 305.

many Dogs & sold their flesh at a great rate to many people, and one day as she walked in the Streets, was like to have been devoured by them, had not some poore Souldiers by chance releeved her'.[9] Instead of rejoicing in frivolous masquerades at carnival in February, Augsburg's poorest inhabitants begged for charity in groups of twenty to thirty people at a time. Knocking on doors, they looked 'shriveled, like dried up wood without colour and like a human figure without any strength; wretchedly wailing just for a morsel of bread'. One by one, they perished of hunger.[10]

In 1635, there was a resurgence of the plague. Over 6,000 people died in the city just in that year. In March, Augsburg's council surrendered to the siege. Catholicism was restored, although Lutherans were allowed to worship in the courtyard of St Anna. Like other Protestants, Hainhofer lost his rank as a patrician again alongside all public offices. By May, the Peace of Prague agreed to expel Swedish, French, and Spanish troops from the German lands.

One year later, in March 1636, Elizabeth Stuart received news that Emperor Ferdinand II was willing to negotiate a gradual restoration of the Palatinate to her son Charles Louis. Elizabeth, daughter of the British King James I, had married the Calvinist Frederick I of the Palatinate in 1613. The young prince was of the right religion and belonged to the group of Germany's seven most powerful rulers who elected the Emperor. Then, after accepting the Bohemian Crown and losing the Battle of the White Mountain against the Catholic League, Frederick I had lost the Palatinate and his title as elector to Maximilian I of Bavaria. He died in exile in 1632, leaving the 'Winter Queen' Elizabeth to campaign vigorously for their son Charles Louis to return to rule the Palatinate. Much of the letter Elizabeth received in March 1636 from Balthazar Gerbier, a calligrapher and miniature artist by training, who now served as one of the British Crown's secret agents, remains impossible to decode. Yet its message remains clear: anti-Habsburg armies were melting like snow and soldiers were forced to eat nothing but carrots and turnips. A further peace treaty that included a settlement on the Palatinate was urgent. The text is intermixed with numerical cyphers which can only be decoded in part:

> 1 The Courier saith to carry a happy dispatch. The Emperour declares the Low Palatinat shalbe restored forthwith.
>
>
>
> The said 26.36.70.58.54. [baron] to passe towards 74.64.39.90.54.16. [Spayne] soe 95. [his Majesty?] likes it there to worke with 228. [King of Spain?] for his consent, since soe the world goeth, & then if the matters takes bon fires for an 233. [marriage?] & restitution of Palatinat, which if soe God orders (for the common good of Christendom) may it be

[9] William Crowne, *Travels of Thomas Lord Howard* (London, 1637, repr. Amsterdam, 1971), 60.
[10] Bernd Roeck, *Eine Stadt in Krieg und Frieden*, vol. 1, 18.

400 *Ulinka Rublack*

soone, many soe happy to see that day & I may plant trees in this 63.35.36.69.29. [p-arc] to see that sweete 63.69.3.53.29.16.72.74.20. [princesse] eate fruites thereof:....[11]

London quickly sent a man of quality on a diplomatic mission. Thomas Lord Howard, Earl of Arundel and Surrey, swiftly 'departed from Greenwich to Germanie' in April to serve as British ambassador.[12] Arundel was one of England's top diplomats and among the country's most ambitious art lovers. On his way to Germany, he first spent three days in The Hague with the exiled Elizabeth, whose brother Charles I had ruled Great Britain and Ireland from 1625. Arundel had accompanied the young princess to her glorious wedding in Heidelberg; now his mission was to negotiate on her behalf with Emperor Ferdinand II and open conversations about a peace treaty. The Emperor seemed willing to restore the Lower Palatinate immediately to Charles Louis and the Upper Palatinate and the Electoral title after Maximilian I of Bavaria died.[13]

Armed with Elizabeth's determined letters addressed to the Emperor and Empress and with his own King's instructions, Arundel arrived at Linz castle at the beginning of June 1636. He stayed for nineteen days, at the Emperor's cost. Ferdinand II received Arundel three times in private, while the Empress saw him separately twice. Ferdinand II, an ailing man, aimed to prepare the election of his son as King of Romans at a meeting of the electors alongside international diplomats in Regensburg by autumn. He needed to appear capable of ensuring 'universal peace'; this forced him to show that he was willing to settle the question of the Palatinate succession. Arundel prepared to stay in the German lands for the Regensburg summit and Ferdinand III's election, representing the interests of the both British Crown and Elizabeth.

While still trying to establish where they might find the Emperor, Arundel and his entourage voyaged through 'Townes, Villages, and Castles' in the German lands. They found all of them 'battered, pillaged or burnt' from Cologne onwards, and occasionally fed poor, begging people and children with their own provisions.[14] Nuremberg was the first major city which had not been destroyed, so that Arundel was able to look at its rarities in churches, the town hall, and burgher houses. The Englishmen moved on to Linz, stayed in Vienna, and travelled on to Prague. They admired much of Rudolph II's collection of paintings and curiosities, including clockworks and 'cups of Amber', a 'great unicorn', and 'Indian worke' that remained on display. On their return to Regensburg, their coaches soon rolled over the White Mountain battlefield where they saw 'a great company of bones lying by on a heape, where were slaine in all on both sides about thirtiethousand'.[15]

They left for Augsburg on the 21 July. On arrival 'that day and the next was spent in seeing pictures'. Arundel stayed for a week, visiting the new town hall, fountains,

[11] Nadine Akkerman ed., *The Correspondence of Elizabeth Stuart, Queen of Bohemia*, vol. 2 (Oxford, 2013), Letter 227, 19 March 1636.

[12] Crowne, *Travels*, 1.

[13] Akkerman, *Correspondence*, Letter 227, 19 March 1636.

[14] Crowne, *Travels*, see in particular 16.

[15] Crowne, *Travels*, 37.

the 'Fugger house, water works most innumerable and admirable rare and curious buildings and what not delight the eye'.[16]

Hainhofer served as one of Arundel's guides and both men were keen to complete deals. Warfare sharpened the eyes of dealers and collectors for owners or heirs who might be on the brink of bankruptcy and amenable to sell at the lowest price. During the price inflation of the *Kipper und Wipper* time in 1622, Hainhofer enthusiastically told August the Younger:

> We live here in terrible inflation and some people must out of necessity part with things they would otherwise have kept in order to make money from them, which is how about four days ago I bought for your Grace from a household here the twelve Apostles in wood-cuts by Lukas Cranach which are beautifully illuminated, and a thick manuscript medicinal handbook for 14 thalers, whereas the medicinal alone is worth four times that sum.[17]

By the time Arundel visited in July 1636, Hainhofer's economic situation had declined to such an extent that he himself was now at the mercy of art lovers who equally enjoyed getting good deals through wartime profiteering. He struggled to survive. The contributions levied on Augsburgers like him, he complained, 'draw...the marrow out of the legs and the blood from the heart', for 'money', he continued in Italian, 'is nowadays the second blood' of men.[18]

Money needed to flow. William Harvey, whose ideas on the circulation of blood had been published in Frankfurt in 1628, was in fact included in Arundel's entourage during his embassy, Arundel wittily nicknaming the short man 'little perpetual motion', as he was keen to add on a trip to Italy.[19] *En route*, Harvey defended his theory against the German professor of medicine Caspar Hofman, at Nuremberg's University of Altdorf.[20] Harvey's ideas were debated among learned German elites, and Hainhofer picked up on them to create a powerful image of complete financial depletion ruining the body politic. Merchants like him were kept alive by the circulation of money for rarities, pumped by courts as centres of the body politic, and nurtured by an affection for art. Specifically, the Augsburg agent now urgently needed to find a buyer for a final grand cabinet of curiosities he had finished in the fateful year of 1634. He promoted it everywhere and hoped that Arundel might convince Charles I to acquire it.

One month earlier, in June 1636, Hainhofer borrowed a carriage and horse to visit Maximilian I of Bavaria's Munich court on a final diplomatic mission. He negotiated on behalf of the Lutheran duke August the Younger, who unexpectedly had just become the ruler of the principality of Brunswick, and who maintained political neutrality, and thought it a fine idea to recruit Maximilian I as godfather for his son. August had been helped by Emperor Ferdinand II. Maximilian I, meanwhile, had just entered a second marriage with Ferdinand II's daughter Maria in 1635 after his first wife had died an old childless woman.

[16] Crowne, *Travels*, 40.

[17] Bepler, 'Book Collecting', 693, fn.46.

[18] Häutle, *Reisen*, 299.

[19] Häutle, *Reisen*, 389.

[20] Harvey left the embassy in Regensburg to travel to Italy, and therefore did not visit Augsburg; he later rejoined the embassy to travel home.

Duke August's hopes were justified, as all parties calculated to make political gain. Hainhofer's relation of the trip for August once more nostalgically recalled the age of Albert and Wilhelm of Bavaria. For Hainhofer this had literally been the 'golden' age of art lovers, as the men had spent 'many tons of gold on art and rarities'.

Maximilian I, meanwhile, had never given up hunting for Dürers. In 1627, Nuremberg's city council had presented him with Dürer's *Four Apostles* after lengthy negotiations and to protect the city from war contributions and the Catholic League. During the same year, Maximilian I tasked his officials to scout out master paintings in Brandenburg and Lower Saxony via imperial army officers, and wrote to Pappenheim, the prominent military leader who had just brutally suppressed a peasant rebellion for Maximilian I, that he was particularly keen to be offered any pieces by Dürer.[21]

When he visited the court in June 1636, Hainhofer learnt that Maximilian I's finest paintings, especially the Dürers, had been re-installed in that gallery linked to the duke's bedchamber, where they were displayed alongside select rarities from the cabinet of curiosities. Most of the rarities in the cabinet had been looted, just as in Stuttgart and in Mantua. Much had been thrown away and destroyed out of ignorance; precious metals had been violently removed from valuable artefacts to be melted down.[22] Alongside obtaining such information for August, Hainhofer successfully completed his diplomatic mission, and was swiftly instructed to source and send a baptism gift from Maximilian I to the Lutheran duke of Brunswick. Hainhofer dealt with Maximilian I's secretaries; meeting the Bavarian ruler in person remained out of the question. [37.1]

Arundel arrived in Augsburg just weeks after Hainhofer himself had returned from Munich, on the 23 July. The earl was a long-term and prominent member of England's royal commission for new buildings, and clearly keen to see the fruits of Augsburg's classicizing building boom directed by the exceptional architect Elias Holl (1573–1646). Five days later, Hainhofer reported to August: 'here is already the sixth day of the visit of the earl of Arundel, who is buying up all the drawings and beautifully painted portraits he can get'. He claimed that he daily showed Arundel artwork and architecture, and informed August that the earl remained hopeful about successfully recovering the Palatinate for Elizabeth's descendants, depending on conditions to be agreed with Maximilian I of Bavaria. In writing to Duke August, Hainhofer enclosed a description of Arundel's own art cabinet, estimating it to be worth 'many thousands of crowns'.[23] Just like the Duke of Brunswick, the English collector kept buying paintings, sculptures, rarities, books, and manuscripts. So did Charles I, who in 1627 had acquired the best

[21] Goldberg, 'Dürer-Renaissance', 140.
[22] Häutle, *Reisen*, 293–4.
[23] Gobiet, *Briefwechsel*, 625–5, nr.1187; the description is no longer extant. See Marika Keblusek, 'A Frugal Man in the "Kunstkammer". Cultural Exchanges between Thomas Howard, Earl of Arundel, and Philipp Hainhofer', *Wolfenbütteler Barock-Nachrichten* 41(1/2, 2014), 95–110, here 95–6, 101, fn.22.

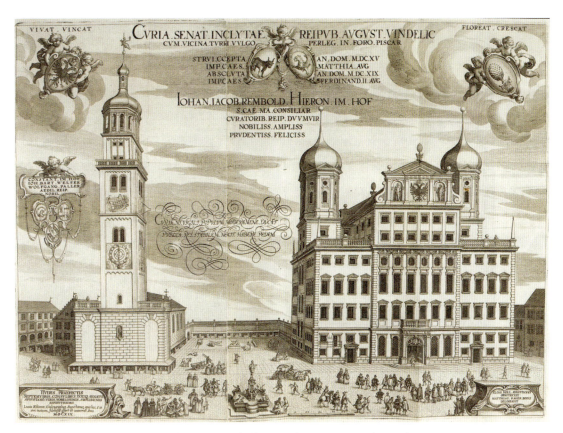

Fig. 37.1 A depiction of Elias Holl's new town hall in Augsburg in 1620 and its wide square. Between 1594 and 1620 Holl intended to rebuild Augsburg as an ideal city founded by the Romans and in the image of Rome. Herzog August Library, Wolfenbüttel, http://diglib.hab.de/mss/23-2-aug-2f/start.htm.

Italian and Flemish master paintings and antique sculptures in the Gonzaga's Mantuan collection at extraordinary cost. [37.2]

A new age of connoisseurship, consumption, and imperial projects in the British Isles was heralded by Arundel, his wealthy, art-loving wife Alathea Talbot, and the much younger Charles I. Arundel himself had only converted to Protestantism in 1616 and most likely for diplomatic reasons; he descended from a prominent recusant family and his wife remained a Catholic. Lady Arundel's own villa in London reflected the recent surge in Asian trading by Dutch and British merchants, as much as their success in plundering Portuguese ships and their cargo. Asian goods were increasingly marketed in London's two refined shopping areas—the Royal Exchange that opened in 1571 and the New Exchange that opened in 1609. In Lady Arundel's house, 'Indian' furnishings provided the backdrop for an enormous collection of porcelain. Leather covering for the floor in red and yellow matched those on the wall.[24] A circle of ladies met in Lady

[24] Linda Levy Peck, *Consuming Splendour: Society and Culture in Seventeenth-Century England*, (Cambridge, 2005), 18–19, 45–9, 83.

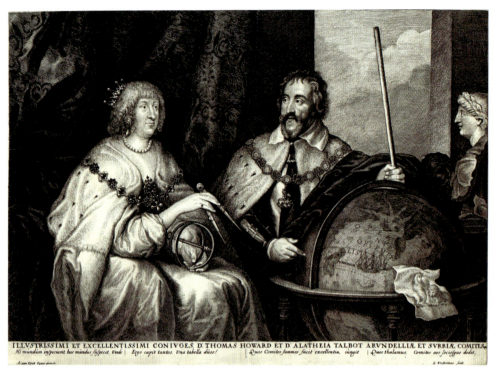

Fig. 37.2 Lucas Vorsterman I (after Anthony van Dyck), Alathea Talbot, Lady Arundel, with a compass and armillary sphere, and Thomas Howard, earl of Arundel, pointing to Madagascar on a large globe, after an oil painting by van Dyck in which they appear decorated and clad like a royal couple, engraving, c.1640–50. © Trustees of the British Museum.

Arundel's house to perfect recipes and cures. Alathea reflected the Stuart drive for improvement in refinement and manufacturing via a more international outlook. She was the first English person to sit for Rubens and owned a rich collection of Netherlandish and Italian paintings.[25]

In London, the first age of Renaissance wonder and curiosity turned into an age of improvement. The legacy of many practices that had been dear to humanists such as Pirckheimer continued to shape intellectual circles in the city and ranged from the recovery and annotating of manuscripts to trying out recipes. A love of scholarly learning ever more frequently mixed with practical knowledge, an interest in people, novel plants, animals, and artefacts from across the globe, accompanied by restless acquisitiveness, ruthless trading, and competitive display. Lady Alathea owned Hieronymus

[25] Linda Levy Peck, 'Building, Buying, and Collecting in London, 1600–1625', in Lena Cowen Olin ed., *Material London, c. 1600* (Philadelphia, 2000), 268–92, here 272; Jennifer Rabe, 'Mediating between Art and Nature: The Countess of Arundel at Tart Hall', in Susanna Burghartz, Lucas Burkhart, Christine Göttler eds., *Sites of Mediation: Connected Histories of Places, Processes, and Objects in Europe and Beyond, 1450–1650* (Leiden, 2016), 183–210.

Brunschwig's book on the art of distillation that had been translated into English during the sixteenth century and she was one of the first English ladies to publish a recipe collection advertising her circles as skilled in 'anatomizing nature'. Just like Pirckheimer and Behaim, these ladies experimented with making *aurum potabile*, while the men in their circle still cared about recipes that restored 'new hair color'd as in Youth'. These wish lists were fired by a new optimism for the idea that recovering old knowledge and engaging in new experiments could renew both people and the world. Hence hair dyes for men, for instance, were not necessarily rejected as an idle vanity project but related to a positive desire for prolonged youth, strength, and health in mankind as originally created by God.[26]

For decades, London bustled with men and women, most of them humble, who observed each other's experiments in a collaborative spirit. Literacy rates were high, and collections as well as ambitious gardening projects had multiplied. Refugees who had settled in London, including many Germans, shared technological advances in relation to scientific instruments and problems ranging from how to save fuel in breweries to identifying new dyes, and medical cures.[27] In fact, the experiments of these ethnically and socially immensely diverse groups were often alchemical rather than mechanical.

Elites increasingly regarded their interests and discoveries to be matters of public significance in a society they deemed to be held together by shared interests, passions, and desires. In line with religious views, men and women were not seen primarily as rational creatures and capable of achieving stoic self-control. It was in their nature to be responsive to passions and sensations stimulated by different types of visual impressions, matter, and artefacts, such as those assembled in cabinets or curiosities. In this lay advantages. This was in line with the renewed emphasis among many writers and scientific thinkers that God himself was not just a lover of regularity but of playfulness through endless new creations in nature which remained ongoing. His designs were for mankind to marvel at and for societies to profit from. Powerful utilitarian voices advised that wonder and ingenuity thus could be instrumentalized to benefit societies through the more systematic generation of knowledge and disciplined ordering of experience (even if this meant compiling incomplete lists for projects, queries, and problems to be solved) to implement economic policies and projects. Arundel, for instance, admired Walter Raleigh and invested in projects for a Madagascar company, not least to make profits that would allow him to further invest in art.[28]

The Arundels sought out agents, collectors, and churches. Arundel used his political influence to further commerce, and his access to Charles I meant that agents and

[26] Vera Keller, *Knowledge and the Public Interest, 1575–1725* (Cambridge, 2015), 3; the reference to hair dyes comes from Robert Boyles's papers.

[27] Deborah E. Harkness, *The Jewel House: Elizabethan London and the Scientific Revolution* (New Haven, 2007).

[28] Keller, *Knowledge*, 4–22; Howarth, *Lord Arundel*, 167–9; Alison Games, *The Web of Empire: English Cosmopolitans in an Age of Expansion 1560–1660* (Oxford, 2008), 181–90.

merchants equally eagerly searched him out. In fact, in 1626, Hainhofer himself approached a German broker at the British court to mediate correspondence with Arundel.[29] Hainhofer's profile matched that of other art agents the Arundels already knew. Since 1633, they had developed close relations with the Flemish Calvinist merchant agent Daniel Nijs (1572–1647), who lived in Venice, traded in textiles, other luxuries, such as lace ruffs for English aristocrats, rarities, and political information, and organized the sale of the Gonzaga's Mantuan collection. Charles I's much delayed payments for the collection significantly contributed to the agent's bankruptcy. As a result, while in Regensburg during his trip to the German lands in 1636, Arundel managed to acquire Nijs's much admired ebony cabinet filled with 'rare paintings, medals, shells and similar curiosities'. The art-loving ambassador paid under half of what it had been valued at in 1631, and in turn was not personally interested in any cabinet Hainhofer had to offer. Nijs and his destitute family moreover received only part of the payment outright; the rest was provided in a place to rent in London and an annual pension.[30]

While Arundel tried to drive hard bargains, he certainly knew when not to be mean. He built and bought so much that he himself fast accumulated debts and still offered to pay more than any competitors. In 1625, for instance, Arundel had been thrilled that the energetic and brilliantly efficient Reverend William Petty, who had served him since 1613, had safely arrived in Istanbul to 'find Antiquities' for him. Arundel knew that the Duke of Buckingham pursued exactly the same hunt for precious classical sculptures and manuscripts. Petty found 'six antiquities in one wall' of Constantinople and more in another. He looked at the Triumphal Arch of the Golden Gate erected by Theodosius the Great in 390. 'Money', Arundel now wrote excitedly, 'will doe any thinge, and I am willing to bestowe it.'[31] Thomas Roe, the British ambassador in Istanbul who favoured Buckingham, advised that simply stealing the sculptures was too dangerous, and that buying them from the Ottomans would be impossible. However, they could be removed once a clergyman had made it plausible that they violated Islam, then could be taken to a private place, 'from whence, after the matter is cold and unsuspected' the sculptures might be transported to England for a sum of around 600 crowns.[32]

Arundel's choice of sending a chaplain and trained classicist had been particularly clever—Petty was able to decipher inscriptions and convince the Ottomans that these antiquities did not accord with their religion. Cyril Lucaris, a leading Greek Orthodox theologian with a residence in Constantinople, was already nicknamed the 'Protestant

[29] Keblusek, 'Frugal Man', 103.

[30] Christina M. Anderson, *The Flemish Merchant of Venice: Daniel Nijs and the Sale of the Gonzaga Art Collection* (New Haven, 2015), esp. 67–71, 161. For connections to the textile and art trades see also Levy Peck, *Consuming Splendour*, 178–9. For Arundel's collecting in a comparative perspective see Krzysztof Pomian, *Le musée, une histoire mondiale*, vol. 1 (Paris, 2020), 464–70.

[31] Mary F.S. Hervey, *The Life, Correspondence & Collections of Thomas Howard Earl of Arundel, 'Father of Vertu in England'* (Cambridge, 1921), 270; see also David Howarth, *Lord Arundel and his Circle* (New Haven, 1985), 88–93 and Michael Vickers, *The Arundel and Pomfret Marbels in Oxford* (Oxford, 2006).

[32] Hervey, *Arundel*, 271–2.

patriarch' because he had corresponded with a Dutch minister from 1612.[33] In the meantime, Reverend Petty travelled on, found further astonishing Greek antiquities for Arundel, got shipwrecked, lost everything, and recovered some with the help of local fishermen who dived deep and hoisted them onto the shore ('there was never a man', Roe noted with admiration, 'so fitted to an employment, that encounters all accidents with so unwearied a patience; eats with Greekes on their worst days; lies with fishermen on planks, at the best; is all things to all men ...').[34] Roe devised elaborate plans on how the Golden Gate statues might be stolen, while lamenting to Arundel about forgeries of classical statues he himself had been landed with at great expense. One of these botched forgeries had been transported to Constantinople on an eighteen-day journey by mule. Alas, this 'half-woman' lacked a hand, nose, and lip, and, Roe thought, 'is so deformed, that shee makes me remember [someone in] a hospital'.[35]

Roe knew that real rarities could be converted into political currency to gain advancement—a French priest employed by Charles I's wife Queen Henrietta Maria had apparently travelled in the East 'robbing all Greece' by borrowing precious manuscripts from patriarchs in monasteries that he never returned. Roe thought that he would have gifted them to Rome in the hope of a cardinal's hat.[36] Recklessness, art loving, a thirst for knowledge and trade were inextricably intertwined. Art lovers masked the realities of looting and deals brokered in asymmetrical power relations through a rhetoric of friendship: acquisitions came about through loving service and shared affection within their network. Arundel signed his letter to Roe as his 'most affectionate true frende', and told him that Reverend Petty spent all his time showing Arundel his 'love' through dedicated service.[37] Arundel received his marbles from the East in 1627; a team of three scholarly experts led by John Selden immediately set upon deciphering the Greek and Roman inscriptions in his garden and only a year later had published the catalogue.[38] The sculptures are now among the treasures of the Ashmolean Museum in Oxford.

The way in which art was obtained, through theft, looting, imperial scramble, or bargains, left no mark once objects had entered collections. Owners of these collections obliterated these histories by providing a refined setting in a new location. Peter Paul Rubens (1577–1640), the Flemish artist and diplomat whose own identities blended and blurred those of an artist, art lover, and Spanish ambassador, hence thought he had never seen anything as rare as Arundel's marbles. He portrayed Arundel in 1629 and formed a high opinion of the English. They seemed a 'rich and flourishing people, at the height of peace', when he might have still expected the country to be rather barbarian.[39]

[33] Swan, *Rarities*, 179.
[34] Hervey, *Arundel*, 274.
[35] Hervey, *Arundel*, 274.
[36] Hervey, *Arundel*, 276.
[37] Hervey, *Arundel*, 277.
[38] Hervey, *Arundel*, 280.
[39] Hervey, *Arundel*, 283.

Art in this way indexed civility and social practices that turned into political currency. Rubens's embassies sought to ensure among the gentlemen that accompanied him 'sweetness and courtesie' in behaviour, and carefulness 'by all meanes to avoid discourse or arguments of Religion or State; leaving all Nations to their owne Laws and Customs'. Just as Hainhofer had seen in Eichstätt, art served as a perfect topic of uncontroversial conversation between men of different confessions and territories, and during lengthier stays at courts, at political summits or in cities, provided a much-needed alternative pastime to hunting and drinking.[40]

Arundel hence always kept several irons in the fire regarding the enlargement of his collection. He was always quick to respond to agents, and ready to strike 'whilst the iron was hotte' when a ruler was bankrupted, a New Christian merchant was imprisoned by the Inquisition, or when other calamities forced collectors to sell.[41] In 1636, he was on a German wartime shopping spree during this intermittent period of peace negotiations. Arundel had stayed in Nuremberg for eleven days, until he was sure where in the German lands to find the Emperor. He told William Petty that he had come to a most miserable country in which there was nothing to be bought, while in Nuremberg there was: 'not one scratch of Alb: Duers paintinge in oyle to be sold, though it were his Countrye, nor of Holbein, nor any other greate Master. They say within these three or four yeeres great store of good things have bin carried out at easy rates; and, not longe since, a Liefehever [art-lover, UR] dyinge, an Italian hath bought and carried away many of AD drawings'.[42] Arundel tried to track this Italian down. Another letter instructed Petty: 'I have bidden Walker write you by this, the name of the merchant in Bologna which showed Daniel Neece so many designs of Alberto Durero there, which I pray enquire of'.[43]

As we have seen, Lutheran Nuremberg precariously tried to retain neutrality during the war, and hence treated the ambassador's visit as an opportunity to strengthen its diplomatic ties: the magistrates showed Arundel around, supped him, dined him again the next day, and recommended him to 'take the air in some of the Gardens'. By the time Arundel returned, on his way back to England in November, they had prepared 'a long Dutch poem' to please him. Arundel knew Dutch but no German. Hainhofer corresponded with him in Italian and presented him with a description of his latest art cabinet in French. In any case, speaking modern languages was an art lover's way, as vocabularies moved with the time to accommodate new inventions, names, and things.

[40] See the instructions issued to his entourage in 1632, Hervey, *Arundel*, 315.
[41] Hervey, *Arundel*, 369; see also Marika Keblusek, 'The Pretext of Pictures: Artists as Cultural and Political Agents', in ead and Badeloch Vera Noldus eds., *Double Agents: Cultural and Political Brokerage in Early Modern Europe* (Leiden, 2011), 147–60.
[42] Hervey, *Arundel*, 365–6.
[43] Hervey, *Arundel*, 385.

During that November 1636, the English ambassador was finally shown Nuremberg's town hall with what remained of its impressive painting collection. Exceptionally, and as a representative of the English King, he was presented with two Dürers: the 1498 self-portrait, and thus a rarity, and a portrait of Dürer's father. The latter is now in the National Gallery in London and appears to have been a copy. Its background showed cracks, either through the poor technique of a copyist or because the artificial ageing of copies of masterpieces through cracking was already a common technique.[44] Just like Maximilian I of Bavaria, Arundel educated young connoisseurs how to tell a copy from an original through extensive exposure to art, not least in order not to be overcharged as future buyers.[45] In an ever more integrated European art market, the circulation of originals, authorized copies, and forgeries increased. Arundel's ability to obtain copies of paintings in the royal collection as authorized replicas served as a mark of privilege. He asked for copies of both the Dürer's paintings he received for the British King at Nuremberg, and asked the artist Wenzel Hollar (1607–77), whom he had met on this trip to Cologne and had patronized ever since, to create engravings of them. These engravings informed others of the fact that they were made after paintings in Arundel's collection, promoted the collection's value, and even suggested that he owned the original. [37.3]

During that final November visit to Nuremberg, Arundel had been shown further Dürers in local patrician collections. He visited the castle in Nuremberg and was treated to two further dinners. Next, having hired one hundred musketeers for protection, Arundel travelled on via Würzburg, where the bishop presented him with the 'Picture of our Ladie, done by Albertus Durerus, being one of his best peeces'.[46] The account obscures whether or not Arundel paid for these Dürers, but the context strongly suggests that he did. Here was an art lover travelling through war-ravaged parts of the country with money to buy art.

His Catholic upbringing and sympathies would have made him particularly esteem a painting of the Virgin Mary. Did Arundel tell any of his Catholic acquaintances that he had never known his father, who had miserably died as a recusant imprisoned in the Tower of London, and that his mother, a noted poet, had lost many of her possessions and lived under house arrest during Queen Elizabeth's reign? It would have softened their hearts. To Reverend William Petty, Arundel coolly reported at the end of November: 'The Bishop of Wirtzberge on Thursday last gave me a fine Madonna, originall of AD, worth *all the trash* I have bought in this countrye.' A further letter to Petty added, if rendered in modernized spelling: 'I wish you saw the Picture of a Madonna of AD which the bishop of Würtzburg gave me last week as I passed by that way;

[44] Susan Foister, 'Dürer's Nuremberg Legacy: The Case of the National Gallery Portrait of Dürer's Father', https://www.nationalgallery.org.uk/media/15326/durer_nuremberg_legacy.pdf, 1–8.

[45] Hervey, *Arundel*, 383.

[46] Crowne, *Travels*, 54–7.

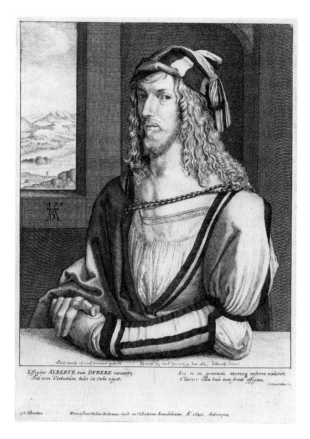

Fig. 37.3　Wenzel Hollar, engraving of Albrecht Dürer's 1498 self-portrait, 1645. Rijksmuseum, Amsterdam, public domain.

and though it were painted at first upon an eneven board, and is varnished, yet it is worth more than *all the toyes* I have gotten in Germany, and for such I esteem it, having ever carried it in my own coach since I had it; and how then do you think I should value things of Leonardo, Raphael, Corregio, and such like!'.

He beseeched Petty to only buy paintings for the Arundel family.[47] By December, the diplomat and his entourage had reached Düsseldorf to continue their voyage on the Rhine, when, as William Crowne's official description of the trip reports, 'as soone as we came but neere the shore, out came the Noble Duke of Neuburgh, and clambered over other Ships to come into ours,…, being much joyed at our safe returne, and had made provision at his House to entertaine his Excellence, but perceiving he would not stay, sent for a wilde Bore, Wine, and *five Pictures*, and presented them to his Excellence,…'.[48]

[47] See Hervey, *Arundel*, 394, my emphasis. The second original letter is in the British Library, Add. MSS. 15970, f.58.

[48] Crowne, *Travels*, 64, my emphasis.

The Imhoff Sale

To leave Germany with three rare Dürer paintings was an extraordinary coup. But there had been more to the Nuremberg deal. When Arundel had made his particular interest in anything connected to Dürer known during his first visit to Nuremberg in May, the heirs of the Imhoff family were interested. As we have seen, their father had lamented in his 1573 inventory how little his uncle Willibald Pirckheimer's library had been valued. The values of his Dürer paintings had not increased either, and investment in art of this kind, at this point, had seemed unprofitable. It was a passion, as well as a commitment to his heritage, rather than pure economic reason, that had driven Pirckheimer's collecting. Imhoff, the major collector of Dürer's prints and paintings, had died in 1580. Eight years later, Rudolph II raised the idea of purchase to his widow, Anna Harsdörferin, who hailed from one of Nuremberg's patrician families and whose mother had been a Welser. Her response indicates that she had mixed feelings about her husband's passion. Naturally, she stressed the fact that Willibald Imhoff had built up the collection 'over many long years and at great cost' and had already been approached by many princes and foreign potentates willing to pay 'big money'. This was probably true. In any case, he had regarded art as his treasure, so much so that he had asked several of his sons on his deathbed to vow that they would never sell it. The collection was to be kept intact as a mark of eternal honour for the Imhoff family. However, Anna's letter to Rudolph II now quickly changed in tone. She was happy to hear about the Emperor's pleasure in the pieces he had specified and would send them by cart and well packaged to Prague straightaway. The letter also included an inventory of all the 130 works by Dürer the family owned. Anna was more than ready to sell to the Emperor.[49] [37.4]

Two decades after Anna's death in 1601, her son Hans Hieronymus remembered things differently still. According to him, Willibald had told his sisters on his deathbed that he regretted having spent so much money on art and that he had lost all pleasure in it; it would be up to his sons to decide what to do with the collection. Maximilian I of Bavaria had contacted them as heirs, but they had only sent him works after further pressure. Maximilian I had then judged many of them copies and bought very little.

The family's fortunes turned in 1633, when the Dutch agent Abraham Bloomart (1626–c.1675) had approached the family on behalf of the learned and cultivated Amsterdam merchant Joachim de Wicquefort (1596–1670). Wicquefort was among the best-connected art lovers of his time, and hence characteristically curious about a wide range of objects. He was just becoming an active diplomat in the German lands at the time, and was enthusiastically extending the range and significance of his collections.

[49] Fritz Koreny, *Albrecht Dürer und die Tier- und Pflanzenstudien der Renaissance* (Munich, 1985), 263–5.

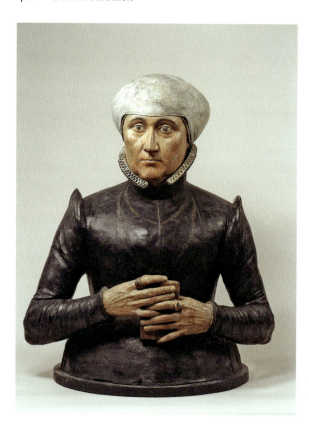

Fig. 37.4 Johann Gregor van der Schardt, bust of Anna Imhoff (1528–1601), terracotta and paint, c.1580. Bode Museum, Berlin. bpk/Skulpturensammlung und Museum für Byzantinische Kunst, SMB/Jörg P. Anders.

In 1634, Wicquefort thus told a friend who was about to return to Bantam as a commander of a Dutch East India Company fleet that he 'was curious' about acquiring as much Chinese glass and porcelain as possible from Batavia, as well as sandalwood cabinets, carpets, 'curious small paintings', and many other things. A noted French diplomat visiting Wicquefort's collection in 1644 was duly struck by the 'curiosities, medals, agates, engraved stones, vases, crystals, objects from the East and West Indies' he owned. Indeed, on ordering agate and jasper cups Wiquefort had noted that he valued them the 'larger and the more bizarre in colours' they were.[50] Dürer's works were incorporated into just such rich displays before they were sold on. They were part of Dutch merchant homes which were furnished to create a stimulating environment to further bonds with other men and women through shared interests in music, art, and literature that had the power to forge political loyalty.[51]

When Bloomart approached Imhoff's sons on Wicquefort's behalf, they felt confident enough to decide that their father's will did not actually specifically comment on

[50] Swan, *Rarities*, 64, 88, 245.
[51] Marika Keblusek, 'Merchants' Homes and Collections as Cultural Entrepôts: The Case of Joachim de Wicquefort and Diego Duarte', *English Studies*, 92/5 (2011), 496–507, here 502.

the art cabinet or bind them to keep the collection. They faced economic hardship because of the war. It seemed fair to turn their father's investment into cash, especially as many watercolours were already in bad condition. This was likely to get worse. Hans Hieronymus Imhoff sent a selection of good and bad pieces to Amsterdam, and was overjoyed when Bloomart responded to a local painter's evaluation with an offer of 3,400 imperial florins in cash.

This was an enormous sum, especially as some of the pieces were, as Hans Hieronymus Imhoff conceded, likely to have been forgeries. They instantly agreed on the sale. In 1634, the brothers sold further pieces from the larger collection to Mattheus van Overbeke (1584–1638), a German-born merchant and art lover who had settled in Leiden and held salons at his house.[52] Overbeke bought the Imhoff's pieces for 700 imperial florins without even having seen them, and then disliked most of what he received. In some ways, this was not surprising, as such collections mixed quality designs with quick sketches and later forgeries or copies, rather than being carefully curated.

But the deal was done. The Imhoff family sales were part of the more general depletion and destruction of German family collections, including libraries and archives, not only through bankruptcies, the war, and the need to realize assets in difficult times but also through ignorance. For example, after the Welser merchants had gone bankrupt in 1614, Hainhofer reported to August the Younger, 'their heirs have burned all such correspondence and letters, perhaps through ignorance or from shame that such a distinguished family has become insolvent and thus robbed many honest people, widows, and orphans of several thousand florins'. This included manuscripts and books assiduously assembled by the noted humanist Marcus Welser. Meanwhile, Hainhofer continued,

> the Peutingers, whose ancestor was also a very learned man and advisor to Emperor Friedrich, are also said to have a very fine correspondence, but I do not know whether they would be willing to sell. Mr. Ilsung in Trazberg, Landvogt in Swabia, was also a learned man and now and again had correspondence with prominent people, but their fine writings were burned with the whole of Trazberg by the Swedes. This is said to have been a wonderful thesaurus of learning.

By 1630, Hainhofer tried to sell his own manuscripts and books to August, expecting to leave his 'palace' in Augsburg to move to 'a cellar in Nuremberg'. In 1645, he professed, 'the vicissitudes of the times have sadly robbed me of all my things and rarities, and what I have left is pawned'.[53]

All of this explains why for families such as the Imhoffs, any possibility to sell to known art lovers during such precarious times seemed a lesser evil. Arundel took time from his diplomatic mission to look at items in person and closely. He visited the Imhoffs three times and wanted the Pirckheimer library, although he would soon, as we have seen, speak about it ironically as part of the 'trash' he had acquired in Germany.

[52] Keblusek, 'Merchants' Homes', 496.
[53] Bepler, 'Book Collecting', fns.50–3.

As Hans Hieronymus's brother had died, the guardians of his children argued that many of these books were now available in modern editions and that the manuscripts were difficult to read. They were mostly in Greek. It was time to sell.

Still, Hans Hieronymus Imhoff struggled more in trying to justify accepting an offer for the library than deciding to sell the paintings. He came up with four good reasons. His wife was extremely ill, he suffered from a bad fever, his garden had been demolished, and his income from land was depleted through the long years of warfare. He needed cash. He tried to sell the library for 400 imperial florins. Arundel had his way, assessed each item closely and only paid 350—not a great deal for the Imhoffs, but at least no loss. Arundel quickly turned to the rest of the collection. The British earl dropped and broke two large Jasper gemstones, but bought fourteen of the beautiful deer antlers Pirckheimer had loved, and collectors like the Bishop of Eichstätt still esteemed, because 'nature played wonderfully' in them. The Imhoffs tried to sell the remainder of the collection quickly at the summit in Regensburg, but made little profit, and then sold some more pieces to Overbeke in 1637, and other parts of the collection, mostly unprofitably, over the next years.[54] Wicquefort's generous offer had been the family's only great lucky break.

Arundel was forever on fire to collect. His political mission had failed; Charles I unsurprisingly proved unwilling to wage war against Spain to recover the Palatinate. While the embassy had been extremely costly for the monarch, it was worthwhile in terms of the acquisitions. As soon as Charles I returned to London, he privately visited Arundel to 'see the pictures he has brought from Germany'. Arundel's next mission was to work on the Vatican's agent to convince the Pope of agreeing to release valuable ancient statues once owned by the Pighini family, for Charles I. In February 1637, the Vatican agent was shown around Lady Arundel's house in the presence of the King. The men joked about her husband's eagerness to amass paintings by particular artists but never to give them away: Arundel by now owned thirty Holbeins and, when pressed, professed to support the doctrine of free will (which Erasmus had famously defended against Luther) 'in everything except in the matter of giving away pictures'. Alathea cruelly suggested that they 'give the Queen a most beautiful altarpiece by Dürer'. Arundel was dismayed and, much to the amusement of observers, started quarrelling with his wife. The Queen 'at first made difficulties, saying it would be a pity to deprive people of what they seemed so much to delight in', whereupon the papal agent wittily assured her that 'it would be a work of charity to remove any occasion of dissension between husband and wife'. Queen Henrietta Maria was devoted to religious art with

[54] Koreny, *Tier- und Pflanzenstudien*, 263–6; Keblusek, 'Frugal Man'; Grebe, *Dürer*.

Catholic themes, and so it is perfectly possible that the Bishop of Würzburg's *Madonna* by Dürer entered her collection. Arundel, meanwhile, next pursued Persian treasures. He invited guests appropriately dressed in Oriental clothes for a Persian-themed banquet before Lent, and persuaded Charles I to have his ambassador in Persia accompanied by a painter able to capture everything—architecture, 'antiquities, and other curiosities'.[55] Further commercial links with Persia were of great interest at the time. International trade, knowledge, and collecting could make the world seem full of opportunities despite the ever greater devastation through warfare on the Continent.

The 1637 Amsterdam Crash

In January 1637, Arundel ordered his secretary to follow up the sale of six precious books of Dürer's work that the Imhoff brothers had sold to Joachim Wicquefort. Once more, Arundel knew how to strike when 'the iron was hot' and exploit the fact that other art lovers were in crisis. Prices for tulip bulbs had boomed in the Dutch Republic since August 1635. They bust in precisely the months between February and April 1637.

Dutch art lovers suffered, as some of their gardens stocked bulbs which cost many hundreds of florins each. Switsers, the most coveted tulip variety, had recently been auctioned at over 1,000 florins a bulb. The value of most paintings, by contrast, had remained consistently low. Around *twenty per cent* of all paintings which sold at Amsterdam auctions in their thousands cost just about *one florin*. In the period between 1597 and 1619, just one per cent of paintings sold for over 100 florins at these auctions, and even fewer in the period 1620–38.[56]

As regards tulips, the bottom suddenly fell out of a roaring market for rare varieties, leaving sellers with bulbs for which their buyers no longer paid. As prices dropped, men such as Wicquefort clearly became nervous about a loss in the value of other parts of their collection they had paid good money for—in this case his Dürers. Dutch moralists decried these brief months of crisis as a sign that the 'tulipmania' had been the downfall of men overly invested in material possessions. In truth, spring 1637 sparked the first major debate about what it meant to live in a material society, and especially what it meant when suddenly art lovers no longer agreed that the same things were that valuable and thus could no longer trust each other in their intellectual and commercial evaluations.[57] Connoisseurs faced a social and cultural crisis. There was no prolonged financial collapse, but neither did the prices of paintings and prints rise during the next years. Art lovers who frequented auctions did their best to keep prices low.

Daniel Mytens (*c.*1590–1647/8), Arundel's trusted artist, acted as his intermediary in Amsterdam and sought out whether Wicquefort might be willing to sell. He reported that he could not buy the books for below 500 gilders. In addition, he would chase up

[55] Hervey, *Arundel*, 398–401.
[56] John Michael Montias, *Art at Auction in 17th-Century Amsterdam* (Amsterdam, 2002), 74; table. 9.2., 89.
[57] Anne Goldgar, *Tulipmania: Money, Honor, and Knowledge in the Dutch Golden Age* (New Haven, 2007), 260.

pictures by Dürer, Holbein, and Raphael in Amsterdam 'to see and cheapen them'.[58] Just as with Rottenhammer, it made sense to employ artists as experts confident to judge a master's hands and happy to be complicit in driving bargains. By the middle of March 1637, Mytens could report his success: he had brought down the Dürers and other pictures in Amsterdam to the 'lowest price', buying

> a woman's picture to the knee (of Andre del Sarto as they saye, but we hold it to be of Titciano) at 600 gil(ers). A man's picture of Holbeen, a foot high, 300 gild. A Madonna of Albert Dürer, about the same highte, at 150 gild. A dead man of Albrecht Dürer, in water cullors, at 120 gild. A picture of Raphael which is held to be of his hand, but we hold it not so to be, and is held at 60 gild. Six books, as I have written before, at 500 gild: amounteth in all to 1730 gild.[59]

When an extensive collection of Dürer's woodcuts and copper plates that had been sold by his brother Endres to the artist Bartholomäus Spranger came up for auction in Amsterdam in February 1638, prices remained affordable despite the fact that the sale happened just before the bust. Spranger's collection in Prague had been brought to Amsterdam by his nephew Gommer, a wealthy merchant who died in October 1637. Dürer's own annotated copy of his book of proportions sold for 2½ florins. Rembrandt was a regular at these friendly auctions, held among like-minded connoisseurs, most of whom were merchants and enterprising artistic craftspeople like himself. The inventory records that Rembrandt bought '12 cooks by Alboduer'. Five of his friends bought the same number of woodcuts of the cook and other Dürer prints for around 2 florins a lot. Dürer remained among the most consistently valued printmakers in the Netherlands and Europe; some impressions even went for less. Rembrandt and his friends bought multiples and traded them on, so that a single Dürer print retailed for *stuivers*—for pennies rather than florins.[60]

And so, Europe's art market rolled on. In June 1637, the Arundel family was spreading its tentacles to Basel, especially to target the renowned collection of Basilius Amerbach through which they hoped to obtain more original master pieces by Holbein. Holbein the Younger (1497–1543) had been a generation older than Dürer, and no meeting of the two most famous German Renaissance artists is recorded. Holbein's father had trained him to perfection as a painter by the age of eighteen. Holbein had left his native Augsburg nonetheless because he would not have been able to make a living as a painter. Basel, the city of print, seemed more of a prospect for a regular income. After

[58] Hervey, *Arundel*, 404–5; these books of drawings were referred to earlier in Arundel's correspondence.
[59] Hervey, *Arundel*, 405.
[60] Montias, *Art*, 177–8.

the Reformation, Holbein then left Basel to gain more opportunities as a painter and ended his career in London, where he served King Henry VIII.[61] Arundel's fascination with Holbein and Dürer made these German Renaissance geniuses more visible in England than they had ever been elsewhere. Hollar, who kept working for Arundel, was deeply engaged with both their artistic styles and made them known to broader circles through brilliant engravings that copied their work.

Frugal Times and New Opportunities

Yet for Arundel none of this passion for art led him to become a benevolent patron of contemporary makers. Hainhofer himself complained in 1638 that the earl was 'frugal' with his money, and tried to pay only half of what any object was worth. Hainhofer knew that England had now emerged as an affluent market. He judged that what remained of his own cabinet was only worth £1,000, while the art cabinet he had finished in 1634 needed to be sold for £2,500. He still targeted the King as a potential buyer. The price seemed realistic, provided negotiations could be kept secret from Arundel.[62] The war had taken its toll. Hainhofer now wrote rambling letters. He claimed that no German craftsmen were left who could make anything like his cabinet. It featured inlaid copper paintings of Mars, Venus, and Cupid as allegories of love aiming to overpower war. This vision seemed out of step with the contemporary reality of prolonged warfare on the Continent and its rationale, as Europe's major powers fought amongst themselves. Hainhofer's cabinet, which he had wanted to sell to Charles I, included £30 worth of shells, Indian feather-work, scientific instruments, board games, a pharmacy, a barber set, and much more: it was a final unique production of Hainhofer and his team that drew on over twenty-five years of collecting. An engraving by Dürer decorated the inside of one of the cabinet's doors.[63]

The timing was bad: Antwerp's resurgence as a centre for the production of art in Europe which could be shipped overseas to the Americas, meant that its craftsmen quickly assembled cabinets that could be customized by owners and were offered at a more affordable price than those of Augsburg's cabinetmakers, and especially Hainhofer's bespoke artistic creations.[64] Six months later, in 1638, Hainhofer renewed his approach to Arundel as broker, and this time he lowered the price. Could the earl facilitate a sale of the cabinet to Charles I for just £2,000?[65] No reply is preserved, but we know that the sale came to nothing. To lower the price, Hainhofer eventually had to divide the cabinet into an upper part that was sold to Vienna, while Duke August of Brunswick-Wolfenbüttel, who had watched Hainhofer become increasingly desperate,

[61] Hervey, *Arundel*, 406.

[62] Sheffield University, Hartlib Papers, 36/3/3A-10B, 22 April 1638; Keblusek, 'Frugal Man', 106–9.

[63] Sheffield University, Hartlib Papers, 36/3/11A-12B, April 1638.

[64] Nadja Baaadj, 'Collaborative Craftsmanship and Chimeric Creation in Seventeenth-Century Antwerp Art Cabinets', in Burghartz et al. eds., *Sites of Mediation*, 270–96.

[65] Keblusek, 'Frugal Man', 109.

bought the lower part just days before Hainhofer died in 1647, to satisfy the powerful Swedish general Wrangel with a secret diplomatic gift. Hainhofer had to drop its original price by half, to 6,000 imperial thaler.[66] The total assessed wealth of Augsburg's merchants now merely stood at one-sixth of the pre-war level; its population had declined by over fifty per cent. Even so, Augsburg's luxury trades would revive and Hainhofer's international business doubtlessly would have continued to flourish if he had lived on beyond these darkest times.[67]

Yet overall, as we have seen, states had now taken over from influential cities to spearhead destructive or progressive policies. Developing domestic industries was a foremost concern. In Germany, war-ravaged cities such as Augsburg hence contrasted to new model towns such as Friedrichstadt in the North of Germany, founded by Duke Frederick of Schleswig. In 1618, the Husum laywer Hermann Lather had dedicated a political treatise to the young duke, outlining 'the political utility of the patronage of arts, new inventions, manufactures, urbanism', and collecting rarities.[68] Protestant Friedrichstadt allowed craftsmen and merchants of different faiths to settle, including Sephardic Jews from the Netherlands. While Augsburg was under siege and suffering its worst years, Frederick sent ambitious embassies to Muscovy in 1634–35 and Persia in 1635–39, not least to build a silk road reaching from Holstein to China. His castle Gottorf encompassed a Persian garden, an alchemical laboratory, a great library, rarities from one of Europe's foremost collections of exotica, and paintings—some of them obtained from Charles I's collection.

In October 1648, the Peace of Westphalia ended the Thirty Years' War. Meanwhile, the English Civil War had broken out in 1642; Arundel and his wife died in exile. In 1649, King Charles I was executed, and his collection was used to settle debts. David Murray, the King's tailor, presided over a group of discerning creditors who were satisfied with the objects they were allocated to sell on, including Dürer's self-portrait and painting of his father, valued at one hundred pounds. A group presided over by the King's embroiderer was awarded a Titian and Rubens's *War and Peace*.[69] As we have seen in this book, the royal tailor and embroiderer would not have been 'ordinary people'—they were art lovers in their own right.

[66] Keblusek, 'Frugal Man', 109–10. Yet Arundel's lack of interest was unlikely to be a sign of his more 'British Italian taste' in the light of which Hainhofer's cabinets looked 'too old fashioned, too conservative and perhaps too central-European'. Wrangel in fact was about to become the new governor of Swedish Pomerania, see also Wenzel, *Handeln*, 319–20.

[67] Helmut Graser, Mark Häberlein, B. Ann Tlusty, 'Sources and Historiography', in Tlusty, Häberlein eds., *Companion Augsburg*, 3–19, here 11.

[68] Volk Knüttel, 'Hainhofer', fn.51.

[69] Francis Haskell, *The King's Pictures: The Formation and Dispersal of the Collections of Charles I and his Courtiers* (New Haven, 2013), 146; Jerry Brotton, *The Sale of the Late King's Goods: Charles I and his Collection* (London, 2007), 258.

In subsequent decades, Dürer's legacies lived on in Britain. Samuel Hartlib (*c.*1600–62), for instance, was a German-born polymath and Protestant who had arrived in England in 1625, just after Francis Bacon had published his *New Atlantis*. Hartlib led many discussions in this new age of British improvement. These remained in dialogue with ideals that linked to Dürer's vision to further the commerce in crafts.[70] Inspired by Bacon's ideas and by the Czech reformer Comenius, his tireless mission would be to improve society and human life through new empirical knowledge, by joining experiment with scholarship, and by building a large cross-confessional network of correspondence that would promote a universal reformation. Hartlib thus knew all about Gottorf, but his vision was that institutions and laboratories would now be built not just for the principal benefit of one state or religion 'but also to the health and wealth of all mankind'.[71] Such German patronage of the 'Arts and Sciences Philosophicall, Chymicall & Mechanicall' helped trade, his friend John Dury (1596–1680) agreed, and it unfolded the secrets of Nature, so that God's 'wonderfull power, wisdome and goodness is to be seene more apparently in bodily things than ever heretofore'.[72]

Practical concerns about the import and manufacturing of textiles, threads, dyestuffs and technical knowledge from across the globe to achieve and fasten colours inspired many members of the Royal Society, founded in 1660. Discussions principally focused on increasing British wealth in an age of more aggressive colonization. John Evelyn, whom the Arundels had trained into an art lover, talked to 'workmen, coach makers, cabinet makers' in France during the 1650s in order to learn about the secrets of varnish, and the Royal Society heard papers on topics including varnish, leather, dyes, and hats during the 1660s and 1670s.[73] Wenzel Hollar was highly regarded by many, and Fellows could tell the quality of one engraving, mezzotint, or painting from another. They frequented painters' studios, following on-site experiments and networking with people of influence. As art lovers, they keenly collected, travelled, and would have talked to merchants. One fellow of the society sent pigments and earths from the Levant to London, where meetings often focused on new materials and methods of analysing and processing them. Fellows keenly discussed cheap imitation techniques, such as staining marble, or discussed colorants from local plants that might produce cheaper dyestuffs than those imported from the Americas.[74] Art connoisseurship thus remained rarely detached from questions about where and how to source materials as well as knowledge about making in the arts and crafts, or about botany, agriculture,

[70] He would exchange Lady Alathea's recipe book with Robert Boyle for a treatise by Basilius Valentine, who at the time was thought to be a fifteenth-century German author of great alchemical knowledge, Raabe, 'Mediating between Art and Nature', in Burghatz et al. eds., *Sites of Mediation*, 185–7.

[71] Vera Keller, Leigh T.I. Penman, 'From the Archives of Scientific Diplomacy: Science and the Shared Interests of Samuel Hartlib's London and Frederick Clodius's Gottorf', *Isis* 106, no.1 (2015): 17–42, here 29.

[72] Keller, Penman, 'Archives', 33.

[73] Levy Peck, *Consuming Splendour*, 311–19; Games, *Web of Empire*, 289–99.

[74] Sachiko Kusukawa, 'The Early Royal Society and Visual Culture', *Perspectives on Science*, vol. 27, no.3, May–June 2019, 350–94.

420 *Ulinka Rublack*

and animal breeding; rather, these concerns remained bound up with each other and with collecting as well as with a vision of improvement and happiness that fed into the Enlightenment. 'Die the body may, and must: arts cannot die', ended a poem dedicated to John Tradescant that prefaced the 1656 catalogue of the famous museum of rarities that he and his father had built up.[75]

The Royal Society would soon acquire Willibald Pirckheimer's books and manuscripts and one of Dürer's letters from Venice, as Arundel's grandson Henry Howard (b. 1628) donated his library. One of Dürer's letters and some of Pirckheimer's books remain among the holdings of the Royal Society to this day, while other parts of the library were later sold principally to the British Library in London.

The London collector Sir Hans Sloane (b. 1660) meanwhile bought several volumes of Dürer's manuscripts that are now likewise in the British Library and are thought to have previously belonged to Pirckheimer. These unique manuscripts mostly encompass Dürer's proportion, architectural and perspective studies, and are written and drawn in Dürer's own hand. Marked with the date 1637 and with Dutch titles, the volumes were sold either by the Imhoffs under wartime duress to Wicquefort and by Wicquefort under the duress of the 'tulipmania' crisis to Arundel in 1637 (and then eventually to Sloane), or by Endres and Ursula Dürer to Bartholomäus Spranger and via the 1638 Amsterdam auction of Gommer Spranger's inheritance to eventually be bought by Pieter Spiering Silvercrona, an art agent from The Hague who served Christina of Sweden.[76]

Dürer's original manuscripts, prints, watercolours, and drawings in the British Library and British Museum remain a unique treasure. Sloane and other collectors who bequeathed their holdings to the British Museum worked Dürer into Britain's artistic heritage. Dürer would inspire William Morris, John Ruskin, and the Pre-Raphaelites as they rediscovered Northern Gothic art and the values of craft; he has inspired countless makers and writers in Britain and around the world ever since.

[75] Levy Peck, *Consuming Splendour*, 161.

[76] The provenance has not been conclusively established; for recent arguments see Christoph Metzger, 'Images and Itinerary: Dürer's Drawings from his Travels through the Netherlands', in Foister, van den Brink eds., *Dürer's Journeys*, 149–64; a secure attribution to Silvercrona that fails to discuss which volumes Arundel in this case would have bought via Mijtens in 1637 in Amsterdam; see also Giulia Bartrum ed., *Albrecht Dürer and His Legacy: The Graphic Work of a Renaissance Artist* smanuscripts when he died in 1652.

Flos Solis maior.

Epilogue

As I finish writing this book, I get on a train from Cambridge to London. Equipped with a special permission, I am to inspect one of the British Library's most precious volumes: an edition of the *Hortus Eystettensis*— the *Eichstätt Garden*. It is one of few surviving hand-coloured copies in the world and believed to have perhaps belonged to Wilhelm V of Bavaria. Because the Library restricts the number of readers during the Covid pandemic, my time slot lasts three hours. At the outset, this does not unnerve me. I am familiar with this garden book: I have closely examined a first black-and-white edition, own a mass-market paperback of an illuminated copy, and have looked at a digital edition of another illuminated version. As I sit down at my desk, the enormous book—printed, as we have seen, on the largest size of paper available for printing anywhere in the world in 1613—awaits me and soon casts it spell.

Expert bookbinders sewed together these enormous single sheets that had come from the printer and been labouriously hand-coloured by the best illuminators. They created a perfect book with a flexible spine made for connoisseurs that would open easily to facilitate reading. The skill and knowledge embedded in this project at every level of its making are astonishing. I am not even halfway through the book when my time is nearly up, and I begin to rush turning the pages. I am absorbing the extraordinary intensity of green, yellow, and red that blend in the leaves of an Asian *Amaranthus Tricolour* (its German name is aptly rendered 'Parrot feathers'), and realize that the *Garden*'s famous 'Indian' sunflower is yet to come. On every page, depictions of fine roots turn into exercises in calligraphy. The project exudes the immense care with which delicate flowers must have been cut and transported from Eichstätt to Nuremberg to be drawn. I have looked at dozens of hyacinths and astonishing varieties of tulips with energizing displays of colours. Many common wild flowers local to the region feature. There is no hierarchy between the plants, although those that are considered most stunning and rare get a full page to themselves. Several of these are named after Ottoman Sultans; and then, of course, there are the aubergine, tomato, pepper, and potato plants from the Americas.

The total cost of the book production for the bishop (and his successor) amounted to about 17,500 florins, but he would have known that this was the first garden ever to have been captured in print. This tome is testimony to a great art lover in the German

lands who wished to share his passion for divinely created nature and champion religious peace as much as demonstrate his wealth and magnificence. It built on decades of networked exchanges among Europe's botanists from Rome to Leiden and Amsterdam and to Nuremberg that served to agree on the names of particular plant varieties and to establish their origin, and, with the help of their merchant friends, to get hold of those specimens. Ottoman flower breeders were envied for their skill. It built on the expertise of gardeners, and men and women knowledgeable about plants, from across the globe. It mirrors that world of vigorous trade and violent empire-building, and merges it with that fascination of minutely observing the natural world as a purpose of art that began with the Renaissance and with Dürer.

As a milestone in the history of the book, the *Garden* thrived on that German confidence in the possibilities of fine print which Dürer's achievements continued to inspire. The black-and-white version made for a wider audience is an exhilarating display of technological advances in the art of bookmaking in Germany around 1600. Yet, during these three hours spent in the British Library, I fully comprehend just why the bishop and other connoisseurs were so captivated by the beauty of these plants, and why more and more Europeans thought that painters could do no better than to mimic them. A highly skilled illuminator proudly signed individual sheets with his initials, or even with his full name, and a date. He might have spoken to the pharmacist who led the garden project to find new pigments to capture spectacular colours. The pharmacist himself hoped to distil new drugs from some of the plants, and added a frontispiece depicting his equipment and many small glass bottles filled with medicines. Men like Philipp Hainhofer marketed the *Garden* itself as an object to speculate with, on the assumption that its price would quickly rise because of its rarity—besides which, rare bulbs and trees of course likewise seemed a promising investment with which to speculate.

If it is true that early modern German culture sometimes tends to be thought of as bookended by the ideas of Martin Luther and Johann Wolfgang von Goethe, but little of significance in between, then the *Garden* is one of the candidates we have encountered in this book to change that view. Objects, as much as literature and music, further our understanding of early modern German culture. *Dürer's Lost Masterpiece* has sought to show that German culture was neither stagnant or nationally focused after 1555, nor just embroiled in confessional polemics and cut off from the dynamism of Europe's overseas trading nations. Innovative craftspeople, merchants like the Fuggers, agents like Hainhofer and collecting rulers positioned Germany at the centre of artistic developments and benefited from the terms of global trade. A new age of interconnection among Europeans through their interest in the arts began. My interpretation moves on from accounts dominated by the view that merchants were simply interested in hoarding and ownership as patrons, or by the conception that markets were an anonymous force. Renaissance art was about a new world of knowledge linked to commerce as well as to dynamic social, religious, and political values and deeply personal beliefs. The value and cultural significance of artefacts significantly shifted over time, telling us as

much about the period and its merchants as about artists as agents in the making of it. I have pointed to the day-to-day interactions and rich emotional experiences that often lay at the heart of the relationships between artists, patrons, merchants, and collectors, as a result of which our ideas about clearly defined identities and interests marking out creatives from business people begin to fade. Hard calculating and speculating often went together with an attachment to art as medium that could help manage feelings of loss and hopelessness, or with sustaining an entire vision of just how societies might reform and create a better, joyful world. All three of our merchants—Heller, Fugger, and Hainhofer—were deeply religious men. Objects, animals, plants, and materials created cognitive, spiritual, affective, and sensuous meaning in people's lives. As the new history of material culture shows, exotic feathers, vibrantly red dyes, soft silks, or clay earthenware actively shaped inner worlds—how people emotionally experienced themselves and others, and how they generated their ideas and practices.[1]

Since the 1970s and 1980s, historians and art historians have become far more confident in asserting that intensified commerce and encounters in a new global age changed the consumption, production, and categorization of art. Yet it would be misleading to dismiss the histories of merchants as if they collectively spurred on a superfluous type of consumerism rooted in a ruthlessly acquisitive age that paved the way to modern materialism. Merchants can easily be treated as a collective force, their 'mental landscape' firmly focused on having and holding objects to gain power.[2] By contrast, historians have recently highlighted the important role of merchants in early modern knowledge-making processes and cultural exchange. Their interests as connoisseurs could be wide and their competences multiple. Just as there were different types of collectors, so there were different types of merchants, many of them fired by passionate curiosity in the 'pursuit of the new'. They had different attitudes to risk-taking, status aspirations, and participation in politics. Like Hans Fugger, some of them were guided by firm principles and common-sense approaches, others—like Philipp Hainhofer—by a greater depth of learning.

Persistence united almost all of them. The day-to-day efforts of merchants can thus tell us about their extraordinary tenacity in accumulating precise information to acquaint themselves fully, for example, with the potential of a particular drug from a specific locality to improve medical treatments—an endeavour they shared with scholars in an age of empirical science. Their existence built on the ability to discern the quality of goods intimately through the senses—such as touch—and to connect such judgements with their knowledge about what determined the quality of materials and making. Just like empiricist scholars, they constantly trained their attention

[1] Susanna Burghartz, Lucas Burghart, Christine Göttler, Ulinka Rublack eds., *Materialized Identities: Objects and Affects in Early Modern Europe* (Amsterdam, 2021). This approach puts methodological pressure on Arjun Appadurai's contention that only 'human transactions, attributions, and motivations' endow objects with meaning, Appadurai, 'Introduction', in idem ed., *The Social Life of Things* (Cambridge, 1986), 5.

[2] See the pioneering account of Lisa Jardine, *Worldly Goods: A New History of the Renaissance* (London, 1996), 15–16.

426 *Ulinka Rublack*

on particulars through hands-on research. And just like scholars, they fostered sociability to gather information, endlessly inviting passing guests to their homes. Those who were successful developed reliable systems of archiving correspondence and information so that information and details could be retrieved. As markets became ever more diversified and specialized, one of their main preoccupations was the ability to assess new inventions, judging good from bad imitations, and imitations from the real thing. It further aligned their interests with scholars and virtuosi, assessing the authenticity of coins, manuscripts, plants, stones, and other things. Authority to judge authenticity was of great relevance, as a greater interest in paintings stimulated the production of copies and outright forgeries. Hence merchants were trained not only to be shrewd in fixing prices but also to convey passion about what they regarded as true quality in order to market it for profit. They understood the skill that had gone into the making and sourcing of products, and the best of them projected their enthusiasm for exquisite craftsmanship and novelties in infectious ways to create desire for their wares. Cultivated merchants turned into Europe's prominent tastemakers.

Their influence on society and politics grew in this new commercial age. In Europe, cultivated merchants, acting as 'art lovers' were able to achieve uncompromised social status, something that the influence of Christian ideas, which associated their wealth with avarice, had previously denied them. Just as artists like Dürer fought for their status as gentlemen, so did merchants in this age of wonder. Merchants and artists learnt how to turn their activities to the benefit of rulers and society, as when Dürer designed fortifications, or human and animal skeletons were sold to develop prosthetic limbs for those mutilated in Europe's abundant wars. Globes and astronomical charts, such as Dürer designed, had a wide audience. The central argument of this book, therefore, has been that artists behaved more like merchants and merchants more like creators as art markets kept integrating. To understand Dürer and his age, we need to understand the art of the merchant. Both merchants and artists were experts in materials and their transformation, in communication and the creation of possibilities, in risk-taking and curiosity, in measuring and calculating. These skills were required as much as emotional intelligence in their judgement of both their subjects and clients.

Merchants thus were in the vanguard of that important pan-European cultural movement that gained strength around 1580, and continued to be of great influence into the eighteenth century. As new and ever more confident elites, they joined creators, scholars, burghers, aristocrats, and rulers as self-professed 'lovers of art'. Just as in China and Japan during the same period, this loosely organized cultural movement of connoisseurs was linked to distinctive practices that expressed new ideas about civility. These included increased travel to visit the burgeoning number of collections, printing catalogues of them, gardening with tulips (or plum trees in China), wearing new types of clothes and fragrances, and communicating about the same values in different European languages. These men and women were knowledgeable aesthetes and credible enthusiasts: hence their description as 'lovers', *liebhaber* or *liefhebber*.

The point therefore is simply that mercantile cultures in many parts of the globe increasingly had power in shaping and creating connoisseurly knowledge, tastes, affects, and identities.

The history of material culture thus shows us how matter, things, and human interaction with them, had become fundamental to religious and political transformations in the early modern period. Art loving connected Europeans of different backgrounds and faiths through their fascination with the commerce in things. It even led to hopes that things would broker politics and religion across continents. Many of the things art lovers prized came from faraway countries, and thus were linked to a politics of how the world beyond Europe was imagined, valued, or exploited in an age of deepening global interconnections, missionizing, and expansion. German history is often recounted as intensely local; yet, as global historians show, German collections, trade, crafts, artistic and scholarly projects stimulated cultural interests in Europe and across the world, and equally fed off materials and technical achievements elsewhere. The Japanese daimyo of Odaware ordered his copy of the *Eichstätt Garden* from Dutch sellers in 1668. Meso-American feather mosaics inspired Johannes Schwegler's creations of miniature birds crafted from natural feathers.

Maximilian I in turn prominently included Schwegler's miniature birds in that spectacular cabinet of arts he sent to China's Emperor Wanli in 1617. They adorned a depiction of the Three Magi presenting their gifts to Jesus, appeared alive, and created a sensation of wonder about such artistry. The Bavarian Duke spent over 3,000 florins to buy the cabinet itself from Augsburg, which included many of Germany's cutting-edge automata, clocks, and precision instruments, to which he added further rarities, such as fine silks, miniature artefacts, and religious objects. He told the Emperor that the cabinet championed 'Europe's' ingenious arts. China, with its ancient culture of industry and ingenuity in the arts, would know how to appreciate them.[3] Art loving, it was hoped, would spread Christianity and interconnect civilizations across continents and nations within Europe.

The inspirations of Northern Renaissance print certainly forged connections between Britain and Germany. After my slot to look at the *Eichstätt Garden* has finished, I leave the British Library at lunchtime and decide to walk across Bloomsbury. Finishing a book is a transitional state, and it is natural that I should experience much of what I see as resonant with what I have written about. My feet track traces that link the past

[3] Annette Schommers, 'Der Kunstschrank Herzog Maximilians I. von Bayern für den Kaiser von China', in Christoph Emmendörfer, Christoph Trepesch eds., *Wunderwelt: Der Pommersche Kunstschrank* (Berlin, 2014), 97–115; Harold J. Cook, *Matters of Exchange: Commerce, Medicine and Science in the Dutch Golden Age* (London, 2007), 348.

with the present. Ten minutes away from the British Library is the British Museum with its beautiful study room in the Department of Prints and Drawings. Any member of the public can make an appointment, and the experience of looking at its rich holdings of Dürer's original works propped up on wooden stands without any glass in front of them is one of the most amazing privileges one can imagine.

A few streets further, I pass by the Art Workers' Guild in Queen's Square. Members of the Arts and Crafts movement founded the guild in 1884, and William Morris became one of its masters. Today, the guild counts over four hundred 'brothers' and 'sisters' who practise more than sixty crafts. They demonstrate them to each other and are joined by academics and writers in the exchanges of ideas. Would the Art Workers' Guild be Dürer's natural home if he lived in London today, I ponder? It's an open question. As we have seen, he abhorred a language of brotherhood in his own time and was not used to guilds in his native Nuremberg. He certainly would be anxious to dress better than anyone else.

I walk over to Bloomsbury Place, and past the site of one of the houses of Hans Sloane, the man whose collection built the British Museum and who bought Dürer's precious manuscripts as well as prints. Sloane (1660–1753) passionately collected insects and some other animals, dried seeds, fruits, and leaves, and he documented materials and craftsmanship from across the globe to further agriculture, science, and industry. Watercolour images of people in different costumes fascinated him, and he collected shoes to understand different customs and technologies across the globe. He financed all this through wealth he gained from investing in land and by profiting from investments in plantations in Jamaica and the slave trade. Many of the objects he collected and the way he collected them betray hierarchies, cultural stereotypes, and debates representative of his time. Sloane, for instance, consistently spoke out against 'magic' uses of objects and occult beliefs. He took 'idols' to London to intervene in debates about the history of religion relevant in Europe.[4] Debates during the last years have shown how important it is to uncover the meaning of objects in communities they originally came from and to which they were taken, how those meanings have changed over time, and to ask what the theft, loss, sale, acquisition of and traffic in artefacts has meant in the past. This book has told some of this story for the period of the Renaissance and Thirty Years' War, and analysed how the movement for collecting also thrived off social competition and the commercialization of art and natural resources that included unequal exchanges between those who supplied rarities and Europeans who exhibited them. Its approach qualifies any facile fascination with cabinets of curiosities.

[4] James Delbourgo, *Collecting the World: The Life and Curiosity of Hans Sloane* (London, 2017), 277–8; Alison Walker, Arthur McGregor, Michael Hunter eds., *From Books to Bezoars: Sir Hans Sloane and his Collections* (London, 2012), here especially chapters by Sloan and Hunt; for a German context see Christine Sauer, 'Die Memorabilien in der Stadtbibliothek Nürnberg', in ead. ed., *Wunderkammer im Wissensraum: Die Memorabilien der Stadtbibliothek Nürnberg im Kontext städtischer Sammlungskulturen* (Wiesbaden, 2021), 50–5.

Artefacts thus do not reflect timeless, or universal, or 'purely' aesthetic ideals. Investigating object histories means scrutinizing beliefs and practices connected to what societies value as art. Germany's Renaissance artefacts for the moment still represent stable value for London's auction houses. Dürer's prints regularly come up for sale at Sotheby's and Christie's, and whereas they changed ownership for pennies in Rembrandt's Amsterdam, the best of them now cost around £100,000. An illuminated early copy of the *Eichstätt Garden* will sell for at least £2,000,000. Most recently, Philipp Hainhofer's grandest friendship album attracted worldwide attention. It was long believed to have been lost, and was in private hands. I inspected it at Sotheby's in 2019, astonished at what I saw. It sold to the Herzog August Library in Wolfenbüttel for £2,500,000 a year later. The album has now been digitized and can be fully researched for the first time. Everyone is able to look at what Hainhofer achieved as one of the most discerning cultural entrepreneurs and political operators, and at what made rulers and aristocrats from all over Europe gasp with wonder.

This book, in sum, has investigated the making of a modern world of art and commerce. Commerce and commercial mindsets operate as a cultural force, and what this book has tried to show is how these concerns wove themselves into history and understandings of art as Europe's art market became more integrated and institutionalized, and the influence of the world economy on Europe grew. I have attempted to recover how Dürer produced art by approaching these historical contexts in an anthropological vein—by asking who gave what meaning and value to the visual, how, and why. Instead of focusing on what artworks might have represented through a timeless aesthetic language of form, I have recovered practices, personal relationships, political networks, market relations, and the demands and potential of different kinds of matter and objects themselves. I have highlighted how early modern merchants, in particular, joined rulers, aristocrats, and scholars to act as patrons and also as creative producers of the arts. The intention has been to better understand how artefacts informed cultural and political practices, ranging from connoisseurship, contemplation, and curiosity to a German ruler's understanding of order, time, and cleanliness. I have asked what types of behaviour artefacts could activate.

Luxury artefacts ranging from textiles to tulips and cabinets to paintings in early modern Europe embedded themselves in social life and psychologies. Maximilian I's reverence for neatness intertwined with his love of Dürer. As the examples of shoes, Indonesian shells, reindeer or polar bear skins have likewise shown, objects became a living reality through relationships which activated their meaning through specific bodily, emotional, and mental practices that were connected to particular communities

of values and fascination.[5] It was not only social relationships that endowed objects with meaning. People equally responded to the sensuous materiality of pigments, soft leather, the translucency of shells or feathers, or of plants. To highlight this agency of matter, I have shifted in focus from the study of finished objects and consumers to a reconstruction of the 'productive processes' through which objects emerge. This means exploring how practitioners were aware at a sensory level of the materials from which things are made.[6] The Heller altarpiece has served as my material micro-history to show how Dürer worked with matter via a protracted, spiritual, physical, and technically accomplished process, and how this interrelated with what painting meant to him as he hoped for the curative benefits of his art. Making interlinked with spiritual and philosophical thinking about how the body and soul related to macro-cosmical forces and the divine. Revealing this process has allowed me to show that Dürer and his humanist friends were in part keen to experiment with ideas generated from materials and not just from classical texts, and how their interests fed into Europe's scientific revolution.[7] The social life of the Heller altarpiece as one artwork is part of a far wider story of how a wide range of man-made artefacts, minerals, animals, and plants came to be defined and valued and marketed in relation to economic, religious and philosophical, social and political processes of transformation that defined the early modern world. This approach shows how Dürer and his age can be 'materialized', as ideas were interconnected with bodily perception, matter, and commerce. What this book has brought into closer view is how commodity values for luxury goods were socially agreed on, emotionally charged, enacted, and trusted, or broke down and crashed.

My focus on merchants as one influential group of tastemakers has allowed me to set out a particularly influential nexus for which the making, use, or transmission of artefacts can be described through specific social relations connected to them. I have concentrated on three different types of constellations of merchants and their social worlds in which the visual greatly mattered, and I have argued, as we have seen, that any notion of 'merchants' and 'makers' as fundamentally separated in their mindsets (profit-orientated versus creative aesthetes) rests on shaky ground. In reality, these identities could interrelate so as to aestheticize expert merchants who straddled the worlds of artisanal knowledge, literate cultures and trade as new and powerful elites in European history and to elevate the most successful makers as people of social prestige and income. Both worlds were marked by rules, routines, and the importance of rhetoric, by highly stylized modes of self-representation, and the acceleration of ever more competitive

[5] Boutcher, *Montaigne*, vol. 1., 6–15; Alfred Gell, *Art and Agency: An Anthropological Theory* (Oxford, 1998), here esp. 4–7, 17–21; Anne Goldgar, 'Learning to Perform in Early Modern Art Collections', *Journal of the History of Collections*, 2021, 469–79.

[6] Tim Ingold, *Making: Anthropology, Archaeology, Art and Architecture* (Abingdon, 2013), 7.

[7] Pamela H. Smith, *The Body of the Artisan: Art and Experience in the Scientific Revolution* (Chicago, 2004); Smith has developed these perspectives in a series of further pioneering articles and edited volumes, see, for instance, idem ed., *The Matter of Art: Materials, Practices, Cultural logics c.1250–1750* (Manchester, 2000); and Smith's project website *Making and Knowing* as well as her recent monograph *From Lived Experience to the Written Word: Reconstructing Practical Knowledge in the Early Modern World* (Chicago, 2022).

production and sourcing of artefacts to outdo others through ever more rare, precious, and singular products or ever more quickly produced products.

Just like Lucas Cranach, Dürer achieved success as he manipulated a modernizing art market. Dürer played an important cultural role as innovator who mass-marketed exceptionally skilled work through reproductions in prints and staged the production of quickly made paintings. It remains amazing that he fully recognized these choices and acted on them to escape financial precarity in 1508 and to express himself with new freedom. A result of his drive for creativity, his experiences in Italy, of humanist conceptions of artists, and his immersion in mercantile cultures, Dürer's relationship with Heller quickly reached its breaking point. The underlying tensions rightly point to one of the origins of modern art, not as a singular instance, but as Dürer transformed himself into an artist who produced for the market, who refused to be dependent on such patrons, and who valued himself in terms of how much he could earn, save or consume. There was a price to pay. Dürer gave up accomplishment in one genre and losing the spiritual and artistic expression it offered; it meant giving up his dream of being a great painter of colour in complex compositions.

Frankfurt's Dominican monastery was secularized in 1803. Heller's altarpiece, with Harrich's copy of Dürer's central panel, is now exhibited at Frankfurt's Historical Museum. It is not aimed at art connoisseurs or the faithful but illustrates Frankfurt's rise as an important global financial and trading centre, to mark an episode in the story of economic upswings and downturns that have ceaselessly fluctuated since Dürer's and Heller's time.

The copy does not hint at a masterpiece. It was made under difficult conditions and has subsequently suffered neglect.[8] Yet, as this book has suggested, there are many reasons to regard it as the only surviving trace of a Dürer that is in fact a lost masterpiece. Maximilian I would have never privileged it to the extent he did in his collection if he had thought it second-rate. Dürer painted the Heller altarpiece at the height of his skill, and to secure his artistic fame, and memory. He would not be poor, humble, and forgotten. He wanted to champion new art. At a time when fears of the end of the world were rife, Dürer believed in the power of masterly art to endure and, most amazingly, he thought of us when he finished his work. This painting, he told Heller, had been accomplished with extraordinary care and technique. He wanted it to be kept clean and fresh, so that people would still be able to admire it in five hundred years' time. Because of the fraught process of the painting's creation, it testifies to Dürer's unique daring as a Renaissance artist that he placed his own figure as an artist at the centre. As I have argued, this records a battle for the recognition of makers that resonates today.

[8] See the discussion in Antonia Putzger, *Kult und Kunst – Kopie und Original: Altarbilder von Rogier van der Weyden, Jan van Eyck und Albrecht Dürer in ihrer frühneuzeitlichen Rezeption* (Berlin, 2021), 193–5.

DIGITAL RESOURCES FOR FURTHER VIEWING AND READING

We are fortunate to now be able to browse through Hainhofer's *Great Friendship Album* (*Grosses Stammbuch*):

https://diglib.hab.de/mss/355-noviss-8f/start.htm

Much of Hainhofer's correspondence is available for specialists online via the Herzog August Library, as are many of his detailed reports on his trips and collection. These reports are being edited with great care and excellent commentaries by a team at Wolfenbüttel under the direction of Michael Wenzel:

https://hainhofer.hab.de/informationen-zur-edition

A digital edition of the *Hortus Eystettensis—The Eichstätt Garden* can be accessed here:

https://hlbrm.digitale-sammlungen.hebis.de/urn:nbn:de:hebis:43–1018

Impressions of part of Hainhofer's Uppsala Cabinet are offered here:

https://www.gustavianum.uu.se/collections/art-collections/collections/the-contents-of-the-augsburg-art-cabinet/

Research on Dürer can be accessed via

https://sempub.ub.uni-heidelberg.de/duerer.online/; for a BBC In Our Time-episode on Dürer, with Giulia Bartrum, Susan Foister and the author as discussants, see https://www.bbc.co.uk/programmes/m000p8cb

INDEX

Note: Figures are indicated by an italic "*f*", following the page number.

For the benefit of digital users, indexed terms that span two pages (e.g., 52–53) may, on occasion, appear on only one of those pages.

Adam and Eve engraving (Dürer) 63, 64*f*, 138
Age of Wonder
 curiosities and 157–9
 Fuggers and 168–71
 museums and 159–68
aging
 body and 58–60, 62, 87
 Dürer on 58–9, 127
 hair and 58–60
 life span and 62, 107
Agricola, Johann 144
Alberti Dureri Noribergensis
 (Kilian, L.) 376*f*
*Albrecht and Anna of Bavaria with their
 five descendants* (Mielich) 164*f*
Albrecht Dürer, St Jerome in His Study
 (Dürer) 136*f*
Albrecht of Brandenburg 129–31
Albrecht V of Bavaria 160–3, 167, 212, 214–16, 215*f*
 death of 241
 Fugger, H., and 169, 179–80, 186, 236–7
 Wilhelm V and 231–9, 241
alchemy 99–102, 105
alcohol
 culture and 249–50
 distilling 103
 Fugger, H., and 249–51
 health and 339
 religious processions and 249–50
 taxes 147
 wine and 128, 147, 249–50, 339
Alkmaar altarpiece
 (Heermskerk) 262–3
altarpieces 8. *See also* Heller
 altarpiece
 Alkmaar altarpiece 262–3
 by Barthel Bruyn the Younger 80–1
 Castle Kirchheim 178–9
 copies of 262–3
 'Dürer Renaissance' and 12
 Dürer's self-portraits incorporated into 51, 54, 95
 evangelicals and 139

Feast of the Rose Garlands
 altarpiece 51, 58–9, 63–5, 67, 71–2, 93–4, 155, 359–61
 Flemish 262
 Ghent 262–3
 giving up producing 5, 7, 125
 by Holbein the Elder 93–4
 Landauer Altarpiece 65, 66*f*, 77, 93–4
 learning to create 56–8
 Martyrdom of the Ten Thousand 23–4, 51, 63, 77, 93–4, 361–2
 of Melem 52, 52*f*
 in Netherlands 151
 for Nuremberg chapel 26
 Paumgartner's altarpiece 58–9
 Praying Hands 6–8, 6*f*
 of Renaissance 24–5, 80–1
 of Stalburgs 52–4, 53*f*
 time spent painting 67
 at Venetian church of San Bartolomeo di Rialto 25
 Virgin and Child 63
Alte Pinakothek, Munich 2
Amberger, Christoph 175
Amerbach, Basilius 416–17
America (de Bry) 310*f*
Amman, Jost 206–7
Amsterdam 282–4
 Amsterdam crash of 1637 and 415–17
animals. *See also* birds; feathers; horses; shells
 bones and 167, 324
 equestrianism and 189–90, 195
 exotic rarities and 216
 fairs and 285, 304–6
 furs from 208–9
 keeping of 183–4, 223, 297
 medicinal use of 324
 nature and 58, 167, 277, 285
 skins from 299–304, 302*f*
 trade of 304–6
Anna of Austria (Archduchess) 163, 164*f*
Anne of Bohemia 160–1
Antwerp 4–5, 132–6, 138–9, 144
aphrodisiacs 35–6, 103–4
Apocalypse (Dürer) 2, 47, 58, 128

appearance. *See also* clothing; fashion
 body and 45
 clothing and 45, 47–8
 cosmetics and 102–3
 of Dürer 45, 47–9, 51, 73, 127
 of Fugger, H. 195–7, 206–7
 hair and 49–50
 of Maximilian I (Duke of Bavaria) 344–6
 of Pirckheimer 61–2
 sexuality and 73
 social class and 47
 of Wilhelm V 248–9
appropriation 17
Archduchess Anna of Bavaria
 (Mielich) 215*f*
architecture 267, 307–8, 326, 345–6
 Holl and 402–3, 403*f*
art agents. *See also* Hainhofer, Philipp
 art market and 267–71, 362–6
 art valuation and 363–6
 competition between 363–6
 Hainhofer 267–73
 masterpieces and 362–6
 merchants and 13, 267–73, 362–6, 375
 Rottenhammer and 362–5, 375
art criticism 17, 50, 69, 117–18, 123, 134–5, 259, 265
artificers 156–7
artists. See also *specific artists; specific topics*
 craftsmanship and 97–8, 113, 428
 global expansion and 9
 merchants and 8–9, 25
 narcissism and 50–1
 not signing works 51–2
art lovers 271–3, 290, 419–20. *See also*
 Fugger, Hans; Hainhofer, Philipp; Wilhelm V
 Arundels and 400–18
 collectors and 12–16
 diplomacy and 357
 exotic rarities and 135–7
 Hainhofer and movement of 350
 looting by 406–8
 movement 327, 334, 338–9, 350
 persistence of 425–6

436 Index

art lovers (*cont.*)
 politics and 321–7, 339–40, 357
 religion and 327–9
 speculation and 338–9
art maintenance
 cabinets of curiosities and 355
 cleaning and 210–11
 cleaning shells and 318–19
 damage prevention 121–3
 instructions on caring for Heller
 altarpiece 121–3
 temperature and 122–3
 varnish and 122–3
art market 5–7
 Age of Wonder and 157–71
 art agents and 267–71, 362–6
 art valuation and 76–81
 Arundels and 400–18
 books and 8–9
 boundaries in 8
 Catholic Reformation and 315
 changing taste and 157–9
 commercial print and 8
 commissions and 25
 for copies 262–3
 in crisis times 397–420
 culture and 9, 299–308, 424–7
 debt crisis and 236–9
 Dürer's diary on 137–8
 Fuggers and 168–71
 investing in Dürer and 211–12
 investing in "things" and 209–11
 Kunstbüchlein art theory and 156–7
 for masterpieces 263, 361–2
 merchants and 157–9, 425–7,
 429–31
 museums and 159–68
 prints and 127–30, 138
 Quiccheberg and 159–68
 Reformation and 175
 religion and 175, 269–70, 315
 shells and 315–19
 sourcing 'things' and 219–22,
 295–313, 315–19, 379–87
 speculation and 47, 304–6, 338–9,
 424–5
 Thirty Years' War and 16, 397–418
 van Mander and 259–63
art valuation 176. *See also*
 commissions
 art agents and 363–6
 art market and 76–81
 commissions and 75–81
 Dürer's 75–81, 95, 156–7, 211–12, 429
 fraud and 212
 for Heller altarpiece 369–73
 woodcut and engraving prices
 and 156
Art Workers' Guild 428
Arundels 16
 background on 400
 Dürer works and 409–11, 415, 420

Hainhofer and 401–6, 408, 417–18
Lady Arundel (Alethea Talbot)
 403–5, 404*f*, 414–15
luxury goods and 400–8
negotiation by 406
Nuremberg and 408–11
Pirckheimer and 404–5
religion and 405–10, 414–15
Thirty Years' War and 400–18
Asia 245, 270–1, 427
astrology
 Behaim and 72–3, 99–100, 102
 celestial influences and 101–2,
 175, 417
 colour and 100–1
 Dürer and 72–3
 Fugger, H., and 177–8
 therapeutic 102
Atlantic trade 132
Atlas (Mercatoris) 298, 300*f*
Augsburg 155, 173–5
 Catholics, Protestants, and 252
 Hainhofer and 285–7
 merchants 162, 167–9, 216–17,
 269–70
 Peace of Augsburg and 159–60,
 168–9, 237–8
 religion in 175, 252
August the Younger 401, 413
aurum pigment 105
authenticity
 forgery of 367, 377
 masterpieces and 263
avant-garde 10, 157–9
Aztecs 132–4, 243*f*
azurite 262

'Babylonian Captivity' treatise 130–1
baldness 50
balms, for health 339–40, 351
bankruptcies 236
baptisms 32, 35
Barthel Bruyn's Cologne 122–3
Barthel Bruyn the Younger 80–1
Bavaria. *See also* Court of Bavaria;
 Maximilian I (Duke of Bavaria);
 Thirty Years' War; Wilhelm V
 (Duke of Bavaria)
 Ernst of Bavaria 237–8
 Ferdinand of Bavaria 397–401
 Bavarian collections and 160–1
 Bavarian State Council and 162
 Castle Trausnitz in 213–16
 Wilhelm V as leader of 241,
 244–54
bear skins 299–304, 302*f*
beauty 45, 58, 102, 192, 204
Behaim, Canon Lorenz
 astrology and 72–3, 99–100, 102
 background on 61–2
 Dürer and 60–2, 71, 103
 metallurgy and 99–100

Pirckheimer and 72–3, 102–3
 recipes by 102–3
Behaim, Martin 47–8
Bellini, Giovanni 51, 64–5, 77–8, 115
Besler, Basilius 316*f*, 332*f*, 337*f*
 Bishop of Eichstätt and 331–4
Bible 30, 40, 131, 139, 148
birds 176–7, 334–5. *See also* feathers
 bird houses and 380*f*, 381*f*
 miniatures of 382–5, 387
Bishop of Eichstätt (Konrad von
 Gemmingen) 326
 background on 327–30
 Besler and 331–4
 death of 334
 Eichstätt Garden publication
 and 327, 423–5, 429
 engraving of 328*f*
 family of 327–9
 garden of 327, 330–41
 Philipp II of Pomerania and 330–1,
 334–6, 340–1
 politics and 329–31
 wealth of 330–1
 Wilhelm V of Bavaria and 327,
 330–6, 340–1
black clothing 208–9
Bloomart, Abraham 411–13
Bloomsbury Place 428
blue colour
 azurite 262
 'German blue' 115–16
 lapis lazuli and 91
 pigment and 91
 ultramarine and 106, 114–17
Blum, Katharina 141
Boccardi, Pietro 277
body
 aging and 58–60, 62, 87
 appearance and 45
 beauty and 45, 58
 Four Books of Human Proportion
 and 130, 148
 geometry and 49–50, 52, 58, 63–4
 hands and 97–8, 127
 morality and 250
bones 167, 324
book-keeping 209
books. See also *specific books*
 art market and 8–9
 bookbinding and 423–4
 colour in 423
 copyright and 128
 by Dürer 128, 130–2
 Eichstätt Garden publication
 and 331, 332*f*, 337*f*, 423–5, 429
 gardening 327, 331–4
 knowledge and 99–101
 by Luther 130–1
 religion and 130–1
 religious pamphlets and 131
 trade of 28

Index 437

botanical knowledge 100, 103–4, 423–4
Botticelli, Sandro 78–9
Bragandino, Marco 253
Brandão, João 132–4
Brant, Sebastian 43, 45, 46f, 49
Braun, Georg, and Hogenberg, Frans 241–2, 242f
Brill, Paul 379
British Library 420, 423, 427–8
British Museum 420, 427–8
brokers 217
brothels 60
Brunschwig, Hieronymus 100
brushstrokes 50
Bry, Theodore de 309–11, 310f
Bühler, Conrad 371–3
Buhler, Fritz 65–7
butcher, in Nuremberg 44f

cabinets of curiosities 11, 236
 art maintenance and 355
 development of 162
 Hainhofer and 270–1, 272f, 353–6
 Maximilian I (Duke of Bavaria) and 344, 353–6
 Munich 241–7, 289–90
 The Presentation of the Pomeranian Cabinet and 14f, 390f
 Wotton, Henry, and 389–91
Calvinists 375
 politics and 329–30, 353, 374–5
Campagna, Gerolamo 179–80
Candid, Peter 365
Canobio, Battista 194–5
care. See art maintenance
career
 changes in Dürer's 5–8
 early evolution of Dürer's 56–9
 of Hainhofer 279–87
 of merchants 275–6
 networks and 279–87
 success measures and 72
carnivals. See fairs
Castle Kirchheim 178–9
Castle Trausnitz 213–16
Catholicism. See also Thirty Years' War
 in Augsburg 252
 Court of Bavaria and 11, 248–9
 Heller and 27–8
 Lutheranism and 145–7
 Maximilian I (Duke of Bavaria) and 264–5, 346, 353, 356–7, 374–5, 391
 sin and confession in 130–1
Catholic League 327–30, 343–4, 353, 356–7, 374–5, 391
Catholic Reformation 13–16, 250
 art market and 315
Catholic Renewal 159–60, 180–1
 Protestants and 254
 Wilhelm V and 248–9

Catholics 10
 Protestants and 252, 254, 269–70, 321, 329–30, 343–4, 397–9
Cato the Elder 58
Cato the Younger 359
celestial influences 101–2, 175, 417. See also astrology
Celtis, Conrad 45, 51, 58, 62, 103–4
Cennini, Cennino 115
charitable donations 28–30, 36, 40, 52, 52f
Charles I (king of England) 414–15, 418
Charles V (Holy Roman Emperor) 129–34, 149–50, 173
 politics and 145–6
The Cheese Seller (Thom) 68f
chemistry
 alchemy and 99–102, 105
 art and 99–100
 cosmetics and 102–3
 distilling and 103
 experimentation with 103
 healing and 101–4
 mercury and 103–4
 during Renaissance 99–100
childbirth 32, 33f, 59–60
children
 baptisms and 32, 35
 Dürers and 56, 62, 110–11
 health of 32
 Hellers and 31–6, 110–11, 142
Christ among the Doctors (Dürer) 67
Christianization 45–7
Christina of Denmark 204–6
churches 130–1. See also altarpieces
 art in 24–5
 convents and 104–5, 108
 Dominican church, Frankfurt 35–6, 145–6, 146f, 369–73, 431
 St Bartholomew Church, Venice 155
 St Michael Church, Munich 248–9, 253–4
 St Sebald Church 51–2, 108–9, 307–8
 Venetian church of San Bartolomeo di Rialto 25
The Cities of the World (Braun and Hogenberg) 241–2, 242f
civic life 128
 German transformations in 144–5
 honour systems and 92
 materials and 108–9
 reform and 144–51
 social life and 83–4
Classical rhetoric 63–71, 276
cleaning
 maintenance and 210–11
 of shells 318–19
cloaks 306
clocks 227–8
Cloit, Christian 51–2

cloth. See also textile art
 craftsmanship and 162–3
 'folding fabric' and 260
 leather and 185–9, 187f
 painting on 105–7
 silk 115, 224, 232–4, 233f, 291–4, 297
 velvet 219, 231, 293
clothing 36. See also fashion
 appearance and 45, 47–8
 black 208–9
 carnivals and 60–1
 coats 139
 colour of 115, 208–9
 fashion, Fugger, H., and 185–99
 feather cloaks 306
 Fugger, H., and 183
 gloves 97–8
 of gold thread 52–4
 hats and 201–2, 214–16, 304, 305f
 leather and 185–9, 187f
 leg garments 202
 in museums 162–3
 shoes and 165–7, 166f, 189–99, 224
 silk 197, 208–9, 219–21
 social class and 47–8, 198–9
 solar 101
 stockings 219–21
 tailoring 43, 183
 of women 207–9
coat of arms 29f, 36–7, 141, 149–50, 150f
 Wilhelm V's 238–9
coats 139
Cochläus, Johannes 45–7, 129–30, 144–5
coin collecting 171
collectors 12–16. See also art lovers
Cologne 279–82
Cologne Wars 237–8, 252
colonialism 245, 282–4, 419–20
Colonna, Francesco 49–50
colour. See also pigment; specific colours
 astrology and 100–1
 blue 91, 106, 114–17, 262
 in books 423
 of clothing 115, 208–9
 control of 349f
 degradation 338
 in Dürer's painting manual 115
 dyes and 43, 220
 emotion and 99
 in Feast of the Rose Garlands altarpiece 71–2
 'folding fabric' and 260
 gold 104–5
 health, vitality, and 183–4
 in Heller altarpiece 87, 89, 91, 93, 97–8, 113–18, 267
 from lapis lazuli 91
 nature and 100–1, 115, 259
 by Northern painters 259
 novel dyes and 43

438 Index

colour (cont.)
 perspective and 63–4
 pigment and 3f, 17–18, 91, 93,
 98–100, 104–5, 114, 116–18
 quality of 113–14
 red 135, 183–4
 in Renaissance 43
 saffron and 250–1
 technique and 113–14, 349f
 for textile art 115, 246–7
 tone and 114
 underpainting and 113–16
 varnish and 122–3
 Venetian painting and 115–16
 Venice 115–17
 watercolours and 338
commercialization
 craftsmanship and 113
 of Dürer 17
 trade and 28–30
commercial print 8
commissions
 advances and 119
 art market and 25
 art valuation and 75–81
 contract law and 119–20
 craftsmanship and 79–80
 debt crisis and 238–9
 for frescoes 78–9
 Fugger, H., and 177–8
 Hainhofer and 352, 354
 in Italy 76–8
 materials and 79–80, 89, 91, 93, 373
 for merchants 90–1
 negotiations and 76–7, 81, 85–95,
 117–21, 177–8, 352
 pigment and 91, 93
 style, technique, and cost of 77–9
 time and 75–6, 89
confession 131
contract law 119–20
convents 104–5, 108
copies
 of altarpieces 262–3
 art market for 262–3
 of Dürer 268f, 359–61
 of Dürer's self-portrait 410f
 of Heller altarpiece 37f, 372–3
copper 99–100, 115–16
copyright 128
coral 247, 277
cosmetics 102–3
cost of living, for Dürer 93
costumes 206–7, 214–16, 221
Couffre, Jacque de 309–11
Count of Fürstenberg 209
Court of Bavaria. See also Wilhelm V
 Catholicism and 11, 248–9
 Fugger, H., and 213, 217
 Fugger, M., and 213, 217
 Hainhofer and 318–19
 luxury goods and 213–17

overview of 213–17
 Renata of Lorraine and 213–16
 Wilhelm V and 213–14
craftsmanship
 in Age of Wonder 157–9
 artists and 97–8, 113, 428
 cloth and 162–3
 commercialization and 113
 commissions and 79–80
 luxury goods and 185, 188–9
 materials and 79–80, 97–8, 428
 Moorish 185, 188
 Porsequine shoes and 189–91, 190f,
 193, 195–7
 silk 232–4
Cranach 335
Cranach, Lucas 17–18
Cranach the Elder 244
crime 91–2
 forgery 367, 377
 fraud 212, 253
crises
 Amsterdam crash of 1637 415–17
 art market in times of 397–420
 frugal times and 401, 417–20
 Imhoff sale and 411–15
 Spanish debt crisis and 209, 236
 Thirty Years' War 16, 348, 389–93
 Wilhelm V's debt crisis 231–40, 254
crucifixion 28–30, 108–9
culture
 alcohol and 249–50
 art, history, and 12–16, 424–31
 art market and 9, 299–308, 424–7
 'high' 99
 in Italy 60–1
 knowledge, intellectualism, and 99
 Munich cabinet of curiosities
 and 244
 Quiccheberg and 159–68, 171
 Thirty Years' War and 403–5
curiosities 10, 11f, 13, 285. See also
 cabinets of curiosities
 Age of Wonder and 157–9
 bones and 167
 ethnographic 167, 216, 299–304,
 307–9, 386
 exotic rarities and 132–6, 216
 maps as 298–9, 300f
 museums of wonder and 159–68
 plants as 167
 Quiccheberg and 167, 241–2
 shells as 311–13, 315–19, 316f, 317f, 318f
 skins and 299–304
currencies 93, 311
Custos, Dominic 264f, 359–61

damage
 prevention 121–3
 repair and 122–3
 from transport 179
Datini, Margherita 32–4

Da Vinci, Leonardo 79
debt
 art market and crisis of 236–9
 bankruptcies and 236
 finances and 84–5, 141–2, 209, 213,
 217, 231–40
 settling accounts and 222–9
 Spanish debt crisis and 209, 236
 of Wilhelm V 231–40, 254
delivery
 of Heller altarpiece 119–25
 of luxury goods 223, 225
 time and 75
 transporting art and 179
diary, of Dürer 139
 on Antwerp 138
 on art market 137–8
diet 182–3
diplomacy
 art lovers and 357
 Bishop of Eichstätt and 327–41
 diplomatic gifts and 216–17, 321–2,
 324, 327, 346–7, 356–7, 417–18
 Philipp II, Wilhelm V, and 322–4
 politics and 327–41
 religion and 327–41
 secret agents and 389–93
Discourse on Aesthetics (Dürer) 148
distilling 103
dolls 163–5, 235
Dominican church, Frankfurt 35–6,
 145–6, 146f, 369–73, 431
Dominis, Marco Antonius de 347–8
Donatello 79
Dorfelder, Margaretha 141
dowries 28
Dresden art cabinet 245
dry pigment 114
Duchess of Mantua (Franz Pourbus the
 Younger) 205f
Duke of Württemberg 235, 354–5,
 364–6
Dürer, Agnes Frey (Dürer's wife) 47,
 56–8, 62, 83–4, 132
Dürer, Albrecht. See also altarpieces;
 specific artworks; specific topics
 on aging 58–9, 127
 ambition of 2–4
 Amsterdam crash of 1637
 and 415–17
 in Antwerp 4–5, 132–6, 138–9
 appearance of 45, 47–9, 51, 73, 127
 appropriation of 17
 art valuation for works of 75–81,
 95, 156–7, 211–12, 429
 astrology and 72–3
 Behaim, C. L. and 60–2, 71, 103
 birth of 1–2, 55
 books by 128, 130–2
 Brant and 45
 in British Library 420
 celebrity of 2–5

children and 56, 62, 110–11
commercialization of 17
copies of 268f, 359–61
criticism and 123
'Dürer Renaissance' and 12,
 267–73
Emperor Maximilian I, and 128–9
family of 47, 55–6, 83–4
father of 1–2, 5
Frederick the Wise's letters
 with 77
friendships and 17–18, 45, 55–62
Fugger, H., and 173
Fugger, H., and letters with 10–11
Hainhofer's search for paintings
 by 267, 341, 359–78
hair of 49–50, 58–9, 127
health of 103–4
Heller's letters with 7, 18, 23–4, 26,
 63, 75–6, 85–95, 113–14, 116–22, 125
homes of 69–70, 84, 119–20
investing in 211–12
in Italy 58–60, 63–71
legacy and impact of 4–8, 10,
 17–18, 419–20, 430–1
Lutheranism and 148–9
Luther's letters with 131
marriage of 56–8
memories of 55
Munich cabinet of curiosities
 and 244
in Netherlands 127–39
nude self-portrait of 57f
painting manual by 106, 115
Pirckheimer and 59–62, 69–71,
 130, 171, 212
Pirckheimer's letters with 48,
 64–5, 69–70, 84
poetry by 85, 87, 107
politics for 18
religious beliefs of 8, 109–11
Rudolph II and 263, 359–61
'selfie' habits of 50–1, 95
self-portraits of 2, 3f, 50–1, 54, 57f,
 58, 95, 103–4, 156, 410f
social life of 17–18, 83–4, 128–9,
 138–9
Thirty Years' War and 397, 402–18
visions of 95
writing by 17–18, 87, 95, 109, 130–2
Dürer, Barbara Holper (Dürer's
 mother) 47, 55–6
Dürer, Endres (Dürer's brother) 84
Dürer, Hans (Dürer's brother) 125
Dürer as Old Man with Coat of Arms
 woodcut (Schön) 150f
Durerus, Albertus 409
Dury, John 419
Dutch colonialism 282–4
Dutch East India Company 13, 282–4
Dutch Republic 261–2
Dutch trade 282–4, 311–13, 415–16

dyes
 colour and 43, 220
 for feathers 201
 for hair 59–60
 new tones for 220
 novel 43
 plants and 220

East Indies 47–8
economy 47, 146–7, 159, 188, 269–70.
 See also crises
 global expansion and 9–10, 47–8
Edict of Restitution 397
Ehinger, Hans Ulrich 365–6
Eichstätt Garden publication 331, 332f,
 337f, 423–5, 429
The Element of Water (Fiammingo) 178f
Elisabeth of Lorraine 352, 377–8,
 385, 397
Elizabeth I (Queen) 245, 282, 293,
 409–10
embroidery 104, 418
emotion 17–18, 49
 art and 97–8
 colour and 99
emotional fragility 56, 71
engravings
 Adam and Eve 63, 64f, 138
 by Besler 316f
 hair depicted in 50
 Ill-assorted Couple 166f
 by Kilian, L 323f, 360f, 376f
 by Kilian, W. 328f
 of Maximilian I (Duke of
 Bavaria) 264f
 price of 156
 of Wilhelm V 296f
 Willibald Pirckheimer engraving 143f
 woodcuts and 24–5, 47, 106, 128,
 156
entertainment 60, 213–14, 219, 225,
 345–7
equestrianism 189–90, 195
Ernst, Joachim 330
Ernst of Bavaria 237–8
eryngium 103–4
ethnographic curiosities 167, 216,
 299–304, 307–9, 386
European debt crisis 236
evangelicals 139
Evelyn, John 419–20
experimentation
 with chemistry 103
 with materials 97–8
 with pigment 98–9, 116
 with varnish 122–3

fabric. See cloth; textile art
fairs
 animals and 285, 304–6
 carnivals and 60–1
 in Frankfurt 28–30, 291, 306–12

Imperial Relics Fair 47
 in Netherlands 129–30
Falckenborch, Frederick von 359
family
 of Dürer 47, 55–6, 83–4
 finances, spending, and 209–11
 of Fugger, H. 168–70, 173, 198–9,
 234–5, 293–4
 of Hainhofer 275, 287f, 285–6
 of Heller 27, 31, 141
 of Imhoffs 411–15
 of Pirckheimer 59–60, 70–1, 73
famine 397
fashion
 challenge of innovation in 203–9
 costumes and 206–7, 214–16, 221
 dolls and 163–5
 feathers in 201–3
 footwear and 165–7, 166f,
 189–99
 Fugger, H., and 185–99, 201–4
 furs and 208–9
 hair and 49–50, 203–7
 headwear and 201–6, 210–11,
 304, 305f
 investing in 'things' and 209–11
 jewellery and 203–4, 208–9,
 234, 338
 leather and 185–9, 187f, 197–8
 materials and 207–9
 Medici and 174, 192, 220–1
 metallurgy and 208–9
 necklaces and 208–9
 pattern drawing and 207
 purses and 352
 quality and 207–9
 spending on 201–3, 231
 weddings and 173–4, 207–11,
 213–14, 216, 222
 women and 163–5, 192, 203–9
Feast of the Rose Garlands altarpiece
 (Dürer) 51, 58–9, 63–5, 67,
 93–4, 155
 colour in 71–2
 copy of 359–61
 Rudolph II and 359
feathers 132–4, 334–5
 cloaks of 306
 dyes for 201
 in fashion 201–3
 Fugger, H., and 201–3
 trading 202–3
Ferdinand I (Holy Roman
 Emperor) 163
Ferdinand II of Austria 391, 393,
 397–401
Ferrante Imperato's Museum 11f
fertility 32, 377–8, 397
fevers 63, 73
Fiammingo, Paolo 176–7, 178f
Ficino, Marsilio 100–2
Fickler, Johann Baptist 243–6, 253

440 *Index*

finances. *See also* wealth
 book-keeping and 209
 debt and 84–5, 141–2, 209, 213, 217,
 231–40
 Dürer's cost of living and 93
 Dürer's home and 84
 Dürer's insecurity and difficulty
 with 129–30, 137
 Dürer's monetization and 138–9
 Dürer's savings and 84
 family, spending, and 209–11
 fashion spending and 201–3, 231
 frugal times of Thirty Years' War
 and 401, 417–20
 Fugger, H., and 209–11, 222–9
 of Fugger company 169–70
 gambling and 138–9
 for Hellers 28
 investing in Dürer and 211–12
 investing in 'things' and 209–11
 of Maximilian I (Duke of Bavaria)
 343, 345–7, 357
 monopoly and 142
 settling accounts and 213
 social life and 129
 travel expenses and 227
 value of florins and 93
 wealth and 73, 149
 of Wilhelm V 213–14, 222–9, 231–40
 Wilhelm V's debt crisis and
 231–40, 254
 women and 93
Fleckheimer, Katharina 225
Flemish altarpieces 262
florins, value of 93
'folding fabric' 260
food
 diet, health, and 182–3
 famine and 397
 luxury goods and 35–6, 132–4,
 181–3, 216–17
 merchants 182–3
 at weddings 350
footwear. *See* shoes
forgery 367, 377
Fortunatus 47–8
fountains 307–8
The Four Apostles (Dürer) 156–7, 402
Four Books of Human Proportion
 (Dürer) 130, 148
Franck, Pauwels 176–7, 178*f*
Frankfurt, Germany 25, 127, 144–5
 Dominican church in 35–6, 145–6,
 146*f*, 369–73, 431
 fairs in 28–30, 291, 306–12
 Frankfurt's Historical Museum
 in 431
 Heller and 27–32, 35–40
 Jews in 145, 146*f*
 Luther in 145–6
 reform and rebellion in 150–1
 View of Frankfurt am Main 146*f*

Franz Pourbus the Younger 205*f*
fraud 212
 by Bragandino 253
 forgery and 367, 377
Frauentrachtenbuch (Amman) 206–7
Frederick, John (Duke of Saxony) 167
Frederick I 399
Frederick III (Emperor) 1–2, 9, 28,
 60, 75
Frederick of Schleswig (Count) 418
Frederick the Wise (Duke of Saxony)
 23–4, 50–1, 75
 Dürer's letters with 77
 Martyrdom of the Ten Thousand
 and 23–4, 51, 63, 77, 93–4
 negotiation with 77
frescoes 78–9
Friedrichstadt, Germany 418
friendships, of Dürer 17–18, 45.
 See also *specific people*
 Behaim, C. L., and 60–2, 71
 Pirckheimer and 59–62, 69–71
 unconventional 55–62
Fugger, Georg 198–9, 206–7
Fugger, Hans 10–12, 128, 425
 Age of Wonder and 168–71
 Albrecht V of Bavaria and 169,
 179–80, 186, 236–7
 alcohol and 249–51
 appearance of 195–7, 206–7
 art market and 168–71
 astrology and 177–8
 background on 168–70, 173–4
 clothing and 183
 collections of 176–84
 coloured plate of, in *Fuggerorum et
 Fuggerarum Imagines* 226*f*
 Court of Bavaria and 213, 217
 death of 170, 254
 Dürer and 173
 fashion and 185–99, 201–4
 feathers and 201–3
 Fiammingo and 176–7, 178*f*
 finances of 209–11, 213
 food and 181–3
 fraud against 212
 Fugger family and 168–70, 173,
 198–9, 224–5, 293–4
 global trade and 169–70, 246–7
 hair of 206–7
 health and 250–1
 homes of 174–5, 177–9
 household accounts of 209–11
 investing in Dürer and 211–12
 investing in 'things' and 209–11
 leadership of 175
 leather and 185–9, 187*f*
 letters of 10–11, 173, 185, 223–4
 luxury goods of 180–4
 marriage and wife, Elisabeth,
 and 173–4, 181–3
 merchants and 168–71

Munich cabinet of curiosities
 and 243–4, 246–7
Munich court and 173–4
negotiations and 177–8
Ott and 176–7, 186, 203
Quiccheberg and 168
Reformation and 144
religion and 180–1, 249–50, 252
settling accounts and 222–9
shoes and 189–99
stockings and 219–21
taste for paintings and 173–84
textile art and 246–7
wealth of Fugger family and
 169–70, 209–11
weavers and 253
Wilhelm V and 219–29, 231–40,
 245–54
Fugger, Jakob 168–9
Fugger, Marx 169–70, 174, 198, 224–5,
 254, 295
 collections of 176
 Court of Bavaria and 213, 217
 portrait of 243–4
 Wilhelm V's debt and 176, 231–2
Fugger company 168–71
*Fuggerorum et Fuggerarum
 Imagines* 226*f*
furs 208–9

Gaillard, Martin 188–9
gambling 138–9
gardens 12–13, 225
 of Bishop of Eichstätt 327, 330–41
 books on 327, 331–4
 Eichstätt Garden publication
 and 331, 332*f*, 337*f*, 423–5, 429
Geography (Ptolemy) 142
geometry
 body and 49–50, 52, 58, 63–4
 Four Books of Human Proportion
 and 130, 148
 Instructions on Measurements
 and 130–2, 133*f*, 147–8
'German blue' 115–16
German Reformation 131–2
 Lutheranism and 144–9, 151
German religious divisions 159–60
Gesner, Conrad 364–5
Ghent altarpiece (van Eyck) 262–3
glass
 stained 29*f*, 65–7
 Venetian 106
global expansion
 art and 9–12, 245–7
 currencies and 311
 economy and 9–10, 47–8
 trade and 9–10, 47–8, 169–70
gloves 97–8
gold 47–8
 colour 104–5
 thread 52–4

goldsmiths 30, 47, 55–8
 metallurgy and 99–100
Gonzaga, Margherita 205f
Granvelle, Antoine Perrenot de
 (Cardinal) 359
Greece 406–7
Greek studies 70–1, 99
Grien, Hans Baldung 51–2
ground horns 324
Grünewald, Matthias 124
guilds
 abolishment of 47, 83–4
 Art Workers' Guild and 428
 merchants and 47
 painter's guild 4–5

Habsburgs 128–9, 136–7, 163, 173–4,
 198, 239. *See also* Thirty Years' War
 politics and 279–82
 Protestants and 389
 Rudolf of Habsburg and 214–16
Hainhofer, Philipp 13, 162, 227–8, 425
 art agent career and 267–73
 art lovers movement and 350
 Arundels and 401–6, 408, 417–18
 Augsburg and 285–7
 August the Younger and 401, 413
 background on 275–7
 Bishop of Eichstätt and 327–41
 cabinets of curiosities and 270–1,
 272f, 353–6
 commissions and 352, 354
 Court of Bavaria and 318–19
 diplomacy and 327–41
 Dürer paintings and 267, 341,
 359–78
 family and genealogy of 275,
 285–6, 287f
 friendship album of 279, 280f,
 286–7, 348, 349f, 350, 352–3, 429
 Heller altarpiece and 267, 369–78
 horses for Duke of Bavaria
 and 346–7, 356–7
 Maximilian I (Duke of Bavaria)
 and 343–57, 369–87, 401–2
 Munich cabinet of curiosities
 and 289–90
 Munich court and 297–8, 303–4,
 308–9
 networks and career success
 for 279–87
 Philipp II of Pomerania and 321–6,
 338–41, 345–6, 348, 354–7, 362–7
 politics and 334, 354–5, 389–93
 religion and 343–4, 353, 389, 391–3
 Schwegler and 379–87
 as secret agent 389–93
 shells and 311–13, 315–19, 316f, 317f
 silk trade and 291–4
 sourcing special "things"
 by 379–87
 textile art and 269–70

during Thirty Years' War 389–93,
 397–9, 401–8, 413, 417–18
 weddings and 350
 Wesler, Marx, and 348
 wife of 285–6
 Wilhelm V and 267–9, 273,
 289–90, 295–313, 315–19, 322–4,
 327–36, 340–1, 350, 364–8, 391–3
 The Willibaldsburg in 1611 by 329f
 Wotton and 389–91
hair
 aging and 58–60
 art and 49–50
 baldness and 50
 Dürer's 49–50, 58–9, 127
 dyes for 59–60
 in engravings 50
 fashion and 49–50, 203–7
 of Fugger, H. 206–7
 in Heller altarpiece 50
 shaving 270–1
 wigs and 203–4, 206
 women and 203–6
Hals, Franz 292f
hands 97–8, 127
 in *Praying Hands* altarpiece 6–8, 6f
The Hare (Dürer) 58
Harrich, Jobst 37f, 370–4
Hartlib, Samuel 419
Harvey, William 401
hats 201–2, 214–16, 304, 305f
headwear
 fashion and 201–6, 210–11, 304, 305f
 hats and 201–2, 214–16, 304, 305f
health
 alcohol and 339
 animals' medicinal use and 324
 aphrodisiacs and 35–6, 103–4
 balms 339–40, 351
 celestial influences and 101
 childbirth and 32
 of children 32
 colour, vitality, and 183–4
 of Dürer 103–4
 fevers and 63, 73
 food and 182–3
 Fuggers and 250–1
 healing 101–4, 107–8,
 182–3, 324
 of Heller 89, 141–2
 materials 104
 medical knowledge and 324–5
 medical recipes and 107–8, 182–3,
 324–5
 mercury cures and 102–4
 nature and 103–4
 painter's medicine and 107
 pharmacists and 100, 102
 of Pirckheimer 142
 plague and 102, 282, 293–4, 397, 399
 poisons and 61
 rosewater and 324–5

sexuality and 103–4, 182–3
skin care and 102–4
spirituality and 270–1, 325
therapeutic astrology and 102
vinegar and 101
wound healing and 107–8
Heermskerk, Maerten van 262–3
Heller, Jakob
 background on 27–36
 birth of 27–8
 Catholicism and 27–8
 charitable donations by 28–30, 36,
 40, 52, 52f
 children and 31–6, 110–11, 142
 colleagues of 144–5
 death of 141, 145–6
 depiction of Katharina and 34f
 Dürer's fallout with 54, 91–4, 117–19
 Dürer's final correspondence
 with 125
 Dürer's letters with 7, 18, 23–4,
 26, 63, 75–6, 85–95, 113–14,
 116–22, 125
 estate and will of 30–1, 35–6, 141
 extramarital affairs of 32–5
 family of 27, 31, 141
 finances for 28
 Frankfurt and 27–32, 35–40
 funeral of 145–6
 goldsmiths and 30
 health of 89, 141–2
 heirs of 31
 illegitimate son of 35, 142
 marriage of 28
 merchants and 28–30
 parents of 27–8
 Pirckheimer and 89, 141–2
 politics and 28–30
 popularity of 28–30
 religion and 27–30, 35–6
 stained glass of Heller and von
 Melem arms 29f
 wife, Katharina, and 28–32, 35–6,
 54, 63, 141
Heller altarpiece (Dürer) 13–16, 43,
 52–4, 429–31
 advance for 119
 art valuation and 369–73
 brushstrokes in 50
 chasing 359, 369–78
 colour in 87, 89, 91, 93, 97–8,
 113–18, 267
 commissioning of 23–6, 36–41, 56,
 63, 75–6
 copies of 37f, 372–3
 delivery of 119–25
 display, at Frankfurt's Historical
 Museum 431
 Dominican church and
 negotiations for 369–73
 Dürer's appearance within 48, 51
 Dürer's self-depiction within 51, 54

442 Index

Heller altarpiece (Dürer) (cont.)
 final cost of 119–22, 125
 Hainhofer and 267, 369–78
 hair in 50
 Harrich and 37f
 Hellers' reception and first viewing
 of 124
 images of 37f, 52f
 inscription on 51–2, 151
 maintenance and care for 121–3
 materials in 97–8
 Maximilian I (Duke of Bavaria)
 and 357, 359, 369–78
 negotiation for commission
 of 85–95, 117–22
 negotiations for purchase
 of 369–73
 preparatory drawings for 67
 preparing to paint 63–9
 religious iconography in 94–5,
 110–11, 114, 124
 time spent to create 72, 113
 underdrawing for 93–4, 113–14
 van Mander and 265
 varnish and 122–3
 Virgin Mary in 114, 124
 visiting 155–6, 431
Henrietta Maria (Queen) 414–15
Henry VIII (King) 416–17
'high' culture 99
Hoefnagel, Georg 242f
Holbein the Elder 93–4
Holbein the Younger 416–17
Holl, Elias 402–3, 403f
Hollar, Wenzel 409, 410f, 419–20
Holper's workshop 55
Holy Roman Empire 1, 13–16
 Ferdinand I and 163
 Maximilian II and 201–2
 Rudolf II and 169, 198
 Wittelsbach dynasty and 12
Holzhausen, Hamman von 144–6
homes
 of Dürer 69–70, 84, 119–20
 of Fugger, H. 174–5, 177–9
 of Maximilian I (Duke of
 Bavaria) 343–5
homosexuality 145
honour systems 92
Hopfer, Matthäus 361–2
Hörmann, Hieronymus 279–82
Hornschuh (shoe) 165
horses
 equestrianism and 189–90, 195
 Maximilian I (Duke of Bavaria)
 and 346–7, 356–7
 Philipp II and 346–7, 356–7
 Wilhelm V and 346–7, 352, 356
Hortus Eystettensis (Eichstätt
 Garden) 331, 332f, 337f, 423–5, 429
Howard, Thomas ('Arundel', Earl of
 Arundel). See Arundels

Hulsius, Levinus 299–304, 302f, 306
humanism 12, 17–18, 55–6, 70, 404–5
 Lutheranism and 144–5
 religion and 108–9
Hungary 67–9
hunting 302–4
Hutten, Ulrich von 144–5
Hypnerotomachia Poliphili
 (Colonna) 49–50

Iberian Empire 135–6
identity
 masculinity and 73
 religion and 73
idolatry 139
Ill-assorted Couple (Dürer) 166f
Imhoff, Anna 411, 412f
Imhoff, Hans 91–2, 119–20,
 123–4, 263
 Imhoff sale and 411–15
Imhoff, Hans IV 35–6
Imhoff, Willibald 171
 collections of 210
 death of 212
 Imhoff sale and 411–15
Immolation of an Ox (Pausias) 99
Imperial Diet 155, 173, 235, 250–1,
 329–30, 351–2, 354–5, 374–5
Imperial Relics Fair 47
India 245, 309
 Dutch East India Company and 13,
 282–4
 Portuguese State of India 132
 trade and 13, 132, 282–4
indigenous objects
 of Aztecs 132–4, 243f
 ethnographic curiosities and 167,
 216, 299–304, 307–9, 386
 from Mexico 132–4, 136–7, 216
inequality 17–18
 wealth revolts and 144, 147, 149, 252
innovation, challenges of 203–9
inscription 51–2, 151. See also
 signatures
Instructions on Measurements (Dürer)
 130–2, 133f, 147–8
investing. See art market; finances
Isselburg, Peter 316f
Italy. See also Venice, Italy
 commissions in 76–8
 culture in 60–1
 studies in 63–71

Jacobe of Jülich-Cleve-Berg
 (Duchess) 206
James I (King) 389–91, 399
Jamnitzer, Wenzel 157, 158f, 171
Jannssen, Johann 309–11
Java 301
Jesuits 251–2
Jesus Christ 2, 3f, 28–30, 58
 The Lamentation of Christ and 359

salvation and 130
suffering of 131
Virgin Mary and 109–10
Winepress and 76–7
jewellery 203–4, 234, 338
 necklaces and 208–9
Jews 12–13, 418
 in Frankfurt 145, 146f
 hostility toward 145
Johann Konrad von Gemmingen,
 Prince-Bishop of Eichstätt
 (Kilian, W.) 328f
joy 110–11
 art and 106

Kager, Matthias 379–80, 381f
Karlstadt, Andreas 139
Keller, Hans 189
Kilian, Lucas
 Alberti Dureri Noribergensis by 376f
 engravings by 323f, 360f, 376f
 Philipp II of Pomerania-Stettin, 1613
 by 323f
 Portrait of Albrecht Dürer by 360f
 Rottenhammer and 359–61, 375
Kilian, Wolfgang 328f
Kirchheim Palace 177, 253–4
knowledge
 art and 98–103
 books and 99–101
 botanical 100, 103–4, 423–4
 Classical rhetoric and 63–71, 276
 convents and spread of 104–5, 108
 culture, intellectualism and 99
 from Greek studies 70–1, 99
 medical 324–5
 new and unique 247
 pigment and 98–100, 104–5
 practice, learning, and 98–104
Koberger, Anton 56–8, 109
Kocher, Johannes 369–70
Kraffters 231–2
Kraft, Adam 51–2, 79–80, 80f
Kresser, David 370–5
Kunstbüchlein art theory 156–7

ladies-in-waiting 173–4
The Lamentation of Christ (Dürer) 359
Landauer, Matthäus 65
Landauer Altar (Dürer) 65, 66f, 77,
 93–4
Landsberg Circle 214–16
landscapes 156–7, 335, 335f, 379
Langenbucher, Achilles 382–5
lapis lazuli 91
Lasso, Orlando di 214
learning 98–104. See also knowledge
leather
 fashion and 185–9, 187f, 197–8
 Fugger, H., and 185–9, 187f
 techniques 185
 uses for 188

varnish 185
wallcoverings 185–8, 187f
leg garments 202
stockings and 219–21
Lewes, Robert 293
Leyden, Lucas van 90f
The Life of the Painters (Vasari) 155–6
Life of the Virgin (Dürer) 128
life span 62, 107
linseed oil 106
Lippi, Filippino 78–9
Lives of Artists (Vasari) 79, 151, 259
Lomazzo, Giovan Paolo 259
looting 406–8
Lucaris, Cyril 406–7
Ludwig, Peter 311–12, 318–19
Ludwig, Philipp 330, 356–7
Luther, Martin 8, 12, 17–18
'Babylonian Captivity' treatise
by 130–1
books by 130–1
Dürer's letters with 131
fame and 130
in Frankfurt 145–6
Lutheranism 251–2, 289, 353, 389
Catholicism and 145–7
Cochläus on 144–5
Dürer and 148–9
German Reformation and
144–9, 151
humanism and 144–5
Pirckheimer and 143f
politics and 329–30
during Thirty Years' War 397
luxury goods 47–8, 214. See also
specific goods
art and 5–6, 12
Arundels and 400–8
coats as 139
Court of Bavaria and 213–17
craftsmanship and 185, 188–9
delivery of 223, 225
diplomatic gifts and 216–17
feathers as 201–3
food and 35–6, 132–4, 181–3, 216–17
footwear as 165–7, 166f
of Fugger, H. 180–4
Pirckheimer and 69
Renaissance and 12
settling accounts for 222–9
sourcing, for Maximilian I (Duke
of Bavaria) 379–87
sourcing, for Wilhelm V 219–22,
295–313, 315–19
spice trade and 48, 210, 245
trade and 202–3
weddings and 350

Maddalena, Maria 353
Madonna (Dürer) 414–15
maintenance. *See* art maintenance
Malafranzosa 103–4

Mander, Carel van 50, 271–3
art market and 259–63
Dürer's paintings and 265
Heller altarpiece and 265
Mannstreu 103–4
Man Writing (Leyden) 90f
maps
Braun and Hogenberg's
contemporary depiction of
Munich 242f
as curiosities 298–9, 300f
navigation and 47–8
Margaret of Austria 129–30, 134–5, 139
background on 136–7
collections of 136–7
Dürer's paintings for 137
Maria of Austria 263
marriage. *See also* weddings
dowries 28
of Dürer 56–8
extramarital affairs and 32–5, 61
of Fugger, H. 173–4
of Heller 28
of Maximilian I (Duke of
Bavaria) 377–8, 401
social class and 285–6
Wilhelm V 213–14
Martyrdom of the Ten Thousand (Dürer)
23–4, 51, 63, 77, 93–4, 361–2
martyrs 23–4, 51–2
Mary of Hungary 262–3
masculinity 73, 192
Massa, Isaac Abrahamszoon 292f
masterpieces
art agents and 362–6
art market for 263, 361–2
authenticity and 263
collecting 361–2
demand for master paintings
and 263, 361–2
Maximilian I (Duke of Bavaria)
and hunt for 359–61, 365, 368
materials and materiality
alchemy and 105
civic life and 108–9
commissions and 79–80, 89, 91,
93, 373
craftsmanship and 79–80,
97–8, 428
experimentation with 97–8
fashion and 207–9
feathers and 201–2
health 104
in Heller altarpiece 97–8
matter and 111
nature and 259–60
religion and 108–9
technique and 116
texturing and 197–8
waterproof 303–4
wood 106–7, 122–3, 308
Matthias (Emperor) 347, 374–5

Matthioli, Ferdinand 361–3, 366–7
Maximilian I (Duke of Bavaria) 7–8,
11–16, 297, 427, 429–30
'Age of Maximilian I' and 343–57
appearance of 344–6
architecture and 345–6
cabinets of curiosities and 344,
353–6
Catholicism and 264–5, 346, 353,
356–7, 374–5, 391
Dürer paintings chased by 263–4,
357, 369–78, 402
engraving of 264f
finances of 343, 345–7, 357
governance by 345–6
Hainhofer and 343–57, 369–87,
401–2
Heller altarpiece and 357, 359,
369–78
horses and 346–7, 356–7
hunting for masterpieces
and 359–61, 365, 368
Imhoff sale and 411
marriages of 377–8, 401
Munich court and 343, 357
palace of 343–5
Philipp II and 346–7, 387
politics and 345–6
reign of 264–5, 329–30, 343
Schwegler and 379–87
sourcing 'things' for 379–87
Thirty Years' War and 348,
397–9, 401
Wittelsbach dynasty and 345–6
Wolfgang Wilhelm and 356–7
Maximilian I (Habsburg Emperor)
2–4, 71, 128–9
death of 129
Maximilian II (Holy Roman
Emperor) 201–2, 244
Mechthild of Bavaria 206
medical recipes 107–8, 182–3, 324–5
Medici, Francesco Cosimo I de 174,
192, 220–1, 248–9
Melanchthon, Philipp 151
Melem, Katharina von
altarpiece, as charitable donor
52, 52f
death of 35–6
depiction of 34f
Heller and 28–32, 35–6, 54, 63, 141
stained glass of Heller and von
Melem arms 29f
Melencolia I (Dürer) 5
Men in a Bath-House (Dürer) 58
Mercatoris, Gerardi 298, 300f
merchants 5–8
art agents and 13, 267–73,
362–6, 375
artists and 8–9, 25
art market and 157–9, 425–7,
429–31

444 Index

merchants (*cont.*)
 Augsburg 162, 167–9, 216–17,
 269–70
 brokers and 217
 careers of 275–6
 commissions for 90–1
 Dutch East India Company and 13,
 282–4
 food 182–3
 Fugger company and 168–71
 global expansion and 9
 guilds and 47
 Heller and 28–30
 monopoly of 142
 negotiations for 90–1
 networks for 91–2, 279–87
 politics and 247
 Renaissance and 7–9
 settling accounts and 222–9
 sourcing pigment and 91, 115–16
 sourcing 'things' and 219–22,
 295–313, 315–19, 379–87
 in spice trade 48, 210, 245
 Thirty Years' War and 16
 trade and 9–13, 202–3
Mercurium suplymatum 102
mercury
 chemistry and 103–4
 cures 102–4
Merian, Matthäus 146*f*
metallurgy
 fashion and 208–9
 goldsmiths and 99–100
 metalwork and 338
 mining and 169–70
Meuting, Anton 162
Mexico 132–4, 136–7, 216
Michelangelo 244, 338
Mielich, Hans 164*f*, 215*f*
miniatures 382–5, 387
mining, metal 169–70
modeling 135
monograms 50
monopoly 142
Moorish craftsmanship 185, 188
 Porsequine shoes and 189–91, 190*f*,
 193, 195–7
morality 346
 body and 250
 poetry and 62, 85
 religious iconography and 135
Morris, William 420, 428
Mozart, Anton 14*f*, 390*f*
Mielich, Hans 164*f*, 215*f*
Munich, Germany 289
 Braun and Hogenberg's
 contemporary depiction of 242*f*
 religion in 248–9
 St Michael Church, Munich
 248–9, 253–4
Munich cabinet of curiosities
 culture and 244

Dürer and 244
 evolution of 244
 Fugger, H., and 243–4, 246–7
 gifts as entry 'fee' for 242
 Hainhofer and 289–90
 politics and 244–6
 portraits in 244
 textile art and 245–7
 trade and 245–7
 Visconti, P., and 241–2
 Wilhelm V and 241–7
 Wittelsbach dynasty and 244
Munich court 206, 242, 357
 Fugger, H., and 173–4
 Hainhofer and 297–8, 303–4,
 308–9
 Maximilian I (Duke of Bavaria)
 and 343, 357
Murray, David 418
museums
 Age of Wonder and 159–68
 art market and 159–68
 British Museum 420, 427–8
 clothing in 162–3
 Ferrante Imperato's Museum 11*f*
 Frankfurt's Historical
 Museum 431
 Quiccheberg and 160–8
music 167, 213–14, 236–7, 248–9,
 282, 285
mystery 99–102
Mytens, Daniel 415–16

narcissism 50–1
nature. *See also* animals; plants
 colour and 100–1, 115, 259
 health and 103–4
 materials and 259–60
navigation 47–8
necklaces 208–9
negotiations
 by Arundels 406
 commissions and 76–7, 81, 85–95,
 117–22, 177–8, 352
 Fugger, H., and 177–8
 for Heller altarpiece commissions
 85–95, 117–22, 369–73
 for Heller altarpiece
 purchase 369–73
 for merchants 90–1
Nesen, Wilhelm 145–6
Netherlands
 altarpieces in 151
 Dürer in 127–39
 fairs in 129–30
Neudörffer, Johann 156–7, 171
Northern painters
 colour by 259
 lives of 259–65
 oil of 259
 van Eyck fairy tale and 259–60
Nova Reperta (Straet) 260, 261*f*

nude paintings 290
 Dürer's nude self-portrait 57*f*
nuns 104–5, 108
Nuremberg, Germany
 altarpiece for chapel in 26
 Arundels and 408–11
 brothels in 60
 butcher in 44*f*
 carnivals in 60–1
 Dürer's paintings for Nuremberg's
 council 149–50
 Frederick III and 1–2, 9, 28,
 60, 75
 market square 45
 New Gate 45
 Nuremberg Court 28
 Nuremberg's Great Council 83–4,
 92, 100, 128, 149–50, 155–7, 369
 politics in 47
 Schöne Brunnen fountain in 45–7
 size of 1
 social class in 47, 156–7
 Nuremberg Chronicle (Koberger)
 56–8, 109
nut oil 106

object histories 428–9
oil 373
 cloth painting with 105–7
 of Northern painters 259
 pigment and 97–9
 properties of 106–7
 recipes 107–8
 types 106–7
 on wood 106–7
old age 62, 107
Orpheus, 1628 (Savery) 335*f*, 356,
 379–83
Ortelius, Abraham 298
Ott, David 176–7, 186, 203
Ottoman rain hat 304, 305*f*
Otts 176–7

Page from Hans Weigel,
 Trachtenbuch 190*f*
painter's guild 4–5
painter's medicine 107
painting cloth 105
painting manual, by Dürer 106, 115
paint recipes 106
Panofsky, Erwin 110–11
pants 202
Paracelsus 103–4
pattern drawing 207
Paumgartner's altarpiece (Dürer)
 58–9
Pausias 99
Peace of Augsburg (1555) 159–60,
 168–9, 237–8
Peace of Westphalia 418
Peasant Wars 149, 252
Persia 418

Index 445

perspective 97–8
 colour and 63–4
Perugino 78–9
Petty, William 406–10
Pfister, Marina 167
pharmacists 100, 102
Philip II of Spain 198, 214, 216–17, 253–4, 262–3
Philipp II (Duke of Pomerania)
 Bishop of Eichstätt and 330–1, 334–6, 340–1
 death of 389
 Dürer paintings and 362–7
 Hainhofer and 321–6, 338–41, 345–6, 348, 354–7, 362–7
 horses and 346–7, 356–7
 Maximilian I (Duke of Bavaria) and 346–7, 387
 Wilhelm V and 322–4, 327, 330–1
Philipp II of Pomerania-Stettin, 1613 (Kilian, L.) 323*f*
Pighini family 414–15
pigment. See also *specific colours*
 aurum 105
 colour and 3*f*, 17–18, 91, 93, 98–100, 104–5, 114, 116–18
 commissions and 91, 93
 cosmetics and 102
 cost of 115–17
 dry 114
 Dürer's knowledge of 98–100
 experimentation with 98–9, 116
 knowledge and 98–100, 104–5
 lapis lazuli and 91
 oil and 97–9
 sourcing of 91, 115–16
 ultramarine and 106, 114–17
Pinder, Ulrich 109
 on Virgin Mary 109–10
pious devotion 108–9
Pirckheimer, Willibald 35, 99–100, 420
 appearance of 61–2
 Arundels and 404–5
 assault by 91
 background on 59–62
 Behaim, C. L., and 72–3, 102–3
 belongings of, after death 69, 104
 classical Italian studies and 70–1
 collections of 69, 156, 171, 211–12
 Dürer and 59–62, 69–71, 130, 171, 212
 Dürer's letter's with 48, 64–5, 69–70, 84
 Emperor Maximilian I and 128–9
 family of 59–60, 70–1, 73
 Ficino and 102
 health of 142
 Heller and 89, 141–2
 Lutheranism and 143*f*
 luxury goods and 69
 Paracelsus and 103–4

shopping lists of 69
 sister, Eufemia, and 104–5
 Willibald Pirckheimer engraving 143*f*
 women and 59–62
plague 102, 282, 293–4, 397, 399
Planckfelt, Jobst 128
plants. *See also* gardens
 botanical knowledge and 100, 103–4, 423–4
 as curiosities 167
 dyes and 220
 healing and 103–4
 Hortus Eystettensis 331, 332*f*
 tulips 415–16
Plato 275–6
Pliny the Elder 99
poetry
 by Dürer 85, 87, 107
 morality and 62, 85
poisons 61
polish. *See* varnish
politics 9
 art lovers and 321–7, 339–40, 357
 Bishop of Eichstätt and 329–31
 Calvinists and 329–30, 353, 374–5
 Charles V and 145–6
 diplomacy and 327–41
 diplomatic gifts and 43, 216–17, 321–2, 324, 417–18
 for Dürer 18
 Ferdinand II of Austria and 391, 393
 Fuggers and 168, 173
 Habsburgs and 279–82
 Hainhofer and 334, 354–5, 389–93
 Heller and 28–30
 of Iberian Empire 135–6
 information and secret agents of 279–82
 Lutheranism and 329–30
 Maximilian I (Duke of Bavaria) and 345–6
 merchants and 247
 Munich cabinet of curiosities and 244–6
 in Nuremberg 47
 policy of neutrality and 340
 Reformation and 145–6
 religion and 11–16, 252–3, 279–82, 321, 346, 353–7, 370–1, 374–5, 389–93
 secret agents and 389–93
 Thirty Years' War and 16, 348, 389–93
 trade and 237–8, 245, 247
 wealth and 149
 weddings and 356–7
 Wilhelm V and 253–4
Porsequine shoes 189–91, 190*f*, 193, 195–7
Portrait of Albrecht Dürer (Kilian, L.) 360*f*

Portrait of Isaac Abrahamszoon Massa (Hals) 292*f*
Portuguese gifts 134
Portuguese State of India 132
potters 131–2
Pourbus, Franz 205*f*
Praying Hands altarpiece (Dürer) 6–8, 6*f*
pregnancy 32, 33*f*, 56
pre-Raphaelites 420
pre-Reformation art 264–5
The Presentation of the Pomeranian Cabinet (Mozart) 14*f*, 390*f*
prints
 art market and 127–30, 138
 commercial print 8
 storing 156
Protestant Reformation 13–16
Protestants 10, 175. *See also* Thirty Years' War
 in Augsburg 252
 Catholic Renewal and 254
 Catholics and 252, 254, 269–70, 321, 329–30, 343–4, 397–9
 Habsburgs and 389
 refugees 12–13
Protestant Union 329–30, 343–4
Ptolemy 72, 142
punishment
 shaming and criminal 92
 sin and 32, 110–11, 141
purgatory 130–1
purses 352

Quiccheberg, Samuel
 art market and 159–68
 background on 159–60
 culture and 159–68, 171
 curiosities and 167, 241–2
 Fuggers and 168
 museums and 160–8
 religion and 159–60, 171

rabbits 223
racial stereotypes 303–4
Randel the fool 249
Raphael 81, 415–16
Ratgeb, Jörg 30
recipes
 by Behaim, C. L. 102–3
 medical 107–8, 182–3, 324–5
 oil 107–8
 paint 106
 for varnish 122–3
red colour 135, 183–4
reform
 civic life and 144–51
 in Frankfurt 150–1
 wealth and 147–8
Reformation 127
 art market and 175
 Catholic 13–16, 250

446 Index

Reformation (cont.)
Fugger, H., and 144
German 131–2, 144–9, 151
Lutheranism and 144–9, 151
politics and 145–6
Protestant 13–16
writers 144
refugees 12–13, 307–8, 405
Regensburg Diet 201–2, 357, 392
Regiomontanus 84
religion. *See also* Reformation; *specific religions*
art and 13–16, 52
art lovers and 327–9
art market and 175, 269–70, 315
Arundels and 405–10, 414–15
in Augsburg 175, 252
baptisms and 32, 35
Bible and 30, 40, 131, 139, 148
books and 130–1
Christianization and 45–7
diplomacy and 327–41
Dürer and 8, 109–11
Edict of Restitution and 397
Fugger, H., and 180–1, 249–50, 252
German religious divisions 159–60
Hainhofer and 343–4, 353, 389, 391–3
health, spirituality, and 270–1, 325
Heller and 27–30, 35–6
homosexuality and 145
humanism and 108–9
identity and 73
martyrs and 23–4, 51–2
materials and 108–9
in Munich 248–9
pious devotion and 108–9
poetry and 62
politics and 11–16, 252–3, 279–82, 321, 346, 353–7, 370–1, 374–5, 389–93
Quiccheberg and 159–60, 171
religious pamphlets and 131
rituals and 30, 40
sin and 32, 110–11, 130–1, 141
social life and 429–30
spiritual guidance and 109–11
Thirty Years' War and 389–93, 397–9
trade and 253, 269–70
women and 58
religious iconography 97–8, 128, 130–1. *See also* Jesus Christ; Virgin Mary
evangelicals and 139
in Heller altarpiece 94–5, 110–11, 114, 124
idolatry and 139
morality and 135
religious processions 248–50
religious stereotypes 251–2
Rembrandt 416

Renaissance 2–4, 427–8
altarpieces of 24–5, 80–1
art that dominated 43
chemistry during 99–100
colour in 43
'Dürer Renaissance' 12, 267–73
luxury goods and 12
merchants and 7–9
Renata of Lorraine 204–6, 213–16, 295
repair, of damage 122–3
Return of the Dutch Second Voyage to Nusantara (Vroom) 283*f*
Rhein, Margaretha vom 52–4, 53*f*
Rhinoceros woodcut (Dürer) 2, 4*f*
riding boots 189–90, 195
rituals 30, 40
Roe, Thomas 406–7
rosewater 324–5
Rösslin, Eucharius 32, 33*f*
Rottenhammer, Hans
art agents and 362–5, 375
background on 362–3
Kilian, L. and 359–61, 375
Royal Society 419–20
Rubens, Peter Paul 407–8, 418
Rudolf of Habsburg 214–16
Rudolph II (Emperor) 169, 198, 201–2, 248, 311–12, 363–4
death of 368–9
Dürer's paintings and 263, 359–61
painting of, in Hainhofer's friendship album 349*f*
ruling women 163
Ruskin, John 420

saffron colour 250–1
St Bartholomew Church, Venice 155
St Michael Church, Munich 248–9, 253–4
St Sebald Church 51–2, 108–9, 307–8
salvation 130–1
sarcasm 148
Satan 130–1
Savery, Roelandt 335, 335*f*, 356, 379–83
Schaller, Cyprian 167–8
Schardt, Johann Gregor van der 412*f*
Schedel, Hartmann 109
Scheurl, Christoph 92
Schön, Eberhard 50*f*
Schöne Brunnen fountain, Nuremberg 45–7
Schongauer, Martin 24–5
Schümberger, Johann 167–8
Schwegler, Johannes 295, 315–16, 334–5, 379–87, 380*f*
scientific revolution 347–8
scissors 270–1
sculptures 28–30, 157, 158*f*, 175
'selfie' habits 50–1, 95
self-portraits
of Dürer 2, 3*f*, 50–1, 54, 57*f*, 58, 95, 103–4, 156, 410*f*

Dürer's two final 67–9
of Kraft 80*f*
nude 57*f*
Senckenberg, Johann Christian 316*f*
Serpent labret with articulated tongue, gold, Aztec 243*f*
The Seven Daily Times of Prayer (Dürer) 109
sexuality
appearance and 73
health and 103–4, 182–3
male fidelity and 103–4
sexual boasting and 60, 73
women and 58
shading 97–8
shaving 270–1
shells
cleaning of 318–19
as curiosities 311–13, 315–19, 316*f*, 317*f*, 318*f*
nature and 13, 247–8, 277, 365–6
shields 134
Ship of Fools woodcut (Brant) 43, 46*f*
shoes 165–7, 166*f*
Fugger, H., and 189–99
Italian courtier wearing 190*f*
masculinity and 192
Porsequine 189–91, 190*f*, 193, 195–7
riding boots 189–90, 195
for Wilhelm V 192–3, 224
women's 192
Sibmacher, Johann 302–3
Sickingen, Franz von 142
signatures 50
inscription and 51–2, 151
not signing works with 51–2
use of 51–2
silk
cloth 115, 224, 232–4, 233*f*, 291–4, 297
clothing 197, 208–9, 219–21
craftsmanship 232–4
Hainhofer and trade of 291–4
stockings 219–21
sin 249–50
confession and 131
punishment and 32, 110–11, 141
salvation and 130–1
skin care 102–4
skins, animal 299–304, 302*f*
slavery 132
Sloane, Hans 420, 428
snails 247. *See also* shells
social class 83–4
appearance and 47
clothing and 47–8, 198–9
'high' culture and 99
marriage and 285–6
in Nuremberg 47, 156–7
social life
ambition and 129
civic life and 83–4

of Dürer 17–18, 83–4, 128–9, 138–9
 finances and 129
 honour systems and 92
 religion and 429–30
 social status and 83–4
solar energy and 'things' 101, 103
Song of Songs (biblical) 62
Spanish conquest 132–4
Spanish debt crisis 209, 236
spectacles 135
speculation
 art lovers and 338–9
 art market and 47, 304–6, 338–9,
 424–5
Spengler, Lazarus 87, 107
spice trade 48, 210, 245
spiritual guidance 109–11
spirituality 270–1, 325
Stadholders 311–12
stained glass 29f, 65–7
Staininger, Hans 361–2
Stalburg, Claus 144–6
 altarpiece of 52–4, 53f
Staupitz, Johann 130–1
Stecher, Bernhard 128
stereotypes
 racial 303–4
 religious 251–2
stockings 219–21
Stoss, Veit 92
Straet, Jan van der 260, 261f
Stuart, Elizabeth 399
style. *See* fashion
suffering, of Christ 131
Sustris, Friedrich 174, 178–9, 248
syphilis 103–4, 182–3

tailoring 43, 183
Talbot, Alathea (Lady Arundel)
 403–5, 404f, 414–15
tapestries 348, 350–2
taxes 146–7, 252, 398
technique
 colour and 113–14, 349f
 commissions and 77–9
 leather and 185
 materials and 116
 shading and 97–8
temperature 122–3
tennis 219, 225, 239
textile art 162–3, 224–5, 231–2
 colour for 115, 246–7
 embroidery and 104, 418
 Fugger, H., and 246–7
 Hainhofer and 269–70
 Munich cabinet of curiosities
 and 245–7
 silk trade and 291–4
 tapestries and 348, 350–2
 trade and 245–6, 291–4
textile manufacturing 244–5, 419–20
 weavers and 253, 292–3

texturing 197–8
Theatre of the Whole World
 (Ortelius) 298
theft 406–8
Theodosius the Great 406
therapeutic astrology 102
Thirty Years' War 7–8, 12, 428
 Amsterdam crash of 1637
 and 415–17
 art market and 16, 397–418
 Arundels and 400–18
 collectors and 16
 culture and 403–5
 Dürer's works during 397, 402–18
 Edict of Restitution and 397
 end of 418
 famine during 397
 Ferdinand II and 397–401
 Frederick I and 399
 frugal times and 401, 417–20
 Hainhofer during 389–93, 397–9,
 401–8, 413, 417–18
 Imhoff sale during 411–15
 Lutheranism during 397
 Maximilian I (Duke of Bavaria)
 and 348, 397–9, 401
 merchants and 16
 Peace of Westphalia and 418
 plague and 397, 399
 politics and 16, 348, 389–93
 religion and 389–93, 397–9
Thom, Hans 68f
Three Books on Life (Ficino) 100–2
time 67
 commissions and 75–6, 89
 delivery and 75
 on Heller altarpiece 72, 113
 success measured by 72
Titian 25, 173, 179–80, 361–2, 370, 418
tones, colour 114
Tossignani, Alessandro 247
trade
 Amsterdam and 282–4
 of animals 304–6
 Atlantic 132
 of books 28
 commercialization and 28–30
 currencies and 93
 Dutch 282–4, 311–13, 415–16
 Dutch East India Company and 13,
 282–4
 feathers 202–3
 global expansion and 9–10, 47–8,
 169–70
 India and 13, 132, 282–4
 luxury goods and 202–3
 merchants and 9–13, 202–3
 Munich cabinet of curiosities
 and 245–7
 navigation and 47–8
 politics and 237–8, 245, 247
 religion and 253, 269–70

of shells 315–19
silk 291–4
sourcing 'things' and 219–22,
 295–313, 315–19, 379–87
spice 48, 210, 245
textile art and 245–6, 291–4
transporting art. *See* delivery
travel
 expenses 227
 voyages and stories of 299–304
Tuchers 67–9, 119–20
tulips 415–16

ultramarine 106, 114–17
uncommissioned paintings 2,
 67–9, 83
underdrawing 93–4, 113–14
underpainting 113–16

Valckenborch 369–73
value. *See* art valuation
van Eyck, Jan 262–3
van Eyck fairy tale 259–61
varnish
 colour and 122–3
 experimentation with 122–3
 Heller altarpiece and 122–3
 leather 185
 maintenance and 122–3
 polish and 102, 315–16
 recipes for 122–3
Vasari 214–16, 261
 The Life of the Painters by 155–6
 Lives of Artists by 79, 151, 259
Vaudémont 353
velvet 219, 231, 293
Venetian church of San Bartolomeo
 di Rialto 25
Venetian Council of Ten 64–5
Venetian glass 106
Venice, Italy
 colour in 115–17
 Dürer in 58–60, 63–71
 St Bartholomew Church in 155
View of Frankfurt am Main (Merian) 146f
vinegar 101, 324–5
Virgin and Child altarpiece (Dürer) 63
Virgin Mary 139, 175, 409–10
 in Heller altarpiece 114, 124
 Jesus Christ and 109–10
 Mary's Assumption and
 Coronation 109–10, 151
 Pinder on 109–10
 power of 108–9
 sorrow of 109–10
Virgin on the Rocks (Da Vinci) 79
Vischer, Peter 51–2
Visconti, Gasparo 231
Visconti, Prospero 194–5, 238–9,
 241–2
vitality 183–4
Vladislav (King of Hungary) 67–9

448 Index

Von Gemmingen, Johann Konrad.
 See Bishop of Eichstätt
Vorsterman, Lucas 404*f*
Vroom, Cornelis 283*f*

wallcoverings 185–8, 187*f*
Walther, Bernhard 84
Wanli (Chinese Emperor) 270–1, 427
War and Peace (Titian and Rubens) 418
watercolours 338, 428
waterproof materials 303–4
wealth
 of Bishop of Eichstätt 330–1
 civic reform and 147–8
 finances and 73, 149
 Fortunatus myth and 47–8
 of Fugger family 169–70,
 209–11
 of Imhoff family 411–15
 Peasant Wars and 149
 politics and 149
 revolts against 144, 147, 149, 252
 spice trade and 48, 210, 245
weather 122–3
weavers 253, 292–3
weddings 285–6
 fashion and 173–4, 207–11, 213–14,
 216, 222
 food at 350
 Hainhofer and 350
 luxury goods and 350
 politics and 356–7
Weigel, Hans 190*f*
Weinsberg, Hermann 80–1
Weiss, David 252
Weißenstein, Elisabeth Nothafft
 von 173–4, 181–3
Welser, Ludwig 245–6
Welser, Marcus/Marx 348, 353–4,
 362, 413
Wicquefort, Joachim de 411–13
wigs 203–4, 206
Wilhelm V (Duke of Bavaria) 175–6
 in *Albrecht and Anna of Bavaria with
 their five descendants* 164*f*
 Albrecht V of Bavaria and
 231–9, 241
 appearance of 248–9
 Bishop of Eichstätt and 327,
 330–6, 340–1
 Catholic Renewal and 248–9

coat of arms 238–9
Court of Bavaria and 213–14
death of 393
debt crisis of 231–40, 254
diplomacy and 327–41
Dürer paintings and 361,
 364–8
engraving of 296*f*
Ferdinand II and 393
finances and spending of 213–14,
 222–9, 231–40
Fugger, H., and 219–29, 231–40,
 245–54
Hainhofer and 267–9, 273, 289–90,
 295–313, 315–19, 322–4, 327–36,
 340–1, 350, 364–8, 391–3
horses and 346–7, 352, 356
leadership of 245–54
marriage of 213–14
Medici and 248–9
Munich cabinet of curiosities
 and 241–7
Philipp II of Pomerania and
 322–4, 327, 330–1
politics and 253–4
private collection of 248
settling accounts of 222–9
shells and 315–19
shoes for 192–3, 224
sourcing 'things' for 219–22,
 267–9, 273, 289–90, 295–313,
 315–19
state-building mission of 253–4
stockings and 219–21
Willibald Pirckheimer engraving
 (Dürer) 143*f*
The Willibaldsburg in 1611
 (Hainhofer) 329*f*
Wimpfeling, Jakob 24–5
wine 128, 147, 249–50, 339
Winepress 76–7
witchcraft 92
Witch Riding Backwards (Dürer) 58
Wittelsbach dynasty 12, 216–17,
 222–3, 237–8, 248–9
 during debt crisis 237–9
 Maximilian I (Duke of Bavaria)
 and 345–6
 Munich cabinet of curiosities
 and 244
Wittenberg castle 155

Wolfgang Wilhelm (Count Palatine
 of Neuburg) 356–7
Wolgemut, Michael 56–8, 62
women
 brothels and 60
 childbirth and 32, 33*f*, 59–60
 clothing of 207–9
 dolls and 163–5
 fashion and 163–5, 192, 203–9
 fertility and 32, 377–8, 397
 finances and 93
 hair and 203–6
 ladies-in-waiting 173–4
 marriage, extramarital affairs,
 and 32–5, 61
 necklaces and 208–9
 Pirckheimer and 59–62
 pregnancy and 32, 33*f*, 56
 religion and 58
 ruling 163
 sexuality and 58
 shoes for 192
 witchcraft and 92
 in *Witch Riding Backwards* 58
wood 106–7, 122–3, 308
woodcuts 298, 416
 Apocalypse 2, 47, 58
 Dürer as Old Man with Coat of Arms
 woodcut (Schön) 150*f*
 engravings and 24–5, 47, 106,
 128, 156
 experimenting with 2
 of Fortunatus 47–8
 price of 156
 rhinoceros 2, 4*f*
 Rhinoceros woodcut 2, 4*f*
 Ship of Fools 43, 46*f*
Wotton, Henry 389–91
wound healing 107–8
writing
 by Dürer 17–18, 87, 95, 109, 130–2
 Dürer's poetry 85, 87, 107
 Instructions on Measurements, by
 Dürer 130–2, 133*f*, 147–8
 poetry and 62, 85
 Reformation writers and 144
 The Seven Daily Times of Prayer, by
 Dürer 109

Zwölbrüderstiftung, Hausbuch der
 Mendelschen 44*f*, 68*f*